Nineteenth-Century Theories of Art

CALIFORNIA STUDIES IN THE HISTORY OF ART

Walter Horn, Founding Editor
James Marrow, General Editor

Discovery Series

NINETEENTH-CENTURY THEORIES OF ART

JOSHUA C. TAYLOR

UNIVERSITY OF CALIFORNIA PRESS

Berkeley, Los Angeles, London

University of California Press
Berkeley and Los Angeles, California

University of California Press, Ltd.
London, England

First Paperback Printing 1989

Library of Congress Cataloging-in-Publication Data

Nineteenth-century theories of art.
 (California studies in the history of art; 24)
 Includes bibliographical references and index.
 1. Art criticism—Europe—History—19th century.
I. Taylor, Joshua Charles, 1917–1981. II. Series.
N7476.T44 1987 701'.1'8094 86-7054
ISBN 0-520-04888-1 (alk. paper)

Printed in the United States of America
 3 4 5 6 7 8 9

The paper used in this publication meets the
minimum requirements of American National Stan-
dard for Information Sciences—Permanence of Paper
for Printed Library Materials, ANSI Z39.48–1984. ∞

Contents

Preface

During his many years as a professor of Art History at the University of Chicago, Joshua C. Taylor offered a course on nineteenth-century theories of art. For use as instructional aids, he translated numerous French and Italian texts that he selected for their unexpected insights into the activities of artists and critics. He eventually conceived of collecting in one volume texts by some sixty British, Italian, French, and German authors, a number later reduced to the forty-seven writers represented in this volume. In 1970, after assuming the directorship of the National Museum of American Art (then the National Collection of Fine Arts), Taylor grouped the translations with the aid of his first assistant at the museum, Richard N. Murray.

Taylor envisioned a volume of six thematic sections, each of which was to be preceded by an essay that would elucidate the associations among the writers there represented. To complement his own translations of French and Italian texts, Taylor selected outstanding previously published translations; for German texts, he solicited the help of former students and colleagues with specialized knowledge of German language and literature. He also began to prepare biographical headnotes to introduce the individual selections. At the time of his death in April 1981, he had completed introductions to the six sections, prepared a general introduction to the volume, and composed footnotes for all the translations. Only six of the forty-seven biographical headnotes remained incomplete, their preparatory materials interfiled among the miscellaneous drafts. On a separate list, Taylor had also noted bibliographic items and dating problems to be researched and resolved before publication of the volume.

In the fall of 1981, under the aegis of the museum's acting director, Harry Lowe, and later under the present director, Charles C. Eldredge, the manuscript was examined and plans were made to publish it with minimal modification. As the editor encharged to oversee the final preparation of the manuscript, I researched and verified all dates, titles, and bibliographic references and wrote the six remaining headnotes based on Taylor's notes; these brief additions are identified by the initials "J.L.Y." All bracketed annotations and footnotes signed "Ed." are Taylor's; other footnotes follow those of the original published sources. Unless otherwise noted, all translations were made by Taylor.

Nineteenth-Century Theories of Art juxtaposes well-known texts with virtually unknown writings by artists and critics. Joshua Taylor favored texts dating from the late eighteenth and early nineteenth centuries, giving more attention to authors such as Gilpin, Chateaubriand, and Milizia than to later figures. He found it difficult, in fact, to locate late-century texts worthy of inclusion, and his final decision was to exclude writings by artists, such as Monet and Pissarro, among whose works he could discover no substantive theoretical tracts. For Taylor, the most original and insightful contributions to this volume—and those he personally enjoyed most—were the Italian texts, many here translated into English for the first time.

In the course of the decade or more during which Taylor worked on the volume, many colleagues contributed to its progress, most notably his former student and assistant at the National Museum of American Art, Richard N. Murray, who located most of the original sources. Two other former students of Taylor contributed significant translations. Michael Snideman translated three German texts and also provided the footnotes for the selection from Friedrich Overbeck. José A. Argüelles was responsible for the translation and the footnotes for the excerpt from Charles Henry's work.

In the final stages of the project, individuals at the National Museum of American Art who aided me in preparing the manuscript for publication included Charles C. Eldredge, Harry Lowe, Birute Anne Vileisis, and Charles J. Robertson. The technicalities of computerized encodement to facilitate typesetting of the volume were handled by Ralph Walker of the Smithsonian Institution's Office of Information Resource Management.

In undertaking the publication of this book, the National Museum of American Art seeks to provide readers with new perspectives regarding international artistic currents of the nineteenth century and to make available for study one of Taylor's finest scholarly endeavors. All royalties from the book will be contributed to the Joshua C. Taylor Fellowship Fund and thus will be applied to the encouragement of scholarship in the history of art, a cause Taylor heartily promoted throughout his life. *Nineteenth-Century Theories of Art* will pay lasting tribute to a singularly insightful thinker and gifted teacher who reveled in exploring relatively uncharted areas of nineteenth-century art history.

James L. Yarnall
National Museum of American Art
Smithsonian Institution
January 1984

Introduction

A theory of art may be many things, from a complex philosophical treatise to a few basic observations jotted down by an artist that illumine the direction of his work. The late eighteenth- and nineteenth-century writings gathered here were selected not because they completely formulate systems governing art, but because they were closely allied with the actual activity of artists. Some were written by artists, some present ideas to which artists responded, and some were composed by critics or historians who were in close touch with the artists and sought to explain their artistic goals.

Many of the essays presented here do reflect to some degree the larger philosophical concerns of the time as argued by "professional" philosophers. But contact between the art community and the universities, where such matters were discussed, was variable. While it was during just this period that the philosophy of aesthetics developed, as the nineteenth century progressed it was a rare philosopher who had anything to say directly to the artist or about contemporary art. There are notable exceptions, particularly in Germany early in the century in the case of Goethe, Ludwig Tieck, August and Friedrich Schlegel, and Schelling, and in France, Victor Cousin and Hippolyte Taine. But for the most part, the large philosophical orientations worked their way into the public consciousness and the formulations of artists through intermediaries, although philosophy was not so exclusively a professional study in the nineteenth century, and literate people read philosophy more than do their twentieth-century counterparts. The works of Hegel, for example, were more influential than those of any other philosopher of the time, yet we must wonder how many people who talked about the Hegelian dialectic had read the works themselves.

The theories on which artistic activity was based, however, were not simply those that trickled down from on high. They had their own integrity, which was proved not by argument but by the creation of works of art. The theory of an artist may be shown to be faulty, but if it aided him in the creation of significant works of art, it cannot be ignored: despite its errors, it remains in its way a part of the substance of his art. And it is significant that in the nineteenth century most artists felt it necessary to found their artistic practice on a consciously established premise. Quite possibly just this peculiar involvement be-

tween art and theory makes this period so much a part of what we recognize as modern art.

Factions in the artistic community had existed in the past, based on diverse traditions, usually geographical in origin, but only in the later eighteenth century were they so consciously formulated and militantly maintained. In art, as in other areas of human endeavor, one could no longer simply accept the faith of one's fathers. Every artist had to choose his direction, had to decide for himself what art was about. What is often referred to as nineteenth-century eclecticism was in effect the opening of the intellect to multifarious pursuits. But to choose requires some criterion, even if caprice, and the selection of a criterion, in turn, prompts a defense of the choice. Many of the essays reproduced here are in fact defenses of artistic choices, decisions made because of an artistic leaning or desire, then rationalized by theory. But even if *post facto* to the judgment, the theory was necessary for artistic fulfillment. It created the intellectual environment in which the artistic impulse could be realized. More and more, the theoretical premise became identified with the subject of art.

The reading interests of artists, as evidenced from their works and writings, changed significantly throughout the century. Literary works such as the Homeric epics and the Bible gave way to philosophical, historical, and eventually scientific writings. With science came poetry, which eventually supplanted history or narrative. The painter painted as the poet wrote; their arts did not copy one another but joined with music as equivalents in the new understanding of the arts and the mind. As the artists changed, so too the intellectual preparation for art demanded of the spectator changed. What was one to read in order to make contact with the works of the Impressionists? A treatise on perception and color provided by the critics? the fantasies of Odilon Redon? the poetry and critical writings of Baudelaire and Flaubert? Literary values did not decrease as the century progressed, but the nature of the literature deemed relevant changed.

A major problem in studying the nineteenth century is posed by the fact that it was constantly studying itself. When someone is continuously telling you what he thinks and feels and indeed is, it is difficult at times to separate the self-portrait from reality. We have inherited many slogans and terms from the time—classicism, realism, romanticism—that provide tempting handles for discussion. But historians must resist these ready-made categories—or at least put them aside—if they wish to understand the fascinating complexity of the time. Headlines from the past are not a very good basis for history, precisely because they were formulated to make history. In order to try to restore some of the intricate context of these banner movements, I have organized this volume on the basis of general orientations that are not tied to single movements. "Realism" was not the progenitor of a kind of art, but one conceptualization of

art and life that was worked out in other formulations as well. It is more pertinent to ask what embracing the term *Realism* meant to Courbet than to assume he had a corner on reality itself. *Impressionism* was a term applied almost at the end of a varied and complex movement; once the term became current, the movement took on a somewhat different meaning. The insistence on this kind of terminology is part of the texture of nineteenth-century thought, just as the use of manifestos was the expression of a particular attitude toward art in the early twentieth century. The nineteenth century cannot be properly studied without a careful review of its critical language.

In almost all instances, the entries in this volume are complete essays. Although they contain many quotable aphorisms, the method of exposition is often as important as the individual statements. In the translations I have tried to follow as closely as possible the rhetoric of the authors, even though another way of formulating the idea might be more characteristic of English. I have tried, in other words, to keep the translation from being an interpretation. No translation, however, can substitute completely for the original statement, since each language has its own internal logic and cultural connotations.

Because of the extraordinary expansion of communication during the nineteenth century and the establishment of various centers that drew artists from throughout the Western world, art and ideas about art—even those with a nationalistic ring—tended to be international. Nonetheless, each country had its own way of doing things. The tenacious hold of artistic officialdom in France created a totally different situation from that in Italy or the United States. Countries striving for a national identity, such as Russia or the diverse American nations, placed different emphases on various tendencies, sometimes reacting strongly to ideas that were readily acceptable elsewhere. This volume presents some of the major tendencies held to a degree in common; it should be supplemented by further studies closely tied to local situations.

I

BEAUTY AND THE
LANGUAGE OF FORM

A painter reaching maturity in the last quarter of the eighteenth century was faced with a problem quite new in the history of Western art. He was offered, for one thing, an extraordinary freedom of vision, acquainted as he was with many diverse forms of art from far places and remote times, and he might assume that his visual acquaintance would expand. There was no reason for his not doing precisely as he pleased, choosing his vocabulary from a wide range of possibilities, extending from an exact and styleless imitation of nature to a highly sophisticated and self-consciously artistic construction. He was encouraged by the philosophers to regard himself as a free agent, a unique and self-determining individual. But with unlimited choice comes doubt, and the very freedom from traditional order can carry the threat of chaos and the loss of long-established conventions of communication. Isolation and loneliness often go hand in hand with assertive individuality and willful freedom.

There were two opposing responses to this characteristically modern situation. One was to subjugate all threat of chaos—whether springing from the complexities of perception or from an agitated emotional state—to the clear, constructive powers of the rational mind. Significant content, harmony, and beauty would then be considered to exist only in the realm of the reasonable. Through the persuasive power of art, which could be at once material and rational, man would be able to sense his place in a defined and ordered universe. According to such a plan, true freedom was possible in the sensuous world only when rational limits had been clearly established. The other tendency, as we shall see in Part II, was to bring about in some manner an identity with a spiritual source that could not, by definition, be generalized or set forth in a rationalized form, to be aware of an inner order that could be reached only through a deeply personal, cultivated intuition. For artists who believed in this way of thinking, truth and beauty were to be found only in the realm of imaginative insight and eluded all definition by the powers of reason. Indeed, they held that reason had to be set aside if imagination and inspiration were to func-

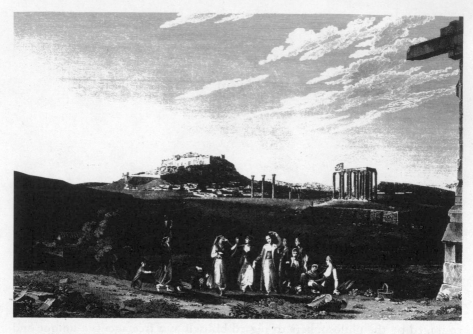

James Stuart and Nicholas Revett, "Temple of Jupiter Olympius," 1794, engraving in *The Antiquities of Athens*.

tion. Only when the artist was willing to cast off dependence on rationally fixed spatial and temporal limits was he free to find his spiritual home.

The first of these directions discovered a means for expression in a study of the arts of ancient Greece and Rome. The products of new excavations (Pompeii was discovered in 1748 and systematic study and excavation were carried on there, at Herculaneum, and at many sites in Greece and Asia Minor), as well as the classical masterpieces known for centuries, furnished objective and measurable criteria for a style that would embody the order, nobility, and heroic stature necessary for the desired rational society. The imitation of ancient Greek and Roman works was not new in art—much sixteenth-century artistic theory was postulated on the perfection of ancient models. But the new interest was even more intense and more determined in its effort to find in the early works the clue to perfect abstract harmony, to perfect beauty. It was as if rationality itself were being threatened, and visual order must serve as a bulwark in its defense.

Rome was the gathering place of artists and connoisseurs sympathetic to this new art that was meant to order and harmonize the modern world. Around Cardinal Alessandro Albani gathered a zealous group that included the painter

Anton Raphael Mengs (1728–1779) and the German antiquary Johann Joachim
Winckelmann (1717–1768), who served as the Cardinal's librarian. Winckel-
mann's *Thoughts on the Imitation of Greek Art in Painting and Sculpture* (Dresden,
1755) singled out those aspects of Greek style that seemed to embody most
clearly transcendent moral virtue and pure beauty. Beauty, he said, was like
fresh spring water "which, the less flavor it has—that is, when it is free from
every foreign particle—the more it is considered salubrious." Art, then, should
strive to separate itself from the local, the particular, and all violent passion in
order to achieve its symbol of perfection. Beginning with a comment from
Winckelmann's book, Gotthold Ephraim Lessing in his *Laocoön* (1766) went
further in separating the experience of the visual arts, which he described as
purely spatial, from the dominance of literature, which he considered tem-
poral. The goal of art, he made clear, was a formal spatial beauty, and beauty
was harmony. Anything that would detract from that harmony, whether
strong expression, historical particularity, or narrative action, was foreign and
destructive of the visual arts. To the followers of Lessing, the primary content
of the visual arts was to be found in its formal order, in its style, whereas in
literature, style was subordinate to narrative, argument, and imagery.

Anton Raphael Mengs, who came to be looked upon as the great renova-
tor of modern painting, set out to embody in his work the new sense of form
drawn from antiquity. He published his ideas on art in an influential book,
Thoughts on Beauty and Taste in Painting (1762). A ceiling fresco of Parnassus
that he completed in the Villa Albani in Rome in 1761 was heralded by his ad-
mirers as possessing true antique quality.

The concept of a pure, abstract beauty that came to the fore in the 1760s did
not remain unchallenged, however, even by those sympathetic to formal per-
fection. For many, the supremacy of didactic moral values in art remained a
major concern. Subject matter, with its ethical overtones, and the relationship
of subject matter to style preoccupied most critics, including Sir Joshua Reyn-
olds who gave a series of lectures to the Royal Academy in London. There was
much discussion of the choice of moment, within the strictures of Lessing, and
many artists still believed that a new subject gleaned from ancient authors was
necessary for a new picture, despite Lessing's having ridiculed the long list of
possible subjects published by the Comte de Caylus. If style were constant,
devoted to a concept of the beautiful, it stood to reason that innovation had to
spring from the treatment of the subject.

As time went on, there were those also who wished to identify the new so-
ber style with social and religious revolution, with a "rational" social structure.
It should be remembered, however, that the new taste was developed under the
patronage of monarchs and an established nobility. It was the projection of an
ideal, not the expression of existing society. The French painter Jacques-Louis
David probably more than any other single individual succeeded in making the

severe rational taste the badge of the French Revolution. However, he also found it appropriate as an apotheosizing style for the empire of Napoleon.

But, as the essay of Quatremère de Quincy indicates, the concept of a pure art of abstract beauty survived earlier didactic responsibilities and political associations. In fact, that which was called "classical" in the nineteenth century was, almost by definition, remote from contemporary association in any sense. It belonged specifically to that special realm of experience christened "aesthetic" by Alexander Baumgarten in 1735 and nicely articulated by Immanuel Kant in his *Critique of Judgment* (1790). It responded to the educated eye, as Francesco Milizia would have it, and the sublimating mind. As the articulation of the concept progressed, moreover, less emphasis was placed on objective measure and more on the intuition of the perceiver and the transforming genius of the artist, qualities that Kant emphasized as basic. A sense of order was considered a predisposition of the human mind. Jean-Auguste-Dominique Ingres considered himself to be a defender of the classical spirit, yet his harmonies, his way of synthesizing instinctively the vagaries of natural form into flowing lines no less sensuous in themselves than the flesh they depicted, are highly personal and unsympathetic to rules. He did not imitate the Greeks but sought to prove the justness of the inherited classical harmony by personally savoring such qualities as he found them in nature itself.

The commonly used term *neoclassical,* so often rather grossly applied to this period and its dominant stylistic directions, as well as the subordinate terms *Roman Revival* and *Greek Revival,* are hardly adequate to suggest the changes of goal and the variations of method that this pursuit of beauty through the definition of harmony and the study of ancient forms underwent. Except for a relatively brief period when modern societies attempted to identify themselves with the ancient world for ideological reasons—and the early years of the American republic form no less an example than the Republic, Consulate, and Empire of France—the emulation of Greek and Roman art was looked upon principally as an authoritative means for achieving an aesthetic end. Ingres admired the Renaissance painter Raphael without thinking himself any less classical. To describe the period in terms of its means rather than its goals can be dangerously misleading. The self-consciously moral and heroic definitions couched in terms of antiquity describe only part of a larger movement that set as its goal the formulation of a realm of experience in which the mind could feast undisturbed on order and harmony.

In their enthusiastic belief in public institutions as a means for raising the level of private morality, reformers in the late eighteenth century did not distinguish between a purely aesthetic order and the institutional form that, extended even to society, would in their optimistic thinking effect a new utopia. Symmetry and rationally articulated structure were adopted as principles of

government and were applied as well to the plans of new towns. Each person, each family unit became an element in the aesthetically designed social machine. But social disillusion eventually sealed the perfect form once more in the province of the mind, to make it a refuge from the chaos of an ever more complex and incomprehensible world.

"Classical" art functioned for society at this time in a way far different from art in Greece at the golden moment of the late fifth century B.C. for which the word *classical* was coined. It was consciously supported as a corrective to sensuous excess and moral disintegration. To be classical was to be a reformer: to carry on an active battle with the powers of darkness, however they might be defined. "Neoclassical" does not so much describe a new classical sense of harmonious equilibrium between animal nature and the divine aspect of the human mind, as an almost opposite view of the world in which uncertainty about the very nature of humankind prompts the imposition of a limiting order. The very desire to assume quite deliberately the trappings of the classical is a revealing symptom of a nonclassical state of mind.

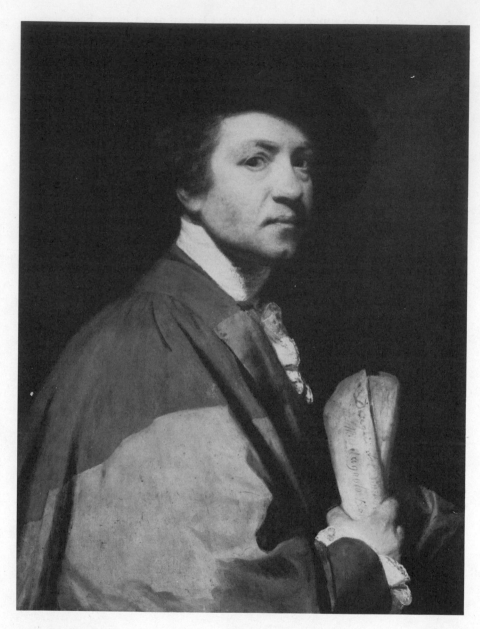

Sir Joshua Reynolds, *Self-Portrait*, 1775, oil on canvas.

SIR JOSHUA REYNOLDS

Discourses on Art (1771)

The idea of an academy dedicated to the discussion and teaching of art goes back to the sixteenth century. It was based originally on the assumption that the visual arts may be analyzed intellectually, and criticized and improved according to laws not different from those governing literature codified by Aristotle and other authors of the ancient world. While the oldest academy to survive is the Accadèmia di San Luca in Rome, established in 1593 (see Minardi's address to the Accadèmia in Part II), the academy that had the most far-reaching effect was doubtless that founded in France in 1648, with a branch in Rome established in 1666.

Basic to the French academy's thinking, as it was to the thought of earlier academies, was the principle that art was to draw its models from the finest of ancient works and works by selected Renaissance masters, which would serve as guides in confronting the complexities and vagaries of nature. When it came to organizing a painting, one must follow rules of unity and decorum like those advanced for literature. Although in establishing these rules they referred to Aristotle and Horace, among others, the modern academies probably drew more immediate stimulus from contemporary formulations such as Nicolas Boileau's *L'Art poétique* (1674). In art the most revered contemporary text was Charles Alphonse Du Frenoy's long Latin poem, *De arte graphica,* published with a French translation in 1668 and translated into English in 1695 by John Dryden.

From the middle of the eighteenth century a fresh wave of interest in maintaining or raising the intellectual stature of the visual arts prompted the founding of new academies throughout Europe. (The first academy of art in the Americas was founded in Mexico in 1785.) One of the most significant of these was the Royal Academy in London, established in 1768 with Sir Joshua Reynolds (1723–1792) as its first president. The Royal Academy, like others, maintained a school for young artists in which it endeavored to propagate an art that would be consistent with academic beliefs. It was for the special sessions of the school, when the students gathered together with the members of the Academy, usually for the distribution of student prizes, that Reynolds presented his famous discourses.

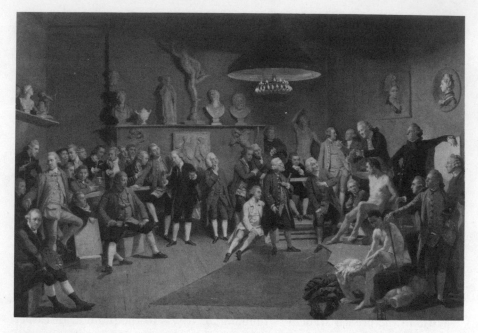

Johann Zoffany, *The Academicians of the Royal Academy*, 1771–72, oil on canvas.

Sir Joshua Reynolds was himself a painter, although he followed few of his own recommendations regarding subject matter—almost all his works are portraits. Well read and member of a brilliant intellectual circle, he speaks in his discourses more as a critic and theorist than as a painter. Yet when it comes to technical matters, notably the use of color, his exploratory interest as an artist breaks through and at times contradicts the dogma. Despite his comments on the Venetians, he devoted much time to penetrating what artists at the time referred to as Titian's "secret" of color. By the time he delivered his final discourse in 1790, he was willing also to concede greater importance to unbridled genius, even to the powerful inspiration of Michelangelo.

Reynolds presented fifteen discourses in all, the first in January 1769 and the last in December 1790, and each discourse was published individually after its presentation. In 1797 the first edition of the collected discourses was printed. The discourses, quickly translated into other languages, were widely read by artists for some generations. The present text is based on the best modern edition of the *Discourses on Art,* that edited by Robert R. Wark (San Marino, Calif.: Huntington Library, 1959), reprinted with the permission of the Henry E. Huntington Library and Art Gallery.

DISCOURSE IV

(Delivered to the students of the Royal Academy on the distribution of prizes, December 10, 1771.)

Gentlemen,

The value and rank of every art is in proportion to the mental labour employed in it, or the mental pleasure produced by it. As this principle is observed or neglected, our profession becomes either a liberal art, or a mechanical trade. In the hands of one man it makes the highest pretensions, as it is addressed to the noblest faculties: in those of another it is reduced to a mere matter of ornament; and the painter has but the humble province of furnishing our apartments with elegance.

This exertion of mind, which is the only circumstance that truly ennobles our Art, makes the great distinction between the Roman and Venetian schools. I have formerly observed, that perfect form is produced by leaving out particularities, and retaining only general ideas: I shall now endeavour to shew that this principle, which I have proved to be metaphysically just, extends itself to every part of the Art; that it gives what is called the *grand style,* to Invention, to Composition, to Expression, and even to Colouring and Drapery.

Invention in Painting does not imply the invention of the subject; for that is commonly supplied by the Poet or Historian. With respect to the choice, no subject can be proper that is not generally interesting. It ought to be either some eminent instance of heroick action, or heroick suffering. There must be something either in the action, or in the object, in which men are universally concerned, and which powerfully strikes upon the publick sympathy.

Strictly speaking, indeed, no subject can be of universal, hardly can it be of general, concern; but there are events and characters so popularly known in those countries where our Art is in request, that they may be considered as sufficiently general for all our purposes. Such are the great events of Greek and Roman fable and history, which early education, and the usual course of reading, have made familiar and interesting to all Europe, without being degraded by the vulgarism of ordinary life in any country. Such too are the capital subjects of scripture history, which, besides their general notoriety, become venerable by their connection with our religion.

As it is required that the subject selected should be a general one, it is no less necessary that it should be kept unembarrassed with whatever may any way serve to divide the attention of the spectator. Whenever a story is related, every man forms a picture in his mind of the action and expression of the persons employed. The power of representing this mental picture on canvass is what we

call Invention in a Painter. And as in the conception of this ideal picture, the mind does not enter into the minute particularities of the dress, furniture, or scene of action; so when the Painter comes to represent it, he contrives those little necessary concomitant circumstances in such a manner, that they shall strike the spectator no more than they did himself in his first conception of the story.

I am very ready to allow that some circumstances of minuteness and particularity frequently tend to give an air of truth to a piece, and to interest the spectator in an extraordinary manner. Such circumstances therefore cannot wholly be rejected: but if there be any thing in the Art which requires peculiar nicety of discernment, it is the disposition of these minute circumstantial parts; which, according to the judgement employed in the choice, become so useful to truth, or so injurious to grandeur.

However, the usual and most dangerous error is on the side of minuteness; and therefore I think caution most necessary where most have failed. The general idea constitutes real excellence. All smaller things, however perfect in their way, are to be sacrificed without mercy to the greater. The Painter will not enquire what things may be admitted without much censure: he will not think it enough to shew that they may be there; he will shew that they must be there; that their absence would render his picture maimed and defective.

Thus, though to the principal group a second or third be added, and a second and third mass of light, care must be yet taken that these subordinate actions and lights, neither each in particular, nor all together, come into any degree of competition with the principal; they should merely make a part of that whole which would be imperfect without them. To every kind of painting this rule may be applied. Even in portraits, the grace, and, we may add, the likeness, consists more in taking the general air, than in observing the exact similitude of every feature.

Thus figures must have a ground whereon to stand; they must be cloathed; there must be a back-ground; there must be light and shadow: but none of these ought to appear to have taken up any part of the artist's attention. They should be so managed as not even to catch that of the spectator. We know well enough, when we analyze a piece, the difficulty and the subtilty with which an artist adjusts the back-ground, drapery, and masses of light; we know that a considerable part of the grace and effect of his picture depends upon them; but this art is so much concealed, even to a judicious eye, that no remains of any of these subordinate parts occur to the memory when the picture is not present.

The great end of the art is to strike the imagination. The Painter is therefore to make no ostentation of the means by which this is done; the spectator is only to feel the result in his bosom. An inferior artist is unwilling that any part of his industry should be lost upon the spectator. He takes as much pains to discover, as the greater artist does to conceal, the marks of his subordinate assiduity. In

works of the lower kind, every thing appears studied, and encumbered; it is all boastful art, and open affectation. The ignorant often part from such pictures with wonder in their mouths, and indifference in their hearts.

But it is not enough in Invention that the Artist should restrain and keep under all the inferior parts of his subject; he must sometimes deviate from vulgar and strict historical truth, in pursuing the grandeur of his design.

How much of the great stile exacts from its professors to conceive and represent their subjects in a poetical manner, not confined to mere matter of fact, may be seen in the Cartoons of Raffaelle.[1] In all the pictures in which the painter has represented the apostles, he has drawn them with great nobleness; he has given them as much dignity as the human figure is capable of receiving; yet we are expressly told in scripture that they had no such respectable appearance; and of St. Paul in particular, we are told by himself, that his *bodily* presence was *mean*. Alexander is said to have been of a low stature: a Painter ought not so to represent him. Agesilaus was low, lame, and of a mean appearance: none of these defects ought to appear in a piece of which he is the hero. In conformity to custom, I call this part of the art History Painting; it ought to be called Poetical, as in reality it is.

All this is not falsifying any fact; it is taking an allowed poetical licence. A painter of portraits retains the individual likeness; a painter of history shews the man by shewing his actions. A Painter must compensate the natural deficiencies of his art. He has but one sentence to utter, but one moment to exhibit. He cannot, like the poet or historian, expatiate, and impress the mind with great veneration for the character of the hero or saint he represents, though he lets us know at the same time, that the saint was deformed, or the hero lame. The Painter has no other means of giving an idea of the dignity of the mind, but by that external appearance which grandeur of thought does generally, though not always, impress on the countenance; and by that correspondence of figure to sentiment and situation, which all men wish but cannot command. The Painter, who may in this one particular attain with ease what others desire in vain, ought to give all that he possibly can, since there are so many circumstances of true greatness that he cannot give at all. He cannot make his hero talk like a great man; he must make him look like one. For which reason, he ought to be well studied in the analysis of those circumstances, which constitute dignity of appearance in real life.

As in Invention, so likewise in Expression, care must be taken not to run into particularities. Those expressions alone should be given to the figures

1. The cartoons were full-scale drawings commissioned for the Sistine Chapel in the Vatican, executed in Raphael's workshop after his designs. Seven of the ten original cartoons were brought to England by Charles I and, at the time Reynolds spoke, were in Buckingham House. They are now in the Victoria and Albert Museum, London.—Ed.

which their respective situations generally produce. Nor is this enough; each person should also have that expression which men of his rank generally exhibit. The joy, or the grief of a character of dignity, is not to be expressed in the same manner as a similar passion in a vulgar face. Upon this principle, Bernini, perhaps, may be subject to censure.[2] This sculptor, in many respects admirable, has given a very mean expression to his statue of David, who is represented as just going to throw the stone from the sling; and in order to give it the expression of energy, he has made him biting his under-lip. This expression is far from being general, and still farther from being dignified. He might have seen it in an instance or two; and he mistook accident for generality.

With respect to Colouring, though it may appear at first a part of painting merely mechanical, yet it still has its rules, and those grounded upon that presiding principle which regulates both the great and the little in the study of a Painter. By this, the first effect of the picture is produced; and as this is performed, the spectator as he walks the gallery, will stop, or pass along. To give a general air of grandeur at first view, all trifling or artful play of little lights, or an attention to a variety of tints is to be avoided; a quietness and simplicity must reign over the whole work; to which a breadth of uniform, and simple colour, will very much contribute. Grandeur of effect is produced by two different ways, which seem entirely opposed to each other. One is, by reducing the colours to little more than chiaro oscuro,[3] which was often the practice of the Bolognian schools; and the other, by making the colours very distinct and forcible, such as we see in those of Rome and Florence; but still, the presiding principle of both those manners is simplicity. Certainly, nothing can be more simple than monotony; and the distinct blue, red, and yellow colours which are seen in the draperies of the Roman and Florentine schools, though they have not that kind of harmony which is produced by a variety of broken and transparent colours, have that effect of grandeur which was intended. Perhaps these distinct colours strike the mind more forcibly, from there not being any great union between them; as martial musick, which is intended to rouse the nobler passions, has its effect from the sudden and strongly marked transitions from one note to another, which that style of musick requires; whilst in that which is

2. Gian Lorenzo Bernini (1598–1680), the greatest Italian sculptor of the seventeenth century, was singled out often in the late eighteenth century as a symbol of the artistic decay against which the modern movement rebelled. His fluently sculptured works create the effect of continuous action rather than of a fixed dramatic moment of unstrained balance. His *David* (1623) is in the Borghese Gallery, Rome.—Ed.

3. *Chiaroscuro*, literally "light and shade," was a term used by those critics who emphasized the definition of volume as more significant than the effect of color. Since most colors are at their richest in the middle values, neither extremely light nor dark, a strong chiaroscuro makes a full and resonant use of color unlikely, if not impossible. Note Reynolds's later strictures on the Venetian painters.—Ed.

intended to move the softer passions, the notes imperceptibly melt into one another.

In the same manner as the historical Painter never enters into the detail of colours, so neither does he debase his conceptions with minute attention to the discriminations of Drapery. It is the inferior stile that marks the variety of stuffs. With him, the cloathing is neither woollen, nor linen, nor silk, sattin, or velvet: it is drapery; it is nothing more. The art of disposing the foldings of the drapery make a very considerable part of the painter's study. To make it merely natural is a mechanical operation, to which neither genius or taste are required; whereas, it requires the nicest judgement to dispose the drapery, so that the folds shall have an easy communication, and gracefully follow each other, with such natural negligence as to look like the effect of chance, and at the same time shew the figure under it to the utmost advantage.

Carlo Maratti was of opinion, that the disposition of drapery was a more difficult art than even that of drawing the human figure; that a Student might be more easily taught the latter than the former; as the rules of drapery, he said, could not be so well ascertained as those for delineating a correct form.[4] This, perhaps, is a proof how willingly we favour our own peculiar excellence. Carlo Maratti is said to have valued himself particularly upon his skill in this part of his art; yet in him, the disposition appears so ostentatiously artificial, that he is inferior to Raffaelle, even in that which gave him his best claim to reputation.

Such is the great principle by which we must be directed in the nobler branches of our art. Upon this principle, the Roman, the Florentine, the Bolognese schools, have formed their practice; and by this they have deservedly obtained the highest praise. These are the three great schools of the world in the epick stile. The best of the French school, Poussin, Le Sueur, and Le Brun, have formed themselves upon these models, and consequently may be said, though Frenchmen, to be a colony from the Roman school.[5] Next to these, but in a very different stile of excellence, we may rank the Venetian, together with the Flemish and the Dutch schools;[6] all professing to depart from the great purposes of painting, and catching at applause by inferior qualities.

I am not ignorant that some will censure me for placing the Venetians in this inferior class, and many of the warmest admirers of painting will think them

4. Carlo Maratti (1625–1713) was a very successful, though rather superficial, Italian painter.—Ed.

5. Nicolas Poussin (1593/4–1665), the greatest French painter of his time, formed his style in Italy and spent most of his life in Rome; Eustache Le Sueur (1617–1655), French history painter; Charles Le Brun (1619–1690), a prolific painter and decorator, was one of the founders of the French Academy in 1848.—Ed.

6. Reynolds is referring to the seventeenth-century Dutch and Flemish painters of genre, landscape, and still life, all of which he considered inferior forms of art, following a scale of values set up in France in the late seventeenth century.—Ed.

unjustly degraded; but I wish not to be misunderstood. Though I can by no means allow them to hold any rank with the nobler schools of painting, they accomplished perfectly the thing they attempted. But as mere elegance is their principal object, as they seem more willing to dazzle than to affect, it can be no injury to them to suppose that their practice is useful only to its proper end. But what may heighten the elegant may degrade the sublime. There is a simplicity, and I may add, severity, in the great manner, which is, I am afraid, almost incompatible with this comparatively sensual style.

Tintoret, Paul Veronese, and others of the Venetian school, seem to have painted with no other purpose than to be admired for their skill and expertness in the mechanism of painting, and to make a parade of that art, which as I before observed, the higher stile requires its followers to conceal.[7]

In a conference of the French Academy, at which were present Le Brun, Sebastian Bourdon, and all the eminent Artists of that age, one of the academicians desired to have their opinion on the conduct of Paul Veronese, who, though a Painter of great consideration, had, contrary to the strict rules of art, in his picture of Perseus and Andromeda, represented the principal figure in shade.[8] To this question no satisfactory answer was then given. But I will venture to say, that if they had considered the class of the Artist, and ranked him as an ornamental Painter, there would have been no difficulty in answering—"It was unreasonable to expect what was never intended. His intention was solely to produce an effect of light and shadow; every thing was to be sacrificed to that intent, and the capricious composition of that picture suited very well with the stile which he professed."

Young minds are indeed too apt to be captivated by this splendour of stile; and that of the Venetians is particularly pleasing; for by them, all those parts of the Art that gave pleasure to the eye or sense, have been cultivated with care, and carried to the degree nearest to perfection. The powers exerted in the mechanical part of the Art have been called *the language of Painters;* but we may say, that it is but poor eloquence which only shews that the orator can talk. Words should be employed as the means, not as the end: language is the instrument, conviction is the work.

The language of Painting must indeed be allowed these masters; but even in that, they have shewn more copiousness than choice, and more luxuriancy than judgment. If we consider the uninteresting subjects of their invention, or at least the uninteresting manner in which they are treated; if we attend to their capricious composition, their violent and affected contrasts, whether of figures

7. Jacob Tintoretto (Jacopo Robusti, 1518–1594); Paolo Veronese (Paolo Calieri, ca. 1528–1588). Significantly, Reynolds does not mention Titian, the greatest of the school. He later excuses Titian somewhat from his criticisms.—Ed.

8. The canvas is now in the museum at Rennes, France.—Ed.

Paolo Veronese, *Perseus and Andromeda*, 1803, engraving in *Annales du Musée*.

or of light and shadow, the richness of their drapery, and at the same time, the mean effect which the discrimination of stuffs gives to their pictures; if to these we add their total inattention to expression; and then reflect on the conceptions and the learning of Michael Angelo, or the simplicity of Raffaelle, we can no longer dwell on the comparison. Even in colouring, if we compare the quietness and chastity of the Bolognese pencil to the bustle and tumult that fills every part of a Venetian picture, without the least attempt to interest the passions, their boasted art will appear a mere struggle without effect; *a tale told by an ideot, full of sound and fury, signifying nothing.*

Such as suppose that the great stile might happily be blended with the ornamental, that the simple, grave and majestick dignity of Raffaelle could unite with the glow and bustle of a Paulo, or Tintoret, are totally mistaken. The principles by which each are attained are so contrary to each other, that they seem, in my opinion, incompatible, and as impossible to exist together, as that in the mind the most sublime ideas and the lowest sensuality should at the same time be united.

The subjects of the Venetian Painters are mostly such as give them an opportunity of introducing a great number of figures; such as feasts, marriages, and processions, publick martyrdoms, or miracles. I can easily conceive that Paul Veronese, if he were asked, would say, that no subject was proper for an historical picture, but such as admitted at least forty figures; for in a less number, he would assert, there could be no opportunity of the Painter's shewing his art in composition, his dexterity of managing and disposing the masses of light and groups of figures, and of introducing a variety of Eastern dresses and characters in their rich stuffs.

But the thing is very different with a pupil of the greater schools. Annibal Carrache thought twelve figures sufficient for any story: he conceived that more would contribute to no end but to fill space; that they would be but cold spectators of the general action, or, to use his own expression, that they would be *figures to be let.*[9] Besides, it is impossible for a picture composed of so many parts to have that effect so indispensably necessary to grandeur, that of one complete whole. However contradictory it may be in geometry, it is true in taste, that many little things will not make a great one. The Sublime impresses the mind at once with one great idea; it is a single blow: the Elegant indeed may be produced by repetition; by an accumulation of many minute circumstances.

However great the difference is between the composition of the Venetian, and the rest of the Italian schools, there is full as great a disparity in the effect of their pictures as produced by colours. And though in this respect the Venetians

9. Annibale Carracci (1560–1609), one of the central figures of the Bolognese school of the late sixteenth and early seventeenth centuries, to which Reynolds refers. The other painter most often cited at this time was Guido Reni (1575–1642).—Ed.

must be allowed extraordinary skill, yet even that skill, as they have employed it, will but ill correspond with the great style. Their colouring is not only too brilliant, but, I will venture to say, too harmonious, to produce that solidity, steadiness, and simplicity of effect, which heroick subjects require, and which simple or grave colours only can give to a work. That they are to be cautiously studied by those who are ambitious of treading the great walk of history, is confirmed, if it wants confirmation, by the greatest of all authorities, Michael Angelo. This wonderful man, after having seen a picture by Titian, told Vasari, who accompanied him, "that he liked much his colouring and manner;" but then he added, that "it was a pity the Venetian painters did not learn to draw correctly in their early youth, and adopt a better *manner of study.*" [10]

By this it appears, that the principal attention of the Venetian painters, in the opinion of Michael Angelo, seemed to be engrossed by the study of colours, to the neglect of the *ideal beauty of form,* or propriety of expression. But if general censure was given to that school from the sight of a picture of Titian, how much more heavily, and more justly, would the censure fall on Paulo Veronese, and more especially on Tintoret? And here I cannot avoid citing Vasari's opinion of the style and manner of Tintoret. "Of all the extraordinary geniuses," says he, "that have ever practised the art of painting, for wild, capricious, extravagant and fantastical inventions, for furious impetuosity and boldness in the execution of his work, there is none like Tintoret; his strange whimsies are even beyond extravagance, and his works seem to be produced rather by chance, than in consequence of any previous design, as if he wanted to convince the world that the art was a trifle, and of the most easy attainment." [11]

For my own part, when I speak of the Venetian painters, I wish to be understood to mean Paulo Veronese and Tintoret, to the exclusion of Titian; for though his style is not so pure as that of many other of the Italian schools, yet there is a sort of senatorial dignity about him, which, however aukward in his imitators, seems to become him exceedingly. His portraits alone, from the nobleness and simplicity of character which he always gave them, will intitle him to the greatest respect, as he undoubtedly stands in the first rank in this branch of the art.

It is not with Titian, but with the seducing qualities of the two former, that I

10. Reynolds twists Vasari's report somewhat to his own use. Michelangelo was not so damning of Titian nor so specific in what he meant by drawing. The passage from Vasari's life of Titian continues: "If this man, said he, was aided by art and design as he is by Nature, especially in copying from life, he would not be surpassed, for he has ability and a charming and vivacious style." Vasari, *The Lives of the Painters, Sculptors, and Architects,* trans. A. B. Hinds (London: J. M. Dent and Sons, 1900), 4:207. Both the original and Wark's edition of the *Discourses* reproduce the original Italian text.—Ed.

11. Vasari, himself a prolific but less than great painter, here speaks in his own person in his life of Battista Franco. Both the original and Wark's edition of the *Discourses* reproduce the original Italian text.—Ed.

could wish to caution you against being too much captivated. These are the persons who may be said to have exhausted all the powers of florid eloquence, to debauch the young and unexperienced, and have, without doubt, been the cause of turning off the attention of the connoisseur and of the patron of art, as well as that of the painter, from those higher excellencies of which the art is capable, and which ought to be required in every considerable production. By them, and their imitators, a style merely ornamental has been disseminated throughout all Europe. Rubens carried it to Flanders; Vo[u]et, to France; and Luca Giordano, to Spain and Naples.[12]

The Venetian is indeed the most splendid of the schools of elegance; and it is not without reason, that the best performances in this lower school are valued higher than the second rate performances of those above them: for every picture has value when it has a decided character, and is excellent in its kind. But the Student must take care not to be so much dazzled with this splendour, as to be tempted to imitate what must ultimately lead from perfection. Poussin, whose eye was always steadily fixed on the Sublime, has been often heard to say, "That a particular attention to colouring was an obstacle to the Student, in his progress to the great end and design of the art; and that he who attaches himself to this principal end, will acquire by practice a reasonable good method of colouring."[13]

Though it be allowed that elaborate harmony of colouring, a brilliancy of tints, a soft and gradual transition from one to another, present to the eye, what an harmonious concert of musick does to the ear, it must be remembered, that painting is not merely gratification of the sight. Such excellence, though properly cultivated, where nothing higher than elegance is intended, is weak and unworthy of regard, when the work aspires to grandeur and sublimity.

The same reasons that have been urged to shew that a mixture of the Venetian style cannot improve the great style, will hold good in regard to the Flemish and Dutch schools. Indeed, the Flemish school, of which Rubens is the head, was formed upon that of the Venetian; like them, he took his figures too much from the people before him. But it must be allowed in favour of the Venetians, that he was more gross than they, and carried all their mistaken methods to a far greater excess. In the Venetian school itself, where they all err from the same cause, there is a difference in the effect. The difference between Paulo and Bassano seems to be only, that one introduced Venetian gentlemen

12. Peter Paul Rubens (1577–1640) worked in Italy between 1600 and 1608; Simon Vouet (1590–1649), a French painter who worked in Italy between 1612 and 1627, was the teacher of both Le Brun and Le Sueur.—Ed.

13. See Henri Testelin, *Sentimens des plus habiles peintres sur la practique de la peinture et sculpture* (Paris, 1696; repr. Geneva: Minkoff Reprints, 1972), p. 35. Both the original and Wark's edition of the *Discourses* reproduce Poussin's quote in Italian.—Ed.

into his pictures, and the other the boors of the district of Bassano, and called them patriarchs and prophets.[14]

The painters of the Dutch school have still more locality. With them, a history-piece is properly a portrait of themselves; whether they describe the inside or outside of their houses, we have their own people engaged in their own peculiar occupations; working, or drinking, playing, or fighting. The circumstances that enter into a picture of this kind, are so far from giving a general view of human life, that they exhibit all the minute particularities of a nation differing in several respects from the rest of mankind. Yet, let them have their share of more humble praise. The painters of this school are excellent in their own way; they are only ridiculous when they attempt general history on their own narrow principles, and debase great events by the meanness of their characters.

Some inferior dexterity, some extraordinary mechanical power is apparently that from which they seek distinction. Thus, we see, that school alone has the custom of representing candle-light, not as it really appears to us by night, but red, as it would illuminate objects to a spectator by day. Such tricks, however pardonable in the little style, where petty effects are the sole end, are inexcusable in the greater, where the attention should never be drawn aside by trifles, but should be entirely occupied by the subject itself.

The same local principles which characterize the Dutch school extend even to their landscape painters; and Rubens himself, who has painted many landscapes, has sometimes transgressed in this particular. Their pieces in this way are, I think, always a representation of an individual spot, and each in its kind a very faithful but very confined portrait.

Claude Lorrain, on the contrary, was convinced, that taking nature as he found it seldom produced beauty.[15] His pictures are a composition of the various draughts which he had previously made from various beautiful scenes and prospects. However, Rubens in some measure has made amends for the deficiency with which he is charged; he has contrived to raise and animate his otherwise uninteresting views, by introducing a rainbow, storm, or some particular accidental effect of light. That the practice of Claude Lorrain, in respect to his choice, is to be adopted by Landscape Painters, in opposition to that of the Flemish and Dutch schools, there can be no doubt, as its truth is founded upon the same principle as that by which the Historical Painter acquires perfect form. But whether landscape painting has a right to aspire so far as to reject

14. Giacomo Bassano (da Ponte, 1510/15–1592) was the most important of a large family of Venetian painters.—Ed.

15. Claude Lorrain (Claude Gellée, 1600–1682) was a French landscape painter who spent most of his career in Italy.—Ed.

what the painters call Accidents of Nature, is not easy to determine. It is certain Claude Lorrain seldom, if ever, availed himself of those accidents; either he thought that such peculiarities were contrary to that style of general nature which he professed, or that it would catch the attention too strongly, and destroy that quietness and repose which he thought necessary to that kind of painting.

A Portrait-Painter likewise, when he attempts history, unless he is upon his guard, is likely to enter too much into the detail. He too frequently makes his historical heads look like portraits; and this was once the custom amongst those old painters, who revived the art before general ideas were practised or understood. An History-painter paints man in general; a Portrait-Painter, a particular man, and consequently a defective model.

Thus an habitual practice in the lower exercises of the art will prevent many from attaining the greater. But such of us who move in these humbler walks of the profession, are not ignorant that, as the natural dignity of the subject is less, the more all the little ornamental helps are necessary to its embellishment. It would be ridiculous for a painter of domestick scenes, of portraits, landschapes, animals, or of still life, to say that he despised those qualities which has made the subordinate schools so famous. The art of colouring, and the skilful management of light and shadow, are essential requisites in his confined labours. If we descend still lower, what is the painter of fruit and flowers without the utmost art in colouring, and what the painters call handling; that is, a lightness of pencil that implies great practice, and gives the appearance of being done with ease? Some here, I believe, must remember a flower-painter whose boast it was, that he scorned to paint for the *million:* no, he professed to paint in the true Italian taste; and despising the crowd, called strenuously upon the *few* to admire him. His idea of the Italian taste was to paint as black and dirty as he could, and to leave all clearness and brilliancy of colouring to those who were fonder of money than of immortality. The consequence was such as might be expected. For these petty excellencies are here essential beauties; and without this merit the artist's work will be more short-lived than the objects of his imitation.

From what has been advanced, we must now be convinced that there are two distinct styles in history-painting: the grand, and the splendid or ornamental.

The great style stands alone, and does not require, perhaps does not so well admit, any addition from inferior beauties. The ornamental style also possesses its own peculiar merit. However, though the union of the two may make a sort of composite style, yet that style is likely to be more imperfect than either of those which go to its composition. Both kinds have merit, and may be excellent though in different ranks, if uniformity be preserved, and the general and particular ideas of nature be not mixed. Even the meanest of them is difficult

enough to attain; and the first place being already occupied by the great artists in each department, some of those who followed thought there was less room for them, and feeling the impulse of ambition and the desire of novelty, and being at the same time perhaps willing to take the shortest way, endeavoured to make for themselves a place between both. This they have effected by forming an union of the different orders. But as the grave and majestick style would suffer by an union with the florid and gay, so also has the Venetian ornament in some respect been injured by attempting an alliance with simplicity.

It may be asserted, that the great style is always more or less contaminated by any meaner mixture. But it happens in a few instances, that the lower may be improved by borrowing from the grand. Thus if a portrait-painter is desirous to raise and improve his subject, he has no other means than by approaching it to a general idea. He leaves out all the minute breaks and peculiarities in the face, and changes the dress from a temporary fashion to one more permanent, which has annexed to it no ideas of meanness from its being familiar to us. But if an exact resemblance of an individual be considered as the sole object to be aimed at, the portrait-painter will be apt to lose more than he gains by the acquired dignity taken from general nature. It is very difficult to ennoble the character of a countenance but at the expense of the likeness, which is what is most generally required by such as sit to the painter.

Of those who have practised the composite style, and have succeeded in this perilous attempt, perhaps the foremost is Coregio.[16] His style is founded upon modern grace and elegance, to which is superadded something of the simplicity of the grand style. A breadth of light and colour, the general ideas of the drapery, an uninterrupted flow of outline, all conspire to this effect. Next to him (perhaps equal to him) Parmegiano[17] has dignified the genteelness of modern effeminacy, by uniting it with the simplicity of the ancients and the grandeur and severity of Michael Angelo. It must be confessed however that these two extraordinary men, by endeavouring to give the utmost degree of grace, have sometimes perhaps exceeded its boundaries, and have fallen into the most hateful of all hateful qualities, affectation. Indeed, it is the peculiar characteristick of men of genius to be afraid of coldness and insipidity, from which they think they never can be too far removed. It particularly happens to these great masters of grace and elegance. They often boldly drive on to the very verge of ridicule; the spectator is alarmed, but at the same time admires their vigour and intrepidity:

16. Correggio (Antonio Allegri, ca. 1494–1534) worked mostly in Parma and was noted for his paintings of soft, delicate flesh.—Ed.

17. Parmegianino (Francesco Mazzola, 1503–1540).—Ed.

Strange graces still, and stranger flights they had,

.

Yet ne'er so sure our passion to create,
As when they touch'd the brink of all we hate. [18]

The errors of genius, however, are pardonable, and none even of the more exalted painters are wholly free from them; but they have taught us, by the rectitude of their general practice, to correct their own affected or accidental deviation. The very first have not been always upon their guard, and perhaps there is not a fault, but what may take shelter under the most venerable authorities; yet that style only is perfect, in which the noblest principles are uniformly pursued; and those masters only are entitled to the first rank in our estimation, who have enlarged the boundaries of their art, and have raised it to its highest dignity, by exhibiting the general ideas of nature.

On the whole, it seems to me that there is but one presiding principle which regulates, and gives stability to every art. The works, whether of poets, painters, moralists, or historians, which are built upon general nature, live for ever; while those which depend for their existence on particular customs and habits, a partial view of nature, or the fluctuation of fashion, can only be coeval with that which first raised them from obscurity. Present time and future may be considered as rivals, and he who solicits the one must expect to be discountenanced by the other.

18. Alexander Pope, *Epistle to Several Persons (Moral Essays)*, ed. F. W. Bateson (London, [1951]), Epistle II, "To a Lady," lines 49–52. The line omitted by Reynolds reads: "Was just not ugly, and was just not mad."—Ed.

FRANCESCO MILIZIA

The Art of Seeing in the Fine Arts of Design According to the Principles of Sulzer and Mengs (1781)

Francesco Milizia (1725–1798) was an Italian amateur of the arts with a broad knowledge of contemporary theory and a decided taste of his own. Settling in Rome in 1761, he became a friend of the painter Mengs and the circle newly concerned with formulating the rules of a more disciplined order in art. Although Milizia was in many ways a fiercely individual man with strong personal reactions to art, he drew heavily on his wide reading for his artistic theories. For the most part, his publications form a useful synthesis of many of the most influential ideas of his time.

Milizia's emphasis on personal judgment and insistence on particular types rather than on general abstract qualities might seem at times to overwhelm his recommendations of a serene and unified classical manner. Yet it must be remembered that the adjustment of form to agree with purpose was a fundamental tenet of most "classical" theorists. The importance lay in finding the rationally definable key to the special type of particular action, then judging a work according to its inner consistency.

The acute awareness of distinctions in type at this time (Milizia's relative standard of beauty in the coloring of flesh, for example), as distinct from a single perfect paradigm, is also reflected in the intensive studies of physiognomic differences. Johann Caspar Lavater's publications (*Physiognomische Fragmente,* 1775–1778) became a fascinating source for artists, firmly establishing in popular usage both the word *physiognomy* and the concept that the physical formation of a man's face bears a direct relationship to his character. Perfect form was further complicated by an interest in the relationship between states of mind and physical change, on a much more technical level than that of Charles Le Brun, whose work on depicting the passions, first presented at a conference at the French academy in 1667, was, nonetheless, still used. Artists and amateurs were also fascinated by somnambulism, psychosomatic ailments, and insanity—phenomena that exaggerated the relationship between mind and bodily aspect. Their interest did not derive from a desire to rebel against ratio-

nality or formal perfection, but it did establish a much broader context within which order and rationality were to be recognized and judged. To detect the clear relationship between cause and effect was itself a delight to the rational mind, and no situation was more challenging than one that was seemingly irrational in nature.

Given Milizia's preoccupation with structure, it is not surprising that his major interest was in architecture; in his first publication, *Le vite dei più celebri architetti d'ogni tempo* (1768), he praised the structurally logical architecture of Greece and the Gothic Middle Ages. His insistence on structural truth, simplicity, and a machinelike coherence in architectural form give some of his statements a curiously modern ring, yet Milizia's taste, despite the individuality of his statements, held much in common with that of his contemporaries.

Significantly, Milizia addressed *The Art of Seeing* quite particularly to the viewer; the eye of the amateur, to his mind, was just as much in need of education as that of the artist. He did not accept the rather complacent assumption that conceptual knowledge is sufficient to effect perceptual refinement, but suggested that knowledge in art is gained through the eye, or at least through a reciprocal activity of eye and mind. One must indeed have knowledge, but "one arrives at knowing how to see by learning how to see," that is, by engaging in the practice of critical looking, not by reading books or treatises. Reversing an earlier academic principle, he advised amateur and artist alike, if they wished to see well, to "look first at nature and study her as she is in the original, in order to enjoy her better in copies, so difficult to make more beautiful."

This concern for perception as a basis for knowledge and judgment is quite in tune with much scientific and philosophical thought of the time. In an interesting way it suggests some of the principles underlying the theories of Milizia's younger Swiss contemporary Johann Heinrich Pestalozzi (1746–1827), whose influential educational system, similar in many of its assumptions to present educational theory, was based on the belief that learning begins with accurate observation, with a sharpening of the senses. Pestalozzi proposed drawing exercises for all students, not just potential artists, to train the coordination of hand and eye until a student could connect two points by drawing a straight line without the aid of a ruler. To "draw a straight line" was the first step, for perceptual discipline was the means for developing intellectual discipline, which in turn provided the foundation for moral virtue. The procedure was not a matter of first thinking, then seeing, but of thinking through seeing. From this foundation, it is but a short step to the formulations of the philosopher Johann Friedrich Hebart (1776–1841), who knew Pestalozzi and his ideas. In *Aesthetische Darstellung der Welt* (1804), Hebart argued that to assume the mind harbors innate ideal concepts that it finds reflected imperfectly in nature (a tradition from Neoplatonism) is less supportable than to assume that the mind confronts nature quite innocently and depends for its formulating activity

(conceptualizing) on the material afforded by perception. This continuing act of formulating in the face of ever more accurately perceived matter, rather than the matching of preconceptions with forms seen, he maintained, led the mind to proper ethical judgments. The education of the eye, then, was ultimately a moral education, and the aesthetic—form-giving—activity of the mind was basic to a conception of the world.

It is doubtful that Milizia's understanding of these far-reaching implications went much beyond his general feelings. His primary attack was against the substitution of learned bits of information for the pleasures of sight. For him, to regard a work of art was to participate with the artist in an act of perfect formulation, drawing material from a known but complex visual world; without being able to distinguish between simple appearance and willful construction, one could not recognize the process of aesthetic formulation as such, and the morally satisfying participation could not take place.

Johann Sulzer (1720–1779), referred to by Milizia, was a systematic German professor who published a carefully organized four-volume work, *Algemeine Theorie der schönen Künste in einzeln, nach alphabetischer Ordnung der Kunstwörter auf einander folgenden, Artikeln abgehandelt,* in Leipzig between 1771 and 1774. Many of the individual entries were translated and published in the 1777 supplement of the great French *Encyclopédie*. Quite possibly Milizia depended on these French translations, for he clearly drew on other material from the *Encyclopédie,* which was influential in transmitting many ideas and practices in the arts.

Anton Raphael Mengs (1728–1779), to whom Milizia also refers, was considered by many of his contemporaries to be the greatest painter of his time and the founder of modern reform in painting. Born in Bohemia, he came to Rome in 1741 and not long thereafter made it his home, although he worked also in Dresden and spent some years in Madrid. He published his ideas on art, *Gedanken über die Schönheit und über den Geschmak in der Malerey,* in Zurich in 1762, and his work was soon translated into many languages.

The present essay is from the section on painting, chapter 2, of Milizia's *Dell'arte di vedere nelle belle arti del disegno secondo i principii di Sulzer e di Mengs,* first published in Venice in 1781. It was translated into German (1785), French (1798), and Spanish (1823). This translation was made from *Le opere complete di Francesco Milizia risguardanti le belli arti,* 9 vols. (Bologna: Stamperia Cardinali e Frulli, 1826–1828), 1:235–54.

PAINTING

The ultimate goal of painting is exactly the same as that of sculpture, that is, to instruct by delighting the sight with the representation of objects taken from

beauteous nature. The means are different: some are proper to painting, like color and chiaroscuro, which form the principal difference; others are common to both, but even in this community painting demands greater extension and abundance in all parts of the composition. This must be analyzed first, then chiaroscuro and color.

COMPOSITION

Composition is made up of invention and distribution.

INVENTION

All of nature presents itself to the intelligence of the poet and the painter, and presents itself not only as it actually is at the moment, but also as it has been, and as it might have been, or might yet be. To add the indefinite chain of time and space to the present order and to obscure events, to know all causes, to make them act in the mind according to the laws of harmony, to reunite the losses of the past, to solicit the fecundity of the future, to give a tangible sensuous existence to that which does not yet exist and will perhaps never exist except in the ideal essence of things; this, according to Marmontel,[1] is what is called invention in poetry and painting.

But not everything possible is lifelike, nor is everything that is lifelike interesting. That is interesting which touches us to the quick, and to touch us it must be near us. Thus invention is not to throw oneself into that which is remote or beyond the range of our senses, but to combine in various ways our perceptions and affections, and that which takes place around us, among us, and within us. Invention, then, is not to copy faithfully and coldly what is before one's eyes, but to discover, develop, discern, grasp, and bring together that which is not seen by the majority of men, but which nevertheless constitutes an ideal whole, interesting and new, formed by the union of things known, or else a whole that already exists, but purified of all defects and ornamented with new graces and beauties.

It is not impossible that history, fable, society present us naturally with a picture as it should be, yet this is a most rare phenomenon. The most extraordinary of subjects is always weak and defective in some aspect; it is therefore necessary for art to supply that which is lacking, but without seducing us with mostly false brilliance.

Painting is a machine in which everything must be combined to produce a

1. The French playwright Jean-François Marmontel (1723–1799) first published his articles on the theory of literature in the *Supplément à l'encyclopédie, ou dictionnaire raisonné des sciences, des arts et des métiers* (Amsterdam: M. M. Rey, 1776–77) 3:640–43, under the heading "Invention." Milizia drew heavily on Marmontel throughout this section of his essay, although Marmontel's remarks concerned literature rather than the visual arts.—Ed.

common movement. The most worked-over part has no value except insofar as it is essential to the machine, occupying its place exactly and fulfilling its destiny.[2] It is not the beauty of this or that part that determines the choice of subject, but an interesting action that throughout its course produces the proposed effect of interesting, pleasing, and instructing; this is the high point of art.

The rarest gift in invention is that of choice. Nature presents itself to all men and is almost the same to all eyes. But seeing is nothing; to discern is all; and the advantage of the sublime man over the mediocre is his capacity to choose what is appropriate.

Beautiful nature is not the same in a Faun, in an Apollo, in a Venus, in a Diana.[3] The idea of individual beauty varies constantly in all the fine arts because it depends on relationships subject to change. What are the traits that are proper to a fine tree or a lovely landscape? The graces of nature in all its natural negligence. The most natural, simple, and common becomes beautiful and gracious when it interests us. But how to distinguish it in order to select it? It must correspond to the end proposed; this is its character. What is beauty in some circumstances is not in others: to be beautiful it must accord with the effect one wishes to produce. Nature is both physically and morally like the painter's palette, on which the colors are neither ugly nor beautiful. *The relationship of the objects to ourselves:* in this is to be found the principle and the intent of the painter; this is his rule and the essence of all rules.[4]

But with what means is the intention carried out? To distinguish in nature the traits worthy of being imitated and to foresee the effect that must result from them is the fruit of long study; to gather them and have them at hand is the gift of a vivid imagination; to choose them and allocate them opportunely is the property of a delicate sentiment and a sound imagination. The entire theory of art consists in knowing which goal one wishes to reach, and which road in nature leads to it. *Obtaining the most with the least,* it has been said, is the principle of all the fine and mechanical arts.

The painter's goal is to interest the observer through imitation. There are two kinds of interest: one relating to things, the other to art; but both are subject to personal interest. Not everything pleasant is interesting; nor are everstrong passions so; although they might please us, hold us, relieve us from

2. This and the paragraph preceding derive directly from Marmontel. Marmontel wrote: "Un poëme est une machine dans laquelle tout doit être combiné pour produire un mouvement commun." See "Invention," *Supplément à l'encyclopédie* 3:642.—Ed.

3. Well-known Greek and Roman sculptures of these and other figures had long been singled out as embodying the ideal of certain types. See, for example, the carefully organized catalogue of types in Henri Testelin, *Sentimens des plus habiles peintres sur la practique de la peinture et sculpture* (Paris, 1696; repr. Geneva: Minkoff Reprints, 1972). In maintaining that beauty is always relative to type without suggesting the nature of a highest, absolute beauty, Milizia is departing from the doctrine of many of his colleagues.—Ed.

4. Derived from Marmontel, "Intéret," *Supplément à l'encyclopédie* 3:628.—Ed.

boredom as do other things, they may not spur us to activity, action, suspense, or ecstasy. This latter is what interests, all the more so when art knows how to render it more interesting. Spring cheers us and autumn saddens us because the former seems to invite us to new weddings, the latter to funerals.[5]

The artist is sure of his effect when he excites our internal activity, that is to say, our interest, self-love, the principle of all our actions. A man's most interesting days are those in which he has undertaken the greatest amount of activity. It is clear that the artist must interest us in favor not of vice, but of virtue. But in order to interest, he must himself be interested.[6]

Once the interesting subject has been chosen, it must be shown as a whole, organized from a single point of view in such a way as to make all its parts work toward the same end, forming a simple and single whole through their mutual interplay. Herein lies the unity of the composition.

Unity supposes one goal, one subject, toward which everything tends and is directed: unity of action, interest, time, place, customs, and design.

Action is a conflict of causes that tend to produce the event, and of the obstacles that conflict within it. A battle is a single thing, even though composed of so many thousands of objects and diverse actions. The principal action is the result of all the individual actions employed as episodes or as incidents. The episodes must be tied to the principal subject in such a way that not even one figure may be removed without the entire machine falling, or feeling the loss. The simpler, the more beautiful. Simplicity is to remove confusion. Who can be picked out in a mob? And must it be repeated once again that *with the least possible one must obtain the most possible?* A composition may be rich in figures and poor in ideas. The opposite is difficult, requiring great study and talent so as to make each piece variously beautiful, differently expressive, but all necessary, all adapted to the subject and all unified components.

In certain episodes one may occasionally use some negligence so as to give more emphasis to the primary subject, but it takes skill to be negligent.

The interest, or the expression, need not necessarily be brought together in a single person; it should rather be distributed in gradations from the main figure to all the figures, but it is indeed necessary that it be centered on a single point. One must choose a single most interesting moment of the action, without worrying about its antecedents or its consequences. Once this moment is chosen, all the rest follows; everything falls into place at once.

Appropriateness is the relation between the essential properties and the ac-

5. See Marmontel's statement, *Supplément à l'encyclopédie* 3:629.—Ed.

6. "L'artiste qui veut être *intéressant,* doit se intéresser à toutes les affaires tant générales que particulières dont il fait son objet, & se mettre à la place des personnes qu'il fait parler & agir" [The artist who would have his works be *interesting* should himself be at least generally informed about the subjects he chooses to depict, and should seek to put himself in the place of the personages he brings to life in his works]. Johann Sulzer, "Intéressant," *Supplément à l'encyclopédie* 3:628.—Ed.

cessory aspects of a subject. The first virtue is to be exempt from vice. But how rare is *nihil molitur inepte* [rising above the common]! Can a boy playing with a dog enter into a serious subject? It is useless to recall the necessity of appropriateness of garments, architecture, landscape, and everything that might ever enter the composition of any painting; all must relate exactly to the initial assumption.

This first part of the composition, which has been called invention and could also be called the *expressive* part, is the most important; it is the part in which Raphael distinguished himself from all other painters. Look at his works with these principles in mind, and he will be seen admirable in the expression of each concept, each figure, and each accessory. But has he preserved appropriateness in his inclusion of Julius II and Leo X, who intervene where they could not have been? And is unity of action maintained in the *Transfiguration* and the *Saint Peter in Prison?* And can nothing be removed from the *Parnassus* and the *School of Athens?*[7]

Anyone with common sense can play the doctor for composition. Here is a painting; if the subject is not known to you, woe! But come along, find out about it, and be patient if it is difficult; if you already know it, rejoice. Examine the painting to see if the action has been chosen in the most interesting moment, with the most advantageous circumstances, with the most expressive and most appropriate characters. The defects of invention lie in everything that is contrary to nature, to lifelikeness, to unity. Contradictory, obscure, and ambiguous combinations offend just as much as foreign objects, useless and distracting from the main subject.

A person who is erudite and has good taste can render great service to artists by presenting them with subjects taken from the most remarkable events he has come across in his reading. He who has fantasy may even invent and make clear well-thought-out descriptions and then offer the thoroughly prepared material to the artist whose merit it is to execute it.

DISTRIBUTION

Lucidus ordo [clear ordering]. The pleasing effect experienced from seeing a great number of things does not derive from the confusion of objects thrown together by chance, but from their well-ordered arrangement. Each figure must be in its proper place; the most important must be most prominent and

7. In Raphael's fresco, *The Mass at Bolsena,* in the Vatican Palace, the likeness of Pope Julius II, who commissioned the work, is included even though the episode took place during the thirteenth century. In his fresco of Pope Leo I meeting Attila and the Huns, Raphael gave Pope Leo I the likeness of Pope Leo X, under whose papacy the fresco was completed. The *Transfiguration* in the Vatican Picture Gallery includes not only two distinct subjects, the Transfiguration of Christ and the story of the possessed boy, but also two ecclesiastical figures who have no historical justification for being present at either incident. The fresco in the Vatican Palace of the deliverance of St. Peter

A. R. Mengs, *Parnassus,* pen and ink drawing.

the others at a sufficient distance to be moved easily if one wishes them to be clearly seen, and so well related, one to the other, that the imagination can see them all together. All must seem arranged with ease; then the spectator's eye can wander, repose, or linger with satisfaction.

The artifice of grouping contributes especially to this effect. A group is a complex of objects that differ in aspect, position, and character, arranged in such a way as to hold the eye of the viewer pleasantly. Contrast enters into it, but without affectation. The result of all this is the harmony of the eye. A group is well arranged if the illuminated parts make up a mass of light, and those in shadow a mass of shadows, with such lifelikeness that each figure remains distinct and in relief, as in a *gruppo d'uva* [bunch of grapes], from which the word *gruppo* [group] perhaps derives.[8] And now we come to chiaroscuro.

from prison incorporates successive moments of the narrative within the same composition. Unlike the *Parnassus* by Mengs, Raphael's fresco in the Vatican Palace mingles muses and poets from various epochs. Similarly, in his *School of Athens,* he assembled representatives of philosophy from several eras and gave many of them the features of his contemporaries.—Ed.

8. The bunch of grapes, an image attributed traditionally to Titian, was the most common example of subordination within a complex group in which each part is distinct yet contributes to

CHIAROSCURO

Chiaroscuro is usually taken literally and from painters has passed into daily speech to denote the beautiful and the ugly, both physical and moral, and every kind of good and evil event; in fact, in paintings there are often such obscurities as may truly be called horrors.

Dark exists in ratio to light. But what need is there of shadows and obscurity? The need speaks for itself.

Chiaroscuro is the art of using colors and of distributing lights [chiari] and darks [scuri] in order to give the effect of relief to those parts that must appear so, to give roundness to others, to make some smooth, some sparkling. The light need not come as from a window or an opening; it should rather illuminate everything directly in a great mass, with reflections, always keyed to the intensity of lights and colors.

Masses are created by lights placed in the most opportune and elevated areas, without darks. Darks interrupt and cut the masses. When this defect does not exist, the figures may be distinguished even from afar.

Darkness is always unwelcome; it may be removed with reflections. Then with very little light and many reflections one may obtain grand effects with very few small distractions, much sparkle without dazzling.

Raphael did not know of reflections, which contribute so much to clarity and grace. He and the entire Florentine school used light colors in the foreground, as opposed to the Lombards and the best colorists, who used pure colors, red, yellow, and blue, rather than white, to bring objects close.

Never black to white, but gradually from white to ash gray, and from black to dark gray: this is the charm of chiaroscuro, in which Correggio excelled above all others.

COLORING

Coloring is the art of giving to each object its appropriate color so that the whole may beautifully imitate nature.[9] All the effects produced by forms gain greater energy from colors. If nature delights us with forms, she enraptures us with coloring. The union of different colors in painting must make a beautiful whole.

To understand the beauty of artificial coloring, one must first know that of nature in its most beautiful climes and its fairest products—confront, examine,

the larger form of the whole. See Charles Alphonse DuFresnoy, *L'Art de peinture*, 2d ed. (Paris: N. Langlois, 1673), pp. 52–53, and the note in the same by Roger de Piles, p. 201.—Ed.

9. Milizia derived his notion of coloring from Sulzer, "Coloris," *Supplément à l'encyclopédie* 2:511–12.—Ed.

and exercise the eye in the beautiful and the most beautiful. He who examines and reflects sees that the same objects appear beautiful from one viewpoint and not from another, and notices that this results either from a kind of light that shines from the objects, or from the manner in which they receive light. Too much light offends our gaze, and too little weakens it. A place in which the sun's light is tempered by atmospheric vapors is attractive; the obscurity of shadows is pleasing when it is softened by the reflected rays of the blue sky. Therefore the principal cause of fine coloring is the welcome tone of a gentle light. Two kinds of light may be used in a painting, one the direct but well-tempered light of the sun, the other that reflected from a serene sky which spreads a varied softness over the shadows.

The modifications and gradations of colors are dependent on the distance from the eye; then the object takes on more tint from the color of air. In this way the forms and various colors seen from a great distance all take on the common color of an aerial perspective.

To learn the harmony of colors it is well to observe that an object, through the use of light or color, comes forward from the rest of the mass in such a way as to appear detached from it, no longer confused with the others. For the opposite effect, different objects can be presented in a single mass and all be given more vivid light and colors.

Nature makes use of only two metals in coloring herself: iron and copper. All her variety comes from the various combinations of the three principal colors, red, yellow, and blue.[10] A combination of few colors pleases the sight, one of many offends it. What harmony there is in the rainbow! Take away one of its three principal colors, red for example, and farewell harmony! Thus true harmony lies in the equilibrium of the three colors mentioned above.

Each object in painting will be well colored if it is given its true natural color. The whites of fabrics, of canvases, and of flesh are different from each other, and each should appear without crudity and without bringing to mind the artist's palette. These are the *local* colors, that is, the natural colors that an object seems to have, according to the more or less distant point from which it is seen. This is determined by aerial perspective. Red, for example, is the local color of the place in a painting where a scarlet drapery is represented.[11] But insofar as colors come from reflected light, which is subject to many variations due to its intensity and for other reasons, there will be many variations of the

10. Milizia's color theory, based on the harmony of three primary colors, derives from Sulzer, who in turn depended on the very advanced color theory of the German scientist Johann Tobias Mayer (1723–1762), whose writings were published in 1758. See "Couleur," *Supplément à l'encyclopédie* 2:632–34; and Mayer, *De affinitate colorum commentatio* (Göttingen, 1758).—Ed.

11. Sulzer, "Couleur," *Supplément à l'encyclopédie* 2:634–35. Goethe examined the various aspects of color in great detail in his *Zur Farbenlehre* (1810).—Ed.

same color called scarlet. If the sun strikes it strongly or weakly, if from the horizon or from on high; if it is illuminated not by the sun but by the blue of the sky or one or more artificial lights; if it is lighted directly or through some indirect means: from all these and many other circumstances different colors of scarlet result, which will still be called *scarlet,* however, from the lack of different names suited to express all such gradations. Thus, local color in painting is the naturally appropriate color of the object, modified by circumstances such as those mentioned. Thence the reflections, the half-tints, the mixed or broken colors. Reflections and shadows must respond to the color from which they come.

Painting, although ingenious and bold, cannot color different objects in so lifelike a manner as nature. How can the sun, fire, a diamond, gold, smooth bodies be expressed? The painter succeeds only imperfectly by putting into other objects tones that are darker than those of nature.

The complexion of the skin is the most difficult part of coloring and the most interesting because it is man painting himself; other colors are merely accidental and on the surface of things, but in the coloring of man it appears that nature intended to paint his very essence. Color alone manifests life, age, personal character, different degrees of strength and of every internal motion. What a study it is to learn to see!

But what is the most beautiful complexion? Don't ask the African, the American, the Chinese. Even in Europe the taste for this beauty varies. For the French it is a milk white, for some northern peoples an alabaster white. All have agreed that men's coloring should be a half-tint darker than women's. Little men, why pretty yourselves up? A good colorist will color you according to your conditions. A princess will have a complexion whiter, more delicate, and more transparent than a city girl, and a country girl will have one firmer and darker than the latter. Fine complexions show pure and moderately abundant blood, which enlivens all parts of the body differently, tinges the cheeks with lively color, makes the freshness of good health evident in every type of person. Fine complexions demonstrate vigor and soundness everywhere. Therefore the images that appear nourished on roses or lilies, rather than on meat, are unnatural and affected. For a coquette the coloring can be exaggerated to overcome any sign of modesty, and she may then be sprayed with flies attracted by her putrid sweetness.

Harmony of colors[12] results from the art of bringing together in a single

12. Harmony is often spoken of in painting and many other things. I think that it may be understood metaphorically and that it has little to do with harmony in music. This is important to me since recently there has been a tendency, I do not know how successful, to give music every expression. For myself, I have not yet had the fortune to hear the inconceivable music that produced such prodigious results among our venerable ancients. I do know that our charlatans

mass of light the local colors of all the particular objects found in the composition of a painting. From this harmony come unity of tone, relief, and the rounding of figures. But to achieve this accord, the passage from a mild to a stronger color must be made through the mediation of a middle color that breaks the impact of the extremes. Therefore the well-laden brush will not jump to retouch or belabor, but will flow lightly and openly. In this lies the freshness and suavity of coloring, and also the reason for the common saying: "So well painted that it seems natural, and so beautiful that it seems complete."

THE EFFECTS OF PAINTING

Tapestries, fabrics, brocades, arabesques, pictures—all are used synonymously, a certain proof if not of our insensibility, at least of our indifference to painting. There are two principal reasons for this: one, because the subjects are not usually interesting; the other, because very few know how to see.

I. There is little or no interest in allegorical, metaphorical, iconological, and mythological subjects; they are foolish enigmas, like Egyptian hieroglyphics, that do not and cannot reach the heart.

Personification of physical and moral qualities will succeed in poetry, which can explain things as much as it wishes to. But what can sculpture explain by the statue of a river or of Rome? Even painting, with all its extra means, cannot offer explanations. A majestically beautiful woman writing in a large book that rests on a robust old man armed with a sickle, with a double mask on one side and winged creatures with trumpets and piles of scrolls on the other, what is it? Someone must first say, "This is History," and then everyone will repeat, "This is History." It is a masterpiece of painting,[13] and meanwhile no one sincerely feels its effect in his heart. Everyone would feel the effect at once if it were expressed with clearer and more instructive images. Women, especially beautiful ones, do not usually write history. Why not use, instead, an assembly of classical historians?

Worse are the personified "Dawns"; they delight the sight and nothing else. It is even worse if the guide has to explain the painting. Any painting must be easily understandable by those who have a middling education. History must not have to explain the picture, but the picture must explain history. Even more, it must interest, it must instruct. The "Calumny" invented by Apelles is

predict miracles from their own stupidities. I also know that our music tells us nothing, in spite of the worthy men who have applied themselves to it both in theory and practice. Let it speak. Then I shall say if it will or will not influence our lives. At present it is nothing more than a quivering shock of air that gives some pleasure to the ear and nothing more.

[In contrast, Edmé-François Miel, in his essay on Berthon's *Dream of Orestes* (reproduced in Part I), uses music to instruct the painter concerning form, harmony, and expression.]

13. A fresco by Mengs in the Papyrus Room of the Vatican Library.—Ed.

instructive and interesting and is not an enigma;[14] this is true personification. Historical subjects, too, mean little to us since they have for the most part become commonplaces.

II. The choice of an interesting and instructive theme is not sufficient to beautify the composition; the requisites mentioned before must play their part. But theme will suffice for the intelligent professors, who will unanimously hand down a verdict of perfection for such a work. This perfection is shown to the public. The public in our society has been called a flock of sheep, and what one does the others do; a magnificent force of inertia keeps sheepishness perennial. And to perpetuate it even further, some so-called amateurs, and even experts, arise who know and love only terminologies, tales, anecdotes of the lives of the painters, the stories of their works, prices, rarity, celebrity. The celebrity of names makes them raise their eyebrows and praise and blame without any understanding of the cause. All this excitement for thunder and air! With much less effort one might obtain more: that is, to learn to see.

He who would see well, look first at nature and study her as she is in the original, in order then to enjoy her better in copies, so difficult to make more beautiful. In the copies he sees the beauties of nature brought together in many compositional themes, invented and organized with ingenuity and taste, all expressed with correctness, grace, elegance, and propriety in both the drawing and coloring of all the principal and secondary objects, all characterized according to their respective natures, and all tending to make a unity of every situation. Always unity, although always diversified by draperies, architecture, landscapes, et cetera, all producing always an expression to enchant the sight by presenting that which one never finds so beautiful and so composed in nature and society; and all this penetrates to the heart, inciting it to virtue, nourishing the mind with true and useful insights.

How can one remain unhappily insensible before a canvas that in a small space shows as if in relief or in the greatest distance rivers, trees, plains, mountains, habitations, animals in motion, men full of life and feeling, the entire universe; and this is in the most beautiful colors, in a way not seen before, yet so natural that the sight remains enchanted with delight, and so interesting that the mind and heart are moved to true profit?

Indifference and, even more, insensibility are impossible before the combination of the two requisites mentioned; that is to say always, if the painting is real painting, and if he who looks at it knows how to see it.

It has been said that the first effect of painting is to please the eyes, and also that no pleasure must ever detach itself from utility. So painting's aim is necessarily that of being useful to us through the delight of seeing. Painting may thus be defined as the art of bettering oneself through the gracious representa-

14. A famous painting described by Lucian in his *Calumniae non temera credendum.*—Ed.

tion of visible objects with lines and coloring. *"Mores pinxisse videtur"* [the folly of painting appearances], said Pliny of Zeuxis.[15] If painting is merely beautiful, it has missed the point; if it is merely good, it has failed in its means; to be complete it must be beautiful and good.

One may easily deduce from what has been said up to now how much philosophy is required for seeing and executing such a work. Can the spectator then be an ignoramus? The painter a madman? Why then are poets so? Because they are neither poets nor painters. Horace, who was a poet, wants writers to be wise: *"Scribendi recte sapere est principium et fons."*[16]

This *sapere* is not merely a dogma for writing well, it is a universal panacea for speaking, listening, seeing, and for making all our doings good ones. One arrives at knowing how to see by learning how to see; and to learn anything one must first acquire a clear and distinct idea of its essence, its means, and its object, and then observe, examine, and compare the works of nature and the works of art.

15. Pliny, *Naturalis Historiae,* book 35, line 63. This famous line was much commented on in the eighteenth century since it suggested that the Greek painter Zeuxis painted what he actually saw yet, despite what Aristotle said of his work, expressed moral qualities. This point is important to Milizia, who insists that in a painting the moral qualities are a part of the visible fabric of the work, to be apprehended by the eye, not simply a part of the narrative.—Ed.

16. *Ars Poetica,* line 309. "Knowledge is the beginning and the basis of good writing."—Ed.

JACQUES-LOUIS DAVID

The Jury of Art (1793)

David's painting *The Oath of the Horatii,* finished and admired in Rome in 1784 and shown in Paris the following year, has often been cited as a major touchstone in the realization of a style that was eventually to become synonymous with the new social order of France. Far from following the graceful lines of late Greek sculpture recommended by Winckelmann, or the suave forms being popularized by many artists associated with the Villa Albani group, David compounded a harsh and unrelenting image from the materials of nature organized according to rational, architectonic structure. In a sense, his work represented an amalgam of perceptual truth and rational truth, and as such would be in agreement with the principles stated by Milizia. Only secondarily do this and other of his paintings refer to specific antique models; models from past art had taught David how to construct and form, but when he set out to paint he obviously began with a detailed accounting of nature, a process that Milizia recommends also for the intelligent viewer. Consequently, it is not surprising that David should recommend that the judges of works of art should not be principally those people steeped in art, but preferably those practiced in rational thought and those with an intimate knowledge of nature.

David recommended also a third kind of judge: the statesman or revolutionary leader. After all, if reason and natural law can be considered as moving hand-in-hand, the body politic might well be looked upon as both a rational and natural extension of man's nature. The ordering of man's visual world was one element in the ordering of his total social environment and his inner state of mind as well. In the classical sense of Boileau, one principle could underlie all.

It would follow from such ideas that style, which might be considered the perceptible merging of matter and mind, could become both a symbol and a didactic force that works toward a particular concept of order and, at the same time, directs the sentiments to produce such an order by a persuasive argument through the eyes.

So the state was a kind of work of art (like Milizia's beautifully functioning machine), just as a painting, a garden, or the architecture of a planned commu-

nity was both a visible manifestation and an arm of persuasion of rational government.

Probably there is no better example of this last phenomenon than Claude-Nicolas Ledoux (1736–1806). Ledoux was an extraordinarily imaginative architect. Among the many works he executed for members of the court were the saltworks at Chaux, begun in 1775 and only partially completed some years later, and the theater of Besançon (1778–1784). For the saltworks he proposed a rational geometric scheme that provided not only for all aspects of the industrial operation but also for all aspects of the workers' lives. What one saw, how one acted, how one thought were all part of a single rational "style." "Beauty," said Ledoux, "which wholly depends upon proportion, has an irresistible power over men." Each individual was always to be considered only in relation to the whole, but the whole was to be a cooperative product of the parts. Ledoux's plan was, in a sense, a visual formulation of Rousseau's social contract. The style, as regular as it might be, was not thought of as opposing nature; rather, nature was through style freed from chance and vagaries to work in harmony with the utopian system. So employed, nature was at its purest state, at its most natural. In a series of remarkable projects, the equally visionary architect Étienne-Louis Boullée (1728–1799) spelled out in visual form the relationship of man to the universe. The abstraction of form—form detached from the particular—allowed man to see himself always as part of a larger process, whether the process was of history, the state, or the great cycles of nature. Individual men could through art see themselves as Man.

If art was indeed to be so intimately allied in its form and substance with the totality of society, it must of necessity be judged by so heterogeneous a jury as David proposed.

In September 1792 David was named a deputy in the *Convention Nationale* of the revolutionary government of France. As a member of the Committee on Public Education and the Commission of Fine Arts, which was charged with reforming all institutions primarily concerned with the fine arts, David was a frequent speaker in the *Assemblée*. In 1793 it was decided that the annual exhibition of painting and sculpture (the Salon), heretofore in the hands of members of the Academy, should consist of works chosen by a special jury named by the *Convention Nationale*. David headed a committee to select such a jury and reported to the *Convention* in the following address, which may or may not have been of his own composing.

The source for this translation is Jacques-Louis-Jules David, *Le Peintre Louis David, 1748–1825: Souvenirs & documents inédits* (Paris: Victor Havard, 1880), pp. 149–51. ✄

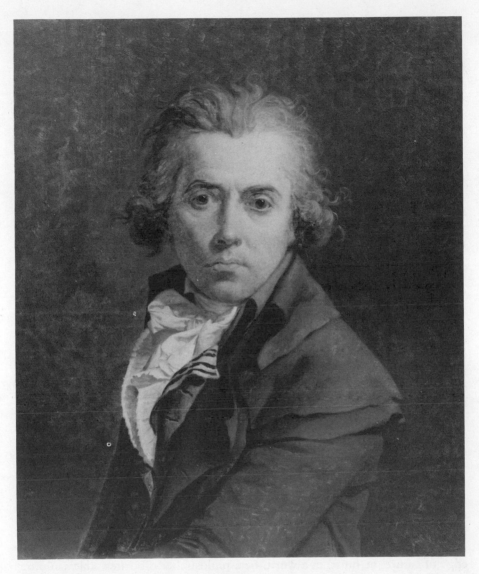

Jacques-Louis David, *Self-Portrait*, 1791, oil on canvas.

Citizens:

In decreeing that those works of art entered in competitions that merit national awards be judged by a jury named by the Representatives of the people, you have paid homage to the unity and indivisibility of the Republic. You commissioned your Committee on Public Instruction to present you with a list of candidates. Your Committee, thereupon, considered the arts in all the respects by which they should help to spread the progress of the human spirit, to propagate and transmit to posterity the striking example of the sublime efforts of an immense people, guided by reason and philosophy, restoring to earth the reign of liberty, equality, and law.

The arts should contribute forcefully to public instruction, but by regenerating themselves: artistic genius must be worthy of the people it enlightens; it must always go accompanied by philosophy, which counsels it only with ideas that are great and useful.

For too long a time tyrants, who shrink from the very images of virtues, have, by enchaining even thought, encouraged licentious mores: art served only to satisfy the pride and caprice of a few sybarites gorged with gold, and despotic corporations circumscribed genius in the narrow circle of their thoughts, proscribing anyone who came forward with pure ideas of morality and philosophy. How many nascent geniuses have been smothered in their cradles! How many have fallen victim to the arbitrariness, prejudices, and passions of those schools that caprice and fashion perpetuated! Let us examine what principle should regenerate taste in the arts, and from that we shall conclude who should serve as judge.

The arts are the imitation of nature in those aspects that are most beautiful and most perfect; a natural sentiment in man attracts him toward the same objective.

It is not only in charming the eyes that works of art have achieved their end; it is in penetrating the soul, in making a profound impression, like that of reality, on the spirit. Then the traits of heroism, and of civic virtues, offered to the eyes of the people electrify their souls and bring forth in them the passions of glory, of devotion to the well-being of their country. The artist, therefore, must have studied all the qualities of humankind; he must have a great knowledge of nature; he must, in a word, be a philosopher. Socrates, able sculptor; Jean-Jacques, good musician; the immortal Poussin, tracing on a canvas the most sublime lessons of philosophy, are witnesses enough to prove that genius must have no other guide than the torch of reason. If the artist must be imbued with these sentiments, the judge must be yet more so.

Your Committee has decided that at this time, when the arts must be regenerated along with morality, to give over the judgment of creations of genius to artists alone would be to leave them in the rut of the routine through which

they crawled before the despotism they once flattered. It is for the strong souls, those who have a sense of the true, of the greatness that a study of nature provides, to give new impulse to the arts by returning them to the principles of true beauty. Thus the man gifted with a naturally fine sensibility—the philosopher, the poet, the learned man—in the different realms that make up the art of judging the artist, the student of nature, will be the most capable judge to represent the taste and knowledge of an entire people when a jury undertakes in the people's name to award the palms of glory to republican artists. In accordance with these views, the Committee has charged me to present to you the following list to form the national jury of the arts.

Dufourny [Louis-Pierre, de Villiers], member of the department
Monvel [Jacques-Marie Boutet], actor
Fragonard [Jean-Honoré], painter
Fragonard, anatomist
Julien [Pierre], sculptor
Pache [Jean-Nicolas], [a deputy]
Varon, writer
Leroy [Julien-David], architect
Fleuriot [J.-B. Edouard Fleuriot-Lescot], assistant public prosecutor
Pasquier, sculptor
Rondelet [Jean-Baptiste], architect
Topino-Lebrun [François-Jean-Baptiste], painter
Cietty [possibly Pierre Cietti], painter
Monge [Gaspard], [geometer]
Naigeon [Jean], painter
Balzac [Louis-Charles], architect
Gérard [Baron François], painter
Lussault [Claude-Thomas], architect
Lebrun [Charles-François], author [and member of the government]
Hazard, shoemaker
Hubert [Auguste], architect
Belle, fils [Augustin-Louis], painter
Prud'hon [Pierre-Paul], painter
Haroux-Romain [J.-B. Philippe Harou, le Romain], architect
Neveu [François-Marie], painter
Thouin [André Thouiün], gardener [botanist]
Bonvoison [Jean], painter
Dordel [Robert-Guillaume], sculptor
Taillasson [Jean-Joseph], painter
Boichot [Guillaume], sculptor
Lesuer, painter

Dupré [Augustin], engraver [and medallion maker]
Ronsin [Charles-Philippe-Henri], general of the revolutionary armies
Caraffe [Armand-Charles], painter [and engraver]
Laharpe [Jean-François de], writer
Hebert [Jacques-René], assistant attorney-general
Delannoy [François-Jacques], architect
Hassenfratz [Jean-Henri], [scholar and revolutionary]
Chaudet [Antoine-Denis], sculptor
Lebrun, picture dealer
Cels [Jacques-Martin], farmer [botanist]
Poidevin [J. F.], architect
Michallon [Claude], sculptor
Dorat-Cubières [Michel de Cubières-Palmezeaux], writer
Ramey [Claude], sculptor
Laïs, actor
Goust, architect
Seguy, doctor
Lesueur [Jacques-Philippe], sculptor
Allais, architect

Substitutes

Talma [François-Joseph], actor
Desroches, painter
Vic d'Azir, anatomist
Merceray, engraver
Michot, actor
Arni, writer
Dejoux, sculptor
Boullé [Étienne-Louis], architect
Willemin [probably Nicolas-Xavier], painter
Tourcaty [Jean-François], engraver

WILLIAM GILPIN

Essay on Picturesque Beauty (1792)

The emphasis on formal beauty as a single unifying rule or principle turned some critics' attention in the later eighteenth century in a contrary direction, to consider the curiously persuasive power of the unformed. The case was convincingly stated by Edmund Burke in *A Philosophical Inquiry into the Origin of Our Ideas of the Sublime and Beautiful* (1757). Burke, drawing on the language of Longinus, pointed out that while beauty, in the perfection of its definition and its unruffled smoothness, gave the mind a sense of transcendence, of rising above the complexity of sense, another equally valid means of spiritual transport was effected when the mind encountered a force that overwhelmed it. Faced with an object, for example, that could not be entirely comprehended either visually or intellectually, the mind becomes aware of the limits of rationality, gives itself over to the provoking force, and engages unquestioningly in the full measure of the overwhelming experience. This surrender is, after the fact, subject to critical evaluation and becomes not destructive in its effect but exhilarating and stimulating to the consciousness. An often-repeated example of such an object was a thundering cataract. Personifying the great, overwhelming force of nature, it could uproot the feelings of the beholder from their tethered, limited play and purge them in a moment of exhilaration, detached from any reasoned cause. One lost oneself in the totality of the act. But this loss of self was concomitant with an intuitive perception of a power greater than self, the realization of God. More people have been converted by a waterfall than by a preacher, Thomas Gray once remarked.

This kind of forcible spiritual transport was called the sublime, a term taken from Longinus's treatise *On the Sublime,* which had in the late seventeenth century been reintroduced into the modern consciousness by Nicolas Boileau (1636–1711).

But William Gilpin (1724–1804) was concerned with an experience not sufficiently stirring to be called the sublime, yet one that left an aesthetic satisfaction that did not agree with definitions of the beautiful. He called it the "picturesque" because, although it was found in nature, it was associated in his mind with a quality he had detected in painting. Unless carefully defined the term is not especially helpful since, as Gilpin noted, pictures can be smooth and

formally organized as well as painted with "roughness" and intricate variation. But the word caught favor and was much used in Gilpin's sense throughout the late eighteenth and the early nineteenth centuries.

The concept of the picturesque as initially developed in England applied to nature, rather than to art, in reaction to formal gardens with their equally formal architecture based on Italian and French models. A new preference developed for gardens that appeared to be organized by no rational principle, thus belonging more to nature than to art. Strict hedges gave way to clumps of trees, and natural-seeming ditches replaced visually confining walls. On a large estate one might pass from "beautiful" prospects—rolling lawns, regular open spaces—into rocky patches of woods with hidden ponds, shattered snags, and possibly the shapeless ruin of a tumbled building. Dark, mysterious brambles, seemingly the victims of time and the destructive force of nature, were sometimes referred to as providing "sublime gloom," yet they were no less constructed and planned than the open beautiful areas. Two seventeenth-century painters were chosen to symbolize these two opposing modes: Claude Lorrain's paintings stood for the beautiful, Salvator Rosa's for the sublime.

The movement was not long confined to England, and the "English" garden became a standard feature in Continental parks during the last quarter of the eighteenth century.

Although certainly impressed with a concept of the sublime and influenced by attitudes toward garden architecture, Gilpin was less concerned with "sublime gloom" than with another, apparently simpler but actually more complicated reaction: the interest and ultimate satisfaction provided by viewing the complexity and continuous change of nature. Not organizable by any rational principle and yet not overwhelming in the mind, the view of the English countryside sparkling in the sun or a craggy view of low hills reflected in a lake was fascinating to the mind for no reason that existing aesthetic theories could explain. Gilpin recommended travel to various spots in England to "discover" the picturesque and began a series of travel publications in 1786. To him, landscape painting and picturesque landscape viewing were much the same thing.

The affirmation of a concept of the picturesque, along with the concept of the sublime, had a leavening effect on theories of art. When a critic discussed beauty he now had to admit, either tacitly or openly, that other aspects of the visual world offered their satisfactions, and rational theories had to be regarded in a context that was becoming ever wider in its range of possibilities. "Tho art often abounds with regularity," wrote Gilpin, "it does not follow that all art must do so."

Gilpin's curious conclusion to his essay is significant: after suggesting all the existing theories that might govern the phenomenon he enthusiastically describes, he is content to conclude that there is no rational explanation, and that

this in no way hinders his pleasure in the picturesque. Like Milizia, in a sense, he emphasized the process of seeing rather than the nature of the object itself. As Gilpin said, the eye pursued not order but change, "amused with gliding up and down among the endless transitions."

Gilpin sent a copy of this essay to Sir Joshua Reynolds, who was rather slow to acknowledge it. When he replied, he did not deny the fascination of the picturesque but concluded that it invariably was characteristic of a minor and inferior school of painting, like that of the Dutch. His disparaging characterization aside, the mention of Dutch art might be considered just; seventeenth-century painting from Holland had a wide popularity in the later eighteenth century and was repeatedly cited in the nineteenth as a worthy example by various self-conscious reformers opposed to the domination of classical rules.

The terms *beautiful, sublime,* and *picturesque* remained as part of the vocabulary of landscape architecture well into the nineteenth century. Of particular interest in this regard are Sir Uvedale Price's *An Essay on the Picturesque as Compared with the Sublime and the Beautiful; and on the Use of Studying Pictures for the Purpose of Improving Real Landscape* (London, 1794); Richard Payne Knight's *The Landscape* (London, 1794); and a work by a later American author, Andrew Jackson Downing's *A Treatise on the Theory and Practice of Landscape Gardening, Adapted to North America, with a View to the Improvement of Country Residences and with Remarks on Rural Architecture* (New York, 1841).

The present essay is taken from the second edition of William Gilpin, *Three essays on picturesque beauty; on picturesque travel; and on sketching landscape, to which is added a poem, On Landscape Painting* (London: R. Blamire, 1794), pp. 3–33. 🔣

Disputes about beauty might perhaps be involved in less confusion, if a distinction were established, which certainly exists, between such objects as are *beautiful,* and such as are *picturesque*—between those, which please the eye in their *natural state;* and those, which please from some quality, capable of being *illustrated by painting.*

Ideas of beauty vary with the objects, and with the eye of the spectator. The stone-mason sees beauties in a well-jointed wall, which escape the architect, who surveys the building under a different idea. And thus the painter, who compares his object with the rules of his art, sees it in a different light from the man of general taste, who surveys it only as simply beautiful.

As this difference therefore between the *beautiful,* and the *picturesque* appears really to exist, and must depend on some peculiar construction of the object; it may be worth while to examine, what that peculiar construction is. We inquire not into the *general sources of beauty,* either in nature, or in representation. This

would lead into a nice, and scientific discussion, in which it is not our purpose to engage. The question simply is, *What is that quality in objects, which particularly marks them as picturesque?*

In examining the *real object,* we shall find, one source of beauty arises from that species of elegance, which we call *smoothness,* or *neatness;* for the terms are nearly synonymous. The higher the marble is polished, the brighter the silver is rubbed, and the more the mahogany shines, the more each is considered as an object of beauty; as if the eye delighted in gliding over a surface.

In the class of larger objects the same idea prevails. In a pile of building we wish to see neatness in every part added to the elegance of the architecture. And if we examine a piece of improved pleasure-ground, every thing rough, and slovenly offends.

Mr. Burke, enumerating the properties of beauty, considers *smoothness* as one of the most essential. "A very considerable part of the effect of beauty," says he, "is owing to this quality: indeed the most considerable: for take any beautiful object, and give it a broken, and rugged surface, and however well-formed it may be in other respects, it pleases no longer. Whereas, let it want ever so many of the other constituents, if it want not this, it becomes more pleasing, than almost all the others without it."[1] How far Mr. Burke may be right in making smoothness the *most considerable* source of beauty, I rather doubt.[2] A considerable one it certainly is.

Thus then, we suppose, the matter stands with regard to *beautiful objects in general.* But in *picturesque representation* it seems somewhat odd, yet perhaps we shall find it equally true, that the reverse of this is the case; and that the ideas of the *neat* and *smooth,* instead of being picturesque, in reality strip the object, in which they reside, of all pretensions to *picturesque beauty.*—Nay, farther, we do not scruple to assert, that *roughness* forms the most essential point of difference between the *beautiful,* and the *picturesque;* as it seems to be that particular quality, which makes objects chiefly pleasing in painting.—I use the general term *roughness;* but properly speaking roughness relates only to the surfaces of bodies: when we speak of their delineation, we use the word *ruggedness.* Both

1. See Edmund Burke, *A Philosophical Enquiry into the Origin of Our Ideas of the Sublime and Beautiful* (New York: G. & C. & H. Carvill, 1829), p. 155.—Ed.

2. Mr. Burke is probably not very accurate in what he farther says on the connection between *beauty,* and *diminutives.*—Beauty excites love; and a loved object is generally characterized by diminutives. But it does not follow, that all objects characterized by diminutives, tho they may be so because they are loved, are therefore beautiful. We often love them for their moral qualities; their affections; their gentleness; or their docility. Beauty, no doubt, awakens love: but also excites admiration, and respect. This combination forms the sentiment, which prevails, when we look at the Apollo of Belvidere, and the Niobe. No man of nice discernment would characterize these statues by diminutives.—There is then a beauty, between which and diminutives there is no relation; but which, on the contrary, excludes them: and in the description of figures, possessed of that species of beauty, we seek for terms, which recommend them more to our *admiration* than our *love.*

ideas however equally enter into the picturesque; and both are observable in the smaller, as well as in the larger parts of nature—in the outline, and bark of a tree, as in the rude summit, and craggy sides of a mountain.

Let us then examine our theory by an appeal to experience; and try how far these qualities enter into the idea of *picturesque beauty;* and how far they mark the difference among objects, which is the ground of our inquiry.

A piece of Palladian architecture may be elegant in the last degree. The proportion of it's parts—the propriety of it's ornaments—and the symmetry of the whole may be highly pleasing. But if we introduce it in a picture, it immediately becomes a formal object, and ceases to please. Should we wish to give it picturesque beauty, we must use the mallet, instead of the chissel: we must beat down one half of it, deface the other, and throw the mutilated members around in heaps. In short, from a *smooth* building we must turn it into a *rough* ruin. No painter, who had the choice of the two objects, would hesitate which to chuse.

Again, why does an elegant piece of garden-ground make no figure on canvas? The shape is pleasing; the combination of the objects, harmonious; and the widening of the walk in the very line of beauty. All this is true, but the *smoothness* of the whole, tho right, and as it should be in nature, offends in picture. Turn the lawn into a piece of broken ground: plant rugged oaks instead of flowering shrubs; break the edges of the walk: give it the rudeness of a road; mark it with wheel-tracks; and scatter around a few stones, and brushwood; in a word, instead of making the whole *smooth,* make it *rough;* and you make it also *picturesque.* All the other ingredients of beauty it already possessed.

You sit for your picture. The master, at your desire, paints your head combed smooth, and powdered from the barber's hand. This may give it a more striking likeness, as it is more the resemblance of the real object. But is it therefore a more pleasing picture? I fear not. Leave Reynolds to himself, and he will make it picturesque: he will throw the hair dishevelled about your shoulders. Virgil would have done the same. It was his usual practice in all his portraits. In the figure of Ascanius, we have the *fusos crines;* and in his portrait of Venus, which is highly finished in every part, the artist has given her hair,

 ... *diffundere ventis.*[3]

Modern poets also, who have any ideas of natural beauty, do the same. I introduce Milton to represent them all. In his picture of Eve, he tells us that

3. The roughness, which Virgil gives the hair of Venus, and Ascanius, we may suppose to be of a different kind from the squalid roughness, which he attributes to Charon:

> Portitor has horrendus aquas, et flumina servat
> Terribili squalore Charon, cui plurima mento
> Canities inculta jacet.

Charon's roughness is, in its kind, picturesque also; but the roughness here intended, and which can only be introduced in elegant figures, is of that kind, which is merely opposed to hair in nice order.

> . . . to her slender waste
> Her unadorned golden tresses were
> Dishevelled, and in wanton ringlets waved.

That lovely face of youth smiling with all it's sweet, dimpling charms, how attractive is it in life! how beautiful in representation! It is one of those objects, that please, as many do, both in nature, and on canvas. But would you see the human face in it's highest form of *picturesque beauty,* examine that patriarchal head. What is it, which gives that dignity of character; that force of expression; those lines of wisdom and experience; that energetic meaning, so far beyond the rosy hue, or even the bewitching smile of youth? What is it, but the forehead furrowed with wrinkles? the prominent cheek-bone, catching the light? the muscles of the cheek strongly marked, and losing themselves in the shaggy beard and, above all, the austere brow, projecting over the eye—the feature which particularly struck Homer in his idea of Jupiter,[4] and which he had probably seen finely represented in some statue; in a word, what is it, but the rough touches of age?

As an object of the mixed kind, partaking both of the *beautiful,* and the *picturesque,* we admire the human figure also. The lines, and surface of a beautiful human form are so infinitely varied; the lights and shades, which it receives, are so exquisitely tender in some parts, and yet so round, and bold in others; it's proportions are so just; and it's limbs so fitted to receive all the beauties of grace, and contrast; that even the face, in which the charms of intelligence, and

In describing Venus, Virgil probably thought hair, when *streaming in the wind,* both beautiful, and picturesque, from its undulating form, and varied tints; and from a kind of life, which it assumes in motion; tho perhaps its chief recommendation to him, at the moment, was, that it was a feature of the character, which Venus was then assuming. [The passage cited is from Virgil's *Aeneid,* Book VI, verses 298–300, and can be translated as follows: "Charon is the squalid ferryman, guardian of those seething waters; his white hair lies tangled; disheveled and unruly his chin."—Ed.]

4. It is much more probable, that the poet copied *forms* from the sculptor, who must be supposed to understand them better, than from having studied them more; than that the sculptor should copy them from the poet. Artists however, have taken advantage of the pre-possession of the world for Homer to secure approbation to their works by acknowledging them to be reflected images of his conceptions. So Phidias assured his countrymen, that he had taken his Jupiter from the description of that god in the first book of Homer. The fact is, none of the features contained in that image, except the brow, can be rendered by sculpture. But he knew what advantage such ideas, as his art could express, would receive from being connected in the mind of the spectator with those furnished by poetry; and from the just partiality of men for such a poet. He seems therefore to have been as well acquainted with the mind of man, as with his shape, and face.—If by κυανεησιν εποφρυσι, we understand, as I think we may, *a projecting brow, which casts a broad,* and *deep shadow over the eye,* Clarke has rendered it ill by *nigris superciliis,* which most people would construe into *black eye-brows.* Nor has Pope, tho he affected a knowledge of painting, translated it more happily by *sable eye-brows.*—But if Phidias had had nothing to recommend him, except his having availed himself of the only feature in the poet, which was accommodated to his art, we should not have heard of inquirers wondering from whence he had drawn his ideas; nor of the compliment, which it gave him the opportunity of paying to Homer.

sensibility reside, is almost lost in the comparison. But altho the human form in a quiescent state, is thus beautiful; yet the more it's *smooth surface is ruffled,* if I may so speak, the more picturesque it appears. When it is agitated by passion, and it's muscles swoln by strong exertion, the whole frame is shewn to the most advantage.—But when we speak of muscles swoln by exertion, we mean only natural exertions, not an affected display of anatomy, in which the muscles, tho justly placed, may still be overcharged.

It is true, we are better pleased with the usual representations we meet with of the human form in a quiescent state, than in an agitated one; but this is merely owing to our seldom seeing it naturally represented in stong action. Even among the best masters we see little knowledge of anatomy. One will inflate the muscles violently to produce some trifling effect: another will scarce swell them in the production of a laboured one. The eye soon learns to see a defect, tho unable to amend it. But when the anatomy is perfectly just, the human body will always be more picturesque in action, than at rest. The great difficulty indeed of representing strong muscular motion, seems to have struck the ancient masters of sculpture: for it is certainly much harder to model from a figure in strong, momentary action, which must, as it were, be shot flying; than from one, sitting, or standing, which the artist may copy at leisure. Amidst the variety of statues transmitted from their hands, we have only three, or four in very spirited action.[5] Yet when we see an effect of this kind well executed, our admiration is greatly increased. Who does not admire the Laocoon more than the Antinous?

Animal life, as well as human, is, in general, beautiful both in nature, and on canvas. We admire the horse, as a *real object;* the elegance of his form; the stateliness of his tread; the spirit of all his motions; and the glossiness of his coat. We admire him also in *representation.* But as an object of picturesque beauty, we admire more the worn-out cart-horse, the cow, the goat, or the ass; whose harder lines, and rougher coats, exhibit more the graces of the pencil. For the truth of this we may examine Berghem's pictures: we may examine the smart touch of Rosa of Tivoli. The lion with his rough mane; the bristly boar; and

5. Tho there are only perhaps two or three of the first antique statues in *very spirited* action— the Laocoon, the fighting gladiator, and the boxers—yet there are several others, which are *in action*—the Apollo Belvidere—Michael Angelo's Torso—Arria and Paetus—the Pietas militaris, sometimes called the Ajax, of which Pasquin at Rome is a part, and of which there is a repetition more entire, tho still much mutilated, at Florence—the Alexander, and Bucephalus; and perhaps some others, which occur not to my memory. The paucity however of them, even if a longer catalogue could be produced, I think, shews that the ancient sculptors considered the representation of *spirited action* as an achievement. The moderns have been less daring in attempting it. But I believe connoisseurs universally give the preference to those statues, in which the great masters have so successfully exhibited animated action.

the ruffled plumage of the eagle,[6] are all objects of this kind. Smooth-coated animals could not produce so picturesque an effect.

But when the painter thus prefers the cart-horse, the cow, or the ass to other objects *more beautiful in themselves,* he does not certainly recommend his art to those, whose love of beauty makes them anxiously seek, by what means it's fleeting forms may be fixed.

Suggestions of this kind are ungrateful. The art of painting allows you all you wish. You desire to have a beautiful object painted—your horse, for instance, led out of the stable in all his pampered beauty. The art of painting is ready to accommodate you. You have the beautiful form you admired in nature exactly transferred to canvas. Be then satisfied. The art of painting has given you what you wanted. It is no injury to the beauty of your Arabian, if the painter think he could have given the graces of his art more forcibly to your cart-horse.

But does it not depreciate his art, if he give up a beautiful form, for one less beautiful, merely because he can give it *the graces of his art more forcibly*— because it's sharp lines afford him a greater facility of execution? Is the smart touch of a pencil the grand desideratum of painting? Does he discover nothing in *picturesque objects,* but qualities, which admit of being *rendered with spirit?*

I should not vindicate him if he did. At the same time, a free execution is so very fascinating a part of painting, that we need not wonder, if the artist lay a great stress upon it.—It is not however intirely owing, as some imagine, to the

6. The idea of the *ruffled plumage of the eagle* is taken from the celebrated eagle of Pindar, in his first Pythian ode; which has exercised the pens of several poets; and is equally poetical, and picturesque. He is introduced as an instance of the power of music. In Gray's ode on the progress of poesy we have the following picture of him.

> Perching on the sceptered hand
> Of Jove, thy magic lulls the feathered king
> With ruffled plumes, and flagging wing:
> Quenched in dark clouds of slumber lie
> The terror of his beak, and lightening of his eye.

Akenside's picture of him, in his hymn to the Naiads, is rather a little stiffly painted.

> . . . With slackened wings,
> While now the solemn concert breathes around,
> Incumbent on the sceptre of his lord
> Sleeps the stern eagle; by the numbered notes
> Possessed; and satiate with the melting tone;
> Sovereign of birds . . .

West's picture, especially the two last lines, is a very good one.

> The bird's fierce monarch drops his vengeful ire,
> Perched on the sceptre of th' Olympian king,
> The thrilling power of harmony he feels
> And indolently hangs his flagging wing;
> While gentle sleep his closing eyelid seals,
> And o'er his heaving limbs, in loose array,
> To every balmy gale the ruffling feathers play.

difficulty of mastering an elegant line, that he prefers a rough one. In part indeed this may be the case; for if an elegant line be not delicately hit off, it is the most insipid of all lines: whereas in the description of a rough object, an error in delineation is not easily seen. However this is not the whole of the matter. A free, bold touch is in itself pleasing.[7] In elegant figures indeed there must be a delicate outline—at least a line true to nature: yet the surfaces even of such figures may be touched with freedom; and in the appendages of the composition there must be a mixture of rougher objects, or there will be a want of contrast. In landscape universally the rougher objects are admired; which give the freest scope to execution. If the pencil be timid, or hesitating, little beauty results. The execution then only is pleasing, when the hand firm, and yet decisive, freely touches the characteristic parts of each object.

If indeed, either in literary, or in picturesque composition you endeavour to draw the reader, or the spectator from the *subject* to the *mode of executing* it, your affectation[8] disgusts. At the same time, if some care, and pains be not bestowed on the *execution,* your slovenliness disgusts as much. Tho perhaps the artist has more to say, than the man of letters, for paying attention to his *execution.* A truth is a truth, whether delivered in the language of a philosopher, or a peasant: and the *intellect* receives it as such. But the artist, who deals in lines, surfaces, and colours, which are an immediate address to the *eye,* conceives the *very truth itself* concerned in his *mode* of representing it. Guido's angel, and the angel on a sign-post, are very different beings; but the whole of the difference consists in an artful application of lines, surfaces, and colours.

It is not however merely for the sake of his *execution,* that the artist values a rough object. He finds it in many other respects accommodated to his art. In the first place, his *composition* requires it. If the history-painter threw all his draperies smooth over his figures; his groups, and combinations would be very awkward. And in *landscape-painting* smooth objects would produce no composition at all. In a mountain-scene what composition could arise from the corner of a smooth knoll coming forward on one side, intersected by a smooth knoll on the other; with a smooth plain perhaps in the middle, and a smooth

7. A stroke may be called *free,* when there is no appearance of constraint. It is *bold,* when a part is given for the whole, which it cannot fail of suggesting. This is the laconism of genius. But sometimes it may be free, and yet suggest only how easily a line, which means nothing, may be executed. Such a stroke is not *bold, but impudent.*

8. Language, like light, is a medium; and the true philosophic stile, like light from a north-window, exhibits objects clearly, and distinctly, without soliciting attention to itself. In painting subjects of amusement indeed, language may gild somewhat more, and colour with the dies of fancy: but where information is of more importance, than entertainment, tho you cannot throw too *strong* a light, you should carefully avoid a *coloured* one. The stile of some writers resembles a bright light placed between the eye, and the thing to be looked at. The light shews itself; and hides the object: and, it must be allowed, the execution of some painters is as impertinent, as the stile of such writers.

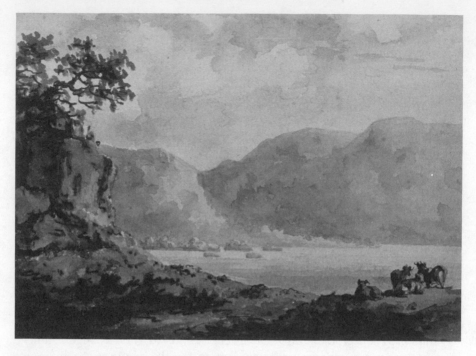

William Gilpin, *Lake Scene with Cattle,* watercolor.

mountain in the distance? The very idea is disgusting. Picturesque composition consists in uniting in one whole a variety of parts; and these parts can only be obtained from rough objects. If the smooth mountains, and plains were broken by different objects, the composition might be good, on a supposition the great lines of it were so before.

 Variety too is equally necessary in his composition: so is *contrast.* Both these he finds in rough objects; and neither of them in smooth. Variety indeed, in some degree, he may find in the outline of a smooth object: but by no means enough to satisfy the eye, without including the surface also.

 From *rough* objects also he seeks the *effect of light and shade,* which they are as well disposed to produce, as they are the beauty of composition. One uniform light, or one uniform shade produces no effect. It is the various surfaces of objects, sometimes turning to the light in one way, and sometimes in another, that give the painter his choice of opportunities in massing, and graduating both his lights, and shades.—The *richness* also of the light depends on the breaks, and little recesses, which it finds on the surfaces of bodies. What the painter calls *richness* on a surface, is only a variety of little parts; on which the light shining shews all it's small inequalities, and roughnesses; or in the painter's language,

inriches it.—The beauty also of *catching lights* arises from the roughness of objects. What the painter calls a *catching light* is a strong touch of light on some prominent part of a surface, while the rest is in shadow. A smooth surface hath no such prominences.

In *colouring* also, *rough* objects give the painter another advantage. Smooth bodies are commonly as uniform in their colour, as they are in their surface. In glossy objects, the smooth, the colouring may sometimes vary. In general however it is otherwise; in the objects of landscape, particularly. The smooth side of a hill is generally of one uniform colour; while the fractured rock presents it's grey surface, adorned with patches of greensward running down it's guttered sides; and the broken ground is every where varied with an okery tint, a grey gravel, or a leaden-coloured clay: so that in fact the rich colours of the ground arise generally from it's broken surface.

From such reasoning then we infer, that it is not merely for the sake of his *execution,* that the painter prefers *rough* objects to *smooth.* The very essence of his art requires it.

As picturesque beauty therefore so greatly depends on *rough* objects, are we to exclude every idea of *smoothness* from mixing with it? Are we struck with no pleasing image, when the lake is spread upon the canvas; the *marmoreum aequor,* pure, limpid, smooth, as the polished mirror?

We acknowledge it to be picturesque: but we must at the same time recollect, that, in fact, the smoothness of the lake is more in *reality,* than in *appearance.* Were it spread upon the canvas in one simple hue, it would certainly be a dull, fatiguing object. But to the eye it appears broken by shades of various kinds; by the undulations of the water; or by reflections from all the rough objects in it's neighbourhood.

It is thus too in other glossy bodies. Tho the horse, in a *rough* state as we have just observed, or worn down with labour, is more adapted to the pencil, than when his sides shine with brushing, and high-feeding; yet in this latter state also he is certainly a picturesque object. But it is not his smooth, and shining coat, that makes him so. It is the apparent interruption of that smoothness by a variety of shades, and colours, which produces the effect. Such a play of muscles appears, every where, through the fineness of his skin, gently swelling, and sinking into each other—he is all over so *lubricus aspici,* the reflections of light are so continually shifting upon him, and playing into each other, that the eye never considers the smoothness of the surface; but is amused with gliding up, and down, among those endless transitions, which in some degree, supply the room of *roughness.*

It is thus too in the plumage of birds. Nothing can be softer, nothing smoother to the touch; and yet it is certainly picturesque. But it is not the smoothness of the surface, which produces the effect—it is not this we admire: it is the breaking of the colours: it is the bright green, or purple, changing per-

haps into a rich azure, or velvet black; from thence taking a semi–tint; and so on through all the varieties of colour. Or if the colours be not changeable, it is the harmony of them, which we admire in these elegant little touches of nature's pencil. The smoothness of the surface is only the ground of the colours. In itself we admire it no more, than we do the smoothness of the canvas, which receives the colours of the picture. Even the plumage of the swan, which to the innacurate observer appears only of one simple hue, is in fact varied with a thousand soft shadows, and brilliant touches, at once discoverable to the picturesque eye.

Thus too a piece of polished marble may be picturesque: but it is only, when the polish brings out beautiful veins, which in *appearance* break the surface by a variety of lines, and colours. Let the marble be perfectly white, and the effect vanishes. Thus also a mirror may have picturesque beauty; but it is only from it's reflections. In an unreflecting state, it is insipid.

In statuary we sometimes see an inferior artist give his marble a gloss, thinking to atone for his bad workmanship by his excellent polish. The effect shews in how small a degree smoothness enters into the idea of the picturesque. When the light plays on the shining coat of a pampered horse, it plays among the lines, and muscles of nature; and is therefore founded in truth. But the polish of marble-flesh is unnatural.[9] The lights therefore are false; and smoothness being one of the chief qualities to admire, we are disgusted; and say, it makes bad, worse.

After all, we mean not to assert, that even a simple smooth surface is in no situation picturesque. In *contrast* it certainly may be: nay in contrast it is often necessary. The beauty of an old head is greatly improved by the smoothness of the bald pate; and the rougher parts of the rock must necessarily be set off with the smoother. But the point lies here: to make an object in a peculiar manner picturesque, there *must be* a proportion of *roughness;* so much at least, as to make an opposition; which in an object simply beautiful, is unnecessary.

Some quibbling opponent may throw out, that wherever there is smoothness, there must also be roughness. The smoothest plain consists of many rougher parts; and the roughest rock of many smoother; and there is such a variety of degrees in both, that it is hard to say, where you have the precise idea of *rough* and *smooth.*

To this it is enough, that the province of the picturesque eye is to *survey nature;* not to *anatomize matter.* It throws it's glances around in the broad–cast stile. It comprehends an extensive tract at each sweep. It examines *parts,* but never descends to *particles.*

9. On all human flesh held between the eye and the light, there is a degree of polish. I speak not here of such polish as this, which wrought marble always, in a degree, possesses, as well as

Having thus from a variety of examples endeavoured to shew, that *roughness* either *real,* or *apparent,* forms an essential difference between the *beautiful,* and the *picturesque;* it may be expected, that we should point out the reason of this difference. It is obvious enough, why the painter prefers *rough* objects to *smooth:* [10] but it is not so obvious, why the quality of *roughness* should make an *essential difference* between objects of *beauty,* and objects suited to *artificial representation.*

To this question, we might answer, that the picturesque eye abhors art; and delights solely in nature: and that as art abounds with *regularity,* which is only another name for *smoothness;* and the images of nature with *irregularity,* which is only another name for *roughness,* we have here a solution of our question.

But is this solution satisfactory? I fear not. Tho art often abounds with regularity, it does not follow, that all art must necessarily do so. The picturesque eye, it is true, finds it's *chief* object in nature; but it delights also in the images of art, if they are marked with the characteristics, which it requires. *A painter's nature* is whatever he *imitates;* whether the object be what is commonly called natural, or artificial. Is there a greater ornament of landscape, than the ruins of a castle? What painter rejects it, because it is artificial?—What beautiful effects does Vandervelt produce from shipping? In the hands of such a master it furnishes almost as beautiful forms, as any in the whole circle of picturesque objects?—And what could the history-painter do, without his draperies to combine, contrast, and harmonize his figures? Uncloathed, they could never be grouped. How could he tell his story, without arms; religious utensils; and the rich furniture of banquets? Many of these contribute greatly to embellish his pictures with pleasing shapes.

Shall we then seek the solution of our question in the great foundation of picturesque beauty? in the *happy union of simplicity and variety;* to which the *rough* ideas essentially contribute. An extended plain is a simple object. It is the continuation of only one uniform idea. But the mere *simplicity* of a plain produces no beauty. Break the surface of it, as you did your pleasure-ground; add trees, rocks, and declivities; that is, give it *roughness,* and you give it also *variety.* Thus by inriching the *parts* of a united *whole* with *roughness,* you obtain the combined idea of *simplicity,* and *variety;* from whence results the picturesque.—Is this a satisfactory answer to our question?

By no means. *Simplicity and variety* are sources of the *beautiful,* as well as of the *picturesque.* Why does the architect break the front of his pile with orna-

human flesh; but of the highest polish, which can be given to marble; and which has always a very bad effect. If I wanted an example, the bust of arch-bishop Boulter in Westminster-abbey would afford a very glaring one.

10. Gilpin refers the reader at this point to his discussion of smoothness and roughness earlier in the essay.—Ed.

ments? Is it not to add variety to simplicity? Even the very black-smith acknowledges this principle by forming ringlets, and bulbous circles on his tongs, and pokers. In nature it is the same; and your plain will just as much be improved *in reality* by breaking it, as *upon canvas.*—In a garden-scene the idea is different. There every object is of the neat, and elegant kind. What is otherwise, is inharmonious; and *roughness* would be disorder.

Shall we then change our ground; and seek an answer to our question in the nature of the art of painting? As it is an art *strictly imitative,* those objects will of course appear most advantageously to the picturesque eye, which are the most easily imitated. The stronger the features are, the stronger will be the effect of imitation; and as rough objects have the strongest features, they will consequently, when represented, appear to most advantage.—Is this answer more satisfactory?

Very little, in truth. Every painter, knows that a smooth object may be as easily, and as well imitated, as a rough one.

Shall we then take an opposite ground, and say just the reverse (as men pressed with difficulties will say any thing) that painting is *not* an art *strictly imitative,* but rather *deceptive*—that by an assemblage of colours, and a peculiar art in spreading them, the painter gives a semblance of nature at a proper distance; which at hand, is quite another thing—that those objects, which we call picturesque, are only such as are more adapted to this art—and that this art is most concealed in rough touches, rough objects are of course the most picturesque.—Have we now attained a satisfactory account of the matter?

Just as much so, as before. Many painters of note did not use the rough stile of painting; and yet their pictures are as admirable, as the pictures of those, who did; nor are rough objects less picturesque on their canvas, than on the canvas of others: that is, they paint rough objects smoothly.

Thus foiled, should we in the true spirit of inquiry, persist; or honestly give up the cause, and own we cannot search out the source of this difference? I am afraid this is the truth, whatever airs of dogmatizing we may assume. Inquiries into *principles* rarely end in satisfaction. Could we even gain satisfaction in our present question, new doubts would arise. The very first principles of our art would be questioned. Difficulties would start up *vestibulum ante ipsum.* We should be asked, What is beauty? What is taste?—Let us step aside a moment, and listen to the debates of the learned on these heads. They will at least shew us, that however we may wish to fix *principles,* our inquiries are seldom satisfactory.

One philosopher will tell us, that taste is only the improvement of our own ideas. Every man has naturally his proportion of taste. The seeds of it are innate. All depends on cultivation.

Another philosopher following the analogy of nature, observes, that as all mens faces are different, we may well suppose their minds to be so likewise. He

rejects the idea therefore of innate taste; and in the room of this makes *utility* the standard both of taste, and beauty.

Another philosopher thinks the idea of *utility* as absurd, as the last did that of *innate taste*. What, cries he, can I not admire the beauty of a resplendent sunset, till I have investigated the *utility* of that peculiar radiance in the atmosphere? He then wishes we had a little less philosophy among us, and a little more common sense. *Common sense* is despised like other common things: but, in his opinion, if we made *common sense* the criterion in matters of art, as well as science, we should be nearer the truth.

A fourth philosopher apprehends *common sense* to be our standard only in the ordinary affairs of life. The bounty of nature has furnished us with various other senses suited to the objects, among which we converse: and with regard to matters of taste, it has supplied us with what, he doubts not, we all feel within ourselves, *a sense of beauty.*

Pooh! says another learned inquirer, what is a *sense of beauty? Sense* is a vague idea, and so is *beauty;* and it is impossible that any thing determined can result from terms so inaccurate. But if we lay aside a *sense of beauty,* and adopt *proportion,* we shall all be right. *Proportion* is the great principle of taste, and beauty. We admit it both in lines, and colours; and indeed refer all our ideas of the elegant kind to it's standard.

True, says an admirer of the antique; but this proportion must have a rule, or we gain nothing: and a *rule of proportion* there certainly is: but we may inquire after it in vain. The secret is lost. The ancients had it. They well knew the principles of beauty; and had that unerring rule, which in all things adjusted their taste. We see it even in their slightest vases. In *their* works, proportion, tho varied through a thousand lines, is still the same; and if we could only discover their *principles of proportion,* we should have the arcanum of this science; and might settle all our disputes about taste, with great ease.

Thus, in our inquiries into *first principles,* we go on, without end, and without satisfaction. The human understanding is unequal to the search. In philosophy we inquire for them in vain—in physics—in metaphysics—in morals. Even in the polite arts, where the subject, one should imagine, is less recondite, the inquiry, we find, is equally vague. We are puzzled, and bewildered; but not informed, all is uncertainty; a strife of words; the old contest,

Empedocles, an Stertinii deliret acumen?[11]

In a word, if *a cause be sufficiently understood,* it may suggest useful discoveries. But if it be *not so* (and where is our certainty in these disquisitions) it will unquestionably *mislead.*

11. "Whether Empedocles or sharp-witted Stertinus is dotingly mad." To illustrate human diversity, Horace humorously juxtaposes the Pythagorean physicist Empedocles and the Stoic philosopher Stertinium.

ALEXANDER COZENS

A New Method of Assisting the Invention in Drawing Original Compositions of Landscape (1785)

Alexander Cozens (1717–1786) was an inventive English land-scape painter more concerned with the painting of picturesque views than with the construction of conventional classical landscapes. Nonetheless he was firm in his belief that art was a matter of invention, not imitation, even when invention must seem to follow the principles of nature rather than geometry. Since, like Gilpin, he looked to art and nature for a stimulating variety of experiences, he placed compositional invention at the top of his list of essential qualities for art.

Painters setting out to depict a landscape, Cozens noted, were likely either to fall into stock mannerisms in organizing the scene or to become lost in the confusion of details. Neither would result in the picturesque pleasure Cozens favored. Like Milizia, he recommended the education of the eye, a study of "the art of seeing properly." It was for this that he promoted his use of ink-blots—to surprise the imagination in discovering forms and activities that provided both interest and uncalculated unity. No less a believer than Milizia in the language of form, he wished to expand the vocabulary by alerting the mind to formal discovery.

As Gilpin knew, Leonardo da Vinci had long before suggested that ideas for compositions might sometimes be inspired by shapes seen in an old wall or streaked stones, but Cozens was setting forth an active procedure directed toward a specific end. From the beginning he associated his freely formed ink-blots with nature and looked at them as if they were, indeed, landscapes. The fact that they exhibited a visual unity, yet were the result of a seemingly non-rational process, made them, so far as the eye was concerned, an equivalent to nature. Moreover, Cozens's inkblots were not the excuse for fantasizing or for prodding the awareness of more remote emotional associations, although many intellectuals of the late eighteenth century were indeed interested in other than rational aspects of the mind. Cozens was a practical artist looking for a way to make the language of art as varied and interesting as were the seemingly vagari-

ous forms of nature. Nature might very well provide the source of such experience, but only to the prepared eye. In the spirit of his time, he set about creating a deliberate method for making paintings that depended for their expression on the fact that they seemed not to be deliberate. The spot and the resultant painting could interest the mind because they presented themselves as being, in a sense, mindless, and thus available to be explored infinitely without prejudice of pre-existing rules. Alexander Cozens's essay, privately published shortly before his death, had little currency at the time, but Cozens's predisposition to theory was well known. Following the essay reproduced here, Cozens described in detail the material and procedures for carrying out his practice. The original edition also included twelve aquatints that offered examples of ink-blots. The entire essay and illustrations of the original plates are reproduced in Adolph Paul Oppé, *Alexander and John Robert Cozens* (London: Adam and Charles Black, 1952), pp. 165–77.

By way of introduction to the following treatise, I venture to avail myself of the just observation in the commentary on the first book of that beautiful poem, "the English Garden;" but at the same time, I take the liberty of altering the words in favour of composition of landscape by invention, that being, in great measure, the subject of the present work.

The powers of art and invention, impart picturesque beauty, and strength of character to the works of an artist in landscape painting; as a noble and graceful deportment confers a winning aspect on the human frame. Composing landscapes by invention, is not the art of imitating individual nature; it is more; it is forming artificial representations of landscape on the general principles of nature, founded in unity of character, which is true simplicity; concentring in each individual composition the beauties, which judicious imitation would select from those which are dispersed in nature.

I am persuaded, that some instantaneous method of bringing forth the conception of an ideal subject fully to the view (though in the crudest manner) would promote original composition in painting; and that the want of some such method has retarded the progress of it more than impotence of execution.

Hence proceeds the similarity, as well as the weakness, of character, which may be seen in all compositions that are bad, or indifferently good: they may be also owing more particularly to the following causes;

1. To the deficiency of a stock of ideas originally laid up in the mind, from which might be selected such as suit any particular occasion;
2. To an incapacity of distinguishing and connecting ideas so treasured up;
3. To a want of facility, or quickness, in execution; so that the composition, how perfect soever in conception, grows faint and dies away before the hand of the artist can fix it upon the paper, or canvas.

To one or more of these causes may be imputed that want of nature and originality, which is visible in many productions.

How far the incapacity of combining our ideas with readiness and propriety in the works of art, may arise from neglecting to exercise the invention, or from not duely cultivating the taste and judgment, cannot perhaps be easily determined: but it cannot be doubted, that too much time is spent in copying the works of others, which tends to weaken the powers of invention; and I scruple not to affirm, that too much time may be employed in copying the landscapes of nature herself.

I here find myself tempted to communicate an accident that gave rise to the method now proposed of assisting the imagination in landscape composition, which I have constantly pursued, as well in my private studies as in the course of my teaching, ever since; and which I now lay before the public, after a full proof of its utility, from many years experience.

Reflecting one day in company with a pupil of great natural capacity, on original composition of landscape, in contradistinction to copying, I lamented the want of a mechanical method sufficiently expeditious and extensive to draw forth the ideas of an ingenious mind disposed to the art of designing. At this instant happening to have a piece of soiled paper under my hand, and casting my eyes on it slightly, I sketched something like a landscape on it, with a pencil, in order to catch some hint which might be improved into a rule. The stains, though extremely faint, appeared upon revisal to have influenced me, insensibly, in expressing the general appearance of a landscape.

This circumstance was sufficiently striking: I mixed a tint with ink and water, just strong enough to mark the paper; and having hastily made some rude forms with it, (which, when dry, seemed as if they would answer the same purpose to which I had applied the accidental stains of the 'forementioned piece of paper) I laid it, together with a few short hints of my intention, before the pupil, who instantly improved the blot, as it may be called, into an intelligible sketch, and from that time made such progress in composition, as fully answered my most sanguine expectations from the experiment.

After a long time making these hints for composition with light ink, the method was improved by making them with black ink; and the sketches from these are produced by tracing them on transparent paper.

In the course of prosecuting this scheme, I was informed, that something of the same kind had been mentioned by Leonardo da Vinci, in his Treatise on Painting. It may easily be imagined how eagerly I consulted the book; and from a perusal of the particular passage which tended to confirm my own opinion, I have now an authority to urge in its favour; an authority, to which the ingenious will be disposed to pay some regard. The passage is as follows.

"Among other things I shall not scruple to deliver a new method of assisting the invention, which, though trifling in appearance, may yet be of considerable

service in opening the mind, and putting it upon the scent of new thoughts; and it is this. If you look upon an old wall covered with dirt, or the odd appearance of some streaked stones, you may discover several things like landscapes, battles, clouds, uncommon attitudes, humorous faces, draperies, &c. Out of this confused mass of objects, the mind will be furnished with abundance of designs and subjects perfectly new."

I presume to think, that my method is an improvement upon the above hint of Leonardo da Vinci, as the rude forms offered by this scheme are made at will; and should it happen, that a blot is so rude or unfit, that no good composition can be made from it, a remedy is always at hand, by substituting another. But, according to Leonardo, the rude forms must be sought for in old walls, &c. which seldom occur; consequently, the end of the composer may sometimes be defeated.

An artificial blot is a production of chance, with a small degree of design; for in making it, the attention of the performer must be employed on the whole, or the general form of the composition, and upon this only; whilst the subordinate parts are left to the casual motion of the hand and the brush.

But in making blots it frequently happens, that the person blotting is inclined to direct his thoughts to the objects, or particular parts, which constitute the scene or subject, as well as to the general disposition of the whole. The consequence of this is an universal appearance of design in his work, which is more than is necessary to a true blot. But this superabundance of design is of no disadvantage to the drawing that is to be made from it, provided it is done with judgment and spirit; for if what is intended for a blot, proves to be a spirited sketch, the artist has only the less to invent in his drawing, when he is making it out.

A true blot is an assemblage of dark shapes or masses made with ink upon a piece of paper, and likewise of light ones produced by the paper being left blank. All the shapes are rude and unmeaning, as they are formed with the swiftest hand. But at the same time there appears a general disposition of these masses, producing one comprehensive form, which may be conceived and purposely intended before the blot is begun. This general form will exhibit some kind of subject, and this is all that should be done designedly.

It was thought necessary to give this particular description of a true blot, in order to compare it with one, in which too much attention has been paid to the constituent parts.

The blot is not a drawing, but an assemblage of accidental shapes, from which a drawing may be made. It is a hint, or crude resemblance of the whole effect of a picture, except the keeping and colouring; that is to say, it gives an idea of the masses of light and shade, as well as of the forms, contained in a finished composition. If a finished drawing be gradually removed from the eye, its smaller parts will be less and less expressive; and when they are wholly un-

(a)

Alexander Cozens, (a) *Ink Blot 14* and (b) *Ink Blot 40,* illustrations in *A New Method of Assisting the Invention of Drawing Original Compositions and Landscape.*

distinguished, and the largest parts alone remain visible, the drawing will then represent a blot, with the appearance of some degree of keeping. On the contrary, if a blot be placed at such a distance that the harshness of the parts should disappear, it would represent a finished drawing, but with the appearance of uncommon spirit.

To sketch in the common way, is to transfer ideas from the mind to the paper, or canvas, in outlines, in the slightest manner. To blot, is to make varied spots and shapes with ink on paper, producing accidental forms without lines, from which ideas are presented to the mind. This is conformable to nature: for in nature, forms are not distinguished by lines, but by shade and colour. To sketch, is to delineate ideas; blotting suggests them.

In order to illustrate farther the scheme of blotting, the opinion of a celebrated author (the late Dr. Brown) may have some weight, who was so obliging as to give it me in writing.

"A blot in drawing," says this ingenious Gentleman, "is similar to the historical fact on which a poet builds his drama; in this historical fact there is nothing but light and dark masses, void of any thing that can be called ordo-

(b)

nance or design; upon this the poet works, producing, by the power of imagination, regular light and shade, variety of corresponding objects, properly grouped and contrasted, with all the characters requisite to form a finished poem, or picture, and not less original than if the historical fact had never existed." He might have added . . . and not less natural than if the poem or picture were intirely historical.

The reader hath already seen what a blot is; I shall now speak more particularly of its use and extent, in the practice of our art.

In order to produce the drawing, nothing more is required than to place a piece of paper, made transparent, upon the blot; or if the practitioner chooses to make the sketch upon paper not so transparent, he should procure a frame, made on purpose, with a glass for small drawings, and strained gauze for larger, to stand on a table, as is mentioned hereafter. The blot with the paper is to be put on it. The first operation in composing from the blot, is to make out the sketch, by giving meaning and coherence to the rude shapes, and aërial keeping to the casual light and dark masses of the blot.

I conceive, that this method of blotting may be found to be a considerable improvement to the arts of design in general; for the idea or conception of any subject, in any branch of the art, may be first formed into a blot. Even the his-

torical, which is the noblest branch of painting, may be assisted by it; because it is the speediest and the surest means of fixing a rude whole of the most transient and complicated image of any subject in the painter's mind.

There is a singular advantage peculiar to this method; which is, that from the rudeness and uncertainty of the shapes made in blotting, one artificial blot will suggest different ideas to different persons; on which account it has the strongest tendency to enlarge the powers of invention, being more effectual to that purpose than the study of nature herself alone. For instance, suppose any number of persons were to draw some particular view from a real spot; nature is so precise, that they must produce nearly the same ideas in their drawings; but if they were one after the other, to make out a drawing from one and the same blot, the parts of it being extremely vague and indeterminate, they would each of them, according to their different ideas, produce a different picture. One and the same designer likewise may make a different drawing from the same blot; as will appear from the three several landscapes taken from the same blot, which are given in the four last plates or examples.

To the practitioner in landscape it may be farther observed, that in finishing a drawing from a blot, the following circumstance will occur, viz. in compositions where there are a number of grounds or degrees of distance, several of them will be expressed in the sketch by little more than tracing the masses that are in the blot, the last ground of all perhaps requiring only an outline: for the greatest precision of forms will be necessary in the first or nearest ground; in the next ground the precision will be less, and so on.

There must doubtless be left a power of rejecting any part of the blot which may appear improper, or unnatural, while the sketch is making; for which no previous directions can be given: in this case imagination leads, while the judgment regulates.

However it is still evident, that, notwithstanding the variety which chance may suggest, and this discretionary power of rejecting any part of a blot, a very indifferent drawing may yet be produced from other causes, such as want of capacity, inattention, &c. the effects of which are not to be counteracted by any rules or assistance whatever.

It hath been already observed, that the want of variety and strength of character may be owing either, first;

To a scantiness of original ideas: or, secondly,

To an incapacity of distinguishing and connecting such as are capable of being properly united: or, thirdly,

To a want of facility and quickness in execution.

But to each of these defects, the art of blotting, here explained, affords, in some degree, a remedy. For it increases the original stock of picturesque ideas;

It soon enables the practitioner to distinguish those which are capable of being connected, from those which seem not naturally related; and

It necessarily gives a quickness and freedom of hand in expressing the parts of a composition, beyond any other method whatever.

It also is extremely conducive to the acquisition of a theory, which will always conduct the artist in copying nature with taste and propriety.

This theory is, in fact, the art of seeing properly; it directs the artist in the choice of a scene, and to avail himself of all those circumstances and incidents therein which may embellish or consolidate his piece.

But there is a farther, and a very material purpose that may be attained by it, which is, that of taking views from nature. In doing which, as well as composing landscapes by invention, the following principles are necessary, viz. A proper choice of the subject, strength of character, taste, picturesqueness, proportion, keeping, expression of parts or objects, harmony, contrast, light and shade, effect, &c. All these may be acquired by the use of blotting; so that what remains necessary, for drawing landscapes from nature, is only a habit in the draughtsman, of imitating what he sees before him, which any one may learn through practice, assisted by some simple method.

In short, whoever has been used to compose landscapes by blotting, can also draw from nature with practice. But he cannot arrive at a power of composing by invention, by the means of drawing views from nature, without a much greater degree of time and practice.

In order to encourage those who wish to design original compositions, it may be remarked, that there is to be discerned, in all whole compositions in nature, a gradation of parts, which may be divided into several classes; for instance, the class of the smaller parts, the class of those of larger dimensions, and so on to the largest. The curious spectator of landscape insensibly acquires a habit of taking notice, or observing all the parts of nature, which is strengthened by exercise. It may be perceived, that the application of this notice in youth is directed to the smaller parts (which are also the most strongly retained in idea), from which it is gradually transferred to the larger as we approach to age, at which time we generally take notice of whole compositions. By the means of this propensity we lay up a store of ideas in the memory, from whence the imagination selects those which are best adapted to the nature of her operations. All the particular parts of each object may not be preserved in the memory, yet general ideas of the whole may be thrown as it were into the repository, and there retained.

Every one knows, that the youthful and the ignorant, as well as the mature and the refined, express their approbation (frequently from their own feelings) of performances that are worthy of praise. What can this proceed from? . . . There must be an inward criterion by which they are led to judge and approve. This criterion is the store of ideas before-mentioned, which are in the possession of all who have been used to the proper subjects. Some of these ideas are drawn forth by the merits of such performances as are presented, and so be-

come the scale or rule of judgment and taste, by which the operations of criticism are carried on.

Ideas may also be revived by recollection, whether casual or intended. To these may be added, the method of blotting now offered, which has a direct tendency to recall landscape ideas.

On the foregoing principles, very few can have reason to suspect in themselves a want of capacity sufficient to apply the use of blotting to the practice of drawing, nor can they be totally ignorant of the parts of composition in nature, for as they are previously prepared with ideas of parts, as before proved, so this art affords an opportunity of calling them forth, and likewise presents an ocular demonstration of the principles of composition. Previous ideas, however acquired (of which every person is possessed more or less) will assist the imagination in the use of blotting; and on the other hand, the exercise of blotting will strengthen and improve the ideas which are impaired for want of application.

I beg to consider this matter in a further light. It is probable, that all persons retain ideas of what they have seen, but that there are many who have no aptitude for imitating what they do see, in order to make a copy of it. So that in regard to composing landscapes by invention, there is only required a method (as blotting) to bring out those ideas visibly on paper, &c. But no method can give an aptness, or an eye, for copying to a person who is not possessed of it from nature, which may be compared to a want of ear in music.

If it be said, that a person must have genius in order to be able to make out designs from blots; the truth of this assertion may be examined by enquiring what genius is, and to what principal purpose genius is indispensably necessary; and on the other hand, what are the requisites necessary to make designs from blots.

A definition of genius may be attempted as follows. Strength of ideas; power of invention; and ready execution.—So that a man of true genius conceives strongly, invents with originality, and executes readily.

It is to be suspected, that the world entertains but confused notions concerning genius. This probably arises from mistaking certain qualities for genius, which are totally distinct from it; as perception, judgement, imagination, partiality for an art, experience, memory, taste, perseverance, industry, attention, knowledge, &c. Any one of these, or any number, or even all of them together, cannot produce such transcendent beauties as are the fruits of genius, when furnished with proper materials. Yet much is, and may be done by the force of those qualities alone, without any proof of the existence of real and original genius.

When a person shews a very great inclination to any profession, employment, or art, &c. and pursues it with unremitting perseverance, and even enthusiasm; this is not really a proof of genius, but merely of a strong attachment.

When a person, by being inured to the perception of beauty, has acquired taste, suppose it in the greatest degree, so as to be a consummate judge of the highest style of beauty; this also is not a proof of genius.

But when a person frequently and readily performs works which are novel, and these with precision of meaning; this is a proof of genius; which, as before-mentioned, consists of strength of ideas, with power of invention, and ready execution.

Lastly, when a person endued with genius has, from some incidental cause, directed his attention steadily to any pursuit, and feels a strong attachment to it; and has acquired taste, by inuring himself to the sight and perception of beauty; then enthusiasm and taste thus combined with genius, invest him with triple power, to create and execute works transcending in beauty and perfection.

The principal purpose to which genius is indispensably necessary is, the production of whole compositions new to the performer.

As to the requisites necessary for making out designs from blots, they may be seen in this treatise, where they are particularly set forth in many places. There it may be clearly understood, that it is in the power of most capacities to make designs from blots, to a considerable degree of perfection, and that genius is not indispensably necessary for that purpose. But it must be confessed, that if a person possesses genius, according to the definition, he will avail himself more of those accidental forms, &c. which the blot presents to him, and consequently will compose with greater facility and meaning from them, than one who has no genius. From this it may be presumed, that the use of blotting may be a help even to genius; and where there is latent genius, it helps to bring it forth.

Having thus far given to the reader an account of the art of blotting, and urged some arguments in its favor; the next matter is, to lay before him such rules and examples as will be useful or necessary in the practice of it.

EDMÉ-FRANÇOIS ANTOINE MIEL

The Dream of Orestes by Berthon (1817–1818)

Music has often been cited in various relationships to the visual arts, usually as an example of measure and harmony. Since the more obvious problems of imitation in the visual arts have not plagued musical theory, music has often been a paradigm for the nonrepresentational aspects of art and has often been considered more closely allied with architecture than with painting. Milizia, to be sure, was highly scornful of music as a meaningful art, either for harmony or for expression, but most theorists accepted it as a perfect example of artistic order, and the antique musical modes were sometimes adopted to describe various classes of form in the other arts.

Edmé-François Antoine Miel (1775–1842), however, in this surprising review of what was doubtless a mediocre painting, uses music for quite a different purpose: to show the effective suiting of form to an expressive purpose. He was not concerned with a general mode or mood; he saw the effect of a work, whether music or painting, as the response to specific formal procedures. His sense of utility and economy of means does not basically differ from the views of Milizia or Quatremère de Quincy, yet his goal is expression, not beauty, and his means are formal.

That he should choose Gluck, rather than some other composer, is significant, and that he should use operatic music is also of interest. Gluck's influence on French opera was great, and he was hailed precisely for his skillful evocation of emotion in which no extraneous musical adornment was allowed to intrude. Gluck's approach was sufficiently distinctive to provoke opposition from those who maintained quite different musical standards; those who supported him dubbed themselves "Gluckistes." His *Iphigénie en Tauride* was first produced at the opera in Paris on April 15, 1774, and became part of the standard repertory. Significantly, Gluck was also one of the favorite composers of Ingres.

Two of Gluck's many virtues Miel would hold up to painting: each line, phrase, and rhythm is appropriately expressive, exactly suited to the situation; and yet all this affecting expression is produced by means that are enclosed within a very narrow range. The musical "space" is rigorously restricted, and all motion is tightly related to a central "axis."

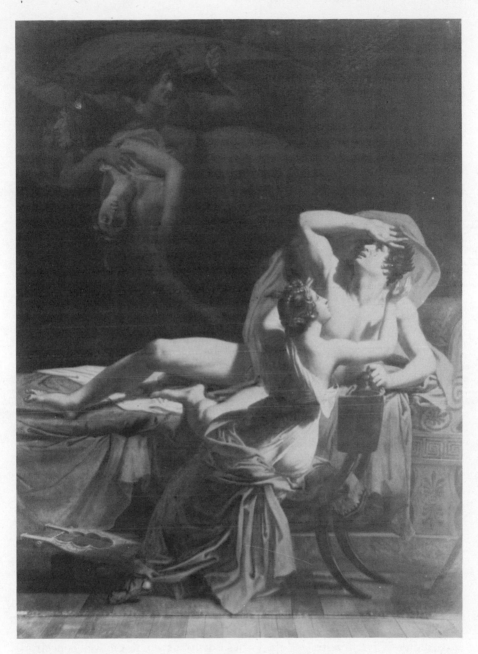

René–Théodore Berthon, *The Dream of Orestes,* 1817, oil on canvas.

Miel was a division chief in the prefecture of the Seine in Paris. He was an amateur of the arts, not an artist, and waited until he was forty-two years old before publishing his remarks on art. When his review of the Salon of 1817 appeared, it created a sensation, it is said, because of his unorthodox views. He was committed to no particular school and looked with equal favor on the art of the Middle Ages and the art of antiquity. As with Quatremère and, to a degree, Ingres, a given style was less of concern to him than were consistency, clarity, and suitability to the evident purpose.

This translation is from Edmé-François Miel, *Essai sur les beaux-arts, et particulièrement sur le Salon de 1817; ou Examen critique des principaux ouvrages d'art exposés dans le cours de cette année* (Paris: Didot le Jeune, 1817–1818), pp. 199–208. 🐦

Orestes is stretched out on his bed in the hope of sleeping, but hardly has he closed his eyes when the bleeding cadaver of his mother appears to him, borne by the Furies. He awakens with a start. His arm is raised to his forehead in a sigh of fright, and his hand seems to ward off the phantom. Electra is seated in the foreground. She has put down the lyre, so powerful in its effect on the troubled spirits of mortals. Turned toward Orestes, she looks at him with tender solicitude. She lavishes on him her caresses and attention. Thus the brother and sister remain wakeful, he because the Eumenides deny him an instant of rest, and she in order to calm and console her brother. As long as heavenly vengeance pursues this family, none of them will again know sleep.

Berthon's brush is facile but cold. His color is more consistent than harmonious. In his drawing he tries to evoke the antique, but if it does so it is more through the artist's personal way of seeing than through any true feeling. Nonetheless, in the execution there is something rather grand and impressive. But the invention is feeble.

Orestes should be shown as a character dark and sinister in feature, with a strong and powerful contraction of the muscles but little motion in the limbs; the frightful nightmare of parricide is a highly concentrated situation. I look for the torment of remorse and find only the convulsions of physical grief. This is a disturbing composition, but not interesting.

The moment chosen for the painting is not clearly enough indicated: one cannot tell if Orestes has awakened or if, open eyed, he still sleeps. If he is sleeping, I certainly do not approve of this kind of somnambulism, an equivocal state between sleeping and waking. If he is no longer sleeping, the phantom would have had to disappear, since the vision is only a dream. Furthermore, the apparition of Clytemnestra and the Furies does not seem to me well conceived. This phantasmagoria is all right for the opera; there it is necessary because the

stage depends on action. But in a painting it seems to me superfluous. Further, it is misplaced and the effect is only puerile, unless a frightening manner of execution is enough to make one tremble.

If the artist wants to look for inspiration in the opera, he should not look to borrowing from the poet or the stage designer. But he could borrow usefully from the musician. Here is how the situation has been handled by the immortal Gluck, that eloquent painter of nature and the human heart.

Orestes hopes to find some respite from his suffering in a short moment of sleep. He believes that calm is returning to his heart and says so; the unfortunate creature deceives himself without realizing it. He mistakes exhaustion for repose.

The song (D) proceeds in broken, unequal phrases; its ascending motion has something ominous about it, expressing the progression of mounting grief. The crisis reaches its final phase; a shattering cry (G) completes it. This explosion is followed by the abatement.

The harmonic succession of chords, after having ascended diatonically (from the beginning of the part up to G), descends in half tones (from J to the end of the section). This descending progression, I think, permits us to understand Orestes' succumbing to lassitude. But sleep is only on his eyelids, just as calm is only on his lips. The orchestra lets us know what is going on inside him.

Throughout this section (C), the dominant is heard in the bass distributed in groups of three notes separated by rests. These tercets, which are repeated continuously without change, are already a very energetic representation of remorse fixed on its prey.

But the effect of this funereal ticking is fortified by a veritable alarm sounded by the alto (B) rapidly doubling the insistent dominant. One recognizes in this monotonous and sinister tremor the agitation of the criminal, the moral tocsin that sounds the alarm in the depths of a disturbed conscience. The syncope that breaks these doubled notes destroys the sense of measure and thus completes the image of interior trouble, associating the idea of agitation with irregularity.

The violin accompaniment, executed in duo (A), is conceived with no less depth. It is a phrase always similar in its form, alternately composed of abrupt jerks and sighs. It proceeds by starts. In the various modulations it goes through, it is scanned in the same manner. Its rhythm expresses the convulsive heaving of a palpitating breast, the efforts of labored breathing, the persistence of oppression. It is then that the unfortunate man cries out to the gods to let him breathe. No, he cannot breathe. His heart palpitates violently. But to breathe is to experience a kind of ease, and for a parricide there is no more ease than there is repose.

The picture is not complete. A new brushstroke is added to this somber en-

Pl. 26

1

Page 204

EXTRAIT de l'OPÉRA
D'IPHIGÉNIE en TAURIDE,
PAR GLUCK.

mes maux ont donc las - - sé

la co - - le - - re cé - les - -

-te; je tou - -

H.t Bois 8.

-che au ter - -me du mal - heur;

oui, oui,

le cal _ _ _me ren _ _tre

dans mon cœur.

(Gravé par M.^{me} PIQUÉ.)

ergy. The oboes (E) mix their shrill and nasal tone with these terrible combinations. They support the effect with a long and sustained note, augmenting the torment of the ear and soul.

Note that neither the melody nor harmony is dispersed; there are no jumps in the melody nor great movement in the chords. Everything is closed, everything is internal, like remorse itself, and the dominance of the alto, the intermediate part between the violins and the bass, helps especially to concentrate the effect.

In spite of the agitation, the interruptions, the general economy of the piece is such that one cannot resist its lethargic impression. The effect is so melancholy that the inclination to sleep is irresistible. The starts that one experiences before an uneasy sleep, the efforts one uses to overcome sleep, the abject heaviness that precedes stupor are expressed by the G and its immediate return to A (F). The general languishment to which the suffering being succumbs in sleep could not be better depicted than by the oscillations of the bass, which passes alternately several times from G to B, balanced around A (from F to H). One feels laziness; one must sleep despite oneself; Orestes also sleeps, but what punishment is afforded by such sleep! I know of no stronger conception than that of this piece, nor a more moving effect produced by simpler means. There is not a note that is without picturesque intention, that is not essential. All bears the mark of genius. The creations of Gluck have neither extraneous bits nor padding.

Although, faced with a mediocre painting, I have examined an admirable piece of music, I have not strayed from my subject. Music and painting are linked by intimate relationships that derive from poetry, the common bond of all the arts. Greece for the ancients, like Italy in the modern period, was the common homeland of both painting and music. The one, to be sure, operates on the organ of sight, while the other affects the sense of hearing, but both address themselves to the soul, to the imagination. While their means are different, their aim is similar: both set out to please, interest, move, even exalt, and to draw men to virtue through pleasure. Music paints with sound, as painting does with color; the latter colors space, as the former, time. They borrow language from one another; thus, through fraternal exchange, painting has *tones,* music *nuances,* and both have *harmony.* The one, by means of moral impressions, promotes the conception of physical expressions; the other leads from the sensuous world to the ideal world. They are sisters to such an extent that each of their forms in some way complements a sensation produced in the other, and a gracious, pathetic, or terrifying situation is never more vividly felt than when the two arts concur in its representation. I cannot hear passionate music without thinking of painting, nor see a dramatic painting without trying to render it in terms of melody and harmony. You cannot imagine how much

interest and charm this reciprocal translation holds. On one side, a fixed and positive base; on the other, the whole realm of the imagination. Under pain of lacking conformation, every painter should love music, every musician painting.

Look at the painting *The Marriage at Cana;*[1] you will see there Paul Veronese, Tintoretto, and Titian playing instruments. Leonardo da Vinci excelled in music and advised painters to cultivate it. Cherubini is as agreeable a draftsman as he is a musician; Baillot is one of the most sensitive men regarding picturesque beauties; the first of our landscape painters, Valenciennes, is an able violinist; one of our best violinists, Norblin, has depicted familiar scenes; and the present leaders of our school of painting, Gérard, Girodet, Guérin, are very distinguished amateurs in music.[2] I have cited a few examples as authority; I could cite a thousand others. The technique of a virtuoso has its characteristics, like the technique of a painter, and the talent of both can be defined with almost equal precision, based on analogous qualities and equivalent terms. Poetic analysis of the two arts is based on the same laws, follows corresponding rules, and can be developed in parallel fashion. However, criticism of a musical work is based only upon rather vague fugitive impressions and, more often than not, on simple recollections of impressions; it requires more finesse, more alacrity, a livelier and more delicate sense of taste, a more exquisite sensibility. Rameau's art draws just as much on conventions as Raphael's and supposes some degree of initiation. It is still true that the means for judging music well are more restricted and less available to amateurs. Although we may not have the works of Michelangelo or Daniele da Volterra before us, we can, up to a point, study prints;[3] but it is only with an orchestra and good execution that we can come to know Handel, Gluck, Haydn, and Mozart. We have often heard the masterpieces of these great musicians perfectly played. Will we not be permitted to recommence this kind of truly classical course? Let us hope that the muse of Euterpe will not always remain mute and alone, that an enlightened administration will sponsor the noble and interesting performances of the Conservatory. Let us bring together all the elements of our supremacy. Let it not be said that we are depriving ourselves of a pleasure for which all Europe envies us. But beyond this, some temporary, accidental circumstances have nothing to

1. Paolo Veronese's painting, *The Marriage at Cana* (1563), is in the Louvre. In the foreground, he depicted his fellow Venetian painters in the guise of musicians.—Ed.

2. Daniele da Volterra (Daniele Ricciarelli, 1509–1566), a pupil of Sodoma who "clothed" the nudes of Michelangelo in the *Last Judgment* in the Sistine Chapel.—Ed.

3. Luigi Cherubini (1760–1842) was an Italian composer residing in Paris; Henri de Valenciennes (1750–1842) is discussed in Part II of this volume; Louis Pierre Martin Noblin de la Gourdaine (1781–1854) was a French cellist; and Baron François Gérard (1770–1837), Anne-Louis Girodet de Roucy-Trioson (1767–1824), and Jean-Baptiste Paulin Guérin (1783–1855) were significant French painters of the period.—Ed.

do with the matter; basically, the criticism of a musical work is the same as for a painting. The simultaneous examination of painting and music offers a vast field of observation. This comparative study becomes a fertile source for new insights, unusual approaches, unexpected results. The amateur, by generalizing thus the principles of his judgment, enlarges the sphere of his enjoyment. The communication between the two arts should throw a more vivid light on each.

QUATREMÈRE DE QUINCY

On the End of Imitation in the Fine Arts (1823)

Antoine Chrysostome Quatremère de Quincy (1755–1849) exerted considerable influence over the art of Paris for a long period of time. His ideas on art were formed largely in Rome in the 1770s—at the same time that David was a student there—and remained largely unchanged throughout his long and active life. Like David, he was associated with the Revolution, but his concept of art was far less tied to a social ideal. He strongly criticized Napoleon for appropriating the masterpieces of Rome to found a museum in Paris, insisting that art existed above and beyond the strictures of contemporary politics. In 1816 he was appointed to the post of secretary in the Bureau of Fine Arts, where he was closely associated with the Institute des Beaux-Arts (the post-Revolution form of the erstwhile Académie Réale), a position he held until 1839.

Quatremère's principles are not far different from those of Reynolds or Milizia, but times had changed. On one hand, the proliferation of the style traditionally cited as stemming from David had produced an increasingly mechanical and stereotyped form of "classical" expression. Various countercurrents had begun to develop, notably an interest in the simple observation of nature (by the 1820s much advanced from Gilpin's observations), the exaltation of "naive" taste, and an emphasis on personal emotive content (see the introduction to Part II). The first of these opposing tendencies seems most to have disturbed Quatremère, and much of his essay "On the End of Imitation in the Fine Arts" is a refutation of perceptual painting as such. The word *imitation,* he believed, was threatened by erroneous interpretations, and earlier theorists had too easily assumed the object of artistic imitation to be an ideal image.

Although a well-trained antiquarian and archaeologist, Quatremère did not insist on formulating a style based on a period of Greek art, as did Winckelmann. Much more knowledgeable about antique works than Winckelmann, Quatremère recognized and delighted in the great variety of Greek expressions. When the sculptures of the Parthenon were brought from Athens to London, Quatremère accepted them at once as great works that exemplified a hitherto unknown aspect of Greek sculpture; many of his contemporaries, however, relying on a synthetic notion of Greek beauty, rejected them as inferior products.

His conception of the ideal was not limited to a particular form or a determined notion of beauty. For him the ideal consisted in whatever "is composed, formed, and executed by virtue of that faculty in man which enables him to conceive in his mind and to realize what he has conceived."

Quatremère viewed himself as engaged in a struggle to keep alive the notion of art as the embodiment of man's highest intellectual achievement. Art's function was to maintain for modern society a level of thought and judgment equal to the highest attainments of the past. To destroy the intellectual basis of art would be to destroy the possibility of continuity with the timeless community of great minds—a position shared by Ingres.

Art thus conceived was impossible without a knowledge of tradition. The perfect artist, for Quatremère, was the summation of all past virtues but modern in his understanding and perceptions. Tradition did not place limits on individual creative activity, but the serious artist necessarily created within the intellectual environment of great art, and the naive person was simply insufficiently educated to be a serious artist. Unsympathetic to Rousseauistic concepts of man as a child on nature, Quatremère believed that man was true to his nature only when exploiting his intellect and the intellectual accomplishments of his culture to the utmost. Art depended on inventing, he insisted, not finding; a work of art is a creative act, not a recording or a simple response to something.

Although certainly Milizia's borrowed image of the machine would not have appealed to Quatremère, he did maintain that pleasure is derived from the fabricated object, not from what it reflects. His objection in the present essay to paintings of David Teniers was not based on the lowly nature of his subjects but on Teniers's failure to transform the sensuous aspect of the scene so as to distinguish it from nature itself. The first necessary characteristic of a work of art, maintained Quatremère, is that it not be misconstrued as nature; art is not the stylistic reduction of a thing seen and is false so far as its likeness to nature is concerned. Rather art is a convincingly true embodiment of an idea—that which previously did not exist in matter; it is a concrete presentation of an intellectual abstraction.

The word *ideal* became a battle cry in the aesthetic struggles of the nineteenth century, more vociferously insisted on by some as values generally became more materialistic. The writings of Quatremère de Quincy, which were widely known, might be taken as representative of the many such efforts in the first half of the nineteenth century to sustain the concept of the ideal in art.

The translation is by J. C. Kent, *An Essay on the Nature, the End, and the Means of Imitation in the Fine Arts* (London: Smith, Elder and Co., Cornhill, 1837), pp. 177–218. ✦

Poeta tabulas cum cepit sibi,
Quaerit quod nusquam est gentium, reperit tamen.[1]
Plautus Pseudolus

Chapter I. Pleasure, the Object of Imitation.— Of the Two Kinds of Pleasure It Affords.— Which of the Two Is Its End

Nature, in according the faculty of imitating to man, intended no doubt that it should first be subservient to his wants. To it is man indebted for the ability to form those incipient sounds, which by degrees he learns to modify, as his ear conveys to him the rudiments of language. By it all the arts that he sees performed become his own, and he appropriates the forms, motions, accents, and habits of all that has preceded him, to communicate them in like manner to those who shall come after him in the career of life.

Nature having under every circumstance associated pleasure with wants, the faculty of imitating must consequently acquire new developments in an improved state of society. After having been exercised in fixing, by the imitative signs of objects, the ideas of those objects, it came to pass that lineaments thus roughly traced by and from necessity were invested with greater perfection. Finally, when casting off the fetters of symbolical images, writing had reached the point of representing ideas by abbreviated signs, or arbitrary strokes designating not the things themselves, but the sounds of the words expressing them, the art of repeating the forms of bodies was applied to another purpose, the principal object of which was to please.

All this is too well known to render it necessary that I should stop to point out the cradle of the arts of imitation, in the wants attendant on every kind of communication that by degrees society establishes among men.

Thus the pleasure of imitation succeeded every where to the want of imitation.

As pleasure sprang from want, so, under another state of things, it created in its turn new wants. To perpetuate the memory of benefactors or of benefits; to raise the mind to ideas of immortality by the sight of monuments; to embody and treasure up in expressive language, moral opinions, and religious sentiments: these were indeed true wants among civilized people; and to supply such would prove an end as advantageous to the imitation of the fine arts as to society.

1. "[But as the] poet, with his tablets in hand, seeks for what nowhere is, yet finds it [makes a lie seem true]."—Ed.

This point of view, however, can never enter, either directly or necessarily, into a theory which has only to do with imitation in itself. It is with this theory, as with poetics, in which, without discussing the moral purpose of poetry, which ought to have a tendency to render men better, the end proposed is to show how, and of what, good poems are formed, and not how they may influence the manners of a people. In like manner here, having to make known what imitation, viewed theoretically in its *nature,* its *end,* and its *means,* ought to be, it would be irrelevant to join to those considerations, that of the moral action which the lessons contained in works of art exercise on public feelings and opinions.

The end we have assigned to imitation is that of pleasing. But it will be seen, that the kind of pleasure involved in that end is not denuded of all action on the moral nature of man.

The better to prosecute this second part according to the conclusions arrived at in the first, we shall begin by recalling what has already been said: namely, that the imitation of the fine arts is capable of procuring more than one sort of pleasure, which admits of different degrees according as the senses are more or less concerned in it. In every art the pleasure of the senses necessarily proceeds from that component part which, as in man, may be termed its physical substance.

There is no one art, as already shown, that does not address itself more or less directly to some one of our external organs, and by some means or agency more or less dependent upon matter. The pleasure that the organ thus receives is indeed one of the ends of every art, since, if that pleasure did not exist, the action of the art itself would be as though it were not. But that such can be its true end, that is, the essential and definitive end of imitation, is one of the errors arising from ignorance and thoughtlessness: as well might it be maintained that the pleasure derived from eating and drinking is the aim or end of that want; while it is surely nothing more than a means of attaining another pleasure, that of health, strength, and the use of our faculties.

Undoubtedly the pleasure of the senses must accompany the action of imitation upon us, but after the same manner, that is, less as an end than a means, which nature has herself placed as an incentive to those appetites, that lead the way to the accomplishment of all her designs.

In like manner in the action of the fine arts, the charms of sensual enjoyment should only invite and lead us on to enjoyments of a higher order. The senses do but perform the office of introduction. The generality, it is true, having no suspicion of any thing beyond the external impression, [should] stop short at it, like one who should take the porch of the temple for the temple itself. But such miscalculation proves nothing save disregard or ignorance of the true value of the fine arts. For our own part, without denying that the pleasure of

the senses may be one of the ends of imitation, we look upon it only as a prelude to another pleasure, constituting the definitive aim of the fine arts.

The analysis of the elements of imitation discloses to us three degrees of pleasure corresponding to different faculties of man.

The first is that of mere instinct, which, confined to matter, requires only in the image, the repetition of reality by reality, and which is alike deceived in what it requires, and in what it receives. This pleasure is necessarily excluded from the consideration of the theory we are discussing.

The second, limited to the impressions of the senses, though produced by legitimate means of art, stops short at the sensation derived from an imitation, technical rather than intellectual. In this, the choice of subjects, and the servile manner of representing them in the spirit of reality, reduces, as regards the mind, the distance that separates the model from the image. In this kind of pleasure, as previously shown, the act of placing in apposition, and comparing, is rendered of none effect, and there is nothing for the imagination to regard beyond what the eye embraces.

The third sort of pleasure, though without excluding the preceding, is the true end of imitation. Seeing that it is derived from all that is most exalted in the sphere of imitable objects, and rarest and most excellent within the range of imitative power, this pleasure stands related to all that is most noble in ourselves, I mean, to the faculties which most distinguish man from other creatures, to the intellectual organs, so superior in their nature and action to those of the body.

The pleasure I speak of cannot exert its sway, but through the especial co-operation of those who experience it. Its impressions have no share in common with those of matter. It requires other eyes than those of the body to see, other ears to hear. The imitation that gives rise to this pleasure consists in relations which cannot influence the senses. The distance that separates its creations from their generating principle can be measured only by understanding; and it requires far other sensibility than that of the nerves to experience the sentiment of beauty which is its effect.

The pleasure here assigned as the end of imitation is then far higher in degree than that termed *physical,* it is in short a *moral* pleasure.

I have explained that the word *moral,* as applied to imitation, is not intended to signify any useful influence on morality or manners resulting from works of art, but is employed in an opposite sense to that attached to the words *physical, material, sensual.* A play may afford the finest examples of virtue, but presented in a system of low imitation so nearly approaching reality that its impression may be reduced to that of physical pleasure.

The subject of a painting may form a good moral lesson, and yet the mode of treating it occasion us no other kind of pleasure than that limited to the

senses. Such, for instance, would be the case, in the representation of the fable of the labourer and his children trying to break the bundle of sticks.[2] Suppose the scene be presented to us as the interior of a poor and rustic cottage, with the costume and portraits of its peasant inhabitants, and, if you will, let Teniers be the painter;[3] the imitation of an incident in itself so moral, will in that case produce only the *physical* pleasure of imitation. Suppose now the same scene expressed by the historical painter, with all the nobility of character, beauty of form, variety of expressions and attitudes that the subject will admit of, the mind will then enjoy the *moral* pleasure of imitation. Nay more, the same effect may even be produced in the representation of events stamped with a character of the greatest immorality. I shall be content to cite the massacre of the innocents of Raffaello.[4]

Furthermore, in making use of the word *moral* to express the opposite idea to that of physical and material, I do so only until the development of this theory concerning the true end of imitation, has enabled me to substitute another word; the employment of which, however, not being as yet defined, would here perhaps be premature,[5] and lastly that the aim of art should be moral utility.

CHAPTER II. ON THE RIGHT UNDERSTANDING, ACCORDING TO THE SPIRIT OF THIS THEORY, OF THE IDEA OF REALITY OR IDENTITY IN IMITATION, AND OF THAT OF THE PLEASURE RESULTING FROM IT

If, as seen in the first part of this work, the employment of reality, considered either in itself or in the mechanical means of repetition that appertain to it, disannuls the effect of the imitation which is properly that of the fine arts, and is consequently contrary to its nature, one cannot disallow the consequences of a fact thus found to be invariable, that is, the analogies which are dependent on it.

Nothing in theory is more dependent on what is termed the nature of a thing, than what is termed its spirit. From its nature are derived the general laws of its being or constitution. Such, for instance, in the case of every country or people, is the character impressed on it by natural causes. The spirit of

2. In one of Aesop's fables, a laborer demonstrates the strength of unity to his quarreling children by tying together weak sticks into an unbreakable bundle.—Ed.

3. David Teniers (1610–1690), one of a family of Flemish painters known for pictures of humble life and rustic characters.—Ed.

4. Raphael's drawing for the *Massacre of the Innocents* was engraved by Marcantonio Raimondi.—Ed.

5. Kent adds, in a translator's footnote, an excerpt from a translation of Quatremère's "The Destination of Works of Art," made by "Mr. Howard, R.A.," which concludes that "the most ideal imitation is also the most moral."—Ed.

Abraham Teniers, *Village Fete* (after David Teniers), c. 1650s, engraving.

that people is a subsequent result of such character, and is depicted in their manners and opinions.

It is the same with the fine arts, the natural principle of imitation once discovered, what is termed its spirit will assuredly partake, in a more or less evident manner, of the nature of its principle. That is to say, the same ideas are, in the investigation of this secondary object, capable of the same applications, which no other difference than that which distinguishes the absolute laws of nature, from the less rigorous rules of taste.

Thus the ideas of *identity, reality* and *proximity,* which we have applied, in their simple and absolute sense, to all surreptitious imitation, in which *a thing is found reproduced by some other that is only the repetition of it,* we find, I say, that those ideas, though only in their figurative and relative meaning, are equally applicable to that kind of image, the spirit of which is to represent objects just

Marcantonio Raimondi, *Massacre of the Innocents* (after Raphael), c. 1513–15, engraving.

as they are, without pretending to give rise to views or conceptions beyond: and the pleasure resulting from such imitation is that we term the pleasure of the senses.

This being understood, when, in the future course of our theory we employ the words *identical resemblance,* they must no longer be taken in the sense of repetition of reality by reality, but in that of an imitation which gives rise to the idea of it, which aspires to be only a kind of mirror or *fac simile* of things and objects. That is, those words and ideas should simply be taken in their spirit, and according to their conventional sense, not according to the grammatical strictness of the terms.

Although, in what is gone before, arguments have been frequently drawn, as by virtue of a necessary link between the nature of imitation and its spirit, it would yet seem well to determine this point with still greater precision, in order to avoid the mistake of understanding the things in question in a too material sense.

For instance, I maintain that an action is represented according to the system of identity or in the spirit of reality, when the imitator, whether poet or painter, relates or reproduces its details and circumstances in such manner as that, though its material truth be recognizable, yet it is restricted to that simple

character, without any thing that might lead the mind to perceive any relation with the moral causes of the event, the affections fitted to shed an interest over it, or the effects that would tend to give it importance.

But I prefer rather to limit my observations to the idea of portraiture, which I shall hereafter have occasion to bring forward as demonstrative, in an inverse sense, of what ought to be the end of imitation. (See the remarks on the effect of portraiture, in the next chapter.)

In painting a portrait the artist aims at nothing more, than that a certain individual should be recognized in his image. To achieve this, he studies to repeat with extreme precision the particular features, nay, even the deformities, of his model. Thus the usual encomium on a portrait *(it is he himself,)* serves, in the best possible manner, to define that spirit of *identity, repetition, reality,* which is peculiar to this kind of image; those words thus understood, and not taken in their strict sense, are applicable, in general theory, either to imitation or its works, according as the pleasure derived from them is more or less founded on sensations that are more or less restricted to physical effects.

Not to lose sight of the comparison, there is assuredly no pleasure more limited than that which is usually the result of a portrait. If we abstract from it all the interest that individual and public feeling, or the talent of the artist clothes it with, we shall to a certainty find, that the mind and the imagination have but small share in such kind of imitation; and for this reason, because the appositions to be brought about are few in number, and the operation of the mind in comparing very slightly active.

From this instance, to which no one will find it difficult to add many others, we may conclude, that imitation, when exercised in the sphere most circumscribed by reality, then contributes most to that pleasure which we have termed the pleasure of the senses, which may truly be said to be the only one that the vulgar require of the arts, and moreover the only one they receive from them.

By vulgar, I would be understood to mean, as well all those whose minds have not been cultivated, or at least not on this subject, as those in whom the sensual part has obtained the mastery over the other faculties. Hence, we may explain the avidity with which the vulgar, of whom I have just spoken, hasten to seek every where and in every branch of art, impressions so closely bordering on those of reality, that scarcely any room is left for comparison.

It explains the preference awarded at certain periods to certain kinds of imitation, to a certain class of subjects, which are capable of affecting the senses alone, and to relish which needs neither imagination nor understanding.

And it also explains to us why, at those same periods, the kinds of imitation, of subjects, and of works, whose models and comparison are alike beyond the ken of the vulgar, are found to have been neglected.

We do not wish to infer from this, that the pleasure of the senses should be excluded from among the number of the pleasures of imitation. The previous

chapter has sufficiently shown how and by what title it takes rank among them. We would only maintain that this species of pleasure, by its close approximation to the impressions of *reality* and *identity,* so directly contrary to the nature of imitation, is essentially qualified to divert it from its proper aim.

We come then to the conclusion that the imitation which only presents objects to us in the spirit of reality, is that by which the pleasure of the senses is produced, and that such pleasure cannot be the true end of the fine arts.

CHAPTER III. OF THE SUPERIORITY, IN IMITATION, OF THE PLEASURE OF THE MIND, OVER THAT ADDRESSED TO THE SENSES ALONE

In order to form a just estimate of what ought to be the end of imitation, that is, of the pleasure towards which it should incline, it will be necessary to render a further account of this pleasure, not in itself, but in its effects, I mean its useful effects.

It is already known what utility I speak of, and that neither political utility, nor that related to morality, can have any thing to do with this theory.

The useful effects of the pleasure of imitation consist in the knowledge, the sensations, the ideas, and the images we acquire through it; in other words, in that which increases the scope of our understanding, enriches our minds with new conceptions, and opens to our imaginations vistas without number, revealing prospects without a limit.

Now, I ask what the imitation that is limited to the senses, in the choice of its subjects and in its mode of representing them, I ask what are its useful effects, what its images can teach me, restricted as they are to the gratification of the eye. I ask what they show me that I do not already know; what they put me in a condition to perceive over and above their model, what impressions depending on art they communicate to me; in short, what acquisition such kind of imitation can promise me or give me reason to hope for.

I shall be told that it gives me what nature, whose portraiture it is, gives me. I answer, no. It does not give it, precisely because it is only a portrait, and because a portrait is only a part of the resemblance of the natural object, and presents only a single aspect; because such an image, thus limited, and which cannot carry my imagination beyond the confines of reality, gives only the finite, instead of the infinite, to which the soul aspires.

There can be no doubt that what we should require of imitation in the fine arts, is that it satisfy the cravings of our minds after unlimited impressions, and ever renewed sensations, that is, inexhaustible in their effects as is nature in her combinations. Such is the enjoyment that we demand of art; and such cannot be

that of an imitation whose sole property is to exhibit objects, precisely as they are everywhere and at all times presented to us. This imitation is somewhat similar, if I may be forgiven the comparison, to that of a certain animal, whose instinct prompts him to repeat the motions and outward signs of the actions he witnesses, though without comprehending the reason or motive for them, and without suspecting the intelligent principle that actuates them.

Is this all that we are to expect from imitation? And shall we lavish our admiration on a result thus fruitless as regards the mind?

And yet what else can be said of a work of art which, limited to being a mirror only of the object, like a mirror, can in no wise, either add, curtail, correct, modify, perfect, or generalize, and which in truth, morally speaking, gives us nothing, since it but gives us the same thing a second time, and, according to the spirit of the principle of imitation, has a tendency to be, as little as possible, imitation?

We have already had occasion to remark in what estimation every system of imitation must be held, in which is alone repeated vulgar manners, trivial phrases, the common-places of every day language, scenes drawn from the lowest grades of society, or images presenting only the individuality of persons and bodies, as well as all representations which can be accounted no other than so many copies, the types and proofs of which are matters of daily experience, instead of being true originals, either in the common or figurative sense of the word; for that is no true original the model of which can anywhere be instanced.

Wherefore should I wish for a copy? What need have I of the appearances of things whose reality I am wholly indifferent to? What worth can I attach to the image, when I hold its model in contempt, more especially since there is nothing beyond to compensate for the absence of all those properties which nature denies it?

Whatever amount of sensual pleasure may arise from such like productions, allowing that pleasure to be the end of imitation, is there any thing, I ask, to warrant me setting so high a value upon its works? Can the end attained be worth the pains bestowed? To whatever degree of excellence the execution of such labours may attain, can we do other than class their results as among those costly productions of industry, the frivolous inventions of luxury, destined to pamper the cravings of a curiosity yet more frivolous?

I have surely no need to designate more clearly the works to which I would apply these considerations. The reader's mind will have adverted to the productions of a certain school of painting, as remarkable for precision, technical finish, and fidelity of tones, as for the insignificance of its subjects, the meanness of its forms, expressions, and personages, and an absence of all invention. Without raising any question about the difficulty, the skill, or the merit of these images of plebeian nature, I shall rest contented with pointing out to observa-

93

tion, that class of persons to whom they are most pleasing.[6] Present a picture of Teniers and one of Poussin to the vulgar multitude before mentioned; there can be no doubt as to which would obtain the preference.

It is requisite to make some distinction, on this point of criticism, respecting the greater or less estimation due to the works, in which art is limited to that local, partial, or individual truth, which I cannot allow to be the definitive aim of imitation. And first of all it is necessary to distinguish between the *kind* of imitation, and what is termed *style, taste, manner,* as applied to the work of imitation. Thus the Flemish pictures are of a *kind,* which, presenting to us the mechanism of art in its greatest perfection, have no pretension beyond that of speaking to the eye, without addressing aught to the mind. The pleasure these works afford is not the only one to be expected from imitation. But we can require nothing more from works which neither give promise of, nor are fitted to produce any thing more.

There are others which, though destined to a higher purpose, are from the *taste* and *manner* in which they are conceived and executed, far from responding to it. I could cite instances in every period. But, that I may be the better understood, I will confine myself to those of the earliest ages of art, when it was not yet brought to perfection. In those works, despite the charm their want of affectation, and their simplicity invest them with, we nevertheless discover additional proof of the positions here maintained: namely, that what is too frequently taken for the end of imitation, is not so; since the pleasure arising from individual truth, only exists in the productions of that period, from the absence of what art had not then acquired the means of producing.

It needs but to complete the parallel, in order to prove to demonstration what we have just advanced. If those works, conceived and executed in the spirit of portraiture, (I speak of those of the fifteenth century,) be compared with the works of the sixteenth, (such as those of Michael Angelo, Rafaello, and their schools,) it will not be difficult to obtain a clear and distinct idea of the description of pleasure which I maintain ought to constitute the true end of imitation.

What are those paintings of the early stages of the renovation of art? Portraits, doubtless faithful ones, of the men of that period. Physiognomy, attitudes, attire, character, form, and expression, in all, the exact image of the personages then existing, after the manner that they really were, the fashion of the habiliments, costumes, and accessaries of the times. Well! those paintings had not, for contemporaries, and still have not, for us, (setting aside the interest imparted to them by antiquity,) any other value than that appertaining to the

6. Quatremère here refers not only to seventeenth-century Dutch painters of genre but also, by extension, to the growing popularity in his own day for narrative and documentary painting of modern life.—Ed.

repetition of what one sees; they make no other impression than that of a portrait. Nothing more can be expected, and the most lively imagination would in vain seek for any other pleasure, from them. Even subjects of history, either ancient or drawn from a foreign country, personages to whatever age or nation they may be supposed to belong, when subjected to the same local costume, the same reality of portraiture, are insufficient to carry the spectator beyond this limited point of view, and, whatever useful lessons the artist may derive from them, such works leave us devoid of ideas, impressions, images, feelings and desires.[7]

Pass we to the next century and the works of art when fully developed. What a different world do Rafaello and the grand masters of his time open up to us! How many ideas and images that would have been unknown to us, had not imitation attained its aim! What another kind of truth, and in what a different sphere is it revealed to the artist! By how new a manner of viewing nature is her realm enlarged! How much additional food for the imagination, how many new objects for the mind to observe and become acquainted with, and fruitful subjects for taste to criticise! What an unfailing source of pleasures for the understanding and the sentiment! In short, what creations, for the existence of which we are indebted to imitation, not that which is limited to showing us what is real, but that which, by the aid of what is, shows us what has no real existence!

I shall not stop to apply the same standard of criticism to all the fine arts, but shall content myself with indicating that the same result would attend it.

For, what works are they, of which the succession of years and ages has been as yet insufficient to search out all the merits, to number all the beauties, or to exhaust admiration? What conceptions, whether epic or dramatic, are they, from which, with inexhaustible impressions, we receive pleasures ever new? What productions of the chisel are those which we see again and again as though we had never seen them: because the mind finds in them wherewith to find on for ever?

For myself, I have no hesitation in saying, that they are the works which have been conceived in that kind of imitation, the model of which can be nowhere shown.

CHAPTER IV. WHAT IMITATION IT IS, WHOSE MODEL CANNOT BE SHOWN, AND WHAT NAME IS GIVEN TO IT

The poet, says Plautus, *when he sets about composing, seeks what is nowhere, and yet finds it.* What does Plautus mean by *seeking, and finding what is nowhere?*

7. For contemporaneous interpretations of the differences between fifteenth- and sixteenth-century Italian painting, see the excerpts from Minardi and Rio.—Ed.

The answer to this question, contains the element of our theory, concerning what is the *end* of imitation.

From all that has gone before, there can, I presume, be no question, that to please, and, consequently, to please as much as possible, is the goal to which imitation tends; and that the greatest pleasure cannot be that of the senses, but, on the contrary, that of the mind; in other words, that which the understanding or the imagination procures. Now, as already seen, that which constitutes the object of physical or sensual pleasure, is of a nature to be met with at all times, and in all places, by the organ of the senses, and the instinct that guides it; while that which constitutes the object of moral or intellectual pleasure, can be neither sought for, nor found, but by that internal sense which is termed *genius*.

Every art has indeed a model, which the artist finds every where, and which he has not even the trouble of seeking after; this model is reality; and the mode of reproducing it, by a conformity more or less perceptible, is sufficiently known. For the copyist there is the *reality* of actions, in the representation of which he follows, without any modification either, for instance, what history relates concerning them, or what he himself has witnessed, and exactly in the same manner that it occurred. There is the *reality* of discourse, the imitation of which consists in servilely copying the common forms of familiar language. The *reality* of manners and character, the type and imprint of which may be repeated without any of those changes fitted to set them forth in a better light. The *reality* of persons and physiognomy, of which the art of portrait painting affords a sufficiently correct idea. In short, there are as many species of *realities*, as there are species of imitable objects in every form of composition in art. Thus, in painting, there is the *reality* of situation, and of points of sight, that of costume, forms, expression, &c. But I have said more than enough to render myself understood.

It has been sufficiently proved (see Chap. II) that the pleasure proceeding from that sort of imitation which is confined to the spirit of reality, is universally the most feeble.

It would seem therefore that such was not the pleasure that Plautus was desirous of providing for his hearers; for he might have found the subject of it everywhere. Now he sought after one, the subject and object of which were nowhere. What is this but to say, that in composing his dramatic pieces, he took for his model, an action the elements and details of which, though imbued with verisimilitude, could nowhere be found combined in a true and real event; that is, he placed in the mouth of his actors, language conformable to their conventional situation, for the truth of which language he was indebted to no one, but to general observation on the language expressive of the affections of the mind: he brought into play and placed in contrast, throughout the unravel-

ling of his plot, characters whose physiognomy was not that of any individual; and in short, gave life to personages whom every one thought they could recognise, and yet of whom no one could in reality show the original, an original unknown even to the poet himself.

The poet then had good reason to say that he sought what nowhere existed. The same may be said of every invention, and it is perhaps the best distinction that can be made, between the words *invent* and *find*. What exists may be found. That only can be invented which does not exist.

It would scarcely be judicious to found any argument of importance on this synonymous distinction, since it rests on a point of taste, respecting which unanimity cannot be expected except between persons of a similar bias. Although it may be objected that to *invent,* signifying in its simple sense the same as to *find,* the object of the search must, from very necessity, be somewhere, I do not the less persist in maintaining, that in rendering an account of the thing sought by the poet, one may still allow the strictness of their literal meaning to his words.

In fact, what he seeks, is an action where every thing concurs towards one end, in which are mingled interests and dialogues conformable to the subject, in which the personages are placed in situations fitted to excite curiosity, the characters exhibited in contrasts that render them efficient, and all the circumstances and incidents so mingled together without being confounded, as to maintain variety, and produce that unity of impression which was the effect he had proposed to attain.

This is that whole, that aggregate of incidents, that harmonizing concord of relations, which nature will never present to him, of which he will in vain look to her for a complete and altogether real model, and which nowhere exists. Yet this it is that he finds. *Quod nusquam est gentium, reperit tamen.*

Nor is what he thus finds one of those fantastical creations, the fruits of an undisciplined imagination, which are fitly ranked in the class of dreams or monstrosities. What he finds, not only does not exceed the laws of nature, but is, on the contrary, its very spirit and epitome: since what is commonly taken from nature, is very far from answering to the name, seeing that we should understand by it, not all that is as it is, but what ever is as it might or ought to be. There are so many things in nature, as we shall further show hereafter, existing as exceptions to her general laws, that we are compelled to acknowledge, that all she produces in detail, is not always the faithful and entire expression of her will; so that, as regards imitation, the study of nature does not consist so much in the special investigation of an individual and barren reality, as in the observation of the fertile principles of an ideal and generalized model.

It is here necessary to anticipate what will be found in the sequel, by remarking, that what the artist ought to search after, he can only find in that general

model which, in truth, is nowhere, in as much as it is general. What is individual and particular may be everywhere found, and may always be evidenced to the senses; but that which is *universal* and *general,* can only be grasped by thought or the action of the mind.

This *general,* as regards imitation, can only be defined by the understanding, and genius alone can imitate it.

Here then we have the key to the enigma of Plautus; which is, that, in every art, whatever comes within the scope of the understanding, of sentiment, and of genius, does not really exist any where, has neither substance nor place, and is subjected to no one of the senses; while he who finds it is unable to point out where he has seen the model of it.

That which genius finds, named invention, it displays to us ready found in its works, but it cannot teach us how to discover it ourselves; else might genius teach it to itself. All we can do is to conjecture its course, by spying out its steps, and by founding on the analysis of its effects, the systematic theory of imitation.

For, be it remarked that whatever the poet may tell us concerning the mysterious operation of his mind in its inventions, every other artist will either tell us the same himself, or will teach it us by the works of his genius.

If we ask of Phidias where he found the grand conception and sublime character of his Jupiter, he will alike reply *nowhere.*[8] For, he will say, what model is included in the two verses of Homer? And if it was or is there, why have not others, before and since Phidias, seen it there?

Zeuxis, having made his Helen a complete beauty, we are told that five of the most beautiful women in the city were provided for him.[9] What, if we admit the fact, one of those models the less, or all, or any others in their stead, and would not Helen still have been a finished work? And why have so many other painters before and since Zeuxis, been unable, with the same means, to attain the same beauty? We shall be told that they had not the same genius. What then is a model in reality, if genius be still necessary in order to imitate it? Who shall tell us whether it is the model that causes genius to see the image of the beauty, or that genius sees its own idea in the model?

Well then, that which the genius of the artist seeks for and finds, is nowhere. If you would have proof of this in a fact that cannot be controverted: take, for instance, in the imitation of the human body, any model you please. Have the most exact copy taken of it by all the designers in the world. Lo! you will find

8. Phidias (ca. 490–432 B.C.), the greatest Greek sculptor of the fifth century B.C., created his huge figure of Zeus for the city of Olympia. It is described in detail by Pausanius. Quatremère published a study on the statue.—Ed.

9. Zeuxis, a Greek painter working between 424 and 380 B.C., was reported to have combined the most perfect features of five beauties in creating his famous painting of Helen for the city of Croton.—Ed.

as many different copies as there are copyists. A certain proof that besides the local and individual model contemplated by all alike, each one has within himself another, which he consults and imitates.

After all then, what is it that is sought after and is found, although it nowhere exists?

It may be, that it is a something whose existence is only immaterial. It may be that it is nothing more than that idea of the true, the beautiful, the befitting, and the perfect, the elements of which nature undoubtedly furnishes for the imitator, but which she cannot present to him realized, as a complete type for imitation, because nature, as we shall hereafter repeat, has made nothing with a view to imitation.

It may be that it is, in every kind of imitation, but the image of a whole, the elements of which genius discovers, combines, arranges, and perfects by study, skill, and observation, according to the purport, and in furtherance of, imitation; that is, with the design of bringing the work to such a degree of generalized perfection on some one point, as to enable it to challenge the individual model in nature.

By one mode then nature is partially imitated, from a model which is every where. Of such the sole result is the pleasure the senses experience from resemblances which are not elevated above the reality of objects. This kind of imitation is that, which to judge, gives the mind the least possible labour, which leaves the imagination idle, in which sentiment has little share, reason little employ, and which has for its admirers, the vulgar and the greater number of those in whom the outward organ alone receives the impressions of the arts.

By another mode nature is imitated generally, that is, from a model which is neither local nor individual, which cannot be arrested in any determinate place, nor, wholly, in any distinct object, because it resides in the higher and invisible region of principles, of causes, and of that intelligent reason, the true source of all the effects which possess any active influence on the faculties of our minds.

It is this imitation, the works of which are not the images of any object that can be called real, since it is formed by the study of the artist, and is manifested in his productions, by the aid of an aggregate of ideas, forms, relations, and perfections, that no reality could furnish united in a single being,—a single subject.

Finally, it is this imitation which is conceived only in idea, and which is termed *ideal*.

Thus it would seem that so reciprocal an accordance is established between the notions already developed, and those which will accrue as consequences from them, that they may serve respectively as proofs the one of the other. If, on the one hand, the corollary drawn from the theory on the nature of imitation, (viz., that the pleasure it affords is in the ratio of the distance that separates it from reality,) leads us to regard the ideal as necessarily producing the highest

degree of pleasure, and thence, as being the definitive end of imitation, on the other, the superiority we shall be compelled to acknowledge in the pleasure derived from the ideal image, will confirm the truth of the foregoing corollary.

CHAPTER V. ON THE IDEAL.—DEFINITION OF THE WORD.—OF THE MEANING TO BE ATTACHED TO IT

The word *idea* is frequently understood and interpreted in a manner as insufficient as it is erroneous, more especially in applying it to the arts of corporeal imitation, that is, to those whose model belongs in part, and would seem in some to belong wholly, to the province of matter.

The word *ideal* being formed from the word *idea,* which doubtless expresses whatever is least material, persons are apt to imagine that it ought never to be found associated with words designating either bodies, or their images: as though the imitation of bodies embraced none but material relations; as though the properties and qualities of those bodies were not connected on several points with the order of moral and intellectual things; and as though their impressions could, from their nature, be addressed to none but the external sense.

The different acceptations of the word *ideal* have not failed to carry some confusion into this subject. The word is in fact sometimes taken in the sense of *imaginary, chimerical;* and since, as every one knows, the name *ideal* is applied, in every kind of imitation, to productions invented by whim and fancy, the vagaries of a fantastical imagination, the name to many appears synonymous with whatever is false and contrary to nature.

Owing to a strange inconsequence, those even who reject the notion of the ideal from the theory of the arts of design, make no difficulty in associating this word with the notion of the beautiful or of beauty. Thus every one agrees in saying *ideal beauty (le beau ideal).* Yet if ideal ought rightly to signify something contrary to or out of nature, the beauty so called would then be neither true nor natural, which no one surely would understand by it, or would wish to have understood. But, if any thing conformable to nature and truth may be allowed to be called ideal, I would ask why beauty alone should have that privilege. (See the close of this chapter.)

It is clear that there is some misapprehension in all this.

Etymology, though pointing out the formation of words, does not always afford a key to their true signification: yet, when a word carries with it in so evident a manner, the impress of the primitive type, it were difficult to be mistaken as to its proper meaning, or the notion it is intended to express.

Properly speaking, *ideal* is not a word formed from another. It is the adjective of idea. The manner, therefore, of understanding the substantive, will furnish that of explaining the adjective. *Idea* being derived from the Latin *idea,*

and from the Greek εἶδος, would signify no other than *image*. These two words mutually express one another, and often indistinctly, the notions of the things imprinted on our minds (for it was necessary to borrow from matter wherewith to express an operation the most immaterial). The words *idea* and *image* being synonymous, some metaphysicians have proposed to determine their variation, by applying the word *idea* to notions of intellectual objects, and the word *image* to those of corporeal objects. But this distinction would apply only to the objects of the notions, and not to the faculty of receiving them.

Ideal then is an adjective serving to designate and characterize, either notions existing in the mind or understanding, or works which would seem to be more especially connected either with the operation of the mind, or the employment of intellectual means fitted to give rise to impressions other than those of the physical senses.

In whatever manner the formation of ideas is explained, (and I confess I have no wish even to touch upon this question be it ever so slightly,) all are agreed, that the mind of every one receives from every object, and from every kind of objects, or relations of objects, notions, or what are termed ideas, differing widely according to the moral faculties of individuals, and it is also agreed, that, according to the difference of the physical faculties, the impression on the senses produces on the mind of each, very different images from the same object, or the same kind either of objects or relations.

We recognize, therefore, two different principles of action in the formation of ideas: one of the mind, and the other of the senses.

We also recognize both by reason and experience, that some men receive the impressions of objects in a different manner from others, receiving them more or less forcibly or energetically, transiently or superficially; and that those impressions give occasion in some, more than in others, to numerous appositions[10]—varied, simple, and compound, the source of those combinations to which different names are appropriated, according to the particular class and nature of the works resulting from them.

No one can refuse to acknowledge that the same object, be its nature moral or physical, will be viewed, according to the measure of the faculties of each, by one under a limited point of view, by another under an extended aspect and the most varied relations. Supposing the same fact to be witnessed and related by two persons of different degrees of intelligence, it is scarcely possible to conceive the difference between the two narrations. And this because the person of limited understanding sees in the action, nothing more than what is

10. Quatremère here uses "rapprochements," which might better be rendered as "associations" or "parallel instances." In a translator's note Kent explains, "I should not be doing justice to the author, did I not again call attention to the signification of this word, as before explained to mean that preliminary process to comparison, to designate which, as far as I am aware, no word has hitherto been set apart in the English language."—Ed.

matter-of-fact, while the other seizes, in the circumstances of the case, and in the apposition of effects with their causes, that which attracts the mind, which excites curiosity, and sustains the interest. Truth will belong to both recitals. But the truth of the one, limited to the outward form of the action, will be barren; that of the other fertile in impressions as the source from which it emanated.

This shows us the difference between those works in which the principle of action of the judgment and understanding is predominant, and those where it is wanting; and the works in their turn enable us by their effects, to comprehend the difference between the two ways of receiving the impressions of things, and the two faculties of producing their images.

It is natural enough that a work emanating from the faculty of receiving a great number of ideas, and of working them out under the most numerous and the most extended relations, that such work, when placed in opposition to that proceeding from the faculty limited to the mere reality of things, should have been called by a name which is expressive of the elements of which it is composed, namely, ideas or images notably so called. For though, strictly speaking, there is *idea* in every work of art, yet we say a work is without idea, and the artist consequently destitute of ideas, when it produces impressions which are feeble, common-place, and confined within a very narrow circle. On the other hand, we say a person is rich in ideas, a work abounding in ideas, a composition full of ideas, when they are remarkable for the mental and moral power displayed in them.

And as idea, according to the metaphysical definition of the word, is the notion imprinted on the mind, *ideal* applied to works of imitation, designates their characteristic quality, in as much as they are produced by the principle of the notions which belong to the labour of the judgment and understanding.

The senses and the mind are so linked together, and the connection existing between the operations of both those faculties is such, that human reason may well despair of explaining the mystery. But in the theory of the fine arts this solution is not required; it is sufficient that the twofold fact be recognized, that, in the formation of ideas, there is one action proper to the senses, and another which is proper to the mind. Hence, setting aside all question as to the origin of ideas, our theory being in accordance with language, which is a kind of universal criterion, recognizes, in the works of imitation, as in the twofold faculty whose concurrence is necessary, two species of qualities which divide them into classes.

The works of the first class, produced by the action of the senses in particular, have the individual work of nature for their absolute and exclusive model, and it is essential to this manner of imitating, that it be conformable to what it takes for its model, without adding, curtailing, or changing any thing whatever. It is imitation in the world of realities.

The works of the second class are specially produced by that faculty of the understanding, which takes for their model, not only what the outward sense sees in reality, but also what can only be discovered by that organ which scrutinizes the causes and motives of nature, in the formation of things and beings. As such a model has nowhere any material existence, and as it is the mind that alike copies and discovers it, the works resulting from it are called creations or inventions. It is imitation in the world of ideas;—*ideal imitation*.

Ideal signifies, therefore, whatever, in the imitation of the fine arts, is composed, formed, and executed by virtue of that faculty in man, which enables him to conceive in his mind, and to realize what he has conceived, that is to say, a whole such as nature would never present to him in its reality.

It may now be readily seen, how wrong it is to apply the notion of the ideal (as it is too much the custom to do in the arts of design), solely to works which require the imitation of beauty, I mean corporeal beauty, whether limited to juvenile or to female figures. The idea of the beautiful or of beauty, thus restricted, would confine the ideal within too narrow a circle. There is a sort of corporeal beauty belonging to every time of life, even though the farthest removed from that in which the charm of beauty, as commonly understood, shines forth. The customary idiom of languages affords proof of it. We say a beautiful old man, as we say a beautiful young one. This arises from the idea of beauty being formed from that of the perfection appropriate to every thing and being; and, therefore, every species of object, and every kind of quality being capable of perfection, may also have its ideal. Ugliness may have its ideal, as well as beauty; a satyr in a work of art, as well as a Venus. There may even be an ideal horrible. The Satan of Paradise Lost is, in its kind, as ideal as it is possible to conceive; but its character is not of that corporeal ideal beauty which the imagination conjoins with youth, when it would picture to itself, or would represent an angel. In like manner there is in poetry an ideal of all the most opposite qualities. While in Achilles we have the ideal of courage, Thersites equally displays the ideal of cowardice.

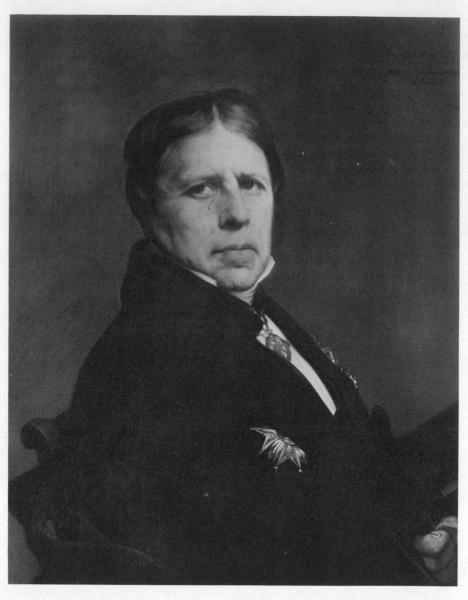

Jean–Auguste–Dominique Ingres, *Portrait de l'Artiste,* c. 1864, oil on canvas.

J. A. D. INGRES

Commentaries on Art

At one time or another in his long career, the French painter Jean-Auguste-Dominique Ingres (1780–1867) was called an anticlassical rebel, a primitive, a classicist, and an academic. None of these labels was ever quite accurate, yet none was totally inapplicable. Trained in the studio of David, but early accused of deserting the palpable solidity of David's vigorous imagery, Ingres single-mindedly and passionately remained true to a very personal concept of the beautiful.

A winner of the Prix de Rome, Ingres settled in that city in 1806. In 1820 he moved to Florence and did not return to France until 1824, on the exhibition of his painting commissioned for Montauban, his birthplace, *The Vow of Louis XIII*. Only after this notable appearance at the Paris Salon did Ingres gain a following in France. From 1834 to 1841 he was again in Rome, as director of the French Academy there. Although he was invariably cited as the opposite of a number of tendencies, the critics were often at a loss in specifically classifying his work; most admitted, however, although often grudgingly, that it was of considerable quality. As was the case with David, the many disciples of Ingres, the "Ingristes," failed to approach the essential character of his work, and much that was said about Ingres applied more particularly to his followers. Possibly they followed what the master said rather than what he did.

After Ingres's death, his diverse remarks on art were gleaned from letters and notebooks and assembled by an admirer, Viscount Henri Delaborde. These remarks are sometimes contradictory; but Ingres was not notably reasonable in supporting his assumptions, which constituted a deeply felt, personal credo. In his work he was totally dependent on intuition, yet he firmly believed that his procedure was rational. This contradiction in his nature did not make Ingres an easy man to deal with, and throughout his career he was at odds with major critics, hurt and baffled by their words. From an early age he felt himself injured and misunderstood, despite the considerable patronage he enjoyed.

One of the puzzling aspects of Ingres's remarks is his repeated admonition to imitate nature humbly and directly, which, if taken literally, would agree with the views of Constable or Ruskin. Amory Duval relates that Ingres once banned him from the studio for remarking that in a particular painting Ingres

had much improved on the figure of the model who posed for it. Ingres maintained that he drew nature exactly and never altered it. It is true, to be sure, that every part and detail of his paintings was the product of many specific studies from models. Yet in one of his comments he recommended as well, "Have in your eyes, and in your mind, the entirety of the figure that you want to represent, and let the execution be only the bodying forth of that image which has already been made your own by being preconceived," which is precisely the point made by Quatremère de Quincy. The resolution of these two opposite procedures can be understood, however, in Ingres's remarks to a student, "If you want to see that leg as ugly, I know that there will be cause for you to do so, but I will tell you, 'Take my eyes and you will see it as beautiful.'" Ingres "saw" in terms of a personal will to form and discovered his kind of harmonies in the most diverse natural things and shapes. The "image" preconceived in his mind was not a determined form based on rules of proportion or antique models, but a particular predisposition to formulate that found its fulfillment in organizing intuitively the perceived aspects of nature. In the sense of Hebart, although he had a will to form, his knowledge was actually formulated through his eyes; Ingres thought in terms of form. So in spite of his continuous references to nature, Ingres was just as much a maker, in contrast to a perceiver, as Quatremère's ideal artist.

Even more emphatically, Ingres insisted on the importance of tradition. Art was a perpetual colloquium of high thinkers of all time, who had proved the quality of the human mind by their creations. For him, Apelles, Raphael, and Homer were coexistent, though Homer was the father of all art because he was the first great creator among men: "Homer is the principle and the model of all beauty, in the arts as in letters." *The Apotheosis of Homer* (1827), a ceiling panel for the Louvre, was the first major commission that Ingres executed after his return to France from his voluntary exile in Italy. For this great panel he gathered together his intellectual community: Plato and Socrates, Phidias, Apelles holding Raphael by the hand, Boileau looking over the shoulder of Longinus, Gluck and Mozart, and many others. Shakespeare is almost lost in the crowd, and Voltaire is notably absent. But for an artist to become a part of this tradition, he had to create, not copy, and create as did Homer, from nature. Ingres painted few works depicting events and characters from the Homeric epics, but he copied out long passages from them in his notebooks. It was Homer's creative power that impressed him. He wished not to illustrate Homer, but to be a Homer of his own time. "There is nothing essential to discover in art after Phidias and Raphael, but there is always enough to do, even after them, to maintain the cult of the true and to perpetuate the tradition of the beautiful," he said.

Given this view it is understandable that Ingres should wax so angry on the

subject of "the new." "Our task is not to invent but to continue," he asserted. The task of maintaining the timeless values of beauty and perfection in the face of modern upheaval was a difficult and sacred trust that could admit of no exception. "There are not two arts, there is only one," he proclaimed, and he passionately fought the diverse tendencies he believed to be evil.

The following comments on art are taken from among those selected and organized by Delaborde from letters, manuscripts, and studio conversations of the painter. They were first published in his *Ingres: Sa Vie, ses travaux, sa doctrine d'après les notes, manuscrites et les lettres du maître* (Paris: Plon, 1870).

The comments were grouped by Delaborde according to the subject treated, without regard to occasion or date. Therefore they should be read as separate assertions, not as part of a consecutive discourse. The translation is by Walter Pach, published in his *Ingres* (New York: Harper, 1939), pp. 160–65, 170–74, 178–79, 182–87, and 189–91.

On Art and the Beautiful

There are not two arts, there is only one: it is the one which has as its foundation the beautiful, which is eternal and natural. Those who seek elsewhere deceive themselves, and in the most fatal manner. What do those so-called artists mean, when they preach the discovery of the "new"? Is there anything new? Everything has been done, everything has been discovered. Our task is not to invent but to continue, and we have enough to do if, following the examples of the masters, we utilize those innumerable types which nature constantly offers to us, if we interpret them with wholehearted sincerity, and ennoble them through that pure and firm style without which no work has beauty. What an absurdity it is to believe that the natural dispositions and faculties can be compromised by the study—by the imitation, even, of the classic works! The original type, man, still remains: we have only to consult it in order to know whether the classics have been right or wrong and whether, when we use the same means as they, we lie or tell the truth.

There is no longer any question of discovering the conditions, the principles of the beautiful. The thing is to apply them without letting the desire to invent cause us to lose sight of them. Beauty, pure and natural, has no need to surprise through novelty: it is enough that it be beauty. But man is in love with change, and change, in art, is very often the cause of decadence.

The study or contemplation of the masterpieces of art should render the study of nature only more fruitful and easier: it should not tend to cause any

rejection of it, nature being that from which all perfections emanate and draw their origin.

It is in nature that one may find that beauty which constitutes the great object of painting; it is there that one must seek it, and nowhere else. It is as impossible to form the idea of a beauty apart, of a beauty superior to that which nature offers, as it is to conceive a sixth sense. We are obliged to establish all our ideas, even that of Olympus and its divine inhabitants, upon purely terrestrial objects. The whole great study of art therefore, is to learn to imitate these objects.

The principal and most important part of painting is to know the production of nature which is most beautiful and best suited to art, in order to choose it according to the taste, the way of feeling of the ancients.

One should remember that the parts which compose the most perfect statue can never, each by itself, surpass nature, and that it is impossible for us to lift up our ideas beyond the beauties of nature's works. All that we can do is to succeed in assembling them. To speak strictly, the Greek statues surpass nature only because the sculptors assembled in them all the beautiful parts which nature joins together so rarely in a single subject. The artist who proceeds in this way is admitted into the sanctuary of nature. He then enjoys the sight of the gods and the sound of their speech; like Phidias, he observes their majesty and learns their language so that he may communicate it to mortals.

Phidias arrives at the sublime by correcting nature through herself. For his *Olympian Jupiter* he made use of all natural beauties together, so that he might reach what is clumsily called ideal beauty. That term should be conceived only as expressing the association of the most beautiful elements of nature, which is rarely found to be perfect in this matter; nature being, moreover, so constituted that there is nothing above it, when it is beautiful, all human effort cannot surpass it, nor even equal it.

It is on our knees that we should study the beautiful.

In art one arrives at an honorable result only through one's tears. He who does not suffer does not believe.

You should look upon your art with religious feeling. Do not think to produce anything good, even approximately good, without elevation of soul. In order to form yourself for the beautiful, look on nothing save the sublime. Look neither to the right nor to the left, and even less to what is beneath. Go

Jean-Auguste-Dominique Ingres, *The Vow of Louis XIII*, engraving after Luigi Cala-
matta, with annotations by Ingres.

forward with your head raised toward the skies, instead of inclining it toward the earth, like the pigs who keep their eyes on the mud.

Art lives on elevated thoughts and noble passions. Let us have character, let us have warmth! One does not die of warmth: one dies of cold.

What one knows, one must know sword in hand. It is only through fighting that one gains anything and, in art, fighting is the work one imposes upon oneself.

Draw, paint, imitate above all, and were it no more than a still life. All that is imitated from nature is a work, and that imitation leads to art.

The nature of the masterpieces is not to dazzle. Their nature is to persuade, to convince, to enter into us through our pores.

Bad practices kill everything: they do not exist in nature.

Poussin had the habit of saying that it is through observing things that the painter becomes skillful rather than through wearying himself by copying them. Yes: but it is necessary that the painter have eyes.

The great point is to be guided by reason in order to distinguish the true from the false, and that result is reached only by learning to become exclusive which, in turn, is learned by the sole and continual frequentation of the beautiful. Oh, the comic and monstrous love that men have when, with the same passion, they love Murillo and Raphael!

In the matter of the true, I prefer to see men overshoot the mark a little, whatever risk there may be in doing so for, as I know, the true may be lacking in probability. Very often the question is no more than that of a hair's breadth.

In art's images of man, calm is the first beauty of the body, even as in life, wisdom is the highest expression of the soul.

Let us seek to please so that we may the better impose the true. It is not with vinegar that one catches flies, it is with honey and sugar.

Look at that [the living model]: it is like the ancients and the ancients are like that. It is an antique bronze. When you study the ancients you see that they did not correct their models, by which I mean that they did not denature them. If you sincerely translate what is there, you will be proceeding as they did and you

will arrive at the beautiful as they did. If you follow any other course, if you think to correct what you are seeing, you will arrive only at the false, at the equivocal and the ridiculous.

When you are lacking in the respect which you owe to nature, when you dare to offend her in your work, you are kicking your mother in the belly.

Art is never at so high a degree of perfection as when it resembles nature so strongly that one might take it for nature herself. Art never succeeds better than when it is concealed.

Love the true because it is also the beautiful, if you are able to discern it and to feel it. Let us strive to have eyes that see well, that see with sagacity: that is all I ask. If you want to see that leg as ugly, I know that there will be cause for you to do so, but I will tell you, "Take my eyes and you will see it as beautiful."

The ugly: men go in for it because they do not see enough of what is beautiful.

You tremble before nature: tremble, but do not doubt!

One always reaches beauty when one reaches truth. All the faults that you commit come, not from any lack of taste and imagination on your part, but from your not having put in enough of nature. Raphael and that [the living model] are synonymous with each other. And what was the road that Raphael took? Even he was modest, even he—Raphael that he was—was submissive. Let us therefore be humble before nature.

Sculpture is an art that is severe, rigid: therefore it was consecrated by the ancients to religion.

Woe to him who deals lightly with his art! Woe to the artist who does not retain seriousness of mind!

Do not concern yourself with other people, concern yourself with your work alone; think only of doing it the best way you can. See how the ant carries its egg: it goes its way without stopping, then, when it has arrived, it looks back to see where the others are. When you shall have reached old age, then you will be able to do the same and compare what you will have produced with the productions of your rivals. Then, but only then will you look at all things without danger, and then will you estimate all things at their true value.

.

ON DRAWING

Drawing is the probity of art.

To draw does not mean simply to reproduce contours; drawing does not consist merely of line: drawing is also expression, the inner form, the plane, modeling. See what remains after that. Drawing includes three and a half quarters of the content of painting. If I were asked to put up a sign over my door, I should inscribe it: *School for Drawing,* and I am sure that I should bring forth painters.

Drawing contains everything, except the hue.

One must keep right on drawing; draw with your eyes when you cannot draw with a pencil. As long as you do not hold a balance between your seeing of things and your execution, you will do nothing that is really good.

A painter who trusts to his compass is leaning on a ghost.

Never spend a single day without tracing a line, said Apelles. By that he meant what I repeat to you: line is drawing, it is everything.

If I could make musicians of you all, you would thereby profit as painters. Everything in nature is harmony: a little too much, or else too little, disturbs the scale and makes a false note. One must reach the point of singing true with the pencil or with brush quite as much as with the voice; rightness of forms is like rightness of sounds.

When studying nature, have eyes only for the ensemble at first. Interrogate it and interrogate nothing but it. The details are self-important little things which have to be put in their place. Breadth of form and breadth again! Form: it is the foundation and the condition of all things; smoke itself should be rendered by a line.

Consider the relationships of size in the model; therein resides the whole of character. Let yourselves be vigorously impressed by that, and it is vigorously, also, that you should render these relative sizes. If instead of following this method, you merely feel about, if you make your research on the paper, you will do nothing of value. Have in your eyes, and in your mind, the entirety of the figure that you want to represent, and let the execution be only the bodying forth of that image which has already been made your own by being preconceived.

When tracing a figure, set yourself above all to determine and characterize the movement. I cannot too often repeat to you that movement is the life of the drawing.

Let us not complain as to the time or the labor we give in order to arrive at purity of expression and at perfection of style. Let us even, in order to correct ourselves without cease, use whatever facility we may have. Malherbe, it is said, worked with prodigious slowness: yes, because he was working for immortality.

One must render invisible all the traces of facility; it is the results and not the means employed which should appear. Facility is a thing to be used and at the same time despised; but despite that, if one has a hundred thousand francs' worth of it, one must still get another two cents' worth.

The simpler the lines and forms are, the more there is of beauty and of strength. Every time that you divide up the forms, you weaken them. The case is the same as that of the breaking up of anything else.

Why do men not get largeness of character? Because in place of one large form, they make three little ones.

When character is not based above all upon the great lines, the resemblance arrived at is no more than a doubtful one.

In constructing a figure, do not proceed piecemeal. Carry the whole thing along together and, as our good expression has it, draw the "ensemble."

One must not attempt to learn to produce fine character: one must discover it in one's model.

The beautiful forms are those with flat planes and with rounds. The beautiful forms are those which have firmness and fullness, those in which the details do not compromise the aspect of the great masses.

What is necessary is to give health to the form.

The completion of the form is achieved by finish. There are people who, in drawing, are satisfied by feeling; with feeling once expressed, the thing suffices them. Raphael and Leonardo da Vinci are there to prove that feeling and precision can be allied.

The great painters, like Raphael and Michelangelo, have insisted on line in finishing. They have reiterated it with a fine brush, and thus they have reanimated the contour; they have imprinted vitality and rage upon their drawing.

From the material standpoint, we do not proceed like the sculptors, but we should produce sculptural painting.

A painter is perfectly right to be preoccupied with finesse, but to that he should add force, which does not exclude finesse—far from it. The whole of painting resides in drawing that is at once strong and delicate. Let anyone say what he will, painting is a matter of drawing that is firm, proud, and well characterized, even if the picture in question is supposed to impress by its grace. Grace alone does not suffice, neither does a chastened drawing. More is needed: drawing must amplify, it must envelop.

There is good always, whatever defects may also appear, in a work where the head has commanded the hand. One should feel that, even in the attempts of a beginner. Skill of hand is acquired by experience; but rectitude of feeling, of intelligence, there is a thing which may be shown from the very start, and there also, to a certain extent, is a thing that can make up for everything else.

Draw with purity, but with breadth. Pure and broad: there you see drawing, there you see art.

Draw for a long time before thinking of painting. When one builds on a solid foundation, one sleeps in peace.

Expression in painting demands a very great science of drawing; for expression cannot be good if it has not been formulated with absolute exactitude. To seize it only approximately is to miss it, and to represent only those false people whose study it is to counterfeit sentiments which they do not experience. The extreme precision we need is to be arrived at only through the surest talent for drawing. Thus the painters of expression, among the moderns, turn out to be the greatest draftsmen. Look at Raphael!

Expression, an essential element of art, is therefore intimately bound up with form. Perfection of coloring is so little required that excellent painters of expression have not had, as colorists, the same superiority. To blame them for that is to lack adequate knowledge of the arts. One may not ask the same man for contradictory qualities. Moreover the promptness of execution which color needs in order to preserve all its prestige does not harmonize with the deep study demanded by the great unity of the forms.

.

ON COLOR, TONE, AND EFFECT

Color adds adornment to painting; but it is only the tiring-woman [court lady charged with dressing a queen], for she does not go beyond rendering more amiable the veritable perfections of art.

It is unexampled that a great draftsman has not had the color quality exactly suited to the character of his drawing. In the eyes of many persons, Raphael did not use color; he did not use color like Rubens and Van Dyck: *parbleu,* I should say not! He would take good care not to do such a thing.

Rubens and Van Dyck may please the eye, but they deceive it; they are of a bad school of color, the school of the lie. Titian: there is true color, there is nature without exaggeration, without forced brilliance! He is exact.

Never use a too ardent color; it is anti-historical. Fall into gray rather than into ardent tones, if you cannot attain a perfectly true tone.

The *historical* tone leaves the mind tranquil. Have no more ambition about that than about other things.

The essential matters about color do not reside in the ensemble of light or dark masses in the picture; they are rather in the particular distinguishing of the tone of each object. For example, place a fine and brilliant white cloth upon a dark or olive-hued body, above all let your spectator see the difference between a blond color and a cold color, between accidental colors and those which result from the local tints. This thought was inspired in me by the chance which caused me to see on the thigh of my *Oedipus,* reflected in a mirror, a white drapery, so brilliant and beautiful in its contrast with that warm and golden flesh color!

.

The quality of making objects in painting "detach" (which many people regard as such an important thing), was not one of the matters on which Titian, who is moreover the greatest colorist of all, principally fixed his attention. It was painters of inferior talent who treated that as the essential merit of painting, as it is still considered by herds of art enthusiasts, inevitably satisfied and charmed when they see in a picture a figure so painted that, as they say, "it seems as if one could walk around it."

Sometimes the little pictures of the Flemings and Dutch themselves are, with their limited dimensions, excellent models for the color and effect of a

historical picture. In that respect, one may ask them for guidance and note them as examples.

On the Study of the Antique and of the Masters

Doubt itself is blameworthy when we are considering the marvels of the ancients.

To claim that we can get along without study of the antique and the classics is either madness or laziness. Yes, anti-classic art, if one may even call it an art, is nothing but an art of the lazy. It is the doctrine of those who want to produce without having worked, who want to know without having learned; it is an art as lacking in faith as in discipline, wandering blindly because of its having no light in the darkness, and demanding that mere chance lead it through places where one can advance only by means of courage, experience, and reflection.

The one reason why the ancients were so superior to us was because their manner of seeing depended on good sense as much as on power; it was as sincere as it was beautiful. This principle among men was never lost; they applied it to everything, they made it habitual in every circumstance. And so we admire the ruins of their art or of their industry down to the last details, down to the common pottery which they doubtless held in light esteem, but whose beautiful contours still enchant us.

It is that way of seeing which we must regain. The thread is broken; it was joined anew for a moment during the renaissance of the arts in Italy; new centuries of barbarism broke it again: we must strive to bind it together once more.

It was through the debris of the works of the ancients that the arts came to a new birth among the moderns; it is through the means that they themselves employed that we must seek to make the ancients live again among ourselves, that we must seek to continue their work.

We must copy nature always and learn to see it well. It is for that purpose that we need to study the antique and the masters, not to imitate them; what we need, as I repeat, is to learn to see.

Do you think that I send you to the Louvre to find what is conventionally called "ideal beauty," something different from what is in nature? It is foolish ideas like that which, in bad periods, have brought on the decadence of art. I send you to the Louvre because you will learn from the antique to see nature,

because it is itself nature: and so you must live upon it, feed upon it. The same is true of the paintings of the great centuries. Do you think that in ordering you to copy them I want to turn you into copyists? No, I want you to get the juice of the plant.

Address yourself to the masters, therefore, speak to them, they will answer you, for they are still living. It is they who will instruct you; I myself am no more than their quiz-master.

All I have is the small merit of knowing the road that one must follow in order to arrive, and I indicate it to you. Here is our purpose: to approach that [the antique]; and what is that? It is nature, it is intimate acquaintance with beauty and form and the finished, philosophic expression of those things.

.

If we consult experience, we shall find that it is by making oneself familiar with the inventions of others that, in art, one learns oneself how to invent, as one accustoms oneself to think through reading the ideas of others. Therefore it is only by observing, by constantly studying the masterpieces, that we can vivify our means and give them their development.

.

He who is not willing to ask the contribution of any mind other than his own will soon find himself reduced to the most miserable of all imitations, which is to say the imitation of his own works.

An able painter, one who is in no danger of being corrupted, can make advantageous use of many things, even those which may be vicious. He will derive benefit from complete mediocrities, and in passing through his hands, their work will turn into perfections. In the coarse attempts to produce art which derive from the time before its renewal he will find original ideas, happy combinations or even more than those, for at times he will discover nothing less than sublime inventions.

Every time that I have refreshed myself through looking at the compositions painted on ancient vases, I have come forth from the experience more persuaded than ever that it is from such models that the painter must work, that they are the thing for him to imitate when he paints Greek subjects. He can do Greeks only when he imitates them, following them step by step. Far more than that: he can, without being a cold plagiarist, take entire compositions from the paintings on the vases and translate them on a canvas. There is still genius, in knowing how to re-create the nature which was so well indicated already, though it had previously been only half expressed by mere outline; this re-creation is achieved by the perfection of the colors, and by a finish like that of nature herself; and it will be attained through study.

The example of others, far from weakening our imagination and our judgment, as many people think it does, serves, on the contrary, to strengthen and consolidate our ideas of perfection, for at their beginnings, these ideas are weak, formless and confused. They become solid, perfect and clear, through the authority and the influence of the men whose work has been consecrated by the approbation of the centuries, as we may very safely say. Compared to the things that make the glory of the ancients, what are those which cause the pride of the moderns? Pompous designs, flatteries achieved through color, through the balancing of masses, the linking together of groups, and any number of *coquetteries* of the craft, things which have no word to say to the soul. It was to the soul that the ancients would speak, and it alone was considered by Raphael, Michelangelo and the others as worthy to receive the homage of art. By the same token, it is the soul which has generally been neglected by the painters who stand as the great colorists, the great *machinists,* all those, in a word, who have particularly excelled in those picturesque means which so many moderns have been pleased to celebrate as signs of progress; and it is because of this that they have had the audacity to award to themselves the prize which they have refused to antiquity.

One may say, without in any way detracting from the glory of the ancients, that they did not generally know, as do the moderns, about the multiplying of planes in their pictures, about observing the gradations which these successive planes demand, about linking figures to figures or groups to groups, and about captivating the eye by the prestige of color which is not that of nature and which causes itself to be accepted as nature. Yes, they did neglect these things, or they knew them but little, because they regarded them as distractions from the beautiful, which was their goal; they considered that these secondary elements of art would do nothing but turn the mind of the spectators, and their own as well, from those elements which merit all attention.

Homer is the principle and the model of all beauty, in the arts as in letters.

.

Let me hear no more of that absurd maxim: "We need the new, we need to follow our century, everything changes, everything is changed." Sophistry—all of that! Does nature change, do the light and air change, have the passions of the human heart changed since the time of Homer? "We must follow our century": but suppose my century is wrong? Because my neighbor does evil, am I therefore obliged to do it also? Because virtue, as also beauty, can be misunderstood by you, have I in turn got to misunderstand it? Shall I be compelled to imitate *you!*

Upon this globe there was a little corner of earth which was called Greece, where, under the fairest sky, among inhabitants endowed with an intellectual organization that was unique, letters and the arts shed what was practically a second light upon the things in nature, for all the peoples and all the generations to come. Homer was the first to reveal through poetry the beauties of nature, as God organized life by bringing it forth from chaos. He has forever instructed the human race, he has established the beautiful through precepts and through immortal examples. All the great men of Greece, poets, tragedians, historians, artists of every kind, painters, sculptors, and architects, are all born of him: and, as long as Greek civilization lasted, as long after that as Rome reigned over the world, men have continued to put into practice the same principles that once were found. Later on, in the great modern periods, men of genius did over what had been done before them. Homer and Phidias, Raphael and Poussin, Gluck and Mozart have, in reality, said the same things.

It is error then; error to believe that health for art resides in absolute independence; to believe that our natural disposition runs the risk of being stifled by the discipline of the ancients; that the classic doctrines impede or arrest the flight of the intelligence. Quite the contrary: they favor its development, they render its strength more certain and fructify its aspirations; they are a help and not a hindrance. Moreover, there are not two arts, there is but one: it is that which is founded upon the imitation of nature, of beauty—immutable, infallible, and eternal. What do you mean, what is it you come to preach to me with your pleadings in favor of the "new"? Outside of nature there is no such thing as the new, there is nothing but what is called the baroque; outside of art, as it was understood and practiced by the ancients, there is nothing, there can be nothing but caprice and aimless wandering. Let us believe what they believed, which is to say the truth, the truth which is of all times. Let us translate it differently from them, if we can, as far as expression is concerned, but let us be like them in knowing how to recognize it, to honor it, to adore it in spirit and in principle, and let us leave to their howling those who try to insult us with a word like "old-fashioned."

They want novelty! They want, as they say, progress in variety, and to refute us who recommend the strict imitation of the antique and of the masters, they cast up to us the movement of the sciences in our century! But the nature of the latter is quite different from the nature of art. The domain of the sciences enlarges through the effect of time; the discoveries in them are due to the most patient observation of certain phenomena, to the perfecting of certain instruments, sometimes even to chance. What can chance reveal to us in the domain created by the imitation of forms? Does any part of drawing remain to be dis-

covered? Shall we, by means of patience or of better eyeglasses, perceive in nature any new outlines, any new color, a new kind of modeling? There is nothing essential to discover in art after Phidias and Raphael, but there is always enough to do, even after them, to maintain the cult of the true and to perpetuate the tradition of the beautiful.

II

ART AND THE COMMUNITY
OF SOULS

Although the belief in art as a determinable and systematic language of form could be stretched quite broadly, to encompass the exaltations of the Swiss-English painter Heinrich Füssli, the concepts of the sublime or the picturesque, it was nonetheless bounded by a devotion to rationality and an ultimate faith in systematic order. The irrational was of interest to the well-ordered mind as a complement, a source of ideas or information that could then be dealt with rationally. As Sir Joshua Reynolds said, although recognizing the leavening contribution of the imagination, "In the midst of the highest flights of the fancy or imagination, reason ought to preside." In reply to this remark, William Blake wrote in the margin of his copy of the *Discourses,* "If this is True it is a Devilish Foolish Thing to be An Artist."

Probably the fundamental difference between the opposing attitudes toward art and its purposes that were formulated by the 1790s is to be found in the reaction to the possibility and inherent virtue of humanly devised systems of form and conduct. To one group of artists and theorists, the pursuit of generalizations that allowed the mind to triumph over the vagarious differences provided by sense, imagination, or geographical distinction was a virtuous activity, consistent with the nature of man, since man, they held, was fundamentally a rational being; but for an opposing group the same pursuit was destructive of what was most essential to man and fostered a terror of being cut off from vital experience, rather than lending needed reassurance. Even superstition, Wilhelm Wackenroder remarked, is better than belief in a system. The quarrel did not lie in the opposition of calculated disorder and calculated order, which was recognized as a defensible contrast by such theorists as Gilpin, but arose from a fundamental and irreconcilable divergence of belief in the nature of man. Those opposed to rationally devised systems put their faith in a different species of order, an order that was perceivable to man but was beyond his intellectual capacity for definition. Man could make contact with this higher order only as it was revealed in individual instances, whether in visions or in the exact study of nature, but could never presume to dominate it or prescribe its limits with a

general law. Rather, a knowledge of its very existence depended on a subjugating humility, and anyone who would insist on maintaining an external model of order, visual or verbal, would thereby be denied even the awareness that another, higher, order existed. Consequently, the devised formula of perfect beauty, far from being a reflection of divine beauty, was considered by those who shared this conception to be a vain distraction, an obstacle to the realization of what true beauty was. This accusation against aesthetic rules was made equally by visionaries such as Blake and followers of the close perception of nature such as Constable.

Basic to the difference between visionaries and perceptionists was the fact that the rational schemes were postulated on the premise that there was a discrete separation between sense and reason, as well as between reason and enthusiasm, or imagination. Problems of perception and thought were analyzed with detachment and care, and the mind's processes were anatomized with expert efficiency. Two of Blake's villains in modern thought, it should be noted, were Francis Bacon and John Locke. This analytical procedure in which reason, perception, and imagination were identified as distinct elements providing distinct categories of truth, or different manifestations of a single guiding spirit in man, centered in his soul, and potentially led to the same transcendent truth. The single guiding spirit was described differently by different individuals, but in all cases the acceptance of its existence allowed the artist a chance to explore without preconception, to be continuously alert to his own responses and to feel himself an indivisible part of an extensive, eternal universe that he did not, nor could he, dominate or control. The goal of artists who embraced this belief was to reaffirm a human synthesis that was being threatened by the preoccupation with analytical investigation.

Both those who fancied that they followed a classical precedent and their opponents were concerned with man as part of a community, but they differed radically in their concept of how a community was formed. As noted in reference to Ledoux and his planned city, one idea of the perfect association of men could be geometrically projected. The community could be thought of as a whole to which each part contributed, like Milizia's notion of the aesthetic "machine." To Wackenroder, who wrote in the person of a cloistered monk, a community was not formed by external order, but by each man's feeling within himself that related him both to other men and directly to God. The work of art for Wackenroder, then, had only one purpose: to awaken in the soul of the viewer an insight realized in the soul of the artist, and it was usually assumed that the insight would be a revelation of God's unity. This was communication on a profound level, not rationally analyzable, but only on the basis of such inner communion, believed Wackenroder and others, could a true community be established. The outward aspect of such a community would be diversity,

rather than unity, a natural product of self-determining parts; and it must have no set boundaries but be as infinite in extent as nature.

The idea that prompted the work of an artist should continue to grow and have meaning for him after the work of art was complete; in the same way, the idea gleaned from the work of art must continue to expand in the consciousness of the viewer. The work of art serves only as a bridge, a link between a higher and lower consciousness, and must not be given value simply for itself. A work is as good as what it evokes, regardless of how its technical means might be discussed from other viewpoints. The true artist is always greater than the work he produces; the work simply provides a glimpse of his immortal soul.

The language of much of this theory was borrowed from Christian teachings, although Christianity as doctrine did not in itself advocate a disaffection from formal order. In France under the Revolution, the suppression of the Church and the establishment of a state cult that assumed the trappings of ancient Greece and Rome (some of the pageantry was designed by David) could have encouraged a rebellious emphasis on Christianity and other than classical reference, but the opposing tendency was too widespread to be simply the reaction to a local political effort. For all his pose as a pious monk, Wackenroder counseled a universal sympathy that was to extend well beyond the boundaries of Christian culture: "you and your unknown brothers have received your spiritual gifts from the same hand," he said in discussing the unity of Western art with that of Africa, India, or the South Seas. The movement could probably be described most accurately as a desperate effort to maintain a liberating sense of the unknown, of mystery, in a world that was becoming too clear and too defined. The inspiration of Christianity was there to be adopted for use, but not all aspects of Christian doctrine served everyone alike. Evangelical homiletic arguments fell coldly on the ear of Blake or Friedrich Overbeck. Philipp Otto Runge was much impressed with the writings of the sixteenth-century German mystic Jakob Böhme; Blake followed his personal mysticism supported by the teaching of Emanuel Swedenborg; and many found solace in the mystical rites of the Roman Catholic church. There were only two main requisites for participation in this mystical art: the commitment had to be emotional and personal, and the cult had to be taken on faith, appealing to a deep-seated longing to be absorbed into a unity rather than to a desire simply for social organization. These artists preached aloneness, but they wanted to be alone together. Notions of artistic brotherhoods persisted from the time a group of "Primitives" formed in David's studio to the gathering of artists in the forest of Barbizon, but the brotherhoods all had to be based on the communion of souls.

To be antirational did not mean to spurn discipline. One of the most often-repeated criticisms of a purely formal procedure made by those of spiritual

bent was that it encouraged a superficial rhetoric that could be maintained with no serious effort or commitment. From formalist systems of measurable schemes and paradigms there developed a kind of free, improvising method that allowed the artist to display his facility of hand without betraying the state of his heart. The spiritually inspired wished to force a reintegration of form and feeling, and this, they believed, could be brought about only by the most rigorous personal discipline. Every temptation to dazzle with facility or attain quick effects had to be forsworn; what John Ruskin would later call the quality of sacrifice—selfless devotion and hard work—had to be clearly evident. With so honest a revelation of an inner state, only pious men could make pious pictures, and how one lived and thought was as important to the reformers as what one did. Maurice Quay, one of the "Primitives" in David's studio, finished almost nothing; Friedrich Overbeck spent much more time drawing studies than painting; and Tommaso Minardi for some years restricted himself only to the most rigid program of drawing. To study was more important than to produce a "completed" work because it manifested a laudable humility in the face of ultimate truth. Furthermore, no work should be considered complete, but only a marker on the road to further spiritual knowledge.

This self-absorbing study, although personal, was in no sense directed toward self-expression. Rather, it set out to be the expression, through self, of a universal idea. The self, with its petty ambitions and local demands, was an obstacle to be overcome. The tendency among these artists was to achieve detachment by forcibly breaking all ties to contemporary circumstances and restrictive worldly context. The contemporary world was becoming not only more rationalistic in its problem solving, but industrial, rather than craftsmanly, urban rather than rural, and secular rather than spiritual in its social (and even religious) organization. One means of withdrawal was to follow the image of the cloister as suggested by Wackenroder and practiced briefly in Rome by the German painters dubbed the Nazarenes. More prevalent was the use of history to identify oneself with those periods least like the present. For various reasons, the most popular points of reference were the centuries loosely defined as the "Middle Ages," which for the early nineteenth century meant from about the thirteenth through the fifteenth century. But artists also turned to the periods evoked by Ossian and Homer (although both had been preempted to an extent by the "rationalist" faction) and the period of the Old Testament.

The "formal" artists were quite willing to accept the art of all these periods, at least as historical artifacts or as complements to "mature" periods. They did not exclude the possibility of virtue in what they considered to be nonrational art. Gothic-style churches were built on request by architects devoted to the principles of Vitruvius, and they often took a mildly antiquarian interest in their design. Those who believed in the supremacy of the soul, however, de-

Johann Heinrich Füssli, *The Artist Moved by the Grandeur of Antique Fragments*, 1778–80, red chalk and sepia wash.

spite their protestations of universal brotherhood, were rather less charitable toward the rational point of view, nor were they tolerant of a rationally devised eclecticism. To them, an experience either was of spiritual foundation or it had no value; the opposite of spirituality was sinfulness and depravity. Just such terms were eventually hurled at the proponents of fair reason by Augustus Welby Pugin, an architect who believed that Gothic architecture alone was the product of pious men and would, in turn, produce pious thoughts.

One result of the concerted support of previously neglected periods of art, notably the period from the thirteenth to the fifteenth century, was a revised concept of the pattern followed by the history of art. Since the fifteenth century it had been fashionable to look upon art as having decayed during the late Roman Empire and as not having revived until the fourteenth and fifteenth centuries in Italy, after some intervening centuries of total barrenness. From this concept, of course, the terms *Middle Ages* and *Renaissance* were derived. As is evident from Chateaubriand, Minardi, and A. F. Rio, this view was almost exactly reversed by those who enthusiastically supported what they characterized as Christian art. The sixteenth century, which had traditionally been regarded as the highest point of art since ancient times, they looked upon as a faded flower, a decay; the favored century became the fifteenth, followed by the fourteenth and the thirteenth, with some variation that depended on the country in question.

During the controversy that developed between the artists and theorists who were proponents of these opposing principles, certain words were introduced into the critical vocabulary and others took on new meanings. One of the most important of these was *primitive,* whose two quite different denotations—first in historical time or primal in the order of human experience—were fused, a tendency still common. "Primitive" art, for the historians and theorists of the time, was that which immediately preceded the "fully developed" art of the late fifteenth and sixteenth centuries; in some instances, it was used to describe the art of pre-Periclean Greece. Thus it was the "childhood" of an art that later "matured." Although the classical view would naturally favor the rational adult over the untrained child, Minardi, among others, cited the untainted intuition of the child as an example for the artist. By the same reasoning, the "childhood" of art could be recommended as a model, rather than be spurned as immature. The young Ingres was damned for seeming to imitate the "primitives," for advocating a return to the childhood of art—charges he denied. Others at the same time were trying to identify their own pursuit of primary values with a primitive epoch.

An allied term was *naive,* which can best be understood in opposition to *mannered. Naive* referred to a convincingly direct expression that seemed not to be couched in terms of a pre-established vocabulary. Although Reynolds held manner (but not "mannered") to be an essential quality of superior art, it was a

mark of falseness to those who valued primitive directness and naive honesty. *Naive* could apply to various aspects of art: to the direct spiritual inspiration of Blake, to the direct observation of nature, or to any seemingly direct and uninhibited execution of a painting.

Basic to all these terms is a concept of *purity,* which was, however, used in two diametrically opposed senses. *Pure form* was used to describe form detached from the vagaries and particularities of nature. However, *pure* was also used to describe a quality untainted by rational schemes or contemporary perversions. This type of purity in art could reflect a pure path to the soul by which a sense of spirituality was shared. Yet pure form, by calling attention to its own aesthetic qualities, was an obstacle to such communion.

Even the nonformal definition of purity, however, served in two rather different applications. One meaning referred to art that concentrated on the mystical and took its subject matter from Christianity; its artistic direction came from Fra Angelico and Raphael. The other referred to an art that was considered pure in its vision of nature without necessarily making a commitment to religious themes or past masters. (This second notion was basic to the developing interest of landscape painting, as we will see in Part III.) One other application was far rarer in contemporary usage, the use of *purity* to allude to a more passionate breaking down of the barriers between man and man, and between man and things, that allowed the artist to impregnate each external form with feeling. This activity was different from the melodramatic exaggerations of Füssli, the terrifying fantasies of E. T. A. Hoffmann's stories, or the "Gothic" novels of Mrs. Radcliffe—although these works were sometimes regarded with sympathy by the proponents of the new feeling. Delacroix did not seek out the bizarre or outlandish and disliked bombast and overstatement; he worked on each canvas until it seemed a direct expression of vital intensity. One could say that his was a purity forged by fire rather than by contemplation.

Of all terms developed during the period, certainly the most variable and confusing, both then and now, was *Romanticism.* At one time or another it has been applied to every aspect of thought and procedure we have been discussing. Baudelaire's definition, which comes very late, applies principally to the aspect of passionate involvement exemplified by Delacroix. The various artistic manifestations of ideas opposing the theories of form could certainly not be grouped under a single style: Blake, Overbeck, Delacroix, and so on, make odd companions when considered in terms of pictorial form. While all these tendencies toward the re-establishment of personally felt spiritual meaning equally opposed the theories of ordered form, their means and formulations of their goals differ widely. This variety is quite understandable from the premises of the theories themselves. With the belief that man should not set limits to his experience but push always beyond definition, artists so persuaded could hardly accept a common program that would in itself restrict their freedom to sense

intimations of truth beyond their expectations. To bridle such a pursuit with a single term is an ironic contradiction of the tendency itself. One can only describe the tendency in terms of its infinite complexity, much as the artists themselves set out to describe nature. The rationalists, on the other hand, could well set forth their premises, means, and ends with a touching faith in the perfectibility of human reason.

Romanticism, then, should be seen as an impulse, a point of departure, certainly in no serious sense a style. It was an open-ended pursuit by highly sophisticated society of a primitive quality that would allow individuals to feel intuitively at one with nature and the universe, however either might be defined, moving always toward an internal unity of spirit rather than toward an externally formulated order. In itself, Romanticism was not a way but a direction; the ways were many and diverse.

To suppose that Romanticism historically succeeded a tendency too easily dubbed Classicism is less defensible than many theorists of history would have one believe. The two attitudes were born together in the eighteenth century and remained fruitful opponents throughout much of the nineteenth century, sharing materials and methods, but always ultimately diverging in the definition of ends.

WILHELM WACKENRODER

Outpourings from the Heart
of an Art-loving Monk (1797)

Wilhelm H. Wackenroder (1773–1798) conceived of artistic crea-
tion as a deeply felt, divinely inspired effusion from the spirit of the artist that
was transmitted to the world through his works. *Outpourings from the Heart of
an Art-loving Monk* was compiled in 1797 by his intimate friend Johann Ludwig
Tieck (1773–1853). The book had great influence on later artists and writers,
most notably on the Nazarenes under the leadership of Friedrich Overbeck.
The following extracts were translated by Richard Murray from *Herzen-
sergiessungen eines kunstliebenden Klosterbruders*, in Wilhelm Wackenroder, *Werke
und Briefe* (Heidelberg: Verlag Lambert Schneider, 1967), pp. 9–10, 25–29,
51–56, and 79–82. ✣

TO THE READER OF THESE PAGES

In the solitude of a cloistered life, in which I only sometimes dimly remem-
ber the faraway world, little by little the following essays came to be. In my
youth I greatly loved art, and this love has remained with me, like a true friend,
to this day. Without thinking about it, I wrote down my reminiscences out of
an inner urge, and you, beloved reader, must view them with a forbearing eye.
They are not composed in the fashion of today's world, because this manner is
not in my power; and too, if I should be completely sincere, I cannot abide it.

In my youth I was very much a part of the world and worldly affairs. My
greatest desire was art, and I wished to devote my life and my few talents to it.
According to the judgment of some friends, I was not unskilled in drawing,
and my copies as well as my own inventions were not totally displeasing. But I
always thought of the great and glorious saints of art with a quiet, holy awe:
when the name of Raphael or Michelangelo came to mind it seemed strange—
yes, even absurd—that I guided the brush or crayon in my hand. I have to con-
fess that I often had to weep out of an indescribable, melancholy ardor when I

clearly envisioned their works and lives. I could never bring myself—indeed, such a thought would have seemed to me blasphemous—to separate the good from the so-called bad in my chosen favorites and in the end to set them all up in order and examine them with a cold, critical view, as now the young artists and so-called connoisseurs take so much trouble to do. So I have read, I freely admit it, with little pleasure in the writings of H. von Ramdohr;[1] anyone who likes his writing ought to discard what I have written, because it will not please him. These pages, which I at first had not intended for publication, I dedicate especially to young, beginning artists or to youths who think of devoting themselves to art and who still carry forth a sacred reverence for the past ages in a quiet, unaffected heart. Possibly through my otherwise unimportant words they might be more touched, stirred to a still deeper reverence because they read with the same love with which I have written.

Heaven has willed that I finish my life in a monastery: thus, these endeavors are all that I can now do for art. If they are not totally displeasing, then perhaps a second part will follow, in which I would want to refute opinions concerning some particular works of art and, if Heaven grants me health and time, to organize my thoughts and publish them in a more articulate discourse.

RAPHAEL AND THE STUDENT

In that bygone age when an admiring world still beheld Raphael living in its midst (I can scarce speak his name without involuntarily calling him Divine), in that bygone age—oh how willingly I would give up all the cleverness and wisdom of subsequent centuries to have lived then!—in a small town in the realm of Florence, there lived a young man whom we shall call Antonio who was studying the art of painting. He had felt a strong inclination for painting since childhood and even as a boy diligently copied all the pictures of saints that fell into his hands. But with all the steadfastness of his zeal and his eagerness to create something outstanding, he possessed perhaps a certain timidity and narrowness of spirit, with the result that his art, like an undernourished plant, continued stunted and infirm and could not spring up healthy and free toward the heavens. Under this unfortunate constellation of attributes, many an incomplete artist has come into the world.

Antonio had already made studies after various masters of his own time, and he had reached the point where the closeness of his copies to the originals gave him great satisfaction and also a very exact idea of his progress. Finally he saw several drawings and paintings by Raphael. He had often heard his name pro-

1. Carl Friedrich von Rumohr (1785–1843) published his *Italienische Forschungen* between 1827 and 1831.—Ed.

nounced with great respect, and he immediately decided to copy the paintings of this celebrated man. But, unable to satisfy himself with his copies yet not knowing why, he impatiently put down his brush, thought over what he could do about it, and finally composed the following letter:

"*To the most excellent artist, Raphael of Urbino:*

"Forgive me for not knowing how to address you, for you are an extraordinary and exalted man; moreover I am not practiced in wielding the pen. I have also pondered for a long time whether it was quite proper for me to write to you without ever having met you in person. But since everyone speaks of your kindly and affable disposition, I have finally decided to venture it.

"I will not, however, take up your valuable time with a lot of words, because I can understand how busy you must be. Instead I will simply open my heart to you and lay my plea before you without further ado.

"I am a young beginner in the admirable art of painting, which I love above all things and which so gladdens my heart that I can hardly believe that anyone else (naturally I except you and the other celebrated masters of our time) can feel so deep a love and so constant an attraction for it. I try my best to draw ever a bit closer to the distant goal that I see before me. I am not idle a single day, indeed, hardly a single hour; and every day I see myself making progress, however small. I have already practiced in the style of many of the famous men of our time, but when I began to copy your works it seemed to me that I knew absolutely nothing and that I would have to start all over again from the beginning. I have depicted many heads in which no fault or inaccuracy in contour or in light and shade can be found, but when I transfer the heads of your apostles and disciples as well as those of your Madonnas and the Christ child to my panel, stroke by stroke, with such precision that my eyes seem about to fail me, and then step back to compare my copy with the original, I am stunned to find that they are worlds apart, and that I have painted an entirely different face. And yet your heads, when they are first seen, seem to be simpler than the others. They look so natural, and one immediately recognizes the persons represented, as if one had seen them in life. Furthermore, I do not find in your paintings those difficult and extraordinary foreshortenings of limbs with which today's masters like to demonstrate their skill and torment us poor students.

"Although I have thought about it a great deal, I have not been able to explain what it is that makes your paintings so unique or to discover the real reason that one cannot accurately copy you, nor in any way equal you. Oh help me in this, I urgently and beseechingly beg you. And tell me (because certainly you can best do it) what I must do to become in only some degree comparable to you. Oh how deeply shall I absorb what you say! With what zeal I shall follow it! I have—forgive me—often thought that you must have some secret in your work that no other person can comprehend. How happy I should be if I could

watch you work, if only for half a day. But perhaps you allow no one to do this. If I only were a great man, I would offer you thousands of gold pieces for your secret.

"Pray, be indulgent with me for having dared to go on so with you. You are an exceptional man, and surely you must look down on other men with contempt.

"You must work day and night to accomplish such marvelous things, and when you were young you probably made more progress in a single day than I make in a whole year. Well, in the future I too will strain my every faculty and work as hard as I am able.

"Others, who see more clearly than I, also praise above all the expression in your paintings and maintain that no one knows as well as you how to bring out the qualities of character in his subjects, so that from their mien and bearing, so to speak, one can divine their thoughts. But I do not yet understand much about these matters.

"I must at last stop troubling you. Oh, what an inspiring reassurance it would be for me if you would send even a few words of advice to,

<div style="text-align:right">

your very respectful,
Antonio."

</div>

So ran Antonio's letter to Raphael, and Raphael smilingly wrote him the following answer:

"My good Antonio:

"It is wonderful that you love art so much and that you study so diligently; in this you have made me very happy. But what you want to know from me I cannot, unfortunately, tell you; not because it is a secret I do not want to reveal—for I would want with all my heart to tell it to you and to everyone—but because I do not understand it myself.

"I suspect that you will not believe me, and yet it is so. I can no more tell you why figures take one form and not another under my hand than a person can account for the fact that he has a harsh or an agreeable voice.

"The world discovers many exceptional qualities in my paintings, and when my attention is directed to this or that merit in them, I myself must sometimes smile in looking at my work, it has succeeded so well. But it is accomplished as in a pleasant dream, and while working I have always thought more about the subject than about the manner in which I might represent it.

"If you cannot entirely grasp and reproduce that which you find unique to my work, I advise you, dear Antonio, to choose one or another of the other justly celebrated masters of our present age as your model, because each one of them has something worth imitating. I profitably based my studies on them

and still feast my eyes on their manifold excellencies. That I now have a certain way of painting and not another—as everyone cultivates his own—is because it was implanted in my nature from the beginning. I have not achieved it by the sweat of my brow, and it was not produced by a plan that one can study. Continue, meanwhile, to practice art with love.

Farewell."

A Word About Universality, Tolerance, and Humanity in Art

The Creator of our earth and of all that is upon it encompassed the whole world at a glance and poured the stream of his blessings out over the entire globe. But from His mysterious workshop He scattered over our sphere thousands of infinitely varied seeds that produce infinitely varied fruits, and the most varied gardens spring up to His greater glory. With his wonderful wisdom He sends His sun around the earth in measured circles so that its rays reach the earth from a thousand directions and in each latitude the substance of the earth ferments and pushes forth the most varied creations.

In a single great moment, He contemplates his handiwork with an unprejudiced eye and receives with equal satisfaction the offerings of the whole of animate and inanimate nature. The roar of the lion is as pleasing to Him as the cry of the reindeer, and the aloe is as pleasingly fragrant as the rose and the hyacinth.

Mankind also issued from His creative hand in a thousand forms. Brothers of the same house do not know or understand one another; they speak different languages and astonish one another; but He knows them all, and all of them please Him. He contemplates his handiwork with an unprejudiced eye and receives the offerings of the whole of nature.

In many ways, he hears the voices of humankind talking at one another of spiritual matters and knows that all of them—all, even against their knowledge and their will—in fact refer to Him, the Ineffable.

Thus also does He hear the inner feelings of people in various regions and in various epochs speaking various languages. He hears how they quarrel and fail to understand one another; but to the Eternal Spirit, all resolves in harmony. He knows that everyone speaks the language with which He has endowed them, that each expresses his inner self as he can and as he must. When in their blindness people quarrel among themselves, He knows and understands that each is in himself right. He looks with satisfaction upon each and every one and is gladdened by this variegated mixture.

Art may be called the flower of human feeling. It raises itself to the heavens

Friedrich Overbeck, *Italia und Germania*, 1811–28, oil on canvas.

from the most diverse regions of the earth in ever-changing forms. For the Father of all things, who holds in His hand the terrestrial globe with everything that is upon it, this flowering too has but a single fragrance.

In each work of art from every region of the earth He perceives the traces of the divine spark, which, having issued from Him to penetrate the breasts of humankind, passes into their small creations; in these the greater Creator sees it shine forth anew. To Him the Gothic temple is as pleasing as the Greek temple, and the primitive war chants of the savages sound in His ear as agreeably as the artistic choruses and hymns of the church.

And now when I leave Him, the Infinite, and after crossing the immeasurable space of the heavens return to the earth and look about among my fellow

men—alas! I must loudly bewail that they strive so little to emulate their eternal model in heaven. They quarrel among themselves and do not understand one another. They do not see that they hasten toward the same goal. Each remains standing with his feet firmly planted in his own stronghold and does not know enough to lift his eyes to see the whole.

Ignorant people do not understand that there are antipodes on our earthly sphere and that they themselves are antipodes. They imagine that they stand at the earth's gravitational center, and their spirits lack wings to fly around the entire globe, to encompass in one view the self-combined totality.

And they regard as well that their own tastes are the center of all beauty in art; they pronounce decisive judgments on everything as if from a court of law, without considering that no one has set them up as judges and that those whom they condemn could as well claim this function.

Why not condemn the Indian because he speaks his language and not ours?

And would you condemn the Middle Ages for not having built temples like those of ancient Greece?

Oh!—that by some presentiment you would be enabled to see into unfamiliar souls and observe that you and your unknown brothers have received your spiritual gifts from the same hand! You would understand then that every being can create forms only by virtue of the power he has received from Heaven and that the creations of each must be measured against what he is himself. And if you cannot penetrate unfamiliar beings by way of your feelings, in order to understand their works through their souls, at least try to achieve this end through reason.

Had the hand of the heavenly sower let your seed fall on the African desert, you would proclaim to the whole world that glistening black skin, heavy, blunt features, and short kinky hair were essential elements of the highest beauty, and would deride or detest the first white man who came along. Had your soul germinated a few hundred miles further to the east, on the soil of India, you would feel the mysterious spirit that breathes in the strangely formed, many-armed idols, which seem so incomprehensible to us, and upon seeing the Medici Venus would not know what to think. And had it been the pleasure of Him in whose power you were, and still are, to cast you among the tribes of the South Sea Islands, you would find deep meaning in savage drum beats and the harsh, shrill rhythm of melodies that are now quite outside your understanding. But in any of these cases would you have received your creative gifts or your ability to enjoy art from any source other than the eternal and universal one, to whom you now owe all your treasures?

The calculation tables of the intellect follow the same laws in all the nations on earth, but in one place they are applied to an infinitely larger field, in another to a very reduced field of objects. Similarly, artistic feeling derives from one and the same heavenly ray of light, which, however, in passing through the

many-faceted prism of the senses of various regions of the world, breaks into thousands of different colors.

Beauty: what a singularly wonderful word! But first discover new words for each particular kind of artistic feeling, for each particular work of art! A different color plays over each, and different nerves have been created in the human body to apprehend each.

But you, through intellectual skill, stretch this word to make it a strict system and want to force all people to feel in accordance with your prescriptions and rules—and you yourself feel nothing.

He who has faith in a system has driven universal love from his heart. Intolerance based on feeling is more acceptable than intolerance based on intellect. Superstition is better than belief in a system.

Can you force the melancholy to be pleased by lighthearted songs and gay dances? Or the sanguine to open their hearts joyfully to the horrors of tragedy?

Oh! allow every mortal being and every people under the sun their beliefs and happiness! And rejoice when others are rejoicing, even though you do not understand how to enjoy what they hold most dear and precious.

To us, the children of this century, has fallen the privilege of finding ourselves standing at the summit of a high mountain from which we may see many lands and many ages spread about at our feet. Let us then profit from this good fortune and look about with a calm, clear eye at all epochs and all peoples and endeavor to discover the constant human element in all their various feelings and works.

Every being strives toward the highest beauty; but it cannot escape its own self and can only see this supreme beauty in itself. As to each mortal eye the rainbow takes a different form, so for each person the world reflects a different image of beauty. But universal natural beauty, which we cannot express verbally but can only conceive of in moments of illumination, appears to Him who has made both the rainbow and the eye that sees it.

My discourse began with Him, and now I return to Him—as the spirit of art—just as all spirits issuing from Him return to Him, across the atmosphere of the earth, in sacrifice.

How One Should Contemplate the World's Greatest Artists and Employ Them for the Well-being of One's Soul

I continually hear the childish and thoughtless world complain that God has put so few truly great artists on the earth. The common mind impatiently fixes its eye on the future, wondering if the Father of mankind will not soon bring a new generation of brilliant masters to being. But I say to you that the world has

never had too few excellent masters; indeed, some among them are of such quality that a mortal being could spend his entire life viewing and coming to understand their works. In truth, there are far too few who are equipped fully to understand the works of these beings, who are made of a nobler clay, and (what amounts to the same thing) to honor them deeply enough.

Picture galleries are taken for annual fairs where new wares may be judged in passing, praised and scorned. They should be temples where in calm and silent humility and in exalting solitude one may admire great artists as the most noble of mortals, and where in long, uninterrupted contemplation of their works one may warm oneself in the sun of the most enchanting thoughts and emotions.

I compare the enjoyment of the noblest works of art with prayer. Heaven is not pleased with those who speak to it only to acquit themselves of their daily obligation, who string words together without thought and who boastfully measure their piety on the beads of their rosary. Rather, Heaven loves him who, with submissive longing, awaits the chosen hours when sweet heavenly rays fall freely upon him, splitting open the insignificant earthly envelope in which mortal spirits are customarily contained, so that his nobler inner self wells up and is laid bare. Only then does he kneel and, turning his open heart in calm rapture to the bright light of Heaven, saturates himself with the ethereal light. He arises happier and more melancholy, with a fuller and lighter heart, and turns his hand to some great good work. This is my idea of prayer.

I believe that masterpieces of art must be approached in the same manner, if you are to use them beneficially for the welfare of your soul. It is considered a sacrilege if someone, when taken up with worldly pleasures, staggers away from the resounding laughter of his friends to enter a nearby church merely out of habit and speak with God for a few minutes. A similar sacrilege is committed when, at such a time, in a like situation, a person crosses the threshold of the house in which the most admirable creations to come from the hand of man are displayed as a silent, eternal message of the dignity of the species. You must wait, as with prayer, for the blessed hours when the favor of Heaven illumines your inner being with superior receptivity. Only then will your soul unite completely with the works of artists. Their magical figurations are mute and impenetrable when they are looked upon coldly. If they are to speak to you and exercise their great powers over you, you must first address them forcefully with your heart.

Works of art are, in their manner, as little suited to the common flow of everyday life as are thoughts of God. They rise above the ordinary and the habitual, and we must elevate ourselves to them with our whole heart if our eyes, which are so often clouded by the mists of the atmosphere, are to reflect them as the superior objects they are.

Anyone can learn to read the alphabet; anyone can read accounts of the history of the past ages in learned chronicles and can recount them in his turn;

anyone can also study the theoretical bases of science and grasp formulas and facts—because the letters of the alphabet exist only in order that their forms can be recognized by the eye, and theorems and events are objects of our concern only as long as the mind's eye works to grasp and understand them. As soon as we have assimilated them, our mind's activity is at an end, and then we can only gloat in a dull and unfruitful contemplation of our treasures. This is not the case with the works of the great artists. They do not exist merely to be seen by the eye, but rather to be penetrated by a willing heart, to be lived and breathed. A precious painting is not like a paragraph from a textbook, which I can lay aside after I have spent a bit of effort to extract the meaning of the words. It is much more than this. A great work of art is a source of constant and everlasting pleasure. We believe that we penetrate them ever more deeply, and yet they always excite our senses anew; and we cannot imagine a limit beyond which our souls will have exhausted them. In our eyes, the flame of perpetual life burning in them will never be extinguished.

I pass over the first viewing impatiently, because the surprise of the new—which many individuals, seeking the pleasures of constant change, would declare the chief merit of art—always seems to me only to be a necessary evil. True appreciation demands the calm, quiet concentration of the soul. It is not manifested in exclamations and handclapping but only in an inner stirring. It is a sacred holiday for me when I go gravely and with my soul prepared to contemplate noble works of art. I return to them often and endlessly. They remain firmly impressed on my senses; and as long as I live on earth I shall carry them with me, like spiritual amulets, for the consolation and comfort of my soul, and I will take them with me to the grave.

He whose feelings can be moved and who is sensitive to the secret charms that lie hidden in art is often stirred to the very depths of his soul at that which another passes by in indifference. In his lifetime he will often partake of the joys that attend the salutary stimulation and excitement of the soul. Often when, occupied with other thoughts, I pass through some great and beautiful colonnaded passageway, its mighty and majestic columns, with their graceful sublimity, attract my involuntary gaze and fill my soul with a singular emotion. And I feel myself inwardly bow before them, and continue on my way with an untrammeled heart and a richer soul.

The essential thing is that we not gloss over the spirits of illustrious artists with bold presumption, look down upon them disdainfully, and dare to judge them. This is a foolish enterprise of vain human arrogance. Art is above humankind. We can only admire and venerate the glorious works of those ordained to it, and open our entire soul before them for the illumination and purification of our feelings.

WILLIAM BLAKE

A Descriptive Catalogue of Pictures (1809)
Marginalia to Reynolds's *Discourses* (ca. 1808)

The extraordinary English artist and poet William Blake (1757–1827) can hardly be considered a typical figure of his time; indeed, none of the people represented in this section of this volume could be considered typical, nor would they have wanted to be so considered. There are, after all, no typical geniuses, and for these artists and theorists the quality of genius was primary and indispensable.

Certainly Blake was one of the most militantly original artists of his period and was conscious of his singular position. Yet he did not court isolation or eccentricity but wished to feel himself a part of society. It had to be a society, however, that was organized on the basis of communion with an inner spirit, responsive to imagination and the intimations of God. The larger society of his own time he found wholly repugnant. He longed for the New Jerusalem.

Blake is usually called a visionary, and indeed he was, even by his own characterization.

But visionary often carries the connotation of dreamer, a person too vague, too nebulous in thought and statement to take part in what is complacently referred to as the practical world. This was largely Reynolds's view, and he warned his young listeners that to "await the call and inspiration of genius" was futile, that such an attitude might provide "notions not only groundless but pernicious." But for Blake, inner vision was far sharper in focus than ocular vision, for the eyes were sure to be clouded by all manner of material circumstance. This inner vision could produce perceptions more specific and clear than Reynolds's eclectically produced generalizations. "Strictly speaking," said Blake, "all knowledge is particular," and he much disliked the attempts of scientists to deduce general laws. So far as he was concerned, any generalization might to a degree apply to many things but actually got at the essence of nothing; and thus generalizations were per se untrue and were relevant only in the world of generalization.

When Blake spoke of "inner vision," he meant the term quite literally: the form and the idea were born together in his mind and he felt he could "see" his

ideas, not simply grasp at concepts. Once he had "seen" an idea clearly in his mind or, in his terms, in the Imagination, to alter the form would be to tamper with the content.

Blake was much taken with the ideas of Emanuel Swedenborg (1688–1772), a Swedish mineralogist of considerable note who, as the result of a series of visions, began looking upon the physical world as simply the temporal and spatial manifestation of a spiritual world, the dimensions of which were moral rather than physical. Swedenborg considered what he "saw" in his visions as moral phenomena limited by neither time nor space. He could thus consult with historical personages, who appeared to him in their "true" form. As a scientist he was aware of the complexity and mutability of matter, and he sought the key by which all natural processes could be understood in spiritual terms. For example, by equating the lungs and the heart with Divine Wisdom and Divine Love, he could understand the growth of the body as a spiritual development. Since the body was thus the physical being of Wisdom and Love, any changes in those qualities would be manifest through physical changes. As posited by Neoplatonic theorists in the Renaissance, one could become earthbound and fail to recognize the spirituality of which the physical being was only the dimensional aspect; a spiritual man was one who could perceive physical form in its spiritual context.

This coexistence of two worlds between which there was a complete congruence, Swedenborg described in terms of "correspondences." If all people could be brought to recognize the higher, timeless correspondence of everything perceived in the sensuous world, they would be able to enjoy the spiritual company. Heaven could be experienced in life; death was only the loss of the physical dimension. Hell was not a punishment after death but the fate of those who lacked moral vision, who were bogged down in a temporal world of materiality. Each person carried within himself the potentiality for Heaven or Hell. It was a vision of the spiritual dimension that Blake identified as the Imagination. "He who does not imagine in stronger and better lineaments, and in stronger and better light than his perishing and mortal eye can see does not imagine at all," he declared. And not to imagine was to build one's own Hell.

In 1809 Blake published a lengthy descriptive catalogue of his watercolors in which he took pains to make clear that each was a serious embodiment of spiritual meaning. He took a combative stance in support of his belief in the Imagination and in the superior clarity of inner vision, and he had no patience for those who could not—or would not—accept his revelations as fact.

Nowhere does Blake reveal more clearly the controversial aspect of his ideas as applied to traditional theories of art than in the marginal notes he wrote in around 1808 in his copy of Reynolds's *Discourses* (1798). Blake had the habit of thus arguing with the books he read, and Reynolds often moved him to pas-

sionate ire. He did agree on a few points, most particularly in the condemnation of the sixteenth-century Venetian painters. In this he believed Reynolds too lenient, since he himself was far more damning of their rich sensuousness. Clearly their paintings were born within the perceptions of the sensuous world, not in the Imagination as Blake defined it. He approved also of Reynolds's emphasis on line, although for different reasons than those given by Reynolds. Like Wackenroder, however, Blake disapproved of the entire academic procedure and particularly of the assumption that one could learn to be an artist. For Blake, as for others imbued with the need to carry a spiritual message, the artist followed a calling, not a profession.

The first of the following passages appeared under the fourth catalogue entry in *A Descriptive Catalogue of Pictures, Poetical and Historical Inventions, Painted by William Blake, in Water Colours* (London, 1809), pp. 36–38; the second consists of the comments made by Blake in the margins of his copy of Sir Joshua Reynolds's *Discourses* (1798). The texts are based on *The Poetry and Prose of William Blake*, ed. David V. Erdman (Garden City, N.Y.: Doubleday, 1965), pp. 532, 635–41, and 647–50. ✤

A DESCRIPTIVE CATALOGUE OF PICTURES

The connoisseurs and artists who have made objections to Mr. B.'s mode of representing spirits with real bodies, would do well to consider that the Venus, the Minerva, the Jupiter, the Apollo, which they admire in Greek statues, are all of them representations of spiritual existences of God's immortal, to the mortal perishing organ of sight; and yet they are embodied and organized in solid marble. Mr. B. requires the same latitude and all is well. The Prophets describe what they saw in Vision as real and existing men whom they saw with their imaginative and immortal organs; the Apostles the same; the clearer the organ the more distinct the object. A Spirit and a Vision are not, as the modern philosophy supposes, a cloudy vapour or a nothing: they are organized and minutely articulated beyond all that the mortal and perishing nature can produce. He who does not imagine in stronger and better lineaments, and in stronger and better light than his perishing mortal eye can see does not imagine at all. The painter of this work asserts that all his imaginations appear to him infinitely more perfect and more minutely organized than any thing seen by his mortal eye. Spirits are organized men: Moderns wish to draw figures without lines, and with great and heavy shadows; are not shadows more unmeaning than lines, and more heavy? O who can doubt this!

DISCOURSE III

A Work of Genius is a Work "Not to be obtaind by the Invocation of Memory & her Syren Daughters, but by Devout prayer to that Eternal Spirit, who can enrich with all utterance & knowledge & sends out his Seraphim with the hallowed fire of his Altar to touch & purify the lips of whom he pleases." Milton

The following "Discourse" is particularly Interesting to Blockheads, as it Endeavours to prove That there is No such thing as Inspiration & that any Man of a plain Understanding may by Thieving from Others, become a Mich Angelo

. . . the genuine painter . . . instead of endeavouring to amuse mankind with the minute neatness of his imitations, . . . must endeavour to improve them by the grandeur of his ideas; . . .[1]

Without Minute Neatness of Execution, The Sublime cannot Exist! Grandeur of Ideas is founded on Precision of Ideas

The Moderns are not less convinced than the Ancients of this superior power existing in the art; nor less sensible of its effects.

I wish that this was True.

Now he begins to Degrade to Deny & to Mock

Such is the warmth with which both the Ancients and Moderns speak of this divine principle of the art; . . . enthusiastick admiration seldom promotes knowledge. Though a student by such praise may have his attention roused, and a desire excited of running in this great career, yet it is possible that what has been said to excite may only serve to deter him. He examines his own mind, and perceives there nothing of that divine inspiration, with which, he is told, so many others have been favoured. He never travelled to heaven to gather new ideas, and he finds himself possessed of no other qualifications than what mere common observation and a plain understanding can confer. Thus he becomes gloomy amidst the splendour of figurative declamation, and thinks it hopeless to pursue an object which he supposes to be out of the reach of human industry.

And such is the Coldness with which Reynolds speaks! And such is his Enmity

Enthusiastic Admiration is the first Principle of Knowledge & its last

The Man who on Examining his own Mind finds nothing of Inspiration ought not to dare to be an Artist he is a Fool, & a Cunning Knave suited to the Purposes of Evil Demons

1. Reynolds's text appears in italics to distinguish it from Blake's commentary.—Ed.

The Man who never in his Mind & Thoughts traveld to Heaven Is No Artist

Artists who are above a plain Understanding are Mockd & Destroyd by this President of Fools

It is Evident that Reynolds Wishd none but Fools to be in the Arts & in order to this, he calls all others Vague Enthusiasts or Madmen

What has Reasoning to do with the Art of Painting?

. . . most people err [not so much from want of capacity to find their object, as] from not knowing what object to pursue.

The Man who does not know what Object to Pursue is an Idiot

This great ideal perfection and beauty are not to be sought in the heavens, but upon the earth. They are about us, and upon every side of us . . . But the power of discovering . . . can be acquired only by experience; . . .

A Lie. A Lie. A Lie

. . . art [must] get above all singular forms, local customs, particularities, and details of every kind.

A Folly

Singular & Particular Detail is the Foundation of the Sublime

The most beautiful forms have something about them like weakness, minuteness, or imperfection.

Minuteness is their whole Beauty

This idea [acquired by habit of observing] . . . which the Artist calls the Ideal Beauty, is the great leading principle. . . .

Knowledge of Ideal Beauty is Not to be Acquired. It is Born with us. Innate Ideas are in Every Man Born with him. they are truly Himself. The Man who says that we have No Innate Ideas must be a Fool & Knave. Having no Con-Science, or Innate Science

. . . from reiterated experience an artist becomes possessed of the idea of that central form . . . from which every deviation is deformity.

One Central Form Composed of all other Forms being Granted it does not therefore follow that all other Forms are Deformity

. . . the ancient sculptors . . . being indefatigable in the school of nature, have left models of that perfect form. . . .

All Forms are Perfect in the Poets Mind, but these are not Abstracted nor Compounded from Nature but are from Imagination

[Even the] great Bacon treats with ridicule the idea of confining proportion to rules, or of producing beauty by selection.

The Great Bacon he is Calld I call him the Little Bacon says that Every Thing must be done by Experiment his first princip[le] is Unbelief. And Yet here he says that Art must be producd Without such Method. He is like Sir Joshu[a] full of Self-Contradiction & Knavery

There is a rule, obtained out of general nature, . . .

What is General Nature is there Such a Thing

what is General Knowledge is there Such a Thing? Strictly Speaking, All Knowledge is Particular

. . . it may be objected, that in every particular species there are various central forms, . . .

Here he loses sight of A Central Form, & Gets into Many Central Forms

. . . still none of them is the representation of an individual, but of a class. . . . in each of these classes . . . childhood and age . . . there is a common form. . . .

Every Class is Individual

There is no End to the Follies of this Man. Childhood & Age are Equally belonging to Every Class

There is . . . a kind of symmetry, or proportion, which may properly be said to belong to deformity. A figure lean or corpulent . . . though deviating from beauty.

The Symmetry of Deformity is a Pretty Foolery

Can any Man who Thinks Talk so? Leanness or Fatness is not Deformity. but Reynolds thought Character Itself Extravagance & Deformity

Age & Youth are not Classes but Properties of Each Class so are Leanness & Fatness

. . . when [the Artist] has reduced the variety of nature to an abstract idea. . . .

What Folly

. . . [the painter] must divest himself of all prejudices . . . disregard all . . . temporary ornaments, and look only on those general habits. . . .

Generalizing in Every thing the Man would soon be a Fool but a Cunning Fool

Albert Durer, as Vasari has justly remarked, would, probably, have been one of the first painters of his age . . . had he been initiated into those great principles [practiced by his contemporaries in Italy.]

What does this mean? *" 'Would have been' one of the first painters of his Age"* Albert Durer *Is!* Not would have been! Besides, let them look at Gothic Figures & Gothic Buildings, & not talk of Dark Ages or of Any Age. Ages are All Equal. But Genius is Always Above The Age

I [do not mean] to countenance a careless or indetermined manner of painting. For though the painter is to overlook the accidental discriminations of nature, he is to exhibit [general forms] distinctly, and with precision, . . .

Here he is for Determinate & yet for Indeterminate

Distinct General Form Cannot Exist. Distinctness is Particular Not General

A firm and determined outline is one of the characteristics of the great style in painting; and . . . he who possesses the knowledge of the exact form which every part of nature ought to have, will be fond of expressing that knowledge with correctness and precision in all his works.

A Noble Sentence

Here is a Sentence Which overthrows all his Book

. . . I have endeavoured to reduce the idea of beauty to general principles: . . . the only means of advancing science: of clearing the mind . . .

[Sir Joshua Proves that] Bacons Philosophy makes both Statesmen & Artists Fools & Knaves

DISCOURSE IV

The Two Following Discourses are Particularly Calculated for the Setting Ignorant & Vulgar Artists as Models of Execution in Art. Let him who will, follow such advice; I will not. I know that The Mans Execution is as his Conception & No better

The value and rank of every art is in proportion to the mental labour employed in it, or the mental pleasure produced by it. As this principle is observed or neglected, our profession becomes either a liberal art or a mechanical trade.

Why does he not always allow This

I have formerly observed that perfect form is produced by leaving out particularities, and retaining only general ideas.

General Ideas again

Invention in Painting does not imply the invention of the subject; for that is commonly supplied by the Poet or Historian.

All but Names of Persons & Places is Invention both in Poetry & Painting

. . . the usual and most dangerous error is on the side of minuteness; . . .

Here is Nonsense!

All smaller things, however perfect in their way, are to be sacrificed without mercy to the greater.

Sacrifice the Parts. What becomes of the Whole

Even in portraits, the grace, and . . . the likeness, consists more in taking the general air, than in observing the exact similitude of every feature.

How Ignorant

A painter of portraits retains the individual likeness; a painter of history shews the man by shewing his actions.

If he does not shew the Man as well as the Action he is a poor Artist

He cannot make his hero talk like a great man. He must make him look like one. For which reason we ought to be well studied in the analysis of those circumstances, which constitute dignity of appearance in real life.

Here he allows an Analysis of Circumstances

Certainly nothing can be more simple than monotony, and the distinct blue, red, and yellow . . . in the draperies of the Roman and Florentine schools, though they have not that harmony which is produced by a variety of broken and transparent colours, have the effect of grandeur which was intended. Perhaps these distinct colours strike mind more forcibly, from there not being any great union between them; as martial music which is

intended to arouse the nobler passions has its effect from the sudden and strongly marked transitions from one to another, which that style of music requires. Whilst in that which is intended to move the softer passions the notes imperceptibly melt into one another.

These are Fine & Just Notions Why does he not always allow as much

. . . the historical Painter never enters into the detail of colours [nor] does he debase his conceptions with minute attention to the discriminations of Drapery.

Excellent Remarks

Carlo Maratti [thought] that the disposition of drapery was a more difficult art than even that of drawing the human figure; . . .

I do not believe that Carlo Maratti thought so or that any body can think so. the Drapery is formed alone by the Shape of the Naked *[illegible word]*

Some will censure me for placing the Venetians in this inferior class. . . . Though I can by no means allow them to hold any rank with the nobler schools of painting, they accomplished perfectly the thing they attempted . . . elegance.

They accomplished Nothing. As to Elegance they have not a Spark

Paul Veronese, although a painter of great consideration, had—contrary to the strict rules of art, in his picture of Perseus and Andromeda represented the principal figure in the shade. . . . an ornamental Painter [whose] intention was solely to produce an effect of light and shadow; . . . everything sacrificed to that . . . capricious composition suited . . . style.

This is not a Satisfactory Answer

To produce an Effect of True Light & Shadow is Necessary to the Ornamental Style—which altogether depends on Distinctness of Form. The Venetian ought not to be calld the Ornamental Style

The powers exerted in the mechanical parts of the art have been called the language of painters. . . . The language of Painting must indeed be allowed these masters [the Venetians]; . . .

The Language of Painters cannot be allowd them if Reynolds says right at p. 97 he there says that the Venetian Will Not Correspond with the Great Style

The Greek Gems are in the Same Style as the Greek Statues

Such as suppose that the great style might happily be blended with the ornamental, that the simple, grave and majestick dignity of Raffaelle could unite with the glow and bustle of a Paolo, or Tintoret, are totally mistaken. The principles by which each is attained are so contrary to each other that they seem in my opinion impossible to exist together, as that in the same mind the most sublime ideas and the lowest sensuality should be at the same time united.

What can be better Said on this Subject? but Reynolds contradicts what he says continually. He makes little Concessions, that he may take Great Advantages

. . . the Venetians show extraordinary skill . . . their colouring . . . I venture to say . . . too harmonious to produce that solidity, steadiness, and simplicity of effects which heroic subjects require, and which simple or grave colours only can give to a work.

Somebody Else wrote this page for Reynolds. I think that Barry or Fuseli wrote it or dictated it

Michael Angelo [thought] that the principal attention of the Venetian painters [was to] the study of colours, to the neglect of the ideal beauty of form. . . . But if general censure was given to that school from the sight of a picture of Titian, . . .

Venetian attention is to a Contempt & Neglect of Form Itself & to the Destruction of all Form or Outline Purposely & Intentionally

As if Mich. Ang°. had seen but One Picture of Titians

Mich. Ang. Knew & Despised all that Titian could do

> On the Venetian Painter
>
> He makes the Lame to walk we all agree,
> But then he strives to blind those who can see.

If the Venetians Outline was Right his Shadows would destroy it & deform its appearance

> A pair of Stays to mend the Shape
> Of crooked Humpy Woman:
> Put on O Venus! now thou art,
> Quite a Venetian Roman.

. . . there is a sort of senatorial dignity about [Titian] . . .

Titian as well as the other Venetians so far from Senatorial Dignity appear to me to give always the Characters of Vulgar Stupidity

Why should Titian & The Venetians be Named in a discourse on Art

Such Idiots are not Artists

> Venetian; all thy Colouring is no more
> Than Boulsterd Plasters on a Crooked Whore.

The Venetian is indeed the most splendid of the schools of elegance; . . .

Vulgarity & not Elegance—The Word Elegance ought to be applied to Forms not to Colours

. . . elaborate harmony of colouring, a brilliancy of tints, a soft and gradual transition from one to another, . . .

Broken Colours & Broken Lines & Broken Masses are Equally Subversive of the Sublime

excellence . . . is weak . . . when the work aspires to grandeur and sublimity.

Well Said Enough

Rubens,—formed on Venetians . . . took figures from people before him . . . was more gross than they. . . .

How can that be calld the Ornamental Style of which Gross Vulgarity forms the Principal Excellence

Some inferior dexterity, some extraordinary mechanical power is apparently that from which [the Dutch school] seek distinction.

The Words Mechanical Power should not be thus Prostituted

An History-painter paints man in general; a Portrait-painter, a particular man. . . .

A History Painter Paints The Hero, & not Man in General, but most minutely in Particular

Thus if a portrait-painter desires to raise and improve his subject . . . he leaves out all the minute breaks and peculiarities in the face . . . and changes the dress from a temporary fashion to one more permanent, which has annexed to it no ideas of meanness from being familiar to us.

Folly! Of what consequence is it to the Arts what a Portrait Painter does

Of those who have practised the composite style, the foremost is Correggio.

There is No Such a Thing as A Composite Style

The errors of genius, however, are pardonable. . . .

Genius has no Error it is Ignorance that is Error

On the whole it seems to me that there is but one presiding principle which regulates and gives stability to every art. The works . . . built upon general nature, live for ever; . . .

All Equivocation & Self-Contradiction

DISCOURSE VII

The Purpose of the following Discourse is to Prove That Taste & Genius are not of Heavenly Origin & that all who have Supposed that they Are so, Are to be Considered as Weak headed Fanatics

The obligations Reynolds has laid on Bad Artists of all Classes will at all times make them his Admirers but most especially for this Discourse in which it is proved that the Stupid are born with Faculties Equal to other Men Only they have not Cultivated them because they thought it not worth the trouble

. . . obscurity . . . is one source of the sublime.

Obscurity is Neither the Source of the Sublime nor of any Thing Else

[That] liberty of imagination is cramped by . . . rules; . . . smothered . . . by too much judgment; . . . [are] notions not only groundless, but pernicious.

The Ancients & the wisest of the Moderns were of the opinion that Reynolds Condemns & laughs at

. . . scarce a poet is to be found, . . . whose latter works are not as replete with . . . imagination, as those [of] his more youthful days.

As Replete but Not More Replete

To understand literally these metaphors or ideas expressed in poetical language seems as absurd as to conclude that because painters sometimes represent poets writing from the

dictates of a little winged boy or genius, that this same genius did really inform him in a whisper what he was to write; . . .

The Ancients did not mean to Impose when they affirmd their belief in Vision & Revelation Plato was in Earnest. Milton was in Earnest. They believd that God did Visit Man Really & Truly & not as Reynolds pretends

How very Anxious Reynolds is to Disprove & Contemn Spiritual Perception

It is supposed that . . . under the name of genius great works are produced . . . without our being under the least obligation to reason, precept, or experience. . . . [One can] scarce state these opinions without exposing their absurdity. . . .

Who Ever said this

He states Absurdities in Company with Truths & Calls both Absurd

. . . prevalent opinion . . . considers the principles of taste . . . as having less solid foundations, than . . . they really have. . . .

The Artifice of the Epicurean Philosophers is to Call all other Opinions Unsolid & Unsubstantial than those which are Derived from Earth

We often appear to differ in sentiments . . . merely from the inaccuracy of terms. . . .

It is not in Terms that Reynolds & I disagree. Two Contrary Opinions can never by any Language be made alike. I say Taste & Genius are Not Teachable or Acquirable but are born with us. Reynolds says the Contrary

We apply the term taste to . . . like or dislike . . . we give the same name to our judgment on a fancy . . . and on unalterable principles. However inconvenient this may be, we are obliged to take words as we find them; . . . distinguish the things to which they are applied.

This is False the Fault is not in Words, but in Things. Lockes Opinions of Words & their Fallaciousness are Artful Opinions & Fallacious also

It is the very same taste which relishes a demonstration in geometry, that is pleased with the resemblance of a picture to an original, and touched with the harmony of musick.

Demonstration Similitude & Harmony are Objects of Reasoning. Invention Identity & Melody are Objects of Intuition

. . . as true as mathematical demonstration. . . . But besides real, there is also apparent truth, . . .

God forbid that Truth should be Confined to Mathematical Demonstration

He who does not Know Truth at Sight is unworthy of Her Notice

. . . taste . . . approaches . . . a sort of resemblance to real science, even where opinions are . . . no better than prejudices.

Here is a great deal to do to Prove that All Truth is Prejudice for All that is Valuable in Knowledge is Superior to Demonstrative Science such as is Weighed and Measured

As these prejudices become more narrow, . . . this secondary taste becomes more and more fantastical; . . .

William Blake, *The Laocoön,* c. 1822, line engraving.

And so he thinks he has proved that Genius & Inspiration are All a Hum

Having laid down these propositions I shall proceed with less method. . . .

He calls the Above proceeding with Method

We will take it for granted, that reason is something invariable. . . .

Reason or A Ratio of All We have Known is not the Same it shall be when we know More. he therefore takes a Falsehood for granted to set out with

[Whatever of taste we can] fairly bring under the dominion of reason, must be considered as equally exempt from change.

Now this is Supreme Fooling

The arts would lie open for ever to caprice . . . if those who . . . judge of their excellencies had no settled principles. . . .

He may as well say that if Man does not lay down settled Principles, The Sun will not rise in a Morning

My notion of nature comprehends . . . also the internal fabric . . . of the human mind and imagination.

Here is a Plain Confession that he Thinks Mind & Imagination not to be above the Mortal & Perishing Nature. Such is the End of Epicurean or Newtonian Philosophy it is Atheism

[Poussin's Perseus and Medusa's head] . . . I remember turning from it with disgust, . . .

Reynolds's Eye could not bear Characteristic Colouring or Light & Shade

A picture should please at first sight, . . .

Please! Whom? Some Men Cannot See a Picture except in a Dark Corner

No one can deny, that violent passions will naturally emit harsh and disagreeable tones: . . .

Violent Passions Emit the Real Good & Perfect Tones

. . . Rubens . . . thinking it necessary to make his work so very ornamental, . . .

Here it is calld Ornamental that the Roman & Bolognian Schools may be Insinuated not to be Ornamental

Nobody will dispute but some of the best of the Roman or Bolognian schools would have produced a more learned and more noble work.

Learned & Noble is Ornamental

. . . weighing the value of the different classes of the art, . . .

A Fools Balance is no Criterion because tho it goes down on the heaviest side we ought to look what he puts into it.

If a European who has cut off his beard, put false hair on his head, or tied up his own, and . . . with the help of the fat of hogs covered the whole with flour . . . issues forth and meets a Cherokee Indian, who has bestowed as much time on his toilet . . . laid on his ochre . . . which ever first feels himself provoked to laugh, is the barbarian.

Excellent

[In the highest] flights of . . . imagination, reason ought to preside from first to last. . . .

If this is True it is a Devilish Foolish Thing to be An Artist

Discourse VIII

Burke's treatise on the Sublime & Beautiful is founded on the Opinions of Newton & Locke. on this Treatise Reynolds has grounded many of his assertions in all his Discourses. I read Burkes Treatise when very Young at the same time I read Locke on Human Understanding & Bacons Advancement of Learning. on Every one of these Books I wrote my Opinions & on looking them over find that my Notes on Reynolds in this Book are exactly Similar. I felt the Same Contempt & Abhorrence then; that I do now. They mock Inspiration & Vision Inspiration & Vision was then & now is & I hope will always Remain my Element my Eternal Dwelling place. how can I then hear it Contemnd without returning Scorn for Scorn—

FRANÇOIS RENÉ,
VICOMTE DE CHATEAUBRIAND

The Beauties of Christianity (1802)

François René, Vicomte de Chateaubriand (1768–1848), was a great projector of images, both in his life and in his writing. In fact it is difficult at times to distinguish between fact and fiction in his works since everything he produced was highly personal and introspective. He spent the last years of his life writing his autobiography, *Mémoires d'outre-tombe,* published after his death in twelve volumes.

Chateaubriand actively opposed the Revolution and took no part in the national idealism then current, remaining in exile in England until 1800. He briefly occupied a political position under Napoleon but entered active political life only with the Bourbon regime. Among other activities, he served as ambassador at the Congress of Vienna. His political career was cut short by the Revolution of 1830, and although he supported legitimist causes, he thereafter devoted most of his time to writing on earlier court life and working on his memoirs.

For those who liked to see their epoch characterized by the melancholy hero, the restless genius always at odds with fate, Chateaubriand furnished a winning example. The image was much helped by the publication of his ruminations on the Christian spirit, *Le Génie du christianisme, ou Beautés de la religion chrétienne* (1802), which included episodes of his enormously popular *Atala* and *René. Atala* emphasizes the natural piety of primitive man and is set in America, which Chateaubriand had visited as a young man; but its overriding theme is the powerlessness of individual man in the face of destiny.

Chateaubriand's Christianism was quite different from the attitudes toward Christianity expressed by Wackenroder, Overbeck, or Blake. It was less concerned with universal brotherhood or mystical spiritual insight than with personal emotion and an agreeable anguish. Christianity afforded him an emotional outlet denied by the rigors of national classical thought. Winckelmann had said that great spirits are like the sea; although the depths may be stirred, the surface remains calm. Although Chateaubriand believed that Christian pas-

sion was purged of ugliness and distortion by virtue of the promise of salvation, his subjects engaged in open expression of ecstasy or anguish and made no effort to suppress their feelings under a calm surface.

Another aspect of Christianity that concerned Chateaubriand, as evident in his brief historical discussion of art and the Church, was its history of triumphs over massive obstacles, the ultimate victory of the pious and spiritual over the calculating and the evil. The thirteenth century, not the Renaissance, was the great period in man's history, for then, as he said, "the Christian religion, after encountering a thousand obstacles, brought back the choir of Moses in triumph to the earth." From that moment on, proper patronage made possible the flowering of the arts. The spiritual joy of Christianity, as Chateaubriand described it, was attained always in spite of some opponent and was more readily describable in terms of triumph over adversity than in terms of a specific character of its own. The authoritative image of the Last Judgment dominated Chateaubriand's vision of beauty.

In much of the literature depicting artists who were inspired by attitudes such as those of Chateaubriand, the artist is represented as a lonely genius triumphing against odds, overcoming persecution and mercantilism to preserve his spiritual integrity. As a creator he was, in Chateaubriand's terms (although the image was not original with him), an earthly imitator of God himself. While the pious secretiveness of Wackenroder or Friedrich Overbeck made them content to see the artist withdraw quietly into a monkish life, Chateaubriand expressed a kind of righteous indignation on behalf of the artist in the face of society. In Chateaubriand's moody, personal religion of martyrdom can be found the seeds of much that was popularly described as French Romanticism.

Possibly Chateaubriand's strong emotional persuasion is less readily understandable in his discourse on historical painting than in *René* or *Atala,* both of which furnished the subjects of many paintings for years to come. His discussion of Gothic architecture, however, clearly reveals his sentiment with regard to nature and its awe-inspiring mystery, for him so closely linked to Christian spirituality. Christianity, for Chateaubriand, was a natural religion, readily identifiable with the mysteries of nature. The Christian hero was not a person who dominated nature but one who recognized in nature the working out of Christian fate and who, after appropriate anguish and struggle, submitted to it.

Le Génie du christianisme, ou Beautés de la religion chrétienne was first published in five volumes in 1802 (Paris: Migneret). The present excerpts with the translator's footnotes are from the first English edition, *The Beauties of Christianity,* 3 vols., translated by Frederic Shoberl with a preface by Henry Kett (London: Colburn, 1803), 2:234–42 and 249–52. 🐦

Chapter III. On Historical Painting Among the Moderns

The pleasing writers of Greece relate that a young female, perceiving the shadow of her lover upon a wall, chalked the outline of the figure. Thus, according to antiquity, a transient passion produced the art of the most perfect illusions.

The christian school has sought another master; it has discovered him in that Great Artist, who, moulding a morsel of earth in his mighty hands, pronounced these words, *Let us make man in our own image!* For us then, the first stroke of design existed in the eternal idea of God; and the first statue which the world beheld was that noble figure of clay animated by the breath of the Creator.

There is a force of error which compels silence, like the force of truth: both carried to the highest pitch, produce conviction, the former negatively, the latter affirmatively. When, therefore, we hear it asserted that christianity is inimical to the arts, we are struck dumb with astonishment, for we cannot forbear calling to mind Michael Angelo, Raphael, the Caracci, Domenichino, Lesueur, Poussin, Coustou, and crowds of other artists, whose names alone would fill whole volumes.

About the middle of the fourth century, the Roman empire, invaded by barbarians, and torn in pieces by heresy, crumbled into ruin on every side. The arts found no asylum except with the christians and the orthodox emperors. Theodosius, by a special law, (*de excusatione artificum,*) exempted painters and their families from all taxes, and from the quartering of troops. The fathers of the church bestow never-ceasing praises on painting. St. Gregory thus expresses himself: "I frequently gazed at a figure, and could not pass it without shedding tears, as it placed the whole story before my eyes in the most lively manner."[1] This was a picture representing the sacrifice of Abraham. St. Basil goes still farther; for he asserts that painters *accomplish as much by their pictures as orators by their eloquence.*[2] A monk, named Methodius, executed, in the ninth century, that *Last Judgment* which converted Bogoris, king of the Bulgarians.[3] The priests had collected, at the College of Orthodoxy, the finest library in the world, and all the master-pieces of antiquity: here, in particular, was to be seen the Venus of Praxiteles,[4] which proves, at least, that the founders of the catholic

1. *Second Council of Nicaea,* act. XL.—Ed.
2. St. Basil, hom[ily no.] 20.
3. Shoberl here cites Louis Maimbourg, *Histoire de l'héresie des Iconoclastes,* 2 vols. (Paris, 1683).—Ed.
4. Shoberl again cites Louis Maimbourg's *Histoire.*—Ed.

worship were neither *barbarians* without taste, *bigoted monks,* nor the votaries of *absurd superstition.*

This college was demolished by the iconoclast emperors.[5] The professors were burnt, and it was at the risk of their lives that some christians saved the dragon's skin, one hundred and twenty feet long, on which the works of Homer were written in letters of gold. The pictures belonging to the churches were consigned to the flames. Stupid and furious bigots, nearly resembling the puritans of Cromwell's time, hacked to pieces with their sabres the admirable mosaic works in the church of the Virgin Mary at Constantinople, and in the palace of Blaquernae. To such a height was this persecution carried, as to involve the painters themselves: they were forbidden, upon pain of death, to prosecute their profession. Lazarus, a *monk,* had the courage to become a martyr to his art. In vain Theophilus caused his hands to be burned, to prevent him from holding the pencil. This illustrious friar, concealed in the vault of St. John Baptist, painted with his mutilated fingers the great saint whose protection he sought;[6] worthy, undoubtedly, of becoming a patron of painters, and of being acknowledged by that sublime family which the breath of the spirit exalted above the rest of mankind.

Under the empire of the Goths and Lombards, christianity continued to lend her assisting hand to talents. These efforts are particularly remarkable in the churches erected by Theodoric, Luitprand, and Desiderius. The same spirit of religion actuated Charlemagne; and the church of the Apostles erected by that great prince of Florence is, even at the present day, accounted a superb structure.[7]

At length, about the thirteenth century, the christian religion, after encountering a thousand obstacles, brought back the choir of Muses in triumph to the earth. Every thing was done for the churches, both by the patronage of the pontiffs and of religious princes. Bouchet, a Greek by birth, was the first architect, Nicolas the first sculptor, and Cimabue the first painter that recovered the antique style from the ruins of Rome and Greece. From that time the arts were raised by different hands and different geniuses to the pitch of excellence which they attained in the great age of Leo X., when Raphael and Michael Angelo burst forth like resplendent luminaries.[8]

5. The *Iconoclastae* were the breakers of images, and the church of Rome gave this name to all who rejected the worship of images. Contests continued in the church upon this subject from the eighth to the sixteenth century, when the protestants abolished such an idolatrous practice in the reformed churches.

6. Shoberl again cites Louis Maimbourg's *Histoire.* See Giorgio Vasari, *The Lives of the Most Excellent Painters, Sculptors, and Architects,* 1568, introduction.—Ed.

7. Although the Church of the Holy Apostles in Florence was traditionally traced to Charlemagne, the early structure dates from the eleventh century.—Ed.

8. "But see each Muse, in Leo's golden days,
 Starts from her trance, and trims her wither'd bays;

The reader is aware that our subject does not require us to give a technical history of the art. All that we undertake to shew is in what respect christianity is more favourable to painting than any other religion. Now it is an easy task to prove three things: 1stly, that the christian religion, being of a spiritual and mystic nature, furnishes the painter with the *beautiful ideal* more perfect and more divine than that which arises from a material worship; 2dly, that, correcting the deformity of the passions, or powerfully counteracting them, it gives a more sublime expression to the human countenance, and more clearly displays the soul in the muscles and conformation of the body; 3dly, and lastly, that it has furnished the arts with subjects more beautiful, more rich, more dramatic, more pathetic, than those of mythology.

The first two propositions have been amply discussed in our examination of poetry; we shall, therefore, confine our attention to the third only.

CHAPTER IV. OF THE SUBJECTS OF PICTURES

Fundamental truths.

1stly. The subjects of antiquity continue at the disposal of modern painters; the same is the case with the mythological scenes, and they have the christian subjects in addition.

2dly. A circumstance which shows that christianity has a more powerful influence over genius than fable is, that our great masters, in general, have been more successful in sacred than in profane subjects.

3dly. The modern styles of dress are ill adapted to the arts of imitation; but the catholic worship has furnished painting with costumes equally dignified with those of antiquity.[9]

Pausanias, Pliny, and Plutarch,[10] have preserved the description of the pictures of the Greek school. Zeuxis took for the subjects of his three principal

> Rome's ancient Genius o'er its ruins spread, •
> Shakes off the dust, and rears his ruin'd head.
> Then Sculpture and her sister arts revive,
> Stones leap'd to form, and rocks began to live,
> With sweeter notes each rival temple rung—
> A Raphael painted, and a Vida sung."

9. These costumes of the fathers and the first christians (which have been transmitted to our clergy) are no other than the robe of the ancient Greek philosophers denominated περιβόλαιον, or *pallium*. It was even a cause of persecution for the believers; for when the Romans or the Jews perceived them thus attired, they would exclaim, Ο Γραικός σπινετης, *O Greek impostor!* (*Jerom. ep.* 10. *ad Furiam.*) Consult Kortholt. *de Morib. Christ. cap. iii, p.* 23; and Bar. an. lvi. n. 11. Tertullian has written a work expressly on this subject *(de Pallio).* [Chateaubriand's errors in citing and interpreting the Greek texts have not been corrected.]

10. Shoberl here cites Pausanius, *Periegesis of Greece,* book 5; Pliny the Elder, *Historia Naturalis,* book 35, chaps. 8 and 9.; and Plutarch, *Parallel Lives,* the lives of Pompey, Lucullus, etc.—Ed.

productions, Penelope, Helen, and Cupid; Polygnotus had depicted on the walls of the temple of Delphi, the sacking of Troy and the descent of Ulysses into hell; Euphranor painted the twelve gods, Theseus giving laws, and the battles of Leuctra and Mantinea; Apelles drew Venus Anadyomene with the features of Campaspe; Aetion represented the nuptials of Alexander and Roxana, and Timantes delineated the sacrifice of Iphigenia.

Compare these subjects with the christian subjects, and you will perceive their inferiority. The sacrifice of Isaac, for example, is equally affecting, and in a more simple style than that of Iphigenia: here are no soldiers, no groups of people, none of that bustle which serves to draw off the attention from the principal action. Here is the solitary summit of a mountain, a patriarch who numbers a century of years, a knife raised over an only son, and the hand of God arresting the paternal arm. The histories of the Old Testament are full of such pictures, and it is well known how highly favourable to the pencil are the patriarchal manners, the costumes of the East, and the grandeur of the animals, and of the deserts of Asia.

The New Testament changes the genius of painting. Without taking away any of its sublimity, it imparts to it a higher degree of tenderness. Who has not a hundred times admired the *Nativities,* the *Virgins and Child,* the *Flights in the Desert,* the *Crownings with Thorns,* the *Sacraments,* the *Missions of the Apostles,* the *Taking down from the Cross,* the *Women at the holy Sepulchre?* Can bacchanals, festivals of Venus, rapes, metamorphoses, affect the heart like the pictures taken from the Scripture? Christianity every where holds forth virtue and misfortune to our view, and polytheism is a system of crimes and prosperity. As for our religion, it is our own history; it is for us that so many tragic spectacles have been given to the world: we are parties in the scenes which the pencil exhibits to our view. A Greek, most assuredly, felt no kind of interest in the picture of a demi-god, who cared not whether he was happy or miserable; but the most moral and the most impressive harmonies pervade the christian subjects. Be for ever glorified, O religion of Jesus Christ, who hast represented, in the Louvre, the *Crucifixion of the King of Kings,* the *Last Judgment* on the ceiling of our court of justice, a *Resurrection* at the public hospital, and the *Birth of our Saviour* in the habitation of those orphans who are forsaken both by father and mother!

We may here observe respecting the subjects of pictures, what we have done elsewhere concerning the subjects of poems: christianity has created a dramatic department in painting far superior to that of mythology. It is religion also that has given us a Claude Loraine, as it has furnished us with a Delille and a St. Lambert.[11] But what need is there of so many arguments: step into the gal-

11. The Abbé Jacques Delille (1738–1813) and Marquis Jean François de Saint-Lambert (1716–1808) were philosophical poets.—Ed.

lery of the Louvre, and then assert, if you can, that the spirit of christianity is not favourable to the fine arts.[12]

CHAPTER VIII. OF GOTHIC CHURCHES

Every thing ought to be put in its proper place. This is a truth become trite by repetition, but without its due observance, there can be nothing perfect. The Greeks would not have been better pleased with an Egyptian temple at Athens, than the Egyptians to have a Greek temple at Memphis. These two monuments, by changing places, would have lost their principal beauty, that is to say, their relations with the institutions and habits of the people. This reflection is equally applicable to the monuments of christianity. It is even curious to remark that in this infidel age, the poets and novelists, by a natural return towards the manners of our ancestors, are fond of introducing dungeons, spectres, castles, and Gothic churches into their fictions; such charms are there in recollections, associated with religion, and the history of our country!

In vain would you build Grecian temples ever so elegant and well lighted, for the purpose of assembling the *good people* of St. Louis and Queen Blanche, and making them adore a *metaphysical God;* still they would regret those *Nôtre Dames* of Rheims and Paris, those venerable cathedrals, overgrown with moss, full of generations of the dead and the ashes of their forefathers; still would they regret the tombs of those heroes the Montmorencys on which they loved to kneel during mass: to say nothing of the sacred fonts to which they were carried at their birth. The reason is, that all these things are essentially interwoven with their manners, that a monument is not venerable, unless a long history of the past be, as it were, inscribed beneath its vaulted canopy, black with age. For this reason also, there is nothing marvellous in a temple, whose erection we have witnessed, whose echoes and whose domes were formed before our faces. God is the eternal law; his origin, and whatever is attached to him, ought to be enveloped in the night of time.

You could not enter a Gothic church without feeling a kind of awe and a

12. As it may not be very easy for an Englishman to satisfy his curiosity by "stepping into the gallery of the Louvre" at present, he may content himself with confirming the justness of the observation by viewing the admirable pictures in his own country. Let him repair to the Marquis of Stafford's and Mr. Angerstein's in London; to the University of Oxford; to the Duke of Marlborough's, at Blenheim; to Lord Carlisle's, at Castle Howard, &c., &c., and then determine whether the Woman taken in Adultery, by Rembrandt; Christ bearing his Cross, in the chapel of Magdalen College, Oxford; the Madonna, by Carlo Dolci, and the Magdalen by Carlo Marat, the Death of St. Jerom[e] by Dominichino, and the Marys by H. Caracci are not superior in every excellence of the art of painting, particularly for effect, and the representation of the *beau ideal,* to all the heathen gods and goddesses, fauns, satyrs, and bacchanals, that Guido, Titian, or Rubens, ever painted.

vague sentiment of the divinity. You were all at once carried back to those times when a fraternity of cenobites, after having meditated in the woods of their monasteries, met to prostrate themselves before the altar, and to chant the praises of the Lord, amid the tranquillity and the silence of the night. Ancient France seemed to revive altogether; you beheld all those singular costumes, all that nation so different from what it is at present; you were reminded of its revolutions, its productions, and its arts. The more remote were these times, the more magical they appeared, the more they inspired ideas which always end with a reflection on the nothingness of man and the rapidity of life.

The Gothic style, notwithstanding its barbarous proportions, possesses a beauty peculiar to itself.[13]

The forests were the first temples of the divinity, and in them men acquired the first idea of architecture. This art must, therefore, have varied according to climates. The Greeks turned the elegant Corinthian column, with its capital of foliage, after the model of the palm-tree.[14] The enormous pillars of the ancient Egyptian style represent the massive sycamore, the oriental fig, the banana, and most of the gigantic trees of Africa and Asia.

The forests of Gaul were, in their turn, introduced into the temples of our ancestors, and those celebrated woods of oaks thus maintained their sacred character. Those ceilings sculptured into foliage of different kinds, those buttresses which prop the walls and terminate abruptly like the broken trunks of trees, the coolness of the vaults, the darkness of the sanctuary, the dim twilight of the ailes, the chapels resembling grottoes, the secret passages, the low doorways, in a word, every thing in a Gothic church reminds you of the labyrinths of a wood, every thing excites a feeling of religious awe, of mystery, and of the divinity.

The steeple, or the two lofty towers erected at the entrance of the edifice, overtop the elms and yew-trees of the church-yard, and produce the most picturesque effect on the azure of heaven. Sometimes their twin heads are illumined by the first rays of dawn; at others they appear crowned with a capital of clouds, or magnified in a foggy atmosphere. The birds themselves seem to make a mistake in regard to them, and to adopt them for the trees of the forest; they hover over their summits, and perch upon their pinnacles. But hark! con-

13. Gothic architecture, as well as the sculpture in the same style is conjectured to have been borrowed by us of the Arabs. Its affinity to the monuments of Egypt, would rather lead us to imagine, that it was transmitted to us by the first christians of the East; but it is still more congenial with our sentiments, to refer its origin to nature.

14. Vitruvius gives a different account of the invention of the Corinthian capital; but this does not confute the general principle, that architecture originated in the woods. We are only astonished that there should not be more variety in the column, after the varieties of trees. We have a conception, for example, of a column that might be termed *Palmist,* and be a natural representation of the palm-tree. An orb of foliage slightly bowed and sculptured on the top of a light shaft of marble, would, in our opinion, produce a very pleasing effect in a portico.

fused noises suddenly issue from the top of these towers, and scare away the affrighted birds. The christian architect, not content with building forests, has been desirous to retain their murmurs; and, by means of the organ and of bells, he has attached to the Gothic temple the very winds, and the thunders that roll in the recesses of the woods. Past ages, conjured up by these religious sounds, raise their venerable voices from the bosom of the stones, and sigh in every corner of the vast cathedral. The sanctuary re-echoes like the cavern of the ancient Sibyl; loud-tongued bells swing over your head, while the vaults of death under your feet are profoundly silent.

FRIEDRICH OVERBECK

Diaries and Letters (1811, 1814)

In 1809 a group of young painters who had been studying at the
Vienna Academy of Fine Arts became dissatisfied with the coldness of aca-
demic instruction. Impressed by ideas such as those of Wackenroder, they de-
cided to form an association that would express their aims in art and afford to
each other a kind of mutual encouragement. The leaders of this organization
were Friedrich Overbeck (1789–1869) and Franz Pforr (1788–1812). In honor
of Saint Luke, the patron of painters who had himself reportedly executed a
portrait of the Virgin, the "brotherhood" elected to call itself the *Heiliger
Lukasbund* (Society of Saint Luke). This choice of name, however, did not im-
ply emulation of the Academy of Saint Luke in Rome; the *Lukasbund* envi-
sioned no similar fixed program for art, no director, and no actual school.
Rather, the group sought to project the image of a communal, monkish society
in which all served as brothers. For an emblem, the *Lukasbund* created a wood-
cut in the style of Dürer, depicting Saint Luke illuminating a manuscript in his
study, with the legendary portrait of the Virgin at his side. In the border were
inscribed the initials of the original adherents: Hottinger, Wintergerst, Pforr,
Overbeck, Vogel, and Sutter.

In 1810 a nucleus of group members set up headquarters in Rome with the
permission of the occupying French army. Residing at the former monastery of
San Isidro, they affected simple dress and let their hair grow long, which even-
tually led them to be dubbed the "Nazarenes." Wackenroder's image of Raphael
and Dürer standing hand in hand, a union of German and Italian ideality,
greatly appealed to them. Devoting themselves to the intensive study of nature
and fifteenth-century art, the *Lukasbund* rapidly became known throughout
Rome.

In 1815 the Prussian consul at Rome, Bartholdy, commissioned the group to
execute frescoes for his residence on the Via Gregoriana, not far from the mon-
astery. In this first serious opportunity to revive the craft of fifteenth-century
Italian mural painting, the Nazarenes were joined by Peter Cornelius (1783–
1867), who had been made a brother of the order after his arrival in Rome in
1811. Artists and potential patrons alike were impressed by the Casa Bartholdy

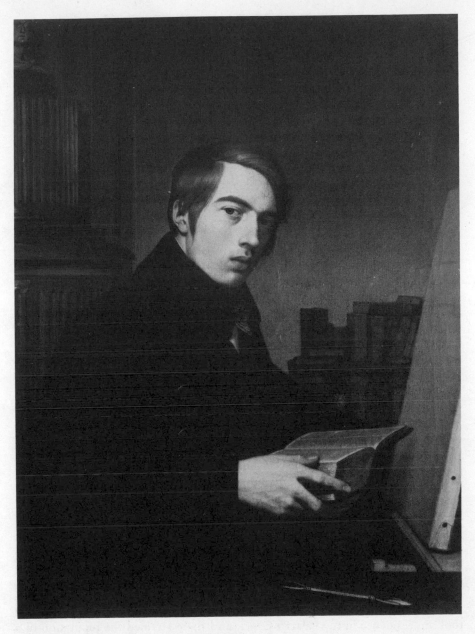

Friedrich Overbeck, *Self-Portrait with Bible*, 1809, oil on canvas.

Friedrich Overbeck, *Device of the Lukasbund,* 1809, drawing.

frescoes, as well as by a later never-completed series in the Casino Massimo. In 1819 Ludwig I of Bavaria, who had enjoyed mingling with the artists in Rome, established Cornelius at Munich, initiating both a revival of fresco painting in Germany and a restructuring of German art education according to Nazarene ideals. Academies established in Düsseldorf, Munich, and Berlin emphasized the practice of apprenticeship under a master combined with rigorous training in drawing from nature. During the second quarter of the century, these academies drew students from throughout the world.

While Cornelius was occupied with fresco commissions and the reorganization of art instruction in the North, Overbeck remained quietly in Rome. He took up residence in the Palazzo Cenci, and there attained the reputation of a saintly figure to whom artists and patrons flocked. Declining an academic post in Germany, Overbeck continued to reside in Rome throughout the remainder

of his life. His journals and letters reflect a continuing belief in the importance of intensive study of nature for the production of expressive works of art. The following extracts were translated and annotated by Michael Snideman from Margaret Howitt, *Friedrich Overbeck: Sein Leben und Schaffen*, 2 vols. (Bern: Herbert Lang, 1971), 1:173–74 and 332–39. 🗡

ON PORTRAIT PAINTING

[From Overbeck's diary, Rome, September 11, 1811]

A painter ought not to desist from the uninterrupted study of nature or miss any opportunity to paint portraits with great care according to nature, especially those of distinguished faces. And he ought to investigate how the facial features of a certain character are in keeping with each other, in order to apply such observations to his own devices so that he will not fall into the error of many painters in our time, that of joining a nose and a mouth or a forehead and a nose of quite contradictory character. In portrait painting the ultimate purpose should be to grasp correctly the character of the person who is to be represented and to imitate it with the greatest possible fidelity. In attaining this, clothing and even the simplest background can also contribute to the effect. Thus, for example, a melancholy character is shown far more tellingly against a gloomy, black background than against a light or brightly colored background; a serious but cheerful character best against a background lighter than the facial color; an energetic, joyful one against a colorful background such as a bright carpet; and so forth. In order to express the tenderness and weakness of their sex, one always renders feminine faces best by painting very soft shadows so that the background appears darker than the shadows of the flesh color. Yet heroic women constitute an exception, in relinquishing the tenderness of their sex and acquiring masculine strength.

LETTER TO SUTTER, ROME, SEPTEMBER 1, 1814

May I succeed in stimulating and encouraging you anew through a truthful description of the progress our good cause is making in this place. Yes, truly one can say without exaggeration or self-deception and with fullest confidence that a better time is already emerging and the really good time certainly no longer so distant. When I came to Rome something over four years ago, the German artists were accustomed to gathering almost every evening to betake themselves together to some wineshop or other. Without bringing to mind

that what took place was usually not very dignified, there was also a common understanding that art would not be discussed, partly in order to prevent quarrels and partly because they thought that after an entire day of being vexed by something so wearisome as art they might in good conscience unburden themselves a bit in the evening. How entirely different, Gottlob, is the prospect now! At that time they generally held it very much against us that we did not participate in such revels but, rather, stayed calmly in our monks' cells to woo, in sweet solitude, Art as our beloved betrothed. We bore that and had to bear it. Yet, behold, already we see fruits ripening from the best seed we scattered in silence. In place of those drinking bouts have arisen general conferences of German artists in which what can be done for the betterment of art is deliberated in the most dignified and edifying manner, with common vitality and zeal as well as complete accord and unity. Oh, that you, my dear brother, could attend a session like the one we held last evening!

Its purpose was to ratify a petition that Platner had written in the name of all German artists. This petition, which will be conveyed to Prince Metternich for the impending congress in Vienna by von Lebzeltern, the Austrian minister here, demonstrates that the academies have operated in a manner not advantageous but, rather, detrimental to the advancement of art, and it urges the German princes to reappropriate for the production of artworks the large sums of money that are so uselessly squandered on the academies. Two additional copies of the document will be sent at the same time to the crown prince of Bavaria and to the Prussian minister, Prince von Hardenberg, so that the matter will be viewed as one of common German concern.[1] This alone suffices to give you proof that we are not idle here and to indicate what sort of spirit has quickened generally among Germans.

This leads me to our narrower society of artists, and it is necessary that I tell you quite candidly about it. For a long time now several new friends and zealous defenders of the good cause have participated in our weekly meetings, which have resumed with proper ardor. First, since I spoke of him above, I shall mention Platner, a man who, because of a lack of talent by his own candid admission, will probably never attain greatness through his paintings, no matter how unmistakably good his strivings are, but who is very important to us because of another talent, that of literary presentation, which he has already proven in several excellent articles governed by the purest taste and the truest conception of art. He who intends to erect a building needs not only skilled people from a single craft, but all kinds of workers: masons and carpenters, stonecutters and locksmiths, each of them needed for his capacity to contribute to the single purpose. Thus we too must not believe that industrious men

1. The German states did not take the matter into consideration. —M.S.

equipped with talents quite different from our own are dispensable; we must, rather, unite all elements in the service of our great purpose. Moreover, Platner is a highly estimable human being of the noblest principles, diligent in all his activities, a man from the old honorable breed with extraordinary zeal for what is good.

Further, I shall mention Schadow's older brother, a sculptor who has gradually become acquainted with our principles and is now an adherent of them.[2] Not long ago he completed a statue in marble which afforded us all such extraordinary joy that we were in agreement about not having seen anything so striking and genuine among new works in this medium.[3] He too is doubtless a worthy participant in our gatherings. Aside from him, two other sculptors participate. One of them is your countryman and acquaintance Schaller,[4] a man who has become very dear to all of us because of his serious, dignified mind. He has perhaps not yet achieved for art what is required, as much as his works finished here are full of merit; but he purifies himself more and more through his striving. He recognizes and wants what is good and is therefore welcomed to us. Last of all, I mention the sculptor Eberhard, although I should like most to say something about him. I call him a sculptor because it is in this medium that he was trained, although I do not value his sculptural works highly in comparison with what he has done recently in painting. For approximately a year this already more than forty-year-old man has revealed a talent of such an outstanding kind that it has amazed and shamed all of us practiced painters. . . .[5]

These dignified artists have been participating in our weekly meetings now for a long time and are to be regarded as our brothers, even though they have not yet received our official letter of acceptance. For the essential, namely, their principles and true zeal for the good, is what renders them our brothers and comrades, not those external and inessential matters that we add as of mere formal concern. With regard to the latter, experience has taught us, by the way, that several of our original regulations are not applicable on a permanent basis. If it is our sole concern to effect what is good and to further what is true, then we must not insist obstinately on things that are of no importance. Thus, for example, we found at the very outset of our sojourn in Rome that the stipulated method of bestowing the stamp of Saint Luke on our pictures would result in great difficulties, and we soon let it drop. Quite different is the missive of the

2. Rudolf Schadow, born 1786 in Rome, where his father then was living. He died in Rome in 1822.—M.S.
3. Probably the "Sandal-girder," which established Schadow's reputation.—M.S.
4. Johann Nepomuk Schaller (1777–1842) lived in Rome as an Austrian pensioner from 1812 to 1822.—M.S.
5. In his letter to Vogel of November 10, 1813, Overbeck praises Eberhard's paintings of the Holy Family as "very simple and grand."—M.S.

order; as a nice tie with distant league-brothers, both known and unknown, this practice must, I believe, be steadfastly retained. I wish your assent to the unqualified admission of the new league-comrades. . . .

As for me, the situation is still that I am to do much work but to exist meagerly, by fault of the queen, who, unacquainted with the circumstances of a poor painter living from the work of his hands, still leaves me waiting for my recompense. My present works are the picture for Vogel's father that depicts Christ with Martha and Mary, a Blessed Virgin for a Herr Dall'Armi in Munich, and an Adoration of the Shepherds for Herr Honegger in Switzerland. The first already has its underpainting; the second is currently at hand, and as soon as I have done its underpainting I will finish painting the first and then go on to do the underpainting of the third, which is only sketched as of now. A fourth picture, a little Holy Family, was recently commissioned from Munich through Professor Langer, but I do not know whether my terms will be found acceptable. My last-finished work is a drawing executed for our brother Schadow, who intends to send it to his father in Berlin. It presents a Burial of Christ and is, as I believe and as those who have seen it confirm, one of my most successful works. . . . But, in any case, to put something from my present work before you, I send the following impression of a small engraving from the first attempts that I have made in this medium; in consideration of which you will want to view it with special tolerance. I attempted it when urged to personally engrave drawings for one of my proposed works, and since I found in these trials that the matter is not as difficult as is usually thought, I have it in mind to pursue this challenge over the course of time. So much about me and my doings. . . .

It is to be hoped that you will soon learn more extensively about what the Germans in Rome are achieving, because we intend to organize a grand exhibition for all Germans. . . . Then you will see to your great reassurance that we have developing here a circle of men who in days to come will accomplish many beautiful works for their fatherland and will proclaim for dissemination to all places in all lands the joyous message of new, rejuvenated, genuine Art. . . . May you be filled even more with proud joy upon bearing in mind that you helped to lay the ground for a magnificent edifice in which—may God grant it—even the hearts and minds of distant posterity will take delight. Think, my dear fellow, of what you projected to all of us and of what your example, your firmness, your zeal, your pure, noble striving will be for us constantly! Be reassured by this, as well you may, and hope with confidence that the Lord will let another joyful day rise for you too. Behold, all of us, and especially I, exist wretchedly and very often feel our wings bound by oppressive poverty. Yet what is it that lifts us powerfully above all pressure and bursts the fetters and bonds? The hope for, the trust in the silent but sure path of truth

and mutual stimulation. . . . Along with many others who wish him well and honor his talent, I greatly look forward to Koch's return to Rome. I hope you will not let him journey to me without a few lines; how much must he have to tell me of you and your works! Oh, that you could come with him! Well, the time for that will also come; we do not intend to abandon this splendid hope. Until then, let these dead lines be the kiss and handshake and embrace that your faithful brother Overbeck sends to you in spirit.

ADOLPHE THIERS

On Naïveté in the Arts (1822)

Marie-Joseph-Louis-Adolphe Thiers (1797–1877) is better remembered for his political career than for his writings on art. Trained as a lawyer, he early became interested in history as well as current political events and began to publish critical essays in the early 1820s. In 1823 the first two volumes of his monumental *Histoire de la Révolution* appeared, a work that eventually extended to ten volumes. Two decades later Thiers published a sequel, *Histoire du Consulat et de l'Empire*.

Thiers began his long and active political career in 1830 when he entered the House of Deputies. Subsequently, he served as minister of foreign affairs, president of the Cabinet, and, from 1871 to 1873, as head of the provisional government.

Thiers's writings on art include critical essays on two Salons, those of 1822 and 1824. As this brief excerpt from the 1822 review suggests, he was quite willing to accept new viewpoints in art—attitudes often inconsistent with the theories of those dominating official taste. His sympathetic reception of Delacroix's work in 1824 (the year that the artist exhibited the *Massacre at Chios*) also revealed Thiers's flexibility as a young man to accept the new. Unhappily, it was while Thiers was heading the provisional government in 1873 that Gustave Courbet was held as responsible for the destruction of the Vendôme Column, a fact more often remembered than Thiers's sensitive early art criticism. Thiers bequeathed his extensive art collection to the Louvre, where it was catalogued by Charles Blanc.

Thiers's review of the 1822 Salon was first published in *Le Constitutionnel*. The present translation was made from *Salon de mil huit cent vingt-deux* (Paris: Librairie Maradan, 1822), pp. 70–73. ✑

It is usual at a mature age to mourn for one's childhood. We at the present, an old and civilized people, love to go back to those times when men cultivated their fields with their hands and were nourished by milk from their herds; when young girls went together to draw water from the same fountain and wash their light garments. There is for us an infinite charm attached to all that

nature leads us to do spontaneously. It is doubtless this that moves us to think and to give purpose to all our motions. But nothing charms us in that which is carefully thought out. Either prudence forces us to calculate our actions—and prudence is useful but not pleasing—or vanity reminds us that we are being watched, and vanity is ridiculous. Watch a lovely woman; what grace in her spontaneous motions inspired by a lively humor! Then she realizes that someone is watching; she studies her bearing and begins consciously to control herself. And that is that: calculation has cast out the graces.

Among the early peoples, there being no distinction of classes, all customs are the same, all concerns of life are equally noble. The poet who depicts these manners has no need to choose. He is diffuse because the spirit is not yet forced or satiated. If he suffers, if he loves, he says so naively, and every word has its value in the heart of truth. Such is the poetry of earlier times. Without calculation, without art, the poets tell of their life just as it is; everything is noble because there is nothing to hide; everything is moving because all is real; it costs little effort for they neither combine nor choose. They tell about what is, and in poetry as in the sciences, the neatly and simply rendered fact is full of truth and charm. Also, the poetry of all the earliest peoples looks the same—in the north or south, in ancient and more recent ages—so long as people are beginning they are the same. Homer, Ossian, the patriarchs have the same poetic sense, that is, they have none at all. They sing the way a bird flies or a child plays, the way all nature works: by instinct and by need.

We, a people filled with thoughts and cares, divided into great and small, wise and ignorant, endlessly observers and observed, we are forced to hide ourselves beneath general and conventional forms. And when we would seize upon and paint this nature, we must search for it with difficulty in souvenirs of the past; in our children, in whom it is still alive, not yet snuffed out; in the ignorant classes who have not yet learned to disguise it. We must incessantly spy it out to seize upon it wherever it reveals itself. Among us one must have genius to be natural and simple like those who never dreamed of being so. Today a poet is a drudge, while in the earliest ages he was just a man more lively, more spontaneous, and more given to speech than his contemporaries.

When a direction first takes form in a people and they begin to cultivate an art, there are at the outset movements of a kind we call naive. Thus when the arts were reawakened in Italy, when literature developed in France, there reappeared the simplicity, abandon, and naturalness of earliest times.

The naïveté of the Italian painters was an awkward mixture because reflection and abandon cannot be maintained at the same time. But the art later matured and became more skillful, though less naive. In the masters of the new school one sees the ideal and the true united; but all they were able to do was to unite naturalness with the reason of maturity. One must not regret that which can no longer exist: we cannot be at once children and men. However, some

fortunate geniuses retain some traits of this first age. La Fontaine wrote as in the earliest epoch of the world; and today the painter Hersent unites a naive simplicity with the most carefully considered taste.[1] He has chosen his last subject from the Bible, and nowhere else could he find a theme more suited to his talents. . . .

1. Louis Hersent (1777–1860), a student of Regnault, specialized in historical pieces, which he exhibited with great success at the Paris Salon from 1802 until about 1830.—Ed.

TOMMASO MINARDI

On the Essential Quality of Italian Painting from Its Renaissance to the Period of Its Perfection (1834)

By the close of the eighteenth century, the movements opposing the rational academic system and the concept of a uniform style of the beautiful had become so general that it is difficult to trace statements and tendencies to one particular source. All pronouncements placed inspiration above the formal language gleaned from tradition, all emphasized the direct relationship between the individual and nature, and all looked back with favor on the centuries of art preceding those most praised by critics who believed in formal virtues.

By 1806 Tommaso Minardi (1787–1871), a young painter from Faenza and a protégé of the sculptor Antonio Canova (1757–1822), was turning his attention in the direction of the spiritual opposition. In a moody self-portrait, which showed him pensive in a barren attic, he saw himself as having achieved the strange, clear atmosphere of a fifteenth-century Flemish painting. Like the German painter Friedrich Overbeck, Minardi devoted himself to drawing more than to painting, and in order to discipline his expression he went for several years without touching a brush. Although his works are rather more lyrical in form than those of the German painters, they show the same clear reference to Umbrian painting of the fifteenth century.

Through the intervention of Canova, Minardi became head of the Perugia Academy in 1818, a post that, except for a brief interval, was maintained for many years by one of his followers. In 1825 he was recalled at the insistence of his students to resume teaching at the Academy of Saint Luke in Rome; though his methods were opposed by those members who were proponents of a classical style, they were eager for his severely disciplined instruction. He insisted that his students work meticulously from nature, and placed more emphasis on individual moral values and personal development than on the acquisition of style. Overbeck became a good friend, and the two became the arbiters of Christian art in Rome throughout the second quarter of the century.

Tommaso Minardi, *Self-Portrait*, 1806, oil on canvas.

In the 1830s and early 1840s the divergent tendencies in art created increasingly intense critical partisanship. An artist was convinced that he could not simply paint but had to belong to one declared tendency or another. On Ingres's return to France in 1824 with his *Vow of Louis XIII*, painted in Florence, he became not the spokesman for the classical academy but a unifying figure

for many who held ideas not far from those of Overbeck and Minardi. Ingres served as director of the French Academy in Rome from 1834 to 1841, and under his tutelage the pensioners turned to perfectly finished, somewhat senti- mental religious paintings. During Ingres's tenure the battle between classicists and their antagonists raged rather fiercely. In the 1830s the term *Purism* was introduced to characterize the point of view of painters like Minardi, and in 1842, in answer to an attack by a painter who believed in the classical tradition, a public manifesto of Purism was signed by Minardi, the sculptor Tenerani, and the writer and painter Antonio Bianchini, who took credit for first applying the term to art. The manifesto reiterated three key points: one must work di- rectly from nature to find those forms that identify themselves in the intuition with expressive qualities; one studies not Raphael, but as Raphael studied; one must avoid all manner, grand or otherwise, in order to render both a moral and a visual truth.

Most young artists from various countries who were working in Rome in the 1830s were persuaded by these ideas and spread the gospel abroad. In En- gland it had its effect through Sir Charles Eastlake and William Dyce; in Mex- ico the Academia de San Carlos, founded in 1785, was reformed in 1846 by a pupil of Minardi, Pelegrin Clavé, and a pupil of Tenerani, Manuel Vilar; in Bar- celona, the native city of Clavé and Vilar, a self-conscious group of Purists con- tinued to work and set forth their ideas; certainly the painting of Hippolyte Flandrin, a pupil of Ingres, shows the marks of the Roman school, as do the many murals painted in Parisian churches throughout these years. Although these artists protested against style as such, there gradually developed an inter- national Purist style (often called the Christian style) that was a chaste mixture of intensive observation and fifteenth-century manner, be it German, Flemish, or Italian.

The Pre-Raphaelite Brotherhood, founded in London in 1848 by Holman Hunt, John Everett Millais, Dante Gabriel Rossetti, and their associates, was one of the last organizations founded on Purist principles. For this group, the writings of John Ruskin were of great importance. Of course, their insistence on nature and morality fell into quite a different historical context than that of their Italian predecessors. Nonetheless, their tenets were much the same, even to Holman Hunt's placing greater emphasis on the process of creation and on moral life than on the total effect of a painting.

Minardi's lecture in 1834 to the Academy of Saint Luke, the stronghold in Rome of conservative formal doctrine, must be looked upon as a courageous statement. It was addressed to a group that already felt threatened by changes in artistic principles. To be sure, Minardi was careful not to sound polemical, and yet gradually the significance of his premises emerges with convincing clarity. To be able to declare finally to such an audience that Giotto was as great a painter as Raphael, and not simply because he provided a foundation for later

painting, required a kind of reasoning about art not to be found in the academic tradition. [Minardi's theory of history, equally noteworthy, is discussed in the headnotes to the selection of A. F. Rio.]

The text of Minardi's discourse is translated from *Scritti del cavaliere Prof. Tommaso Minardi sulla qualità essenziali della pittura italiana dal suo risorgimento fino alla sua decadenza, pubblicati per opera di Ernesto Ovidi* (Rome: Tip. Salviucci, 1864), pp. 1–41. ♠

If ever a speaker needed indulgent listeners, most eminent princes, most revered academicians, I do above all others, and I desire them and hope for them. For he who speaks in your presence today is no expert at public speaking and is almost incapable of thoughts worthy of public statement. If I had asked to speak to you or had taken it upon myself, I would justly be called presumptuous or perhaps be pitied as one of unsound mind; but this has been imposed upon me by those whose will is law to me, and so, having thus been compelled, I must be forgiven. On the other hand, if I recognize those before me as persons most famous for lofty talent, I recognize as well the flower of courtesy, and I judge that you will listen graciously to him who, not out of desire for applause but only from obedience, offers you a few unadorned phrases.

But what can I say that befits this solemn occasion, which, after patient hopes and with many good wishes from all of Rome, sees gathered today under one roof and squeezed in annual embrace both the fine arts and archaeology, loving sisters divided despite themselves for so long a time.

I confess to you that I had many doubts as to what material to choose, naturally not expecting to find anything that would be new to you but wishing at least not to bore you. And at last I thought of submitting to your judgment the complaints that I have been hearing from many artists and men of letters.

The former claim that one should not listen to those who write and speak about the beautiful, since it often happens that men who are trained only in speculation may judge the arts falsely, granting fame to mediocre or inferior things and decrying or ignoring the good. Thus history is falsified, pride and arrogance allowed to artists of no merit, and the best talents are degraded and left undeveloped. For youth is most eager for praise and capable not only of abandoning the right path if it sees it disdained, but even of entering the wrong one if it is highly commended.

The latter complain in like manner, in no less sonorous a voice, rather with writings that cannot be silenced. They say that the fine arts are slandered by many who, in applying themselves wholly to practical matters, feel only contempt for the sciences and those who cultivate them, and function without knowing the reasons for what they do. They say that history, that poetry of all

kinds can and must guide the artist to wise thinking and composing, in sculpture, painting, and architecture. From such discord both sides are seriously damaged: since there is no helpful exchange between them, they break up into new factions and prepare the way for even graver errors. There are some, for example, who firmly assert that the only masters are those of the fourteenth and fifteenth centuries; after them art is dead, and Raphael himself is worthless after his first, or at best his second, period. Others, smiling, consider all these painters very poor, and such opinions very miserable, saying that one should only look to the masters of the sixteenth century as those who possess all the beauties of art; and so, with the air of being sublime thinkers, they think only they are following the main road. Still others, laughing inwardly at the sublimity of sixteenth-century painters and more openly at the primitive masters as banal antiquities, greatly praise and imitate the works of the seventeenth century.

There are those who make even stranger judgments, and God grant that they may not make up the larger number, but certainly they are such that you know and recognize them without my reminding you of what they think and do.

The controversy is very serious and damaging; because of the mistaken judgments of men of letters, fools take to considering science itself as useless, and thus their ways are further confirmed in ignorance. Even worse, the public is confused by these disagreements, and can neither know nor separate true from false, the beautiful from the ugly; this is the worst of the evils. Now since only you, glorious in art, glorious in letters, can judge and resolve this quarrel, I beg you to consider if any of the above-mentioned be right, and in what way.

Even though I myself have given the matter much thought, I shall not be so bold as to give my decision in your presence. But since in order to arrive at a just idea of the means necessary to function in art and to judge them well, one must observe how art is born and what causes have hindered or encouraged it, I intend to speak to you only of this, and I shall limit myself strictly to my own art, as the only one of which I may speak without being openly accused of presumption. Receive benignly what I in my clumsy way can tell you of the nature and spontaneous growth of painting, and you can then give your mature judgment according to your wisdom, as only you can.

As everyone knows, visible objects form impressions in the mind of man, which, like images in a mirror, represent a real painting within him. As a result of the operating forces of his intellect, man always tries to put into action and express externally that which he feels most strongly within; thus he spontaneously produces the artifact of the painting according to his temperament. This does not, however, take place in all men but only in those gifted above others with highly refined sentiments. These internal impressions in man must be considered under two aspects (for they are in reality so): one has to do only

with the images of objects, as they are or as they represent themselves through their external beings; the other concerns the moral sense, which all objects possess more or less, in one way or another, relative to nature and to the condition of man. They therefore have two expressions, one material through the formal images of things they represent, the other spiritual or moral through the rapport they establish with man's feelings. The child senses and retains in his mind the image of his mother, with much the same clarity as the images of other similar women; but when the image of his mother is presented to him and his feelings respond to it, he does not react simply as he would to the material images of other women, no matter how similar. Rather, he feels ever more vividly the moral ties and sentiments that for him distinguish it incomparably from the others. And while he may feel indifference for all others, he is attracted to this one alone; this one excites him: he plays, then frets, and fears, and weeps. The moral expression, then, is necessarily that which interests the soul of man above all else, and which he feels above all, and by which, more than anything else, he is moved and set to action.

But we must go further. When man becomes an adult he feels for external objects ties and affections that are much more elevated than those a child feels for its mother; he becomes aware that external material objects generate totally spiritual relationships within him, which give rise to a new order of ideas, and he is elevated to a new kind of sentiment far different from and superior to that for mere physical objects. I speak of religious sentiments: these make him sublime, transporting him to enthusiasm; these become part of him and fuse with all that is visible and substantial, with the result that the material world without these sentiments becomes for him like a dead thing, insignificant, almost nothing.

If, therefore, the child had in some way the possibility of drawing images, the first would certainly be that of his mother shown in loving relationship to himself, and this first drawing would be the expression of his corresponding love; the Greeks did well to pretend that this art had its first origins in love. But in the adult man, religious ideas and sentiments are the most powerful and, mingling with the natural sentiments of love, elevate, as I said, his fantasy to enthusiasm. Therefore it is from these sentiments, more than from others, that painting will draw its greatest life, its greatest growth.

But what would that first drawing, that first painting of the child be like? Certainly it would be not only of a loving act, as I remarked, but in the most simple style and of the truest character. Simple, because the child, due to his natural condition, could never choose the more complicated of the loving actions known to him; of the truest character, because he takes it from truth itself, nor can he do otherwise. It would also be the most vividly expressive, since the less expressive, being felt less by him, could never by nature be

chosen. And this painting would naturally be of a perfect unity of composition. Since the child's soul, completely involved in the sentiment of the loving image, would feel only that which is strictly connected with the expression of the image itself, all accessory matter would simply remain unobserved. So there would be nothing superfluous, nothing useless.

If one might suppose this faculty in an adult, his painting for these reasons would necessarily be furnished with equal virtues, even more so in that the man is greater than the child. An exact analysis of this, perhaps not impossible, would give evidence of my assertion; but there is no time, and I must be as brief as possible.

I repeat, then, that for these reasons there would be in the painting of the adult (note that painting will always be primarily figured with human images, because man loves himself above all and before all), there would be, through natural necessity, maximum expression always united with the greatest simplicity and suitableness, unity of subject always proportioned to the subject itself, natural ingenuity in all because all is born spontaneously from the first impressions, from the first concept of pure nature.

It is true, and must here be stated, that this painting at its outset in regard to execution, or rather the artifice with which it is formed, can only be most imperfect, man in the beginning being ignorant of or through inexperience understanding almost nothing of the means for achieving his purpose. Since man distinguishes first of all in bodies their external geometric and essential forms and acquires more or less exact ideas of them in proportion to the excellence and efficacy of his own senses, and since he immediately joins to his awareness of the geometric and characteristic aspect of those forms the ideas that he develops concerning their modifications and movements analogous to their expressions, so the execution of this first painting will principally consist of a very simple natural representation of bodies in their general characteristic form, shaped by an ingenuous geometry. Marvelously enough, man is always led to *geometrize* in all things, even before understanding science. And not only will everything that he succeeds in doing unequivocally make its point, it will do so pleasurably because it is spontaneous and without convention. Indeed, the very ancient primitive monochrome paintings that have come down to us principally on the so-called Etruscan vases are simply geometrically expressed drawings and, characteristic of the first conceptions of human fantasy, are no less expressions of the soul's internal images most connected with its dominant affections, that is, those of religion, love, and war, made externally evident in the simplest way, both regarding the essential idea and the technique of execution. Thus it is that they still please us so much, please in fact all who have eyes to see, and form the object of our admiration and even our study.

But let us not linger too long on analysis but depend on the facts that alone

bring greater clarity. So that these may be limpid and free from uncertainty of research, I shall consider the facts of our reborn painting, reborn from the pure natural genius of our land.

Behold the first period of art arising luminously by virtue of several men of high intellect, principally the famous Giotto, most extraordinary of all, and his school. With what light is this time resplendent? With that light which is the very first in art, even the soul of art itself, that is, the true and just expression of human passions. The expression is not only extremely alive in its essential characteristics and most fitting but, even more, marvelously reduced to such unity and such maximum simplicity of form, that neither the Greeks first, nor Leonardo and Raphael afterward, exceeded it. He who does not see this in so many of the vast number of works of this first epoch is blind. I am speaking to those who see too clearly for me possibly to abstain from demonstrating this. If you will recall for a moment the references made earlier to how painting is born, you will readily note that from the very beginning this highest expression of the passions, reduced to the greatest simplicity and unity, excellently proportioned to its subject, always produced with ingenuous and characteristic means, for necessary natural reasons had to achieve this manifestation spontaneously and not by means of precepts. I shall even say more: this epoch and no other was that of sublime conceptions. If sublime conceptions are fathered only by men *of genius,* that is, of the highest sentiment, and if there were then such men, as in fact there were (and perhaps there always are, even if they are unproductive from the weight of an adverse destiny), these geniuses, painting, with their souls not distracted by any of the many things that art actively requires but having in mind only the expression of the passions, their sentiment, which was of the highest, was in the most favorable condition to give proof of its full force. Since the agitation of the passions in those sublime spirits who are all intent on them bursts forth into sublime concepts, these geniuses must have found themselves apt for this state above all else, and thus to produce their sublime works. He who does not wish to believe in my reasoning may go to Assisi, may go to Florence, may go where the works of Giotto and of that glorious period are, and will find there reason to be convinced, if he has a sound mind.

Those two otherwise respectable writers showed themselves very poor in understanding and discretion when, trying to demonstrate the power of expression in Giotto, they held forth on a certain thirsty man in the Assisi paintings, in the attitude of drinking from a stream, a thing which, even supposing that it held the beauties they imagined—which are not there at all—is really too small and simple when compared to so many other sublime inventions expressed there, of which they say not a word. And the greater glory of Giotto is often renewed through this drinking man, by the flock of sheeplike writers who make boast of their erudition by delivering pronouncements on the fine arts. What is more, I have heard certain artists repeat this foolish praise, and so

give proof that they know nothing of the famous man from Vespignano who so highly honors our Italy. In such a way do the half-educated keep babbling about Count Ugolino and Francesca da Rimini and know little or nothing of that wholly miraculous poem of the divine Dante.

From the very resurrection of the art of painting, then, the greater fundamental and regulatory principles of art itself were established in a marvelous way; invention and composition of subjects most interesting to the human heart, the most alive and suitable expression, the truest and most just characters and customs, and the whole simple and unified: in consequence, all moderated by the most fine economy, and proportioned to the place, the time, and the subjects themselves. In sum, everything that forms the essence of tragedy and epic is established.

At this point I imagine someone saying: you tell us what indicates perfection in painting, but who ever held the art of this time to be so great? To which I respond: I speak of facts obvious to all, not fantasies. And I add, this is still not all of the art of painting. Please: did I not say that this primitive painting, sublime in everything that makes up its concept, was still tied to the very imperfect technique of its execution? Genius takes flight and in one swoop reaches and passes the highest stars. But here the question is not that of getting off the ground: one needs rather the strength to descend. Impetus and velocity are impediments where it is more proper to remain still, to be slow and laborious. Execution in painting, its technique, is the product of long and patient experience, repeated attempts, and fortuitous happy combinations, that the genius reaches sooner than all others but reaches only when he slowly scrapes the earth, and then often has need of fortune's aid. If in all human works artifice is difficult, the artifice of painting is the most difficult of all. And this is worked out and demonstrated in the second period.

At this point it is well to say (as I have already told you and beg you to remember in what follows) that whatever beauty the first period succeeded in realizing in painting, it realized with such an ingenuous simplicity of forms profiled in an innocent geometry that they instantly expressed the essential character of the objects. This is the element: the most important quality of the execution and the most fecund seed of perfection. Then in the chiaroscuro there was another element already reduced to precept and deduced from such profound and hidden reasoning that it even escaped the notice of worthy masters in later times. This element and seed produced one of the fairest flowers of the most laborious part, the marvelous, the magic of execution, that is the effect of chiaroscuro, which later, dressed in fine colors, ended in bewitching, seducing, and charming entire schools, becoming their only idol. I speak of that element of chiaroscuro whose rule was then established, that every body containing secondary parts more or less prominent or hollowed out, as a result of full or dispersed minor lights and shadows, might keep these parts in very

delicate light and shadow, contrary to common vision, vibrating strongly only where the mentioned prominences or cavities indicated the forms and the essential articulations of the bodies themselves. I can never consider this rule without the greatest astonishment, because it seems that to discover it and raise it to precept there is needed not only extreme refinement of feeling but also at the same time, or even before, a profound and very difficult analysis of our way of seeing objects and how their images are modified in our fantasy, a method unknown in those times. But let us move quickly on to this second period.

This is noted, as I said, for being the epoch of the discovery and ordering of the part of art concerned with execution: dress, ornament, effects, in short, that which delights, surprises, and enchants the eye, and which alone frequently carries away and deceives the reckless (who are the majority).

This essential part, then, is discovered and composed: since to the moral and characteristic expression of beings found by man in the first period man himself added through greater observation a clearer and more precise idea of the physical appearance of those very beings, he is naturally driven to try to find, and in fact does find through repeated experiences, new physical means and new knowledge for representing them in painting. And because this progress in execution is born from man's fixing his attention principally on the material form of individuals and in studying the means of execution with intensity, it necessarily results that the soul is distracted from the moral expression of beings, and thus there is a certain weakening of the expression itself. This weakening, of course, takes place among the ordinary painters, and the facts of this period demonstrate it. This does not happen, however, in painters of great talent. Expression remains equally strong and beautiful for them and, thanks to improved execution, may even appear greater and more splendid, as it shone forth for this reason alone in Masaccio. I say for this reason alone, because he was basically of Giottesque background, though some may say to the contrary, and his chapel in our San Clemente shows him to be so. The Giottesque way of painting, that I shall always consider sublime, remained alive well into the fifteenth century and shone, and still shines, and is admired and praised even by those who follow other paths. And is it not true that the works of the blessed Fra Angelico from Fiesole, who worked until 1455, are still admired by all in our time? And is he not substantially, and justly so called, the last of the famous Giottesque painters? even if in mental vigor he stands far below his Giotto. If his flourishing fame is owed in large part to his blessed and angelic grace, nevertheless much of it is due to his refinement of execution, which developed in him from Giottesque elements alone. Oh! if certain outspoken painters or certain men of letters who sit in judgment knew how or deigned to make due distinctions, they would not sentence to death or deride as contemptible that which, without realizing it, they praised and exalted shortly before. But let us proceed in peace.

Here one must mention that the execution arises in part from the discoveries of material and in part from the qualities of sentiment of him who discovers; these discoveries, returning, so to speak, and amalgamating themselves with the sentiment of the creator, produce new progress, new discoveries, and marvels of execution. If I were merely to refer to the discoveries of perspective and the great effects of this science on the spirit, I should abuse your patience too much, necessary as it might be. I therefore restrain myself and say that even though the works in the second period are generally devoid of great conceptions and the expressive force that is resplendent in the preceding period, as a result of the spirit's being distracted from feeling the passions and being intent instead on discoveries of technique, nevertheless the expression, such as it is, continues simple and pure, always tending to a unity, which it does not, however, always achieve. These are fundamental qualities necessarily born from the causes of the first period, causes that still existed since the ideas, the images of visible things in human minds, were still natural and pure and not corrupted by unnatural and conventional ideas, and only similar portraits, pure and plain, could come forth, such as they were. This may be said of the mass of painters. But oh, how many still did not decline in so many of their stupendous works! Masaccio above all, Ghiberti, a man no less marvelous, born more than twenty-three years before Masaccio, who also should be listed, in my opinion, among the painters Lippi, Verocchio, Bellini, Piero della Francesca, Signorelli, Ghirlandaio, Perugino, Mantegna (who in some respects should be considered apart), and so many others whom there is no time now to mention, the glorious list is too long.

In many works of these men, those great principles of the first period are preserved unspoiled, but in a few others they are not to be found intact, due to distraction, or excessive pleasure in displaying the tricks recently discovered. Yet that there must have been in the fifteenth century an identity with the great fundamental principles of the fourteenth can certainly be seen if you call to mind the causes of the earlier period, which persisted in the second not completely erased from the minds of the creators.

The wonderful thing, quite appropriate to the second period, is the extreme purity of execution. There is naturalness and the highest precision in drawing, marked, it is worth repeating, by a geometry so spontaneous as to ennoble it stupendously. One would seek in vain to find better in the epoch of perfection, but it shortly disappeared. And let it be noted that this geometric skill is not limited only to general external forms, as in the first period; here it is the rule, is diffused, and spontaneously dominates down to every small internal part so that the drawing has in a special sense that high virtue painters call "well-modeled." This virtue, perforce, brings with it another most important one, that is, the supreme knowledge of chiaroscuro in individual forms. It may be added that, thanks to this geometry, the art of drawing was but a step away

from perfection, so that if an indomitable genius pervaded by transcendental enthusiasm—the terrible Michelangelo—had not arrived to stagger the world with his tremendous splendor, the art of drawing would easily have reached Greek perfection. It did not fail, thanks to two other qualities then added to it: the study of anatomy and the study of proportion, eventually promoted so well, especially by da Vinci. It succeeded more perfectly in that it drew its perfection from nature alone, not yet from the examples that have come down to us in ancient marbles, which, if they later were of great use in creating the ideal for historical images, still universally inflicted infinite damage. It is a truth terrible to utter, but truth in fact.

More color in some, less in others, in all tending to the real, in many very real, false in none, and illuminated with such a pure and diffused light as an open sky illuminates the day, the technique blended admirably with the simplicity of invention and the purity of design. If many who came later have been offended by the extreme precision, which they call dryness and miserable aridity, let them understand—these wordy babblers who understand nothing—that without this dryness and aridity (we repeat the phrase with a smile) painting would never have arrived at its perfection; I say this only for the sake of brevity. Woe to those young students who do not travel along the same road, narrow indeed, but straight and smooth!

But we have arrived at the third period, the period of highest rewards, the period of perfection. If the dawn was so splendid, and if to announce its arrival there arose such bright stars, how strong do you imagine the light of the sun itself would be? I have no words to express it; so many thoughts crowd into my mind that I know not which to utter first. The wisest thing would be to restrain them all and proceed as we have been.

From the state and quality of things of the first and second periods, the third, that of perfection, is necessarily born. Let us see how.

In the first, the conception of all that forms the spirit of tragedy and epic—which is also that of painting—was seen to be established. In the second, execution, or the giving of body and color to conceptions, was carried to the most exact imitation of nature, while the great principles of the first continued in general to exist. A few steps still remained to be overcome, few but important; everything was prepared and disposed for this goal.

In the first place, those great principles that nature herself had taught to man, as we saw, for the just formation of conceptions, had to be reconfirmed and reduced to more demonstrable precepts. In the second place, the conceptions had to be joined to the execution of the work in relationship to the effect of chiaroscuro, color, and design, according to our way of seeing modified by moral affections, so that their union might form a simple and unified whole.

To say this now is to state certain evident truths. We may look at objects in front of us with attention in order to understand them well, observing them

close at hand; in such a case the images imprinted on our minds are complete in all parts, design, chiaroscuro, and color. To give their true portrait in painting, then, they must be most diligently worked out in all these relationships. This regards only the exact imitation of the representational aspect of the objects in themselves. Of such a nature in general was the execution for the painters in the fifteenth century, that is, of the second period.

But objects are also viewed by us with scant attention. Sometimes we look at them carelessly, with the result that a number of images may remain uncertain and confused in our imagination. At other times our attention is more vividly attracted by some more interesting object, and in this case, just as the image of the interesting object is impressed on us exactly, as I said before, those seen with little attention remain uncertain and generally suggested. In order to imitate these objects well, the painter must execute them with uncertainty, make them shadowy, merely suggesting them only generally in the design, as in the chiaroscuro and the color. Distance of objects produces a similar state of things.

To demonstrate better the point made here, it would be useful to observe a group of objects contained within the cone of visual rays according to the visual faculty of our eyes. But circumstances are not right, and words must suffice. This concerns our perception of objects as they are according to our way of seeing. An effort at unity, this remained to be stabilized in the third period.

But as a result of our attention being intensively applied to the principal objects more than to the accessories, another marvelous effect takes place: since we see principal objects more vividly in their light, with light attracting light, and light reverberating, these objects compose themselves and merge into large luminous masses which are degraded and diminished in accordance with the major or minor attention given them, the visual faculty, or the distances involved. The result is a harmonious, magic, and highly suitable effect of chiaroscuro and color that marvelously blends and subordinates itself to the unity of the whole work. I shall speak later of the part the drawing of individual forms plays in the same unity.

But this perception of objects is also highly modified and, so to speak, changed by the various positions and affections of our soul. Let us examine a brief example. What a pleasant and brilliant picture for a soul tranquil and happy in innocence would be a gentle landscape on a serene spring day, watered by a pretty stream and animated by little cottages, where the shepherd plays his pipes and watches his flock!

But oh, how the delight of this same landscape diminishes before a soul that is melancholy and afflicted by adversity! Does it not appear tinged with pallor in each of its parts? The very sky loses its serenity, everything changes its aspect, and even the sound of the pipes, so sweet before, is heard as a dirge.

If, finally, there passes a soul heavy with crime, the sky is heavy, every pleasant thing is heavy and gloomy, nothing delightful is seen, only brambles and thorns are to be found, and the attention fixes only on some unfortunate plant that has lacked nourishment or life. But I digress too much.

Permit me, then, to add that in regard to this matter I am certain that from considerations of this nature made with exact analysis, one may firmly stabilize not only what is true painting basically, but also what is particular, and in this way fix the types of the various natural and ideal styles, and even which just modifications may and which may not take place according to the varied inclinations of men and nations. But it would be too difficult a task, and to accomplish it one would need nothing less than a very profound philosopher who is at the same time a worthy professional painter, otherwise the work would be defective on one side or another.

But I must speak of how the drawing of details might arrive at perfection and aid the unity.

When the art of drawing is brought to the point of knowing how to represent beings in their natural appearance with the utmost simplicity and exactness, man (but only he who possesses this art) realizes that there exists for these beings a higher essence of aspect, that is, a perfection of their external conformation, the lack of which (a most common happening in nature) is rather an accident than a convention. Thus are framed general ideas of the essential forms of bodies, that is, of their best qualities made evident and therefore beautiful—and behold, drawing is brought to ideal beauty, that is to say, to its perfection.

But this is not sufficient for arriving at unity, which is pursued in this other way.

When man comes to know in what the ideal beauty of, for example, a head or a face consists, if through too great a love for the best he conforms all his heads to this ideal type, he will have a boring and always unpleasant uniformity instead of a unity, which is always the principal cause of delight. Therefore, he must make use of it with rigorous economy. Let it be reserved for noble characters, more frequently for the most noble. He must deny it to the opposite type, even to the point of completely depriving them of it, because these, whether vile or vulgar, when made so appear brought to their essence through imperfection. One must remark that certain abject images of men are not suited for even the shadow of the ideal, in fact, exactly the opposite might apply (the opposite of ideal beauty is found also in nature), as for certain criminals, for example, adapted, however, to their type and level. Thus the suitable and rigorously economical application of this ideal design creates a unity in the drawing itself; on the other hand, an equal application of it in all instances destroys this relationship. Furthermore, the design itself departs from nature and becomes conventional; instead of advancing to perfection it falls into deca-

dence, as we shall see. I quickly note that chiaroscuro and color also acquire ideal beauty in the same way. So the development of all these things and their harmonious relationship could and did bring painting to perfection. You see how important these last steps were.

But there is yet another that brings perfection to the summit, the extreme height.

Nature is all life, all motion. Inert, inanimate, or dead things themselves, although immobile to our eyes, in one way or another still show us the powerful forces that led them to death, or the traces of the blows of other motions that struck and overthrew them.

In animated beings everything is a continuous succession of movements, which are communicated to all that adheres to them, even to the inanimate; from this, everything is subject to instantaneous modifications and to an infinite diversity of aspects.

Since beings are represented in our minds in a way that is entirely immediate and occasional, and since our minds certainly recognize very well the diversity of these appearances as they relate to the motion that has produced them (painting would otherwise be immobile and inflexible), it seemed impossible that one should have been led to imitate so contrary a thing. With this achievement certainly the final, extreme level of art, its peak of perfection, is attained. And yet one sees this final step marvelously taken.

Who was the agile one, the chosen one, the one necessary for this? In truth, there was needed, besides all the things prepared, as I said, in the first and second periods, there was needed, I repeat, a man in whom the highest strength of mind was joined to the most refined sensibility possible; he alone might find the just target for such a high aim. Behold Leonardo da Vinci, the happy discoverer of this, the promoter of true perfection through both example and counsel, a most wonderful man, prepared for all things, and in whom the loftiest sensibility never prevailed over the intellect, which in him was both extremely elevated and extremely profound.

With the efficacy of his teaching and with immortal writings, he reduced to demonstrated precepts those great principles that we have already seen dictated to man by natural sentiment, in writings that, even though they might be called unformed, are so profound and inexhaustible a treasure that wise men have even found in them the germs of the optical science of Newton. Through his discoveries on light he joins, in the effects of color and chiaroscuro, a highly refined execution to sublime conception, in a simple and unitary fashion, since he not only knew but even refined that of the preceding period.

This is shown in his head of the Medusa in the gallery of Florence, a work that is a prodigious catalogue containing every virtue, that deserves a temple for itself alone. Then there is his *Last Supper*, where the expression of the passions is a truly great wonder, and the ideal beauty of the design is brought to

unity with so fine an economy, so sublime an art, that it establishes a perfect type.

We have ample and sublime demonstrations of this ideal beauty of chiaroscuro, the passions, and instantaneous movement, all continually tending to unity, in the painting of the Magi in the above gallery, left in monochrome by Leonardo and evidently a school of sublimity for Raphael. Finally, the *Battle of Anghiari,* too, is a perfect type of the representation of beings in immediate action, circumstance, impetus, and upset.

I regret the brevity of time, which merely allows me to hint at these works and not to speak at all of many others. Oh, what a vast field for a thousand essential reflections! Still, it must be said that not all the virtue of this truly divine man was put into practice. If only he had not been distracted by many more important tasks that required all his energy, and by an infinity of lofty desires of every kind to which he was violently driven by just that universal attitude of his body and soul that embraced all things! And, one may add, he was driven by an insatiable need to philosophize over everything; and the numerous theories he so devised, which, when it is necessary to act and act quickly and arrive at a difficult goal through action, are always a binding hindrance and quite chill the sentiment of even a great man. If all this had not been we should have works from his hand in which we should see the perfect example of all that which constitutes perfection.

But then there was already born, or descended from the stars, he who was to supply that: Raphael Sanzio, who flew over the brilliant path marked in the sky by da Vinci and arrived at the highest glory, whose highest seat he obtained thanks to the Graces. In the works of Raphael there is everything; it is useless to state it. Everything is wonderfully subordinated to the great moderating principles of art; the most extraordinary thing is that in the midst of the highest art, art never appears, but the work seems rather to take place spontaneously and almost accidentally. This is the sign and seal of a truly divine genius. But I beg of you: recall for just a moment the last power of art, which raised art itself to extreme perfection. Behold, Raphael not only stands above all but becomes the wonder of all, beyond whom no one can go. Let no one yearn or presume to follow Raphael to his extreme height. He will fall into inevitable ruin. If he still has wings, he may yet pass over the same ways trod by Raphael himself. But let us look at this angel briefly, flown to the supreme summit, the highest peak.

His flying figures of all types and number are animated in all their parts by so instantaneous and lively a movement, and by an impulse so harmonious, agreeable, and justly proportioned to their various gestures, that, in sum, they seem to us living, moving figures stopped by a miracle. This movement is not limited, perfect only in certain given figures; no, you see it diffused throughout the entire representation of the work, either quietly, if that is fitting, or with

Tommaso Minardi, *Madonna del Rosario,* copy after Raphael, 1841, watercolor.

impetus, so that it appears to pass like a wind from group to group. This diffusion of life and movement and casual circumstance is everywhere expressed with so much propriety, economy, and elegance that it becomes enchanting. The enchantment then transports one to a higher pleasure, because all graces are discovered always and everywhere. These are the pure, the honest, the ingenuous graces, those that were then such excellent company for good Fra Bartolomeo, Raphael's friend, and for Andrea del Sarto; not the false, alluring, seductive ones that were later to be adored in others. He embellishes each of his creations with these winsome graces in such a way that the result is a harmony of ineffable elegance that has beguiled people of whatsoever age, sex, nature, nation, and school for centuries entire. O soul truly harmonized in paradise! And you showed us these directions the more when by you and in you they were tempered to less transcendent awesomeness and made more mild and human. You made gentle, finally, the extreme savagery of that proudest and most terrible genius who suddenly burst upon that time to upset the entire world of art with his tremendous power. You alone, O Raphael, if heaven had seen fit to leave you with us, might have curbed that overwhelming force. Yes, the more-than-mortal Michelangelo brought the world a totally unique kind of painting; it is the extreme type of robustness, of savagery, of the terrible, the melancholy, the excessive—even nature shows itself excessive in some of his works. But woe to the man who exceeds; Buonarroti's example is not for him. His is a spirit always so impetuous and excessive in everything that in managing the material and reducing it to his conceptions he seems a god who commands, not a man who acts, so much does he disdain all human logic! No one may approach him. But it would have been far better for us had he never existed. Instead, O God! Raphael disappeared, the secure guide, the perfect example, the most valid support, the most noble part of painting's life. What an immeasurable tragedy!

Meanwhile da Vinci moved and transplanted his sublime seeds to Lombardy, where he founded a school of true beauty. But to my way of thinking, he did not find the ground ready for such sublime seed. Nearby was one who understood and gathered through his own strength part of the happy impulse. He too was a genius of singular nature: Allegri from Correggio. I am certain that his nature, ready and formed to feel the magic effects of light, suddenly developed merely through the influence of the great theories and through the stupendous examples of Leonardo's work, to be seen in those parts where they aroused wonder and acclaim on the part of all; the school of Mantegna could communicate nothing suitable to him, indeed, may have hindered him. It would not be difficult or unfitting to make this fact clear, but there is not time. Certainly Correggio demonstrated the perfection, the high point, of the art of chiaroscuro, principally reducing it in a wonderful way to unity, to agreement, to a gentle and masterly combination and harmony, that might be called in-

imitable, or at least is filled with the danger of failure for one who would imitate it.

There is in this part of Correggio (in the innate, the characteristic, the sublime part of himself), as in all of Buonarroti, a certain extraordinary and uncommon nature, not made for the mass of men; to fulfill it he uses certain means, that I might call magic and not real, such as are conceded to genius alone and to no others. It therefore happens that others who attempt to use these means end up either fools or failures, as is shown in fact by the followers of both Correggio and Buonarroti. Thus, such geniuses are always the cause of decadence in art.

This did not happen, rather the contrary took place, in Giorgione and Titian as regards the most pleasing part of painting, color. This rose to the height of perfection in all its aspects in these two Venetian geniuses, by means of the same ordinary ways, through the same natural and simple principles, that, as we have already seen, caused the other areas of painting to rise to perfection; therefore their works were always a solid example and later formed the most famous colorists, even those of foreign nations, so that the Venetian school continued and retained its beauty of color in later times despite the universal corruption. This point is worthy of important consideration.

Color in the Venetian painters had already from the fifteenth century on shown itself to be more wonderfully true and exact than elsewhere, particularly in preserving in painting the representation of local color, which is not merely the great but the fundamental principle of good coloring. The Venetians were readily progressing at the same time in the practical manipulation of the material with methods suitable to their intent, methods no different from those of the other Italian schools, but more perfect, when Giorgione, above all, made these qualities blaze forth. He carried these qualities much further in his work, demonstrating clearly and fully in his paintings how effectively these local colors might be contrasted to produce the most varied effects, always pleasant and surprising. He showed in actual practice (which is always more valuable than any theory and is the most useful of teachings) and reduced to a practical rule the most pleasing combinations of colors, the most dulcet and, at the same time, the most vigorous, strong, and striking effects. The practice of painting under the eyes of that true genius, intent only on the observation of colors, revealed to him the very great importance of using vivacity of color with rigorous restraint, even with avarice; then how effectively the abundant use of half-tints and low, discolored tones, called muted by painters, served to bring the major ones into prominence; then too, how well it served to subordinate the various problems, the secrets of our way of seeing in respect to the visual faculty and the process dependent on our greater or lesser attention, as previously shown. These secrets, let me repeat, he learned and taught to many others, more efficaciously because, having dealt with matters of execution through ex-

perience, he could make tangible what abstract theory could barely—and often uncertainly—make understandable.

Here it must be stated that through performance similar effects were created by the hand of Raphael, who had already grasped the same principles, and likewise by Correggio, Andrea [del Sarto], and Fra Bartolomeo. Practice and continual experiment with material allowed Giorgione to ascertain that material used in one way rather than in another plays a very essential role in achieving the best effect in the art of color. Since it is certain that the same ray of light that hits a rough, porous, fibrous, or polished surface is reflected in a completely different manner from each and gives the eye different impressions of color, then one may see how necessary it is that the painter reduce the material mass of color and make it conform to the various types of surface that the forms he wishes to imitate have in nature. From this, Giorgione drew the surest norms, new for the most part, for the appropriate handling, and for the strong broad stroke, of the brush. From this he discovered still another aspect of material most important for the best formation of the tones of colors. Prepared in a certain way and worked out in another, these one way and those differently, the colors would be pleasing to the eye in a degree that could not be achieved by another method, no matter if the painter were a consummate colorist.

The artist of Cadore, Titian, aroused by the earliest activities of Giorgione, embraced boldly these examples and discoveries and entered the new field. The Titianesque and Giorgionesque methods being merged through active emulation, a new and flowering school of color arose: an infallible standard and rule for the simplest, purest, and most vigorous way of handling color, the best of all: it never surpassed nature but followed her in everything. While it left to others the vain display of overrefined and painfully concocted color schemes, it always arrived surely at its goal with few tints, so subtle that one can hardly detect from what hues they came. It is like music composed of few notes that, masterfully tempered with expressive and vigorous melody, delights more than any clamorous or elaborate concerto. It is a way of coloring that pleases and enchants people of all types and all lands, and that has always been called the best by the most varied schools in every age.

Let me say here that if you see these two great men placed higher in the art of color than others, this does not necessarily mean that Raphael is inferior. The grace of his colors, although perfect, is not apprehensible and apparent for three reasons: his understanding was not concerned with pursuing this alone; he did not sacrifice the other aspects of art to this, but rather placed them before it; and finally, he was so admirable in all these things that the attention of the observer cannot fasten on one alone. Certainly he was by nature and in practice equal to these and to all others. God knows how much further beyond he might have gone, if his days had not come to so sudden an end!

In all that has been said heretofore, and in nothing else, lies the highest, the perfect art of painting, which depends only on this.

Sirs, it would be fitting at this point to explain the beginnings of the decadence that now so quickly took place. It should not be difficult, given what has been said, to show its true causes, which may all, in my belief, be reduced to the following.

Art, when arrived at its perfection, not yet painting in the abstract, makes man aware of what the highest beauty consists in, of ideal beauty. Certainly this ideal beauty is formed by presenting clearly in painting the best state of man, the best essence of visible beings in their circumstantial relationships. One arrives at this superior representation only after having acquired exact general ideas of the apparent nature of beings. I say exact general ideas, that is, absolutely all must be immediate first-born offsprings of nature or, let us say, composed purely from ideas, from a strict understanding of what beings are individually, without a shadow of convention.

When art has arrived at this point of maximum perfection, and man clearly sees of what excellent painting consists, he then disdains further research in it. He ceases to form his art after natural objects because these are all more or less imperfect, and he thinks he will degrade, impoverish, and consume himself by following and imitating them. So he necessarily loses sight of individuals and withdraws unawares from the exact imitation of nature (the most essential foundation of art). In throwing himself with all his soul into the study of the works of men who brought painting to its height and forming his painting on them, he fills himself only with ideas of general knowledge, which are born in him incomplete, even of necessity affected and false, because they are not formed, connected, and based on exact ideas of the individuality of nature. Thus everything becomes conventional and forced, and the ingenuousness, simplicity, and purity of nature itself are destroyed. Glance at any one of the most beautiful works created after the period of perfection, even if of perfect conception, and consider well with an unprejudiced mind the ways in which it has been formed and executed; then tell me if that which I refer to has not taken place, at least in part.

Here it might be well to state that man has two wonderful reasons for greatly deluding himself in this process: one is the small amount of effort involved, the great ease afforded by this kind of operation; the other is the very alluring satisfaction to his self-esteem (an agent that greatly predominates in us). Since he is intent on drawing his knowledge only from works in which he thinks he can find everything, he firmly believes that all he does is lofty and perfect; nor can he ever suspect otherwise.

Therefore he laughs at the artist who does not proceed in this way. With more fatal illusion, discerning one or another splendor in the varied beauties

that make up different types in the works of the great period, he thinks he understands how easily to form new compositions filled with the varied and separate beauties of others. Often he gives himself up wholly to his illusion. Then art not only becomes conventional but, of necessity, degenerates into mannerism, and then into mannerisms so exaggerated and monstrous as to seem but incredible madness.

In summary, he takes off, he begins his journey from that point at which the strongest and most sublime geniuses ended theirs and rested, there being no road beyond, no greater height. Taking off from this high point he presumes that he will go farther. Naturally, he descends with every step. He who goes fastest goes farthest afield, and he who is left to himself alone falls in ruin, for the high mountain is surrounded by pitfalls and precipices.

Let this great truth be understood and borne well in mind: no one will ever be able to come near the utmost height, much less attain it, except by walking, and treading with well-measured step, those selfsame ways along which those geniuses themselves proceeded cautiously, I almost said slowly, even though they had wings. These ways are marked and prescribed by nature; outside of them a fall is irreparable.

Nothing ever came to a good end running counter to nature.

Sirs, if I have not spoken vanity (which I strongly fear, since these thoughts of mine were born in me solely from the examination of facts and not from extraneous reflection), and if I am correct, even if in the past they took off from that highest peak of perfection and today or in the future other lines of painting might depart from there, I still would say: Here in the history of art is a ruler, here is a square; use them for yourselves and see if they are straight or not and in what way, and if all disputes might not thus be resolved.

I shall not tell you the answer; I have already said too much, and you yourselves, much better than I, can pronounce it with professional authority.

A. F. RIO

The Poetry of Christian Art (1836)

During the period covered by this volume, two disciplines developed rapidly: one was a systematic consideration of aesthetics; the other, a new rigor in the writing of history, including the history of art. Until the early years of the nineteenth century, writings in the history of art focused primarily on the articulation of the rise and decline of certain predetermined values. Most writers tended to emphasize virtues evident in the art of their own day, a tendency most likely derived from the example given in Pliny's discussion of ancient art. According to this schema, from crude, early works Greek art evolved through a refinement process that reached its perfection in the Periclean age, the "classical" period. But various forces occasioned the decline of this great tradition, which was ultimately submerged by barbarian invasions from the North. In the early fifteenth century, Lorenzo Ghiberti appropriated this schema to describe the art of the century preceding his own. In retrospect, he felt his work to be a factor in the rebirth of the great artistic traditions that had lain virtually dormant since the fall of the Roman Empire. Similarly, Giorgio Vasari saw himself as part of the highest point in this rebirth, a "renaissance" that in some respects surpassed the work of the ancients. This view was echoed during the late eighteenth century by writers such as Reynolds and Francesco Leopoldo Cicognara (1767–1834), who again saw preceding decades as a period of decay from which vantage point their own work appeared as a sort of rebirth.

All such views were based on the assumption that there had been a moment of perfection in art—a stage of development in Greece—that could be reached again, and that this achievement would be recognized by the similarity of new works to Greek prototypes. While this schema allowed for continual changes, art could be progressive in only a limited sense because the goal to be reached was of a predictable character. The history of art was viewed as the cyclical rebirth (renaissance) of a single set of predetermined values.

Such a vision of history is itself an aesthetic construction, abiding by the same laws of unity and utility as the "perfect" work of art. Each artist contributes one part to the rebirth, much as do the individual forms in a compositional machine; there is a single point of focus at the moment of the highest achieve-

ment, and less significant achievements are lost in a surrounding dimness. Above all, this vision of art history has a sense of completeness that made its form beautiful in the eyes of theorists. History itself took on an aspect of harmonious predictability, and events that disturbed the regularity of development could be rejected as being inconsistent with the true form.

A loss of faith in formal beauty dictated a changed notion of history. Neglected periods needed to be brought again into the light, and the entire schema, the aesthetic of history, had to change. If, as the followers of Maurice Quay maintained (see the essay by Delécluze, which follows), early Greek vases reflected the greatest achievement of Greek art, art might be said to decline from its birth, to continuously begin again yet remain always at a primitive stage. Such a statement is, of course, an oversimplification, but by no means is it unrepresentative of the beliefs voiced by many artists and theorists. As the century progressed, certain writers simply denied that history had any clearcut form.

Gradually, art historians began to look at the past somewhat in the way landscapists began to look at nature: as a process whose form was held together by a fascinating complexity beyond the structure of reason. Greater interest was shown in discovering new aspects of the past than in bolstering the older conceptions. Thus the first histories of art that were not merely intended as "lives of the painters" began to appear during the late eighteenth century. Luigi Lanzi's history of Italian painting, published in 1789, went through numerous revisions and translations, as did Franz Kugler's detailed and systematic *History of Painting Since Constantine the Great,* first issued in German in 1841. In 1827 Karl Friedrich Rumohr began publishing his detailed *Italienische Forschungen,* and the number of serious art historical writings proliferated rapidly.

One result of the new approach to the writing of art history was a deepening interest in disciplined archaeology. For those intrigued by medieval studies, one of the great events of the century was the completion between 1842 and 1880 of the thirteenth-century Cathedral of Cologne, which was executed according to the original plans, discovered in 1814. Another consciously historical Gothic project was the rebuilding of the Parliament in London after its destruction by fire in 1834, carried out according to the designs of James Barry and Augustus Welby Pugin. In Germany, collectors such as the Boisserée brothers and Heinrich Olivier began to specialize in the acquisition of fifteenth-century Flemish and German art. In writing, this revived interest in medievalism was most fully reflected in Séroux D'Agincourt's massive volumes, *Histoire de l'art par les monuments,* which he had begun to compile before the French Revolution but were first published posthumously in 1823. Although ostensibly dedicated to tracing a period of art in decay, his documentation of medieval art was indeed precise and wide-ranging.

In England during the mid-eighteenth century, Gothic style had been con-

sidered merely picturesque and had often been mingled with the architecture of grottoes or with Chinoiserie. During the nineteenth century, as Gothic art became a subject for archaeological concern, finer and finer distinctions were detected in the varieties of medieval styles. Ultimately, interest also turned to the culture that had produced the works. Writers gradually became aware that changes in society profoundly influenced stylistic evolutions, both in painting and in architecture. A. F. Rio (1797–1874) brought this new concept of history and historical context to his approach to medieval Christian art. Like Chateaubriand, he recognized the general motivations of Christianity and was conscious of the variety within what at first glance might seem a monotonous group of similar works. But unlike Chateaubriand, Rio's principal aim was to reconstruct the historical situation and the personal intention that underlay the works. To do so he needed to investigate the source of the artist's subjects and study the symbolism of their time, a study he pursued with obvious satisfaction. In this attempt to revive the original meanings of these works, Rio was not alone. Many studies were published on the practices of the early church, Christian iconography, and even the technical aspects of medieval painting: F. C. Husenbeth's *Emblems of the Saints* (1850), A. T. Didron's *Iconographie chrétienne, histoire de Dieu* (1843), and Mrs. Anna Jameson's popular *The Poetry of Sacred and Legendary Art* (1848) and *Legends of Monastic Orders* (1850). In England the organization of the Camden Society and the efforts of the Oxford group supported a return to early church practices and the documented study of Gothic art. Durandus de Sancto Porciano's (1270/75–1834) treatise on ecclesiastical practice, published by the Camden Society in 1843, became a kind of handbook. Sir Charles Locke Eastlake (1793–1865) published his volume of early documents, *Contributions to the Literature of the Fine Arts,* in 1847 and began his extensive publication of *Materials for a History of Oil Painting.* The movement even had its own history as early as 1872 in Eastlake's *A History of the Gothic Revival.* It is just this kind of historical preoccupation that Delécluze, brought up in the school of David, despised. But it marked the beginning of a kind of thinking about art in its historical context, an approach to art that would persist well beyond the end of the century and would influence later artists and critics alike.

The following extract is excerpted from A. F. Rio, *The Poetry of Christian Art,* translated from the French (London: T. Bosworth, 1854), pp. 123–29, 146–49, and 224–28. ✎

MYSTIC SCHOOL

At this point the sphere of those who are commonly called *connoisseurs* ceases, the particular faculty which applies itself to the appreciation of the kind

of productions of which we are about to speak no longer being that by which ordinary works of art can be judged. Mysticism is to painting what ecstasy is to psychology—a definition which sufficiently explains how delicate are the materials we shall have to make use of in this part of our history. It is not sufficient to point out the origin and to follow the development of certain traditions which impress one common character, almost always easily recognised, on works which have issued from the same school; it is further necessary to associate ourselves by a strong and profound sympathy to certain religious ideas, with which this artist in his studio, or that monk in his cell, have been more particularly pre-occupied, and to combine the results of this pre-occupation with the corresponding sentiments in the minds of their fellow-citizens. It is extremely difficult for us, who have not breathed that atmosphere of Christian poetry in the midst of which the generations of that time lived, to fulfill this condition, and we generally pass with supercilious disdain before those miraculous paintings which have for several centuries exercised the most soothing influence over a multitude of human souls. We do not reflect, that this silent image of the Madonna and the infant Jesus has spoken a mysterious and consoling language to more than one heart pure and humble enough to comprehend it, and that there are perhaps no tears more precious in the sight of God than those which have watered the stones of these modest oratories. It is in the lives of the saints, rather than in the lives of the painters, that proofs of the interesting affinity between Religion and Art must be sought. San Bernardino of Siena went every day beyond the Porta Comollia, on the road to Florence, and there passed long hours in prayer before a Madonna, which he preferred to all the masterpieces exposed in the churches, and about which he delighted to hold converse with his cousin Tobias, who was the confidante of his pious enthusiasm.[1] The powerful influence which the work of an obscure artist exercised over the imagination of the young Bernardino; the preference given to it by him above all the other pictures offered to his veneration; the longing he experienced to pray there rather than elsewhere, and afterwards to pour his simple emotions into another pure and childlike heart, capable of participating in and comprehending them;—all this array of facts, which abound in the history of the saints, and in that of the people, but which, by a kind of tacit agreement, are placed beyond the reach of common observation, are capable, nevertheless, of shedding at the same time a new charm and a new light on the hitherto sterile researches which have Christian art for their object. It is in exploring this mine, so fertile in psychological considerations of the highest order, that we shall find the explanation of the vicissitudes which certain works, universally admired in one century, and entirely forgotten in another, have experienced; and we shall understand why the lower orders, whom the connoisseur calls

1. Rio here cites *Lives of the Saints* by Simon Martin, 1 : 1261.—Ed.

superstitious and *fanatic,* have alone remained faithful to the worship of those antiquated images, before which they kneel in the evening when their work is finished; why they alone remember to supply the little lamp with oil, and the tabernacle with flowers. He who approaches this study with the dispositions requisite to understand the *beautiful* in its most extensive acceptation, will only have to fear one danger, analogous to that to which the too-exclusive partisans of mystical lore are exposed,—he will run the risk of sacrificing more or less the other elements of the history of art, in order to breathe more freely the soft and wondrously varied perfume of popular devotion. A circumstance which occurred in one of my excursions in the lagunes of Venice, and the recollection of which is dearer to me than that of the magnificent monuments I most admired there, will serve to illustrate the importance which attaches to the observations of this kind, particularly when they are accompanied by a mass of circumstances calculated to render them still more valuable. We were rowing, one beautiful spring morning, towards the ruins of Torcello, when, on passing out of the canal which traverses the whole length of Murano, we perceived a small island covered with trees in full blossom, and shortly after a modest cottage, which was concealed behind them, met our view. Near the spot where our gondola touched we perceived a Madonna sculptured in the wall, with a lamp burning before her, flowers freshly gathered, and a purse suspended to a long pole to collect alms of the gondoliers and fishermen. In landing to visit the garden, we found an old man seated on the threshold of the door, and the gentleness of his voice and the serenity of his noble countenance having encouraged us to inquire into the kind of life which he led in this solitude, we learnt from him the most interesting details of his own history; of that of his island, formerly occupied by Franciscan monks, who had been driven from it by foreign invasion; and of the Madonna, which the profane hands of the French soldiers had vainly attempted to drag down from her tabernacle of stone—and he laid greater emphasis upon this last part of his recital than upon the rest. For more than twenty-five years he had lived almost constantly alone on this confined spot; and when we inquired if this solitary existence did not sometimes make him melancholy, he replied, with a smile of confidence accompanied by a very expressive gesture, in pointing to the Madonna, that, having always had the mother of God so near him, he had never felt his solitude; that the proximity of such a protectress was sufficient to make him happy; and that his sweetest occupation consisted in supplying the lamp and renewing the flowers before her image.

Assuredly, it was not the work of art alone that cheered the tedium of his voluntary exile, but its influence was necessary to sustain in him that sentiment of inward poetry which is the most enviable privilege of pure and simple souls. An analogous incident occurs in the history of the blessed Umiliana, who nourished her singular devotion for the holy Virgin by means of an image,

which assisted the sublime flights of her soul, and before it she maintained a lamp, which, whenever it was extinguished, was rekindled either by an angel, or by a dove carrying in its beak a rose resplendent as the sun.[2] It was in this domestic sanctuary, consecrated by the miraculous presence of the Madonna, that the most interesting events of her life occurred: there it was that she experienced her prolonged ecstasies; there she poured forth her most consolatory prayers and tears; and when obliged, by cruel persecutions, to shut herself up in the stronghold of her family, this precious image was the only thing she carried away with her when she took refuge under the paternal roof.

The history of the saints is replete with analogous incidents, which show the intimate connexion that existed in the glorious centuries of Christian faith between art and those mysterious and exalted sentiments, which impart a kind of foretaste of celestial blessedness to the soul that experiences them. If this exaltation, far from being chimerical in its object or deplorable in its consequences, is, on the contrary, the seal of predestination, with which the most privileged among the elect on earth are provisionally marked by the Almighty, it is certain that painting becomes singularly enrolled by her intervention in this order of phenomena; that she then appears in her true light as the daughter of heaven; and that then alone she is raised to her highest power.

From hence it necessarily follows, that the artists who have best understood the aspirations of this nature, and have been most successful in satisfying them, are also those who are entitled to occupy the highest ranks in the hierarchy, and who have more particularly merited the surname of *divine*. In the vast field open to their imagination and pencil they have made choice of that which promised inexhaustible resources and never-failing inspirations. If they have sometimes descended from the region of the ideal into that of the living and material nature, it has not been to please themselves or to dwell there, but only to borrow forms and colours, which might serve at the same time as the limit and the partial manifestation of the infinite beauty of which they had enjoyed a faint glimpse. Although it has sometimes, and indeed very frequently, happened, that the combination of the form with the idea has not taken place in conformity to the laws of geometry, of optics, or good taste, the incomplete work which is the result of this transgression does not on that account lose all claim to our attention, and we are not the less bound to seek, under this repulsive exterior, the treasures of Christian poetry which lie hid beneath it.

If, during the whole of the fourteenth century, we have not had occasion to point out the qualities which essentially distinguish this school from every other, it is because this distinction did not then exist. Naturalism, confined within the limits assigned to it by the instinct of Christian artists, had not as yet formed an independent domain; and paganism, having become entirely es-

2. Rio here cites Brocchi, *Vite dei Fiorentini*, 1:205.—Ed.

tranged from the recollections of the people, only reappeared at long intervals as a harmless phantom, whose presence was scarcely noticed.

But in the first half of the fifteenth century the Florentine school, forced more exclusively into a new direction by the influence of Masaccio and his disciples, set itself to work out naturalism in all its bearings with a success hitherto unknown, and for which it would not be just to make it alone responsible. At the same time, the increase of the public wealth, and of patrician vanity, the far from disinterested patronage of the Medici, sometimes also the popular favour, together with a multitude of other circumstances, unfortunately too seductive to the artists who had entered on this career, diminished every day, at least in Florence, the number of those who sought their inspirations at a higher source. Thus, it is not within the walls of this lettered capital that we must seek the elements of the mystic school; we shall find them, dispersed like so many odoriferous flowers on the surrounding hills, in the modest villages of Tuscany, in the little towns scattered along the sides of the Apennines, from Fiesole to Spoleto, but, above all, in the convents, which we must ever consider as the real sanctuaries of Christian painting. . . .

Fra Angelico da Fiesole

. . . "Fra Angelico," says Vasari, "might have led a very happy life in the world; but being anxious, above all, for the salvation of his soul, he embraced the monastic life, and entered the order of the Dominicans, without, however, renouncing his no less decided vocation for painting—thus combining the care of his eternal interests with the acquisition of an immortal name among men."[3]

One very remarkable circumstance in the history of this incomparable artist, is the influence he acquired over his biographer Vasari, who lived in an age when very little enthusiasm was felt for mystical paintings; and yet, in his account of those by Fra Angelico, he appears to have emancipated himself from all contemporaneous prejudices in order to celebrate, in accents of fervent admiration, the sublime virtues which adorned his soul, and the innumerable masterpieces produced by his pencil. In the fervour of his momentary conversion he goes so far as to say, that so elevated and extraordinary a genius as Fra Angelico possessed could only be vouchsafed to one of pre-eminent holiness: and that in order to succeed in the representation of holy and religious subjects, it was necessary that the artist should be holy and religious himself.[4]

3. *Acquitarsi ridendo santamentè il regno celeste, e virtuosamentè operando eterna fama nel mondo.*

4. *Non potera e non dovera discendere una somma e straordinaria virtù, come fu quella di Fra Giovanni, se non in uomo di santissima vita; percioschè devono coloro che in cose ecclesiastiche e sante s'adoperano essere ecclesiastici e santi uomini.*

This superiority, to which Vasari pays such flattering homage, did not consist, however, either in perfection of design, relief of the figures, or in truth of detail; the arrangement of the subject is never assisted by a skilful distribution of light and shade, as in the frescos of Masaccio; and that which must appear a more unpardonable fault in the eyes of many is, that the lifelike expression which abounds in the heads, and is sustained in the upper parts of the figures, diminishes in the lower limbs, so that they have all the stiffness of artificial supports. But we must, indeed, be very insensible to all the delicious emotions which Christian art excites in souls susceptible of its influence, if we can allow ourselves to criticise minutely the technical imperfections of this divine pencil—imperfections which, after all, were much less owing to any feebleness of execution in the artist, than to his indifference for everything which was foreign to the transcendental aim with which his pious imagination was preoccupied.

The compunction of the heart, its aspirations towards God, ecstatic raptures, the foretaste of celestial bliss—in short, all those profound and exalted emotions, which no artist can express without having previously experienced them, formed, as it were, a mysterious cycle for the exercise of the genius of Fra Angelico, and afforded him never-failing delight. In works of this kind he appears to have exhausted every combination and shade of distinction, in so far at least as they relate to the quantity and quality of expression; and if we examine, however slightly, certain pictures in which a wearisome monotony appears to prevail, we shall discover in them a wonderful variety, embracing all the poetry which the human countenance is capable of expressing. It is especially in the Coronation of the Virgin,[5] surrounded by angels and the celestial hierarchy; in the representation of the Last Judgment—that part of it, at least, which relates to the elect; and in that of Paradise, the extreme limit of the arts of imitation;—it is in these mystical subjects, so perfectly in unison with the vague but infallible presentiments of his soul, that he has so profusely displayed the inexhaustible riches of his imagination. It may be said, that painting with him served as a formulary to express the emotions of faith, hope, and charity. In order that his task might not be unworthy of Him in whose sight it was undertaken, he always implored the blessing of Heaven before he began his work; and when an inward feeling told him that his prayer was answered, he considered himself no longer at liberty to deviate in the slightest degree from the inspiration vouchsafed him from on high, persuaded that in this, as in everything else, he was only an instrument in the hand of God.[6] Every time that he painted Christ on the cross, tears flowed as abundantly from his eyes as if he had as-

5. Rio's translator here notes that the frontispiece of his English edition is "taken from the celebrated Coronation in San Marco with this only difference, that in the original there are six kneeling figures of saints, two of which have been omitted, as the size of the page did not admit of their being introduced."—Ed.

6. Vasari, *ibid*.

sisted on Calvary at this last scene of the passion; and it is to this sympathy, so real and profound, that we must attribute the pathetic expression he has imparted to the different personages who are witnesses of the crucifixion, of the taking down from the cross, or of the entombment. . . .[7]

SERAPHIC ELEMENT IN PAINTING

. . . This work[8] consists of two grand divisions, Heaven and Earth, which are united to one another by that mystical bond, the sacrament of the Eucharist. The personages whom the church has most honoured for learning and holiness are ranged in picturesque and animated groups on either side of the altar, on which the consecrated wafer is exposed. St. Augustine dictates his thoughts to one of his disciples; St. Gregory, in his pontifical robes, seems absorbed in the contemplation of the celestial glory; St. Ambrose, in a slightly different attitude, appears to be chanting the Te Deum; while St. Jerome, seated, rests his hands on a large book, which he holds on his knees. Peter Lombard, John Scot, St. Thomas Aquinas, Pope Anacletus, St. Bonaventura, and Innocent III., are no less happily characterised; while, behind all these illustrious men, whom the church and succeeding generations have agreed to honour, Raphael has ventured to introduce Dante with his laurel crown, and, with still greater boldness, the monk Savonarola, publicly burnt ten years before as a heretic.

In the glory, which forms the upper part of the picture, the three Persons of the Trinity are represented, surrounded by patriarchs, apostles, and saints: it may, in fact, be considered in some sort a *resumé* of all the favourite compositions produced during the last hundred years by the Umbrian school. A great number of the types, and particularly those of Christ and the Virgin, are to be found in the earlier works of Raphael himself. The Umbrian artists, from having so long exclusively employed themselves on mystical subjects, had certainly attained to a marvellous perfection in the representation of celestial beatitude, and of those ineffable things of which it has been said that the heart of man cannot conceive them, far less, therefore, the pencil of man portray; and Raphael, in surpassing them all, and even in this instance in surpassing himself, appears to have fixed the limits, beyond which Christian art, properly so called, has never since been able to advance.

7. In the collection of the academy of the Belle Arti at Florence there are two rather large pictures of this class: in the first, Joseph of Arimathea shows to another personage the bloody nails which have pierced the feet and hands of Jesus Christ. This silent act tells us more than the most eloquent tirade of Klopstock. [Friedrich Klopstock (1724–1803), German poet, author of *La Mesíada.*—Ed.]

8. The work Rio refers to is a fresco in the Stanza della Segnatura, Vatican, painted about 1509.—Ed.

Must we, then, consider the decline of this transcendent genius to have commenced immediately after the completion of the Dispute on the Sacrament, at the very time when a new world seemed to open before him, when he was placed at the centre of all Christian inspirations, under the immediate patronage of the court of Rome, and consequently on a theatre on which he might command the admiration of the whole of Christendom?

It will be time to reply to these questions when we have occasion to speak of the Roman school, which was founded by Raphael at this time, when he irrevocably renounced the Umbrian traditions in order to place himself in harmony with the changes the public taste, and perhaps his own heart, had undergone.

The contrast between the style of his first works and that which he adopted during the last ten years of his life is so striking, that it is impossible to regard the one as the development of the other. We find an evident solution of continuity—the former faith has been abjured and a new creed embraced. Consequently, the admirers of his first manner regard the productions posterior to the epoch of which we are speaking with indifference, or even with a sort of repugnance, while the reverse may be remarked of the exclusive partisans of his second manner.

This remarkable dissidence has struck all who have occupied themselves seriously with the history or the theory of art. It has been the opinion of some, that Raphael's early pictures would naturally have a greater attraction for the habitually passive mind, because they imperceptibly transport it to a region of innocence, serenity, and eternal peace; whilst the later works of the artist, being executed with a fuller consciousness of his powers, and, therefore, possessing more life and expression, and also greater grandeur and variety in the forms, would be more pleasing to the active imagination. It is thus that the celebrated Goethe accounts for the different impressions produced by the two styles of Raphael.[9]

Others have explained it in a still more singular manner. For example, Rumohr, whose explanation leads to the most unlooked-for conclusion, namely, that in Raphael's early pictures the classical taste predominates, and modern taste in those of his later manner. According to him, the artist of antiquity always sacrificed movement and expression to the mathematical instinct of harmony in every combination of lines, figures, and forms; and this sentiment had been partially adhered to amid the darkness of the middle ages, as is proved by many monuments in which we find this idea of configuration constantly prevailing. But in the course of the fifteenth century the beauty of lineal arrangement had been almost entirely lost sight of in the Florentine school, while, on the contrary, it had always been cultivated with special care in that of Perugino; and it was from having inherited this classical tradition, forgotten

9. Rio here cites Goethe, *Kunst und Alterthum,* 3 vols., 1:145–48.—Ed.

elsewhere, that Raphael was able to give such an indefinable charm to his early works. In the following period, his aim becoming different, his manner naturally underwent a change: the symmetrical element of the beautiful gave place to the picturesque element—the fusion and harmony of colours, of tone, aërial perspective, chiaroscuro, large masses of light and shade, finely managed gradations, and all the other technical resources of the art, naturally acquired an aesthetical importance unknown before.[10]

It is impossible to imagine anything more admirably calculated to elucidate the theory of the fine arts than this luminous distinction between symmetrical and picturesque beauty; but its application in this instance by Rumohr is not equally felicitous, it is even in manifest contradiction with what he elsewhere says of the kind of merit which peculiarly characterises the Umbrian school.[11] A certain naive purity may, indeed, be common to it, and to the productions of the best period of classical art; but in the works of Perugino and his disciples there prevails an element which I am tempted to call *seraphic*, and which is entirely independent of symmetrical arrangement. It is this element, introduced for the first time into art by Christianity, which gives the pictures of the Umbrian artists such a superiority over all others, and produces the effect of a fine poem on minds capable of appreciating this order of beauty. The enthusiasm of the spectator depends, therefore, on feelings which place him more or less in harmony with the object before him. Every imagination endowed with sufficient activity creates a world for itself, and seeks among the productions of the fine arts beings with which to people it. The admirer of antiquity delights in all that recalls to his mind the robe of the senator or of the archon, the bas-reliefs of Trajan's column, or the Parthenon. The philosopher of Nature will extol the Florentine or the Venetian school, according to the more or less religious tendency of his system; and if we may hazard a conjecture on the subjects most congenial to the executioner, the butcher, or the low voluptuary, we should point to images of torture, or the nudities which abound in modern art collections, as objects of their predilection.

The pious solitary, also, creates to himself a world beyond the narrow limits of his cell; and if, in order to people it, he were called upon to choose between the productions of the different schools which have divided the domain of art, his choice would instinctively fix itself on that of Perugino; and if he were further required to name the artist who had most excelled in graceful contours and ideal forms, the palm would undoubtedly belong to Raphael, but only up to the period of his defection, the deplorable consequences of which we shall shortly have to notice in another chapter.

10. Rio here cites Karl Friedrich Rumohr, *Italienische Forschungen,* 3rd thesis, pp. 81, 82.—Ed.
11. [*Ibid.*] *Ein saehnsuchtvoll schwarmerischer Ausdruck welcher die Umbrischen Gemälde von deuin anher Schulen unterscheidet.*—It would be impossible to characterise this school with greater felicity or precision.

ÉTIENNE-JEAN DELÉCLUZE

"The Beards" of 1800 and
"The Beards" of Today (1835)

Étienne-Jean Delécluze (1781–1863) is best known as a journalist, writing for the *Journal des débats* from 1819 to the end of his life. As a boy he studied in the studio of David but, although he later gave drawing lessons, he was never able to become successful at painting. His education had been made difficult by the Revolution, but he followed a well-disciplined course of self-instruction in ancient and modern literature and philosophy. He became interested in English literature and was much influenced by the introduction of German thought by Mme. de Staël and others, and he eventually published translations of Dante and criticism of Italian literature.

Delécluze was central in a group of young intellectuals who considered themselves Romantic in outlook but were opposed to all excess, either aesthetic or political. Their views were liberal and tolerant, with primary concern for intellectual freedom and individual liberty, regardless of the kind of political system. Above all they believed in the importance of rational discourse and the analytical examination of seeming problems. As historians, they attempted a dispassionate study of works and events, avoiding the treatment of history as heroic activity or national glory.

Through his many years as a thoughtful critic, Delécluze concerned himself chiefly with art and opera, with some criticism also of literary works. He published *Mademoiselle Justine de Liron,* a novel, in 1832.

This translation was made from the appendix to *Louis David, son école et son temps, Souvenirs par M.E.J. Delécluze* (Paris: Didier, 1885), pp. 420–38. ✵

I have always been clean shaven. However, I had earlier—and still have to-day—friends who had and have a mania for wearing a beard and dressing in a strange and bizarre fashion. They go to great pains, in other words, not to seem to be of their country, their century, or their time. Among these friends and acquaintances were and still are some men who lack neither wit, nor merit or even talent. The extravagancies of fools do not interest me, of course, but

those of persons of a certain quality, I observe them, I study them even willingly and with care, the way one listens more attentively to the false pitch of an instrument that he would like to put in tune.

I have had two generations of bearded friends. The one from 1799 to 1803, the other from 1827, I believe, until the present year, 1832. Let us go back and take a look at the history of the first group.

It has been recognized that the revolution which took place in the fine arts and in the science of antiquity in Europe preceded the great political revolution in France by some years. Heyne's and Winckelmann's serious studies of the writings and monuments of antiquity having brought the Greeks and Romans back into favor,[1] one can readily understand how this intellectual predisposition might have helped to shape the tendency of the political revolutionaries of 1789 to govern us and even dress us in the manner of Sparta or Rome. Whatever the case, the fact is that this fad of imitating the ancients caught on, if not with the keenest minds, at least with those who were most energetic and enterprising. The imitative arts, theater, literature in general, and everything right down to furniture all manifested this furor to imitate first the Romans and, later, the Greeks. It was some time after the Terror that a knowledge of Greek vases—called Etruscan—became more familiar to artists, and it is from just that period that the taste for Greek forms and ornaments dates, and was applied to feminine fashions, the decoration of apartments, and the most common utensils.

My first bearded friends were from this time. Until then they shaved and dressed like everyone else. But it happened that David, of whom they were students as I was myself, had just exhibited his painting of the *Sabines*.[2] This work, which was much admired by the public, did not have the complete approval of some of the master's disciples. These young men first chanced some mild criticism, then more serious, until finally the judgment was made that, although the painting expressed every intention of following in the way of the Greeks, there was nothing in it so simple, grand, *primitive* finally—for this was the great word then—as in the paintings of Greek vases. As a result of this verdict, David was called by his heretical students Vanloo, Pompadour, and Rococo. (It should be noted that these nicknames, originated in the painting studios, are more than twenty-five years old.)

However, David could not accept such criticism of his work, coming even from his own school. Without making a fuss, he found a way to make it clear to those of his disciples for whom his lessons were no longer suitable that they should not disturb the studies of their former companions.

It was then that the sect of thinkers or primitives was formed; they were

1. Christian Gottlob Heyne (1729–1812) and Johann Joachim Winckelmann (1717–1768) were classical archaeologists.—Ed.
2. David's *Rape of the Sabines* (1794–1799) is now in the Louvre Museum, Paris.—Ed.

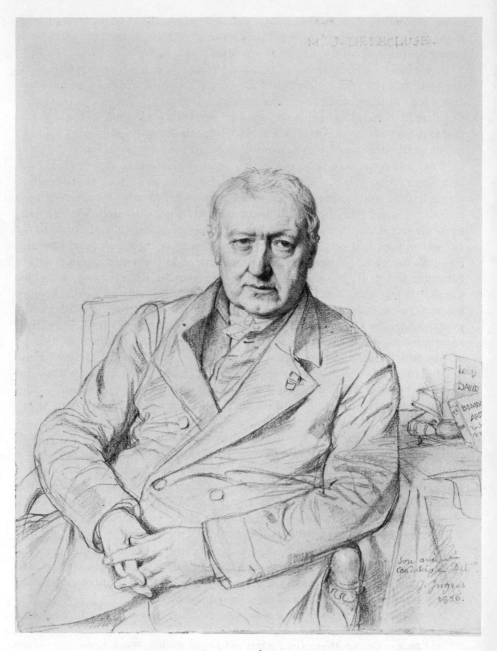

Jean–Auguste–Dominique Ingres, *Portrait of Étienne-Jean Delécluze,* 1856, graphite and white chalk on cream wove paper.

called by both names indiscriminately. Without yet speaking of the singular principles by which they intended to practice the art of painting, it was agreed within the group that, to assure themselves against the mannered and artificial habits of modern society, they would adopt Greek dress, and of Greek costume they would avail themselves only of that used in ancient Greece. For them, Pericles was another Louis XIV and his period already gave signs of decadence. In brief, they had their clothes made after the pattern of those worn by figures on Sicilian vases, considered to be the oldest of all, and let their hair and beards grow.

The number of those who were sufficiently strong of will and had the necessary means to carry on this fantasy was not large. It amounted to only five or six. But they excited considerable curiosity. Without a doubt there are still people in Paris who can remember having seen walking down the street, about 1799, two bearded young men, one dressed as Agamemnon, the other as Paris, in Phrygian dress. I was a friend of both, but especially of Agamemnon,[3] who came to my home rather often—to the astonishment of the doorman of the building and my neighbors.

Agamemnon was then about twenty years old. Tall, thin, with black bushy hair and beard, an intense look and an expression at once passionate and benevolent, he had a quality that was at the same time overpowering and attractive. One rediscovered in this man some of Mohammed and some of Jesus Christ, two personages for whom he had a profound veneration. Agamemnon, a very intellectual young man, had an easy, harmonious, and elegant way of speaking. Whether it was natural or was an acquired quality, he always displayed in the arrangement of his phrases and in his frequent use of the most brilliant comparisons and images that somewhat emphatic abundance that one notes in the discourses and writings of Orientals. However, his conversation was full, substantial, and varied. As for his costume, which consisted of a great tunic that came down to his ankles and a vast mantle with which he covered his head in case of rain or sun, it was very simple. I have seen few theater people, and I do not except even Talma, who wore this kind of dress with more grace and ease than did my friend Agamemnon.

One would have to believe that my basic character pleased Agamemnon, because I was far from sharing his exorbitant doctrines on the practice of the imitative arts. I did not even take the least precaution in contesting his opinions, although he was accustomed to have them recognized as law by his adepts and imitators. I saw him only once or twice in his studio. It was an immense room in which a canvas, thirty feet long, was placed diagonally. In the dark triangular space behind the canvas was some straw to sleep on and a few house-

3. Delécluze's friend Maurice Quay (1779?–1804).—Ed.

Pierre-Nolasque Bergeret, *The Barbus in David's Studio,* c. 1805, lithograph.

hold articles. The other triangle formed the studio proper, and it was here that I saw my friend Agamemnon setting his palette, which was four feet in diameter, in front of the canvas on which, only drawn in, was the subject of Patrocles sending Briseis back to Agamemnon, the king of kings.

This work was never even brushed in. Nevertheless, the painter Agamemnon was very assiduous, as opposed to his imitators, the *thinkers* and *primitives*. In the school of David he had made a rather large number of studies, to which he had given a stamp of truth, grandeur, and beauty that struck everyone. Since those days, and in the meantime my judgment has been formed by the comparison of a great number of paintings, I have had the opportunity of again seeing this young man's productions, and it is certain that they showed promise of his becoming a painter.

It was after he had declared himself the leader of the sect and abandoned David's studio that his ideas, already much exaggerated, became confused and brought him bit by bit to a state of permanent ecstasy and enthusiasm, which was tinged I believe with madness. But it was before this catastrophe that he

used to come to my home where we would get together with some of his friends and mine.

The familiar names of all the antique monuments which are admitted among those that may serve as models of study and the formation of taste are already well known. According to him, in order to cut short pernicious doctrines and stop the propagating of bad taste, it would be necessary to preserve only three or four statues in the museum of antiquities as it was and to burn down the painting gallery after having removed some dozen works at most. The basis of his system was to observe the antique but work only after nature. But he regarded imitation as only a very subordinate means and the most sublime beauty as the only true end of art.

Among the reasons that my company was agreeable to him despite our divergence of opinion on the nature and true end of art in our modern society, I supposed that a quite strong one was the rather extensive study of Greek language I was then engaged in. His literary tastes were quite as exclusive as his artistic doctrines. Just as in antique Greek art he esteemed only vase painting, statues, and bas-reliefs in the most ancient style, so far as writing was concerned he found true, solid, incontestable merit only in the Bible and the poems of Homer and Ossian.[4] He brought everything back to these three chief works and accorded attention to others only insofar as they related more or less to these three literary monuments. Agamemnon had made up for the drawback of a neglected education by his reading, generally well chosen, and read with rare intellectual penetration. He was well versed in knowledge of the Old and New Testaments; he had read, besides the translation of Homer's poems, those of all the Greek writers of the best period; and finally, he knew the French translation of Ossian almost by heart. I had the chance to note at that time how a small number of books, read with affection and intelligence, could render the mind happily fecund. Agamemnon gave me striking proof of this by his judgment, strongly exaggerated in its form, no doubt, but basically true. After having discussed Homer, one of our favorite subjects of conversation, the name of Sophocles came up, and his tragedies were passed in review with the respect due a disciple of Homer, a poet who had had the strength to preserve intact the high traditions of Greek antiquity. But unfortunately the name of Euripides escaped my lips. At this word my painter-friend Agamemnon jumped up furious and shouted disdainfully, "Euripides? Vanloo! Pompadour! Rococo! He is like Voltaire!"

4. In 1760, the Scottish poet James Macpherson published translations of heroic poetic fragments that he claimed to be by the third-century Gaelic bard, Ossian, son of Fingal, the king of Morven. The poems enjoyed enormous popularity in many countries, even though their origin was doubted. They eventually were proven to be the work of Macpherson himself.—Ed.

Originally his comrades in David's studio had nicknamed him Don Quixote. This suited him rather well, as can be seen. But what is worthy of note is the satisfaction that Agamemnon drew from being compared to this personage for whom he had respectful admiration and whom he placed, although at an immense distance, in the lineup of those, like Jesus Christ, who are born to accomplish great things but are ridiculed by men. Another irony, which he bore nonetheless with good grace, was the flaw that gave him the most unfavorable idea of the character of those who let themselves go.

My habit of always steering clear of mockery gave me a place quite within the good graces of Agamemnon. I remember one summer evening when we were together at my home. He had brought a separate translation of Ecclesiastes, a book of the Bible I had not yet had occasion to know. He read almost the entire work to me with a simplicity at once tender and majestic, and the recollection is vividly implanted on my memory. In thanking him for having introduced me to this beautiful work and for having read it to me in so touching a manner, I asked him if there were some books among those he saw about us from which he would like to know some fine passages. "Yes," he said shortly, "read me a bit from Homer, but in Greek! In Greek!" I do not know whether it was his beard and the strange dress he wore that created the illusion, or if it was the rapidity with which he manifested his desire that blocked all reflection at the moment, but I quickly chose a volume of Homer and read him in Greek the admirable description of the tempest from the fifth book of the *Odyssey,* which I was then studying. I read as if I were sure he was able to understand, and for his part he listened with all the attention and apparent satisfaction of a person who possessed a complete knowledge of the Greek language. When I had finished he appeared moved. He rose and, gravely placing his hand on my head, said in a tone expressing at once gratitude and regret at not seeing me more enthusiastic, "Poor child! Thank you. But you do not know your good fortune." I was none too sure where I stood, and I asked myself inwardly whether it was not preferable to be moved by the sound of Greek syllables rather than to understand reasonably the meaning of the words and phrases of the language. However, neither he nor I judged it appropriate to comment at too great a length on this strange reading, and the conversation soon settled on the poems of Ossian.

At that time no one doubted their authenticity. Some, like my friend Agamemnon, simply found them sublime, admirable; others judged them monotonous and sometimes boring. I was one of the latter. After numerous quotations from Fingal, quotations which gave me the opportunity to support my strictures with surer strength and justness, Agamemnon, quite insensible to the objections I had raised regarding his favorite poems, and disdainful even of responding to my criticism, told me with the grave authority and transport of a prophet, "Homer is admirable, but Genesis, Joshua, Job, Ecclesiastes, and the

Evangelists are much superior to the books of Homer, that is surely certain. But let me tell you," he added, with still greater emphasis, "Ossian surpasses them all in grandeur. And this is why: he is much more true—listen well—he is more *primitive!*" Since these statements had more the air of an exposition of dogma than of literary criticism, I replied nothing and shifted my unsure and doubtful glance like one who is inclined neither to approve an opinion he deplores nor contest an error that he considers foolishness. My perplexity increased even more my friend Agamemnon's assurance, and he, wrapped at the moment in his mantle, stroking his long beard, seemed to focus all his thoughts on a single point in order to reduce them to one thought, one firm, short phrase. "Homer? Ossian?" he demanded. "The sun? The moon? That is the question. Actually I think I prefer the moon. It is simpler, grander; it is more *primitive!*"

Such were more or less the opinions and the mode of discourse of the grand master of the men who wore beards in Paris during the last years of the eighteenth century, a man who, despite the eccentricity of his mind, captured the esteem, friendship and sometimes the temporary admiration of those who saw and heard him. As for the greater number of his imitators who were only timid *Greeks* or *primitives,* who never expressed their opinions except within the group, who put on false beards and tunics when they returned home in the evening to admire themselves in the mirror, who slept in the proximity of antique statues in the pretense of reflecting on art, and who spoke randomly of the sun and moon—of them we shall say nothing. It was that contemporary troupe of foolish and servile imitators such as are supplied by every epoch.

It is a common occurrence, sad but useful to recognize: from such imaginative efforts, such extraordinary, even original, conversations, what remains? Nothing; not a work of painting, not even a historical notice, a letter of the time proving that I have not here been telling a fabricated story!

This sect of *thinker-primitive* artists was the most acute and most boldly projected point of the kind of cone that then encompassed society. It was under the Directoire and during the Consulate. From the end of the Terror, the taste for antique art had replaced religious sentiments for the moment, as well as all the other social and literary interests that had engaged the spiritual and intellectual faculties before the Revolution. France was presenting itself a performance of paganism. All classes were lost in the shows and surrounded by pleasure. In the public parks, women, dressed in Greek styles, showed off the grace and beauty of their figures. All young men, from the poorest to the wealthiest, daily exposed their naked limbs on the banks of the Seine, rivaling each other in their strength and skill in swimming. In the Bois de Boulogne, each evening in summer, there was a famous match of *barres*. On holidays there were foot, horse, and chariot races in the Champ-de-Mars, all in Greek style. In public ceremonies one saw high priests in the manner of Calchas, urn bearers as

in Parthenon friezes, and more than once I saw, in the great squares of the Champs-Élysées, pitch-resin instead of incense burning before a cardboard temple copied from those at Paestum. All classes of society mixed, strolled, laughed, danced together under auspices of the only true aristocracy then recognized in France: beauty.

In truth, the story of my friend Agamemnon's *beard* is a summary of the time in which he lived, for he died young and his death coincided with the end of the saturnalias initiated by the Directoire.

With Agamemnon dead, all his fellow members shaved their beards, put on their stockings, and wore once again the despised frock coat. Bonaparte was already there with his three-cornered hat and his sword at his side.

I would not speak of some twenty or so little hairbrained sorts, clumsy imitators of Agamemnon's sect, had they not worn beards. But since they did not shave and dressed in a slovenly Greek or Scandinavian fashion, they have a right to be included in the present discussion. These people, although they spent most of their time in ecstasy before Etruscan vases—because they, too, were painters—befuddled their minds especially with Ossianic poems and mythology. They all lived in Paris, but they spoke constantly of the sound of the sea breaking on the rocks and of the forests of Morven. One evening, after having drunk a little too much beer—which they preferred to wine because it was more Ossianic—they determined with one accord to leave the city of vice, Paris, to live in the woods. They departed with the most extravagant of the lot at their head carrying a guitar that served in lieu of the bards' harp. Finally they arrived on foot at the Bois de Boulogne and began to declaim and even to sing the prose of Le Tourneur.[5] It was autumn. Our inspired souls had not thought of the fact that night comes on quickly and that evenings are cool in that season of the year. Surprised by the darkness and cold, they decided in an excess of enthusiasm to act exactly like the heroes of Ossian. After striking a light they tried to set fire to a tree. But the flames had hardly begun to glow when the police, alarmed by the fact that a fire was breaking out, rushed to the spot, arrested all the Parisian bards, and took them to the police station, where they were released only after having shaved.

Since then, 1802, until 1825–26, except for the army sappers, no one has walked the streets of Paris unshaven. It is only from the later date I have indicated, from the time Lord Byron's death in Greece made fashionable here the deliverance of that unhappy country,[6] that young Parisians engaged in literature and the arts are to be seen letting their mustaches grow, wearing little Oriental

5. Pierre Prime Félicien Le Tourneur (1737–1788), translator of numerous English literary works into French, including Macpherson's Ossianic poems.—Ed.

6. George Gordon, Lord Byron (1788–1824), died at Missolonghi, Greece, where he had gone to support the Greek cause in the war against Turkey.—Ed.

caps, and smoking Turkish pipes while stretched out in their armchairs and sofas.

The revolution that Heyne, Winckelmann, and Hamilton provoked in 1772 by their works,[7] to restore antiquity and ancient art to an honorable place and erect a barricade against the depraved taste then dominating Europe, Lord Byron cut short by his works, substituting quite another. He imposed on the men of his time a very personal—eccentric, as the English say—taste, which was nothing more than the at once energetic and fashionable fantasies of the author of *Lara* and *Don Juan* himself. Since 1824 everything produced in prose, verse, and painting, in the theater or novels, in the style given to apartments and the forms of furniture—all has suffered the effect and does so still of this fantastic, cruelly impartial, and mocking caprice that delights in strangling the good and beautiful with the bad and ugly; of that caprice which in a single act appreciates and debases every being, every object, and every thing; finally, of that powerful caprice—it is truly satanic—that stamped the works of Lord Byron with their sublime beauties and their grievous faults. Still today it is the capricious force of that man that fills the sails of vessels—frail barques to great ships—in which our writers and artists launch themselves on the poetic ocean.

The impulse that Lord Byron gave to letters and art, although excessively strong, struck only a glancing blow, if I may be permitted the phrase, and so cannot have a lasting effect. In fact, experience has already proved the truth of what I say. From the imitation of the works of this poet, in which he delighted in depicting the reveries of fantastic characters whose country, name, or precise misfortunes are not even known, we were not slow to pass to imitating Sir Walter Scott[8] (because we French always need someone to push us in order to change our course). We were not slow, I say, to throw ourselves into a pastiche of medieval works. Chronicles have been composed for the twelfth, thirteenth, and fourteenth centuries; the language of Rabelais has been counterfeited, with the regret that it is impossible to revive that of Joinville and Villehardouin;[9] and, not content with bringing back to light these curiosities of the old style, old manuscripts have been searched and their miniatures studied to give the surcoat, the purse, and the pointed shoes the greatest possible degree of reality in the imitations that must be made from them.

In the Middle Ages, men wore beards. The infatuation of Paris for the modern Greeks had already introduced the use of the mustache. Then one allowed a

7. Gavin Hamilton (1723–1798), British neoclassical painter inspired by the study of antique vase painting.—Ed.

8. Sir Walter Scott (1771–1832), author of such popular works as *Waverly, The Antiquary, The Bride of Lammermoor, Kenilworth*, and *The Talisman*.—Ed.

9. François Rabelais (1494?–1553) is best remembered for his *Gargantua and Pantagruel*. Jean, Sire de Joinville (1224–1317), and Geoffroi de Villehardouin (1150?–1212?) were early French chroniclers.—Ed.

little "royale" to grow [a small beard under the lip], and then, a bit later, it was decided to wear a complete beard.

It was in studying with confused devotion the paintings on Etruscan vases and antique statuary that my friend Agamemnon and his imitators came to dress in a Greek manner and let their beards grow. In a later fashion, the four or five years just past, all those who have curiously investigated the center axis of ogival windows, who have been enamored of the costumes from the time of Charles VI, who have studied the symbolic and enigmatic little demons sculptured on cathedrals, who have nourished their minds on Dante's *Inferno* and the kind of infernal mythology introduced into Europe by Catholicism and chivalry—all these, having learned from manuscripts and the miniatures that decorate them that the men who lived at the time when all these things were invented, sung, painted, and loved, wore beards, have let their own grow and, insofar as fashion and propriety would allow, have even worn—and still wear— outfits made and decorated like those worn in the Middle Ages.

However, it must be said that the *gothiques* of 1832 are not such sincere enthusiasts of the Middle Ages as the *antiques* of 1799 were of Homeric Greece. It is not the costume of the period of Alexander or even of Pericles that was adopted by my *primitive* painter, but that of Agamemnon, of Calchas.

How shameful for writers, painters, and even a good number of fashionable people today who are taken with the Middle Ages: instead of being seen in the clothing of the twelfth and thirteenth centuries, the heroic period of chivalry, they adopt the dress (imperfectly copied at that) of Henry III and take on the appearance of somber and preoccupied valets!

But this difference can be explained in a word: our people who are mad for the Middle Ages are not so stupid as they would like to appear, and as much out of necessity as of taste, wear white gloves and frequent salons. My poor friend Agamemnon regarded society with horror because there he encountered frock coats and lace bonnets, and he dressed in a Greek fashion with the intention of regenerating the habits, tastes, and even mores of his contemporaries.

If one puts aside the degree of good faith or foolishness of the one or the other and considers this mania, which has existed in Europe since Luther's reformation, to *restore* manners, beliefs, government, tastes, arts, and even dress based on the old styles rendered obsolete by time and progressive improvement, one is astonished that these attempts, which have had slim success and produced few good results, should still periodically captivate all the young minds in each generation. The comic aspect of the thing is to observe the later mad enthusiasts very justly and reasonably mock those who came before. Just so, I remember my friend Agamemnon holding his sides with laughter on hearing the account of a dinner in which Mr. Dacier, the translator of Homer under Louis XIV, almost poisoned his friends with a black broth prepared in the Lacedaemonian fashion. Those of our readers who wear a pointed beard

and fitted vest, as seen in 1581 at the marriage of the Duke of Joyeuse, will not fail to exclaim at the inconceivable folly of poor Agamemnon and the members of his sect.

"But that's just a story spun by the author," they will say. "How could men, if they were not raving mad, maintain the idea of reviving the ideas, customs, and dress of Greek paganism in a Christian country? Such ideas were entirely contrary to our religious beliefs. The practices of Greek sculptors and the whole *artistic* system of antiquity, based on a mythology and on ideas of morality as petrified today as the statues that bear signs of them, are no longer in harmony with our religious and national customs!" "That is true without a doubt," another will say, who has gone to great pains to assume the pale and disheveled look of the Chevalier Bertram in *Robert the Devil*. [10] "Those men were crazy, with their antique Greece and their opera costumes. But everything in art was theatrical then. Nothing was natural, because people looked outside our religion, outside our country, outside our customs for the principle of everything they did and said. We are Christians; let us be more precise, we are Catholics. True modern civilization dates from the Middle Ages. It was born with the ogival monuments, with religious and chivalric poems of the Round Table and Dante. Our imagination finds sympathy in giants, dwarfs, angels, fairies, devils, ghosts, and Satan. That is the period to which we must return in order to resume the true way, lost to us by the writers and artists of the supposed renaissance under François I and of *classicism* under Louis XIV. Then we shall be really original and natural in our productions, and if we cling to it with no matter how little skill, we shall succeed in being naïf, you can depend on it."

What is curious and amusing, in comparing the actions and pronouncements of the beards of 1799, with those of the beards of 1832, is to note the analogies that are to be found in even the smallest details in the opinions of the two sects. Homer stands for one group as Dante does for the other; the earlier wanted to become *primitive,* the later modestly aspire to naïveté. My friend Agamemnon accepted as architecture only the temples of Sicily and Paestum, and as models for painting, only Greek vases; the *naïfs* of our day study religiously only the Cathedral of Cologne, paintings of the first German school, and vignettes of the oldest manuscripts. The *naïfs* of today have even found an analogue for the northern, misty poems of that poor Ossian, now so totally forgotten, in the medieval English and Scottish ballads published by Percy and put to use by Walter Scott. [11]

Without even considering the beard, these similarities are striking.

But let us return to the beard and carefully examine the influence that it

10. *Robert Le Diable* (1831), an opera by Giacomo Meyerbeer (1791–1863).—Ed.
11. Thomas Percy (1729–1811). His *Reliques of Ancient English Poetry,* published in 1765, had great influence on both English and Continental verse.—Ed.

exerted over the merit, talent, and production of the *primitives* who wore it in 1799, and then look at the advantages that the bearded *naïfs* of 1832 have derived from it. In the earlier period we saw that my friend Agamemnon and his fellows produced nothing, left no work behind to mark their passage in this world, while the two Chéniers, and such as Ducis, Delille, Parny, David, Girodet, Chateaubriand, L. Lemercier, Gérard, Gros, Ingres, Hersent, and others,[12] who were clean shaven, have not lacked merit and have given us works that, although not made to be fashionable, created and continue to create quite a stir in the world.

The beard in 1799, then, was an indication of virtue one wished to possess, of the genius with which one believed oneself endowed, but not at all proof of a real or acquired talent.

Then I note that at the present, beyond those living whom I have named above, La Mennais, Lamartine, Casimir Delavigne, Victor Hugo, Prosper Mérimée, Sainte-Beuve, Alfred de Vigny, Robert, Schnetz, Paul Delaroche, Horace Vernet, Champmartin, Eugène Delacroix, the Johannot brothers, and others—all shave.[13]

To wear a long beard, then, when everyone else shaves, is not, as some would today believe, a sure means of becoming naïf or original, of having true talent, robust or poetic, and of giving a new and fruitful direction to letters and the arts. It simply indicates that one aspires to those qualities, this merit, and often enough believes that one possesses them indeed.

In every country and among all peoples, the beard worn by isolated men in the midst of a beardless population has always been an unmistakable sign of a desire on their part to restore, to regenerate some old customs or ancient tastes that time has exhausted. From the time that Octavian Augustus adopted the habit for himself of shaving every day and passed on the custom to the high society of Rome, all the philosophy merchants, everyone who trafficked in

12. The two Chéniers are, presumably, Louis de Chénier (1723–1796), French historian, and Marie Joseph Blaise de Chénier (1764–1811), French dramatist, poet, and politician. Jacques Delille (1738–1813), French poet and translator of Virgil; Evariste Désiré De Forges, Vicomte de Parny (1753–1814), French poet; Anne-Louis Girodet de Roucy-Trioson (1767–1824), French history painter; Louis Jean Lemercier (1771–1840), French dramatist and poet; François Gérard (1770–1837), French history painter; Baron Antoine Jean Gros (1771–1835), French painter; Louis Hersent (1777–1860), French painter.—Ed.

13. Hugues de Lammenais (1782–1854), French publicist; Alphonse de Lamartine (1790–1843), French poet, historian, and statesman; Jean-François Casimir Delavigne (1793–1843), French dramatist; Victor Hugo (1802–1885), French Romantic writer; Prosper Mérimée (1803–1870), French novelist and dramatist; Charles Augustin Saint-Beuve (1804–1869), French critic; Alfred de Vigny (1797–1863), French novelist and poet; Hippolyte Paul Delaroche (1797–1856), French painter; Émile Jean Horace Vernet (1789–1863), French history painter; Eugène Delacroix (1798–1863), French painter; the Johannot brothers, Charles Henri Alfred (1800–1837) and Tony (1803–1852), both French engravers, painters, and book illustrators.—Ed.

rhetoric and verse in the city—even down to those little diehard peevish repub-
licans who, under the emperors, parodied Cato the Elder and Regulus—all
tinted their faces with cumin water until they were quite yellow, wore a beard,
and carried a staff and dagger to affect the air of being more virtuous and better
citizens than the rest.

Men's follies change in form; basically they are always the same.

CHARLES BAUDELAIRE

What Is Romanticism? (1846)

EUGÈNE DELACROIX

Journals (1824–1847)

Charles Baudelaire (1821–1867) is better known as a poet and essayist than as a critic of art. In his occasional writings on art, he was primarily interested in the expressiveness of themes and their treatment rather than in the technical or theoretical aspects of artistic creation. Above all else, Baudelaire admired art that revealed the feelings and thoughts of a great artistic personality, and he perceived these qualities in the work of Eugène Delacroix (1798–1863). Baudelaire considered such an artist as an exemplary individual dedicated to the pursuit of beauty and truth, worthy of emulation. Baudelaire's Salon reviews of 1845 and 1846 were early manifestations of these attitudes toward art, which persisted throughout his career. His later alliances with the "art for art's sake" movement, which brought him into the sphere of Whistler, were logical extensions of this aesthetic philosophy.

Delacroix's love of poetry was no less intense than Baudelaire's passion for art. "Delacroix has an affection for Dante and Shakespeare, two other painters of human sorrow," wrote Baudelaire: "he knows them thoroughly and knows how to translate them freely." The names of Baudelaire's favorite poets appear with frequency in Delacroix's journals, inspiring musings about art, society, and the nature of man. Delacroix's impassioned, at times anguished, art appealed to the moral dimension of his audience, and it revitalized traditions of the great Italian and Flemish masters.

Baudelaire's essay on Delacroix was translated from *Curiosités esthétiques* (Paris: Louis Conard, 1923), pp. 89–121. Delacroix's journal entries were translated from the first volume of *Journal d'Eugène Delacroix 1822–1852*, edited by André Joubin (Paris: Librairie Plon, 1950), 1:42, 53, 73–74, 95–97, 102–4, and 194–96. 🐾

Édouard Manet, *Profile Etching of Charles Baudelaire* (state 2), c. 1862.

CHARLES BAUDELAIRE: WHAT IS ROMANTICISM?

Few people today will want to give a real and positive meaning to this word; yet will they dare to say that a generation has carried on a battle for several years for the sake of a flag that symbolizes nothing?

When one recalls the troubles of these recent times, one will realize that if few romantics remain, it is because few really discovered romanticism, even though all sought it sincerely and steadfastly.

Some applied themselves only to the choice of subjects; they had not the temperament for their subjects. —Others, still believing in a Catholic society,

sought to reflect Catholicism in their works. —To call oneself a romantic and to look systematically to the past is to contradict oneself. —These, in the name of romanticism, blasphemed the Greeks and the Romans, but Romans and Greeks can be made romantic if one is romantic himself. —Truth in art and local color misled others. Realism had existed for a long time before this battle, and besides, to compose a tragedy or a picture to the taste of M. Raoul Rochette is to expose oneself to a possible rejection by the first viewer—if he is more learned than M. Raoul Rochette.[1]

Romanticism is precisely located neither in the choice of subject nor in exact truth, but in the mode of feeling.

They looked for it outside themselves, and it is only to be found within.

For me, romanticism is the most recent, the most up-to-date, expression of the beautiful.

There are as many kinds of beauty as there are habitual ways of seeking happiness.[2]

The philosophy of progress explains this clearly; thus, just as there have been as many ideals as there have been ways for conscientious people to understand morality, love, religion, etc., so romanticism will not consist in a final perfect formulation, but in a conception analogous to the moral philosophy of the time.

It is because some have based it on the perfection of technique that we have had the rococo of romanticism, without question the most intolerable of all.

It is necessary then, first of all, to know those aspects of nature and of the human situation that artists of the past have disregarded or not known.

Who says romanticism, says *modern art*—that is, intimacy, spirituality, color, aspiration toward the infinite, expressed by every means at the disposal of the arts.

From this it follows that there is an obvious contradiction between romanticism, and the works of its chief partisans.

Is it a surprise that color should play such a very important part in modern art? Romanticism is a child of the North, and the North is colorist; dreams and fairy tales are children of the mist. England, that country of fanatical colorists, Flanders, and half of France are all plunged in fog; Venice herself is bathed in lagoons. As for the Spanish painters, they are more devoted to contrast than to color.

The South, on the other hand, is naturalist, because there nature is so beautiful and bright that, with nothing left to desire, man can find nothing more beautiful to invent than what he sees.

Here art is of the out-of-doors; several hundred leagues to the north it is

1. Raoul Rochette (1789–1854), a systematic archaeologist.—Ed.
2. Baudelaire acknowledges Stendhal as the source of this statement.—Ed.

made up of studio dreams and the faraway look of the imagination lost on the grey horizon.

The South is as brutal and positive as a sculptor even in its most delicate compositions; the North, suffering and restless, consoles itself with the imagination, and if it turns to sculpture, will more often be picturesque than classical.

Raphael, for all his purity, is but a material spirit ceaselessly investigating the solid; but that scoundrel Rembrandt is a potent idealist who makes us dream and imagine the beyond. The one composes creatures in a pristine and virginal state—Adam and Eve; but the other shakes tatters before our eyes and tells us of human sufferings.

However, Rembrandt is not a pure colorist, but a harmonizer. How novel then would be the effect, and how admirable the romanticism, if a powerful colorist could render our dearest feelings and dreams in color appropriate to the subjects!

Before going on to examine the man who up to the present is the most worthy representative of romanticism, I should like to set forth a series of reflections on color, which will not be without use for the complete understanding of this little book.

ON COLOR

Let us suppose a beautiful expanse of nature, where everything is freely green, red, dusty, or iridescent; where all things, variously colored in accordance with their molecular structure, changing from moment to moment in the shifting light and shade, agitated by the force of internal heat, exist in perpetual vibration that makes the lines tremble and fulfills the law of eternal and universal movement. An immensity that is sometimes blue and often green, extends to the edge of the sky: it is the sea. The trees are green, the grass is green, the moss is green; green entwines the tree trunk, and the unripe stalks are green; green is the basis of nature because green goes readily with all other colors.[3] What strikes me first of all is that everywhere—poppies in the grass, pimpernels, parrots, etc.—red sings the glory of green; black—when it exists—a solitary and insignificant cipher, intercedes on behalf of blue or red. Blue—that is, the sky—is cut by airy white flecks or gray masses which pleasantly temper its bleak crudeness; and as the atmosphere of the season—winter or summer—bathes, softens, or engulfs the contours, nature seems like a top which spins so rapidly that it appears gray, even though it is composed of all colors.

3. Except its components, yellow and blue. However, I refer here only to pure colors. This rule is not applicable to transcendent colorists who have a profound knowledge of the science of counterpoint. [Certainly Baudelaire demonstrates here some knowledge of Chevreul's color theories, first published in 1839, for he utilizes much of Chevreul's terminology.—Ed.]

The sap rises and, through a mixture of principles, expands in *mixed tones;* trees, rocks, and granite masses gaze at themselves in the water and cast *reflections;* transparent objects pick up passing light and color from near and far. As the orb of day alters its position, tones change in value but, always respecting their natural sympathies and antipathies, continue to live in harmony by making reciprocal concessions. Shadows slowly shift and put colors to flight or block them out, while light, also changing, makes them vibrate anew. These colors in the sun interchange their reflections and, by modifying their own characteristics by "glazing" them with borrowed transparent qualities, infinitely multiply their melodious marriages and match harmony ever easier. When the first great brazier of the sun drops into the sea, red fanfares burst forth on all sides; a bleeding harmony breaks upon the horizon, and green turns richly purple. But soon immense blue shadows rhythmically sweep before them the host of orange and delicate rosy tones which are like the faraway, faint echo of the light. This great symphony of today, which is the eternal variation of the symphony of yesterday, this succession of melodies whose variety springs continuously from the infinite, this complex hymn is called *color.*

In color are found harmony, melody and counterpoint.

If one examines the detail within the detail in an object of medium size—for example, a woman's hand, a bit pink, rather slender, with the finest skin—one will see that there is perfect harmony between the green of the strong veins with which it is furrowed and the rosy tones that mark each joint; rose-colored nails stand out on the fingertips, which are also toned gray and brown. As for the palm of the hand, the lifelines, pinker and almost wine-colored, are separated from one another by the system of green or blue veins that run across them. A study of the same object, made with a magnifying glass, will show within however small an area a perfect harmony of gray, blue, brown, green, orange, and white, warmed by a touch of yellow—a harmony that, when combined with shadows, produces the effect of modeling for the colorist, which is essentially different from that of the draftsman, whose difficulties are reduced more or less to those of copying a plaster cast.

Color is thus the accord of two types of color. Warm color and cool color, on whose opposition all theory is based, cannot be defined in an absolute manner; they exist only in a relative sense.

The magnifying glass is the colorist's eye.

I do not mean to conclude from all this that a colorist should proceed by means of a minute study of commingled tones in a very limited space. For if you admit that every molecule is endowed with its own particular tone, it would follow that matter is infinitely divisible; and besides, since art is only an abstraction and a sacrifice of detail to the whole, it is important to concern oneself above all with *masses.* I merely wished to prove, if the case is possible, that

tones, regardless of how many they might be, so long as they are logically juxtaposed, will blend naturally in accordance with the law that governs them.

It is because of chemical affinities that nature cannot make mistakes in the arrangement of tones; for nature, form and color are one.

Nor can the true colorist make mistakes; and everything is allowed him, because he has known from birth the whole range of tones, the strength of tone, the results of mixtures, and the whole science of counterpoint; and thus he can produce a harmony of twenty different reds.

This is so true that if an anticolorist landowner took it into his head to repaint his property in some absurd manner and in a discordant system of colors, the thick and transparent varnish of the atmosphere and the learned eye of Veronese would put the whole thing right and produce a satisfying ensemble on canvas—conventional, no doubt, but logical.

This explains how a colorist can be paradoxical in the way he expresses color, and how the study of nature often leads to a result entirely different from nature.

The air plays such an important part in the theory of color that if a landscape painter were to paint the leaves of a tree just as he sees them, he would arrive at a false tone, considering that there is a much smaller expanse of air between the spectator and the picture than between the spectator and nature.

Falsehoods are continually necessary, even in order to create a *trompe-l'oeil*.

Harmony is the basis of the theory of color.

Melody is unity within color, or the coloring in general.

Melody requires a cadence; it is an assembly in which all the individual effects merge in one general effect.

Thus melody leaves a profound impression on the mind.

Most of our young colorists lack melody.

The right way to know if a picture is melodious is to look at it from far enough away to make it impossible to understand either its subject or its lines. If it is melodious, it already is meaningful and has already taken its place in the repertory of memories.

Style and feeling in color come from choice, and choice comes from temperament.

There are colors that are gay and playful, playful and sad, rich and gay, rich and sad, commonplace and original.

Thus Veronese's color is calm and gay. Delacroix's color is often plaintive, and M. Catlin's color often carries a quality of terror.[4]

4. George Catlin (1795–1872), the American painter of Indians, exhibited some of his paintings in the Salon of 1846. Baudelaire discusses them in depth later in his critique.—Ed.

For a long time I have had outside my window a tavern painted half and half in crude red and green, which has been for my eyes a delicious pain.

I do not know if any analogist has ever absolutely established a complete scale of colors and feelings, but I remember a passage in Hoffmann that expresses my idea perfectly and that will appeal to all those who sincerely love nature: "It is not only in dreams, or in that mild delirium that precedes sleep, but is even awakened when I hear music: I find an analogy and an intimate connection between colors, sounds, and perfumes. It seems to me that all these things were engendered by the same ray of light, and that they must be reunited in a marvelous concert. The smell of brown and red marigolds especially produces a magical effect on my being. It throws me into a deep reverie, and I hear, as if in the distance, the solemn, deep tones of the oboe."[5]

It is often asked if the same man can be at once a great colorist and a great draftsman.

Yes and no; for there are different kinds of drawing.

The quality of a pure draftsman consists above all in precision, and this precision excludes the "touch"; there are such things as happy touches, and the colorist who undertakes to express nature through color would often lose more by suppressing his happy touches than by attempting a greater austerity of drawing.

Certainly color does not exclude great draftsmanship, that of Veronese, for example, which depends above all on ensemble and mass; but it does exclude the drawing of detail, the contour of the little part, where the touch will always eat away line.

The love of air and the choice of subjects in movement call for the use of flowing and blending lines.

Artists who only draw act according to an opposite yet analogous procedure. Alert to follow and surprise the line in its most secret undulations, they have no time to see air and light, that is to say, their effects; they even force themselves not to see them in order not to conflict with a principle of their school.

One can be both a colorist and a draftsman, but only in a certain sense. Just as a draftsman can be a colorist in his broad masses, so a colorist can be a draftsman through the complete logic of his linear composition; but one of these qualities always absorbs the detail of the other.

Colorists draw like nature: their figures are defined naturally by the harmonious interplay of colored masses.

Pure draftsmen are philosophers and abstractors of quintessences.

Colorists are epic poets.

5. E.T.A. Hoffmann (1776–1822). Baudelaire notes this as from *Kreisleriana*.—Ed.

EUGÈNE DELACROIX

Romanticism and color lead me straight to Eugéne Delacroix. I do not know if he is proud of his title of romantic, but his place is here, because for a long while—even from his very first work—the majority of the public have placed him at the head of the *modern* school.

As I begin this section, my heart is full of serene joy, and I purposely select my newest pens, so great is my desire to be clear and limpid, so content do I feel in embarking on my most cherished and sympathetic subject. But in order that the conclusions of this chapter be well understood, I must go back some distance in the history of this period and place before the eyes of the public certain documents which, although already cited by earlier critics and historians, are necessary for the completeness of my demonstration. Besides, it is not without keen pleasure that the true admirers of Eugène Delacroix will reread an extract from the *Constitutionnel* of 1822, taken from the *Salon* of M. A. Thiers, the journalist.[6]

No picture more clearly reveals the future of a great painter, in my opinion, than that of M. Delacroix representing Dante and Virgil in the Underworld. Here above all you can recognize that burst of talent, that spirit of *naissant* superiority which revives our hopes, a bit discouraged by the too moderate worth of all the rest.

Dante and Virgil, conducted by Charon, are crossing the infernal stream and with difficulty fend off the crowd that swarms around the barque in order to clamber aboard. Dante, shown as a living man, bears the dreadful taint of the place; Virgil, crowned with somber laurel, exhibits the colors of death. The wretched creatures, doomed eternally to crave the opposite bank, cling to the boat. One has clutched at it in vain and, thrown backwards by his precipitate effort, is plunged once more into the waters; another clings to it and pushes away with his feet those who, like himself, want to get on board; two others grip with their teeth at the timber that eludes them. There you have all the egoism and despair of Hell. In this subject, which borders so closely on exaggeration, one finds however a severity of taste, an appropriateness of setting that in its way enhances the design, though severe judges—but ill advised in this case—might criticize it for a lack of nobility. The brushwork is broad and firm, the color simple and vigorous, although a trifle raw.

Besides that poetic imagination which is common to both painter and writer, this artist has artistic imagination, what one might in some ways call "graphic imagination," which is quite different from that of the writer. He thrusts his figures, groups them and bends them at will with the boldness of Michelangelo and the fertility of Rubens. An indefinable reminiscence of the great painters takes hold of me at the sight of this picture; in it I find that savage power, ardent but natural, which yields without effort to its own impulse. . . .

I do not think I am wrong: M. Delacroix has been given genius. May he carry this

6. Marie-Joseph-Louis-Adolphe Thiers, *Salon de mil huit cent vingt-deux* (Paris: Maradon, 1822), pp. 56–57. Baudelaire probably specified "Thiers journaliste" to disassociate himself from Thiers's most recent political activity.—Ed.

promise forward; may he undertake immense works, an indispensable condition for talent. And that which should give him still more confidence is the fact that the opinion I am expressing here on his account is also that of one of the great masters of the school.

A. T——rs.

These enthusiastic lines are truly staggering, as much for their precocity as for their boldness. If the editor-in-chief of the journal had pretensions himself as a connoisseur of painting, as it may be presumed he had, the young Thiers must have seemed to him a trifle mad.

To obtain a proper idea of the profound disturbance of mind that the picture of *Dante and Virgil* must have produced at the time—the rage, the outcry, the insults, the enthusiasm and bursts of insolent laughter that surrounded this fine picture, true signal of a revolution—it must be remembered that in the studio of M. Guérin,[7] a man of great worth but a despot and absolutist like his master David, there was only a small group of pariahs who devoted themselves to the old masters on the side and dared shyly to conspire in the shadow of Raphael and Michelangelo. There was as yet no question of Rubens.

M. Guérin, who was harsh and severe toward his young pupil, only looked at the picture because of the clamor that raged around it.

Géricault,[8] who had returned from Italy and, it was said, under the impact of the great Roman and Florentine frescoes, had given up some of his quite original qualities, complimented the new, still timid painter so warmly that he was almost overcome.

It was in front of this painting, or some time afterward, in front of the *Pest-Stricken of Scio*,[9] that Gérard himself, who seems to have been more a wit than a painter, cried, "A painter has just been revealed to us, but he is a man who runs along the rooftops!" —To run along the rooftops you need a firm step and an eye sparked by an interior light.

Let glory and justice be accorded to MM. Thiers and Gérard!

The interval that separates *Dante and Virgil* from the paintings in the Palais Bourbon is no doubt lengthy; but the biography of Eugène Delacroix is poor in incident.[10] For such a man, so endowed with courage and passion, the most interesting struggles are those he has to maintain against himself; horizons need not be vast for battles to be important, and the most curious events and

7. Baron Pierre-Narcisse Guérin (1774–1833).—Ed.
8. Théodore Géricault (1791–1824).—Ed.
9. I write 'pest-stricken' instead of 'massacre' in order to explain to the astonished critics the often criticized flesh tones. [Baron François Gérard (1770–1837), a very successful follower of David.—Ed.]
10. Delacroix was commissioned in 1838 to decorate the Library of the Palais Bourbon, the seat of the Chamber of Deputies. The work was completed in 1847.—Ed.

revolutions take place beneath the heavens of the cranium, in the close and mysterious laboratory of the brain.

Now that the man had been duly revealed and continued to reveal himself more and more (in the allegorical picture *Greece, Sardanapalus, Liberty,* etc.), the contagion of the new gospel becoming more virulent from day to day, academic disdain found itself forced to concern itself over this new genius. One fine day, M. Sosthène de la Rochefoucauld, then Director of Fine Arts, sent for Eugène Delacroix and told him, after many compliments, that it was vexing for a man of so rich an imagination and so fine a talent, toward whom the government was favorably disposed, not to agree to add a little water to his wine; he asked him once and for all if it would not be possible for him to modify his manner. Eugène Delacroix, vastly surprised at this bizarre condition and these ministerial counsels, replied, in an almost comical rage, that obviously if he painted in this way, it was because he had to and because he could paint in no other. He fell deep into complete disgrace and for seven years was cut off from any kind of work. He had to wait for 1830. Meanwhile M. Thiers had written a new and very lofty article in *Le Globe.*

A trip to Morocco seems to have left a deep impression on his mind; there he could study at leisure both man and woman in their independence and native originality of movement, and understand antique beauty through the appearance of a race kept pure of *mésalliance* and adorned with health and the free development of muscles. Probably from this period the composition of *The Women of Algiers* can be dated, as well as a mass of sketches.[11]

Until now, Eugène Delacroix has been treated unjustly. Criticism, for him, has been bitter and ignorant; with one or two noble exceptions, praise itself must often have seemed shocking to him. Generally speaking, and for most people, simply to mention Eugène Delacroix is to bring to mind no telling what vague ideas of ill-directed fire, turbulence, false inspiration, even disorder; and for these gentlemen, who make up the majority of the public, pure chance, that loyal and obliging servant of genius, plays an important part in his happiest compositions. In that unhappy period of revolution of which I was speaking a moment ago and whose numerous errors I have recorded, Eugène Delacroix was often compared to Victor Hugo.[12] There was the romantic poet; there had to be the painter. This necessity of finding at any cost counterparts and analogues in the different arts often leads to strange blunders, and this time it was proved once again how little people understand. Without a doubt the comparison must have seemed painful to Eugène Delacroix, possibly to them

11. Delacroix spent time in Morocco in 1832; the *Women of Algiers* (1834) is now in the Louvre.—Ed.

12. Victor Hugo (1802–1885); in his *Journals,* Delacroix expressed similar views of Hugo.—Ed.

both; for if my definition of romanticism (intimacy, spirituality, etc.) places Delacroix at the head of romanticism, it naturally excludes M. Victor Hugo. The parallel has endured in the banal realm of convenient ideas, and these two misconceptions still clutter many feeble brains. These rhetorical stupidities should be finished off once and for all. I beg all those who have felt the need to create some kind of aesthetic for their own use and to deduce causes from their results, to compare carefully the productions of these two artists.

M. Victor Hugo, whose nobility and majesty I certainly have no wish to belittle, is a workman far more skillful than inventive, a laborer much more correct than creative. Delacroix is sometimes clumsy, but he is essentially creative. M. Victor Hugo, in all his pictures, both lyric and dramatic, exposes a system of alignment and uniform contrasts. Even eccentricity in his works takes symmetrical forms. He is in complete possession of and coldly employs all the variations of rhyme, all the resources of antithesis, and all the tricks of apposition. He is a composer of the decadence or transition, who handles his tools with a truly admirable and curious dexterity. M. Hugo was by nature an academician even before he was born, and if he were still living in the time of fabulous wonders, I would readily believe that the green lions of the *Institut* would often murmur to him in a prophetic tone, "You will belong to the Academy."

For Delacroix, justice is slower. His works, on the contrary, are poems, great poems naively conceived and executed with the customary insolence of genius.[13] In the works of the former there is nothing left to guess at, for he takes so much pleasure in exhibiting his skill that he omits not one blade of grass or even the reflection of a streetlamp. The latter in his works opens great avenues for even the most adventuresome imagination. The first enjoys a certain calmness, or rather, a kind of spectator egoism, which gives his poetry indefinable coldness and moderation—qualities which the tenacious and consuming passion of the second, struggling with the encumbrances of his craft, does not always permit him to maintain. The one starts with detail, the other with an intimate knowledge of his subject; from this it follows that one captures only the skin, while the other extracts the very entrails. Too materialistic, too attentive to the surface aspects of nature, M. Victor Hugo has become a painter in poetry; Delacroix, always respectful of his ideal, is often, without being aware of it, a poet in painting.

As for the second preconception, the preconception of "chance," it has no more validity than the first. Nothing is more impertinent or foolish than to talk to a great artist, as learned and as thoughtful as Delacroix, about the obliga-

13. One must understand the 'naivety' of genius to mean a combination of technique and γνῶθι σεαυτόν [know thyself], but a technique modest enough to allow temperament to assume the major role.

tions he might owe to the god of chance. It simply makes one shrug one's shoulders in pity. There is no chance in art, any more than in mechanics. A happy discovery is the simple consequence of sound reasoning, the intermediate deductions of which are sometimes skipped, just as a fault is the consequence of a false principle. A picture is a machine of which all the systems are intelligible to the practiced eye; in which everything has its reason for being, if the picture is good; in which one color serves always to show off another; in which an occasional fault in drawing is sometimes necessary, in order not to sacrifice something more important.

This intervention of chance in the business of Delacroix's painting is all the more improbable since he is one of those rare beings who remains original after having imbibed of all the true sources, and whose indomitable individuality has passed unshackled under the yoke of all the great masters in turn. Many would be quite surprised to see a study he made after Raphael, a patient and laborious masterpiece of imitation; and few today remember his lithographs after medals and engraved gems.

Here are a few lines from Heinrich Heine that explain Delacroix's method rather well, a method that is, as for all strongly constituted men, the result of his temperament:[14]

> In matters of art, I am a supernaturalist. I believe that the artist cannot find all his forms in nature, but that the most remarkable are revealed to him in his soul, all at once, as an innate symbolism of innate ideas. A modern professor of aesthetics, who has written *Recherches sur l'Italie*, has tried to restore the old principle of the *imitation of nature*, to honor and to maintain that the plastic artist must find all his types in nature. This professor, in thus setting forth his supreme principle of the plastic arts, only forgot one of these arts, one of the most basic;—I mean architecture. One has now belatedly tried to trace the origins of architectural forms in the branches of the forest and in the grottoes of rocks. These forms were never located in external nature, but rather in the human soul.

Delacroix, then, begins with this principle: that a picture should first of all reproduce the intimate thought of the artist, who dominates the model as the creator dominates his creation; and from this principle there emerges a second, which seems at first sight to contradict it: one must carefully concern oneself with the material of execution. He professes a fanatical regard for the cleanliness of his tools and the preparation of the elements for his work. In fact, since painting is an art of profound reasoning, and one that requires immediate, concurrent use of a great range of qualities, it is important that when the hand needs something, it should encounter the fewest possible obstacles and should

14. Heinrich Heine (1797–1856), the German poet, wrote a review of the Salon of 1831 that was translated into French and published in his *De la France* (1833). The professor in question was doubtless Carl Friedrich von Rumohr (1785–1843).—Ed.

carry out with servile rapidity the divine orders of the brain. Otherwise the ideal will have fled.

As slow, serious, and conscientious as the conception may be for this great artist, his execution is quick. This, moreover, is a quality he shares with the one whom public opinion has designated his opposite, M. Ingres. But to be brought to bed is not the same as to bear the child. These great knights of painting, endowed with a seeming indolence, show marvelous agility when it comes to covering a canvas. *Saint Symphorien* was entirely redone several times, and in the beginning contained far fewer figures.[15]

For Eugène Delacroix, nature is a vast dictionary whose leaves he turns and consults with a sure and probing eye; and this painting, which issues above all from memory, speaks above all to memory. The effect produced upon the viewer's soul is analogous to the artist's means. A picture by Delacroix, *Dante and Virgil*, for example, always leaves a deep impression that grows in intensity with distance. Continually sacrificing detail to the whole, and fearing to weaken the vitality of his thought by the drudgery of a tighter and more calligraphic execution, he rejoices fully in an unbounded originality, which forms the intimate quality of the subject.

The function of a dominant note can legitimately be maintained only at the expense of the rest. An excessive taste requires sacrifices, and masterpieces are never other than diverse extracts from nature. That is why one must suffer the consequences of a great passion, whatever it may be, accept the fate of a talent, and try not to bargain with genius. This is something not dreamed of by the people who have jeered so much at Delacroix's draftsmanship: particularly the sculptors, men more partial and narrow than they have a right to be, whose judgment is worth at the most no more than half the judgment of an architect. Sculpture, for which color is impossible and movement difficult, has nothing to quarrel about with an artist chiefly concerned with movement, color, and atmosphere. These three elements necessarily require a somewhat imprecise contour, light floating lines, and boldness of touch. Delacroix is the only one today whose originality has not been invaded by the system of straight lines; his figures are always restive and his draperies fluttering. From Delacroix's point of view, line does not exist; for no matter how thin it may be, a maddening geometer can always suppose it thick enough to contain a thousand others; and for colorists, who seek to imitate the eternal palpitations of nature, lines are never other than the intimate blending of two colors, as in the rainbow.

Moreover, there are several kinds of drawing, just as there are several kinds of coloring, exact or mindless, physiognomic and imagined.

The first is negative, incorrect by virtue of reality, natural but meaningless;

15. Ingres's *Saint Symphorian* was exhibited in 1834.—Ed.

the second is naturalistic drawing, but idealized—the drawing of a genius who knows how to choose, arrange, correct, intuit, and curb nature; lastly the third, which is the noblest and strangest, can ignore nature; it represents another analogous to the mind and the temperament of the artist.

Physiognomic drawing belongs generally to the obsessed, like M. Ingres; creative drawing is the privilege of genius.[16]

The great quality in the drawing of supreme artists is the truth of movement; and Delacroix never violates this natural law.

But let us pass on to examine still more general qualities. One of the principal characteristics of the great painter is universality. Thus the epic poet, Homer or Dante, can write equally well an idyll, a narrative, a speech, a description, an ode, etc.

In the same way, if Rubens paints fruit, he will paint more beautiful fruit than any specialist.

Eugène Delacroix is universal. He has painted genre pictures full of intimacy and historical pictures full of grandeur. He alone, perhaps, in our unbelieving century has conceived religious paintings that were neither empty and cold, like competition works, nor pedantic, mystical, or neo-Christian, like the works of all those philosophers of art who make religion into a science of archaism and believe it necessary first of all to embrace primitive traditions and symbolism in order to awaken the religious chord and make it sing.

This is easy to understand if one is ready to consider that Delacroix, like all the great masters, is an admirable mixture of science—that is to say, a complete painter—and of *naïveté*—that is to say, a complete man. Go to St. Louis au Marais and look at his *Pietà,*[17] in which the majestic Queen of Sorrows holds the body of her dead Son on her knees, her two arms extended horizontally in a paroxysm of despair, a maternal hysteria. One of the two figures supporting and soothing her anguish is sobbing like the most pitiful characters in his *Hamlet*—a work with which, moreover, this painting has little affinity. Of the two holy women, the first, still bedecked with jewels and tokens of luxury, cringes convulsively on the ground; the other, fair and golden-haired, sinks more softly under the enormous weight of her sorrow.

The entire group is set forth and arranged against a background of dark, uniform green that resembles a mass of rocks as well as a tempest-torn sea. This background is fantastic in its simplicity; like Michelangelo, Eugène Delacroix doubtless suppressed the accessories in order not to obstruct the clarity of his idea. This masterpiece imprints a deep furrow of melancholy on the mind. Furthermore, this was not the first time he had tackled religious subjects. His

16. This is what Thiers called a graphic imagination.
17. Actually in the Church of Saint Denis du Saint-Sacrement.—Ed.

Agony in the Garden and his *Saint Sebastian* had already testified to the seriousness and deep sincerity that he can impress upon such subjects.

But to explain what I declared a moment ago: that only Delacroix knows how to treat religion. I would have the viewer note that if his most interesting pictures are nearly always those whose subjects he has chosen himself—namely, subjects of fantasy—nevertheless, the serious melancholy of his talent is perfectly suited to our religion, a profoundly sad religion, a religion of universal sorrow, and one that, because of its very catholicity, grants full liberty to the individual and asks no better than to be celebrated in each man's own language—if he has experienced anguish and if he is a painter.

I remember that a friend of mine, a lad of some merit, a colorist already fashionable—one of those precocious young men who shows promise all his life, and is far more academic than he thinks himself—called this painting "cannibal painting"!

Certainly it is not in the fascination of a crowded palette or in the discovery of rules that our young friend will be able to discover this bleeding and ferocious desolation, scarcely compensated for by the darker green of hope.

This terrible hymn to sorrow had an effect on his classical imagination comparable to that which the powerful wines of Anjou, Auvergne, or the Rhine might have on a stomach accustomed to the pale violet wines of Médoc.

Thus, universality of feeling—now, universality of science. [Baudelaire here discusses Delacroix's murals in the *Chambre des Députés,* then the *Rape of Rebecca, Romeo and Juliette,* and *Marguerite in the Church.*]

There remains for me to note one last quality in Delacroix to complete this analysis, the most remarkable quality of all and one that makes him the true painter of the nineteenth century: it is the singular and obstinate melancholy that runs through all his works, and that is expressed in his choice of subject, by the expression of his faces, through gesture, and in his kind of color. Delacroix has an affection for Dante and Shakespeare, two other great painters of human sorrow: he knows them thoroughly and knows how to translate them freely. In looking at the succession of his pictures, one might think he was attending the celebration of some dolorous mystery: *Dante and Virgil, The Massacre at Scio, Sardanapalus, Christ in the Garden of Olives, Saint Sebastian, Medea, The Shipwreck of Don Juan,* and the *Hamlet,* which was so much mocked and so misunderstood. In several, one constantly discovers by some inexplicable chance one figure more stricken, more crushed than the others, which seems to embody all the surrounding woes. There is, for example, the kneeling woman with cascading hair in the foreground of *The Crusaders at Constantinople,* or the old woman, so forlorn and wrinkled, in *The Massacre at Scio.* This melancholy pervades even *The Women of Algiers,* his most attractive and florid picture. This little poem of an interior, all silence and repose, crammed with rich stuffs and

trifles of the toilette, exhales some kind of heady perfume associated with houses of ill fame that quickly guides us toward the reachless limbo of sadness. Generally speaking, he does not paint pretty women, at least not from the point of view of the mundane crowd. Almost all of them are ailing and radiate a kind of interior beauty. He never expresses strength by the tone of the muscle, but by a nervous tension. It is not only anguish that he can express better than anyone, but above all moral anguish! And in this lies the prodigious mystery of his painting. This lofty and serious melancholy shines with a gloomy brilliance, even in his color—broad, simple, and abundant in harmonious masses, like that of all the great colorists, yet plaintive and profound as a melody by Weber.

Each of the old masters has his kingdom, his appanage, which often he is constrained to share with illustrious rivals. Raphael has form; Rubens and Veronese, color; Rubens and Michelangelo, "graphic imagination." One portion of the empire remained into which only Rembrandt had made a few excursions: drama, natural and living drama, terrifying and melancholy drama, often expressed through color, but always through gesture.

In the matter of sublime gestures, Delacroix has rivals only outside his art: I know scarcely any one but Frédérick Lemaître and Macready.[18]

It is because of this completely modern and entirely new quality that Delacroix is the latest expression of progress in art. Heir to the great tradition—that is, to breadth, nobility, and grandeur in composition—and a worthy successor to the old masters, he has mastered even more than they, anguish, passion, and gesture! It is really this that establishes the importance of his greatness. For example, suppose that the baggage of one of the old illustrious ones were lost; almost always there will be an analogue who will serve to explain him and make him accessible to the historian's thinking. But take away Delacroix, and the great chain of history is broken and falls to the ground.

In an article that must seem more like a prophecy than a critique, what is the good of calling attention to the faults of detail and microscopic blemishes? The whole is so beautiful that I have not the heart. Besides, it is such an easy thing to do, and so many others have done it! Is it not more novel to view people from their good side? M. Delacroix's defects are at times so obvious that they strike the least-trained eye. One can open at random the first paper that comes to hand, in which they have long persisted, quite in opposition to my system, in not seeing the radiant qualities that constitute his originality. It is known that great geniuses never make mistakes by halves, and that they have the privilege of enormity in every sense.

18. Frédérick Lemaître (1800–1876) was a celebrated French actor. William Charles Macready (1793–1873) was an English tragedian.—Ed.

EUGÈNE DELACROIX: JOURNALS, 1824–1847

SUNDAY, JANUARY 4, 1824

. . . Who can create something grand amid these eternal ties with all that is vulgar? Think of the great Michelangelo. Feed on grand and severe ideas of beauty that nourish the soul. I am constantly turned away from their study by foolish distractions. Seek solitude. If your life is ordered, your health will not suffer from your retreat.

FRIDAY, FEBRUARY 27, 1824

. . . What pleases me is that I am acquiring reason without losing the emotion evoked by beauty. I certainly want to avoid deluding myself, but it seems to me that I am working more calmly than before, and I have the same love for my work. One thing distresses me, and I do not know what causes it; I need distractions, such as gatherings of friends, etc. As for the enticements that bother most men, I have never been disturbed by them, today less than ever. Who would believe it, but what is most real to me are the illusions I create with my painting. The rest is shifting sand.

SUNDAY, APRIL 11, 1824

To come back to my earlier thought, one always does things that one is not concerned with and consequently does them badly; and the more one does, the more one finds to do. Every moment excellent ideas come to me, and instead of executing them at once, when they are cloaked in the charm that imagination lends them in the situation in which they occur at the moment, one promises oneself to do them later; but when? One forgets, or, what is worse, no longer finds any interest in what seemed likely to be inspiring. It is just that with so vagabond and impressionable a mind, one idea drives out another more quickly than the wind swirls in the air and turns the sail in the opposite direction. It happens that I have a number of subjects. Very well, what to do with them? They will remain in storage coldly waiting their turn, and never will the inspiration of the moment animate them with the breath of Prometheus: they will have to be taken from the drawer when there is need to make a picture! This is the death of genius. What is happening this evening? For an hour I have been wavering among *Mazeppa, Don Juan, Tasso,* and a hundred others.[1]

I think that the best thing, when one wants a subject, is not to have recourse to the ancients and to choose among them. For what is more stupid! Among

1. Lord Byron's *Mazeppa* was published in 1819; his *Don Juan* between 1819 and 1824. Torquato Tasso (1544–1595), the Italian poet whose *Jerusalem Delivered* is a classic, was a tragic figure whose life was a source of inspiration for many painters of romantic inclination. —Ed.

the subjects I have retained because they seemed fine to me at one point, what determines my choice of one over another, now that I look upon all of them in the same way? The fact that I can waver between two of them implies a lack of inspiration. Certainly if I took up my palette at this moment—and I am dying from the need to—the beautiful Velázquez would set me going. I should like to spread out some good rich, thick paint on a brown or red canvas. To find a subject, then, it would be necessary to open a book capable of furnishing inspiration and be guided by the mood. . . . There are some of these that one must have. The same as with engravings. Dante, Lamartine, Byron, Michelangelo.

This morning I saw at Drolling's several details of figures by Michelangelo, drawn by Drolling.[2] God! What a man! What a beauty! A singular thing, which would also be very beautiful, would be the uniting of Michelangelo's style with that of Velázquez! The idea came to me all of a sudden on seeing the drawing. It is smooth and soft. The forms have that softness which it seems only heavily laid on paint can give, and at the same time the contours are vigorous. Engravings after Michelangelo give no idea of this. This is sublimity in execution. Ingres has something of that. His areas are smooth and little taken up with detail. How that would ease labor, especially in small pictures! I remember that impression with pleasure. Remember those heads of Michelangelo. . . .

FRIDAY, MAY 9, 1824

. . . While returning home this evening I heard the nightingale; I hear it still, though very far away. This warbling is really unique, more because of the emotions it evokes than for itself. Buffon waxes ecstatic as a naturalist over the flexibility of the throat and the varied tones of the melancholy singer of spring.[3] For myself, I find in it that monotony, the indefinable charm that characterizes all that makes a vivid impression. It is like looking out over the vast ocean. One always waits for yet another wave before tearing oneself from the view; one cannot leave it. How I hate all those rhymers with their rhymes, their glories, their victories, their nightingales, their meadows. How many of them really depict what a nightingale makes us feel even though their verses are filled with nothing else? But if Dante speaks of it, it is as new as nature and only what was heard. All is artifice and adornment, created by the mind. How many of them have depicted love? Dante is really the first of poets. One thrills with him, as before the thing itself. Superior in this to Michelangelo, or rather, different; he is sublime, in a different way, but not through truth. *Come colombe adunate alle pasture*, etc. *Come si sta a gracidar la rana*, etc. *Come il villanello*, etc.[4]—This is

2. Michel-Martin Drolling (1786–1851), history painter and portraitist.—Ed.
3. Georges Louis Leclerc, Comte de Bouffon (1707–1788), a famous French naturalist.—Ed.
4. Delacroix is inaccurately quoting two passages from Dante's *Divine Comedy: Purgatorio*, canto 2, line 125, and *Inferno*, canto 32, line 31.—Ed.

what I have always dreamed of without defining it. Be exactly this in painting. It is a unique course—but when something bores you, do not do it. Do not pursue a vain perfection. Certain things that are faults to the vulgar often give life.

My painting is acquiring a torsion, an energetic movement, that absolutely must be completed in it. It needs that good black, that felicitous dirtiness, and those limbs that I know how to do and few attempt. The mulatto will do well. There must be fullness. Although it may be less natural, it will be more rich and beautiful. If only it can have all this. O, smile of a dying man! The maternal look! Embraces of despair, the precious domain of painting! Silent power that speaks first only to the eyes and then reaches and takes possession of all faculties of the soul. That is the spirit, that is the true beauty that belongs to you, O beautiful painting, so insulted, so misunderstood, delivered to fools who exploit you! But there are still hearts that will receive you religiously, souls that are not satisfied by phrases or by inventions and ingenious ideas. You have only to appear with your virile and simple frankness and you will please with a pleasure that is pure and absolute. Let us admit that I have worked with reason. I do not at all like reasonable painting. I recognize that it is necessary for my turbulent mind to be agitated, to destroy its bonds, to try out a hundred manners before arriving at the goal, the need for which torments me in everything. There is an old leavening, a pitch-black depth to satisfy. If I am not agitated like a serpent in the hands of a pythoness, I am cold. This must be recognized and be submitted to; and this is a great pleasure. Everything that I have done well has been done in this way. —No more *Don Quixote* and things unworthy of you. Concentrate profoundly—before your painting and think only of Dante. There is to be found what I have always felt in myself!

MAY 14, 1824

. . . What torments my soul is its loneliness. The more it expands among friends and daily habits or pleasures, the more it seems to escape me and withdraw into its fortress. The poet who lives in solitude but produces much is the person who enjoys most those treasures we carry in our breasts, which forsake us when we give ourselves to others. When you yield yourself totally to your soul, it opens itself completely to you, and then it is that the capricious creature affords you the greatest pleasures, that of which the obituary [of Lord Byron] speaks, that which Byron and Rousseau perhaps did not notice, of appearing under a thousand different forms, sympathizing with others, studying itself, painting itself constantly in its work. I am not talking about mediocre people: yet what is this rage, not only to write but to be published? Aside from the pleasure of praise, it is to reach all souls that can understand yours, and it affords all souls the occasion to meet in your painting. What good is the approba-

tion of friends? It is simply that they understand you; what importance is there in that? But it is living in the minds of others that intoxicates. How distressing! I shall say. You can add still another soul to those who have seen nature in a way all their own. What all these souls have painted is new for them, and you will paint them again as new! They have painted their souls, in painting things, and your soul also asks its turn. And why should you resist its demand? Is its request more foolish than the desire for rest that your limbs express to you when they and all your physical being are tired? . . .

. . . Thou who knowest there is always something new, show it to them in what they have failed to recognize. Make them believe that they have never heard tell of the nightingale or the spectacle of the vast sea, and of everything their gross senses reach out to feel only when others have troubled to experience them first. Don't be embarrassed by language. If you cultivate your soul, it will find a chance to show itself. It will create a language quite as worthy as the hemistiches of this man or the prose of that. Indeed! You are original, you say, and yet your verve kindles only in reading Byron or Dante, etc.! That fever, you take it for the power to create; it is nothing more than a need to imitate. . . . Ah, no! They have not said the hundredth part of what there is to say; in any one thing that they touch upon there is more material for new geniuses than there is . . . and nature has stored in the great imaginations more that is new to say about her creations than she has created things. . . .

FEBRUARY 27, 1847

Grenier came to make a study in pastel from the *Marcus Aurelius*.[5] We talked of Mozart and Beethoven. In the latter, he finds an active tendency toward misanthropy and despair, and more especially a painting of nature, which does not go to such lengths in the others; we compared him to Shakespeare: he does me the honor of placing me in the class with these wild contemplators of human nature. One must confess that, despite his celestial perfection, Mozart does not open that particular horizon to the mind. Would that come from the fact that Beethoven appeared only later? I think one can say that he really reflects more fully the modern character of the arts, turned, as he was, to the expression of melancholy and of that which, rightly or wrongly, people call romanticism. Notwithstanding which, *Don Juan* is full of that sentiment. . . .

MARCH 1, 1847

After breakfast I started to work over the *Christ au Tombeau:* this was my third session on the sketch, and, in my day's work, despite a little indisposition,

5. Possibly François Grenier (1793–1867), a French painter and pupil of David and Guérin. Grenier also had two sons who were painters.—Ed.

I braced it up vigorously, and got into condition for a fourth go.[6] I am satisfied with this lay-in, but when one adds details, how can one preserve that impression of the whole that results from very simple masses? The majority of painters, and I did this formerly, begin with the details and work for the effect at the end. Whatever one's chagrin over losing the effect of simplicity in a fine sketch as one adds more details, there will still remain much more of that impression than one will retain if one proceeds in the opposite fashion. . . .

6. The picture of *The Entombment,* completed in 1848, is in the Boston Museum of Fine Arts. — Ed.

III

TRUTH TO NATURE AND THE NATURE OF TRUTH

A new estimation of the role of the direct study of nature in the production of art took hold among artists and critics as the nineteenth century advanced. The "purest" artists turned to nature, especially praising nature as seen by what they considered to be the naive eyes of fifteenth-century artists, in order to escape the preconceived formal language of the academies. But what exactly characterized the nature that proved so attractive to many artists at this point?

The first quality nature offered to the eye freed from formal preconceptions was complexity, an unanticipatable variety made infinite by type and accident of growth, as well as by the continuously changing situation in which nature was seen. Nature offered unending study, not necessarily to find an ultimate formula that might provide a key to its mysteries—which was the goal of many late-eighteenth-century artists—but to provide a field in which the mind discovered continuously new stimuli, new revelations, proving any belief in pre-existing limitations of knowledge as indefensibly arrogant. There was a contagious excitement among those artists who sought truth through exploration and personal investigation rather than the matching of their talents to a preordained artistic perfection. Great new worlds—microcosms and macrocosms—were waiting to be discovered, as scientists also were continuously making clear, in the structure of a leaf or the workings of the universe. The intellectual import of this scientific zeal for unending research into nature was justified and interpreted in different ways. The transcendental view considered nature as exemplary of something beyond its appearance, awakening the mind to the awareness of a larger truth than that of mere appearance. An opposing view based all truth on the validity of perception and accepted the experience of uninterrupted looking as a satisfaction in itself, finding quite simply in the flux and change of nature a solace for the mind and a corrective for human pretensions. The belief that nature, not the rational faculty, provided in some way the ultimate truth for man gave license to an extraordinary range of tendencies, from mystical pursuits to theories of social organization.

The chief source of fascination for those who held nature as a guide was landscape. Although landscape had been a major independent subject in art beginning in the seventeenth century, only at the end of the eighteenth century and the beginning of the nineteenth did it become a kind of catalyst in forcing a new consideration of just what constituted content in art. Landscape was not accepted easily into the upper reaches of the artistic hierarchy. John Constable was admitted to the Royal Academy as an exception, and in France landscape painting was respected by the theorists only if it had historical or mythological overtones.

As a reflector of man's needs and as a constant reminder of passing time and the cycle of life, landscape had long been a useful source of material both for literature and for art. Eventually an entire vocabulary of natural forms and moments was developed. Particularly in England, and later on the Continent, these terms applied equally to landscaped gardens and to paintings. The "English garden" imitated the seemingly accidental quality of nature. Wildness and irregularity reminded the viewer of the forces beyond man's control and evoked the shock of the sublime; regularity and openness taught the mind the beauty of order. But the new view of nature neither eschewed the hand of man, no matter how cunning, nor looked on nature as a histrionic expression of man's feelings. Nature had its own laws, and man was the better for recognizing them. Man no longer regarded nature as a reflection of himself, but saw himself rather as a single element within the vast natural world. In almost exact contrast to earlier principles, then, a view of nature provided substance for the mind to the degree that it did not conform to a recognizable "vocabulary" of meaning. It must have existence apart from man's inner world.

Although Henri de Valenciennes in the 1780s studied directly from nature in all its changing aspects, as did all the new "classical" landscapists, he believed his studies became meaningful as art only after they were brought into an associative context. However, the context in which nature might be viewed was changing. A new analytical interest, especially among German painters, pierced the poetry of Claude or Poussin to investigate what made a tree grow or what geological activity was evidenced by the strata of rock. A natural object was seen as the product of function, as responding to an internal law, not just as an interesting or expressive chapter. Light, which became a preoccupation with painters, and color, now recognized as a product of light, were also studied as embodying complex but ordered physical principles. Goethe, for one, looked on all such phenomena as revealing significant truths about man and his universe. His treatise on color (*Zur Farbenlehre,* 1810) distinguished all aspects of the phenomenon, including the coloration of objects and the perception of color. Runge's theory of color was no less scientific in approach, but manifests a close relationship between scientific inquiry and philosophical or religious speculation. As the writings of both Runge and Carus show, the end

Joseph Wright of Derby, *Sir Brooke Boothby,* 1780–81, oil on canvas.

of anthropological, geological, or other scientific studies was not simply to compile a roster of hard facts. Each new finding, for one properly prepared, was an additional revelation of the nature of man, his past, and his destiny; the necessary preparation for this revealed perception was an intimation of God. The theological context was not deduced from nature but was the assumed basis for meaning in nature. Yet, in the absence of the surprise and wonder provided by nature, the intimation of God might become dim, perverted by the force of the human ego.

Nature provided the way, then, for a full realization of individual man in his direct relationship to the universe. It admitted of no intercessors and, once the theological premise was accepted, denied the validity of all education other than that acquired by the individual from the direct experience of nature itself. While there might be norms of conduct, there could be neither norms of form nor external standards of aesthetic judgment. Each man, confronting nature, had to learn to judge for himself.

The place of the artist in this view of nature may seem strained. If nature provides the ultimate lesson, is itself an embodiment of moral content, what is

the artist's contribution to the work of art? Each artist and critic had his own answer, but in general they agreed that, if successful, the work of art pointed to the greater truth beyond. The artist was a revealer, rather than a creator, and that to which the work of art pointed was greater than either the artist or the work of art itself. The work of art did not embody an idea, as Quatremère de Quincy argued, but led the viewer to discover where the idea was to be found. Communication lay between nature and the viewer; and in the viewer's contemplations he was joined by the artist, whose heightened sensibility illuminated the way to a revealed truth. To the transcendental mind, the truth of nature lay not in appearance, in simple materiality, but in the creative wonder to which the appearance of things testified.

An increasing number of artists in the early years of the nineteenth century, however, felt no need for a theological context to find nature meaningful. Although Valenciennes admitted the possibility of literal paintings of the natural scene, he could see no reason for them other than as "view paintings" to record a place. Others simply found landscape "interesting," a difficult quality to explain. There was a growing desire among some to make reassuring contact with "what really is," a manifest dissatisfaction with any distracting idealism. Theirs was not an unpoetic or inartistic state of mind; rather, they believed that the truly poetic could not emerge from the specific fact of nature and the immediate evidence of sense.

When the marble sculptures from the Parthenon, brought to England by Lord Elgin, were being considered for acquisition by the British government, a heated controversy arose over their quality. The anatomical specificity, the convincing rendering of flesh and bones, was proof to some connoisseurs that the sculptures were of inferior quality; to others, these same characteristics were proof of their consummate embodiment of truth. Similarly, Titian was damned by academicians for the sensuous, natural appearance of his forms, and praised by others for discovering beauty in the colorful richness of nature. One disrespectful critic finally declared that an artist could learn more from studying a head of cabbage than from studying the head of the Apollo Belvedere. From the natural object he would learn to assess his own capacities for observation and judgment as well as make fresh contact with the world around him. The alerted vision could give a new sense of value to the world.

Eventually a kind of inverse hierarchy of subjects was formed by those believing in truth through perception, the virtual reverse of Reynolds's values. Those subjects deemed most true—most suitable for art—were the least heroic, least grand, and most closely associated with daily human activity. William Hazlitt, for example, maintained that an accurate portrait was the loftiest type of history painting, since the unique configurations of the face were the unmistakable record of specific activity. Constable preferred to paint haywains

rather than chariots. Later, Charles-Émile Jacque devoted himself to the painting of sheep, and by the 1840s Filippo Palizzi could concentrate for hours on a single plantain or haystack. Truth for these artists lay only in that which could not be generalized and could have no extraneous value readily attached to it.

Although this view of the world may have insisted that the artist be humble before nature, it did not produce humility before society. Artists who were convinced of the purity and truth of their vision and, in consequence, of the natural goodness of their conduct often became outspoken critics of social institutions. These champions of natural truth were as unresponsive to formalized conduct and institutional hierarchies as to formal abstraction and hierarchies of subject matter in art. Whether they were open in their opposition or turned their backs on society as a whole, such artists were viewed as suspect in countries undergoing political uncertainties. When Gustave Courbet pronounced himself a Realist, he had not changed his aesthetic postulates, but his stance was a threat to all establishments, artistic or political. Many artists believed that truth had, indeed, set them free.

PIERRE-HENRI DE VALENCIENNES

Advice to a Student on Painting, Particularly on Landscape (1800)

Pierre-Henri de Valenciennes (1750–1819) was a French landscape painter who worked in Rome from 1778 to 1782. Although his chief ambition was to paint large, dramatic landscapes with mythological or historical references, his many freshly painted studies done directly from nature, of which the Louvre possesses a large collection, are more attractive to the modern eye. To understand more clearly the varieties of transient light, color, and form in phenomenal change, Valenciennes would sometimes paint a single group of trees or houses in the environs of Rome at different times of day. He spoke convincingly of the ideal and the arcadian, yet his eye was trained in the specific observation of surrounding nature.

Valenciennes's treatise on perspective and landscape painting, published in 1800, was in many ways typical of the numerous pedagogical books that were published with increasing frequency at the beginning of the nineteenth century. It combined practical advice and instruction for the student, much drawn from earlier books on artistic practice, with comments concerning matters of artistic theory that have a more personal ring. Valenciennes's artistic presumptions and goals are most in evidence in his discussion of landscape.

For Valenciennes and his contemporaries, landscape, if it merited serious consideration, was no less a conceptual production than paintings of mythological and historical incident, subject to the same kind of compositional rules as those described by Milizia in terms of the machine. But another kind of rendering of landscape was slowly achieving greater recognition; Valenciennes called it the "landscape portrait," some referring to it as "view painting." Dependent more on vision than on genius, according to Valenciennes, it had little chance for acceptance by those upholding academic standards. Nonetheless, for all his disparaging remarks, Valenciennes was fascinated by the practice of painting directly from nature, even insisting that the artist work on a study only so long as the original effect was before his eyes.

A reconciliation of this fascination with natural effect and the belief in elevated painting that reflected the mind rather than simple appearances was made

through a practice that at the time was widespread. As Valenciennes describes it, the painter studied continuously from nature, but when he wished to create a work of art he incorporated the knowledge he had gained from his studies into a construction of his own. This was the practice in Rome from the time that Valenciennes was there through at least the first quarter of the nineteenth century, and Rome was for Continental artists the center of landscape painting. Characteristic of such a method are the paintings by Nicolas Didier Boguet (1755–1839), the best-known and most highly praised French landscapist in Rome early in the century, whose finished paintings combined the compositional order of Poussin with carefully observed and meticulously painted effects of light and detail acquired from his tireless study from nature.

The excerpts from this treatise, first published privately by the author in 1800, are here translated from Pierre-Henri de Valenciennes, *Élémens de perspective pratique à l'usage des artistes, suivis de Réflexions et conseils à un élève sur la peinture, et particulièrement sur le genre du paysage* (Paris: Aimé Payen, 1820), pp. 303–11, 336–40, 346–47, and 395–98. ✒

From the time that man first sought to represent nature and succeeded in transmitting its faithful image to paper or canvas with pencils and colors, many landscape painters have acquired a doubtless merited reputation; but of this number very few have had a genius susceptible to being kindled by the enthusiasm that inspires ideal beauty, which, raising nature to a plane beyond itself, conveys profound and delightful sensations to our souls.

There are several whom we have admired for their truth of color, the freshness and softness of tint, the subtle harmony of different effects of light and dark, their lightness of touch and variety of execution. Without a doubt these painters are great men. But have they known how to speak to the heart and to the mind? Have they known how to inspire feeling? Claude Lorrain rendered with the most exact truth and even in a moving fashion the quiet rise and the brilliant descent of the star of day.[1] He admirably painted atmospheric air; no one has sensed better than he that beautiful mist, that vagueness and indecision which give nature its charm and which are so difficult to render. Gaspard copied the most beautiful sights of Italy;[2] he adjusted nature with all possible taste; he chose from it the most beautiful details; he knew how to arrange and combine these alterations of objects so well that he seemed to have made an exact copy without permitting himself the least change. He seized upon all the nuances of nature; he painted her tranquil, agitated, and in the convulsions of

1. Claude Lorrain (1600–1682) maintained a studio in Rome after 1627.—Ed.
2. Gaspard Dughet (1613–1675), known as Gaspard Poussin, was the brother-in-law of Nicholas Poussin, and was celebrated as a landscapist in Rome.—Ed.

storm. He joined a strong color to vigorously pronounced effects. He varied her superb productions infinitely; he is, in sum, as great a landscape painter as Claude Lorrain. But it must be said, both copied nature selectively such as it is, such as one might find it in Italy and also perhaps in some other places; but have they moved the imagination? have they been able to make the soul appreciate any feeling other than admiration? Their works quite simply offer landscapes in which one might desire to have a house, for it would be situated with a beautiful view; one could breathe in the coolness at midday; one might walk along the shady banks of a river, or lose oneself in the thickness of a forest and give oneself over to sentimental reveries. Yet, in the end, all the sensations that their works produce are related to ourselves and do not evoke anything beyond.

There is not in all of their painting a single tree wherein the imagination might expect a hamadryad to dwell; no fountain where a naiad might arise; the gods, the half-gods, the nymphs, satyrs, even heroes are strangers to these beautiful sites, which do not portray their birth or dwelling places. These charming landscapes can be nothing but the dwelling places of modern shepherds and peasants. It is not to them that Tityrus would come to contest for the singing prize with other shepherds whom Virgil gave him as rivals.[3] If that poet had created a landscape he would not have painted a locale by Gaspard or Claude; he would have chosen one appropriate to the shepherds of whom he sang, which would have an entirely different natural tone than the one we see every day.

Nicolas Poussin, Annibale Carracci, Titian, Dominichino,[4] and some others created what Homer, Virgil, Theocritus, and all the famous poets would have created had they painted with colors. These painters were themselves immersed in the reading of these sublime poets; they meditated on them, and when they closed their eyes they saw that ideal nature, that nature adorned with the treasures of the imagination that only genius can conceive of and represent.

It is thus that Poussin visualized that superb landscape of Sicily in which he placed his famous Cyclops to whom the highest pines served only for support.[5] It is thus that he conceived the terrible and lugubrious spectacle of those mountains of which one sees only the tops, soon to disappear beneath the muddy water that must engulf the rest of mankind; thus that he knew how to

3. Tityrus is one of the shepherds referred to in the *Eclogues* of Virgil.—Ed.
4. Nicolas Poussin (1594–1665) was among the most noted French painters working in Rome. Annibale Carracci (1560–1609) was one of the earliest Italian artists to emphasize landscape in his works. Titian (1477–1576) was often cited at this time for the naturalness of his coloring and for his atmospheric effects. Dominichino (Domenico Zampieri, 1581–1641) was a Bolognese painter who, like Annibale Carracci, included sensitive landscape studies in many of his paintings.—Ed.
5. Presumably the *Landscape with Polyphemus* (1649), now in the Hermitage Museum, Leningrad.—Ed.

distinguish in the disorder of nature the serpent, the first cause of mankind's ills, who survived almost all other animals and searches in vain to flee death, the just punishment reserved for him by heavenly vengeance.

It is thus that he treated the four human conditions, dancing to the sound of the lyre responding to the fingers of time. Meanwhile children blow soap bubbles, by this symbol warning of life's brevity and the futility of man's works.

It is thus that the Carracci, Domenichino, and the others envisaged their fine subjects from fables, in terms of the ideal and sublime nature conceived of by the ancients, which seems to exclude man from the earthly environment to make of it the habitation of gods. It is their genius, then, that has seen what the painters who have copied nature servilely will never see. For without enthusiasm there can be no affection of soul, no ideal beauty, nor that flight of imagination that brings man close to the gods and transports him to the place where they live.

Some pretended authorities will object perhaps that these great men did not include in their works all the truth of nature. One will compare the paintings of Poussin with those of Wynants or Karel du Jardin; one will say that Wouvermans painted horses better, that Berghem painted cows better, that Panini rendered architecture better, that Ruysdael gave a truer idea of the tree, and so on.[6] This would be incontestable if Poussin had been only a painter of horses, trees, livestock, architecture, and the like. But he was more than that: when he painted the horses of Castor and Pollux, he did not think of a prince's horse or, even less, of a farmer's. He did not make truth consist of rendering the galling on the animal's neck and back, calluses on the legs, or the reddish tone on the belly caused by the dirty litter on which the animal rested. It was the horse of a god that he wanted to paint, and he made it as it ought to be. Oxen tracing the furrows in the rich plains of Sicily should have another character than those of Flanders. They are not simply accessories of the subject, any more than the ruins and the architecture are. When he painted a tree, he made it great, majestic, healthy and contented in the terrain in which it was planted; it was without wound, without excrescence; its whole and firm bark attested to its vigor and strength. And the manner in which the roots are attached to the ground render the tree capable of resisting winds and tempests. It is very true that often he forgot the mosses, clots of grass, half-decayed bark, twisted and tortured branches that the painters of trees love so well. But in return the trees that spring into being under his brush have the majesty of beautiful nature; each of

6. Jan Wynants (1615?–1668?), Dutch landscape painter and etcher. Karel Dujardin (1622?–1678), Dutch painter of battle pieces and landscapes, often including horses. Nicholas Pietersz Berghem (1620–1683), Dutch landscape painter. Giovanni Paolo Panini (1691–1765) specialized in paintings of the ruins of Rome. Jacob van Ruysdael (1628?–1682) and his uncle, Solomon (1600?–1670), were among the best-known Dutch landscape painters.—Ed.

them is the dwelling place of a dryad who animates it. Nymphs, satyrs, Pan, even Diana and her companions might find refuge from the heat of day under their thick shade.

Claude Lorrain truthfully expressed the rosy color of the morning. One sees its freshness printed on the ground and leaves. But Poussin preceded the chariot of the sun with Aurora, scattering pearls and flowers over nature. One painted the rising sun, the other made the sun rise. Vanderneer painted moonlight in a superior fashion;[7] but not one painting that we know of is worth, so far as spirit is concerned, the charming idea that one of our modern artists executed, in which he allowed a ray of that celestial orb to rest upon the mouth of Endymion. There you have the poetry of painting; there you have that which pleases the scholar, the artist, and all men of taste. These are the sparks of genius whose brilliance warms the heart, seizes the imagination, and multiplies the delights of feeling.

WAYS OF LOOKING AT NATURE

There are two ways of looking at nature, and each offers an infinity of nuances that form and determine the talent of the artist.

The first is that in which we see Nature as it is and represent it as faithfully as possible. According to this procedure, one eliminates objects that do not seem interesting enough, brings forward others that fit, even though they might be far away, looks for harmonies and contrasts, and, finally, chooses this or that view because it seems more agreeable and more picturesque.

The second is that in which we see Nature as it ought to be and in the way enriched imagination presents the view to the eyes of men of genius who have seen much, compared carefully, and analyzed and reflected upon the choice that one must make; men who recognize all the beauties and faults; who warm, inspire, and identify themselves through readings with the celebrated poets who have described and sung of beautiful Nature; who visualize the settings in poetic descriptions; who distinguish the customs and costumes in the works of Homer, Xenophon, Diodoros, Pausanias, and Plutarch; who sometimes live with Anacreon and Sappho, or with Venus, Cupid, and the Graces, other times descend with Virgil into Tartarus to see Sisyphus sustaining his rock or Ixion turning his wheel; still other times walk upon the arid and deserted rocks peopled by the phantoms of Ossian's imagination, or try to lose themselves in the delicious valleys of Arcadia and Tempe; men who become the companions of all men of all centuries and all countries through reading and learning their history.

7. Presumably Aert van der Neer (1603?–1677), Dutch painter.—Ed.

This way of looking at Nature is certainly very much more difficult than the first. One must be born with genius, have traveled much and, still more, reflected on one's travels. One must be nourished by the literature of the ancients and moderns, be familiar with the productions of great painters, be, in a word, gifted with the creative faculties to give birth to those works of art that interest the philosopher and the educated man. It is then that a man produces successfully in his works all the sensations he himself has felt while awakening in the souls of the viewers fear or melancholy, calm or agitation, sadness or gaiety, but always admiration and enthusiasm. The artist does not thus make a cold portrait of insignificant and inanimate nature. He paints it speaking to the soul, having a sentimental action, a determined expression that is communicated easily to all sensitive men.

What a difference there is between a painting representing a cow and some sheep grazing in a field and one showing the funeral of Phocion; between a landscape on the banks of the Meuse and one of shepherds in Arcadia; between a rainy day by Ruysdael and the flood by Poussin! The first are painted with a feeling for color, and the others with the color of feeling. For the first type, models are never lacking. They are always before the eyes in whatever country one happens to be, and many artists, ancient and modern, have given us proof that one can, with skill in the brushstroke and feeling in the color, make what one might call a pretty picture of an object, even copied servilely.

But what models did Poussin copy to represent the terrestrial paradise? Which did he study in order to paint his landscape of Polyphemus? His sublime genius has allowed us to see, one after the other, Egypt, Greece, Syria, Chaldea, sublime Rome under Coriolanus, decayed Rome under the popes. He has been successively the interpreter of Moses, Joseph, Homer, Plutarch, and others, to such a point that seeing his immortal works persuades us that he lived with these great men, that he drew their homes, copied their costumes, and portrayed their domestic scenes from nature to transmit them to posterity.

IDEAL BEAUTY

All artists are convinced that there exists in Nature an Ideal Beauty which the Greeks knew so well and which they succeeded in representing in their figures of gods and heroes: Apollo, Venus, the head of Medusa, Olympian Jupiter, and the Farnese Hercules are indisputable proof of it. The men of genius who created these figures, so to speak, exalted their imaginations to the point of believing themselves in the company of the gods and capable of transmitting their portraits to mortals in whom these figures would inspire a respect so profound that, astonished by the achievement, they would end by adoring the imitations of divinity and the perfection of art presented for homage.

Pierre-Henri de Valenciennes, *Biblis Changed into a Fountain*, Salon of 1793, oil on canvas.

We shall not talk of ideal beauty in general. Winckelmann and other cele-
brated writers have given a definition of it in all its parts. We shall try only to
prove that there exists also an ideal beauty in historical landscape, and that the
great masters who recognized it created works that have nothing to fear but the
destruction of time, works that so long as they exist will command the admira-
tion of all sensitive men and men of sure taste.

Happy the artist who, delivering himself to the charms of illusion, believes
that he sees nature as it ought to be! His joy knows no bounds. He has the satis-
faction, he feels the noble pride of creating, so to speak, a nature too rare to be
encountered in its perfection. Of necessity he produces new things because his
imagination, constantly warmed and nourished by the descriptions of poets, is
infinitely varied and expandable. After giving form to the raging north winds,
bursting noisily from the deep caverns where the god of winds has kept them
imprisoned, he likes to calm himself by representing Narcissus on the edge of
a fountain whose calm and limpid waters exactly reflect the image of that un-
happy lover, whose languorous and faded graces foretell the fatal end that will
give his soul repose. He passes from black Tartarus to the realm of Elysium;
from the smoking peak of Etna to the plain of Amphitrite; and he brings forth

Venus from the bosom of the foamy waves whose silvery ripples lovingly caress the goddess of beauty.

When the man of genius wants to refresh his imagination, he turns his eyes again upon Nature: he contemplates it, he observes it, he looks on all sides for models to help him paint what his enthusiasm has caused him to envisage. Alas! he finds almost nothing. He sees Nature as it is: he admires, but he is not content. The rocks seem trivial to him, the mountains low, the precipices without depth. His genius, at first confined, depressed in every way by the multiplicity of details that meet the eye, soon breaks the bonds that hold it, and, freeing itself from the petty truths that would keep it enchained, expands the rocks, carries the peaks of the mountains into the clouds, and, plunging with imagination into the hollows, gives them the depth of abysses. His oak trees become majestic and leafy and form forests of Druids. The smallest objects acquire nobility and warmth: everything is animated by his magic brush. Even the frail reeds blown by the winds are no longer the simple products of the marshy earth but become the forlorn remains of the god Pan's lover, bathed by the limpid waters of the river Ladon; already these reeds render the plaintive and harmonious sound of the flute. . . .[8]

STUDIES AFTER NATURE

My student has drawn under my direction for some months. He has copied several paintings of the best masters, but he has not yet looked at Nature. He must study it, and in good weather we go together to the country. It is there that I give him my views on how to make studies that may serve him later in composing pictures. These observations are of considerable importance for all painters, for a good many painters, either through negligence, error, or want of reflection, fall into the grave error of wanting to finish studies that should be only sketches made in haste, seizing nature in its actuality.

A painter of history, or of portraits, flowers, or still-life, copies Nature in his studio, which is constantly illuminated with the same kind of light. Since this light is only secondary, it is practically equal and uniform so long as the sun lights the atmosphere, and its variations are hardly noticeable. When the sky is overcast with clouds that completely intercept the direct light, in the studio daylight is more or less the same from morning until evening. Thus one has the time to take pains, to complete and finish all details of the object studied.

But when this object is lighted by the sun, and the light and shade change constantly through the movement of the earth, one cannot continue to copy

8. The nymph Syrinx, pursued by Paris, plunged into the River Ladon. In answer to her pleas, she was transformed into a reed, out of which Pan fashioned his flute.—Ed.

Pierre-Henri de Valenciennes, *Rome, a Sky Filled with Clouds,* c. 1780–86.

Nature for long without seeing the chosen effect of light change so quickly as to be no longer recognizable as that with which one had commenced. We have already observed that the effects of Nature are almost never the same at the same spot or at a similar hour. These variations depend on a great many circumstances, such as a light that is more or less pure, the quantity of moisture in the atmosphere, the wind and rain, the more or less elevated nature of the site, the different reflections caused by the color of the clouds, their lightness or thickness, and, in fact, by an infinite number of causes impossible to detail, especially in a work as brief as this. But what we have said should be enough to prove that it is absurd for an artist to spend an entire day copying a single view from Nature. He should realize that he would be painting the sky at dawn, the background a little later, the third plane at noon, the second at four o'clock, and the foreground in the light of the setting sun. Thus his sky would be of a silvery color, his background vaporous, the third plane almost totally illuminated without any length of shadow, the second plane would begin to turn golden, and the foreground would be lighted by the sunset. The shadows of the background would extend toward the foreground of the painting, those of the foreground would be directed toward the background, those of the third plane would be to one side, while those of the second would be toward the other side. Do not think my criticism out of place and exaggerated: I have seen

a painting by Locatelli, charming in its composition and color, that was lighted half from one side and half from the other.[9]

How many such paintings have we not seen, made by artists less celebrated, that include all the faults I have just described? Those who painted them called them studies after Nature, but they were nothing but errors and lies against Nature. For to want to link together all the successive instances in a day and their gradual effects into one single moment is the height of fallacy and the most complete proof of an absolute lack of judgment.

There are others—and these are the greatest in number—who do not copy Nature for periods longer than two hours and who come back the following day at the same time to continue their studies. Certainly these are more sensible than the first group, in that they have in their work greater unity of effect. But how can they be sure, when they leave their work today, that they will find the same atmosphere tomorrow, the same color of light, shadows, and reflections? There is a proverb that says quite correctly, the days follow each other and do not resemble each other. This is so true that we have known artists of merit who have begun studies that they could not finish because they were never again able to find the same effects in Nature.

LOCAL COLOR

Therefore, a student who would study profitably from Nature should work differently. First he must restrict himself to copying as well as possible only the principal colors of Nature in the effect he has chosen. He should begin his work with the sky, which gives the color of the background, then move to those planes closely related to the sky, then work progressively toward the foreground, which will thus always be in accord with the sky, which has served to create the local color. One readily realizes that in following this procedure it is impossible to give detail to anything, because all studies from Nature should be made strictly within the space of two hours at the most, and for the effect of the rising or setting sun one can work no more than half an hour.

I well understand that great aptitude and much practice in painting from Nature is necessary to produce something good, but once the procedure is grasped the necessary practice is acquired easily, and in a very short time a sketch from Nature can be made with some speed.

It will be objected, no doubt, that in following this method one will not learn how to finish. In one sense this is true. But one can study the details of Nature while copying it when the weather is overcast and objects are deprived of the sun throughout the day. Then one tries to render as best one can all the

9. Andrea Locatelli (1693/5–1741), Roman painter of rugged classical landscapes. —Ed.

details one can see. This study is very necessary also in that it teaches one to finish a painting and to enrich it with those details that make it interesting.

Certainly it is much easier to paint the details of a painting than to grasp the effect of the whole, the local color and light at the moment of the day one wishes to represent. If one has the local color of the effect one wishes to render recorded in a well-executed sketch, one can base the general color of the painting on this and complete it by studies of details, which will serve, however, only for touch and rendering. For the color of the details should always draw upon the local color of the sketch, which gives the total effect and the unity of color that reign at the time of day that has been chosen.

One must be thoroughly convinced that the effect of totality in the painting depends on the color of the sky, that if this tone is not rendered truly the rest will of necessity be false. Thus when one has failed to establish the local color of the sky, one absolutely must start over again, no matter how carefully the work has been done; otherwise one will have the unhappy experience of creating an effect contrary to that conceived of in the beginning. It is better simply to erase the sky than to be obliged to erase all the rest.

It is well to paint the same view at different hours of the day in order to observe the differences that light produces in the forms. The changes are so apparent and so astonishing that one scarcely recognizes the same objects.

After these general principles, I shall go into details with my student and say to him: There are objects you may study separately because they are stationary—monuments, ruins, huts, trees, rocks, anything that conserves its natural state—and sometimes whole landscapes, when the sky remains overcast all day or when the light does not vary appreciably. . . .

Studies from Memory

One essential thing to which you must apply yourself especially is the habit of making memory studies after the sketches you have made during the day, whether imitating the master or copying Nature. It is a sure way to form the memory and stock it with interesting objects. It aids genius, and its usefulness will be especially appreciated in traveling. En route one's time is not always one's own. One often passes superb sites that one cannot stop to copy. Sometimes a storm offers extraordinary effects, or there is a striking effect of moonlight; and there are all the immediate phenomena of Nature that one cannot seize upon at the moment for the want of drawing materials. If the memory is not formed by habitual exercise, these objects will promptly disappear even though they were initially very striking. They are at once replaced by others that immediately succeed them, which sometimes merit less attention. Insofar as one has taught oneself to work from memory, at the first stop one can make

a sketch of the objects seen only in passing but of which one has conserved the still-fresh idea. These sketches serve later as a repertory. Those fragments one put down on paper are enough to recall the rest needed to fill in the whole of the place or of things worth representing.

I have known artists of merit who, although talented in copying Nature, have not had the ability to recall that which was no longer before their eyes. Accustomed to the model, they were not able to execute even the least detail without it. No doubt it is very well to use a model, but in many circumstances it is not possible to have one. The painter who does not know how to work from memory is stopped at each moment or is reduced to painting badly because he remembers only poorly what he has seen.

I exhort you, then: When you have made a study of some sort, redo it without looking at the model. After you have sought to forget nothing, when your memory will furnish you no more, compare the sketch to the original. In this way you will recognize what you have omitted or what you have exaggerated. Most certainly you will be embarrassed the first few times, but I can assure you that you will soon accustom yourself to this procedure, and, furnishing your memory by degrees, you will have far more facility in composing your works. . . .

The Landscape Portrait

One does not have to conquer the same difficulties to copy a view of Nature with all possible fidelity as to compose a heroic or pastoral landscape. The landscape portrait does not require, strictly speaking, much genius. Only the eyes and the hand work; youth and habit provide the facility for making paintings that are agreeable in their exactness and the charm of their color and execution. But this genre is nonetheless susceptible to a kind of perfection, and I shall permit myself some reflections useful to the artist who might wish to take it up.

Since a landscape portrait is the faithful representation of Nature, the greater or lesser beauty of the original makes the copy more or less interesting. According to this principle, this genre will have no character distinct from that of resemblance, and this resemblance will vary according to the artist's change of locale; for since each country offers marked differences in its regions, manners, and costumes, its physiognomy changes gradually and almost without one's noticing it, even in a rather short stretch of road. The same kinds of trees cultivated in one country or another look different because the way they are cared for and trimmed varies in accordance with the practices of the farmers. Houses and, in general, all masonry works take their style from the taste, the fashion, the custom, and the materials dictated by those who had them built. The mate-

rials from which the buildings are constructed give a local character and color to villages and even to the entire mass of large cities. Either brick or stone is used in the construction of buildings, and either mortar, earth, or plaster of various colors is used for cement; these determine a building's physiognomy. The city of Angers is built from a schist that abounds in the area, giving a wholly somber effect. Catania in Sicily, Naples, and most cities near volcanoes are constructed from black or gray lava, which presents a melancholy appearance. All the palaces and monuments in Genoa are in black and white marble, giving a singularly motley character to that city. Constantinople is almost entirely of wood, and London of brick. In the Apennines and in Sicily I have seen very poor villages built of hard stones such as porphyry, jasper, and granite, while great cities a short distance away are built of common limestone. Finally, the roofing of houses, the degree of pitch to the roofs, the different details of the exterior architecture, the form of the buildings, their height—all these things together contribute to form the style and to give physiognomy to the city.

Villages vary almost as much as cities. Here, houses or cottages are arranged in rows almost meant to touch; there, they are separated and surrounded each one by a garden; further on is a farm on which all the houses are isolated. In the district of Seine-Inférieure, in the area of Caux, every sizable village almost always presents only a single house at a time. Those that border the Loire, from Amboise to Tours, are dug into the rocks; the doors of the houses are often higher than the windows. Vines grow on the roofs, and chimneys emerge among the vines. The few houses built alongside these inhabited caves give a singular aspect that cannot be imagined by anyone who has not gone through this area.

If the landscapes vary so from one district to another, what would happen if one compared the differences of governments and climates from every part of the world! Were one to add the diversity of costumes and the variety of fashions in certain countries, one would understand how susceptible the genre of the landscape portrait is to embellishments and variety. It is even interesting solely because of the locality, which gives a hundred times more pleasure to amateurs ṭan views of countries so well known that one is bored from seeing them so often.

The artist must have talent for attracting the viewer by some unusual object or some subject that piques his interest; otherwise, he copies Nature faithfully but in vain, for the copy remains cold and does not even bear comparison with the original.

In choosing the most pleasant aspects and those that compose the best, the artist may partially change such objects as poorly formed trees in order to substitute more picturesque ones that are nonetheless copied after Nature.

The Flemish painters excelled in the landscape portrait; Karel du Jardin painted them with the most grace and truthfulness. His paintings seem to have been made with a camera obscura. Van der Heyden, by the exactness of his design, the variety of his color, and the results of his astonishing patience, gave a most uncommon perfection to his views of Holland.[10] It might be said that he counted all the bricks in the houses and all the leaves on the trees; yet despite this minute attention, he was able, through a general harmony of parts, to avoid the dryness and pettiness that ordinarily result from rendering all the details.

Paul Potter and Vandervelde, among others, made portraits of animals with the greatest superiority.[11]

Artists have only to go to the National Museum of Paris to see in the paintings of the Flemish School everything that is most perfect in the genre of the landscape portrait. I would only have them observe that these masters made such masterpieces only by applying themselves with the most scrupulous exactitude to the representation of Nature. . . .

10. Jan van der Heyden (1637–1712).—Ed.
11. Paul Potter (1625–1672), Dutch painter famous for his depictions of cows. Adriaen van der Velde (1636–1672), Dutch landscape painter.—Ed.

PHILIPP OTTO RUNGE

Letter to Daniel Runge (1802)

This letter by Philipp Otto Runge (1777–1810), a painter from northern Germany, might well have been included in Part II, since Runge was concerned with a "community of souls" and was quite conversant with the ideas of Wackenroder and Tieck. Unlike painters such as Overbeck and Minardi, however, he found little inspiration in earlier art as compared to what he gleaned from his studies of nature. His reading, too, seems to have been primarily theological and scientific, rather than devoted to art.

Runge was much impressed by the writings of the seventeenth-century mystic Jakob Böhme (1575–1624) as well as by eighteenth-century writings on the processes of nature and their theological significance. His cyclical world view of destruction and re-creation accords both theologically and geologically with his contemporaries' theories of the history of the earth and the particulars of the Deluge. In his painting, as in his writing, nature is viewed both in terms of direct, emotive experience and as an overtly symbolic phenomenon.

Much as in earlier Neoplatonic theory, in Runge's complex color theories light and color play important roles as conveyors of symbolic meaning. His theories, which sought to explain not only the scientific and symbolic aspects of color but also other sensory experiences, were included in an addendum to Goethe's *Zur Farbenlehre* (1810).

Runge's letter of March 1802 to his elder brother, Daniel, was translated by Michael Snideman from *Philipp Otto Runge: Schriften, Fragmente, Briefe* (Berlin: Friedrich Vorwerk Verlag, 1938), pp. 14–24.

To Daniel

It has always rather embarrassed me when Hartmann or someone else assumed about me—or at least said of others: So-and-so actually does not quite know what art is. Because I had to admit to myself that I just could not say what it is either. That weighed on my mind terribly and vexed me. Then I attempted to find some light in such general maxims as, for example, "a work of art is eternal" or "a work of art requires the whole being as art requires all

Philipp Otto Runge, *We Three,* 1805, oil on canvas.

mankind" or "one ought to look upon one's life as a work of art," and other such things, all of which seemed to raise a point that still had to be probed before I could entirely understand these sayings we hear bandied about. Well, some time ago a kind of light dawned in my soul, and I intend to see if I can communicate my roving perceptions to you briefly and clearly.

Once I thought of a war that could overthrow the entire world, or how such a war would have to arise, and saw simply no means—since war has now become a science throughout the world and thus does not properly exist any longer, and there is no longer any people extant that might massacre all Europe and the entire civilized world as the Germans once did the Romans when the spirit of that people had departed—I saw, as I said, no means other than the Last Judgment, when the earth would open and swallow us all, the entire human race, so that absolutely no trace would remain of all present-day accomplishments.

These thoughts came to me from a few dejected remarks on the spread of civilization that Tieck made when he was ill recently,[1] remarks that also led to the Judgment Day. The question occurred to me: What sort of relation, insofar as our traditions go, does this most advanced civilization—which, it seems, might be brought to consciousness only by such drastic means—bear to humankind as it formerly was constituted? Also, I wondered how the earth itself once looked; how granite and water, raw masses opposing each other, had more and more united. I found both these formations everywhere, in people, in our life, in nature, and in every era of art. I thought of the various religions, how they had originated and gone to ruin, and again an observation by Tieck struck me, that it has always been just after an age has gone down that masterworks of art have come into being—for example, Homer, Sophocles, Dante: the great Greek works of art and the more recent Roman ones; also in architecture—and that these works of art have each time borne within them the very loftiest spirit of the uprooted religion. From what has been, it flashed before my eyes that after the zenith in every era of art (for example, after the formation of the Olympian Jupiter and after the creation of the Last Judgment), art has declined, disintegrated, and again reached a quite different and almost more beautiful high point. I asked myself, is it not likely that we are again about to carry an age to its grave?

I lost myself in wonderment. I could not think further. I sat before my picture [Triumph of Love], and all that I had at first thought about it—how it had originated in me, the feelings that always mount in me upon beholding the moon or the setting of the sun, this foreboding of spirits, the destruction of the world, the distinct awareness of everything that I had ever perceived—passed before my soul. For me this firm awareness became eternity: God you can only sense as being behind these golden mountains, but of your own self you are certain, and what you perceive in your eternal soul, that too is eternal. What you drew from it is everlasting; art must originate there if it is to be eternal. What then happened within me, to what extent I have worked my way out of these confused feelings and sought to regulate them, you will now hear. What transpired subsequently and whatever else requires explanation—I shall tell you later.

When the heavens above me swarm with countless stars, the wind whistles through immense space, the wave breaks roaring in the vast night; when the atmosphere reddens over the forest and the sun lights up the world, the valley steams and I throw myself into the grass amidst sparkling dewdrops; when every leaf and every blade of grass abounds with life, the earth lives and stirs

1. Ludwig Tieck (1773–1853) published *Phantasien über die Kunst für Freunde der Kunst* in 1799.—Ed.

beneath me; when all things resound in a single, harmonious chord—then my soul shouts for joy and flies about in the immeasurable space around me. There is no more below and above, no time, no beginning and no end; I hear and feel the living breath of God, who contains and carries the world, in whom everything lives and acts. Here is our highest perception—God!

This most profound intimation of our soul, that God is over us; that we see how all has come into existence, has been, and passed away; how everything is coming into existence, being, and passing away around us; and how everything will come into existence, will be, and will again pass away; how there is in us no rest and standing still—this vital soul in us, which issued from Him and will return to Him, which will endure when heaven and earth pass away—this is the most certain, clearest consciousness of ourselves and our own eternity.

We feel that an inexorable severity and appalling everlastingness are opposed to a sweet, eternal, and boundless love in a harsh and violent struggle, like hardness and softness, like rocks and water. We see these opponents everywhere, in the smallest as well as the largest things, in the whole as in the parts. These opponents are the quintessence of the world, are basic in the world, and come from God, and over them is God alone. In violent opposition to each other, they reveal themselves in the origin of every single thing that comes from God, that is basic in man and nature. The more harshly they are opposed to each other, the farther each thing is from its consummation. And the more they come together, the closer each is to its consummation. After the acme of this consummation, the spirit returns to God, whereas the lifeless material elements disintegrate, merge with each other at the innermost core of their existence. Then heaven and earth cease to be, and from its ashes the world develops anew and both forces revive in a pure state, unite, and destroy themselves once more. This unceasing flux we perceive in us, in the entire world, in every lifeless thing, and in art.[2] The human being is born helpless, without consciousness, put into the world so that fate may exercise on him what it can and chooses. Along with what is frightful, that which is most beautiful, maternal love, enters the struggle and unites savage passions with the sweetest love and innocence. At the point of completion, man sees his relationship with the whole world. Earnest desire drives him hence. His soul flies forth without rest through all things and finds no peace, but then love binds him to sweet life and he engages in the circle of life around him. He unifies and completes himself through the opposing forces. Then his spirit returns to God. When our feelings sweep us away so that all our senses tremble through and through, then we

2. These two elements, each purely in its own right, are to unite to achieve the highest fulfillment of a work of art, or to achieve the highest fulfillment of art. Should they, however, merge instead of uniting, then the whole edifice will collapse prior to the highest fulfillment of art. In art, these two forces are feeling and reason. If they do not maintain a balance and one becomes preponderant, then mannerism arises and further progress to the goal is checked.

search for the firm, meaningful signs outside ourselves that have been found by others, and we unite them with our feelings. In our best moments, we can communicate this to others. If, however, we want to protract these moments, an overstraining occurs, that is, the spirit flees the signs that have been found and we cannot regain the unity in us until we have returned to our original fervor or until we have been transformed to children again. This circle, in which one is invariably rendered dead, everyone experiences; and the more often one experiences it, the deeper and more fervent one's feelings are certain to become. And so art comes into existence and goes to ruin, and nothing remains but lifeless signs when the spirit has returned to God.

This perception of how the entire universe relates to us, this jubilating rapture of the most fervent, most vital spirit of our soul, this harmonious chord which, in soaring, strikes our every heartstring: the love that holds and carries us through life, this sweet being who is near to us, who lives in us and in whose love our soul glows—it is this urging in our breast that drives us to communicate. We hold fast to the acmes of these perceptions and thus certain ideas arise in us.

We express these ideas in words, tones, or images and thus provoke the same feeling in the bosoms of people near us. The truth of the perception seizes everyone; all feel themselves together in this relationship. All who feel for Him praise the one God, and thus *religion* arises. We unite these words, tones, or images with our most fervent feeling, our intimation of God, and, through perceiving the unity of the whole, with the certainty of our own eternity. That is, we align these feelings with the most significant and vital beings around us, and—in holding fast to characteristic features of these beings, that is, those features that correspond to our feelings—we present the symbols of our thoughts about great forces in the world. These are the images of God or of the gods. The more people keep themselves and their feelings pure and elevated, the more definite do these symbols of God's powers become, the more acutely is the great almighty power perceived. The symbols compress all the infinitely varied natural powers together into one entity; they attempt to concentrate everything simultaneously in one image and thus to present an image of the infinite. (When the human spirit has reached its highest intimation, then an overstraining occurs and, as soon as the spirit has fled, the signs collapse from within and man must begin again from the first childish feeling.)

These symbols we employ when we want to make clearly intelligible to others great events, beautiful thoughts about nature, delightful or terrifying perceptions of our soul, thoughts about occurrences, or the inner unity of our feelings. We search for an occurrence that corresponds in character to the feeling we want to express, and when we have found it, we have selected a *subject* for art.

Philipp Otto Runge, *Rest on the Flight into Egypt*, 1805–6, pen, pencil, and wash sketch.

When we link this subject to our feeling, we juxtapose those symbols of the powers of nature or of the feelings in us so that they express the peculiar characteristics of both the *subject* and *our perception*. This is *composition*. (Here again, as in presenting the single, highest symbol of God, the human being seeks to express an image of God through the loftiest symbolic composition. He unites his loftiest feelings with the world's greatest event and lets all the symbols of his feelings and of nature take effect in that context until he has expressed his thought about the most profound perception of the soul: the omnipotence of God in the world's greatest and last event. In this manner the spirit is again exhausted; the lifeless materials collapse of themselves, and this marks the limit of historical composition.)

Just as we perceive more clearly and coherently the forms of those entities from which we take our symbols, so, too, do we derive more characteristic outlines and representations of them from their basic existence, from our feel-

Philipp Otto Runge, *Rest on the Flight into Egypt,* 1805–6, oil on canvas.

ings, and from the consistency of the natural subject. We observe the subject in all positions, tendencies, and expressions. We arrange every object within the whole exactly according to nature and in consonance with the composition, the effect, the particular action in its own right, and the action of the entire work. We allow objects to become smaller or larger according to perspective and observe all the subordinate objects that belong to the background, in which everything functions in accordance with nature and the subject. This is *design*.

Just as we behold the colors of the sky and earth, the changes in color caused in people by affects and feelings, the effect of colors as they occur in grand natural phenomena, and their harmony, to the extent that certain colors have become symbolic, so do we give to every compositional subject and to each symbol and object individually its color in harmony with our first, deep feeling. And this is the *color scheme*.

We diminish or augment the purity of these colors according to how near or

far each object should appear to be or how great or small the extent of atmosphere between the object and the eye. This is the *ordering of color*.

We observe the consistency of each object in its local color as well as the effect of brighter or weaker light on it, just as we examine the shadow and the effect on it of nearby, illuminated objects. This is *coloring*.

We attempt to find gradations among the reflections and effects of one object on another and among their colors. We examine all colors in accord with the effect of the atmosphere and time of day, attempting with utter thoroughness to discern this tone as the last resonance of our feeling. And this is the *tone*— and the end.

Thus art is the most beautiful endeavor when it proceeds from and is one with what belongs to all. I wish, then, to set down once more the requisites of a work of art with regard not only to the order of their significance but to their proper order in the creative process:

1. Our intimation of God,
2. the perception of ourselves in relation to the whole; and out of these two:
3. religion and art, that is, expression of our loftiest feelings through words, tones, or images; and there pictorial art seeks first:
4. the subject, then
5. the composition,
6. the design,
7. the color scheme,
8. the ordering of color,
9. the coloring,
10. the tone.

In my opinion, a work of art simply cannot come into being when the artist does not proceed from these primary instances. Moreover, in no other way is a work of art eternal, for the eternality of a work lies really only in its association with the artist's soul, and through this it is an image of the eternal source of his soul. A work of art that originates in these primary impulses and develops only to the stage of composition is worth more than any fancy piece that is begun as mere composition, without the initial stages, even if it is fully executed to the point of tone. Clearly, without that which is primary the remaining parts cannot attain relatedness and purity. Only in this order, then, can art rise again. Here, in the innermost core of the person, it must originate; otherwise it remains mere trifling. Here it arose in the case of Raphael, Michelangelo Buonarroti, Guido, and others. Afterward, it is said, art declined. What does that mean but that the spirit has fled?—Annibale Carracci and the like began only at the level of composition, and Mengs at design; our people currently making noise are concerned only with tone.

When I look at this progression and apply it to life and see a perfectly stylish gentleman who can do nothing more than *parler* French and yet knows how to keep himself in full swing, then it instinctively occurs to me: he is at the stage of tone. Yes, the entire progression holds true also in human life, and "blessed are the pure in heart, for they shall see God."

And what is to come out of all the chitchat in Weimar,[3] where they foolishly want to evoke what has already been, through mere signs? Has such ever been reborn? I hardly believe that so beautiful a thing as the zenith of historical art will occur again until all the corruptible newer works of art have perished. Then it would have to happen in a completely new way, which is already rather evident. Perhaps the time might come when a quite beautiful art could again arise, and it would be landscape painting. Probably we can say that there have actually never been any real artists in this area, only a few now and again, and particularly in more recent times, who have sensed the spirit of art there.

Is it not singular that we become clearly and distinctly aware of the entirety of our life when we see thick, heavy clouds now hastening past the moon, now having their edges gilded by the moon, now altogether swallowing the moon? Existence becomes intelligible to us, as if we could write our whole life history solely in such pictures. And is it not true that there have been no more genuine historical painters since Raphael and Buonarroti? Even Raphael's painting in the gallery here shows a downright tendency toward landscape painting[4]—of course by *landscape* we must here understand something quite apart.

Behold, just as a work of art develops from the first basic feeling, where the two raw forces stand opposed, so, too, has the whole human race developed. Every era of art has shown us how these two forces have increasingly united in the purest beings of the age. In the Egyptians' pictorial art, as in their architecture and in all symbols at that time, there was something far harder and more resistant than in Greek art; so too, the first human beings worshiped every last spring, every tree, rock, fire, and so on. The Christian religion, I mean the Catholic one, still needed four persons in its godhead. Through the Mother of God, there was still the good life in heaven; all the saints went there; and thus historical composition thrived until this religion waned. The Reformation limited itself to three persons in the godhead, which now seems to have collapsed. The spirit of this religion has been more abstract but by no means less fervent; a more abstract art must also arise from it. Now people want to stay with one God. If, however, He is lost to them, then there is probably no other remedy but the coming of the Judgment Day.

3. Runge is referring to the activity in art stimulated by Goethe, and in particular to the annual exhibitions of the Weimarer Kunstfreunde.—Ed.

4. Runge is referring to Raphael's *Sistine Madonna* (ca. 1514–16).—Ed.

Just as a work of art that is not rooted in our own eternal existence will not endure, so too it surely is with the person who is not rooted in God. The blossoms we sprout from a consciousness of this, our primal origin, wherein the sap is drawn from this trunk of the world, will grow into fruit. Every man is a twig on this great tree, and only through the trunk can we obtain the sap for eternal, immortal fruit. He who, within himself, no longer feels union with the trunk has already withered away.

CARL G. CARUS

Nine Letters on Landscape Painting (1831)

Although Carl Gustav Carus (1789–1869) did paint, he was primarily a naturalist devoted to the study of geology and botany. Whereas many artists found a correspondence between their art and science, Carus was the scientist who found his scientific studies intimately associated with art. Inspired by Goethe's comprehensive view of the world, he was eager to extend his investigations and speculations to cover all aspects of knowledge. The painter Caspar David Friedrich (1774–1840) was his primary model of an artist, and Friedrich's conceptions of nature and spirituality doubtless had much to do with Carus's formulations. Like Runge and Friedrich, Carus was familiar with Ludwig Tieck and others of the Jena group who settled in Dresden. His thought also shows the influence of the philosophical writings of Friedrich Wilhelm Joseph von Schelling, whose works such as *Ideen zu einer Philosophie der Natur* (1797), *Von der Weltseele* (1798), and *Bruno, oder Über das Göttliche und natürliche Princip der Dinge* (1802) formulate the principal basis for what became known as the German Romantic view of nature.

The *Nine Letters on Landscape Painting,* published in 1831, were dedicated to Goethe. This translation, by Michael Snideman, was made from Carus's *Neun Briefe über Landschaftsmalerei, geschrieben in den Jahren 1815 bis 1824,* edited by K. Gerstenberg (Dresden: Wolfgang Jess, 1955), pp. 27–38. ◆

THE SECOND LETTER

In these splendid winter days I have spent much time in the open air to delight in the varied, graceful play of light between blue sky and snow-covered earth. In truth, the varied, beautifully fragmented colors that become visible here to the practiced eye are wondrous and splendid! There, a bright snowlight flashes on a crag, setting it off still more from the brownish boulders sparingly adorned with sundry mosses and lichens. Here, masses of snow lie in the shade and display their surface prominences in bluish tones now and then going over into violet. Finally, beneath them rushes the mountain brook edged by ice, and on the mirror of its surface green and purple refractions now grow visible in

concurrence with the blinding radiance of the snow, partly as true, partly as physiological colors.[1]

I was not able to share this enjoyment with you, dear Ernst![2] Yet the space that forces us apart should not be able to prevent a meeting of the minds, to prevent me from conversing with you this very evening, from spinning forth that train of thought on landscape art which was stimulated anew today.

In my last letter I discoursed on the spontaneous poetic bent, which, as it begins to take on form and exist as a work of art, does not yet actually imitate the forms of nature but is articulated, rather, in three modes: the pure proportions of speech, of sounds, or of volumes.[3] And with that we found, so to speak, this one, initial realm of the fine arts complete and delimited. We shall now enter the second sphere, where the enduring forms of nature offer the material in which the Promethean spark of Art is to be incorporated. For surely nothing could be withdrawn fully from the realm of Art, just because Art is that which is veritably human and because everything that the human being discerns and examines must, in a certain way, be at her service. Accordingly, just as Art knows how to turn the realm of concepts into a poem, the innermost physical motion—the trembling, the resonance—into music, yes, even rigid, immobile bodies into architecture, so do the imitations of products in three realms of nature arise for the benefit of plastic art. And here it would be easy to compare the representation of inorganic nature with architecture, the representation of the botanical world with music, and that of the higher zoological world and most notably the human form itself with the poem. Plastic art shapes its works in a twofold manner, either round and truly corporeal—that is, as a volume—or through shading and coloring on a surface, that is, by light. It is divided, then, into sculpting and painting, unless one wishes to regard as a third but somewhat hybrid genre the artistic arrangement of living things themselves, as in horticulture, mime, and dance. The proper sculpting of nature is limited, in accordance with its material, to representations of animal and human forms; whereas painting encompasses all three realms of nature

1. In *Zur Farbenlehre* (1810), Goethe uses the term *physiological colors* to denote those colors that are perceived subjectively through the healthy human eye, as distinct from the phenomena explained by physics.—M.S.

2. The letter is addressed to Ernst and is signed by Albertus to commemorate Ernst Albert Carus, the author's short-lived, first-born son, as Carus explains in a letter dated February 26, 1831, to Johann Gottlob Regis (cited by Marianne Prause, *Carl Gustav Carus: Leben und Werk* [Berlin: Deutscher Verlag für Kunstwissenschaft, 1968], p. 67).—Ed.

3. Carus celebrates the "basic and most splendid triad" of poetic literature, music, and architecture at the end of his prefatory first letter. He supposes it to reflect a consistently "triadic inner organization of nature" (including human physiology, his professional speciality), which, he allows, can be better intuited than investigated. Carus's broad use of *poetic* to mean "artistic per se" stands as a tribute to Goethe, who is also honored by quotations from his verse at the outset of the first letter. Goethe read some of Carus's letters in 1822 and encouraged Carus to have them published.—M.S.

(it represents even architectonic and plastic works of art) and can be divided into landscape and historical painting. The former uses the phenomena of inorganic nature as well as the botanical world; the latter uses those of the zoological world and most notably the form of its noblest member, the human being, as the alphabet in which it is, as it were, to spell out significance. Distinctions are nevertheless half obliterated by multifarious crossings over, as when, for example, sculpture and painting combine in semisublime efforts. Similarly landscape painting, for its part, often admits images of animals and people; while landscape, in turn, must often serve as a background in historical paintings.

And thus the creative power of Art engenders ever more extensively, and the world, as it lies formed before our senses, emerges anew in her hands. Everything addresses us from her creations in wondrous, unique language to the artist's purpose. Sun and moon, sky and clouds, mountain and valley, trees and flowers, the most varied animals and the even more varied and higher individuality of man show themselves to be reborn, with the power particular to each of them affecting us—now gloomily, now cheerfully, but always lifting us high above what is commonplace through the perception of divinity, of the creative power in man. For it is certainly in just this manner that Art appears to us as the mediatrix of religion: in bringing the primal strength and soul of the world, which weak human understanding cannot grasp in its entirety, closer to us, in imparting knowledge of it through a small share contained by the human spirit. Wherefore the artist, on the one hand, ought to behold in himself a sanctified vessel which must remain free and unbesmirched by all that is impure, base, and crude; just as the work of art, on the other hand, ought never to draw too close to nature but, rather, rise above it so that the creation of that work by the human spirit will not be forgotten, nor its relation to man lost.

Let us now, dear friend, turn to closer discussion of the purpose and significance of landscape painting in particular. It is an art that properly belongs to the present age, that is generally undefined and perhaps only now looking toward its prime; whereas most other arts resemble more the backward-turned face of Janus or even repose above the graves of the past as the memorials of better days. But each and every imitative art necessarily has a twofold effect on us: first through the nature of the represented object, whose particularity affects us in a picture in approximately the same manner as it does in nature; then according to the capacity of the work of art as a creation of the human spirit to raise the kindred spirit above the commonplace through a truthful revelation of ideas (much as the world in a higher sense is deemed the revelation of divine ideas).

Let us now consider these effects of landscape art separately so as to prepare a comprehensive and final productive result. What, then, is the effect of landscape subjects in untrammeled nature? Asking this first, we shall then be able to

judge their effect in a picture. Solid ground with its manifold formations, such as rock and mountain, valley and plain, calm and agitated waters, air currents and clouds with their various appearances—these are roughly the forms in which the life of the earth is manifested. Yet it is a life of such immensity for our smallness that human beings are scarcely disposed to recognize and acknowledge it as life. Closer to our level of being, however, is the life of plants, and these with the aforementioned phenomena constitute the proper objects of landscape art.

It is certainly not in a passionate, violent manner that we feel ourselves addressed by these aggregate phenomena when we are out in nature; for that they remain too distant from us, if it is even possible to speak of their aesthetic effect as such.[4] It is self-evident that the shipwrecked would not be able to take interest in the beauty of the waves' dashing; the fire victim, in the beauty of the illumination. Only that which touches us directly, that to which we are closely bound, has the capability of agitating us to the utmost through its fluctuations, of filling us with cravings or hatred. In untrammeled nature as we are able to perceive it objectively we take notice, on the contrary, of a silent, self-sufficient, uniform, regulated life: changes in the time of day and in the seasons; the progression of clouds and every splendor of colors in the sky; the ebbing and rising of the sea; the slow but incessantly progressive transformation of the earth's surface; the weathering away of naked pinnacles whose granules, instantly washed downward, gradually issue in fruitful land; the emergence of mountain springs that come together in brooks and finally in torrents, according to the proclivities of the terrain. Everything heeds silent and eternal laws to which we too are definitely subordinated. These laws carry us along despite all resistance and indeed compel us through secret power to turn our glance to a great, even vast sphere of events in nature, thereby shifting our attention from ourselves and letting us perceive our own smallness and weakness. Yet this consideration at the same time lulls inner storms and has in every way a calming effect. Just ascend the summit of the mountain range;[5] look out over the long rows of hills; behold the streams coursing away and all the splendor that is open

4. Here *aesthetic* presumably means "stirring" according to the more extreme early-Romantic notions of aesthetic empathy. Although Carus is discussing how landscapes affect one's feelings, he emphasizes that tranquility alone results in or from the fullest discoveries of scientific and religious truth. Yet he also invokes the classical doctrine of aesthetic distance, which suits his scientific posture but is inadequate to his late-Romantic conception of religious revelation. In subsequent letters Carus increasingly underplays the importance of effects in landscape painting. If landscape, a poor term for what might better be called *Erdlebenbild* (earthlife painting), is to exceed the achievements of Claude and Ruisdael, it must do so through rendering in an artistic manner the scientific appreciation of Nature's laws and mysterious higher truths. Geological study might, for example, inspire the gifted artist to create the first genuinely "historical" landscape paintings. The clearest discussion of changing emphases in the *Nine Letters* is given by Prause, *Carus,* pp. 45–51.—M.S.

5. Possibly the Brocken, the highest point of the lower Harz Mountains. In 1821 Carus studied the Swiss Alps; before then he had confined his studies of geological "life" to Saxony.—M.S.

to your gaze—and what feeling seizes you? There is a silent reverence within you. You lose yourself in limitless space. Your whole being experiences a silent purification and cleansing. Your sense of self disappears. You are nothing. God is everything.

Yet this is not simply a matter of powerful grandeur as manifested in the life of a planet; so too does the proper viewing of the silent, cheerful life of the botanical world claim its effect. Behold how the plant rises slowly but strongly from the ground, how it unfolds its leaves layer by layer, strides in silent development toward its transformation into calyx and flower, and finally with its seed closes the circle while opening a new one. When we find ourselves surrounded by a luxuriant botanical world left to itself, take in with a glance the various life histories of so many growing things, even hit upon the figures of several venerable trees whose survival spans centuries and almost suggests the life of the earth reckoned in hundreds and thousands of years—then we experience an impression similar to that rendered by the above-mentioned conditions. A quiet, reflective mood takes possession of us. We feel our restless aspirations and strivings assuaged. We enter the sphere of nature and rise above ourselves. Yes, it is truly remarkable that the botanical world even works similar effects physically on our bodies. Just as exhalations of the blossom, which is the plant at its most developed, commonly have a numbing property to induce bodily rest, which is sleep, there are several saps, produced by plants in proximity to their blossoms, that work such effects to a still higher degree, that even lead to total dissolution into and intermingling with composite nature, which is death. Accordingly, the ancients adorned the cavern of the dream god with an endless supply of herbs and sleep-inducing poppies,[6] just as animals and human beings are finally to become gentle and peaceful through a steady diet of plants; whereas the enjoyment of flesh, on the contrary, seems to promote wild cravings and agitations.

Surely, even these few reflections on the effect of objects in landscape paintings can afford several insights. Presumably, they will prove sufficient to illuminate the basis for every beneficial feeling of calmness and clarity experienced before genuine works of landscape art and to provide several indicators for the continuation of these explications. But enough for now! I await your friendly answer.

Your Albertus

6. The "dream god" is likely a reference to Asclepius, the Greek god of medicine, who cured his patients by controlling their dreams.—Ed.

RALPH WALDO EMERSON

Essays (1836–1841)

A concern for nature took on a somewhat different significance in the United States than it did in Europe. As long as artistic standards were based on traditions of past art, American artists and critics were at a severe disadvantage. But when the idea began to germinate, first in literature and philosophical essays and then in painting, that unspoiled nature was the spiritual beginning and end, and art was only the means for revealing nature's truths, the situation was reversed. The poet William Cullen Bryant was not slow to point out that America had the advantage when it came to inspirational natural scenery, unmodified by man, and that American artists should fix their attention on this "wilder image." Less conscious of the traditional styles of rendering that European artists were trying to cast off, artists in the United States, in spite of their protests, did not until mid-century concern themselves with as intense an analytical study of natural form as many European artists. They were, however, keenly aware of natural "truth" as a liberating, though nonetheless spiritual, quality.

Ralph Waldo Emerson (1803–1882) was well read in German philosophy and in Eastern religions. It is not by accident that some of his ideas sound like those of Runge and Carus. The center of the New England transcendentalists, he had a great influence in directing a way of thinking that gave each man the responsibility of finding his own place in the natural universe, freeing himself from the bondage of ego and convention. That his views on art itself are rather conventional was of no great importance, since he did not advocate the study of art but the study of nature. Art was important, Emerson said, as preparation for the wider experience.

The essays "Nature" and "Beauty" are taken from *Nature* (Boston: James Munroe and Company, 1836), pp. 9–14 and 19–31. The selection "Art" is excerpted from *Essays* (Boston: James Munroe and Company, 1847), pp. 322–33. 🐾

NATURE

To go into solitude, a man needs to retire as much from his chamber as from society. I am not solitary whilst I read and write, though nobody is with me. But if a man would be alone, let him look at the stars. The rays that come from those heavenly worlds, will separate between him and vulgar things. One might think the atmosphere was made transparent with this design, to give man, in the heavenly bodies, the perpetual presence of the sublime. Seen in the streets of cities, how great they are! If the stars should appear one night in a thousand years, how would men believe and adore; and preserve for many generations the remembrance of the city of God which had been shown! But every night come out these preachers of beauty, and light the universe with their admonishing smile.

The stars awaken a certain reverence, because though always present, they are always inaccessible; but all natural objects make a kindred impression, when the mind is open to their influence. Nature never wears a mean appearance. Neither does the wisest man extort all her secret, and lose his curiosity by finding out all her perfection. Nature never became a toy to a wise spirit. The flowers, the animals, the mountains, reflected all the wisdom of his best hour, as much as they had delighted the simplicity of his childhood.

When we speak of nature in this manner, we have a distinct but most poetical sense in the mind. We mean the integrity of impression made by manifold natural objects. It is this which distinguishes the stick of timber of the wood-cutter, from the tree of the poet. The charming landscape which I saw this morning, is indubitably made up of some twenty or thirty farms. Miller owns this field, Locke that, and Manning the woodland beyond. But none of them owns the landscape. There is a property in the horizon which no man has but he whose eye can integrate all the parts, that is, the poet. This is the best part of these men's farms, yet to this their land-deeds give them no title.

To speak truly, few adult persons can see nature. Most persons do not see the sun. At least they have a very superficial seeing. The sun illuminates only the eye of the man, but shines into the eye and the heart of the child. The lover of nature is he whose inward and outward senses are still truly adjusted to each other; who has retained the spirit of infancy even into the era of manhood. His intercourse with heaven and earth, becomes part of his daily food. In the presence of nature, a wild delight runs through the man, in spite of real sorrows. Nature says,—he is my creature, and maugre all his impertinent griefs, he shall be glad with me. Not the sun or the summer alone, but every hour and season yields its tribute of delight; for every hour and change corresponds to and authorizes a different state of the mind, from breathless noon to grimmest midnight. Nature is a setting that fits equally well a comic or a mourning piece. In good health, the air is a cordial of incredible virtue. Crossing a bare common,

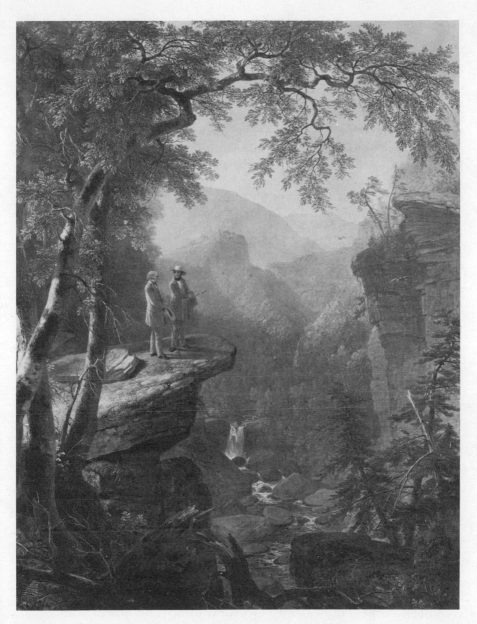

Asher B. Durand, *Kindred Spirits,* 1849, oil on canvas.

in snow puddles, at twilight, under a clouded sky, without having in my thoughts any occurrence of special good fortune, I have enjoyed a perfect exhilaration. Almost I fear to think how glad I am. In the woods too, a man casts off his years, as the snake his slough, and at what period soever of life, is always a child. In the woods, is perpetual youth. Within these plantations of God, a decorum and sanctity reign, a perennial festival is dressed, and the guest sees not how he should tire of them in a thousand years. In the woods, we return to reason and faith. There I feel that nothing can befal me in life,—no disgrace, no calamity, (leaving me my eyes,) which nature cannot repair. Standing on the bare ground,—my head bathed by the blithe air, and uplifted into infinite space,—all mean egotism vanishes. I become a transparent eye-ball. I am nothing. I see all. The currents of the Universal Being circulate through me; I am part or particle of God. The name of the nearest friend sounds then foreign and accidental. To be brothers, to be acquaintances,—master or servant, is then a trifle and a disturbance. I am the lover of uncontained and immortal beauty. In the wilderness, I find something more dear and connate than in streets or villages. In the tranquil landscape, and especially in the distant line of the horizon, man beholds somewhat as beautiful as his own nature.

The greatest delight which the fields and woods minister, is the suggestion of an occult relation between man and the vegetable. I am not alone and unacknowledged. They nod to me and I to them. The waving of the boughs in the storm, is new to me and old. It takes me by surprise, and yet is not unknown. Its effect is like that of a higher thought or a better emotion coming over me, when I deemed I was thinking justly or doing right.

Yet it is certain that the power to produce this delight, does not reside in nature, but in man, or in a harmony of both. It is necessary to use these pleasures with great temperance. For, nature is not always tricked in holiday attire, but the same scene which yesterday breathed perfume and glittered as for the frolic of the nymphs, is overspread with melancholy today. Nature always wears the colors of the spirit. To a man laboring under calamity, the heat of his own fire hath sadness in it. Then, there is a kind of contempt of the landscape felt by him who has just lost by death a dear friend. The sky is less grand as it shuts down over less worth in the population.

BEAUTY

A nobler want of man is served by nature, namely, the love of Beauty.

The ancient Greeks called the world κόσμος, beauty. Such is the constitution of all things, or such the plastic power of the human eye, that the primary forms, as the sky, the mountain, the tree, the animal, give us a delight *in and for themselves;* a pleasure arising from outline, color, motion, and grouping. This

seems partly owing to the eye itself. The eye is the best of artists. By the mutual action of its structure and of the laws of light, perspective is produced, which integrates every mass of objects, of what character soever, into a well colored and shaded globe, so that where particular objects are mean and unaffecting, the landscape which they compose, is round and symmetrical. And as the eye is the best composer, so light is the first of painters. There is no object so foul that intense light will not make it beautiful. And the stimulus it affords to the sense, and a sort of infinitude which it hath, like space and time, make all matter gay. Even the corpse hath its own beauty. But beside this general grace diffused over nature, almost all the individual forms are agreeable to the eye, as is proved by our endless imitations of some of them, as the acorn, the grape, the pine-cone, the wheat-ear, the egg, the wings and forms of most birds, the lion's claw, the serpent, the butterfly, sea-shells, flames, clouds, buds, leaves, and the forms of many trees, as the palm.

For better consideration, we may distribute the aspects of Beauty in a three-fold manner.

1. First, the simple perception of natural forms is a delight. The influence of the forms and actions in nature, is so needful to man, that, in its lowest functions, it seems to lie on the confines of commodity and beauty. To the body and mind which have been cramped by noxious work or company, nature is medicinal and restores their tone. The tradesman, the attorney comes out of the din and craft of the street, and sees the sky and the woods, and is a man again. In their eternal calm, he finds himself. The health of the eye seems to demand a horizon. We are never tired, so long as we can see far enough.

But in other hours, Nature satisfies the soul purely by its loveliness, and without any mixture of corporeal benefit. I have seen the spectacle of morning from the hill-top over against my house, from day-break to sun-rise, with emotions which an angel might share. The long slender bars of cloud float like fishes in the sea of crimson light. From the earth, as a shore, I look out into that silent sea. I seem to partake its rapid transformations: the active enchantment reaches my dust, and I dilate and conspire with the morning wind. How does Nature deify us with a few and cheap elements! Give me health and a day, and I will make the pomp of emperors ridiculous. The dawn is my Assyria; the sunset and moon-rise my Paphos, and unimaginable realms of faerie; broad noon shall be my England of the senses and the understanding; the night shall be my Germany of mystic philosophy and dreams.

Not less excellent, except for our less susceptibility in the afternoon, was the charm, last evening, of a January sunset. The western clouds divided and subdivided themselves into pink flakes modulated with tints of unspeakable softness; and the air had so much life and sweetness, that it was a pain to come within doors. What was it that nature would say? Was there no meaning in the live repose of the valley behind the mill, and which Homer or Shakspeare could

not re-form for me in words? The leafless trees became spires of flame in the sunset, with the blue east for their background, and the stars of the dead calices of flowers, and every withered stem and stubble rimed with frost, contribute something to the mute music.

The inhabitants of cities suppose that the country landscape is pleasant only half the year. I please myself with observing the graces of the winter scenery, and believe that we are as much touched by it as by the genial influences of summer. To the attentive eye, each moment of the year has its own beauty, and in the same field, it beholds, every hour, a picture which was never seen before, and which shall never be seen again. The heavens change every moment, and reflect their glory or gloom on the plains beneath. The state of the crop in the surrounding farms alters the expression of the earth from week to week. The succession of native plants in the pastures and roadsides, which make the silent clock by which time tells the summer hours, will make even the divisions of the day sensible to a keen observer. The tribes of birds and insects, like the plants punctual to their time, follow each other, and the year has room for all. By watercourses, the variety is greater. In July, the blue pontederia or pickerel-weed blooms in large beds in the shallow parts of our pleasant river, and swarms with yellow butterflies in continual motion. Art cannot rival this pomp of purple and gold. Indeed the river is a perpetual gala, and boasts each month a new ornament.

But this beauty of Nature which is seen and felt as beauty, is the least part. The shows of day, the dewy morning, the rainbow, mountains, orchards in blossom, stars, moonlight, shadows in still water, and the like, if too eagerly hunted, become shows merely, and mock us with their unreality. Go out of the house to see the moon, and 'tis mere tinsel; it will not please as when its light shines upon your necessary journey. The beauty that shimmers in the yellow afternoons of October, who ever could clutch it? Go forth to find it, and it is gone: 'tis only a mirage as you look from the windows of diligence.

2. The presence of a higher, namely, of the spiritual element is essential to its perfection. The high and divine beauty which can be loved without effeminacy, is that which is found in combination with the human will, and never separate. Beauty is the mark God sets upon virtue. Every natural action is graceful. Every heroic act is also decent, and causes the place and the by-standers to shine. We are taught by great actions that the universe is the property of every individual in it. Every rational creature has all nature for his dowry and estate. It is his, if he will. He may divest himself of it; he may creep into a corner, and abdicate his kingdom, as most men do, but he is entitled to the world by his constitution. In proportion to the energy of his thought and will, he takes up the world into himself. "All those things for which men plough, build, or sail, obey virtue;" said an ancient historian. "The winds and waves," said Gibbon, "are always on the side of the ablest navigators." So are

the sun and moon and all the stars of heaven. When a noble act is done,— perchance in a scene of great natural beauty; when Leonidas and his three hundred martyrs consume one day in dying, and the sun and moon come each and look at them once in the steep defile of Thermopylae; when Arnold Winkelried, in the high Alps, under the shadow of the avalanche, gathers in his side a sheaf of Austrian spears to break the line for his comrades; are not these heroes entitled to add the beauty of the scene to the beauty of the deed? When the bark of Columbus nears the shore of America;—before it, the beach lined with savages, fleeing out of all their huts of cane; the sea behind; and the purple mountains of the Indian Archipelago around, can we separate the man from the living picture? Does not the New World clothe his form with her palm-groves and savannahs as fit drapery? Ever does natural beauty steal in like air, and envelope great actions. When Sir Harry Vane was dragged up the Tower-hill, sitting on a sled, to suffer death, as the champion of the English laws, one of the multitude cried out to him, "You never sate on so glorious a seat." Charles II., to intimidate the citizens of London, caused the patriot Lord Russel to be drawn in an open coach, through the principal streets of the city, on his way to the scaffold. "But," to use the simple narrative of his biographer, "the multitude imagined they saw liberty and virtue sitting by his side." In private places, among sordid objects, an act of truth or heroism seems at once to draw to itself the sky as its temple, the sun as its candle. Nature stretcheth out her arms to embrace man, only let his thoughts be of equal greatness. Willingly does she follow his steps with the rose and the violet, and bend her lines of grandeur and grace to the decoration of her darling child. Only let his thoughts be of equal scope, and the frame will suit the picture. A virtuous man, is in unison with her works, and makes the central figure of the visible sphere. Homer, Pindar, Socrates, Phocion, associate themselves fitly in our memory with the whole geography and climate of Greece. The visible heavens and earth sympathize with Jesus. And in common life, whosoever has seen a person of powerful character and happy genius, will have remarked how easily he took all things along with him,—the persons, the opinions, and the day, and nature became ancillary to a man.

3. There is still another aspect under which the beauty of the world may be viewed, namely, as it becomes an object of the intellect. Beside the relation of things to virtue, they have a relation to thought. The intellect searches out the absolute order of things as they stand in the mind of God, and without the colors of affection. The intellectual and the active powers seem to succeed each other in man, and the exclusive activity of the one, generates the exclusive activity of the other. There is something unfriendly in each to the other, but they are like the alternate periods of feeding and working in animals; each prepares and certainly will be followed by the other. Therefore does beauty, which, in relation to actions, as we have seen comes unsought, and comes because it is

unsought, remain for the apprehension and pursuit of the intellect; and then again, in its turn, of the active power. Nothing divine dies. All good is eternally reproductive. The beauty of nature reforms itself in the mind, and not for barren contemplation, but for new creation.

All men are in some degree impressed by the face of the world. Some men even to delight. This love of beauty is Taste. Others have the same love in such excess, that, not content with admiring, they seek to embody it in new forms. The creation of beauty is Art.

The production of a work of art throws a light upon the mystery of humanity. A work of art is an abstract or epitome of the world. It is the result or expression of nature, in miniature. For although the works of nature are innumerable and all different, the result or the expression of them all is similar and single. Nature is a sea of forms radically alike and even unique. A leaf, a sunbeam, a landscape, the ocean, make an analogous impression on the mind. What is common to them all,—that perfectness and harmony, is beauty. Therefore the standard of beauty, is the entire circuit of natural forms,—the totality of nature; which the Italians expressed by defining beauty "il piu nell'uno." Nothing is quite beautiful alone: nothing but is beautiful in the whole. A single object is only so far beautiful as it suggests this universal grace. The poet, the painter, the sculptor, the musician, the architect seek each to concentrate this radiance of the world on one point, and each in his several work to satisfy the love of beauty which stimulates him to produce. Thus is Art, a nature passed through the alembic of man. Thus in art, does nature work through the will of a man filled with the beauty of her first works.

The world thus exists to the soul to satisfy the desire of beauty. Extend this element to the uttermost, and I call it an ultimate end. No reason can be asked or given why the soul seeks beauty. Beauty, in its largest and profoundest sense, is one expression for the universe. God is the all-fair. Truth, and goodness, and beauty, are but different faces of the same All. But beauty in nature is not ultimate. It is the herald of inward and eternal beauty, and is not alone a solid and satisfactory good. It must therefore stand as a part and not as yet the last or highest expression of the final cause of Nature.

ART

The office of painting and sculpture seems to be merely initial. The best pictures can easily tell us their last secret. The best pictures are rude draughts of a few of the miraculous dots and lines and dyes which make up the ever-changing "landscape with figures" amidst which we dwell. Painting seems to be to the eye what dancing is to the limbs. When that has educated the frame to self-possession, to nimbleness, to grace, the steps of the dancing-master are

better forgotten; so painting teaches me the splendor of color and the expression of form, and, as I see many pictures and higher genius in the art, I see the boundless opulence of the pencil, the indifferency in which the artist stands free to choose out of the possible forms. If he can draw every thing, why draw any thing? and then is my eye opened to the eternal picture which nature paints in the street with moving men and children, beggars, and fine ladies, draped in red, and green, and blue, and gray; long-haired, grizzled, white-faced, black-faced, wrinkled, giant, dwarf, expanded, elfish,—capped and based by heaven, earth, and sea.

A gallery of sculpture teaches more austerely the same lesson. As picture teaches the coloring, so sculpture the anatomy of form. When I have seen fine statues, and afterwards enter a public assembly, I understand well what he meant who said, "When I have been reading Homer, all men look like giants." I too see that painting and sculpture are gymnastics of the eye, its training to the niceties and curiosities of its function. There is no statue like this living man, with his infinite advantage over all ideal sculpture, of perpetual variety. What a gallery of art have I here! No mannerist made these varied groups and diverse original single figures. Here is the artist himself improvising, grim and glad, at his block. Now one thought strikes him, now another, and with each moment he alters the whole air, attitude, and expression of his clay. Away with your nonsense of oil and easels, of marble and chisels: except to open your eyes to the masteries of eternal art, they are hypocritical rubbish.

The reference of all production at last to an aboriginal Power explains the traits common to all works of the highest art,—that they are universally intelligible; that they restore to us the simplest states of mind; and are religious. Since what skill is therein shown is the reappearance of the original soul, a jet of pure light, it should produce a similar impression to that made by natural objects. In happy hours, nature appears to us one with art; art perfected,—the work of genius. And the individual, in whom simple tastes and susceptibility to all great human influences overpower the accidents of a local and special culture, is the best critic of art. Though we travel the world over to find the beautiful, we must carry it with us, or we find it not. The best of beauty is a finer charm than skill in surfaces, in outlines, or rules of art can ever teach, namely, a radiation from the work of art of human character,—a wonderful expression through stone, or canvas, or musical sound, of the deepest and simplest attributes of our nature, and therefore most intelligible at last to those souls which have these attributes. In the sculpture of the Greeks, in the masonry of the Romans, and in the pictures of the Tuscan and Venetian masters, the highest charm is the universal language they speak. A confession of moral nature, of purity, love, and hope, breathes from them all. That which we carry to them, the same we bring back more fairly illustrated in the memory. The traveller who visits the Vatican, and passes from chamber to chamber through the gal-

leries of statues, vases, sarcophagi, and candelabra, through all forms of beauty, cut in the richest materials, is in danger of forgetting the simplicity of the principles out of which they all sprung, and that they had their origin from thoughts and laws in his own breast. He studies the technical rules on these wonderful remains, but forgets that these works were not always thus constellated; that they are the contributions of many ages and many countries; that each came out of the solitary workshop of one artist, who toiled perhaps in ignorance of the existence of other sculpture, created his work without other model, save life, household life, and the sweet and smart of personal relations, of beating hearts, and meeting eyes, of poverty, and necessity, and hope, and fear. These were his inspirations, and these are the effects he carries home to your heart and mind. In proportion to his force, the artist will find in his work an outlet for his proper character. He must not be in any manner pinched or hindered by his material, but through his necessity of imparting himself the adamant will be wax in his hands, and will allow an adequate communication of himself, in his full stature and proportion. He need not cumber himself with a conventional nature and culture, nor ask what is the mode in Rome or in Paris, but that house, and weather, and manner of living which poverty and the fate of birth have made at once so odious and so dear, in the gray, unpainted wood cabin, on the corner of a New Hampshire farm, or in the log-hut of the backwoods, or in the narrow lodging where he has endured the constraints and seeming of a city poverty, will serve as well as any other condition as the symbol of a thought which pours itself indifferently through all.

A true announcement of the law of creation, if a man were found worthy to declare it, would carry art up into the kingdom of nature, and destroy its separate and contrasted existence. The fountains of invention and beauty in modern society are all but dried up. A popular novel, a theatre, or a ball-room makes us feel that we are all paupers in the almshouse of this world, without dignity, without skill, or industry. Art is as poor and low. The old tragic Necessity, which lowers on the brows even of the Venuses and the Cupids of the antique, and furnishes the sole apology for the intrusion of such anomalous figures into nature,—namely, that they were inevitable; that the artist was drunk with a passion for form which he could not resist, and which vented itself in these fine extravagances,—no longer dignifies the chisel or the pencil. But the artist and the connoisseur now seek in art the exhibition of their talent, or an asylum from the evils of life. Men are not well pleased with the figure they make in their own imaginations, and they flee to art, and convey their better sense in an oratorio, a statue, or a picture. Art makes the same effort which a sensual prosperity makes; namely, to detach the beautiful from the useful, to do up the work as unavoidable, and, hating it, pass on to enjoyment. These solaces and compensations, this division of beauty from use, the laws of nature do not per-

mit. As soon as beauty is sought, not from religion and love, but for pleasure, it degrades the seeker. High beauty is no longer attainable by him in canvas or in stone, in sound, or in lyrical construction; an effeminate, prudent, sickly beauty, which is not beauty, is all that can be formed; for the hand can never execute any thing higher than the character can inspire.

The art that thus separates is itself first separated. Art must not be a superficial talent, but must begin farther back in man. Now men do not see nature to be beautiful, and they go to make a statue which shall be. They abhor men as tasteless, dull, and inconvertible, and console themselves with color-bags, and blocks of marble. They reject life as prosaic, and create a death which they call poetic. They despatch the day's weary chores, and fly to voluptuous reveries. They eat and drink, that they may afterwards execute the ideal. Thus is art vilified; the name conveys to the mind its secondary and bad senses; it stands in the imagination as somewhat contrary to nature, and struck with death from the first. Would it not be better to begin higher up,—to serve the ideal before they eat and drink; to serve the ideal in eating and drinking, in drawing the breath, and in the functions of life? Beauty must come back to the useful arts, and the distinction between the fine and the useful arts be forgotten. If history were truly told, if life were nobly spent, it would be no longer easy or possible to distinguish the one from the other. In nature, all is useful, all is beautiful. It is therefore beautiful, because it is alive, moving, reproductive; it is therefore useful, because it is symmetrical and fair. Beauty will not come at the call of a legislature, nor will it repeat in England or America its history in Greece. It will come, as always, unannounced, and spring up between the feet of brave and earnest men. It is in vain that we look for genius to reiterate its miracles in the old arts; it is its instinct to find beauty and holiness in new and necessary facts, in the field and road-side, in the shop and mill. Proceeding from a religious heart, it will raise to a divine use the railroad, the insurance office, the joint-stock company, our law, our primary assemblies, our commerce, the galvanic battery, the electric jar, the prism, and the chemist's retort, in which we seek now only an economical use. Is not the selfish and even cruel aspect which belongs to our great mechanical works,—to mills, railways, and machinery,—the effect of the mercenary impulses which these works obey? When its errands are noble and adequate, a steamboat bridging the Atlantic between Old and New England, and arriving at its ports with the punctuality of a planet, is a step of man into harmony with nature. The boat at St. Petersburgh, which plies along the Lena by magnetism, needs little to make it sublime. When science is learned in love, and its powers are wielded by love, they will appear the supplements and continuations of the material creation.

JOHN RUSKIN

Preface to the Second Edition
of *Modern Painters* (1844)

The writings of John Ruskin (1819–1900) exerted diverse kinds of influences on his European and American readers because throughout his long career Ruskin continuously changed or modified his views. With a keen moral and religious sense, he castigated all that he found superficial, insincere, or untrue. His first major publication, *Modern Painters* (1843), was written as a defense of J.M.A. Turner, who, he felt, had escaped all convention and self-consciousness to make contact with true nature in all its beauty of flux and change. The book was attacked, of course, since it struck out boldly against the Royal Academy and its established taste. The preface to the second edition of 1844, reproduced here, was a defense of those premises most severely criticized. The four subsequent volumes of *Modern Painters* show a greater leaning toward past art, and Ruskin's later emphasis on the Gothic style in his *Seven Lamps of Architecture* (1849) placed him at the center of a theologically inspired antiquarian revival.

The first volume of *Modern Painters* was hailed by many young artists in England and America. The Pre-Raphaelite Brotherhood, formed in London in 1848, took its cue from Ruskin's work and sought his protection. In the United States, *The Crayon*, the first thorough art periodical in the country, was dominated by Ruskin's ideas, and a "Society for the Advancement of Truth in Art" was founded in 1863 based on Ruskin's principles.

The text of the preface is excerpted from the edition edited by E. T. Cook and Alexander Wedderburn, *The Works of John Ruskin*, 39 vols. (London: George Allen; New York: Longmans, Green, and Co., 1903), 1:20–31, 38–40, and 42–44. ✍

14. It is not, however, merely to vindicate the reputation of those whom writers like these defame, which would but be to anticipate by a few years the natural and inevitable reaction of the public mind, that I am devoting years of labour to the development of the principles on which the great productions of

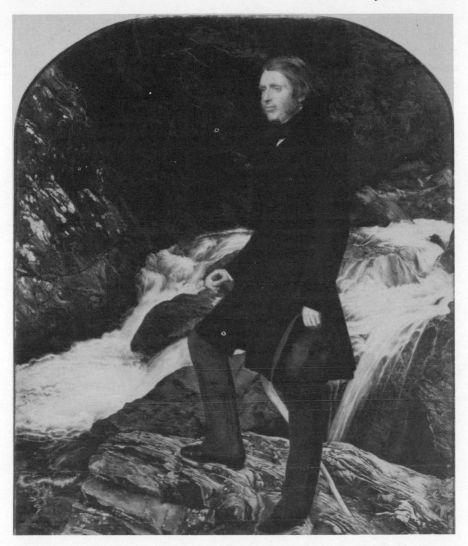

Sir J. E. Millais, *John Ruskin,* 1854, oil on canvas.

recent art are based. I have a higher end in view, one which may, I think, justify me, not only in the sacrifice of my own time, but in calling on my readers to follow me through an investigation far more laborious than could be adequately rewarded by mere insight into the merits of a particular master, or the spirit of a particular age.

It is a question which, in spite of the claims of Painting to be called the sister of Poetry, appears to me to admit of considerable doubt, whether art has ever, except in its earliest and rudest stages, possessed anything like efficient moral influence on mankind. Better the state of Rome when "magnorum artificum frangebat pocula miles, ut phaleris gauderet equus," than when her walls flashed with the marble and the gold "nec cessabat luxuria id agere, ut quam plurimum incendiis perdat." [1] Better the state of religion in Italy, before Giotto had broken on one barbarism of the Byzantine schools, than when the painter of the Last Judgment, and the sculptor of the Perseus, sat revelling side by side.[2] It appears to me that a rude symbol is oftener more efficient than a refined one in touching the heart; and that as pictures rise in rank as works of art, they are regarded with less devotion and more curiosity.

15. But, however this may be, and whatever influence we may be disposed to admit in the great works of sacred art, no doubt can, I think, be reasonably entertained as to the utter inutility of all that has been hitherto accomplished by the painters of landscape. No moral end has been answered, no permanent good effected, by any of their works. They may have amused the intellect, or exercised the ingenuity, but they never have spoken to the heart. Landscape art has never taught us one deep or holy lesson; it has not recorded that which is fleeting, nor penetrated that which was hidden, nor interpreted that which was obscure; it has never made us feel the wonder, nor the power, nor the glory of the universe; it has not prompted to devotion, nor touched with awe; its power to move and exalt the heart has been fatally abused, and perished in the abusing. That which ought to have been a witness to the omnipotence of God, has become an exhibition of the dexterity of man; and that which would have lifted our thoughts to the throne of the Deity, has encumbered them with the inventions of his creatures.

If we stand for a little time before any of the more celebrated works of landscape, listening to the comments of the passers-by, we shall hear numberless expressions relating to the skill of the artist, but very few relating to the perfection of nature. Hundreds will be voluble in admiration, for one who will be silent in delight. Multitudes will laud the composition, and depart with the praise of Claude on their lips; not one will feel as if it were *no* composition, and depart with the praise of God in his heart.

1. Cook and Wedderburn note the source of these two phrases. The first is derived from Juvenal's account of a soldier who, despising Greek art, would "break goblets by great designers for trappings to please his horse"; the second, from Pliny's account of Roman extravagance, "when painting was superseded by marble and gold, and 'luxury ceases not to busy itself in order that as much as possible may be lost whenever there is a fire.'"—Ed.

2. Cook and Wedderburn note Ruskin's discussion of Michelangelo's *Last Judgment* in *Modern Painters*, vol. 2, sec. 2, chap. 3.—Ed.

16. These are the signs of a debased, mistaken, and false school of painting. The skill of the artist, and the perfection of his art, are never proved until both are forgotten. The artist has done nothing till he has concealed himself; the art is imperfect which is visible; the feelings are but feebly touched, if they permit us to reason on the methods of their excitement. In the reading of a great poem, in the hearing of a noble oration, it is the subject of the writer, and not his skill, his passion, not his power, on which our minds are fixed. We see as he sees, but we see not him. We become part of him, feel with him, judge, behold with him; but we think *of* him as little as of ourselves. Do we think of Aeschylus, while we wait on the silence of Cassandra;³ or of Shakspeare, while we listen to the wailing of Lear? Not so. The power of the masters is shown by their self-annihilation. It is commensurate with the degree in which they themselves appear not in their work. The harp of the minstrel is untruly touched, if his own glory is all that it records. Every great writer may be at once known by his guiding the mind far from himself, to the beauty which is not of his creation, and the knowledge which is past his finding out.

And must it ever be otherwise with painting? for otherwise it has ever been. Her subjects have been regarded as mere themes on which the artist's power is to be displayed; and that power, be it of imitation, composition, idealization, or of whatever other kind, is the chief object of the spectator's observation. It is man and his fancies, man and his trickeries, man and his inventions, poor, paltry, weak, self-sighted man, which the connoisseur for ever seeks and worships. Among potsherds and dunghills, among drunken boors and withered beldames, through every scene of debauchery and degradation, we follow the erring artist, not to receive one wholesome lesson, not to be touched with pity, nor moved with indignation, but to watch the dexterity of pencil, and gloat over the glittering of the hue.

17. I speak not only of the works of the Flemish school, I wage no war with their admirers; they may be left in peace to count the spicula of haystacks and the hairs of donkeys; it is also of works of real mind that I speak, works in which there are evidences of genius and workings of power, works which have been held up as containing all of the beautiful that art can reach or man conceive. And I assert with sorrow, that all hitherto done in landscape, by those commonly conceived its masters, has never prompted one holy thought in the minds of nations. It has begun and ended in exhibiting the dexterities of individuals, and conventionalities of systems. Filling the world with the honour of Claude and Salvator, it has never once tended to the honour of God.

Does the reader start in reading these last words, as if they were those of

3. Ruskin here cites in Greek two passages from Aristophanes' *The Frogs* that allude to Aeschylus, and he compares the intensity of Aeschylus's thought to that of Turner.—Ed.

wild enthusiasm, as if I were lowering the dignity of religion by supposing that
its cause could be advanced by such means? His surprise proves my position. It
does sound like wild, like absurd enthusiasm, to expect any definite moral
agency in the painters of landscape; but ought it so to sound? Are the gorgeous-
ness of the visible hue, the glory of the realized form, instruments in the artist's
hand so ineffective, that they can answer no nobler purpose than the amuse-
ment of curiosity, or the engagement of idleness? Must it not be owing to gross
neglect or misapplication of the means at his command, that while words and
tones (means of representing nature surely less powerful than lines and colours)
can kindle and purify the very inmost souls of men, the painter can only hope
to entertain by his efforts at expression, and must remain for ever brooding
over his incommunicable thoughts?

18. The cause of the evil lies, I believe, deep-seated in the system of ancient
landscape art; it consists, in a word, in the painter's taking upon him to modify
God's works at his pleasure, casting the shadow of himself on all he sees, con-
stituting himself arbiter where it is honour to be a disciple, and exhibiting his
ingenuity by the attainment of combinations whose highest praise is that they
are impossible. We shall not pass through a single gallery of old art, without
hearing this topic of praise confidently advanced. The sense of artificialness,
the absence of all appearance of reality, the clumsiness of combination by which
the meddling of man is made evident, and the feebleness of his hand branded
on the inorganization of his monstrous creature, are advanced as a proof of in-
ventive power, as an evidence of abstracted conception; nay, the violation of
specific form, the utter abandonment of all organic and individual character of
object (numberless examples of which from the works of the old masters are
given in the following pages), is constantly held up by the unthinking critic as
the foundation of the grand or historical style, and the first step to the attain-
ment of a pure ideal. Now there is but one grand style, in the treatment of all
subjects whatsoever, and that style is based on the *perfect* knowledge, and con-
sists in the simple unencumbered rendering, of the specific characters of the
given object, be it man, beast, or flower. Every change, caricature, or abandon-
ment of such specific character is as destructive of grandeur as it is of truth, of
beauty as of propriety. Every alteration of the features of nature has its origin
either in powerless indolence or blind audacity; in the folly which forgets, or
the insolence which desecrates, works which it is the pride of angels to know,
and their privilege to love.

19. We sometimes hear such infringement of universal laws justified on the
plea, that the frequent introduction of mythological abstractions into ancient
landscape requires an imaginary character of form in the material objects with
which they are associated. Something of this kind is hinted in Reynolds' four-
teenth Discourse; but nothing can be more false than such reasoning. If there
be any truth or beauty in the original conception of the spiritual being so intro-

duced, there must be a true and real connection between that abstract idea[4] and the features of nature as she was and is. The woods and waters which were peopled by the Greek with typical life were not different from those which now wave and murmur by the ruins of his shrines. With their visible and actual forms was his imagination filled, and the beauty of its incarnate creatures can only be understood among the pure realities which originally modelled their conception. If divinity be stamped upon the features, or apparent in the form, of the spiritual creature, the mind will not be shocked by its appearing to ride upon the whirlwind, and trample on the storm; but if mortality, no violation of the characters of the earth will forge one single link to bind it to the heaven.

20. Is there then no such thing as elevated ideal character of landscape? Undoubtedly; and Sir Joshua, with the great master of this character, Nicolo Poussin, present to his thoughts, ought to have arrived at more true conclusions respecting its essence, than, as we shall presently see, are deducible from his works. The true ideal of landscape is precisely the same as that of the human form; it is the expression of the specific—not the individual, but the specific—characters of every object, in their perfection. There is an ideal form of every herb, flower, and tree, it is that form to which every individual of the species has a tendency to arrive, freed from the influence of accident or disease. Every landscape painter should know the specific characters of every object he has to represent, rock, flower, or cloud; and in his highest ideal works all their distinctions will be perfectly expressed, broadly or delicately, slightly or completely, according to the nature of the subject, and the degree of attention which is to be drawn to the particular object by the part it plays in the composition. Where the sublime is aimed at, such distinctions will be indicated with severe simplicity, as the muscular markings in a colossal statue; where beauty is the object, they must be expressed with the utmost refinement of which the hand is capable.

21. This may sound like a contradiction of principles advanced by the highest authorities; but it is only a contradiction of a particular and most mistaken application of them. Much evil has been done to art by the remarks of historical painters on landscape. Accustomed themselves to treat their backgrounds slightly and boldly, and feeling (though, as I shall presently show, only in consequence of their own deficient powers) that any approach to completeness of detail therein injures their picture by interfering with its principal subject, they naturally lose sight of the peculiar and intrinsic beauties of things which to them are injurious, unless subordinate. Hence the frequent advice given by Reynolds and others, to neglect *specific* form in landscape, and treat its materials in large masses, aiming only at general truths; the flexibility of foliage, but not its kind; the rigidity of rock, but not its mineral character. In the passage

4. Ruskin cites Aristophanes' *Clouds* as a comparable literary description for his concept.— Ed.

more especially bearing on this subject (in the eleventh Lecture of Sir J. Rey-
nolds), we are told that "the landscape painter works not for the virtuoso or the
naturalist, but for the general observer of life and nature." This is true, in pre-
cisely the same sense that the sculptor does not work for the anatomist, but for
the common observer of life and nature. Yet the sculptor is not, for this reason,
permitted to be wanting either in knowledge or expression of anatomical de-
tail; and the more refined that expression can be rendered, the more perfect is
his work. That which to the anatomist is the end, is to the sculptor the means.
The former desires details for their own sake; the latter, that by means of them
he may kindle his work with life, and stamp it with beauty. And so in land-
scape; botanical or geological details are not to be given as matter of curiosity
or subject of search, but as the ultimate elements of every species of expression
and order of loveliness.

22. In his observation on the foreground of the San Pietro Martire, Sir
Joshua advances,[5] as a matter of praise, that the plants are discriminated "just as
much as was necessary for the variety, and no more." Had this foreground been
occupied by a group of animals, we should have been surprised to be told that
the lion, the serpent, and the dove, or whatever other creatures might have been
introduced, were distinguished from each other just as much as was necessary
for variety, and no more. Yet is it to be supposed that the distinctions of the
vegetable world are less complete, less essential, or less divine in origin, than
those of the animal? If the distinctive forms of animal life are meant for our
reverent observance, is it likely that those of vegetable life are made merely to
be swept away? The latter are indeed less obvious and less obtrusive; for which
very reason there is less excuse for omitting them, because there is less danger
of their disturbing the attention or engaging the fancy.

23. But Sir Joshua is as inaccurate in fact, as false in principle. He him-
self furnishes a most singular instance of the very error of which he accuses
Vasari,—the seeing what he expects; or, rather, in the present case, not seeing
what he does not expect. The great masters of Italy, almost without exception,
and Titian perhaps more than any (for he had the highest knowledge of land-
scape), are in the constant habit of rendering every detail of their foregrounds
with the most laborious botanical fidelity: witness the "Bacchus and Ariadne,"
in which the foreground is occupied by the common blue iris, the aquilegia,
and the wild rose;[6] *every stamen* of which latter is given, while the blossoms and
leaves of the columbine (a difficult flower to draw) have been studied with the
most exquisite accuracy. The foregrounds of Raffaelle's two cartoons, "The

5. Cook and Wedderburn note that Reynolds spoke of this picture in Discourse XI, and that
the picture was destroyed in 1866 by fire in the sacristy of SS. Giovanni e Paolo, Venice.—Ed.
6. In a footnote, Ruskin reproduces a letter he received following the publication of *Modern
Painters* in which he was corrected for his misidentification of *Copparis spinosa* as a wild rose.—Ed.

Miraculous Draught of Fishes," and "The Charge to Peter," are covered with plants of the common sea colewort (*Crambe maritima*), of which the sinuated leaves and clustered blossoms would have exhausted the patience of any other artist; but have appeared worthy of prolonged and thoughtful labour to the great mind of Raffaelle.

It appears, then, not only from natural principles, but from the highest of all authority, that thorough knowledge of the lowest details is necessary, and full expression of them right, even in the highest class of historical painting; that it will not take away from, nor interfere with, the interest of the figures, but, rightly managed, must add to and elucidate it; and, if further proof be wanting, I would desire the reader to compare the background of Sir Joshua's "Holy Family," in the National Gallery, with that of Nicolo Poussin's "Nursing of Jupiter," in the Dulwich Gallery. The first, owing to the utter neglect of all botanical detail, has lost every atom of ideal character, and reminds us of nothing but an English fashionable flower-garden; the formal pedestal adding considerably to the effect. Poussin's, in which every vine leaf is drawn with consummate skill and untiring diligence, produces not only a tree group of the most perfect grace and beauty, but one which, in its pure and simple truth, belongs to every age of nature, and adapts itself to the history of all time. If then, such entire rendering of specific character be necessary to the historical painter, in cases where these lower details are entirely subordinate to his human subject, how much more must it be necessary in landscape, where they themselves constitute the subject, and where the undivided attention is to be drawn to them!

24. There is a singular sense in which the child may peculiarly be said to be father of the man. In many arts and attainments, the first and last stages of progress, the infancy and the consummation, have many features in common; while the intermediate stages are wholly unlike either, and are farthest from the right. Thus it is in the progress of a painter's handling. We see the perfect child, the absolute beginner, using of necessity a broken, imperfect, inadequate line, which, as he advances, becomes gradually firm, severe, and decided. Yet before he becomes a perfect artist, this severity and decision will again be exchanged for a light and careless stroke, which in many points will far more resemble that of his childhood than of his middle age, differing from it only by the consummate effect wrought out by the apparently inadequate means. So it is in many matters of opinion. Our first and last coincide, though on different grounds; it is the middle stage which is farthest from the truth. Childhood often holds a truth with its feeble fingers, which the grasp of manhood cannot retain, which it is the pride of utmost age to recover.

Perhaps this is in no instance more remarkable than in the opinion we form upon the subject of detail in works of art. Infants in judgment, we look for specific character, and complete finish; we delight in the faithful plumage of

the well-known bird, in the finely drawn leafage of the discriminated flower. As we advance in judgment, we scorn such detail altogether; we look for impetuosity of execution, and breadth of effect. But perfected in judgment, we return in a great measure to our early feelings, and thank Raffaelle for the shells upon his sacred beach, and for the delicate stamens of the herbage beside his inspired St. Catherine.[7]

33. . . . I have just said that every class of rock, earth, and cloud, must be known by the painter, with geologic and meteorologic accuracy.[8] Nor is this merely for the sake of obtaining the character of these minor features themselves, but more especially for the sake of reaching that simple, earnest, and consistent character which is visible in the *whole* effect of every natural landscape. Every geological formation has features entirely peculiar to itself; definite lines of fracture, giving rise to fixed resultant forms of rock and earth; peculiar vegetable products, among which still farther distinctions are wrought out by variations of climate and elevation. From such modifying circumstances arise the infinite varieties of the orders of landscape, of which each one shows perfect harmony among its several features, and possesses an ideal beauty of its own; a beauty not distinguished merely by such peculiarities as are wrought on the human form by change of climate, but by generic differences the most marked and essential; so that its classes cannot be generalized or amalgamated by any expedients whatsoever. The level marshes and rich meadows of the tertiary, the rounded swells and short pastures of the chalk, the square-built cliffs and cloven dells of the lower limestone, the soaring peaks and ridgy precipices of the primaries, have nothing in common among them, nothing which is not distinctive and incommunicable. Their very atmospheres are different, their clouds are different, their humours of storm and sunshine are different, their flowers, animals, and forests are different. By each order of landscape, and its orders, I repeat, are infinite in number, corresponding not only to the several species of rock, but to the particular circumstances of the rock's deposition or after-treatment, and to the incalculable varieties of climate, aspect, and human interference; by each order of landscape, I say, peculiar lessons are intended to be taught, and distinct pleasures to be conveyed; and it is as utterly futile to talk

7. Let not this principle be confused with Fuseli's "love for what is called deception in painting marks either the infancy or decrepitude of a nation's taste." Realization to the mind necessitates not deception to the eye.

8. Is not this, it may be asked, demanding more from him than life can accomplish? Not one whit. Nothing more than knowledge of external characteristics is absolutely required; and even if, which were more desirable, thorough scientific knowledge had to be attained, the time which our artists spend in multiplying crude sketches, or finishing their unintelligent embryos in the study, would render them masters of every science that modern investigations have organized, and familiar with every form that nature manifests. Martin, if the time which he must have spent on the abortive pebbles of his "Canute" had been passed in walking on the sea-shore, might have learned enough to enable him to produce, with a few strokes, a picture which would have smote, like the sound of the sea, upon men's hearts for ever.

of generalizing their impressions into an ideal landscape, as to talk of amalgamating all nourishment into one ideal food, gathering all music into one ideal movement, or confounding all thought into one ideal idea.

34. There is, however, such a thing as composition of different orders of landscape, though there can be no generalization of them. Nature herself perpetually brings together elements of various expression. Her barren rocks stoop through wooded promontories to the plain; and the wreaths of the vine show through their green shadows the wan light of unperishing snow.

The painter, therefore, has the choice of either working out the isolated character of some one distinct class of scene, or of bringing together a multitude of different elements, which may adorn each other by contrast.

I believe that the simple and uncombined landscape, if wrought out with due attention to the ideal beauty of the features it includes, will always be the most powerful in its appeal to the heart. Contrast increases the splendour of beauty, but it disturbs its influence; it adds to its attractiveness, but diminishes its power. On this subject I shall have much to say hereafter; at present I merely wish to suggest the possibility, that the single-minded painter, who is working out, on broad and simple principles, a piece of unbroken harmonious landscape character, may be reaching an end in art quite as high as the more ambitious student who is always "within five minutes' walk of everywhere," making the ends of the earth contribute to his pictorial guazzetto;[9] and the certainty, that unless the composition of the latter be regulated by severe judgment, and its members connected by natural links, it must become more contemptible in its motley, than an honest study of roadside weeds.

37. Perhaps there is no more impressive scene on earth than the solitary extent of the Campagna of Rome under evening light. Let the reader imagine himself for a moment withdrawn from the sounds and motion of the living world, and sent forth alone into this wild and wasted plain. The earth yields and crumbles beneath his foot, tread he never so lightly, for its substance is white, hollow, and carious, like the dusty wreck of the bones of men.[10] The long knotted grass waves and tosses feebly in the evening wind, and the shadows of its motion shake feverishly along the banks of ruin that lift themselves to the sunlight. Hillocks of mouldering earth heave around him, as if the dead beneath were struggling in their sleep; scattered blocks of black stone, foursquare remnants of mighty edifices, not one left upon another, lie upon them to keep them down. A dull purple poisonous haze stretches level along the desert, veiling its spectral wrecks of massy ruins, on whose rents the red light

9. "A green field is a sight which makes us pardon
 The absence of that more sublime construction
 Which mixes up vines, olives, precipices,
 Glaciers, volcanoes, oranges, and ices."—*Don Juan*.
 10. The vegetable soil of the Campagna is chiefly formed by decomposed lavas, and under it lies a bed of white pumice, exactly resembling remnants of bones.

rests, like a dying fire on defiled altars. The blue ridge of the Alban Mount lifts itself against a solemn space of green, clear, quiet sky. Watch-towers of dark clouds stand steadfastly along the promontories of the Apennines. From the plain to the mountains, the shattered aqueducts, pier beyond pier, melt into the darkness, like shadowy and countless troops of funeral mourners, passing from a nation's grave.

38. Let us, with Claude, make a few "ideal" alterations in this landscape. First, we will reduce the multitudinous precipices of the Apennines to four sugar-loaves. Secondly, we will remove the Alban Mount, and put a large dust-heap in its stead. Next we will knock down the greater part of the aqueducts, and leave only an arch or two, that their infinity of length may no longer be painful from its monotony. For the purple mist and declining sun, we will substitute a bright blue sky, with round white clouds. Finally, we will get rid of the unpleasant ruins in the foreground; we will plant some handsome trees therein, we will send for some fiddlers, and get up a dance, and a picnic party.

It will be found, throughout the picture, that the same species of improvement is made on the materials which Claude had ready to his hand. The descending slopes of the city of Rome, towards the pyramid of Caius Cestius, supply not only lines of the most exquisite variety and beauty, but matter for contemplation and reflection in every fragment of their buildings. This passage has been idealized by Claude into a set of similar round towers, respecting which no idea can be formed but that they are uninhabitable, and to which no interest can be attached, beyond the difficulty of conjecturing what they could have been built for. The ruins of the temple are rendered unimpressive by the juxtaposition of the water-mill, and inexplicable by the introduction of the Roman soldiers. The glide of the muddy streams of the melancholy Tiber and Anio through the Campagna is impressive in itself, but altogether ceases to be so, when we disturb their stillness of motion by a weir, adorn their neglected flow with a handsome bridge, and cover their solitary surface with punts, nets, and fishermen.

It cannot, I think, be expected, that landscapes like this should have any effect on the human heart, except to harden or to degrade it; to lead it from the love of what is simple, earnest, and pure, to what is as sophisticated and corrupt in arrangement, as erring and imperfect in detail. So long as such works are held up for imitation, landscape painting must be a manufacture, its productions must be toys, and its patrons must be children.

39. My purpose then, in the present work, is to demonstrate the utter falseness both of the facts and principles; the imperfection of material, and error of arrangement, on which works such as these are based; and to insist on the necessity, as well as the dignity, of an earnest, faithful, loving study of nature as she is, rejecting with abhorrence all that man has done to alter and modify her. . . .

JOHN CONSTABLE

Letters and Notes on Painting (1802–1836)

John Constable (1776–1837) showed an unswerving devotion to landscape painting from an early age. His first works still employed formulas common enough among English and European view painters. Through continuous study directly from nature in which he recorded in oils the effects of light and changes of color, however, he developed what might be termed a "styleless" landscape. His large paintings are the result not only of innumerable small studies but also sometimes of full-scale preparatory pictures in which, as Constable said, he worked off distracting emotion. Although they may at times lack the boldness of his studies, which appeal more to the modern eye, his finished paintings attain a complexity that sustains interest, permitting the viewer to lose himself in looking, as if he actually contemplated nature.

In 1824 several of Constable's pictures were exhibited in Paris, where many painters, including Delacroix, responded enthusiastically to his directness of vision and freshness of execution. They were not universally acclaimed, however. For example, Delécluze, writing in the *Journal des débats,* remarked that Constable's pictures were like the skillful preludes of pianists: although technically impressive, they did not lead to anything.

Constable's correspondence reveals the artist's great self-assurance concerning his approach to landscape representation. In a humorously detached manner, he was able to discuss criticism of his work without self-aggrandizement or self-depreciation. The letters reproduced here are excerpted from C. R. Leslie, *Memoirs of the Life of John Constable, R.A.* (London: The Medici Society, Ltd., 1937), pp. 20–21, 54–55, 117–19, 134–36, 175–76, and 178–80. The excerpt from the preface to *English Landscape* is from the same volume, pp. 243–44. The other passages are taken from Leslie's notes on Constable's fourth lecture on landscape painting, delivered in London on June 16, 1836, and from a note found by Leslie among Constable's papers, both as reproduced in R. B. Beckett, *John Constable's Discourses* (Ipswich: Suffolk Records Society, 1970), pp. 68–69 and 71. These last extracts are reprinted by permission of the Suffolk Records Society. ✠

John Constable, *Self-Portrait,* c. 1800, pencil drawing.

LETTER FROM LONDON, MAY 29, 1802

My Dear Dunthorne,

. . . For these few weeks past I believe I have thought more seriously on my profession than at any time of my life. That is, which is the shurest way to real excellence. And this morning I am the more inclined to mention the subject having just returned from a visit to sir G. Beaumonts pictures.—I am returned with a deep conviction of the truth of Sir Joshua Reynolds's observation that "there is no *easy* way of becoming a good painture" it can only be obtained by long contemplation and incessant labour in the executive part.

And however one's mind may be elevated, and kept up to what is excellent by the works of the Great Masters—still Nature is the fountain's head, the source from whence all originally must spring—and should an Artist continue his practice without refering to nature he must soon from [*sic*] a *manner,* and be reduced to the same deplorable situation as the french painture mentioned by Sir J. Reynolds! who told him that he had long ceased to look a[t] nature for she only put him out.

For these two past years I have been running after pictures and seeking the truth at secondhand. I have not endeavored to represent nature with the same elevation of mind, but have rather endeavoured to make my performances look as if really *executed* by other men.

I am come to a determination to make no idle visits this summer or to give up my time to common plase people—I shall shortly return to Bergholt where I shall make some laborious studies from nature—and I shall endeavour to get a pure and unaffected representation of the scenes that may employ me with respect to Colour particularly and anything else—drawing I am prety well master of.—There is little or nothing in the exhibition worth looking up to. *There is room enough for a natural painture.* The great vice of the present day is *bravura* an attempt at something beyond the truth in endeavouring to do some thing better than well they do what in reallity is good for nothing. *Fashion* always had, and ever will have its day; but truth (in all things) only will last and can have just claims on posterity.

I have received considerable benefit from exhibiting. It shows me where I am, and in fact tells me what nobody else could. There are in the exhibition few pictures that bring nature to mind, and represent it with that truth that unprejudiced minds require.

These are reflexions that at this time I should have written for my own use—but as I know that I could not write to you on a subject that would be more agreable—I send you them as a letter. And indeed I have had much ado to keep my mind together enough to write to be understood owning to a reumatick pain in one side of my head particularly in my teeth and lower jaw which has

caused one cheek to swell very much. I believe I got cold at Windsor as I was there in the late severe weather.

Should you want anything in the pencil way etc let me know next week for I hope the next to leave London. . . .

LETTER FROM EAST BERGHOLT, JUNE 22, 1812

. . . From the window where I am now writing, I see all those sweet fields that once saw us so happy. . . . I called at the Rectory on Saturday with my mother. The doctor was unusually courteous, and shook hands with me on taking leave. Am I to argue from this that I am not entirely out of the pale of salvation? How delighted I am that you are fond of Cowper. But how could it be otherwise? for he is the poet of Religion and Nature. I think the world much indebted to Mr. Hayley. I never saw, till now, the supplement to the letters; perhaps some of his best are to be found there, and it contains an interesting account of the death of poor Rose, a young friend of the poet's. Nothing can exceed the beautifull appearance of the Country at this time; its freshness, its amenity. . . .

LETTER, JULY 22, 1812

. . . I have been living a hermit-like life, though always with my pencil in my hand. Perhaps this has not been much the case with hermits, without we except Swaneveldt (the pupil of Claude Lorrain); who was called the *hermit of Italy,* from the Romantic solitudes he lived in, and which he loved and which his pictures so admirably describe. How much real delight have I had with the study of Landscape this summer! either I am myself improved *in the art of seeing Nature* (which Sir Joshua calls painting), or Nature has unveiled her beauties to me with a less fastidious hand. Perhaps there is something of both, so we will divide the fine compliment between us. But I am writing this nonsense to you with a really sad heart, when I think what would be my happiness could I have this enjoyment with you. Then indeed would my mind be calm to contemplate the endless beauties of this happy country. . . .

LETTER FROM HAMPSTEAD, OCTOBER 23, 1821

My Dear Fisher,
. . . I am most anxious to get into my London painting-room, for I do not consider myself at work unless I am before a six-foot canvas. I have done

a good deal of skying, for I am determined to conquer all difficulties, and that among the rest. And now talking of skies, it is amusing to us to see how admirably you fight my battles; you certainly take the best possible ground for getting your friend out of a scrape (the example of the old masters). That landscape painter who does not make his skies a very material part of his composition, neglects to avail himself of one of his greatest aids. Sir Joshua Reynolds, speaking of the landscapes of Titian, of Salvator, and of Claude, says: "Even their *skies* seem to sympathise with their subjects." I have often been advised to consider my sky as *"a white sheet thrown behind the objects"*. Certainly, if the sky is obtrusive, as mine are, it is bad; but if it is evaded, as mine are not, it is worse; it must and always shall with me make an effectual part of the composition. It will be difficult to name a class of landscape in which the sky is not the key note, the standard of scale, and the chief organ of sentiment. You may conceive, then, what a "white sheet" would do for me, impressed as I am with these notions, and they cannot be erroneous. The sky is the source of light in nature, and governs everything; even our common observations on the weather of every day are altogether suggested by it. The difficulty of skies in painting is very great, both as to composition and execution; because, with all their brilliancy, they ought not to come forward, or, indeed, be hardly thought of any more than extreme distances are; but this does not apply to phenomena or accidental effects of sky, because they always attract particularly. I may say all this to you, though *you* do not want to be told that I know very well what I am about, and that my skies have not been neglected, though they have often failed in execution, no doubt, from an over-anxiety about them, which will alone destroy that easy appearance which nature always has in all her movements.

How much I wish I had been with you on your fishing excursion in the New Forest! What river can it be? But the sound of water escaping from mill-dams, etc., willows, old rotten planks, slimy posts, and brickwork, I love such things. Shakespeare could make everything poetical; he tells us of poor Tom's haunts among "sheep cotes and mills". As long as I do paint, I shall never cease to paint such places. They have always been my delight, and I should indeed have been delighted in seeing what you describe, and in your company, "in the company of a man to whom nature does not spread her volume in vain." Still I should paint my own places best; painting is with me but another word for feeling, and I associate "my careless boyhood" with all that lies on the banks of the Stour; those scenes made me a painter, and I am grateful; that is, I had often thought of pictures of them before I ever touched a pencil, and your picture is the strongest instance of it I can recollect; but I will say no more, for I am a great egotist in whatever relates to painting. Does not the Cathedral look beautiful among the golden foliage? its solitary grey must sparkle in it.

My last year's work has got much together. This weather has blown and washed the *powder* off. I do not know what I shall do with it; but I love my

children too well to expose them to the taunts of the ignorant, though they shall never flinch from honorable competition.

LETTER FROM CHARLOTTE STREET, DECEMBER 6, 1822

My dear Fisher,

There is nothing so cheering to me as the sight of your handwriting, yet I am dilatory in answering you. . . . I will gladly do all I can for Read's picture, but you know I can only give it its chance. I possess neither affection or favor at that wretched place.[1] It shall go with my own. I shall mention his to Young. Is it not possible to disswade him from coming to London? But perhaps he prefers starving in a crowd, and if he is determined to make the adventure, let him by all means preserve his flowing locks, they will be sure to procure him employment and cannot fail of making him known, they may do him more service than even the talents of Claude Lorrain, if he had them.

Dodsworth shall have his picture when I shall find an opportunity of sending it with your two. I have grimed it down with slime and soot, as he is a connoiseur, and of course prefers filth and dirt to freshness and beauty.

I am getting on here and am very busy. The Cathedral is advancing, and Smith has the frame in hand. Does the Bishop come to town beginning of next month for the parlement?

My altarpiece for the Chappell at M—— is gone by and the Man would not have it. He say I had heard his position—but my brother tells me "the whole concern of those brewers was a low sneak to Archdeacon Jefferson (who could license or not their blackguard public houses) and on his death they were glad to get clear of as much of the expense as they had not actually incurred, as they could. . . ."

I do not think my chance at the Academy so good as last year when I was not elected. I am afraid they are not without their *sneaks*. I have nothing to help me but my stark naked merit, and though that (as I am told) exceeds all the other candidates, it is not heavy enough. I have no *patron* but yourself—and you are not the Duke of Devonshire—or any other great ass. You are only a Gentleman and a Scholar, are a real lover of the art, whose only wish is to see it advance. . . .

I have been to see David's picture (mess) of *The Crowning of Bonaparte and his Empress.* it is 35 ft. by 21. As a picture it does not possess anything of the Language of the art much less of the oratory of Rubens or Paul Veronese; it is be-

1. Constable is referring to the annual exhibition of the Royal Academy.—Ed.

low notice as a work of execution. But still I much prefer it to West—only because it does not remind me of the *schools*. West is only hanging on by the tail of the Shirt of Carlo Maratti and the fag end of the Roman and Bolognese schools—the last of the Altorum Romanorum, and only the shadow of them.

I could not help being angry when I last wrote to you, about the patrons.

Should there be a National Gallery (which is talked of), there will be an end of the art in poor old England, and she will become, in all that relates to painting, as much a nonentity as every other country that has one. The reason is plain; the manufacturers of pictures are then made the criterions of perfection, instead of nature.

LETTER FROM CHARLOTTE STREET, NOVEMBER 17, 1824

My dear Fisher,

. . . I am planning a large picture. I regard all you say but I do not enter into that notion of varying one's plans to keep the publick in good humour. Subject and change of weather and effect will always afford variety. What if Van de Velde had quited his sea pieces, or Ruysdal his waterfalls, or Hobima his native woods. Would not the world have lost so many features in art? I know that you wish for no material alteration; but I have to combat from high quarters, even Lawrence, the seeming plausible argument that *subject* makes the picture. Perhaps you think an evening effect or a warm picture might do; perhaps it might start me some new admirers, but I should lose many old ones. Reynolds the Engraver tells me my *"freshness"* exceeds the freshness of any painter that ever lived; for to my Zest of *"Color"* I have added *"light"*. Ruisdal and Hobima were *black*. Should any of this be true I must go on. I imagine myself driving a Nail; I have driven it some way, and by persevering with this nail I may drive it home; by quiting it to attack others, though I amuse myself, I do not advance them beyond the first, but that particular nail stands still the while. No man who can do any one thing well, will be able to do an other different well; I believe that from our physical construction no man can be born with more than one original feel. This in my opinion was the case with the greatest master of variety—Shakespeare. Send me the picture of the shady lane when you like. Would you like to have any other? The sketch-book I am busy with a few days when I will send it; they are all boats and coast scenes. *Subjects* of this sort seem to me more fit for *execution* than sentiment. I hold the genuine pastoral feel of landscape to be very rare, and difficult of attainment, by far the most lovely department of painting as well as of poetry. I looked into Angerstein's the other day; how paramount is Claude! . . .

LETTER FROM CHARLOTTE STREET,
DECEMBER 17, 1824

My dear Fisher,

. . . My Paris affairs go on very well. Though the director, the Count Forbin, gave them very respectable situations in the first instances, yet on their being exhibited a few weeks, they were so greatly advanced in reputation that they were removed from their original situations to a post of honor, the two prime places near the Eye in the principal Room. I am much indebted to the artists for this clamour in my praise. But I will do justice to the Count. He is no artist (I believe) and he thought *"as the Colors were Rough they must be seen at a distance"*. They found their mistake as they then acknowledged the richness of the texture, and the attention to the surface of the objects in these pictures.

They call out much about their vivacity and freshness, a thing unknown to their own pictures. A gentleman told me the other day he visited the Louvre. He heard one say to his friend—"Look at these English pictures—the very dew is upon the ground." They wonder where the brightness comes from. Only conceive what wretched students they must have been to be surprised at these qualities.

The fact is they study (and they are very laborious students) Art only, and think so little of applying it to nature. They are what Northcote said of Sir J. R. in His Landscapes (at first) made wholly up from pictures, and knew about as much of nature as a *Hackney Coach does of pasture*. In fact they do worse; they make painfull studies of individual *articles*—leaves, rocks, stones, trees, etc., etc., singly, so that they look cut out, without belonging to the whole, and they neglect the *look* of nature altogether under its various changes.

I learnt yesterday that the proprietor of my pictures asks 12,000 franks for them together (500£). They would have bought one for the nation (*The Waggon*), but he would not sell them singly. This he could often have done with either. The *proprietor tells me* the Artists much desire to purchase them and deposit them in a place in which they can have access to them. This may be; but I am still more ambitious of English praise, and *Reynolds* (the engraver) who saw them in the Louvre says he was astonished at their power and the art and nature which appeard in them. He is going over in June to engrave them. He has sent two assistants to paris to prepare the plates. They will be in mezzotint. He is now about my lock. I sent it to him last week and he is to engrave the 12 drawings. All this is very desirable to me as I am at no expense about them, and it cannot fail of advancing my reputation. My wife is now translating for me some of their criticisms; they are very amusing and acute, but very shallow and feeble. This one—after saying "it is but justice to admire the *truth*, the *Color*, and *general Vivacity* and richness"—yet they want the objects more formed and defined—etc., etc., and says that they are like the rich preludes in musick, and

the full harmonies of the Eolian Lyre—which *mean* nothing and they call them orations, and harangues, and high-flown conversations affecting a careless ease—etc., etc., etc. . . . Is not some of this *blame* the highest *praise?* What is poetry? What is Coleridges *Ancient Mariner*—(the best Modern poem) but something like this.

However certain it is they have made a decided stir, and have set all the students in Landscape to thinking. They say on going to begin a landscape Oh! this shall be *a la Constable* . . . *! ! !*

Now you must be tired. Pray believe that there is no other person living but yourself to whom I could write in this manner and all about myself. But take away a painter's vanity, and he will never touch a pencil again. . . .

PREFACE TO *ENGLISH LANDSCAPE*

. . . In art, there are two modes by which men aim at distinction. In the one, by a careful application to what others have accomplished, the artist imitates their works, or selects and combines their various beauties; in the other, he seeks excellence at its primitive source, nature. In the first, he forms a style upon the study of pictures, and produces either imitative or eclectic art; in the second, by a close observation of nature, he discovers qualities existing in her which have never been portrayed before, and thus forms a style which is original. The results of the one mode, as they repeat that with which the eye is already familiar, are soon recognized and estimated, while the advances of the artist in a new path must necessarily be slow, for few are able to judge of that which deviates from the usual course, or are qualified to appreciate original studies. . . .

FOURTH LECTURE ON LANDSCAPE PAINTING, LONDON, JUNE 16, 1836 (FROM CONSTABLE'S *DISCOURSES*)

. . . As your kind attention has so long been given to my description of pictures, it may now be well to consider in what estimation we are to hold them, and in what class we are to place the men who have produced them.

It appears to me that pictures have been over-valued; held up by a blind admiration as ideal things, and almost as standards by which nature is to be judged rather than the reverse; and this false estimate has been sanctioned by the extravagant epithets that have been applied to painters, as 'the divine', 'the inspired', and so forth. Yet, in reality, what are the most subblime productions of the pencil but selections of some of the forms of nature, and copies of a few

of her evanescent effects; and this is the result, not of inspiration, but of long and patient study, under the direction of much good sense.

It was said by Sir Thomas Lawrence that "we can never hope to compete with nature in the beauty and delicacy of her separate forms or colours—our only chance lies in selection and combination". Nothing can be more true—and it may be added that selection and combination are learned from nature herself, who constantly presents us with compositions of her own, far more beautiful than the happiest arranged by human skill. I have endeavoured to draw a line between genuine art and mannerism, but even the greatest painters have never been wholly untainted by manner.

Painting is a science, and should be pursued as an inquiry into the laws of nature. Why, then, may not landscape be considered as a branch of natural philosophy, of which pictures are but the experiments? . . .

LAST LECTURE AT HAMPSTEAD, 1836

. . . The young painter, who regardless of present popularity, would leave a name behind him, must become the patient pupil of nature. If we refer to the lives of all who have distinguished themselves in art or science, we shall find that they have always been laborious. The landscape painter must walk in the fields with a humble mind. No arrogant man was ever permitted to see nature in all her beauty. If I may be allowed to use a very solemn quotation, I would say most emphatically to the student, "Remember now thy Creator in the days of thy youth."

The friends of a young artist should not look or hope for precocity. It is often a disease only. Quintilian makes use of a beautiful simile in speaking of a precocious talent. He compares it to the forward ear of corn that turns yellow and dies before the harvest. Precocity often leads to criticism, sharp, and severe as the feelings are morbid from ill health. Lord Bacon says, "When a young man becomes a critic, he will find much for his amusement, little for his instruction." The young man must receive with deference the advice of his elders, not hastily questioning what he does not yet understand, otherwise his maturity will bear no fruit. The art of seeing nature is a thing almost as much to be acquired as the art of reading the Egyptian hieroglyphics. The Chinese have painted for two thousand years, and have not discovered that there is such a thing as chiaroscuro.

There has never been a boy painter, nor can there be. The art requires a long apprenticeship, being *mechanical,* as well as intellectual.

CAMILLE COROT

Letters and Reflections on Painting

Camille Corot (1796–1875) was no less devoted to the study of light in nature than was Constable, but his training and inclinations were those of a classical landscape painter. He wished to discover in the actual view with its subtle tonalities and forms simplified by light the formal poise of a landscape by Poussin. In this he was not unlike some others who preceded him to Rome, such as the Danish artist Christoffer Wilhelm Eckersberg (1783–1853), Giambattista Bassi (1784–1852), and his own teacher, Achille Michallon (1796–1822).

Corot made his first trip to Italy in 1825 and returned several times thereafter. His delight in perceiving rather than fabricating structure extends even to his more evanescent works executed late in his career. In these late paintings, with their impalpable forms, the sense of delicate equilibrium seems to be most a part of the light-filled view itself. Corot made few allusions to spiritual values; he was absorbed in discovering a harmony within perception itself.

The following letters and journal entries were translated from *Corot raconté par lui-même et par ses amis,* edited by Pierre Cailler (Paris: Vésenaz-Genève, 1946), pp. 82–83, 87–88, and 173–74.

LETTER FROM ROME, MARCH, 1826

. . . You can have no idea of the weather we are having in Rome. For a month now I have been awakened each morning by the brilliance of the sun striking the wall of my room. In short, the weather is always fine. But alas, in revenge, this sun radiates a light that is my despair. I feel the complete inadequacy of my palette. Do console your poor friend, who is so troubled to see his painting so miserable, so sad, next to the radiant nature he has before his eyes! There are some days, really, when I would toss everything to the devil. But I see I am about to belabor you with the vexations and troubles of painting—let's change the subject. . . .

REFLECTIONS ON PAINTING (FROM A NOTEBOOK)

The first two things to study are form and values. . . . Color and execution give charm to the work. It has seemed to me important in preparing a study or painting to begin by indicating the strongest values (assuming the canvas is white) and to continue with orderly gradations up to the lightest. I would determine twenty numbered shades from the darkest to the lightest. Thus your study or painting will be set up in orderly fashion. This order should not at all bother either draftsman or colorist. Always it is the mass, the whole, that has struck us. Never lose the first impression that has moved us. Drawing is the first thing to be worked out. Then values—the relationship of form and values. These are the basic points. Afterward the color; finally the execution. Would you like to make a study or a painting? First conscientiously apply yourself to working out the form. After going as far as you can, move on to the values. Work them out with the mass. Be conscientious. A good method to follow: if your canvas is white, begin with the deepest value and follow in sequence to the lightest. There is little logic in beginning with the sky. . . .

. . . I realized after trying it out that it is very useful to begin by drawing your picture very neatly on a white canvas, having first jotted down the effect on a gray or white paper, then to paint the work part by part, going as far as possible at once so that there is little more to be done once the canvas is covered. I have noted that everything done at the first instance is franker and more agreeable in form, and one can take advantage of many chance happenings, while when one comes back to a work, this harmonious initial touch is often lost. I think this method is especially good in treating foliage, which requires a bit more casualness. Buildings and volumes, in general regular, always require a great deal of rectitude. I am also aware that one must be severe in working from nature and not be content with a hastily made sketch. How often I have regretted in looking at my drawings that I had not had the persistence to spend a half hour longer! They embarrass me and now convey only a vague idea of the situation in which I made them. Regardless of how little they got rubbed in traveling, I no longer recognize anything. One must also have the patience to treat them with care. Nothing must be left indecisive.

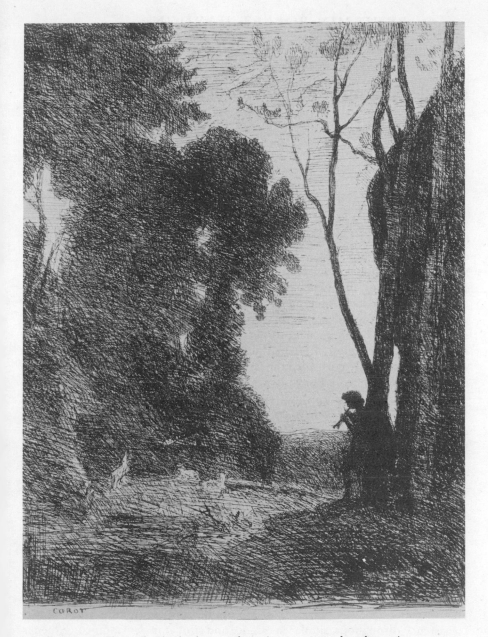

Camille Corot, *The Little Shepherd,* second version, c. 1856, glassplate print.

BENJAMIN ROBERT HAYDON

WILLIAM HAZLITT

Articles from the *Encyclopaedia Britannica* (1816)

The exhibition of the Elgin marbles in London in 1807 stirred a controversy centering on the issue of naturalism in classical Greek art. In articles prepared for the *Encyclopaedia Britannica* in 1816, Benjamin Robert Haydon (1786–1846) and William Hazlitt (1778–1830) singled out aspects of Phidian form and expression for praise. Haydon's fervid article reflects an intensity evident in his tragic life, which ended in suicide. His impassioned journals contained strains of religious sentiment that correspond in many ways with his elevation of Phidias to the status of a godlike figure. Hazlitt, who had studied portrait painting before turning to writing, maintained a more objective, but no less elevated, opinion of the marbles. Both essays represent aesthetic arguments that eventually persuaded the British government to purchase the sculptures for the nation from Lord Elgin.

The *Encyclopaedia* articles are reproduced from *Painting and the Fine Arts: Being the articles under those heads contributed to the seventh edition of the Encyclopaedia Britannica, by B. R. Haydon, Esq. and William Hazlitt, Esq.* (Edinburgh: Adam and Charles Black, 1838), pp. 148–55 and 8–12.

BENJAMIN ROBERT HAYDON: PAINTING

. . . In comparing this illustrious sovereign of modern design [Michelangelo] with Phidias, or the Greeks generally, in the naked figure, he must unquestionably yield to them the palm. Michel Angelo often perplexed his limbs with useless anatomy; it must not be denied, and cannot be refuted, that he did not always clear the accidental from the superfluous. If the principle be a sound one, namely, "that any two parts of a body bearing comparison must keep a consistency throughout, similar in essence and similar in development," then is Michel Angelo grossly inconsistent; because if the spine of the ilium in front be covered fully by the muscles around it, so ought the spine of the scapula behind to be equally covered. If the former be, and the latter be not, then the figure is

inharmonious and inconsistent, and what Phidias would never have tolerated. Now the figure of Michel Angelo's Christ standing with a cross, has the spine of the scapula prominent and bony, and all the muscles shrinking from it, the characteristics of a thin man; whilst the spine of the ilium of the same figure in front, is entirely covered by the muscles around it, the marks of a muscular and fleshy man. What authority had Michel Angelo in nature or antiquity for such inconsistency? These are the excesses which bring dissection into contempt, and which induce anatomists to doubt whether the Greeks dissected or not, because they were never guilty of such absurdities, and because they had too much self-control to make that an end of art which was but a means of the perfection of art. And yet Vasari calls it "mirabilissima." This figure and the Lazarus in Piombo's, as well as several figures in the Last Judgment, are justifiable grounds for asserting he was not equal to the Greeks in the naked figure; though in the conception and arrangement of a vast whole to illustrate a grand principle, he approaches but does not surpass the Parthenon in its glories. In the form he must not be compared to the Greeks; gigantic as he is, he was decidedly inferior.

Michel Angelo's line is by no means "uniformly grand;" and his women may be "moulds of generation," but certainly not of love. His infants may "teem with the man," but they have nothing of the infant. His men may be a "race of giants," but they are brutal in expression, fierce in action, and distorted in position. It is useless in a rapid and general view of art to go over ground which has been so often gone over before; to talk about the prophets and sibyls, after three hundred years' enthusiasm, is worse than useless. Europe knows the awful grandeur of one or two of them, looking like beings to whom God has spoken, and who have never since ceased meditating on the awful voice.

The style of Michel Angelo has been called the style of the gods; but if majesty without pretension, humility without feebleness, power without exertion, and an awful presence without vulgar assumption, be the characteristics of a god, what figure of Michel Angelo's deserves that appellation? Is it in the bullying defiance of Moses? the twisted tortures of Jonah? the cramped agonies of the sleeping Adam? or the galvanized violence of the ornamental figures at the tombs? It must be admitted, that the *Pensoso-Duca* is majestic and silent; but this is an exception, not an habitual characteristic. "Michel Angelo's mind," says Reynolds, "was so original that he disdained to look abroad for foreign help." Disdained! Why there is not a prophet, a sibyl, or a naked figure in the whole chapel where the torso cannot be traced. And what are the works of both Michel Angelo and Raffaelle, but improved completions of all that their predecessors had done for a thousand years in barbarism and obscurity? Shakespeare's plots are all borrowed; Lady Macbeth is not his own; that hideous expression "know Macduff was from his mother's womb untimely ripped," is Hollingshed's. But what of that? It is the new thoughts he puts into them,

which give him claim to the sympathy of the world. Phidias and Raffaelle have one great and decided beauty in their works; their figures, whether in action or expression, always look as the unconscious agents of an impulsion they cannot help. You are never drawn aside from what they are doing by any appearance in them, as if they wished to make you consider how very grand they were, or how very gracefully they were moving. They seem impelled by something they cannot controul; their heads, hands, feet, and bodies immediately put themselves into positions the best adapted to execute the intentions wanted; whereas *often* in Michel Angelo, and *always* in his imitators, there is a consciousness as it were in his arms and limbs, which destroys all idea, as if his figures were unconscious agents of an impulsion they could not help, and which acted by means of the will on the muscular system.

It is an inherent principle of life never to disturb itself for grace, or for any other object either in action or repose, not immediately the natural consequence of the impulsion which moved the body. Style in design is a *result* and not a *cause*. Whatever object is represented in painting or sculpture, the intentions of God in its bodily formation should be ascertained; the means which God has bestowed on it to enable it to execute its only will or gratify its own instincts, should be investigated; and then the aberrations produced by time, accident or disease, or other causes, will be clearly known, so that he who takes upon himself to represent any object in painting, will be able to distinguish accident from essence, and shew the object in its essential properties of body as God first created it. The external form in that body will then be *essential,* and the result of its completion in art will be *style* in design. There are certain inherent principles of our common nature to which all bodies must yield, viz. that compression and extension must have different effects, and so must repose and action. If a great artist represents a figure and makes its parts the same in either case, he must be ignorant of nature or above its simplicity. No doubt, the conception of an idea may be so grand, the beauty of a character may be so angelic, the pathos of an expression may be so deep, that errors or inadequacy in the mode of representation may be overlooked or forgiven; but in order to bring the art to the perfection to which the Greeks brought it, there must be nothing to forgive or to overlook. An idea or conception being the nobler part of the art, we may, in our common conviction of human frailty, *overlook* any inadequacy in the means of imitation; but the very admission proves there must be something to be overlooked and something which, we have a notion, has not been adequately represented.

An art the modes of which to convey thoughts, being the imitation essentially of natural objects, ought surely to have the imitation perfect, because the imperfection of the means has always detracted from the impressions of the thought. Poets are not endured if their grammar is bad, or their language defective; and why should drawing, form, colour, or light, shadow, and surface,

Benjamin Robert Haydon, *Torso of Dionysus Exhibited in the Park Lane Museum*, 1809, pencil drawing.

the grammar of art, be excused more than the poets'? Because the simplest imitation is at once recognised as the imitation of the prototype, why should facility of imitation be any excuse for defect? Ah, but it's the *grand* style. Yes, the grand style of Europe for the last three hundred years; but was it the grand style of the Greeks? Certainly not; their grand style was nature elevated not violated, with none of her inherent bases of life altered a hair's point, none of her essential details omitted, and none of her essential principles overwhelmed by useless detail.

When you see an outline like iron, that is the grand style. When hands were twisted, heads distorted, one leg up, and the other so far removed from the body, that you may question if it will return, that is the *grand style*. All this absurdity originated with Michel Angelo; and though he is not answerable for the excesses of his admirers, there must be something erroneous if every imitator has led to such extravagance from Goltzius downwards. Michel Angelo was a tremendous genius, and his effect on the art was vital; but he did not like the Greeks suffer the unalterable principles of life to keep in check his anatomical

knowledge. This was an error, because we can imagine no beings, and no world where malleable matter is not influenced by the common principles of the solar system, or where any creatures composed of bones, muscles, tendons, and skin, must not yield to the laws which God instituted for their government when he created them.

Thus Michel Angelo often overstepped the modesty of truth, and gave a swaggering air to his figures. Every figure of his looks as if he was insulted and preparing to return a blow. If they sleep they seem as if they would kick; if they move when they are awake, they seem as if all their muscles were cracking. We allude particularly to the naked figures; Jeremiah and the Duke are exceptions, but they are only exceptions. Fuseli observed that Michel Angelo was the *salt of art;* but it would have been more just to have called him the *pepper,* because very little indeed will do for a seasoning. In poetry of sentiment the Medici tombs would perhaps have competed with Phidias; for Michel Angelo being a painter as well as Phidias, he combined in his sculpture a knowledge of effect. In selection of subject and daring execution of hand, perhaps the Sistine Chapel might equal the great works of painting amongst the ancients; but in naked representations *it cannot be compared to it.* The Elgin marbles had not then enlightened the world. The due subordination of all science to nature had not then been so exquisitely seen; the due combination of life without meanness, and of abstraction without losing sight of life, were not so apparent in the great works of ancient art which were found before this period. Had Michel Angelo seen the Theseus and Ilyssus, Jupiter's breast and horse's head, he would have felt the difference between the muscular swing of a blacksmith, and a hero naturally born powerful, without his muscles being distorted by manual labour; and that a hero might be elevated and yet simple, fleshy without fatness, and muscular without being skinny. Michel Angelo has been called the Deity of design; but he was rather the Devil. One can imagine the consternation of Phidias and his pupils, if suddenly at Athens the galvanized figures of the tombs had been let down through the roof, whilst they were preparing the Olympian Jupiter, with his quiet, solemn, steady, thinking, peaceful, awful look.

Reynolds says he prepared the way for the sweeping outline of Rubens; but how many thousands has he ruined? What is the excellence of the Last Judgment? Is there any evidence of power in arranging a whole, like Rubens, Titian, or Tintoretto? Is there any application of any principle of our nature by the due combination of variety and repose? Is it not a mass of separate groups, vulgar in design, academic in action, and demoniac in expression? Is the Christ worthy of Goltzius? Surely it would have disgraced him, and then what devils! Are these the fallen angels of heaven? they are the legitimate offspring of hell. Are these the beings whose glory was obscured, not extinguished? whose majestic forms existed, though in ruin? whose beauty was only disturbed by passions, not destroyed? who were the same grand, heroic, terrific beings as ever, but

scathed by lightning, singed by fire, dingy from darkness, lacerated by thunder, their splendour sparkling through the horrid obscurity, in which they medi-tated revenge? To give them mouths like wolves, ears like asses, noses like pug-dogs, and tails like monkeys, with feet cloven and misshapen, was not to repre-sent a fallen angel, but a deformed monster. Though evil, they were beautiful.

> "Their forms had not yet lost
> *All* their original brightness."

"What matter where, if still I be the same?" says Satan. Could such a sentiment have ever been uttered by the wretch who is dragging a figure down to the bottomless pit, in a way delicacy forbids one even to think of, much more to write or to paint? Michel Angelo's demons would not only torture the damned, but feed upon their bodies.

It is clear, however, that there *was* a time when he was not so exaggerated. The holy Family, in sculpture, brought by Sir George Beaumont from Italy, is playful, natural, simple, and beautiful; it is in fact a divine work. Perhaps the violence of Julius in hurrying him through the Sistine Chapel, and the neces-sity of painting with tremendous exaggeration, on so large a space, got his hand into a fierce power that it never lost. Painting on grand ceilings is like talking in large theatres. He never entirely finished any thing; he left no grand pupils, like Raffaelle; he assisted the humble, but never instructed the gifted. The figure of Lazarus in our national picture, especially the hand and thumb that press the shoulder of the attendant on the left side, is certainly by him; and if it be compared to the timid painting of the Christ, the spectator will be con-vinced of it. In fine, Michel Angelo was a great genius; but let the students of Europe be assured that his style has been grossly overrated; let them banish his works from their eyes, and substitute the Theseus and Ilyssus, and the real grand natural style of Phidias will soon exclude the satanic Etruscan, and vio-lent anatomical distortions of Michel Angelo. He may be and was a giant in art; but Raffaelle was an angel, and Phidias a god. . . .

WILLIAM HAZLITT: THE FINE ARTS

. . . The term Fine Arts may be viewed as embracing all those arts in which the powers of imitation or invention are exerted, chiefly with a view to the pro-duction of pleasure by the immediate impression which they make on the mind. But the phrase has of late, we think, been restricted to a narrower and more technical signification; namely, to painting, sculpture, engraving, and ar-chitecture, which appeal to the eye as the medium of pleasure; and, by way of eminence, to the two first of these arts. In the following observations we shall adopt this limited sense of the term; and shall endeavour to develope the prin-

ciples upon which the great masters have proceeded, and also to inquire, in a more particular manner, into the state and probable advancement of these arts in this country.

The great works of art at present extant, and which may be regarded as models of perfection in their several kinds, are the Greek statues—the pictures of the celebrated Italian masters—those of the Dutch and Flemish schools—to which we may add the comic productions of our own countryman Hogarth. These all stand unrivalled in the history of art; and they owe their pre-eminence and perfection to one and the same principle,—*the immediate imitation of nature.* This principle predominated equally in the classical forms of the antique and in the grotesque figures of Hogarth: the perfection of art in each arose from the truth and identity of the imitation with the reality; the difference was in the subjects—there was none in the mode of imitation. Yet the advocates for the *ideal system of art* would persuade their disciples, that the difference between Hogarth and the antique does not consist in the different forms of nature which they imitated, but in this, that the one is like and the other unlike nature. This is an error the most detrimental perhaps of all others, both to the theory and practice of art. As, however, the prejudice is very strong and general, and supported by the highest authority, it will be necessary to go somewhat elaborately into the question in order to produce an impression on the other side.

What has given rise to the common notion of the *ideal,* as something quite distinct from *actual* nature, is probably the perfection of the Greek statues. Not seeing among ourselves any thing to correspond in beauty and grandeur, either with the features or form of the limbs in these exquisite remains of antiquity, it was an obvious, but a superficial conclusion, that they must have been created from the idea existing in the artist's mind, and could not have been copied from any thing existing in nature. The contrary, however, is the fact. The general form, both of the face and figure, which we observe in the old statues, is not an ideal abstraction, is not a fanciful invention of the sculptor, but is as completely local and national (though it happens to be more beautiful) as the figures on a Chinese screen, or a copperplate engraving of a negro chieftain in a book of travels. It will not be denied that there is a difference of physiognomy as well as of complexion in different races of men. The Greek form appears to have been naturally beautiful, and they had, besides, every advantage of climate, of dress, of exercise, and modes of life to improve it. The artist had also every facility afforded him in the study and knowledge of the human form; and their religious and public institutions gave him every encouragement in the prosecution of this art. All these causes contributed to the perfection of these noble productions; but we should be inclined principally to attribute the superior symmetry of form common to the Greek statues, in the first place, to the superior symmetry of the models in nature; and in the second, to the more constant oppor-

tunities for studying them. If we allow, also, for the superior genius of the people, we shall not be wrong; but this superiority consisted in their peculiar susceptibility to the impressions of what is beautiful and grand in nature. It may be thought an objection to what has just been said, that the antique figures of animals, &c., are as fine, and proceed on the same principles, as their statues of gods or men. But all that follows from this seems to be, that their art had been perfected in the study of the human form, the test and proof of power and skill; and was then transferred easily to the general imitation of all other objects, according to their true characters, proportions, and appearances. As a confirmation of these remarks, the antique portraits of individuals were often superior even to the personifications of their gods. We think that no unprejudiced spectator of real taste can hesitate for a moment in preferring the head of the Antinous, for example, to that of the Apollo. And in general it may be laid down as a rule, that the most perfect of the antiques are the most simple,— those which affect the least action, or violence of passion,—which repose the most on natural beauty of form, and a certain expression of sweetness and dignity, that is, which remain most nearly in that state in which they could be copied from nature without straining the limbs or features of the individual, or racking the invention of the artist. This tendency of Greek art to repose has indeed been reproached with insipidity by those who had not a true feeling of beauty and sentiment. We, however, prefer these models of habitual grace or internal grandeur to the violent distortions of suffering in the Laocoon, or even to the supercilious air of the Apollo. The Niobe, more than any other antique head, combines truth and beauty with deep passion. But here the passion is fixed, intense, habitual;—it is not a sudden or violent gesticulation, but a settled mould of features; the grief it expresses is such as might almost turn the human countenance itself *into marble!*

In general, then, we would be understood to maintain, that the beauty and grandeur so much admired in the Greek statues were not a voluntary fiction of the brain of the artist, but existed substantially in the forms from which they were copied, and by which the artist was surrounded. A striking authority in support of these observations, which has in some measure been lately discovered, is to be found in the *Elgin marbles,* taken from the Acropolis at Athens, and supposed to be the works of the celebrated Phidias. The process of fastidious refinement and indefinite abstraction is certainly not visible there.

The figures have all the ease, the simplicity, and variety, of individual nature. Even the details of the subordinate parts, the loose hanging folds in the skin, the veins under the belly or on the sides of the horses, more or less swelled, as the animal is more or less in action, are given with scrupulous exactness. This is true nature and true art. In a word, these invaluable remains of antiquity are precisely like casts taken from life. The *ideal* is not the preference of that which

exists only in the mind to that which exists in nature; but the preference of that which is fine in nature to that which is less so. There is nothing fine in art but what is taken almost immediately, and as it were, in the mass, from what is finer in nature. Where there have been the finest models in nature, there have been the finest works of art. . . .

THÉOPHILE THORÉ

To Théodore Rousseau (1844)

Théophile Thoré (1807–1869) was one of the most sensitive art critics of mid-nineteenth-century France, yet he was equally concerned with social needs and political criticism. After the publication of one of his political brochures, *La Vérité sur le parti démocratique,* in 1840, he was jailed as a dangerous anarchist. Early in his career, he was sympathetic to the ideas of Saint-Simon and was attracted to the theories of Fourier, which he later repudiated; but his ultimate concept of an ideal society was largely his own. His regard for the individual—and specifically for the creative individual—tempered any notions of a too prescriptive social form. For his part in the unsuccessful revolt of 1849, Thoré had to flee France. He remained in exile until 1860, traveling widely in England, Switzerland, Belgium, and Holland, constantly writing on art, after 1854 under the pseudonym William Bürger. Particularly impressed by seventeenth-century Dutch painting, he wrote the first significant scholarly work on Vermeer. Moved by the new historical spirit, he set out to study artists and collections systematically, believing it necessary to be historically accurate before making judgments.

Of the French art critics of his time, Thoré showed probably the surest judgment and widest taste. Although he could not tolerate pretentiousness and overblown rhetoric, he accepted artists of quite diverse aesthetic tendencies. He supported Delacroix, wrote favorably of Ingres, defended Manet, and singled out the young Monet for praise.

Like many others, Thoré was uncertain about the future of art and of society as a whole. At times he viewed the direction of events pessimistically, seeing his age as a moment of historical decay. Yet the promise of modernity was always present, and he could become an enthusiastic advocate of the expanded, culturally more liberal modern world.

Thoré began writing on art in 1833 and critiqued all the Salons from 1835 until the time of his exile in 1849. His open letter "To Théodore Rousseau" was a part of his Salon review for 1844, first published in *L'Artiste* that same year. This translation was made from *Le Salon de 1844 précédé d'une lettre à Théodore Rousseau* (Paris: Alliance des Arts, 1844), pp. vii–xxxvi.

While we see barely a tiny square of sky, sharply cut as if punched out by our angular windows, you are out-of-doors contemplating the vast horizons of the Midi. Where are you now, you and Dupré? in Landes or in the Pyrenees? And what are you doing, you and he? No doubt you are, as always, looking at all with your large eyes, steady and voracious, which open wide like arches of triumph and seem never to have had enough. Everything passes through them without stooping; the great array of oaks at Fontainebleau, mountains and torrents. At this moment the Pyrenees are doubtless marching beneath the vault of your brows to halt on the other side, within the realm of your imagination. There you will rediscover them some day, in your store of memories, and will see them more clearly from afar than you did close by. Lamennais said to me at Sainte-Pélagie, "It is strange . . . I never saw Italy well until I was here in prison. When I went to Rome to meet an eclipsed pope, I was wrapped in my own thoughts; but here today images are awakened that furtively slipped into my head through my eyes at that time."[1]

You, dear poet, have spent your life regarding the open air, rain and fine weather, and a thousand things beyond the grasp of vulgar eyes. For you nature holds mystical beauties that escape us and secret favors that you lovingly exploit. Before nature, when one feels it and loves it, one must surely be happy to be a painter like you. Otherwise, the pleasure of contemplation is at the same time a pain, since one is powerless to express one's enthusiasm. We profane can have only a sterile and somewhat sorrowful love, like a passion in a novel, impossible to satisfy. Your love, oh painter, is far more real! Painting is a veritable conversation with the exterior, a positive and material communication. You exercise a kind of domination over nature, and from the amorous relationship a new being results, a creation that embodies qualities from both father and mother, from both nature and the artist.

Most men never dream of seeing. They are busy with other things that blot out their view. When on some extraordinary occasion they have to fall back upon what they have seen, they begin to reflect stupidly. What, then, do they reflect? Having no image to reflect, the mirror of their mind remains like a stagnant pool in the fog. Instead of being able to engage in revitalizing contemplation, they get lost in some idea that has nothing to do with the matter.

I once was traveling with a bourgeois who attached himself to me in order to show me his home territory. After a fatiguing journey over tortuous roads, we came in the evening upon a little river deeply embedded between steep rock embankments. The sun was just going down and began to touch the peaks of the rocks with flame; everything along one bank of the little torrent was in the

1. Félicité Robert de Lamennais (1782–1854) was a liberal philosopher and priest who eventually opposed the church in disagreement with the conservative politics of the Pope. He was imprisoned for his revolutionary activities.—Ed.

shadow and exhibited an extraordinary range of tonal values, reciprocated in the water. The two dark shapes, merging at the base, one quaking, head down, drowning itself in the whirlpool of the water like Shakespeare's pale Ophelia, the other grim and immobile like an immense bronze statue, produced a phantasmagoria equal to the dreams of Hoffmann.[2] At the same time, the opposite bank, lit by the rays of the setting sun, was light, rose colored, sparkling, spangling with a thousand precious stones. What a spot and what contrast! What a wonderful effect!

My companion, however, leaned over toward the river with curiosity and cried several times, "How clear the water is! How clear the water is!" Without turning my head I pushed him briskly. "But look at the light and the landscape," I said to him. "The sun drops quickly and the effect is capricious. You will have time later to go into ecstasy over the limpidity of the water."

Have I ever told you about my first trip to the ocean? We set out on foot, all in a group, from a village that was not more than a league from the coast. We had determined to arrive at a point high on the dunes so that I might be taken all at once by the great spectacle of the sea. I ran ahead of the group and, when I reached the summit of the dunes from which I looked down on the immensity, there was a striking effect of silver in the sky and on the sea that I have never again seen so striking. The sea and sky appeared to blend in a supernatural radiance. I asked myself where the sea was. It seemed to me that I had been transported above the sea and earth into a more luminous sphere. I was seized by an expansive enthusiasm that took my breath away. Not being able to take flight, I dropped to the ground and lay at full length so as no longer to be conscious of my body. Not being able to shout the glory of nature with the strength of storms, I began to weep softly, silently, without making any noise, in order to hear the great harmonious voice of the immensity.

I was there, lying on my side, my eyes bathed in the light, when our crowd caught up with me. The first of my companions, seeing me thus overwhelmed and motionless, rushed over and asked, "Are you ill?"

The feeling for art, the sense of beauty, the love of nature, enthusiasm for life are all very rare. In the sixteenth century, such feeling was almost universal. Today, bourgeois society has turned toward the exploitation of dead things under the name of industry. But industry is only the reverse of the social coin. The essential and profound significance is written on the other side, just as on Roman coins the side on the reverse of the living head shows some material emblem, an architectural facade or an allegorical figure, an accessory or a means.

It is indeed true that industry is as human as art. It is indeed true that it is linked to art by some still mysterious bonds. But until now they have been two

2. E.T.A. Hoffmann (1776–1822) was a German author famous for his fantastic tales.—Ed.

almost completely separate worlds. For our civilization has fragmented man into parts that remain foreign to each other. Politics is always concerned with forming castes instead of proposing an ideal of "the whole man in a whole society," as Pierre Leroux has said.[3]

I willingly accept the fact that this material race, which has no access at all to the world of the mind and which is carried on quite outside actual life, is very *useful*. But even while angling for fish in the river one can admire the light on the transparent waters and the rocks of the shore. It is possible that without the servitude of the lower classes, the rich would not have new clothes and set a sumptuous table. But man can get along well to some degree, at least, without the exaggerated pursuit of that which is called useful. Poetry is as useful as bread and iron. For my part, I would rather live in a beautiful countryside, half thinker, half peasant, in a peasant smock and wooden shoes, with baked bread, potatoes from my own garden, and a modest natural wine, than throw myself into an artificial and turbulent life amid luxury and material pleasures. Again, Lamennais once told me in the midst of his discouragement in prison, "I was born to be a gardener. The desire for the beautiful, the good, and the true is more worthwhile than the desire for money. True wealth is to be found in moderation, in human brotherhood, in well-ordered work, in the pleasures of the heart and mind." This is the hidden treasure of George Sand's beautiful novel *Jeanne*.[4]

I do not see that it would be difficult to find a solution to the social problem based on natural conditions; Jean-Jacques was right in the melancholy beginning of *Émile:* "Everything is good on leaving the hands of the author of all things; all degenerates in the hands of man."[5] The *City of God* is to be found within nature and Equality. It is the Republic of the future.

There were always in former times some temperaments and characters especially drawn to material production. Cain the strong beside Abel the poet.[6] Allow me a little fable that will surely suit your taste, Abel.

In a proletarian family were three brothers. The eldest was a vigorous man, sound in mind and body. The second was a poor invalid, deprived of sight and hearing and crippled in all his limbs. The youngest was a frail and poetic type, a dreamer and vagabond in spirit, incapable of maintaining a grasp on reality. His

3. Pierre Leroux (1797–1871), an economist and philosopher, was a follower of Saint-Simon.—Ed.

4. George Sand was the pseudonym of Amandini-Aurore Dudivant (1804–1876). Her novels were identified in criticism with the Romantic circle in Paris, and she was romantically linked with Frédéric Chopin and Alfred de Musset.—Ed.

5. Jean-Jacques Rousseau published *Émile,* a novel concerned with problems of education, in 1762.—Ed.

6. The image of Cain recurs in nineteenth-century art in interesting ways. Initially, Cain is simply an erring man, as in Dupré's sculpture, but eventually he becomes a coarse man who works with his hands, and he is impressively portrayed as a moronic brute by Ripamonti.—Ed.

delicate hands were badly torn in using the spade or plough, and when his brother took him to the fields for the seasonal work, the young poet involuntarily stopped to gaze at the wild flowers or to consider the profile of the earth at the horizon and the clouds in the sky.

Then the broad-shouldered laborer with calloused hands said to him, "Abel, my brother, we have been responsible for nourishing our invalid brother, and have given him the first fruits of the earth and the purest kernels of wheat. But these rough labors exhaust you, and the earth resists your weak efforts. Abel, little poet, go back home. Sit with your poor invalid in the shade of the arbor, or better, watch our flocks on the mountainside. Do what your heart inspires you to do. In the evening when I return from my work in the fields, you will tell me your naive impressions and teach me to love the beauties of nature and to worship God. Thought will reveal secrets to you that will lighten my labor and render it increasingly productive. I like to make my mark on the world with my hands. The work of my hands is enough to provide a living for the three of us. For we are not all destined for the same work. The order of things is so regulated that we may all live in freedom."

But the love of nature, poetry, and art need not isolate us completely from men and society. On the contrary, therein is the normal bond between all men and all things. It is the same feeling as universal religion, for God is everywhere. You, my dear Rousseau, have naively effected a complete detachment from everything not related to your art. You have remained a stranger to the passions that perturb us and to the legitimate interests of communal life. You have lived like the hermits of the desert,[7] in a rather impious concentration. It is true that your desert was a cerebral paradise, resplendent with life and color. But your secret doubts and agitations, your instinctive hurts and sometimes even your want of power to express your poetry, have they not possibly come from this excessive sequestration, this suicide of a part of your faculties? Had you mixed a bit more with men and women, your talent would doubtless have increased in penetration and magnetism without losing originality. Furthermore, if men like you lived in common society, how much would they not contribute to their *fellows?* Perhaps you have understood and performed only half your duty: the perfecting and elevating of your own nature. We have also the duty of contributing directly to the perfecting of other creatures through a holy communion of our feelings and thoughts. Will you say this is politics and not art?

But politics is the sister of your dearly loved poetry. When politics is false, poetry suffers and cannot spread its wings. You remember the time we were seated at the narrow windows of our garret in the Rue Taitbout? We looked at

7. Thoré here uses *Thébaïde,* which refers to the Theban desert in Egypt, where the first hermits took up residence.—Ed.

the angles of the houses and the chimney pipes, which you compared—squinting your eyes—to mountains and great trees scattered over the broken terrain. Not being able to go to the Alps or to the gay countryside, you made a picturesque landscape out of those hideous plaster carcasses. Do you remember the pretty little tree in the Rothschild garden, which we could glimpse between two roofs? It was only green we were able to see. In the spring you were fascinated by the budding green of the little poplar, and we counted the leaves as they fell in the autumn. And out of that tree, with a corner of hazy sky, with the forest of cluttered houses over which we gazed as if over plains, you created mirages that often tricked you in your painting into accepting them as natural effects. You floundered thus, through an excess of strength, feeding on your own inventions, which a view of living nature could not renew. At night, tormented by the continuous flood of varied, floating images brought on by a lack of repose in true fields bathed in sun, you would get up feverish and despairing. By the light of a harsh lamp you tried out new effects on the canvas already covered several times before, and when morning came I found you tired and sad, as the day before, but always ardent and irrepressible.

Did you not make twenty different, successive landscapes based on the same motif, a fantastic and always harmonious music, variations on a single theme, tone for tone, color for color? When, in spite of you, I chanced upon these newborn caprices that had replaced another in the cradle, one that had been much loved and passionately caressed for twenty-four hours, how I scolded you for slaying your progeny in this fashion and not raising them to the estate of fine and robust youth! But you could never leave a fixed image, nor use new canvases for new fantasies. How many times I wanted to spirit away your sublime sketches by force! You would possess today a fine history in paintings of an artist's torments. But you were never satisfied with an incomplete sketch. I told you that you could also accuse the sun of making sketches, more often than not, that vague effects are the most frequent in nature. At least in our climate it is rare for a landscape to be picked out positively in set lines. But you were unmoved by my arguments because you were not striving after *finish* in painting but the infinite in poetry. I agree that I was just about as reasonable as a man who sees a beautiful light effect over the fields and wants to stop the sun and carry away a portion of the earth itself with the effect intact, telling the sun to find another terrain for its gambols. As if one should not admire the sun for ceaselessly recommencing its dazzling magic and for surprising us with each new picture.

Then you replied the way the sun itself might: "Bah, can't I do that again any time I want!" Actually the sun varies its effects eternally. Every second it creates a new nature; it makes new images on the same canvas.

Do not laugh, dear poet, at being compared to the sun, like Louis XIV, who scarcely merited the comparison. Louis XIV was rather more the moon than

the sun, because he assumed his luminosity from the men of genius who adorned his century. You, you illuminate your canvas; you are the sun relative to your painting. You are the moon only because of your relationship with that other, which radiates in the immensity and whose splendor you imitate.

Do you still remember our rare walks in the Meudon woods or along the banks of the Seine when we were able to scrape together fifty sous by ransacking all the drawers? Setting out was an almost mad event. We put on our heaviest shoes as if we were embarking on a trip around the world. We always had the idea of never coming back. But our wretched condition kept hold of our shoestrings and we were forcefully pulled back to our garret, condemned to see no more outside than a single course of the sun. Our purse hardly made do. The air along the Seine is sharp and one gets hungry in the woods. Caporal [low-grade] tobacco is so good when one is coursing in the wind like a runaway horse or lying on some little hill gazing at the blue bands on the horizon! I do not remember the government ever giving as a present an ounce of tobacco or us receiving an offer of hospitality from the tavern-keepers of Saint-Cloud.

But our walks, so modest and sober yet so ardent and filled with enthusiasm, were easily worth a carriage ride in that poor Bois de Boulogne, gutted by fortifications. What beautiful things we saw together, out there no farther than Meudon or Saint-Cloud! Nature presented us with storms at no cost, and unforeseen spectacles, just for us. How happy you were, my dear painter, when the sky decided to act capriciously, to veil itself in clouds and let only a few melancholy rays get through quite by chance! After these splendid decorations, how gray our garret appeared to us in spite of our superb furnishings, quite sufficient for our use: a tattered bed, some Renaissance oak armchairs covered with tattered velvet, a little round table with twisted legs, an unsteady candle in a Japanese vase, a coffee maker, some dusty books, and some fine sketches by the old masters hanging on the plaster wall! It was poor indeed, but less ugly than a bourgeois parlor.

It was there that George Sand came one day to see you, brought by Eugène Delacroix.[8] For you, who have never dreamed of public favor and have always created art out of sheer love, it was nonetheless, I think, one of the finest days of your life. The two greatest artists of the nineteenth century, Eugène Delacroix and George Sand, coming to treat you like a brother; Delacroix modestly finding his palette dull beside your color, he who has created the most beautiful skies in the world; George Sand disavowing her Berry landscapes in comparison with your landscapes of Rue Taitbout, she who has painted in words better than Claude or Hobbema. Was it not then that you forgot all the sleepless nights and desperate days?

8. Delacroix mentions with great pleasure in his journal entry for February 24, 1850, viewing a collection of paintings by Rousseau, whose work he highly regarded at that time.—Ed.

Your *Descent of the Cows* was in the studio,[9] the first complete work of your youth, a landscape in which nature is understood with all the sensitivity of Jean-Jacques and expressed with the originality of Rembrandt. There were also some studies from your first escape to Auvergne, when you were seventeen and abandoned the studies of the Academy to go look at trees and sky. You were asked if one of these vigorous studies was not a caprice by Géricault.[10] There were some that resembled Bonington in their delicacy, and others that resembled Salvator in their bold strokes and spontaneity of effect.[11] Also on the easel was a little painting of a bush, much admired by your two illustrious guests, but it unfortunately disappeared under a new desire. Ah, I have seen thus changed such charming poems between the trees and tempests, between the sun and the brooks! But nature never unveiled the mystery you pursued with the patient and passionate obstinacy of heroic genius.

It is the sureness of your strong and original impressions, as well as the sympathy of true artists, that has sustained you in this obscure struggle. Little by little, in spite of your solitude and modesty, in spite of the jury that has always refused you a public, your name was spread abroad and your works became known. It was said that a great painter was emerging in a little studio closed to vulgar curiosity. In all Salon reviews, Rousseau's landscapes were written about just as if they had been shown at the Louvre. Eugène Delacroix, George Sand, Ary Scheffer, and some others told about what they had seen and were so effective that the studio was breached by intelligent collectors. Today several of your landscapes adorn the two or three most distinguished collections in Paris. Your *Passage with Chestnut Trees,* whose composition is so sound that it makes me think of the cathedrals of the Middle Ages, radiates in the home of Périer alongside the beautiful paintings of Decamps.[12] Today, outward success and fame, which have never been your goal, have become the legitimate result of your industrious life and your love.

At the same time, the restless and savage talent of your early youth has been quieted by your venturesome experiments on the resources of color. You have achieved a victorious technique that is not stopped by difficulties of expression. You are sure of the form and style necessary to translate your intimate poetry.

9. The rejection of Rousseau's *Descent of the Cows* at the Salon of 1836 became a symbol of academic misjudgment. The picture was first shown in the studio of Ary Scheffer (1795–1858), a religious painter born in Holland who worked in France.—Ed.

10. Géricault (1791–1824) was a hero for younger artists, including Delacroix, because of his vigor and uncompromising study of nature.—Ed.

11. Richard Parkes Bonington (1801?–1828) was an English landscapist who worked in France and markedly influenced French landscape painting; Salvator Rosa (1615–1673) was the Italian painter whose rugged landscapes served as an image of wild nature and the picturesque.—Ed.

12. Alexandre-Gabriel Decamps (1803–1860) was a much-admired painter of considerable originality.—Ed.

You have entered your period of productive strength. Now show your flowers and your fruits.

When you return tonight from your strolls under the sky of the Midi, open this Salon review that I send you as a souvenir of our old friendship and our common struggle. Excuse in this little-ordered work, improvised from day to day for the newspaper, many well-intentioned errors and several intentional banalities. In order to write a Salon review worthy of lasting interest, one would have to take a half dozen men—like Delacroix, Ingres, Ary Scheffer, Decamps—who represent particular qualities and attach to these leaders of our school other talents less original. With such artists, one would arrive naturally at the most profound questions of art, meaning, and form. But how many painters at the Salon of 1844 are not more or less failures?

Nonetheless, since God has created a thousand humble plants that rejoice at receiving the sun's rays through the shade of great oaks, do not completely ignore secondary talents. Rembrandt does not obliterate Van Eeckout or Flinck. In the school of great masters, it is possible to find originality and indisputable merit. It is wonderful to find Van Dyck, Sneyders, and Jordaens alongside Rubens.

Courbet: *The Burial at Ornans* (1861)

Jules François Félix Husson (1821–1889) adopted the pseudonym "Champfleury" around 1845. During the late 1840s and early 1850s, Champfleury alternated the writing of art criticism and of pantomime plays. He became an early defender of Courbet, who depicted Champfleury among his friends in *The Studio of the Artist* (1855). In 1856, he launched a short-lived journal, the *Gazette de Champfleury,* which defended the Realist movement in literature. Later he was active as a novelist, producing subjects of a satirical or quasi-fantastic nature. In 1872 he was appointed the curator of collections at the Sèvres Museum, an involvement that eventually led him to compile a massive bibliography on ceramic art, published in 1882.

In *Grandes Figures d'hier et d'aujourd'hui* (Paris: Poulet-Malassis et De Broise, 1861), Champfleury presented essays on four personalities from different artistic disciplines: Balzac, Gérard de Nerval, Wagner, and Courbet. The essay presented here was translated from a reprint of the original, published by Slatkine Reprints (Geneva, 1968), pp. 231–44.—J.L.Y.

I have heard the comments of the crowd before the painting of *The Burial at Ornans,* I have had the courage to read the stupidities written about the picture, I have written this article. Just as in politics, strange combinations of opposing parties get together to fight a common enemy—critics reported to be the most audacious have joined the ranks of fools to fire on reality.

Courbet wanted to paint a small town burial, such as takes place in the Franche-Comté, and he painted fifty people, life-size, going to the cemetery. That is the painting.

Some have found it too big and have directed the painter's attention to the flyspeck school of Meissonier.[1]

Others have complained that the bourgeois of Ornans lack elegance and look like caricatures by Daumier.

1. Jean-Louis Ernest Meissonier (1815–1891), a popular painter of historicizing figure pieces.—Ed.

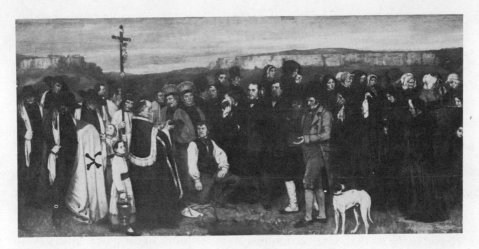

Gustave Courbet, *Burial at Ornans,* 1849–50, oil on canvas.

Some dispirited romantics have spoken out against the ugly, like simple nothings.

The lovers of old ribbons and stale makeup who sing the exploits of eighteenth-century damsels tremble before the black coats and cry, "The world is lost! there are no more pompoms, beauty patches, or pink party favors!"

One would have it that Courbet is a savage who learned to paint while watching the cows.

Some declare that the painter is head of a band of socialists.

The opinion of the fools might finally be summarized in this well-known comment that was current in the Empire:

"Everything to be seen in these paintings is so badly chosen that nature can be recognized only in its degradation. The men's figures are ugly and ill-made, their clothes coarse, their houses mean. They represent only a low kind of truth."

The academician who spoke thus in 1810 intended to refer to Teniers, Ostade, and Brouwer.[2] The critics of 1850 have changed nothing in the academician's arguments.

Oh wretches!

So much noise cannot be made over a picture without its having some serious qualities. Then, the negative critic renders a greater service than the favorable critic. The *against* is more useful than the *for.* It is by such uninten-

2. David Teniers the younger (1610–1690), Adriaen van Ostade (1610–1684), and Adriaen Brouwer (1604/5–1638) all specialized in tavern or rural feasting scenes.—Ed.

tional means that a work achieves success. "I love my enemies more than my friends," said a great man who knew how the tongues of detractors itched, and he was right. "The country is in danger!" writes the *Constitutionnel* concerning Courbet's painting. Soon all the curious in Paris run to court the danger of *The Burial at Ornans*. They come back from the Salon and relate the scandal to everyone who will listen. "The Barbarians have entered the exhibition!" They cry out that Courbet is the offspring of the democratic Republic of 1848; they would hang crepe over the Apollo Belvedere; they propose closing the galleries of ancient art. If one listens to them, the members of the Institute should seat themselves in chairs, like the ancient senators in their curule chairs, and die proudly, trampled by the muddy sabots of the savage realists.

The inhabitants of Ornans tremble on reading in the papers that they might later be suspected of complicity with the "monster" for having lent their faces and costumes to his brush for a moment. I understand the terror of Proudhon, cousin of the revolutionary economist and vice-judge of the peace, who saw no crime in entering the painter's studio, his mourning clothes well brushed, a black coat, polished shoes, his hat in his hand. The youngest Marlet, who studied law at Paris, tries uselessly to calm him.

Tête, the mayor of Ornans, a great jovial man, goes to the café to find out what his administrators have to say. Old man Cardet, who was at the burial in short trousers and blue stockings, goes to find his colleague Secrètan, who lives in the Rue de la Peteuse, and the two worthy vine growers, who are withdrawn from the affairs of this world and do not read newspapers, are astonished at the noise made over the three-cornered hat of the one and the gray coat of the other. Unfortunately, the vine grower Sage's son is in Africa at the moment; he would warmly defend his friend the painter. Max Büchon, the poet, is not there either, but he will defend Courbet in Salin's newspaper. Why is Jean-Antoine Oudot, the painter's grandfather, dead? He was a man of prudent counsel whom all Ornans consulted; he would have brought everyone to their senses.

Only Alphonse Bon remains in town and meets Célestine Garmont the lame, the wife of Alexandre the hunchback. "Everyone in the market is talking about nothing except the painting by the vine grower Courbet's son," she says. "It seems he has not flattered us any. They say he has caricatured us. But when he gets back, just wait. Mrs. Beurey's son has prepared something . . . You can't make fun of people that way. He is a great devil . . ."

Actually, what makes the citizens of Ornans angry is that last year they led the painter into town with a band. Promayer, who directs the music of the National Guard, arranged the surprise for the Parisian. And how has the painter paid back his fellow citizens for this triumphant acclaim? By amusing all Paris at the expense of the vergers of Ornans, the vine grower Jean-Baptiste Muselier, and the shoemaker Pierre Clément.

The parish curate, Monsieur Bonnet, does not like his vergers mocked in this way, because they belong to an extent to the church, and nothing respecting the clergy must be held up to ridicule. Why did the newspapers not mention Cauchi, the sacristan, or the vine grower Colart who bore the cross? There is nothing ridiculous about them, while Pierre Clément's red nose indicates too prolonged conversations with the bottle. The curate thinks that the broad-brimmed hats that the chapelin Cuenot rents for funerals are the reason too that no one has bothered with Étienne Nodier, who carries the body with Crevot.

Courbet's sisters do not know what to think of the newspapers their brother sends them from Paris. They are so sure of his intentions that they try in every way to prove that "Gustave" did not dream of making fun of anyone in town. They go to see Fili Caillot, who posed in the painting, and Joséphine Bocquin, the one weeping with a *capuchon* on her head, and show them a newspaper in which a critic calls them pretty. The women, happy to see the compliment in print, are almost convinced when big Marlet comes in. He has received the *Presse* and reads an article in which the critic states that the painter expressly caricatured his fellow townsmen in order to appear handsomer himself.

"The paper is right," says big Marlet. "Since Courbet knows how to make himself handsomer, he could have made us like himself."

"He is not so handsome, with his pipe!" exclaims mother Promayer.

Only the gravedigger Cassart says nothing. His practice of burying people has taught him to reflect, and he does not unleash his words like a magpie. He listens to Tony Marlet's reproaches while stroking his dog, then goes off whistling along the valley of Manbouc.

I have tried to depict the small-town talk among the characters in *The Burial at Ornans*. It is very important that an effort be made to establish the position of the characters of the painting by Courbet, who is dubbed absolutely *socialist*. Today it is expedient to investigate to see if an author's pen is tainted with communism, if a melody is Saint-Simonian, if a brush is egalitarian. There is not a shadow of socialism in *The Burial at Ornans,* and painting some stone breakers is not enough to demonstrate to me a lively desire to better the lot of the working classes.

These dangerous fantasies tend to class artists by party and to make them advertise this one or that. I can never be persuaded that "Rembrandt was the pupil of Luther." Impure mixtures of cloudy pantheism, symbolic antitheses, and reality—when will we stop browning them in the same casserole and poisoning our youth?

However, I want to go back into this pit from which no truth can come, to show that Courbet is not so socialist as he is made out to be. Not that I want to associate him with another party, which would be just as fatal to the painter and his future works.

Artists who want to teach with their works or associate themselves with

governmental acts of any sort are doomed to misfortune. They may flatter the passions of the crowd for five minutes, but they render nothing more than *news*.

If socialism were actually nothing more than a new form of liberalism, that is to say a kind of *opposition* to other tendencies, what chance would a socialist painter have? His work would pass as quickly as the name of the doctrine itself, already less prominent than in the first two years of the Revolution.

Painting has no more a mission than music to set forth social systems. When a painting is converted into instruction it is no longer painting. It becomes a pulpit that is sad and painful to look at because it contains no preacher.

Happily, Courbet did not want to prove anything by his *Burial*. It is the death of a bourgeois who is followed to his last resting place by other bourgeois. It is evident that this is not a family portrait. What vine grower is rich enough to commission so important a picture? It is quite simply, as I saw printed on the posters when Courbet showed his paintings in Besançon and Dijon, "A *Historical* Painting of a Burial at Ornans." It pleased the painter to show us the domestic life of a small town. He announced that calico dresses and black suits were equal in worth to Spanish costumes, the lace and plumes of Louis XIII, medieval armor, or the spangles of the Regency; and with the courage of a bull he threw himself into painting the immense canvas entirely without precedent.

It is not the size of the painting that interests me. If Meissonier did not paint with a pin, if he understood effect, if his painstaking brush did not trace dirty colors on his microscopic pictures, I would have as much respect for his Tom Thumb painting as for the great architecture of Veronese. But in front of his patient work I visualize Meissonier with a watchmaker's lens in his eye, painting from Babin's cast-off clothing.

Among other recriminations, the fools have cried with one accord, "We understand Ostade, Teniers, and Brouwer, we understand their drinkers and their smokers, but at least they knew enough to restrict themselves to small canvases. Their drinking, their common actions, and their gluttonous feasting took place within small areas."

The Spanish, Murillo and Velázquez in the lead, painted beggars, the louse-ridden poor, and legless cripples in the same format as the Great and the Infantas of Spain.[3] The *Family Feasts*—where someone cries "The King drinks!" where people sing or play on a musette, where one pushes himself away from the table when digestion becomes painful—are painted life-size.

We have a masterpiece in the Louvre, *The Archery Prize,* by Van der Helst.[4] It

3. Courbet admired and copied works by Murillo (1618–1682) and Velázquez (1599–1660).—Ed.

4. Bartholomeus van der Helst (1613–1670), whose *Archery Prize* now hangs in the Louvre.—Ed.

Nadar (Félix Tournachon), *Champfleury* (Jules Fleury), 1865, photograph.

Bartholomeus van der Helst, *The Banquet of the Civic Guard, June 18, 1648, to Celebrate the Conclusion of the Peace of Münster,* 1648, oil on canvas.

is a picture of three sheriffs holding golden vases, which they will present to the most adroit archer. This little easel painting is only the reduction of a picture by Van der Helst that is the same size as Courbet's painting of last year, *After Dinner at Ornans.* In the Amsterdam Museum, across from Rembrandt's *Night Watch,* there is an immense painting by Van der Helst representing a discussion of the burgomasters of the city. This painting is even larger than Courbet's. Why do the fools not know the painting of Van der Helst? Because their science is equal to their sentiment. Ignoramuses, dolts, squabblers!

It will be said that the burgomasters and sheriffs of Amsterdam are important people; but the mayor of Ornans, the vice-justice of the peace of Ornans, the curate of Ornans, the dog of a landowner of Ornans, do they not have the historical importance of Flemish burgomasters and sheriffs? In fifty years the names of these bourgeois will no longer be known—any more than an artist traveling in Holland knows the names of the people in Van der Helst's paintings.

As to the alleged ugliness of the bourgeois of Ornans, it is not at all exaggerated; it is the ugliness of the provinces which it is important to distinguish from the ugliness of Paris. Everyone exclaims that the vergers are ignoble—because the effects of wine show in their faces. A fine business! Wine gives a badge to those who love it, the powerful red color of a drinker's nose. It is the decoration of drunkards. A red nose has never been a saddening object. Those with red noses do not bow their heads in shame; as a rule, they hold them up, convinced that they inspire joy in their fellows. The vergers of Ornans are dressed in red robes and toques like the presidents of the Court of Appeals, and this shocked some *serious* people, who, in their error, were shocked to see *mag-*

istrates bearing such noses. The type is not to be mistaken. Judges, since they are rarely pleasant outside court, do not present wine-marked faces in which the eye and the ear, indifferent to exterior things, seem to pay great attention to interior fumes. Each profession has its nose; and one would have to be very weak in physiognomic ideas to attribute the nose of a verger to a magistrate.

These vergers amuse me singularly. They delight me; therefore they are not ugly. No, you are not ugly, Pierre Clément, with your nose redder than your robe. Console yourself, Jean–Baptiste Muselier, for what the pamphleteers say. Go into a bar and drink another bottle. It's a strange thing, people say the worst things about these vergers with their jovial faces, and no one dreams of broaching the question of the ugliness of businessmen, well represented by a person with a pale face, thin lips, and a cold dry neatness that indicates a meanness of life. That is the portrait of an ugly man, economical and prudent, tidy and *virtuous*. That is ugliness.

The two old men before the open grave, who are taking a snuff and thinking of the past, have great facial character, they are not ugly. The pallbearers are young men with beards and mustaches like all young men. Should Courbet have dressed them in cossack-style trousers and hussars' vests? The gravedigger is an *admirable* figure, kneeling on the ground, full of pride. His job is half done, and he awaits the end of the curate's prayers. He is neither sad nor gay; the burial hardly concerns him; he does not know death. His eyes are fixed on the horizon of the cemetery and he is moved by nature. This gravedigger working constantly on the count of death never gives death a thought. He is a man-of-the-people type in his robust beauty. The choir boy holding the pitcher of holy water is charming; even more appealing is the little girl who holds on to her weeping mother's arm and leans over as if to pick a daisy.

The group of women is composed of young and old. With malicious "realist" caprice, Courbet has enjoyed wrinkling the old women. Their gray hair peeks out from beneath their white linen coifs and great bonnets. But the young women are really youthful and robust, like all women from such cities, half-towns, half-villages, lost in the mountains. Exceptions do exist, however, and the painter has depicted exceptions. In the middle of the group of women, one young woman stands out. Her head is covered with a *capot* of black taffeta, her face is fine and delicate, and the clusters of blond hair stand out against the black of her dress. This is a delicate and charming physiognomy that has none of the conventional markings to be found in the works of young painters of overly refined coloring who emerge from the teaching of Couture.[5]

The critics put Balzac on the grill so often that they finished by burning and injuring him. He only liked to depict rogues, they said, and delighted only in

5. Thomas Couture (1815–1879), an admired and popular teacher of art at the time.—Ed.

335

representing vicious people. You have seen Balzac's defense at the beginning of this volume. He replied that, if the vicious were greater in number than the virtuous, it was doubtless society's fault, and, since he intended to paint society as it truly was, he could not allow himself to change businessmen into gallant bearers of shepherds' crooks.

In the same way as the great master we have lost, Courbet could reply to his pen-wielding judges, "I agree that my vergers are not Antinous; I am even convinced that Winckelmann would not expatiate on my painting because of the *lowness* of some of the characters. But beauty is not common in France. You critics who pretend to understand the Beautiful, go look in a mirror and then dare to print that your face conforms to the *Characters of the Noble Passions,* by the illustrious Le Brun."[6]

Courbet could boldly cite the heads of three of the women, the children, the gravedigger, and a good many others as types of modern Beauty, but the vergers will capture the balance, and the *Burial* will be called the masterpiece of the *ugly.* Is it the painter's fault if material interests, small-town life, mean egoism, and provincial stinginess impress their claws on the face, dim the eye, wrinkle the forehead, and give the mouth a stupid look? Many bourgeois look like that, and Courbet has painted bourgeois.

Following an established procedure, people have contrasted the exhibition of 1851 with that of 1850; they say that *After Dinner at Ornans* was far superior to *Burial at Ornans.* And I have seen twenty times in print, in the presence of this admirable painting, that it was too bad that the painter did not use his robust qualities in a *historical* painting.

There are still many weak spirits in France. Regency courtesans, rouge, beauty patches, and sheep have singularly troubled the minds of these poor people who can find neither glory nor happiness in their own epoch and imagine that the "charming little poem," suppers, and little dogs, marquises, actresses and *guerluchons,* and Collé and Piron would lend a bit of calm to their spirits, where tall dry grass is growing. They ignore the fact that modern costume harmonizes with modern features, and that the gallant comparisons of Watteau would make us look as foolish as Cassandra. Our black and serious dress has its reason for being, and one needed the delicate illusions of a *précieux* to exclaim how fortunate it was that "the next Longchamps would bring leaves to the trees and plumes to men's hats."

Happily, the time has passed when these pantheists made nature act out such silly comedies. A new art has appeared, which is convincing and serious, ironic and brutal, sincere and full of poetry. Those who will expose all these prideful fripperies will not be long in making an appearance; everywhere spirits are re-

6. Charles Lebrun (1619–1690), who prepared a discourse on physiognomy that included grotesque drawings of men compared to animals.—Ed.

viving. The young intellects await the first bold men who will get rid of these word-chasers, this school of pleasantries, these collectors of spirit, these sheep of Panurge who keep jumping over the same ditch, these fabricators of proverbs, these writers of clichés, these pastry cooks whose verses were formed in the same mold.

No temple will be big enough to hold all the yellow-jacketed books that will have to be torn apart before they are thrown out; for it will be necessary to show how badly stitched they were, with what poor quality trash they were filled, and what shoddy stock was underneath. This painful necessity will take more than a day.

The scandal that the *Burial* provoked can be understood when one considers that it was flanked on the left by *The Call of the Victims* by Müller, on the right by the *Departure of the Volunteers* by Vinchon, and was opposite the *Battle of Koulikovo* by Yvon.[7] In other words, it was the case of paintings of sentimental anecdote, academic painting, and painting of fake energy surrounding a virile, powerful, and sincere work.

From a distance, on entering, the *Burial* seems to be framed by a doorway; everyone is surprised by this simple painting, as when looking at the naive, clumsily made woodcuts that head the stories of assassinations published in the Rue Gît-le-Coeur. The effect is the same because the execution is so simple. Masterly art bears the same *accent* as naive art. The appearance is striking, as in a painting by an old master. The simplicity of the black dress achieves the grandeur of the red-robed parliaments painted by Largillière. The modern bourgeoisie stands before us in its ridiculousness, its ugliness, and its beauty.

The *Burial* of Courbet owes a part of the scandal it provoked to a strong individuality, robust and powerful, that crushes the neighboring paintings. The critics are enthusiastic about a somewhat mannered head of a man smoking, the portrait of the artist. There is genius in the *Burial at Ornans;* the portrait, *Man with a Pipe,* can be found painted ten times better in ten of the heads in the *Burial.* I shall not give the painter advice: let him go where his brush leads him. He has produced a work in this time of mediocrities. May he forget in his studies the misery to which the mediocrities have subjected him.

7. Charles Louis Lucien Müller, whose *Roll Call of the Last Victims of the Terror* enjoyed great success at the Salon of 1850; the painting now hangs at Versailles. Auguste-Jean-Baptiste Vinchon (1789–1855), whose *Departure of Volunteers* is also at Versailles. Adolphe Yvon (1817–1893) was a very popular painter of military subjects during the second Empire.—Ed.

JEAN-FRANÇOIS MILLET

Selected Writings (1858–1863)

Jean-François Millet (1814–1875), by birth a member of the peasant class, was sent to Paris on scholarship from his native Cherbourg in 1837. After painting for two years in the studio of Paul Delaroche (1797–1856), Millet supported himself through the sale of pastels while also producing pastoral and mythological oil paintings. In 1849 he made a first trip to Barbizon with Charles-Émile Jacque (1813–1894). He subsequently returned to take up permanent residence there, establishing a close friendship with Théodore Rousseau (1812–1867) and focusing on the depiction of peasant life. His most representative pictures, such as *The Angelus* (1859), portray peasants ennobled by humble labor. His work enjoyed only limited success before 1860 but gradually won acceptance and popularity among both critics and the public. Millet ultimately developed a large following. After his death, his vision of the peasant was promulgated in the work of artists both in France and abroad.

The following extracts from Millet's writings were translated from Étienne Moreau-Nélaton, *Millet raconté par lui-même,* 3 vols. (Paris: Henri Laurens, 1921) 2:60–61, 106–7, 128–29, and 130–32.—J.L.Y.

RESPONSE TO READING DAVID SUTTER, *PHILOSOPHIE DES BEAUX-ARTS APPLIQUÉE À LA PEINTURE* (1858)

The art of painting consists in expressing the appearance of bodies. This is not the end of art but the means, the language one uses to express one's thoughts. That which is called *composition* is the art of transmitting thoughts to others. No rule, however, can be prescribed for anyone. Nothing can be a composition without essentially having *order*. Order puts everything in its proper place and consequently gives clarity, simplicity, and strength. Poussin called this *the proprieties (les convenances)*.

It is wrong to believe that there are *rules of art* discovered and established for the use of those who want them. Whoever can look at nature for himself and draw impressions from it will find no one else with the means to communicate

Nadar (Félix Tournachon), *Jean-François Millet,* c. 1855, photograph.

them to others. That which he alone feels dominates the expression. One does not give a dog the ability to scent; one trains it. That is all that education can do. The example of preeminent persons, what they have done and how different from each other they appear, proves to us that nothing must lack the law of *order;* and this is natural, since without order, expression could not emerge— things take on value only by virtue of the place they occupy. Preeminent men are different from each other only in the final physiognomy of their work. All will teach the same principles. To be frankly Peter or Paul, that constitutes *originality.* One can teach someone the materials of art, but only up to a point. He will repeat, along with what he has more or less badly learned, what the others have said. But he will never walk alone if he does not see through his own eyes. One reads in the *Cuisinier français* something that is more instructive than it at first seems: "To make a rabbit stew, take a rabbit." A man cannot become that which he was not chosen to become; good precepts can only develop that which is in him. The egg needs an incubator; but if the egg is not fertile, what good is the incubation?

LETTER TO THÉOPHILE THORÉ, FROM BARBIZON, FEBRUARY 18, 1862

My dear Thoré,

Since you would like to concern yourself with my paintings exhibited by Martinet, I should like to tell you something about the idea that prompted me to paint them. You may judge for yourself if there is something worth drawing upon in these notes. First, I must tell you that I strive to express in what I do a rustic feeling; I should willingly accept as my motto: *rus!*

In the *Woman Returning from the Well,* I have tried to paint her so that one cannot take her for a water carrier or for a servant; rather, I wish one to suppose that she has just drawn the water to use in her house, water to make soup for her husband and children; that she should seem to carry a load no more or less heavy than the full buckets; that by means of a kind of grimace, as if forced by the weight that tugs at her arms, and the blinking of her eyes caused by the light, one might descry from her face an air of rustic goodness. I have avoided with a kind of horror, as always, anything that might be considered to verge on the sentimental. On the contrary, I have wanted her to perform with simplicity and cheerfulness, without any sense of burden, an act that, like other household work, is a daily chore and a habit of her life. I should like one also to imagine the coolness of the well and realize from its ancient look that many before her have come to draw water there.

In the *Sheep That Have Just Been Shorn,* I have sought to express that kind of

bewilderment and confusion that the sheep experience when they have just been stripped of their wool, and also the curiosity and astonishment of those which have not yet been shorn on seeing such denuded creatures rejoin the flock. I have tried to give the house a rustic, peaceful air so that one could imagine the grassy plot behind, where the poplars are planted to afford protection. Finally, I wanted it to have an air of such antiquity that generations might be supposed to have lived in it.

A Woman Feeding Her Children. I wanted this to seem like a nest of birds who are being fed by their mother. The man is working to provide the nourishment.

Then, in case you think it necessary to mention it, in what I do I want it to seem that things are brought together by chance and for the moment, but that there also exists an indispensable and necessary connection between them. I want the beings I depict to seem consecrated to their position so that it would be impossible to imagine them as other than what they are. In sum, the people and things always must seem to be there for a purpose. I want to present clearly and strongly that which is necessary, but I have the greatest horror of useless things and fillers, which can have no other effect but to enfeeble.

I do not know if there is anything you can draw upon in what I have just said, but there you have it, such as it is.

Accept, my dear Thoré, a hearty handshake with best wishes for perfect health.

J-F Millet

LETTER TO ALFRED SENSIER, FROM BARBIZON, MAY 30, 1863

. . . The gossip about my *Man with the Hoe* always seems to me strange, and I thank you for informing me of it because it is one more instance to astonish me at the ideas people attribute to me. In what camp have my critics ever found me? Socialist! But really, I could reply the way a commissioner from Auvergne did in writing to his constituency, "They have said at home I'm a Saint-Simonist. It's not true. I don't know what that is." One can't then simply admit having the ideas which might come to mind in watching a man devoted to earning his living *by the sweat of his brow?*

There are those who say I spurn the charms of the countryside. I find in it much more than charms: infinite splendors. I see, as well as they, the little flowers of which Christ said, "I say unto you that even Solomon in all his glory was not arrayed as one of these." I see very well the aureoles of the dandelions and the sun out there, spreading its glory through the clouds, stretching to

lands beyond. I see as well the steaming horses toiling in the fields, and in a rocky stretch a man, whose haw! has been heard since morning, trying to straighten up for a moment to breathe. The drama is cloaked in splendor. This is not my invention; the expression "the cry of the earth" came into being long ago. I imagine that my critics are people of learning and taste, but I cannot put myself in their shoes. Since I have seen nothing in my life but the fields, I try to say as best I can what I have seen and felt as I worked there. Those who can do better are fortunate.

I shall stop because you know how I go on when someone brings up this subject. But I do wish to say how flattered and encouraged I am by some of the articles you sent me. If, by chance, you know their authors, please tell them of my satisfaction. I count on your coming soon. Greetings to Rousseau. Yours,

J-F Millet

LETTER TO THÉODORE PELLOQUET, EDITOR OF *L'EXPOSITION,* JUNE 2, 1863

I am happy with the way you speak about my paintings in the exhibition.[1] It has given me great pleasure, especially because of your manner of talking about art in general. You are one of that exclusively small number who believe (so much the worse for those who do not believe) that all art is a language, and that language is created to express thoughts. Say it and say it again. Possibly it will make someone stop to think. If more people believed it, one would not encounter so much pointless painting and writing. This is called "ability," and those who traffic in it are much praised. But, in good faith, if it were true ability, would it not be used only to accomplish a thing well, and then hide itself modestly behind the work? Should ability have the right to open shop on its own account? I have read, I no longer remember where, "Beware of the artist who exhibits his talent before his work." It would be diverting if the wrist preceded all. I do not know the actual text of what Poussin said in one of his letters when he had felt his hand tremble at a time that he felt his brain to be pushing continuously ahead, but in substance it went like this: "And even though this

1. The Exhibition at the Palais de l'Industrie motivated Pelloquet to write: "I have read in a Belgian publication with regard to some exhibition or other that Millet is a *realist*. The partisans of realism, on the contrary, consider him a romantic or an academician, which to their eyes is the same thing. Actually he has nothing to do with either. He conscientiously seeks to discover in the spectacle of men and things of his time, the great laws that guided the masters, and he finds them. He applies them in his own way, which is his originality and strength—a very great originality and a very great strength which no one, at least in France, has possessed before him and no one at the present time has shown to the same degree."—Ed.

Jean-François Millet, *The Gleaners,* drawing.

(his hand) be weak, it nonetheless must be the servant of the other, etc." Again, if more people believed as you do, they would not be so resolutely engaged in praising bad taste and evil passions for their own profit without any concern for what is right. As Montaigne said so well, "Instead of naturalizing art, they *artificialize* nature."

I should be happy for a chance to speak with you. But since that is not possible at present, I should like, at the risk of tiring you, to try to express certain things that for me are matters of faith, and which I hope to be able to render clearly in what I do.

Things should not seem to be brought together by chance or for the moment, but should enter into a liaison that seems inevitable and necessary. I should like the beings that I depict to seem consecrated to their position so that it would be impossible to imagine them as other than what they are. A work ought to be all of a piece, and people and objects should always be there for a purpose. I want to present clearly and strongly whatever is necessary, to such a point that I think if a thing can be said only feebly, it had better not be said at all, because it would appear wasted and worn out. I have a great horror of

Jean-François Millet, *The Sower*, lithograph.

useless things (no matter how brilliant they may be) and fillers. Such things only distract and weaken.[2]

It is not so much the subjects represented that create beauty, as the need one feels to represent them. And this need itself creates the degree of power sufficient to accomplish the work. One might say that everything is beautiful, provided that it occurs at the right time and place, and that nothing can be beautiful that appears out of season. Characters must not be weakened. Let Apollo be Apollo, and Socrates, Socrates. Do not confuse one with the other or they both stand to lose. Which is more beautiful, a straight or a twisted tree? That which best accords with the situation. I would thus conclude that the beautiful is that which is in accord.

This could be developed infinitely and proved by endless examples. But it should be clearly understood that I am not speaking of absolute beauty, since I have no idea what that is; it seems to me the best of all jokes. I believe that people who are concerned with it do so only because they have no eye for natural things. They remain within the confines of past art, not believing nature rich enough to continue to produce. Worst sorts! They are the people who engage in poetics instead of being poets. To characterize, that is the goal! Vasari tells how Baccio Bandinelli made a figure to represent Eve. But in carrying out the work he was told that the figure was too slender for the role of Eve. So he was content to substitute the attributes of Ceres, and Eve became a Ceres! Since Bandinelli was an able man, we might readily admit that there must have been some bits of superb modeling in the figure, based on great knowledge. But all of these, since they did not contribute to a determined character, could only make the work the more pitiable. It was neither fish nor fowl.

Pardon me for having talked so long and having said perhaps very little. But let me say again, if you find yourself in the vicinity of Barbizon, please stop a moment to see me.

J-F Millet

2. Millet evidently thought so well of this formulation that he repeated it almost verbatim from his letter to Thoré of February 1862.—Ed.

GUSTAVE COURBET

Selected Writings (1855–1870)

Gustave Courbet (1819–1877) staunchly advocated the cause of "Realism" in art and successfully fought for its acceptance. Frequently rejected by Salon juries, Courbet took his first strong stance against detractors by setting up his own "Pavilion of Realism" alongside the grounds of the Universal Exposition in Paris in 1855. A preface to the catalogue for the pavilion represents a concise and powerful early statement of his convictions and aesthetic goals.

Courbet's self-promotion bordered on the evangelistic, but he was convinced that conversion to his views did not entail study under a master in the manner common to academic training of the period. Addressing a group of young art students who had withdrawn from the École des Beaux-Arts to place themselves under his tutelage, he reaffirmed that an artist must be of his own time and place, faithful only to his own inner impulses and not imitative of the style of any master. He scorned the art establishment and its hierarchy of recognition, and, at his most acerbic, was merciless in refusing artistic awards, such as the coveted French Legion of Honor. Not surprisingly, when Courbet was elected president of a general assembly under the Commune in 1871, he proceeded to dismantle the academic structure of the École des Beaux-Arts and the Institute, and abolished all medals.

The following passages from Courbet's writings were translated from Charles Léger's biography, *Courbet* (Paris: G. Cres, 1929), pp. 61, 86–88, and 153–55. ✿

REALISM (FROM THE PREFACE TO THE 1855 CATALOGUE)

The title of realist has been imposed on me just as the title of romantic was imposed on the men of 1830. Titles have never given a correct idea of things; if it were otherwise, works would be superfluous.

Without discoursing on the greater or lesser suitability of an appellation that

no one, let us hope, has wanted really to understand, I shall limit myself to a few explanatory words to put an end to misunderstandings.

I have studied, outside of any system and without prejudice, the art of the old masters and the art of the moderns. I have no more wished to copy the one than to imitate the other; nor has my idea been to achieve the vain ends of *art for art's sake*. No! I have wanted quite simply wanted to cull from a complete knowledge of tradition a reasoned feeling independent of my own individuality.

To know in order to be able to do, that was my thought. To be able to translate the customs, ideas, and look of my epoch according to my estimation of them. In a word, to create living art, that is my goal.

LETTER TO A GROUP OF YOUNG ARTISTS FROM PARIS, DECEMBER 25, 1861

Gentlemen and my dear fellows,
You have expressed the wish to open a painting studio where you would be free to continue your education as artists, and you have expressed the wish that it be placed under my direction.

Before replying, I must explain to you my view of the word *direction*. I cannot expose myself to a situation that would make us teacher and pupils. I must tell you what I recently had occasion to say at the Antwerp congress: I do not have, I cannot have pupils. I, who believe that every artist must be his own master, cannot dream of becoming a professor.

I cannot teach my art, nor the art of any school whatsoever, since I deny that art can be taught. I maintain, in other words, that art is entirely individual and each artist must rely solely on the talent arising from his own inspiration and his own study of tradition. I must add that art or talent, to my way of thinking, should be for the artist but the means of applying his personal capacities to the ideas and things of the period in which he lives.

Especially, the art of painting must consist only in the representation of objects that are visible and tangible to the artist. No period can be reproduced except by its own artists, by the artists who have lived in it. I maintain that an artist of one century is entirely incapable of reproducing things of a previous or future century, that is, of painting the past or the future.

It is in this sense that I repudiate historical art directed to the past. Historical art is essentially contemporary. . . .

I maintain also that painting is essentially a *concrete* art and consists only in the representation of *real* and *existing* things. It is an entirely physical language that uses for words all visible objects; an *abstract* object, not visible, nonexistent, is not of the domain of painting.

347

Gustave Courbet, *"Bonjour M. Courbet," The Meeting,* 1854, oil on canvas.

Imagination in art consists in knowing how to find the most complete expression of an existing thing, but never in conjecturing or creating the thing itself.

Beauty exists in nature and is encountered in reality under the most varied forms. Once it is found it appertains to art, or rather to the artist who knows how to see it there. Since beauty is real and visible, it has its own artistic expression. The artist does not have the right to embroider on this expression. It cannot be touched without the risk of denaturing it and thus enfeebling it. The beauty provided by nature is superior to every artistic convention.

Beauty, like truth, is relative to the time in which one lives and to the individual capable of comprehending it. The expression of the beautiful is in direct proportion to the perceptive powers acquired by the artist.

There you have the essence of my ideas on art. With such ideas, to conceive of the project of opening a school for teaching the principles of convention would be to return to the incomplete and banal assumptions that have everywhere directed modern art.

There must be no schools, only painters. Schools serve only to investigate the analytical procedures of art. No school can resolutely lead us toward synthesis. Painting cannot, without falling into abstraction, allow a partial aspect of art to dominate, whether it be design, color, composition, or any other of the many elements whose ensemble alone constitute art.

I cannot, therefore, contemplate opening a school, training students, teaching this or that partial tradition of art. I can only explain to artists who would be my collaborators, and not my students, the method by which, for me, one becomes a painter, by which I myself have tried to become one from the outset—I leave to each the entire direction of his individuality, the full freedom of his own expression in the application of this method. Toward this end, the formation of a common studio, recalling the very productive collaborations of the studios of the Renaissance, could certainly be useful and could contribute toward opening the modern phase of painting, and I will eagerly lend myself to all that you wish of me in order to attain it.

<div style="text-align: right;">

Cordially,
Gustave Courbet.

</div>

LETTER TO MAURICE RICHARD, MINISTER OF FINE ARTS, PARIS, JUNE 23, 1870

At the home of my friend Jules Dupré at l'Isle Adam, I learned of the publication in the *Journal officiel* of a decree naming me chevalier of the Legion of Honor. This decree, which my well-known opinions on artistic awards and noble titles should have spared me, was made without my consent. It is you, Mr. Minister, who have believed it necessary to take the initiative.

Do not fear that I fail to recognize the feelings that have guided you. You came to the Ministry of Fine Arts after a disastrous administration that seemed to have assumed the task of killing off art in our country, and it would have succeeded, by means of corruption or violence, had it not been for a few men of heart who held it in check. You then wanted to announce your arrival by a measure that would be in contrast to the ways of your predecessor.

These proceedings do you honor, sir, but allow me to say that they can change neither my attitude nor my determination.

My opinions as a citizen oppose my accepting a distinction that in essence

revives the monarchial order. This decoration of the Legion of Honor that you have arranged for me in my absence is repellent to my principles.

At no time, under no circumstances, not for any reason would I have accepted it. Far less would I do so today when treason multiplies on every side, and the human conscience is saddened by so many self-interested recantations. Honor dwells in neither a title nor a ribbon; it is to be found in actions and in the motivations for actions. Respect for one's self and one's ideas forms the major part of honor. Thus I do myself honor by remaining faithful to the principles of a lifetime; were I to desert them, I would forfeit honor to accept a badge.

Nor are my feelings as an artist any less opposed to my accepting a reward granted me by the hand of the State. The State is incompetent in matters of art. When it undertakes to reward, it encroaches on public taste. The State's intervention is completely demoralizing: fatal to the artist, who is misled regarding his worth, fatal for the art that it circumscribes by official proprieties and condemns to the most sterile mediocrity. The wisest thing for the State would be to abstain. The day it leaves us free, it will have fulfilled its duty to us.

Allow me then, Mr. Minister, to decline the honor you have wished to bestow on me. I am fifty years old and have lived always a free life. Let me end my existence free. When I am dead, I want it said of me, "He never belonged to any school, to any church, to any institution, to any academy, or, above all, to any regime other than that of liberty."

Please accept, Mr. Minister, with the expression of the feelings of which I have just informed you, my highest regards.

Gustave Courbet

IV

ART AND SOCIETY

The ideas that had prompted some artists to retreat from all institutional restraints in order to discover a more personal law in direct contact with nature moved some to consider their position as artists within a broad social context. For them it was not enough to talk of artistic values; they wished to see their art as an expression of, or possibly an advocate of, specific social values. Undirected empirical study or self-expression seemed insufficient, and they envisaged a broader context for art within a political or social community. They also sought to locate that community in what they came to regard as the progress of history.

Although earlier artists motivated by a strong sense of a revised Christianity had also spoken of community, this new group of artists and theorists looked to a human salvation whose source lay in the reform of social institutions rather than in the introspective activity of individuals. Their concern was not so much with a community of souls—although individual values were certainly not ignored—as with an interacting community of socially conscious citizens. Optimistic about the essential goodness of man—at least those men uncorrupted by vicious social institutions—they speculated about, and at times established, communities in which the individual might flourish as a creative being.

The French social theorist Saint-Simon (1760–1825) had recommended a society in which each man should be valued on the basis of his individual contribution to the whole, with no concern for his family inheritance or traditional position. Indeed, inheritance and private ownership were to be abolished as corruptive of both individual and social health. Although progressing from a Christian premise and advocating in his way the "community of souls," Saint-Simon tended to substitute social interaction for the universal theology of Wackenroder or Runge. Social interaction he defined as the relationship of man to man, not the relationship of individual to a centralized state or institution; the least government was thus the best government.

Although he finally concluded that society required an industrial basis to assure its well-being, industry was to be in the hands of society as a whole,

operated by those selected as most apt, and not controlled by a private few who had attained their position by birth or connivance.

In the first half of the nineteenth century such ideas found many responsive adherents among all classes, but especially among artists and intellectuals who particularly felt the need to be part of a social organism, yet felt excluded from competitive mercantile society. Many attempts were made in Europe and America to create alternative social structures in accordance with new social ideals. Beginning in the 1820s and extending well past mid-century, hundreds of communes were established—usually short-lived—in which agricultural workers, artisans, and intellectuals tried to live together in a new and productive harmony.

The Welsh manufacturer Robert Owen (1771–1858), who came to the United States in 1824 after having attained a notable success with a modified socialist organization of his factories in Lanark, Scotland, was responsible, directly or indirectly, for the formation of many experimental communities in America. The place of religion in such communities was much debated. Some organized around a religious principle, while others followed Owen's direction and sought a guiding and unifying mystique in the social organization itself. Owen's most important American community was established in 1825 at New Harmony, Indiana, on property originally developed by a German religious community. Although New Harmony's strict adherence to Owen's principles lasted only a few years, the experiment caught the imagination of many who dreamed of a new utopia.

In 1841 a group of New England intellectuals in sympathy with the writings of Emerson and fascinated with the idea of a new society, founded Brook Farm, an agrarian community of professional people in Massachusetts. This utopian effort, like many others, was not a prolonged success, but is a noteworthy example of the interest in carrying a new social theory into practice. The urge to form new artistic communities, in contrast to the academies and regulatory institutions, persisted throughout these same years. As Théophile Thoré pointed out, the attitude toward life and art expressed by the Barbizon painters in France was not without social implications, despite the protests of Millet.

As the century progressed, the tendency in both social and relevant artistic theory was becoming increasingly secular, in contrast to the outspokenly religious principles of earlier thinkers. Although medieval art, for example, had been heralded at the beginning of the nineteenth century as the embodiment of Christian piety and passion, by the 1830s and 1840s it was looked upon more as the product of a community in which each man was accorded his creative rights, as a symbol less of individual piety than of social justice. Few of the English Pre-Raphaelites of 1848 carried forward the mysticism and piety of the Lukasbund of 1810.

One of the most interesting and influential social theories to capture the imagination in Europe and America during the 1830s and 1840s was that of Charles Fourier (1772–1837). Fourier believed that, regardless of what Christianity taught, all of man's physical and psychological impulses were basically good and that society should be organized around them, instead of being set up to suppress them through its laws and agencies. His communes, "phalansteries," were to be organized in accordance with this belief. Work accomplished in accord with the harmony of the passions, he maintained, is akin to play, and life should be organized to afford pleasure, much as a work of art. Although Fourier spoke much of God and the Divine in this harmonious plan for man, whom he saw as being corrupted by the present organization of society, the Christian community at large was not pleased with his views on sex, the family, and the social equality of women. But his was the kind of society that some artists—society dubbed them bohemians—could readily understand.

The capacity to think of contemporary society in comprehensive universal terms was closely linked to a way of thinking also about history. Earlier cultures were delineated in terms of style and eventually in terms of social motivations and political organization. Thus one could speak of the past in a kind of symbolic way, each period standing for an attitude or way of thinking. More important, the past was newly seen as a series of "movements," activities leading in some way or other to the present. *Movement* became a popular term in the nineteenth century, referring to trends past or present, to call attention to that aspect of social action that moved toward change: workers' movements, political movements, and artistic movements—all suggested organization to provoke change. This view tacitly assumed history to be a form of progress; implicit within history is a design that humankind works out, even though a particular movement may at times be considered retrograde—as was the "aesthetic movement." From this idea of history as a complex of movements came such notions as progressive, retrograde, and reactionary, and with these distinctions a sense not only of historical destiny but also of historical duty.

The most powerful theories about history and its great design were those of the German philosopher Georg Wilhelm Friedrich Hegel (1770–1831), whose writings were widely read in many languages. Hegel maintained that history followed a predetermined course, working step by step toward the realization of human freedom. He saw in history a repeated pattern, a kind of cycle, that was each time more advanced, moving through a period of superstition and ritual to a state of rational equilibrium, then to a moment of subjective concerns and an emphasis on individual sensibilities. From Hegel's dialectical method and historical determinism, Karl Marx derived his operational scheme.

In England, the essays of Thomas Carlyle (1795–1881) had a great effect on the public's thinking about history as the book in which one might discover the

plan for human destiny. Each act, each ideological cause, could thus be justified or decried on the basis of its place in the context of a historical scheme.

Many theories less profound than Hegel's or less persuasive than Carlyle's saw the past as a progression of systematic social and cultural revolutions. Never before had theorists and their eager public been so conscious of their place in an evolving history. History was itself a kind of intellectual community.

If society, then, was a dynamic interplay of progressive and retrogressive forces that moved steadily onward, what was the place of the individual artist? Each of the writers represented here offers a somewhat different answer. All agree, however, that the artist cannot be allowed simply to go off in his own direction, following the dictates of his fancy. If he does not "belong" to his time he is in danger of being cast aside as chaff, or he may never have a chance to develop as a real artist at all. The most rigid conception of the artist's role in society was developed from Marx's theories. In the *Communist Manifesto* (1848), Marx did not address himself directly to art or to artists, but he made it clear that no one was exempt from social responsibility. The artist, like everyone else, must devote himself to reality, to the working out of society's goals. The reality to be attended to was a process, not a momentarily observable incident or visual fact, and the dynamic progress toward the new condition of man was the truth to be discerned. Ironically, from this point of view, reality depends less on events than on the context in which they are seen, and reality cannot be comprehended in the absence of firm knowledge of the contextual system.

The effect on artists of this abstract way of seeing history and society was not immediate, although through mid-century discussion ensued about the obligation of the artist to society, to serve it and express it. Art that did not explicitly serve a determined social purpose—and some artists deliberately ignored the social context—was dubbed "art for art's sake" and was considered by progressive critics as lying outside the path of cultural progress. With a greater consciousness of the new history, however, many artists began to see themselves and their activity in a new light. If one could look at the past and see artists as significant elements in society, helping to give it shape for posterity, the contemporary artist might then see his social responsibility as that of personifying his time. But before an artist could "express" his time he had to determine its nature in historical terms. What was the essential nature of the present? What was the direction in accord with the march of human progress? In these difficult questions the theories of Hippolyte Taine served many artists and critics alike, as they sought to determine their position and understand the obligation they wished to assume.

To the conservative mind, opposed in principle to the whole concept of systematic social change, radical changes in art, whether of subject matter or method, seemed allied with political and social radicalism. The "Macchiaiuoli" in Italy during the early 1860s and painters in France who insisted on painting

directly from rural nature were looked upon as destroyers of established standards and therefore as dangerous to the traditional fabric of society. Often these artists were thoughtlessly linked with those who would change their nation's social and political structure, even though they may have had little political interest. To destroy hierarchies in painting, Courbet came to realize, seemed analogous to the destruction of distinctions of social class, and he was pleased with the analogy, content to see his "Realism" rationalized by Proudhon as an element in the process of social change. He became a political symbol without knowing too much about the system he symbolized. In 1874, just three years after the short-lived Paris Commune, the group of independent painters who dared to mount a joint exhibition of their unconventional works in a photographer's studio, were considered dangerous revolutionaries. They were dubbed "Impressionists," and for some years the traditionally correct equated the term with rebellious waywardness. This reception was provoked not so much by a change in style as by the changing context in which art was seen. A threat to an established historical pattern was much the same whether it occurred in art or in politics.

For the various social theorists, the artist as genius plays little part, and many who would have provided art for all believed also in art created by all. In a properly organized society, according to Fourier, each person should be allowed to enjoy the sense of creativity entailed by his actions. A created object, then, attained value insofar as it manifested the creative devotion of its maker. A chair might evince as much moral character as a painting and, in the eyes of some critics who deplored the state of the arts, quite possibly a good deal more. By this standard, a sketchy painting was the sign not of great facility and genius, but of a want of energy and industry, just as a shoddy building was the symbol of a dissolute society. Implicit in such a belief are two assumptions upsetting to traditional values: that there is no hierarchy among classes of artistic objects, and that there is no hierarchy among artists or between artists and artisans, at least so far as levels of sophistication are concerned. An artist trained in the rhetoric of the Academy might have a less secure role in society than one who more clearly spoke the language "of his time" but had no traditional training.

William Morris, schooled in the ideas of Ruskin and wooed for some years by the ideal of a socialist society, founded his notions of social morality not on painting but on the crafts. He cast himself in the role of the honest craftsman, creating objects of beauty and use from natural materials for a noncompetitive society. If everyone were to see himself as a craftsman, enjoying the fruits of his own activity, taking pride in the discipline and perfection evident in his work, there would be little need for the artist as such. In Morris's perfect society, taste would so evolve that the creation and judgment of art would be elements in the life of all. The obligation of the artist was to teach society to take care of itself.

THÉOPHILE THORÉ

New Tendencies in Art (1857)

Thoré, whose review of the Salon of 1844 is discussed in Part III of this volume, went into exile in 1849, living first in Switzerland, then in England (1852), and finally in Belgium (1853). In Belgium, he began a new career as a scholar in the history of art, an interest manifested in this 1857 essay. "New Tendencies in Art" was doubtless prompted by artistic events in France, notably the scandalous success of Courbet at the Paris Universal Exposition of 1855. Thoré's essay was first published in Belgium, then later incorporated into *Salons de T. Thoré, 1844, 1845, 1846, 1847, 1848, avec une préface par W. Bürger* (Paris: Librairie Internationale, 1868), pp. xiii–xxix and xl–xliv. 🌿

I

The Universal Exposition of 1855 consecrated once and for all the great artists of the Romantic School.[1] The foremost talents, always contested before then, were decisively recognized by France and Europe. Pictorial Romanticism, like literary Romanticism, has triumphed in public opinion. Thus it is finished. Who has conquered has therefore lived. It is an inflexible law: *Vicit, ergo vixit.*

To conquer freedom of invention and style was to accomplish a great deal. But now that poetry and form, feelings and images, are set free, what will they do with their freedom?

Literary and pictorial Romanticism was only the preparatory instrument of

1. In 1855 Napoleon III organized this huge exhibition, patterned to a degree after the English "Crystal Palace" exhibition of 1851, which included a large and carefully selected international collection of painting and sculpture. Since the exposition was calculated as a bid for French supremacy in manufactury and the arts, the entire project had an official air. There were retrospective exhibitions of works by Ingres, Delacroix, and Horace Vernet. Courbet, offended because the jury would not hang some of the works he wished to show, erected his own pavilion near the exhibition grounds. (The catalogue preface by Courbet for this independent showing is reproduced in Part III of this volume.)—Ed.

Nadar (Félix Tournachon), *Théophile Thoré,* c. 1865, photograph.

a new, truly human art expressing a new society, for which the nineteenth century offers all the symptoms. One of the initiators of Romanticism sensed this when he coined the apt formula, eternally true: "For a new society, a new art."

There is now in France, and everywhere else, a singular restlessness, an irrepressible aspiration toward an essentially different life from that of the past. All the conditions of the older society have been upset: in empirical knowledge and religions (which are the epitome of empirical knowledge); in politics and social economy (which is applied politics); and in agriculture, industry, and commerce (which are the elements of social economy). Incomparable discoveries have given an unforeseen and unlimited extension to all ideas, all facts. Something like an invisible telegraph almost instantly transmits everywhere peoples' impressions, men's thoughts, events, and innovations of all kinds. The slightest moral or physical flutter based on any matter at all is handed on from person to person and is transmitted around the entire globe. Humanity is in the process of putting itself together, and soon it will be conscious of itself down to its fingertips.

The character of modern society—of future society—will be universality.

While formerly—yesterday—a people would shut itself up within the tight confines of its own territory, within its special traditions, its idolatrous creed, its egoistic laws, its shadowy prejudices and customs and language, today it tends to expand beyond its narrow limits, to open up its frontiers, to generalize its traditions and mythology, to humanize its laws and clarify conceptions, to expand its customs and diversify interests, and to spread its activity, language, and genius everywhere.

Such is the present propensity in Europe and even in other parts of the world. Beyond this characteristic trend, everything is only accident, ephemeral phenomenon, not worthy of figuring in the great scheme of civilization. This is all rather commonly admitted, or at least sensed. But what seems to be much less familiar, even to perceptive thinkers, is the transformation that these influences effect in poetry, literature, and the arts.

In what way will the character of the arts be forcibly modified by the social metempsychosis now taking place?

This aesthetic question is certainly one of great interest and above all of great importance for the future of poetry and the fine arts.

II

The last school of literature and art traveled willingly through the past, and one of its qualities was to resuscitate and restore forgotten or disfigured aspects of history—its own history.

Often, too, it ventured forth by instinct into space and undertook its trip

around the world . . . in the imagination. Out of habit, it was from a quiet corner at home that it invented the paintings of "foreign" life. From a kind of mirror, of which artists have the secret, it borrowed phantasmagoric reflections of the "strange" nature that flourishes under faraway skies.

It is true that one spoke of a certain poet who went to Palestine, of another on the banks of the Rhine, of one beyond the Alps or the Pyrenees. But no poet, no writer, found in his marvelous odysseys, true or imagined, the "local color" that Romanticism attempted to employ in its paintings.

The Frenchman, who almost never travels, travels badly. Since his language is spoken almost everywhere, he does not bother to know "foreign" languages, and for this reason, not communicating with the autochthonous population of the countries through which he travels, he learns little and mistakes a great deal.

It was to such "intellectual" excursions, rather than a direct and profound relationship with "foreign" genius, that all these able fantasists owed their success and even their glory.

This was true not only for letters, but also for philosophy, politics, and history.

Among the painters, mighty few had had the privilege of admiring "foreign" skies, but it was in these rare escapees that talent took on originality and force. I am not talking about the little monastic colony that buried itself in the catacombs of Rome. But it happened one day that an impassioned artist got the idea that he wanted to see the patrols and caravans, the schools and cafes of the East; another, in Algeria and Morocco, wanted to see the veiled women, Moors who dance, Arab horsemen, lions and panthers; another, in Switzerland, went to see the descent of the herds along a ravine; another . . . What adventurers!

Painters and writers, however, almost always retained under the regime of the past school, besides their French temperament—which is not a vice, but the contrary—their national, and thus limited, point of view, their French (that is to say, exclusive) prejudices, and their personal ideas.

But now that easy communication has put all people in contact with one another, there is already a generation of young men who know languages, who have studied far from their homeland the ancient Asiatic world and the new world of America. How can one remain enclosed in little systems of philosophy, religion, politics, literature, or art, in little cells, little symbols, little mythologies, when all religions, all institutions, all thought, and all forms interpenetrate when they encounter each other, modifying each other by reciprocal influence, alter all that which is too indigenous and emphasize the cosmopolitan and general; when creeds, formerly most hostile, fraternize together; when political revolutions have dispersed missionaries of all sentiments and all languages through all countries and brought them into agreement; when emigration of entire peoples, plunging into adventure, has become a chronic phe-

nomenon; when China is open to Europeans and when the Chinese themselves leave their homeland to invade western America; when the Indians and all the inhabitants of antique Asia come to visit European expositions at which all the world gets together? Oh! that is the end of the old stigmas of race, old local superstitions, old forms embalmed, by all the people in the shadow of their frontiers. There is but one race, and but one people; there is but one religion and but one symbol: Humanity!

III

The revolution in the making—the revolution that is taking place in poetry, in art and literature—thus directly concerns thought and by no means only form, style, manner, expression. For henceforth the plastic genius is free. Originality, individuality, have they not been conquered? Is not the ability of writers and artists extraordinary? Never have letters, the arts, the use of language, color, drawing, and form in general been practiced with more dexterity. Never has execution been more adroit. It is not in these points that progress is to be made today.

And if the revolution in the making is in the realm of thought, it is, in consequence, taking place as well in the subject matter of the arts. Astonishing, perhaps, but it is true. Having taken the risk of maintaining that subject matter was of indifferent importance in the arts, one needs to emphasize that it was just a simple protest against the importance asserted for heroic and consecrated subjects. Yes, perhaps the subject matter is not important—seeing that the human soul is interested in the artist's creation and man himself is the "hero."

Here, however, is how the changing of thought involves that of the subject.

The great movement that has been called the Renaissance was the daring to make figures in accordance with particular types instead of orthodox and invariable types.

In that sense, Romanticism followed the impulse to freedom given the imagination by the sixteenth century, although, in another sense, it reacted against the Renaissance, which resuscitated the Olympian gods, and, becoming resurrectionist in its turn, restored in particular the old style of the Middle Ages.

But if the Renaissance, and after it all the successive European schools for three centuries, stripped away from religious allegory its immobile form, they nonetheless preserved the basis. Christian art had been and continued to be a mythology, just as much as pagan art—a veritable hieroglyph enveloping thought in a symbolic form.

Thus, like the pagans who instead of making a woman made a Venus, the Christians made a Virgin. In the one allegory as in the other, Venus and Virgin

meant the perfect woman. And the supreme example of the feminine kind had for emblems among the pagans choirs of goddesses and nymphs, a graceful cortege for the mother of Love, and among the Christians choirs of saints and martyrs, a pious escort for the Mother of the Redeemer.

It was the same for all other ideas. Every idea was translated into a metaphoric personification. Wanting to create a fable of the tortures of genius, the ancients bound Prometheus to his Caucasus; Christians attached Christ to his cross. To show sovereign, initiating force, the ancients had thundering Jupiter, "the master of gods and men"; the Christians had the eternal Father, prime generator and supreme judge. For youth and poetic beauty, the one group glorified the harmonious Apollo, the other the mild Saint John, the well-loved disciple. And so for the rest.

And beneath these allegories that borrowed human form, the two mythologies borrowed equally from other living forms, whether it be the immaculate dove and the spotless lamb, or the conquering eagle and the voluptuous swan.

Vegetable and mineral systems as well brought their notes to this conventional and, up to a certain point, esoteric language.

Everything had been invaded by imaginary beings: paganism, which turned its attention to the domain of man here below, had peopled its forests with fauns and satyrs, its fountains with naiads, its seas with tritons and sirens; Christianity, looking toward the future abode of souls, had starred its heavens with angels and archangels, cherubim and seraphim, intermediaries between man and the Divine.

These singular creations could signify a great deal, and they stood, in effect, for a whole doctrine to the initiates of the ancient cult as they did to the faithful of the cult that followed it. But outside the circle of the adepts they were a closed book and a logogriph.

Our winged angels are for the Orientals what their winged chimeras are for us: more or less charming fantasies. Chinese would not be able to figure out what the lamb lying on the cross stands for, any more than we could make sense out of the dragons and fantastic monsters that flame forth on their architecture, their standards, their vases, and their silks. It is, however, the language of their beliefs, their science, their thought, and their life, and a résumé of their particular civilization. Here we call that plastic language *chinoiseries*. So be it. But how should they over there term the products of Western imagination?

The Renaissance, as well as the subsequent schools until now, did not at all break with the symbolism of the Middle Ages. The great men of the sixteenth century always employed the same idea, although in their individual ways. They used different metaphors, but on the same theme. It does not matter that Raphael took his Margareta to make a Madonna; it is basically the Catholic idea. Furthermore, they revived alongside their Christian fictions the fictions

of paganism. As pendant to his Madonnas, his Transfiguration, his Mass at Bolsena, his Archangels with rainbow wings, Raphael painted Apollos and Venuses, the School of Athens, and Parnassus, just as Titian painted his Venuses and Danaës as pendants to his Assumption of the Virgin and his Holy Family. And Michelangelo, da Vinci, Correggio, and all the others did the same as they.

It is between these two languages—these two arts—that all artistic and literary schools have alternated for three centuries. In effect, in our West there are only two forms, each of which expresses a partisan idea—Catholic allegory and pagan allegory—equally impenetrable for "foreigners" and even equally indifferent to the modern spirit of the people who still make use of them.

This is not what the art of the nineteenth century needs.

IV

But religious poetry, if you will, is naturally mystical since it translates more or less abstract dogmas. In every country, creeds have concretized ideas in an emblematic art that must often pass through the senses in order to penetrate to the spirit. Is it not by the eye, that "window of the soul," that light enters? Ancient Egypt and India are not behind the modern West. Each nation has its iconolatry, and savages have their idols. Only the societies produced by the Reformation no longer have such a thing.

Yes. Certainly our religious art—like all the others, moreover—expresses a partisan idea special to our West, incommunicable to other peoples who do not share our doctrines and superstitions. Let us leave that aside and examine other ideas which the arts have also translated in all times and which, apparently, are the objects of poetry just as are supernatural ideas. Do not the arts also represent historical traditions, the real life of peoples?

Very well, there too, in evoking history, art always employed a kind of mythology. There too, the language is fictional and involved. There is a whole series of personages licensed by the so-called competent authorities that one agrees to use to represent human qualities, just as earlier divine personifications were used to represent immaterial thoughts. It is a play, just as earlier it was a "mystery." Always disguise and masquerade. Is not Achilles courage; Ulysses, prudence; Ajax, furious boldness; Leonidus, patriotic devotion; old Brutus, stoic virtue; and so on? True symbols in a conventional alphabet for poets and artists, hieroglyphic characters that have recognized values like the words of a language, pretexts that cover and enclose a veiled meaning, sorts of shells that have to be cracked in order to get hold of the fruit inside—mannequins that simulate life.

After the gods, the demigods, the heroes.

Yes, this does still spring from fable, and to be understood requires a particular initiation to localities special to certain groups of people, foreign to others. Let us go on.

Well, after the more or less fabulous heroes, we still have the monarchs and princes who are in their turn the representatives of more or less recent history, just as the heroes stood for old traditions. Is that not still a fiction, a juggling of human nature?

Even more, in the representation of nature exterior to man, of the earth and its magnificence—in landscape—some ornaments borrowed from fables have almost always been added.

At the beginning of the Renaissance, landscape was hardly known as a specialty. When Titian painted that superb stretch of country in which he ensconced his Venus (no. 486 at the Louvre), when Correggio painted the grove in which his blond Antiope is lying, earth and sky were still considered dependencies and accessories of personages. The second generation of masters, too much praised until now, the Carracci, Albano, Domenichino, Guido, etc., began to subordinate figures to exterior nature. The genre of landscape painting was born and detached from the great poetic bundle, but still on the condition that it be illustrated with charming mythologies.

It was not at all the vulgar landscape of contemporary Italy that one painted: it was imaginary and apocryphal Greece, with Apollos, Daphnes, Dianas and Actaeons, Herculeses and Achelouses, Adonises and Narcissuses.

After the Romans and the Bolognese, Poussin, the noble Poussin, invented—in Rome—landscapes of India (Bacchus), Egypt (Moses), Athens (Diogenes), etc., Bacchanalia and Arcadias. His friend, the great lover of the sun, Claude Lorrain, not content with the splendid light he made radiate across the earth, had to insert or have inserted in his delicate landscapes Ulysses or Cleopatra. The sun could not set in peace without an Aeneas in the foreground.

This antedate of nature, if one might call it that, is singular, yet, except for some caprices by the Neapolitans and Spaniards, and certain factions of the northern school, of which we shall speak later, it has been perpetuated down to our own time, even to the new landscape school that is the glory of France.

Thus, to represent ideas one represented gods; for faculties, heroes; for happenings, princes; and to represent nature itself, one continued to allegorize as to place and time by a stereotype veneer of mythic figures.

There you have the invariable subjects, in spite of their variety of expression, adopted by the average poet and painter up to the present.

Anyone can prove the point for himself by analyzing the works of the masters from this point of view, either in museums or in books.

All these observations about painting apply just as well to sculpture. In sculpture this examination would be still more revealing. Always the same two

molds, from the *Moses* and *Bacchus* of Michelangelo, the *Diana* and *Christ at the Tomb* of Jean Goujon, the *Milo* and *Andromeda* of Puget, the *Magdalene* and *Psyche* of Canova, to the *Psyche* of Pradier, the *Spartacus* of Foyatier, the *Minerva* of Simart, the *Epaminondus* of David d'Angers, the *Gracus* of Cavalier, and all symbolic subjects that encumber contemporary exhibitions.

And on architecture, what could not be said of its anachronism and pastiches, or of its absolute insignificance! But we have here at hand the catalogue (van Hasselt) of the immense work produced by one of the first geniuses of painting. There are 1,461 subjects! What subjects? It is curious.

We have 565 subjects borrowed from the Christian tradition; 295 from pagan fable and allegory; only 74 from history (history of heroes and princes, it is understood, from Romulus to the Archduke Albert); 277 portraits, almost all—except those of the painter himself (15), his wives (5 of Isabel, 17 of Helen), and some friends (van Dyck, Bruegel, Snyders)—almost all portraits of heroes or princes; 66 landscapes, most of them enriched with pagan or Catholic subjects; finally, 46 "familiar and imaginative subjects," among which works are still classified as portraits, Gardens of Love, Roman warriors, and studies. There remain perhaps a dozen paintings in which this fierce *naturalist*, as one likes to call Rubens, painted "man for man," outside of mythologies and allegories, heroes and princes.

The older society, then, must have been absolutely theocratic and oligarchic! But where, then, is society represented—social society—scientific and industrial, intelligent and industrious?

Where is man?

V

Man did not exist in the art of the past—of yesterday; and it remains yet to invent him.

Almost never has man, in his simple quality as man, been the direct subject of painting and the other plastic arts, not even literature—for these two poetic schools always follow each other in parallel and constitute only one.

Doubtless there were exceptions, and these are the greatest among the great whose genius painted human nature without the prestige of religious and poetic fictions. In this they bear their true mark of immortality.

It will be to the eternal glory of Rabelais, Molière, Shakespeare, Cervantes, and some other rare authors to have created men, men with their own names, as worthy of admiration as the heroes "dear to the muses." Panurge is well worth a Thersites; Othello, the furious Orestes; Don Quixote, the invincible Achilles; the worthy Arnolphe running after his Agnes is no less interesting than the husband of the perfidious Helen under the walls of Troy.

Peter Paul Rubens, *Drunken Silenus Supported by Satyrs,* oil on canvas.

It even happened, about that same time, that a mischievous genius, not having the right, according to poetic orthodoxy, to take men for use in his scenes, and not wanting to compromise his art with heroes, took animals and had them speak with as much spirit as princes: La Fontaine.

The novel also, almost from its birth, risked some very audacious behavior, and the extraordinary emotion caused by the *Nouvelle Héloïse* of Jean-Jacques is well known, a novel that undertook to affect the public with a "heroine" who, although still noble, was of a race that had no tie with Jupiter, Caesar, or Louis XIV.

Similarly for the theater, that bold eighteenth century, which tried everything, ventured with Diderot into the field of vulgar drama in reaction to heroic tragedy.

And in our days, after a rather long diversion, some playwrights and novelists, Balzac and George Sand among others, will owe their principal titles for the future to this renovating tendency.

In painting, the exceptions to heroic fury have been no more common than in letters.

The ancient Latin race has always been, quite naturally, reluctant to sacrifice

its traditional mummies. What a scandal in Italy when Caravaggio and his companions, including the Frenchman Valentin, decided to paint life-size pictures of rude adventurers like themselves, well-armed and decked with plumes, very content to exist in the world! Along with them, the Spaniard Ribera and, after him, his pupil Salvadore also became fond of similar subjects and occasionally depicted the "common man," with a grandiose vigor and terrible truth. Even these violent "naturalists" expressed better the wrinkles of the skin or the fripperies of costume than depth of feeling or character.

In Spain, alongside of possibly the most mystical art that ever existed, in Spain, that country of extreme contrasts, the painter of Philip IV, the splendid Velázquez, royally painted drinkers and bohemians, life-size! And after him, the painter of ecstasies and vaporous apparitions, the suave Murillo, gave life also to mendicants and illuminated with his warm colors simple mortals laughing in the cup or biting the grape.

Among the French, there was one moment when the Lenain brothers, sort of misplaced Spaniards, represented peasants and workers with a naive gravity that achieved a level of style, but in small size. It was a good way to be little noticed during the reign of the emphatic Lebrun. Thus almost nothing is known concerning the biography of these singular masters.

In the eighteenth century, Watteau, Chardin, Greuze, even Boucher and Fragonard painted some domestic, pastoral, and peasant subjects, boudoir scenes and conversations, family and household scenes. They were always small; life-size was reserved for Venus or Pompadour. . . .

VIII

. . . Do you think that the common people in France have ever been very interested in Marot and Ronsard, Boileau and Racine, Lamartine and Hugo among writers, in Poussin and Lesueur, in Watteau and Boucher, in Delacroix or Ingres among painters? Purely amusement for the refined sorts, among which we must count ourselves, alas.

It has been justly said that arts and letters have always been the true nobility of France. Nobility, in truth, which has never lowered itself to mix with the plebeian life of the uneducated. But it is just this demarcation of intellectual classes that is unjust, that must be wiped out.

And when, following the expression of Edgar Quinet, "the fictitious formulas having given way to spontaneous accent,"[2] everyone will be initiated into the language of the arts, expressing human and consequently general con-

2. Edgar Quinet (1803–1875), French author of historical works such as *Les Révolutions d'Italie* (1848) and *Du génie des réligions* (1842).—Ed.

Gustave Courbet, *Les Paysans de Flagey, Revenant de la Faire*, 1850, oil on canvas.

ceptions, then doubtless new allegories will be formed on the basis of thoughts held in common, for allegory itself, we freely admit, is as immortal as poetry, its mother. All art, like all language, no matter how universal, is based on group rapport. There is no word or image that does not of necessity move in usage from what is at first a special and concrete meaning to an analogous harmony, more or less collective and abstract. Without this there would have to be as many words and images as there are ideas in the head of man and different objects in nature, that is to say, an infinity.

But the veils of these unforeseen metaphors and fables, fathered by the reciprocal agreement of all minds, can be lifted by everyone.

There is no danger in imprisoning an idea in hieroglyphs when everyone, having the keys, can liberate it.

Voltaire, who once wrote, "Fables are only the history of gross epochs," wrote elsewhere, "Is not a fiction that presents interesting and *new* truths a fine thing?"

Assuredly. Literary and pictorial metaphor is a fine rhetorical mask; but it is still important to know what is underneath.

IX

If form alone were of importance in art, once a certain plastic perfection was attained by a certain people to express a particular idea—and that has been seen several times, as in Greece, at the time of Phidias and Apelles, for example, or in Italy at the time of Michelangelo and Raphael—there would be nothing left for posterity to do, nothing but admire and imitate.

So superficial minds that never penetrate to the essence of things, short-sighted intellects who never can conceive of the future—looking back at images realized with such perfection and never imagining that a similar or even superior perfection might be achieved through the invention of a quite different line of thought—set up the standards of art and beauty, some based on Greek antiquity, others on the Italian Renaissance, some even on the Middle Ages.

But truly there is no single standard in art, any more than there is in nature.

What is the standard of the beautiful landscape? The scorched countryside of the tropics or the frozen countryside of the North? Italy or Scotland? Do you prefer the sea or the mountains? Spring or autumn? Calm or tempest?

What is the most beautiful type in the human race? The Greek type or the Roman type? The Arab type or the English type? Or possibly the Parisian type?

Phrenologists are often asked, What really is the most perfect type of cerebral organization? Show me a head in which everything is "just right"!

But Raphael, who is a painter; Richelieu, a politician; Molière, a poet; Newton, a scholar; Beethoven, a musician; Watt, a mechanic—do you not find them "just right" as they are, each in his own field? One is a painter, the other a poet, this one a scholar, that one a politician: they are just right because they are different. If they all resembled each other, and others resembled them as a common type, one man could stand for everyone. There would no longer be either humanity or society; there would no longer be art, science, thought, action, or anything. A god all alone. Nothing.

To search for a standard type in art is absurd. How can one believe that the future lies behind us!

Art is incessantly and limitlessly changeable and perfectable, like all manifestations of man, like everything that lives in the bosom of the universe.

Why, then, were not Michelangelo and Raphael distraught coming after Phidias and Apelles? And how did they rise in poetry as high as the inimitable Greeks?

By not imitating them.

They followed a different line of thought, different from the thinking of antiquity, and they expressed it with the help of faculties that obviously are not the privilege of only one people or of only one civilization, but that constitute the indefectible genius of humankind.

And why would subsequent centuries not produce artists as great as Raphael and Michelangelo? There is nothing to stop them, if they subscribe to the same condition that permitted the Italians to equal the Greeks: the condition that they not imitate the Renaissance but create on the basis of another idea, expressing another civilization.

Without this, all is done for.

Thought alone creates true revolutions. To change form is pure fantasy, and anyone can contribute with the tip of his pen or the tip of his brush. But to change the basis—that is not lightly accomplished. No one man, not even several, can take responsibility for changing art at its very roots, any more than for changing the internal constitution of a society.

Art will be transformed only if, effectively, the universal spirit changes. Is it changing? It will!

HIPPOLYTE TAINE

The Philosophy of Art (1865)

Hippolyte-Adolphe Taine (1828–1893) was a philosopher and historian who wrote on many subjects: English literature, French society, and various topics in philosophy. He taught at the Sorbonne in Paris and at Oxford, and gave a famous course of lectures at the École des Beaux-Arts. Writing and lecturing in clear, readily understood language, he had a wide following in the world of arts and letters.

In a very practical way he brought to bear on the study of the arts the abstract concepts of society and social change developed earlier in the century, thus making what had been a language of form into a language of culture. He taught that art could be understood or judged only in terms of its time, which one needed to study objectively. Whether art sprang from divine inspiration or not, its realization was dependent on the interaction of genius, society, and the historical moment. To talk about the artist in isolation was, for Taine, simple foolishness. Although he considered artistic values to be relative, he was not beyond indicating his preferences. For Taine the highest qualities in art were not determined by any eternal aesthetic standards, but by how well the work embodied the goals of its time: a great work of art answers a need posed by the artist's epoch, which the historian must study in order to evaluate the work. One might call this a "historical aesthetic," an aesthetic satisfaction derived from the recognition and fulfillment of the study of history.

Taine's influence on the art world was of two kinds. First, his approach restored meaning to areas of art that had been neglected or made trivial by superficial study, thereby opening up new and fruitful avenues of investigation. He did not originate but made popular the application of documentary study to an understanding of art. Second, and of more importance, he imparted to artists a new context in which to view their undertaking. Art did not spring from caprice or personal impulse, but from the convergence of race, environment, and the moment in time; the artist was more than an individual: he was the embodiment of his time.

The *Lectures on Art* were originally published in 1865. The following selections are taken from H. Taine, *Lectures on Art*, first series, translated by John Durand (New York: Henry Holt and Co., 1875), pp. 87–105 and 147–65.

Part II. On the Production of the Work of Art

I

Having investigated the nature of the work of art, there now remains a study of the law of its production. This law, in general terms, may be thus expressed:— *A work of art is determined by an aggregate which is the general state of the mind and surrounding circumstances.* I have stated this principle in the foregoing section, and have now to establish it.

This law rests on two kinds of proof: the one that of experience, and the other that of reason. The former consists of an enumeration of the many instances in which the law verifies itself. Some of these I have already presented to you, and others will soon follow. One may assert, moreover, that no case is known to which the law is not applicable; it is strictly so to those hitherto examined, and not merely in a general way, but in detail; not only to the growth and extinction of great schools, but again to all the variations and oscillations to which art is subject. The second order of proof consists in showing this dependence to be not only rigorous in point of fact, but, again, that it is so through necessity. We will accordingly analyze what we have called the general state of the mind and surrounding circumstances; we shall seek, according to the ordinary standard of human nature the effects which a like state must produce on the public, on artists, and consequently on works of art. Hence we draw a forced connection and a definite concordance, and we establish a necessary harmony which we had observed as simply fortuitous. The second proof *demonstrates* what the first had averred.

II

In order to make this harmony apparent let us resume a comparison already of service to us, that between a plant and a work of art, and note the circumstances in which a plant, or a species of plant, say the orange, may be developed and propagated in a certain soil. Let us suppose all kinds of grain and seed borne by the wind and sown at random; on what condition can those of the orange germinate, become trees, blossom, yield fruit, spread, and cover the ground with a numerous family?

Many favorable circumstances are essential to this end. And at first the soil must be neither too light nor too meagre; otherwise, the roots lacking depth and grasp, the tree would fall at the first gale of wind. Next, the soil must not be too dry; otherwise the tree will wither where it stands, deprived of the moisture of springs and streams. Moreover, the climate must be warm or the tree, which is delicate, will freeze, or at least droop, and never put forth sprouts; the summer must be long, in order that the fruit, which is slow in ripening, may fully mature; and the winter mild, so that January frosts may not

blast or shrivel the oranges that remain green on its branches. Finally, the soil must not be too favorable for other plants, lest the tree, left to itself, might be stifled by the competition and infringement of a more vigorous vegetation. When all these conditions concur, the little orange will grow, become mature, and produce others again to reproduce themselves. Storms will undoubtedly occur, stones fall, and browsing goats will destroy certain plants; but on the whole, in spite of accidents which kill individuals, the species will be propagated, cover the ground, and in a few years display a flourishing grove of orange trees. All this is to be seen in the admirably sheltered gorges of Southern Italy, in the environs of Sorrento and Amalfi, on the shores of the gulfs, and in the small, watered valleys, freshened by streams descending from the mountains, and caressed by the beneficent breezes of the sea. This concourse of circumstances was necessary in order to produce those beautiful round tops, those lustrous domes of a bright deep green, those innumerable golden apples, and that exquisite fragrant vegetation which, in mid-winter, makes this coast the richest and loveliest of gardens.

Let us now reflect on the manner in which things moved in this example. We have just observed the effect of circumstances and of physical temperature. Strictly speaking, these have not produced the orange; the seeds were given, and these alone contained the vital force. The circumstances described, however, were necessary in order that the plant might flourish and be propagated; had these failed, the plant likewise would have failed.

Accordingly, let the temperature be different, and the species of plant will be different. Suppose conditions entirely opposite to those just mentioned; take the summit of a mountain swept by violent winds, with a thin scanty soil a cold climate, a short summer, and snow during the winter; not only will the orange not thrive here, but the greater part of other trees will perish. Of all the seeds scattered haphazard by the wind only one will survive, and you will see but one species to endure and be propagated, the only one adapted to these severe conditions; the fir and the pine will cover the lonely crags, the abrupt precipices, and long, rocky ridges, with their stiff colonnades of tall trunks and vast mantles of sombre green, and there, as in the Vosges, in Scotland and in Norway, you may travel league after league, under silent arches, on a carpet of crisp leaves, among gnarled roots obstinately clinging to the rocks, the domain of the patient, energetic plant which alone subsists under the incessant attacks of gales, and the hoar-frosts of long winters.

We may accordingly regard temperature and physical circumstances as *making a choice* amongst various species of trees, allowing a certain species to subsist and propagate, to the exclusion, more or less complete, of all others. Physical temperature acts by elimination and suppression, in other words, by *natural selection*. Such is the great law by which we now explain the origin and struc-

ture of diverse existing organisms—a law as applicable to moral as to physical conditions, to history as well as to botany and zoölogy, to genius and to character, as well as to plant and to animal.

In short, there is a *moral* temperature, consisting of the general state of minds and manners, which acts in the same way as the other. Properly speaking, this temperature does not produce artists; talent and genius are gifts like seeds; what I mean to say is, that the same country at different epochs probably contains about the same number of men of talent, and of men of mediocrity. We know, in fact, through statistics, that in two successive generations nearly the same number of men are found of the requisite stature for the conscription and the same number of men too small for soldiers. In all probability, it is with minds as with bodies. Nature is a sower of men, and putting her hand constantly in the same sack, distributes nearly the same quantity, the same quality, the same proportion of seed. But in these handfuls of seed which she scatters as she strides over time and space, not all germinate. A certain moral temperature is necessary to develop certain talents; if this is wanting, these prove abortive. Consequently, as the temperature changes, so will the species of talent change; if it becomes reversed, talent will become reversed, and, in general, we may conceive moral temperature as *making a selection* among different species of talent, allowing only this or that species to develop, to the exclusion more or less complete of others. It is through some such mechanism that you see developed in schools at certain times and in certain countries the sentiment of the ideal, that of the real, that of drawing and that of color. There is a prevailing tendency which constitutes the spirit of the age. Talent seeking to force an outlet in another direction, finds it closed; and the force of the public mind and surrounding habits repress and lead it astray, by imposing on it a fixed growth.

III

The foregoing comparison may serve you as a general indication; let us now enter into the details and study the action of the moral temperature on works of art.

For the sake of greater clearness we will take a very simple case, that of a certain mental condition, in which melancholy predominates. This supposition is not arbitrary, for such a condition has frequently occurred in the life of humanity: five or six centuries of decadence, depopulation, foreign invasion, famine, pests, and aggravated misery, are amply sufficient to produce it. Asia experienced such a state of things in the sixth century before Christ, and Europe in the period of the first ten centuries of our own era. In times like these men lose both courage and hope, and regard life as a burden.

Let us contemplate the effect of such a mental condition, together with the

circumstances which engender it, on the artists of an epoch like this. We admit that nearly the same number of melancholy and joyous temperaments, as well as a mixture of both, are met in this as at other times; how and in what sense does the prevailing situation effect their transformation?

It must be borne in mind that the misfortunes that afflict the public also afflict the artist; he is one of the flock, and he suffers as the rest suffer. For example, if invasions of barbarians occur, and pests, famines, and calamities of all sorts prolonged for centuries and spread over the entire country; not only one, but countless miracles, would be necessary to save him harmless in the general inundation. On the contrary, it is probable, and even certain, that he will have his share of public misfortune; that he will be ruined, beaten, wounded, and led into captivity like others; that his wife, children, relatives and friends will share the common fate, and that he will suffer and be subject to fears on their account, as well as on his own. During this long-continued flood of personal misery he will, if he is gay, become less gay, and, if melancholy, still more melancholy. This is the first effect of his social medium.

On the other hand, if the artist is raised among melancholy companions, the ideas he receives in infancy, with those acquired afterwards, are melancholy. The dominant religion, accommodating itself to the lugubrious order of things, teaches him that the earth is a place of exile, the world a prison-house, life an evil, and that all that concerns him is to deserve to get out of it. Philosophy, forming its mortality according to the lamentable spectacle of man's degeneracy, proves to him that it would have been better for him not to have been born. Ordinary conversation teems with only mournful events, the invasion of a province, the destruction of some monument, the oppression of the weak, and civil wars among the strong. Daily observation reveals to him only images of discouragement and grief, beggars, and cases of starvation, a bridge left to decay, abandoned, crumbling houses, fields going to waste, and the black walls of dwellings ravaged by fire. All these impressions sink deep in his mind from the first year of his life to the last, incessantly aggravating whatever melancholy sentiment arises out of his own misfortunes.

They aggravate him so much the more proportionately to the intensity of his artistic feeling. What makes him an artist is the practice of imitating the essential character of things, the salient points of objects; other men only see portions, while he sees the whole and the spirit of them. And as in this case the salient characteristic is melancholy, he accordingly perceives nothing else. Moreover, through this excess of imagination and this instinct of exaggeration peculiar to artists, he amplifies and expands it to the utmost; he becomes impregnated with it, and charges his work with it, so that he commonly sees and paints things in much darker colors than would be employed by his contemporaries.

It must be added also that he finds them of great assistance to him in his

work. You know that a man who paints or writes remains not alone face to face with his canvas or his writing-desk. On the contrary, he goes out and talks to people and looks about him; he listens to the hints of his friends or rivals, and seeks suggestions in books and from surrounding works of art. An idea resembles a seed: if the seed requires, in order to germinate, develop and bloom, the nourishment which water, air, sun and soil afford it, the idea, in order to complete and shape itself into form, requires to be supplemented and aided by other minds. Accordingly, in these epochs of melancholy, what sort of suggestions are other minds capable of furnishing? Only melancholy ones, for only on this side do men labor. As their experience provides them only with painful sensations and sentiments, they can only note the shades of difference, and record discoveries made on the path of suffering: the heart is the only field of observation, and if this is filled with sorrow, sorrow is all that men contemplate. They are, therefore, conscious only of grief, dejection, chagrin and despair. If the artist demands instruction of them this is all the return they can make. To seek in them any idea or any information on the different kinds or different expressions of joy would be labor lost; they can only furnish what they possess. For this reason let him attempt to portray happiness, cheerfulness, or gayety, and he stands alone, deprived of all support, left to his own resources, and which in an isolated man amounts to nothing. His labor will likewise be stamped with mediocrity. On the other hand, when he would paint melancholy sentiments his century would come to his aid. He finds materials prepared for him by preceding schools; he finds a ready-made art, consisting of known processes and a beaten track. A church ceremony, a piece of furniture, a conversation, suggests to him a form, a color, a phrase, or a character still unknown to him; his work, to which millions of unknown co-laborers have contributed, is all the more beautiful, because, in addition to his own labor and his own genius, it embodies the labor and genius of surrounding society, and of generations that have gone before it.

There is still another reason, and the strongest of all, which draws him to melancholy subjects; it is that his work, once exposed to the public eye, finds appreciation only as it expresses melancholy ideas. Men, indeed, can only comprehend sentiments analogous to those they have themselves experienced. Other sentiments, no matter how powerfully expressed, do not affect them; they look with their eyes, but the heart is dormant and directly their eyes are averted. Imagine a man losing his fortune, country, children, health and liberty, one manacled in a dungeon for twenty years, like Pellico or Andryane, whose spirit by degrees is changed and broken, and who becomes melancholy and a mystic, and whose discouragement is incurable; such a man entertains a horror of cheerful music, and has no disposition to read Rabelais; if you place him before the merry brutes of Rubens, he will turn aside and place himself before the canvases of Rembrandt; he will enjoy only the music of Chopin and the

poetry of Lamartine or Heine. The same thing happens to the public and to individuals; their taste depends on their situation; their sadness gives them a taste for melancholy works; cheerful productions are accordingly repudiated, and the artist is censured or neglected. Now an artist composes mostly in order to obtain appreciation and applause; this is his ruling passion. Hence, therefore, besides other causes, his ruling passion, added to the pressure of public opinion, leads him, pushes him, and constantly brings him back to the expression of melancholy, and barring the ways to him which would lead him to the portrayal of gayety and happiness.

Through this series of obstacles every passage would be closed for works of art manifesting joy. If an artist overcomes one obstacle, he is arrested by others. If he meets with joyous natures he will be saddened by their personal misfortunes. Education and current conversation fill their minds with gloomy ideas. The artists' faculties by which they detach and amplify the leading traits of objects, will find for their exercise none but melancholy ones. The experience and labor of others provide them with suggestions and are co-operative only in melancholy subjects. Finally, the earnest and decisive will of the public allows them to produce only melancholy subjects. Consequently, the class of artists and their works suitable for the expression of gayety and joyousness disappear, or end by becoming reduced to almost nothing.

Consider, now, the opposite case, that of a general condition of cheerfulness. That occurs in renaissance epochs, when order, wealth, population, comfort, prosperity, and useful and beautiful discoveries are constantly increasing. By reversing its terms the analysis we have just made is applicable word for word; the same process of reasoning proves that the works of art of such a period will all, more or less, express a joyous character.

Consider, now, an intermediary case, that is to say, a commingling of this or that phase of joy or sadness, which is the ordinary condition of things. By a proper modification of terms, the analysis is equally pertinent; the same reasoning demonstrates that works of art express corresponding combinations, and a corresponding species of joy and melancholy.

Let us conclude, therefore, that in every simple or complex state, the social medium, that is to say, the general state of mind and manners, determines the species of works of art in suffering only those which are in harmony with it, and in suppressing other species, through a series of obstacles interposed, and a series of attacks renewed, at every step of their development.

IV

Let us now leave supposed cases, simplified to give clearness to the exposition, and take up real ones. You will see in glancing at the most important of a historical series, a verification of the law. I will select four which are the four

great cycles of European civilization—Greek and Roman antiquity, the feudal and Christian middle ages, the well-regulated aristocratic monarchies of the seventeenth century, and the industrial democracies of the present day, directed by the sciences. Each of these periods has its own art, or some department of art peculiar to it, either sculpture, architecture, the drama or music, or some determined phase of each of these great arts; in every case a distinct, singularly rich and complete vegetation, which, in its leading features, reflects the principal traits of the art and the nation. Let us, accordingly, consider in turn the different soils, and we shall see that all produce different flowers. . . .

VIII

This brilliant society [France in the seventeenth and eighteenth centuries] did not last; it was its own development which caused its dissolution. The government being absolute, ended in becoming negligent and tyrannical; and, besides this, the king bestowed the best offices and the greatest favor only on such of the nobles of his court as enjoyed his intimacy. This appeared unjust to the *bourgeoisie* and to the people, who, having greatly increased in numbers, wealth and intelligence, felt their power augment in proportion to the growth of their discontent. The French Revolution was accordingly their work; and after ten years of trial they established a system of democracy and equality, in which, according to a fixed order of promotion, all civil employments were ordinarily accessible to everybody. The wars of the empire and the contagion of example gradually spread this system beyond the frontiers of France, and whatever may be local differences and temporary delays, it is now evident that the tendency of the whole of Europe is to imitate it. The new construction of society, coupled with the invention of industrial machinery, and the great abatement of rudeness in manners and customs, has changed the condition as well as the character of man. Henceforth, man is exempt from arbitrary measures, and is protected by a good police. However lowly born, all careers are open to him; an enormous increase of useful articles places within reach of the poorest conveniences and pleasures of which, two centuries ago, the rich were entirely ignorant. Again, the rigor of authority is mitigated, both in society and in the family; a father is now the companion of his children, and the citizen has become the equal of the noble. Human life, in short, displays a lesser degree of misery, and a lighter degree of oppression.

But, as a counterpart of this, we see ambition and cupidity spreading their wings. Accustomed to comfort and luxuries, and obtaining here and there glimpses of happiness, man begins to regard happiness and comfort as his due. The more he obtains, the more exacting he becomes, and the more his pretensions exceed his acquisitions. The practical sciences also having made great progress, and instruction being diffused, liberated thought abandons itself to

all daring enterprises; hence it happens that men, relinquishing the traditions which formerly regulated their beliefs, deem themselves capable, through intellect alone, of attaining to the highest truths. Questions of every kind are mooted, moral, political and religious; men seek knowledge by groping their way in every direction. For fifty years past we behold this strange conflict of systems and sects, each tendering us new creeds and perfect theories of happiness.

Such a state of things has a wonderful effect on minds and ideas. The representative man, that is to say, the character who occupies the stage, and to whom the spectators award the most interest and sympathy, is the melancholy, ambitious dreamer—Réné, Faust, Werther and Manfred[1]—a yearning heart, restless, wandering and incurably miserable. And he is miserable for two reasons. In the first place he is over-sensitive, too easily affected by the lesser evils of life; he has too great a craving for delicate and blissful sensations; he is too much accustomed to comfort; he has not had the semi-feudal and semi-rustic education of our ancestors; he has not been roughly handled by his father, whipped at college, obliged to maintain respectful silence in the presence of great personages, and had his mental growth retarded by domestic discipline; he has not been compelled, as in ancient times, to use his own arm and sword to protect himself, to travel on horseback, and to sleep in disagreeable lodgings. In the soft atmosphere of modern comfort and of sedentary habits, he has become delicate, nervous, excitable, and less capable of accommodating himself to the course of life which always exacts effort and imposes trouble.

On the other hand, he is skeptical. Society and religion both being disturbed—in the midst of a pêle-mêle of doctrines and an irruption of new theories—his precocious judgment, too rapidly instructed, and too soon unbridled, precipitates him early and blindly off the beaten track made smooth for his fathers by habit, and which they have trodden, led on by tradition and governed by authority. All the barriers which served as guides to minds having fallen, he rushes forward into the vast, confusing field which is opened out before his eyes; impelled by almost superhuman ambition and curiosity he darts off in the pursuit of absolute truth and infinite happiness. Neither love, glory, knowledge nor power, as we find these in this world, can satisfy him; the intemperance of his desires, irritated by the incompleteness of his conquests and by the nothingness of his enjoyments, leaves him prostrate amid the ruins of his own nature, without his jaded, enfeebled, impotent imagination being able to represent to him the *beyond* which he covets, and the unknown *what* which he

1. *René,* a novel by Chateaubriand (1807); Faust, hero of Thomas Marlowe's sixteenth-century *Tragedy of Dr. Faustus,* as well as of Goethe's *Faust;* Werther, hero of Goethe's *Sorrows of Young Werther* (1774); and Manfred, protagonist of Byron's poem of this same title (1817).—Ed.

has not. This evil has been styled the great malady of the age. Forty years ago it was in full force, and under the apparent frigidity or gloomy impassibility of the positive mind of the present day it still subsists.

I have not the time to show you the innumerable effects of a like state of mind on works of art. You may trace them in the great development of the lyrical, sentimental and philosophical poetry of France, Germany and England; again, in the corruption and enrichment of language and in the invention of new classes and of new characters in literature; in the style and sentiments of all the great modern writers, from Chateaubriand to Balzac, from Goethe to Heine, from Cowper to Byron, and from Alfieri to Leopardi. You will find analogous symptoms in the arts of design if you will observe their feverish, tortured and painfully archeological style, their aim at dramatic effect, psychological expression, and local fidelity; if you observe the confusion which has befogged the schools and injured their processes; if you pay attention to the countless gifted minds who, shaken by new emotions, have opened out new ways; if you analyze the profound sympathy for scenery which has given birth to a complete and original landscape art. But there is another art, Music, which has suddenly reached an extraordinary development. This development is one of the salient characteristics of our epoch, and the dependence of this on the modern mind, the ties by which they are connected, I shall endeavor to point out to you.

This art was born, and necessarily, in two countries where people sing naturally, Italy and Germany. It was gestating for a century and a half in Italy, from Palestrina to Pergolese, as formerly painting from Giotto to Massaccio, discovering processes and feeling its way in order to acquire its resources. At the commencement of the eighteenth century it suddenly burst forth, with Scarlatti, Marcello and Handel. This is a most remarkable epoch. Painting at this time ceased to flourish in Italy, and in the midst of political stagnation, voluptuous, effeminate customs prevailed, furnishing an assembly of sigisbés, Lindors and amorous ladies for the roulades and tender sentimental scenes of the opera. Grave, ponderous Germany, at that time the latest in acquiring self-consciousness, now succeeds in displaying the severity and grandeur of its religious sentiment, its profound knowledge, and its vague melancholy instincts in the sacred music of Sebastian Bach, anticipating the evangelical epic of Klopstock. In the old and in the new nation the reign and expression of *sentiment* is beginning. Between the two, half-Germanic and half-Italian, is Austria, conciliating the two spirits, producing Haydn, Gluck and Mozart. Music now becomes cosmopolite and universal on the confines of that great mental convulsion of souls styled the French Revolution, as formerly painting under the impulse of the great intellectual revival known under the name of the Renaissance. We need not be astonished at the appearance of this new art, for it corre-

sponds to the appearance of a new genius—that of the ruling, morbid, restless, ardent character I have attempted to portray for you. It is to this spirit that Beethoven, Mendelssohn and Weber formerly addressed themselves, and to which Meyerbeer, Berlioz and Verdi are now striving to accommodate themselves.

Music is the organ of this over-refined excessive sensibility and vague boundless aspiration; it is expressly designed for this service, and no art so well performs its task. And this is so because, on the one hand, music is founded on a more or less remote imitation of a cry which is the natural, spontaneous, complete expression of passion, and which, affecting us through a corporeal stimulus, instantly arouses involuntary sympathy, so that the tremulous delicacy of every nervous being finds in it its impulse, its echo, and its ministrant. On the other hand, founded on relationships of sounds which represent no living form, and which, especially in instrumental music, seem to be the reveries of an incorporeal soul, it is better adapted than any other art to express floating thoughts, formless dreams, objectless limitless desires, the grandiose and dolorous mazes of a troubled heart which aspires to all and is attached to nothing. This is why, along with the discontent, the agitations, and the hopes of modern democracy, music has left its natal countries and diffused itself over all Europe; and why you see at the present time the most complicated symphonies attracting crowds in France, where, thus far, the national music has been reduced to the song and the melodies of the Vaudeville.

IX

The foregoing illustrations, gentlemen, seem to me sufficient to establish the law governing the character and creation of works of art. And not only do they establish it, but they accurately define it. In the beginning of this section I stated that *the work of art is determined by an aggregate which is the general state of the mind and surrounding manners.* We may now advance another step, and note precisely in their order each link of the chain, connecting together cause and effect.

In the various illustrations we have considered, you have remarked first, a *general situation,* in other words, a certain universal condition of good or evil, one of servitude or of liberty, a state of wealth or of poverty, a particular form of society, a certain species of religious faith; in Greece, the free martial city, with its slaves; in the middle ages, feudal oppression, invasion and brigandage, and an exalted phase of Christianity; the court life of the seventeenth century; the industrial and studied democracy of the nineteenth, guided by the sciences; in short, a group of circumstances controlling man, and to which he is compelled to resign himself.

This situation develops in man corresponding needs, distinct *aptitudes* and *special sentiments*—physical activity, a tendency to reverie; here rudeness, and

there refinement; at one time a martial instinct, at another conversational talent, at another a love of pleasure, and a thousand other complex and varied peculiarities. In Greece we see physical perfection and a balance of faculties which no manual or cerebral excess of life deranges; in the middle ages, the intemperance of over-excited imaginations and the delicacy of feminine sensibility; in the seventeenth century, the polish and good-breeding of society and the dignity of aristocratic *salons;* and in modern times, the grandeur of unchained ambitions and the morbidity of unsatisfied yearnings.

Now, this group of sentiments, aptitude and needs, constitutes, when concentrated in one person and powerfully displayed by him, *the representative man,* that is to say, a model character to whom his contemporaries award all their admiration and all their sympathy; there is, for instance, in Greece, the naked youth, of a fine race and accomplished in all bodily exercise; in the middle ages, the ecstatic monk and the amorous knight; in the seventeenth century, the perfect courtier; and in our days, the melancholy insatiable Faust or Werther.

Moreover, as this personage is the most captivating, the most important and the most conspicuous of all, it is he whom artists present to the public, now concentrated in an ideal personage, when their art, like painting, sculpture, the drama, the romance or the epic, is imitative; now, dispersed in its elements, as in architecture and in music, where art excites emotions without incarnating them. All their labor, therefore, may be summed up as follows: they either represent this character, or address themselves to it; the symphonies of Beethoven and the "storied windows" of cathedrals are addressed to it; and it is represented in the Niobe group of antiquity and in the Agamemnon and Achilles of Racine. *All art, therefore, depends on it,* since the whole of art is applied only to conform to, or to express it.

A general situation, provoking tendencies and special faculties; a representative man, embodying these predominant tendencies and faculties, sounds, forms, colors, or language giving this character sensuous form, or which comport with the tendencies and faculties comprising it, such are the four terms of the series; the first carries with it the second, the second the third, and the third the fourth, so that the slightest variation of either involves a corresponding variation in those that follow, and reveals a corresponding variation in those that precede it, permitting abstract reasoning in either direction in an ascending or descending scale of progression.[2] As far as I am capable of judging, this formula embraces everything. If, now, we insert between these diverse terms the accessory causes occurring to modify their effects; if, in order to explain the sentiments of an epoch, we add an examination of race to that of the social

2. This law may be applied to the study of all literatures and to every art. The student may begin with the fourth term, proceeding from this to the first, strictly adhering to the order of the series.

medium; if, in order to explain the works of art of any age, we consider, besides the prevailing tendencies of that age, the particular period of the art, and the particular sentiments of each artist, we shall then derive from the law not only the great revolutions and general forms of man's imagination, but, again, the differences between national schools, the incessant variations of various styles, and the original characteristics of the works of every great master. Thus followed out, such an explanation will be complete, since it furnishes at once the general traits of each school, and the distinctive traits which, in this school, characterize individuals. We are about to enter upon this study in relation to Italian art; it is a long and difficult task, and I have need of your attention in order to pursue it to the end.

X

Before proceeding further, gentlemen, there is a practical and personal conclusion due to our researches, and which is applicable to the present order of things.

You have observed that each situation produces a certain state of mind followed by a corresponding class of works of art. This is why every new situation must produce a new state of mind, and consequently a new class of works; and therefore why the social medium of the present day, now in the course of formation, ought to produce its own works like the social mediums that have gone before it. This is not a simple supposition based on the current of desire and of hope; it is the result of a law resting on the authority of experience and on the testimony of history. From the moment a law is established it is good for all time; the connections of things in the present, accompany connections of things in the past and in the future. Accordingly, it need not be said in these days that art is exhausted. It is true that certain schools no longer exist and can no longer be revived; that certain arts languish, and that the future upon which we are entering does not promise to furnish the aliment that these require. But art itself, which is the faculty of perceiving and expressing the leading character of objects, is as enduring as the civilization of which it is the best and earliest fruit. What its forms will be, and which of the five great arts will provide the vehicle of expression of future sentiment, we are not called upon to decide; we have the right to affirm that new forms will arise, and an appropriate mould be found in which to cast them. We have only to open our eyes to see a change going on in the condition of men, and consequently in their minds, so profound, so universal, and so rapid that no other century has witnessed the like of it. The three causes that have formed the modern mind continue to operate with increasing efficacy. You are all aware that discoveries in the positive sciences are multiplying daily; that geology, organic chemistry, history, entire branches of physics and zoölogy, are contemporary productions; that the

growth of experience is infinite, and the applications of discovery unlimited; that means of communication and transport, cultivation, trade, mechanical contrivances, all the elements of human power, are yearly spreading and concentrating beyond all expectation. None of you are ignorant that the political machine works smoother in the same sense; that communities, becoming more rational and humane, are watchful of internal order, protecting talent, aiding the feeble and the poor; in short, that everywhere, and in every way, man is cultivating his intellectual faculties and ameliorating his social condition. We cannot accordingly deny that men's habits, ideas and condition transform themselves, nor reject this consequence, that such renewal of minds and things brings along with it a renewal of art. The first period of this evolution gave rise to the glorious French school of 1830; it remains for us to witness the second— the field which is open to your ambition and your labor. On its very threshold, you have a right to augur well of your century and of yourselves; for the patient study we have just terminated shows you that to produce beautiful works, the sole condition necessary is that which the great Goethe indicated: "Fill your mind and heart, however large, with the ideas and sentiments of your age, and the work will follow."

PIERRE-JOSEPH PROUDHON

Concerning the Principle of Art and Its Social Purpose (1857)

Pierre-Joseph Proudhon (1809–1865) was a critic of social institutions and a theoretician of social reform. In *What Is Property?* (1840), he outlined his basic scheme of a cooperative organization for society that would free labor from its subservient role and substitute financial cooperation for exploitation and speculation. Although attacked as a dangerous radical, he was much less influential a theorist than Karl Marx, among others. In fact, Marx criticized Proudhon's plan as simply a substitution of industrial for financial capitalism, which he considered equally vicious. Proudhon countered Marx's attacks in his essay "The Philosophy of Misery," which Marx answered in his "The Misery of Philosophy" (1847).

Proudhon launched his first periodical, *Représentant du peuple,* in 1848, but it was suspended after several months. *Le Peuple,* his next effort at journalism, was closed by the police in 1849 and Proudhon was imprisoned. Later that year *La Voix du Peuple* was launched. About this time, or possibly as late as 1852, Courbet and Proudhon met and found they had much in common. Courbet produced four portraits of Proudhon—none from life because the writer did not wish to pose—and looked upon him as the leading spokesman for a new social order.

In 1862 Courbet produced his large controversial painting *The Return from the Conference,* an obviously anticlerical work that represented a group of ecclesiastics staggering happily but drunkenly home from an evidently festive gathering. The painting was refused at the Salon of 1863 because of its subject, nor was it accepted for the famous Salon des Refusés of that same year. Courbet showed it publicly in his studio, however, and it was much commented upon. The painting was then sent to London for exhibition. For the London showing of this and other works, Courbet asked Proudhon to supply a short note to be published in a brochure. The painter was eager to associate himself publicly with Proudhon and to identify his work with Proudhon's social direction. Proudhon's brief remarks, begun in the spring of 1863, grew to be far more than a few pages, and the 380-page book he eventually completed used

Gustave Courbet, *Proudhon and His Children in 1853*, 1865, oil on canvas.

Courbet only as a pretext for a detailed discussion of art in relationship to society, from Egypt to the mid-nineteenth century.

As Zola later pointed out, Proudhon had little appreciation of Courbet's painting as such, finding it often too boldly brushed and assertive in its technique for his taste. But he approved of Courbet as a symbol of aggressive, anti-institutional leadership in art and defended his unconventional subjects. Although Courbet claimed to have sent many pages on art to Proudhon while he was writing the book, there is little that seems to represent the viewpoint of a painter. Proudhon saw clearly the part that art, principally through its subject matter, could play in the evolution of his social scheme and wrote less about the nature of art than the nature of society.

Proudhon's book begins with a brief discussion of the aesthetic sense in man. "I call aesthetic," he wrote, "the specific faculty of man to perceive or discover beauty and ugliness, the agreeable and the unpleasant, the sublime and the trivial in himself and in things, and to make of this perception a new means of enjoyment, a refinement of voluptuousness." But this faculty is of the second

385

order, since the goal is to be found not in the experience itself, but in the perfection of human life and society to which the pleasure leads. As a definition of art he offers: "An idealistic representation of nature and of ourselves to effect the physical and moral perfection of our species." Proudhon then devotes ten chapters to the history of art from Egyptian times, with the relationship between art and society as his criterion. Chapter 14, here reproduced, treats the so-called modern school. All but two of the remaining eleven chapters were left unedited at the time of Proudhon's death. Notably, he did complete the chapter devoted to Courbet's *Return from the Conference* (chapter 17).

The painting that initially occasioned Proudhon's essay was ultimately acquired by a devout Catholic and burned. It is now known only through photographs, although according to Courbet even the photographic negative was confiscated by the police.

This translation was made from Pierre-Joseph Proudhon, *Du principe de l'art et de sa destination sociale* (Paris: Garnier Frères, 1865), pp. 218–34.

Chapter 14. Character of Art Now Taking Form: Definition of the New School

We shall again take up the examination of Courbet's paintings, but before going further let us try to determine the character of art in the period that we entered some ten or fifteen years ago, and to define the new school.

We have said that art is founded on and takes its reason for being from a special faculty of man, the aesthetic faculty. It consists, we have stated, in a more or less idealized representation of ourselves and of things, looking toward moral and physical perfection.

From this it follows that art cannot exist apart from truth and justice, that science and morality are its leaders, and art can be no more than an auxiliary. In consequence, the first new law of art is a respect for morality and rationality. The old schools, classical as well as romantic, maintained on the contrary—and some distinguished philosophers allied themselves with this opinion—that art is independent of all moral and philosophical conditions, that it exists by itself, as does the faculty that gave it birth. This opinion must be examined thoroughly, for it has produced all the difficulty existing among the schools.

Does art, then, think? know? reason? form conclusions? . . . to this categorical question the romantic school, hardier than its rival, has no less categorically responded: *No,* making what it calls fantasy, genius, inspiration, spontaneity, and what is nothing more than systematic ignorance the essential condition of art. To know nothing, abstain from reasoning, keep from reflecting, all of which would chill the vitality and cause a loss of inspiration; to hold

philosophy in horror: such has been the maxim of the partisans of art for art's sake. "We do not condemn science in itself," they say, "we grant its full due for its utility and honorability, and we are not the last to honor its representatives. We only maintain that it is of no aid to art and can, indeed, be fatal to it. Art is all spontaneity; it is not self-conscious but ignorant of itself; it is pure intuition; it does not know what leads it, what it does, nor where it is going. Let others consider the consequences, attach logic to its manifestations. Let them look for the reason; let them indicate its relationships. This is a matter of philosophy, and while it can be considered quite admissible, it really has nothing to do with the artist. The Muse, the universal faculty, the incoercible divine breath, rebels against analysis as well as discipline, visits now this one, now that; she it is who confides to each, 'You will be an artist!' Happy the predestined one she shelters with her wings! He will attract the admiration of men and conquer immortality. But it would be vain to try to restrain the heavenly spirit with chains of meditation; vain to command it in the name of a theory. Dialectic will make it take flight for good. A happy inspiration may come to the most ignorant man, but the rash person who tries to master inspiration through philosophy, criticism, or pure reason will never succeed."

This exclusion of science from the realm of art is extended also to morality. "Art exists by itself," they say again. "It is independent of notions of justice and virtue. It is liberty in its absolute state. Without doubt, and we do not deny it, that which is moral merits every praise and that which is criminal every reprobation. We have never maintained that art might change the nature and the quality of things, rendering virtue a crime and making morally good that which is morally bad. We say that art, insofar as it is art, is released from all moral considerations as well as from all philosophical study. As a result it can appear and develop amid superstition and debauchery, as well as amid science and sanctity, producing works of immoral and absurd subjects no less than in the celebration of ideas and of all civic and domestic virtues."

Thus, because Giulio Romano and others have created with great talent some obscene pictures, because Parney and Voltaire have written *La Guerre des dieux* and *La Pucelle*,[1] it has been supposed that art can be sufficient in itself and that, all else extinct, it would have the power to revive the dead and ennoble humanity. This is to be misled by the grossest sophistry. It has not been understood that such works as these are monsters in which the subject's ugliness is

1. Giulio Romano (1482–1546), Italian painter and architect, published a notorious series of erotic drawings that were engraved by Marcantonio Raimondi and were accompanied by sonnets written by Pietro Aretino. Evariste-Desiré de Forges, Vicomte de Parny (1753–1844), published his long poem attacking Christianity, *La Guerre des dieux* (War of the Gods), in 1799; it was banned in 1827. Voltaire (1694–1788) published his long and witty poem satirizing history and religion, *La Pucelle,* in 1755.—Ed.

arbitrarily wedded to formal beauty, but a beauty *long since established and made known*. The question is not, in effect, to know whether artists like Voltaire and Giulio Romano, coming at a time when the language of literature had reached its full development, could do whatever they wanted with their pens and their paintbrushes: the question is to know whether under the influence of works like *La Pucelle* and engravings like those of *Aretino* language and art would have reached the point at which these great artists found it. The creators of the French language, remember, are Malherbe, Corneille, Boileau, Pascal, Bossuet, and other similar writers, the most severe, precise, and chaste geniuses. Let us judge the rest by this analogy.

The question of the independence of art leads to another, that concerning its end or destination. On this point the earlier schools are no less explicit and decisive. According to the classicists and the romantics—it would be of no consequence to separate them—art is an end in itself. What other purpose could be assigned to a manifestation of beauty and the ideal than to please and amuse? It spurns all useful purpose. If it promotes morality, aids health, contributes to wealth, so much the better for them. Although a person in the government may take it upon himself to impose certain police restrictions on art, it in no way results in art's recognizing any suzerainty outside its own nature. The legislature's ordinances have their point; they must be respected; as citizen the artist submits to them; but as interpreter of the ideal he is in no way concerned with them. His sole end in making you participate in his personal impressions, whatever they may be, is to excite in you that intimate delectation which doubles the enjoyment of reality and often takes the place of its possession. What does morality or logic of the event matter here? What does the economic or moral value of the thing matter? You are seduced, impassioned, transported. It is all the artist wishes. The rest is outside his competence, beyond his responsibility.

I shall not waste my time refuting this theory, founded on an error, which everyone today can judge by its products. For it is this theory that has for sixty years, to go back no farther, brought about the continuous decay of art and reduced it to ruin.

The human mind is constituted of a kind of polarity: *Conscience* and *Science,* in other words, *Justice* and *Truth*. On this fundamental axis, as on a musical key, the other faculties are scaled: memory, imagination, judgment, speech, love, politics, industry, commerce, art. What has led artists astray or, more correctly, has furnished them a false aesthetic, is that they have misunderstood this constitution. They envisioned in the human soul a triad in which feeling, the *aesthetic,* figures as a third term equal to the other two, whereas there is actually only a dyad or, as I have already noted, a polarity to which art cannot be considered as more than auxiliary. The proof of this subordination of art with respect to conscience and science is that, as we have demonstrated earlier (chapter

11),[2] in everything that is pure science and law, the idea and the ideal are identical and sufficient. The role of art in no way conforms to this, since art begins to function only when concerned with particular objects or individuals and their actions, of which the specific idea—that is, the particular form, figure, or image—necessarily different from the general type or principle, is different, thus, from the ideal. Science and conscience are the two sources within us of the ideal: they are the capacity we have for considering things in accordance with their law and our tendency to make them conform to it. An art that might declare itself independent of science and morality would go against its own principle: it would be a contradiction.

I cannot usefully enlarge on this subject. I should have to repeat what I have said on the historical evolution of art,[3] an evolution in which we saw art follow civilization step by step and be roughly thrust aside when it strayed. I spoke, in following, of the irrationality of art in the eighteenth and nineteenth centuries, an irrationality that, degenerating into orgy and debauch, ended by going so far as to kill off the genius. Confident in the intelligence of the reader, I am content to reestablish the true principle here.

It is against this degrading theory of art for art's sake that Courbet, and with him the entire school that until now has been called Realist, has boldly set itself and protested with energy. "No," he says, (I am translating Courbet's thoughts from his paintings rather than citing from his statements), "No, it is not true that the sole end of art is pleasure, because pleasure is not an end. It is not true that it has no other end than itself, because everything blends, everything is linked, all is of the whole, all has one end in humanity and nature. The idea of a capacity without purpose, a principle without consequence, a cause without effect, is as absurd as an effect without a cause. The object of art is to lead us to a knowledge of ourselves through the revelation of our thoughts, even the most secret, of all our tendencies, our virtues, our vices, our ridiculousness, and thus contribute to developing our dignity, to perfecting our being. Art was not given to us to nourish chimeras, to intoxicate with illusions, to fool us and lead us astray with mirages, as art is understood by the classics, the romantics, and all partisans of a vain ideal. Rather, it frees us from these pernicious illusions by denouncing them."

It does not follow from this, I will add in my turn, that a work of art should affect an air of roughness, scolding, and unpleasantness, posing as outraged divinity. Beauty and grace are an essential part of its domain; they take prece-

2. In chapter 11, "The Confusion and Irrationality of Art During the First Half of the Nineteenth Century," Proudhon discusses the work of David, Delacroix, Ingres, David d'Angers, Rude, Léopold Robert, and Horace Vernet, pointing out how each was in some degree false or misguided.—Ed.

3. In chapters 4–9, Proudhon expounds his theory of the "historical evolution" of art; the principal points of these chapters are summarized later in this chapter.—Ed.

dence over the coarse and ugly. For this reason we have seen that art in early stages of societies tends with all its might to represent things not precisely as they are seen, according to Raphael's expression, but as one would like them to be, surrounded by an aura of love, more beautiful than nature, in a word, ideal. It is the childhood of art, if you wish, but the child loves and understands beauty. Would you then thrust childhood out of human life? And note this in justification of the older artists: in the measure that humanity extricated itself from vice, tyranny, and misery, we see the human figure, I mean the figure of living man, come into prominence. Little by little it approached its earlier image as if pursuing a model, thus realizing the antique ideal in modern flesh and blood and bringing to it new creativity as well. This ultimate result is inevitable, unless one denies progress of any kind. Without doubt we are far from this future state; with thirty centuries of false civilization over our heads, other needs claim our attention.

This stated, we can now try to define and give a precise idea of the new school. The four paintings we first examined are sufficient for this.[4]

Courbet's works are not caricatures or indictments. Both his supporters and his adversaries recognize that his work exists in the realm of actual truth, and precisely for this realism some praise him and others reproach him. He does not produce satires, although he does not lack satiric capacity. Satire does not dominate his thinking; it is only a variation in his work, just as it is a variation, a separate genre, in the works of Boileau and Horace. No satiric allusion is to be found in the *Return from the Fair*. Courbet does not proceed by hyperbole, derision, or invective. His irony does not degenerate into calumny. He is as devoid of hatred as of flattery. If as an artist he betrays a certain brutish anger, it is not directed against the subjects he paints, against the vice and foolishness he attacks, but against his fellow artists who persist in going in a false direction. In this regard, one could justly say upon seeing his *Burial, Bather,* etc., in the exhibitions of 1851 and 1853, that he stood out like a local Hercules.

It would mean little to call him a genre painter in the manner of the Dutch and Flemish, whose agreeable and comic but lightweight paintings rarely get to the bottom of things or betray any philosophical preoccupation, showing rather more imagination than observation. Might one cite a Teniers as having the qualities of Courbet? I myself could never say that. I should reply, in any case, that Teniers was ahead of his time, which is not unprecedented among artists. The painter of Ornans's canvases are mirrors of truth, the uncommon merit of which (setting aside some qualities and faults of execution) lies in the profundity of idea, the faithfulness of type, the purity of the glass and the power of its reflection. This painting sees beyond art itself. Its motto is the in-

4. In chapters 12 and 13, Proudhon discusses Courbet's *Peasants of Flagey or the Return from the Fair, The Spinner, The Burial at Ornans,* and *The Bather.*—Ed.

scription from the temple at Delphi: *Men, know thyselves,* concluding, by implication, with John the Baptist, *and amend thy ways,* if you believe in life and honor.

Should one agree with the writers of the new school, then, that these paintings are purely realistic? Take care, I would say to them. Your realism will compromise the very truth that you profess to serve. The real is not the same thing as the true. The former is understood in terms of matter, the latter by the laws that govern it. Only the latter, the true, is intelligible and as such can serve as the object and end of art. The other makes no sense by itself. The older schools departed from the truth by the door of the "ideal." Do not in your turn depart by the door of the "real." You cite as testimony for your realism such ancient masterpieces as the busts of Nero and Vitellius, which you oppose to Clésinger's flattering and false busts of Caesar and Napoleon.[5] I readily recognize the great distance that exists between the works by the Roman artist and those of the French patrician. I feel as much admiration for the one as I do little interest for the other. But before deciding on the realism of the two antique works, note first of all that you are in no position to compare the portraits with the originals. Second, take care in saying that the great merit of these busts is that their creator has done nothing but copy the models, a task which could have been done as well by a caster. He has, rather, without departing from the truth, rendered the physiognomy, the air, the indefinable something that makes a portrait striking, which is not at all a product of matter but a mark of spirit. Without a doubt it is this, if your criticism of Clésinger's busts is correct, for I have not seen them, that this artist has not known how to effect, that which the artists of eighteen centuries ago excelled in. He intended, as did the antique sculptors, to show us the souls of the two emperors; he only knew how to regularize their features, according to Greek canon. Physical reality, remember, is only as good as the spirit, the ideal that breathes within it, and this does not consist only in a certain geometry and elegance of form. In searching for reality, are you then sacrificing spirit to matter, just as worshipers of form, in searching for the ideal, sacrificed truth to a chimera?

I conclude, then, as you yourselves can appreciate, that in order to execute a portrait or, even more, a social scene, the intervention of the ideal is absolutely indispensable. Not, I repeat, that an artist must remake, correct, and beautify nature or society, in the case of crime, for example, but rather that he must preserve exactly in the characters the truth, life, and spirit of their appearance. This is what Courbet, who understands very well what he means even though

5. In a footnote, Proudhon cites an article by Jules-Antoine Castagnary (1831–1888), who had earlier introduced a theory of art that he called "naturalism." The article had appeared in the *Courier de Dimanche,* September 13, 1863. Jean-Baptiste Auguste Clésinger (1814–1883) was a French sculptor who specialized in rendering historical subjects, sometimes in polychrome.—Ed.

he often expresses it badly, meant to say when he hurled this defiance at his adversaries: "You who undertake to paint Caesar and Charlemagne, would you know how to paint the portrait of your father?"

Since the "ideal," then, is essential to art just as much for the new school as for the earlier schools—and since the "real" figures for all schools simply as brute matter, substance or support of form, idea, the ideal—it is not at all by realism that this school is to be defined. It is in the particular way it makes the ideal function. In accordance with its particular ideal, Egyptian art was typical, symbolic, and metaphysical; for the same reason Greek art was idolatrous, devoted to the cult of form; in its turn, Christian art was, in accord with the gospels, spiritual and ascetic; art of the Renaissance was an ambiguous mixture, half pagan, half Christian, with strange results; Dutch art, finally, deriving from democracy and free thought, freed from any hierarchic mythology, allegory, idolatry, or spirituality, accepting people as subject, as type, as sovereign, and as ideal, has merited that we should call it *human art*. But while this latter designation, more revolutionary than philosophical, is excellent for marking the transition that completely separated the Catholic feudal world from the world of science and freedom, it is not sufficient. It lacks horizon for us, suggesting as it does that art has nothing more to do than to continue the Dutch tradition, whereas it has been quite evidently surpassed. As for the idealists of fantasy who, under the names of classical and romantic, occupied the entire period from the Revolution to the second Empire, there can be no question of them in this regard: they were no more "ideal" than pure realists would be, were they to exist.

The question of defining the new school and determining the new character of art is thus reduced to the problem of saying just what, in general, is the nature of the idealism to which one must henceforth refer. In the first place, I assert that the artistic idealism of the Egyptians, Greeks, Christians, and even the Renaissance corresponds to a religious dogma of which the art is only a translation. It centers on the dogma and associates all its inventions, close and remote, with it. In a general way this might be called *dogmatic idealism*. From the time of the Luther-Dutch reforms, the a priori dogma gave way to free thought, and art has since drawn its ideal from everywhere, from the infinity of nature and humanity and from the contemplation of their splendors and their laws. Art no longer climbed as before toward a supreme ideal, the source of all inspiration and the center of all ideality, but toward a much higher end, an end that broke away from the sphere of art itself—to the progressive education of humankind. We can thus firmly say that the decentralized, universal, natural, and human idealism that rules the new art is *antidogmatic*. This purely negative epithet is translatable into an affirmative equivalent: it can be called *critical idealism* or the *critical school*. Unfortunately, I fear the rather arbitrary susceptibility

of our language will not let us say *critical art*.[6] Consequently, to satisfy the men of fastidious taste, I propose to join the adjective *rational* to the word *art,* finding sufficient motivation in the *irrationality* of the art produced through the first half of the century. And *rational* means very nearly the same thing as *critical*.

Just as there has existed since Descartes and Kant an antidogmatic or critical philosophy, and literature, following the example of philosophy, has become in its turn principally critical, so art, developing parallel to philosophy, science, industry, politics, and literature, must also renew itself through criticism.

Criticism comes from the Greek *krino,* "I judge."[7] *Critical art* is to say "judicious art," art that begins by judging itself rigorously, declaring itself the servant not of the absolute but of pure reason and of law. It is an art which is no longer content to express or give rise to impressions, to symbolize ideas or acts of faith, but which, uniting conscience and science with feeling, discerns, discusses, blames, or approves in its way; an art which adds its special sanction, the sanction of beauty and sublimity, to the definition of philosophy and morality; accordingly, it is an art which allies itself with the movement of civilization by adopting its principles and is thus incapable of being perverted through abuse of the ideal or of becoming itself an instrument of falseness and corruption.

Art tells us by means of the new school, its interpreter, that such and such a thought, such an action, such a habit, such an institution is declared by law and philosophy true or false, just or unjust, virtuous or guilty, useful or injurious. I shall eventually demonstrate through the means at my disposal that this same action is also beautiful or ugly, generous or ignoble, gracious or brutish, keen or stupid, agreeable or sad, harmonious or discordant. Thus, once you have obtained the testimony of science, the judgment of justice, and the sanction of art on the same subject, you will be completely certain about it and forever love it or detest it.

Obviously, until the birth of the new school, art had never understood its mission with such clarity and depth. It did not understand itself as an aid and complement to reason. It in no way understood its role as educator. Far from this, it took upon itself to embellish and glorify immorality itself, posing as the standard for manners and beliefs, affecting the prerogatives of the absolute. The aesthetic faculty, depraved through idolatry, became the initiator of sin for men and a ferment of dissolution for society.

6. Proudhon uses the terms *idéalisme critique, école critique,* and *art critique.*—Ed.

7. The French word *critique,* and hence the English *criticism,* derive from the Latin *criticus,* which in turn derives from the Greek *kritikos,* meaning able to discuss, and the Greek verb *krinein,* to judge or discern. Proudhon emphasizes this point to clarify that he uses the term *critical* to denote positive discernment or evaluation, and not just denigration.—Ed.

Now this spontaneous corruption of art and corruption by art of public and private morals is no longer possible. Art—having become rational and reasonable, critical and judicious, marching abreast with *positive philosophy, positive politics,* and *positive metaphysics,* no longer professing indifference in matters of faith, government, or morality, subordinating idealism to reason—art can no longer serve to foster tyranny, prostitution, and pauperism. As an art of observation, and no longer simply of inspiration, it would have to lie to itself and deliberately destroy itself, which is impossible. An artist may sell himself—for a long time still, painting and sculpture, like the novel and the drama, will have their infamies. But art is henceforth incorruptible.

WILLIAM MORRIS

The Art of the People (1882)

William Morris (1834–1896) had an international influence on attitudes toward craftsmanship in the decorative arts at the end of the nineteenth century. He began his career as an associate of Edward Burne-Jones (1833–1898) at Oxford, where he also collaborated with Dante Gabriel Rossetti (1828–1882) on the Oxford Union frescoes in 1857. His major contribution to the field of art was not as a painter but as the founder of the firm of Morris, Marshall, Faulkner and Co. in 1861. Seeking an escape from burgeoning industrialism, Morris called for a return to the kind of craftsmanship and utility found in medieval architecture and decorative arts. Deriving designs from medieval illuminated manuscripts, he created wallpaper and chintz patterns that were widely used and imitated. The Kelmscott Press, which Morris founded in 1891, made significant contributions to the art of the illustrated book.

Morris was additionally a poet, publishing *The Defense of Guenivere* (1858), *Jason* (1867), and the three-volume *Earthly Paradise* (1868–1870).

Hopes and Fears for Art contains five lectures delivered by Morris between 1878 and 1881 in London, Birmingham, and Nottingham. The first edition was published by Ellis & White in London in 1882; this excerpt is reproduced from the first American edition (Boston: Roberts Brothers, 1882), pp. 41–70.— J.L.Y. 🐝

There are some of us who love Art most, and I may say most faithfully, who see for certain that such love is rare now-a-days. We cannot help seeing, that besides a vast number of people, who (poor souls!) are sordid and brutal of mind and habits, and have had no chance or choice in the matter, there are many high-minded, thoughtful, and cultivated men who inwardly think the arts to be a foolish accident of civilization—nay worse perhaps, a nuisance, a disease, a hindrance to human progress. Some of these, doubtless, are very busy about other sides of thought. They are, as I should put it, so *artistically* engrossed by the study of science, politics, or what not, that they have necessarily narrowed their minds by their hard and praiseworthy labors. But since

Abel Lewis, *William Morris,* 1880, photograph.

such men are few, this does not account for a prevalent habit of thought that looks upon Art as at best trifling.

What is wrong, then, with us or the arts, since what was once accounted so glorious, is now deemed paltry?

The question is no light one; for, to put the matter in its clearest light, I will say that the leaders of modern thought do for the most part sincerely and single-mindedly hate and despise the arts; and you know well that as the leaders are, so must the people be; and that means that we who are met together here for the furthering of Art by wide-spread education are either deceiving ourselves and wasting our time, since we shall one day be of the same opinion as the best men among us, or else we represent a small minority that is right, as minorities sometimes are, while those upright men aforesaid, and the great mass of civilized men, have been blinded by untoward circumstances.

That we are of this mind—the minority that is right—is, I hope, the case. I hope we know assuredly that the arts we have met together to further are necessary to the life of man, if the progress of civilization is not to be as causeless as the turning of a wheel that makes nothing.

How, then, shall we, the minority, carry out the duty which our position thrusts upon us of striving to grow into a majority?

If we could only explain to those thoughtful men, and the millions of whom they are the flower, what the thing is that we love, which is to us as the bread we eat, and the air we breathe, but about which they know nothing and feel nothing, save a vague instinct of repulsion, then the seed of victory might be sown. This is hard indeed to do; yet if we ponder upon a chapter of ancient or mediaeval history, it seems to me some glimmer of a chance of doing so breaks in upon us. Take, for example, a century of the Byzantine Empire, weary yourselves with reading the names of the pedants, tyrants, and tax-gatherers to whom the terrible chain which long-dead Rome once forged, still gave the power of cheating people into thinking that they were necessary lords of the world. Turn then to the lands they governed, and read and forget a long string of the causeless murders of Northern and Saracen pirates and robbers. That is pretty much the sum of what so-called history has left us of the tale of those days—the stupid languor and the evil deeds of kings and scoundrels. Must we turn away then, and say that all was evil? How then did men live from day to day? How then did Europe grow into intelligence and freedom? It seems there were others than those of whom history (so called) has left us the names and the deeds. These, the raw material for the treasury and the slave-market, we now call 'the people,' and we know that they were working all that while. Yes, and that their work was not merely slaves' work, the meal-trough before them and the whip behind them; for though history (so called) has forgotten them, yet their work has not been forgotten, but has made another history—the history of Art. There is not an ancient city in the East or the West that does not

bear some token of their grief, and joy, and hope. From Ispahan to Northumberland, there is no building built between the seventh and seventeenth centuries that does not show the influence of the labor of that oppressed and neglected herd of men. No one of them, indeed, rose high above his fellows. There was no Plato, or Shakespeare, or Michael Angelo amongst them. Yet, scattered as it was among many men, how strong their thought was, how long it abided, how far it travelled!

And so it was ever through all those days when Art was vigorous and progressive. Who can say how little we should know of many periods, but for their art? History (so called) has remembered the kings and warriors, because they destroyed; Art has remembered the people, because they created.

I think, then, that this knowledge we have of the life of past times gives us some token of the way we should take in meeting those honest and single-hearted men who above all things desire the world's progress, but whose minds are, as it were, sick on this point of the arts. Surely we may say to them: When all is gained that you (and we) so long for, what shall we do then? That great change which we are working for, each in his own way, will come like other changes, as a thief in the night, and will be with us before we know it; but let us imagine that its consummation has come suddenly and dramatically, acknowledged and hailed by all right-minded people; and what shall we do then, lest we begin once more to heap up fresh corruption for the woeful labor of ages once again? I say, as we turn away from the flagstaff where the new banner has been just run up; as we depart, our ears yet ringing with the blare of the heralds' trumpets that have proclaimed the new order of things, what shall we turn to then, what *must* we turn to then?

To what else, save to our work, our daily labor?

With what, then, shall we adorn it when we have become wholly free and reasonable? It is necessary toil, but shall it be toil only? Shall all we can do with it be to shorten the hours of that toil to the utmost, that the hours of leisure may be long beyond what men used to hope for? and what then shall we do with the leisure, if we say that all toil is irksome? Shall we sleep it all away?— Yes, and never wake again, I should hope, in that case.

What shall we do then? what shall our necessary hours of labor bring forth?

That will be a question for all men in that day when many wrongs are righted, and when there will be no classes of degradation on whom the dirty work of the world can be shovelled; and if men's minds are still sick and loathe the arts, they will not be able to answer that question.

Once men sat under grinding tyrannies, amidst violence and fear so great, that now-a-days we wonder how they lived through twenty-four hours of it, till we remember that then, as now, their daily labor was the main part of their lives, and that that daily labor was sweetened by the daily creation of Art; and shall we, who are delivered from the evils they bore, live drearier days than

they did? Shall men, who have come forth from so many tyrannies, bind themselves to yet another one, and become the slaves of nature, piling day upon day of hopeless, useless toil? Must this go on worsening till it comes to this at last—that the world shall have come into its inheritance, and with all foes conquered and nought to bind it, shall choose to sit down and labor for ever amidst grim ugliness? How, then, were all our hopes cheated, what a gulf of despair should we tumble into then?

In truth, it cannot be; yet if that sickness of repulsion to the arts were to go on hopelessly, nought else would be, and the extinction of the love of beauty and imagination would prove to be the extinction of civilization. But that sickness the world will one day throw off, yet will, I believe, pass through many pains in so doing, some of which will look very like the death-throes of art, and some, perhaps, will be grievous enough to the poor people of the world; since hard necessity, I doubt, works many of the world's changes, rather than the purblind striving to see, which we call the foresight of man.

Meanwhile, remember that I asked just now, what was amiss in art or in ourselves that this sickness was upon us. Nothing is wrong or can be with art in the abstract—that must always be good for mankind, or we are all wrong together: but with art, as we of these latter days have known it, there is much wrong; nay, what are we here for to-night if that is not so? were not the schools of art founded all over the country some thirty years ago because we had found that our popular art was fading—or perhaps had faded out from amongst us?

As to the progress made since then in this country—and in this country only, if at all—it is hard for me to speak without being either ungracious or insincere, and yet speak I must. I say, then, that an apparent external progress in some ways is obvious, but I do not know how far that is hopeful, for time must try it, and prove whether it be a passing fashion or the first token of a real stir among the great mass of civilized men. To speak quite frankly, and as one friend to another, I must needs say that even as I say those words they seem too good to be true. And yet—who knows?—so wont are we to frame history for the future as well as for the past, so often are our eyes blind both when we look backward and when we look forward, because we have been gazing so intently at our own days, our own lives. May all be better than I think it!

At any rate let us count our gains, and set them against less hopeful signs of the times. In England, then—and as far as I know, in England only—painters of pictures have grown, I believe, more numerous, and certainly more conscientious in their work, and in some cases—and this more especially in England—have developed and expressed a sense of beauty which the world has not seen for the last three hundred years. This is certainly a very great gain, which it is not easy to over-estimate, both for those who make the pictures and those who use them.

Furthermore, in England, and in England only, there has been a great im-

provement in architecture and the arts that attend it—arts which it was the special province of the afore-mentioned schools to revive and foster. This, also, is a considerable gain to the users of the works so made, but I fear a gain less important to most of those concerned in making them.

Against these gains we must, I am very sorry to say, set the fact not easy to be accounted for, that the rest of the civilized world (so called) seems to have done little more than stand still in these matters; and that among ourselves these improvements have concerned comparatively few people, the mass of our population not being in the least touched by them; so that the great bulk of our architecture—the art which most depends on the taste of the people at large—grows worse and worse every day.

I must speak also of another piece of discouragement before I go further. I dare say many of you will remember how emphatically those who first had to do with the movement of which the foundation of our art-schools was a part, called the attention of our pattern-designers to the beautiful works of the East. This was surely most well judged of them, for they bade us look at an art at once beautiful, orderly, living in our own day, and, above all, popular. Now, it is a grievous result of the sickness of civilization that this art is fast disappearing before the advance of western conquest and commerce—fast, and every day faster. While we are met here in Birmingham to further the spread of education in art, Englishmen in India are, in their short-sightedness, actively destroying the very sources of that education—jewelry, metal-work, pottery, calico-printing, brocade-weaving, carpet-making—all the famous and historical arts of the great peninsula have been for long treated as matters of no importance, to be thrust aside for the advantage of any paltry scrap of so-called commerce; and matters are now speedily coming to an end there. I dare say some of you saw the presents which the native Princes gave to the Prince of Wales on the occasion of his progress through India. I did myself, I will not say with great disappointment, for I guessed what they would be like, but with great grief, since there was scarce here and there a piece of goods among these costly gifts, things given as great treasures, which faintly upheld the ancient fame of the cradle of the industrial arts. Nay, in some cases, it would have been laughable, if it had not been so sad, to see the piteous simplicity with which the conquered race had copied the blank vulgarity of their lords. And this deterioration we are now, as I have said, actively engaged in forwarding. I have read a little book,[1] a handbook to the Indian Court of last year's Paris Exhibition, which takes the occasion of noting the state of manufactures in India one by one. 'Art manufactures,' you would call them; but, indeed, all manufactures are, or were, 'art manufactures' in India. Dr. Birdwood, the author of this book, is of great ex-

1. Now incorporated in the *Handbook of Indian Art*, by Dr. Birdwood, published by the Science and Art Department.

perience in Indian life, a man of science, and a lover of the arts. His story, by no means a new one to me, or others interested in the East and its labor, is a sad one indeed. The conquered races in their hopelessness are everywhere giving up the genuine practice of their own arts, which we know ourselves, as we have indeed loudly proclaimed, are founded on the truest and most natural principles. The often-praised perfection of these arts is the blossom of many ages of labor and change; but the conquered races are casting it aside as a thing of no value, so that they may conform themselves to the inferior art, or rather the lack of art, of their conquerors. In some parts of the country the genuine arts are quite destroyed; in many others nearly so; in all they have more or less begun to sicken. So much so is this the case, that now for some time the Government has been furthering this deterioration. As for example, no doubt with the best intentions, and certainly in full sympathy with the general English public, both at home and in India, the Government is now manufacturing cheap Indian carpets in the Indian gaols. I do not say that it is a bad thing to turn out real work, or works of art, in gaols; on the contrary, I think it good if it be properly managed. But in this case, the Government, being, as I said, in full sympathy with the English public, has determined that it will make its wares cheap, whether it make them nasty or not. Cheap and nasty they are, I assure you; but, though they are the worst of their kind, they would not be made thus, if everything did not tend the same way. And it is the same everywhere and with all Indian manufactures, till it has come to this—that these poor people have all but lost the one distinction, the one glory that conquest had left them. Their famous wares, so praised by those who thirty years ago began to attempt the restoration of popular art amongst ourselves, are no longer to be bought at reasonable prices in the common market, but must be sought for and treasured as precious relics for the museums we have founded for our art education. In short, their art is dead, and the commerce of modern civilization has slain it.

What is going on in India is also going on, more or less, all over the East; but I have spoken of India chiefly because I cannot help thinking that we ourselves are responsible for what is happening there. Chance-hap has made us the lords of many millions out there; surely, it behoves us to look to it, lest we give to the people whom we have made helpless, scorpions for fish and stones for bread.

But since neither on this side, nor on any other, can art be amended, until the countries that lead civilization are themselves in a healthy state about it, let us return to the consideration of its condition among ourselves. And again I say, that obvious as is that surface improvement of the arts within the last few years, I fear too much that there is something wrong about the root of the plant to exult over the bursting of its February buds.

I have just shown you for one thing that lovers of Indian and Eastern art, including as they do the heads of our institutions for art education, and I am sure many among what are called the governing classes, are utterly powerless to

stay its downward course. The general tendency of civilization is against them, and is too strong for them.

Again, though many of us love architecture dearly, and believe that it helps the healthiness both of body and soul to live among beautiful things, we of the big towns are mostly compelled to live in houses which have become a by-word of contempt for their ugliness and inconvenience. The stream of civilization is against us, and we cannot battle against it.

Once more those devoted men who have upheld the standard of truth and beauty amongst us, and whose pictures, painted amidst difficulties that none but a painter can know, show qualities of mind unsurpassed in any age—these great men have but a narrow circle that can understand their works, and are utterly unknown to the great mass of the people: civilization is so much against them, that they cannot move the people.

Therefore, looking at all this, I cannot think that all is well with the root of the tree we are cultivating. Indeed, I believe that if other things were but to stand still in the world, this improvement before mentioned would lead to a kind of art which, in that impossible case, would be in a way stable, would perhaps stand still also. This would be an art cultivated professedly by a few, and for a few, who would consider it necessary—a duty, if they could admit duties—to despise the common herd, to hold themselves aloof from all that the world has been struggling for from the first, to guard carefully every approach to their palace of art. It would be a pity to waste many words on the prospect of such a school of art as this, which does in a way, theoretically at least, exist at present, and has for its watchword a piece of slang that does not mean the harmless thing it seems to mean—art for art's sake. Its fore-doomed end must be, that art at last will seem too delicate a thing for even the hands of the initiated to touch; and the initiated must at last sit still and do nothing—to the grief of no one.

Well, certainly, if I thought you were come here to further such an art as this I could not have stood up and called you *friends;* though such a feeble folk as I have told you of one could scarce care to call foes.

Yet, as I say, such men exist, and I have troubled you with speaking of them, because I know that those honest and intelligent people, who are eager for human progress, and yet lack part of the human senses, and are anti-artistic, suppose that such men are artists, and that this is what art means, and what it does for people, and that such a narrow, cowardly life is what we, fellow-handicraftsmen, aim at. I see this taken for granted continually, even by many who, to say truth, ought to know better, and I long to put the slur from off us; to make people understand that we, least of all men, wish to widen the gulf between the classes, nay, worse still, to make new classes of elevation, and new classes of degradation—new lords and new slaves; that we, least of all men, want to culti-

vate the 'plant called man' in different ways—here stingily, there wastefully: I wish people to understand that the art we are striving for is a good thing that all can share, that will elevate all; in good sooth, if all people do not soon share it there will soon be none to share; if all are not elevated by it, mankind will lose the elevation it has gained. Nor is such an art as we long for a vain dream; such an art once was in times that were worse than these; when there was less courage, kindness, and truth in the world than there is now; such an art there will be hereafter, when there will be more courage, kindness, and truth than there is now in the world.

Let us look backward in history once more for a short while, and then steadily forward till my words are done: I began by saying that part of the common and necessary advice given to Art students was to study antiquity; and no doubt many of you, like me, have done so; have wandered, for instance, through the galleries of the admirable museum of South Kensington, and, like me, have been filled with wonder and gratitude at the beauty which has been born from the brain of man. Now, consider, I pray you, what these wonderful works are, and how they were made; and indeed, it is neither in extravagance nor without due meaning that I use the word 'wonderful' in speaking of them. Well, these things are just the common household goods of those past days, and that is one reason why they are so few and so carefully treasured. They were common things in their own day, used without fear of breaking or spoiling—no rarities then—and yet we have called them 'wonderful.'

And how were they made? Did a great artist draw the designs for them—a man of cultivation, highly paid, daintily fed, carefully housed, wrapped up in cotton wool, in short, when he was not at work? By no means. Wonderful as these works are, they were made by 'common fellows,' as the phrase goes, in the common course of their daily labor. Such were the men we honor in honoring those works. And their labor—do you think it was irksome to them? Those of you who are artists know very well that it was not; that it could not be. Many a grin of pleasure, I'll be bound—and you will not contradict me—went to the carrying through of those mazes of mysterious beauty, to the invention of those strange beasts and birds and flowers that we ourselves have chuckled over at South Kensington. While they were at work, at least, these men were not unhappy, and I suppose they worked most days, and the most part of the day, as we do.

Or those treasures of architecture that we study so carefully now-a-days—what are they? how were they made? There are great minsters among them, indeed, and palaces of kings and lords, but not many; and, noble and awe-inspiring as these may be, they differ only in size from the little gray church that still so often makes the commonplace English landscape beautiful, and the little gray house that still, in some parts of the country at least, makes an English

village a thing apart, to be seen and pondered on by all who love romance and beauty. These form the mass of our architectural treasures, the houses that every-day people lived in, the unregarded churches in which they worshipped.

And, once more, who was it that designed and ornamented them? The great architect, carefully kept for the purpose, and guarded from the common troubles of common men? By no means. Sometimes, perhaps, it was the monk, the ploughman's brother; oftenest his other brother, the village carpenter, smith, mason, what not—'a common fellow,' whose common, every-day labor fashioned works that are to-day the wonder and despair of many a hard-working 'cultivated' architect. And did he loathe his work? No, it is impossible. I have seen, as most of us have, work done by such men in some out-of-the-way hamlet—where to-day even few strangers ever come, and whose people seldom go five miles from their own doors; in such places, I say, I have seen work so delicate, so careful, and so inventive, that nothing in its way could go further. And I will assert, without fear of contradiction, that no human ingenuity can produce work such as this without pleasure being a third party to the brain that conceived and the hand that fashioned it. Nor are such works rare. The throne of the great Plantagenet, or the great Valois, was no more daintily carved than the seat of the village mass-john, or the chest of the yeoman's good wife.

So, you see, there was much going on to make life endurable in those times. Not every day, you may be sure, was a day of slaughter and tumult, though the histories read almost as if it were so; but every day the hammer chinked on the anvil, and the chisel played about the oak beam, and never without some beauty and invention being born of it, and consequently some human happiness.

That last word brings me to the very kernel and heart of what I have come here to say to you, and I pray you to think of it most seriously—not as to my words, but as to a thought which is stirring in the world, and will one day grow into something.

That thing which I understand by real art is the expression by man of his pleasure in labor. I do not believe he can be happy in his labor without expressing that happiness; and especially is this so when he is at work at anything in which he specially excels. A most kind gift is this of nature, since all men, nay, it seems all things too, must labor; so that not only does the dog take pleasure in hunting, and the horse in running, and the bird in flying, but so natural does the idea seem to us, that we imagine to ourselves that the earth and the very elements rejoice in doing their appointed work; and the poets have told us of the spring meadows smiling, of the exultation of the fire, of the countless laughter of the sea.

Nor until these latter days has man ever rejected this universal gift, but always, when he has not been too much perplexed, too much bound by disease or beaten down by trouble, has striven to make his work at least, happy. Pain

he has too often found in his pleasure, and weariness in his rest, to trust to these. What matter if his happiness lie with what must be always with him—his work?

And, once more, shall we, who have gained so much, forego this gain, the earliest, most natural gain of mankind? If we have to a great extent done so, as I verily fear we have, what strange fog-lights must have misled us; or rather let me say, how hard pressed we must have been in the battle with the evils we have overcome, to have forgotten the greatest of all evils. I cannot call it less than that. If a man has work to do which he despises, which does not satisfy his natural and rightful desire for pleasure, the greater part of his life must pass unhappily and without self-respect. Consider, I beg of you, what that means, and what ruin must come of it in the end.

If I could only persuade you of this, that the chief duty of the civilized world to-day is to set about making labor happy for all, to do its utmost to minimize the amount of unhappy labor—nay, if I could only persuade some two or three of you here present—I should have made a good night's work of it.

Do not, at any rate, shelter yourselves from any misgiving you may have behind the fallacy that the art-lacking labor of to-day is happy work: for the most of men it is not so. It would take long, perhaps, to show you, and make you fully understand that the would-be art which it produces is joyless. But there is another token of its being most unhappy work, which you cannot fail to understand at once—a grievous thing that token is—and I beg of you to believe that I feel the full shame of it, as I stand here speaking of it; but if we do not admit that we are sick, how can we be healed? This hapless token is, that the work done by the civilized world is mostly dishonest work. Look now: I admit that civilization does make certain things well, things which it knows, consciously or unconsciously, are necessary to its present unhealthy condition. These things, to speak shortly, are chiefly machines for carrying on the competition in buying and selling, called falsely commerce; and machines for the violent destruction of life—that is to say, materials for two kinds of war; of which kind the last is no doubt the worst, not so much in itself perhaps, but, because on this point the conscience of the world is beginning to be somewhat pricked. But on the other hand, matters for the carrying on of a dignified daily life, that life of mutual trust, forbearance, and help, which is the only real life of thinking men—these things the civilized world makes ill, and even increasingly worse and worse.

If I am wrong in saying this, you know well I am only saying what is widely thought, nay widely said too, for that matter. Let me give an instance, familiar enough, of that wide-spread opinion. There is a very clever book of pictures[2] now being sold at the railway bookstalls, called 'The British Working Man, by

2. These were originally published in *Fun*.

one who does not believe in him,'—a title and a book which make me both angry and ashamed, because the two express much injustice, and not a little truth in their quaint, and necessarily exaggerated way. It is quite true, and very sad to say, that if any one now-a-days wants a piece of ordinary work done by gardener, carpenter, mason, dyer, weaver, smith, what you will, he will be a lucky rarity if he get it well done. He will, on the contrary, meet on every side with evasion of plain duties, and disregard of other men's rights; yet I cannot see how the 'British Working Man' is to be made to bear the whole burden of this blame, or indeed the chief part of it. I doubt if it be possible for a whole mass of men to do work to which they are driven, and in which there is no hope and no pleasure, without trying to shirk it—at any rate, shirked it has always been under such circumstances. On the other hand, I know that there are some men so right-minded, that they will, in despite of irksomeness and hopelessness, drive right through their work. Such men are the salt of the earth. But must there not be something wrong with a state of society which drives these into that bitter heroism, and the most part into shirking, into the depths often of half-conscious self-contempt and degradation? Be sure that there is, that the blindness and hurry of civilization, as it now is, have to answer a heavy charge as to that enormous amount of pleasureless work—work that tries every muscle of the body and every atom of the brain, and which is done without pleasure and without aim—work which everybody who has to do with tries to shuffle off in the speediest way that dread of starvation or ruin will allow him.

I am as sure of one thing as that I am living and breathing, and it is this: that the dishonesty in the daily arts of life, complaints of which are in all men's mouths, and which I can answer for it does exist, is the natural and inevitable result of the world in the hurry of the war of the counting-house, and the war of the battlefield, having forgotten—of all men, I say, each for the other, having forgotten, that pleasure in our daily labor, which nature cries out for as its due.

Therefore, I say again, it is necessary to the further progress of civilization that men should turn their thoughts to some means of limiting, and in the end of doing away with, degrading labor.

I do not think my words hitherto spoken have given you any occasion to think that I mean by this either hard or rough labor; I do not pity men much for their hardships, especially if they be accidental; not necessarily attached to one class or one condition, I mean. Nor do I think (I were crazy or dreaming else) that the work of the world can be carried on without rough labor; but I have seen enough of that to know that it need not be by any means degrading. To plough the earth, to cast the net, to fold the flock—these, and such as these, which are rough occupations enough, and which carry with them many hardships, are good enough for the best of us, certain conditions of leisure, freedom, and due wages being granted. As to the bricklayer, the mason, and the

WILLIAM MORRIS

like—these would be artists, and doing not only necessary, but beautiful, and therefore happy work, if art were anything like what it should be. No, it is not such labor as this which we need to do away with, but the toil which makes the thousand and one things which nobody wants, which are used merely as the counters for the competitive buying and selling, falsely called commerce, which I have spoken of before—I know in my heart, and not merely by my reason, that this toil cries out to be done away with. But, besides that, the labor which now makes things good and necessary in themselves, merely as counters for the commercial war aforesaid, needs regulating and reforming. Nor can this reform be brought about save by art; and if we were only come to our right minds, and could see the necessity for making labor sweet to all men, as it is now to very few—the necessity, I repeat; lest discontent, unrest, and despair should at last swallow up all society—If we, then, with our eyes cleared, could but make some sacrifice of things which do us no good, since we unjustly and uneasily possess them, then indeed I believe we should sow the seeds of a happiness which the world has not yet known, of a rest and content which would make it what I cannot help thinking it was meant to be: and with that seed would be sown also the seed of real art, the expression of man's happiness in his labor,—an art made by the people, and for the people, as a happiness to the maker and the user.

That is the only real art there is, the only art which will be an instrument to the progress of the world, and not a hindrance. Nor can I seriously doubt that in your hearts you know that it is so, all of you, at any rate, who have in you an instinct for art. I believe that you agree with me in this, though you may differ from much else that I have said. I think assuredly that this is the art whose welfare we have met together to further, and the necessary instruction in which we have undertaken to spread as widely as may be.

Thus I have told you something of what I think is to be hoped and feared for the future of art; and if you ask me what I expect as the practical outcome of the admission of these opinions, I must say at once that I know, even if we were all of one mind, and that what I think the right mind on this subject, we should still have much work and many hindrances before us; we should still have need of all the prudence, foresight, and industry of the best among us; and, even so, our path would sometimes seem blind enough. And, to-day, when the opinions which we think right, and which one day will be generally thought so, have to struggle sorely to make themselves noticed at all, it is early days for us to try to see our exact and clearly-mapped road. I suppose you will think it too commonplace of me to say that the general education that makes men think, will one day make them think rightly upon art. Commonplace as it is, I really believe it, and am indeed encouraged by it, when I remember how obviously this age is one of transition from the old to the new, and what a strange confusion,

from out of which we shall one day come, our ignorance and half-ignorance is like to make of the exhausted rubbish of the old and the crude rubbish of the new, both of which lie so ready to our hands.

But, if I must say, furthermore, any words that seem like words of practical advice, I think my task is hard, and I fear I shall offend some of you whatever I say; for this is indeed an affair of morality, rather than of what people call art.

However, I cannot forget that, in my mind, it is not possible to dissociate art from morality, politics, and religion. Truth in these great matters of principle is of one, and it is only in formal treatises that it can be split up diversely. I must also ask you to remember how I have already said, that though my mouth alone speaks, it speaks, however feebly and disjointedly, the thoughts of many men better than myself. And further, though when things are tending to the best, we shall still, as aforesaid, need our best men to lead us quite right; yet even now surely, when it is far from that, the least of us can do some yeoman's service to the cause, and live and die not without honor.

So I will say that I believe there are two virtues much needed in modern life, if it is ever to become sweet; and I am quite sure that they are absolutely necessary in sowing the seed of an *art which is to be made by the people and for the people, as a happiness to the maker and the user.* These virtues are honesty, and simplicity of life. To make my meaning clearer I will name the opposing vice of the second of these—luxury to wit. Also I mean by honesty, the careful and eager giving his due to every man, the determination not to gain by any man's loss, which in my experience is not a common virtue.

But note how the practice of either of these virtues will make the other easier to us. For if our wants are few, we shall have but little chance of being driven by our wants into injustice; and if we are fixed in the principle of giving every man his due, how can our self-respect bear that we should give too much to ourselves?

And in art, and in that preparation for it without which no art that is stable or worthy can be, the raising, namely, of those classes which have heretofore been degraded, the practice of these virtues would make a new world of it. For if you are rich, your simplicity of life will both go towards smoothing over the dreadful contrast between waste and want, which is the great horror of civilized countries, and will also give an example and standard of dignified life to those classes which you desire to raise, who, as it is indeed, being like enough to rich people, are given both to envy and to imitate the idleness and waste that the possession of much money produces.

Nay, and apart from the morality of the matter, which I am forced to speak to you of, let me tell you that though simplicity in art may be costly as well as uncostly, at least it is not wasteful, and nothing is more destructive to art than the want of it. I have never been in any rich man's house which would not have looked the better for having a bonfire made outside of it of nine-tenths of all

that it held. Indeed, our sacrifice on the side of luxury will, it seems to me, be little or nothing: for, as far as I can make out, what people usually mean by it, is either a gathering of possessions which are sheer vexations to the owner, or a chain of pompous circumstance, which checks and annoys the rich man at every step. Yes, luxury cannot exist without slavery of some kind or other, and its abolition will be blessed like the abolition of other slaveries, by the freeing both of the slaves and of their masters.

Lastly, if, besides attaining to simplicity of life, we attain also to the love of justice, then will all things be ready for the new springtime of the arts. For those of us that are employers of labor, how can we bear to give any man less money than he can decently live on, less leisure than his education and self-respect demand? or those of us who are workmen, how can we bear to fail in the contract we have undertaken, or to make it necessary for a foreman to go up and down spying out our mean tricks and evasions? or we the shopkeepers— can we endure to lie about our wares, that we may shuffle off our losses on to some one else's shoulders? or we the public—how can we bear to pay a price for a piece of goods which will help to trouble one man, to ruin another, and starve a third? Or, still more, I think, how can we bear to use, how can we enjoy something which has been a pain and a grief for the maker to make?

And, now, I think, I have said what I came to say. I confess that there is nothing new in it, but you know the experience of the world is that a thing must be said over and over again before any great number of men can be got to listen to it. Let my words to-night, therefore, pass for one of the necessary times that the thought in them must be spoken out.

For the rest I believe that, however seriously these words may be gainsaid, I have been speaking to an audience in whom any words spoken from a sense of duty and in hearty good-will, as mine have been, will quicken thought and sow some good seed. At any rate it is good for a man who thinks seriously to face his fellows, and speak out whatever really burns in him, so that men may seem less strange to one another, and misunderstanding, the fruitful cause of aimless strife, may be avoided.

But if to any of you I have seemed to speak hopelessly, my words have been lacking in art; and you must remember that hopelessness would have locked my mouth, not opened it. I am, indeed, hopeful, but can I give a date to the accomplishment of my hope, and say that it will happen in my life or yours?

But I will at least say, Courage! for things wonderful, unhoped for, glorious, have happened even in this short while I have been alive.

Yes, surely these times are wonderful and fruitful of change, which, as it wears and gathers new life even in its wearing, will one day bring better things for the toiling days of men, who with freer hearts and clearer eyes, will once more gain the sense of outward beauty, and rejoice in it.

Meanwhile, if these hours be dark, as, indeed, in many ways they are, at

least do not let us sit deedless, like fools and fine gentlemen, thinking the common toil not good enough for us, and beaten by the muddle; but rather let us work like good fellows trying by some dim candle-light to set our workshop ready against to-morrow's daylight—that to-morrow, when the civilized world, no longer greedy, strifeful, and destructive, shall have a new art, a glorious art, made by the people and for the people, as a happiness to the maker and the user.

V

AN ART OF PURE VISION

Although an extraordinary zeal for seizing nature and making it his own made Gustave Courbet a model for rebellious artists throughout Europe, it marked him also as a man allied to an earlier brand of artistic passion. His Realism was more a matter of self-realization than of observation, and he lent his image to a political movement that sought to form, not simply understand, society. He was an advocate in the heroic mold.

By the 1860s many writers and artists had turned away from the utopian schemes and heady idealism of the preceding years to look dispassionately at the processes that characterized the world around them. The key word seemed to be *analysis:* to analyze in ever-increasing detail the structural nature of phenomena, both historical and quotidian. In literature the attitude is nicely exemplified in the novels of Émile Zola. Much impressed with the cultural theories of Taine, Zola tried to create characters who lived their own lives, manifesting the influence of heredity and social environment. Equal to his interest in Taine was his fascination with Prosper Lucas's *Traité philosophique et physiologique de l'hérédité naturelle* (1847–1850), and he studied the development and interaction of his subjects in microscopic detail. Zola wished to be true to what he observed in nature not because it revealed the hand of God but because it brought him into closer contact with the working-out of a complex human situation. To force his characters to act out a plot, or to make his own overt judgments of their actions or the social institutions of which they were a part, would be to betray his fascination with the natural processes of man in society, to allow ego to stand in the way of knowledge. Of his works and those of his followers it was sometimes boasted that they had not "two sous' worth" of plot. They purported to be untouched by scheme or prescription. Zola called his "movement" in art Naturalism.

To apply Zola's vigor to observing the visual aspects of nature, which some artists wished to do, posed a new set of problems. As Zola realized, the artist was no less a product of his heredity and his environment than the material he treated. Each artist was differently equipped, both physically and intellectually, to observe; each had his own temperament, by which Zola meant the entirety of a person's physical and psychological capacity, not merely an emotional pre-

disposition. Thus, although each person might set out to study his environment with all the objectivity at his command, no one could ever arrive at a completely objective report. Each person could see nature only through his own temperament, and no two were alike. Furthermore, one temperament was no better than another—only different.

This concept of temperament was useful for artists who had come to realize that seeing and the thing seen were not necessarily the same. It had once been generally accepted that the most "real" rendering of an object was a tight outline description of its form, but this clear and measurable image was now regarded as totally unreal by those who denied all evidence of truth beyond direct sight. One does not see outlines or isolated forms in nature; like man in society, an object in nature is seen always in relationship to something else. Furthermore, these artists held it equally false to assume that an object has a single color (a *local* color), which is then modified by light and dark or reflections from other objects. The testimony of sight would indicate that every object has an infinite variety of color, depending on the circumstances, and that each colored shape—whether a highlight, shadow, or reflection—is equally important to vision. No truly observing eye admits of preconceptions about identities and remembered forms, or allows foreground to dominate background, or favors significant objects over insignificant. Once freed from traditional habits, the eye is capable of infinite discovery.

Quite probably the photograph played a part in this changed concept of seeing. When first introduced in 1839, the photograph (or daguerreotype) was hailed by artists as a useful adjunct; few looked upon it as a threat. It provided the means for having at hand a host of models to study, models that demanded no pay and did not shift their positions. In various artistic centers, photographs were produced for artists: models dressed in peasant clothing were photographed in Rome, and nude studio models were photographed in Paris. When Delacroix went to the country, he took a sheaf of photographs of nudes so that he might continue to work from "nature."

Later, another aspect of photography was also much appreciated. The camera could record a view of nature in its infinite complexity all at one time. What became known as "photographic detail" was not new to the artist; photographically detailed paintings predated photography. To capture all with an impartial eye, however, was potentially superior to the artist's traditional procedure of adding part to part to create a unity. The unity of the photograph was inseparable from the complex of forms recorded. How could a painting be equally true to vision?

The emotional overtones of the paintings by the Barbizon artists and all narrative subject matter became the enemies of this new way of seeing because they distracted the mind by drawing it away from the persistent study of the direct view of nature itself. Instead of "subject," artists began to talk of "motif"; the

objects in the painting were only an excuse for intensive visual scrutiny. As often as not the model had his back to the viewer, and compositions seemed discovered by chance. Like the "naturalist" writings, the paintings had unity but no plot, if by *plot* one refers to Milizia's definition of construction of forms that operate as a machine to serve the artist's purpose.

Once artists began to see things only in terms of the relationships of colors and shapes, they began to concern themselves with progressively nicer observations. However, instead of pushing observation toward the more exact definition of the thing observed, the motif, artists began to note the infinite variety of the visual experience, the interplay of color and light. To record these intricate relationships, artists devised techniques that would allow them to articulate, rather than generalize, the variety of shape and hue discernible in every part of freely observed nature. Still, with the impassivity of the camera, artists allowed themselves to be absorbed in the visual analysis of the continuously varied and changing scene; the objective observer—with temperament.

This was the stage of observation Monet and some of his associates had reached in the early 1870s. The principles of color on which their work depends had been known for many years, but it was the first time they had been used for precisely this purpose. After the painters had been subjected to ridicule at their first joint exhibition in 1874, apologists tried to construct an elaborate theoretical basis to justify their works. But at that point the painters had little interest in technical theories; they were content with having found a successful way to enter into the world around them. *Impressionism,* the label that came to denote their work, is not very descriptive. Painters had been fascinated with "impressions" of natural scenes for a century and had studied the phenomena of light and color and painted their favorite landscapes out-of-doors for many years. But the total immersion in the intricately related phenomena of color and light for no purpose other than the experience itself, to know by being, was part of a new consciousness and a new set of values.

The simple empirical method was not sufficient for those artists who wished to acquire a more intellectual understanding of the processes of perception. Through the years, a growing body of material on the perception of color had become available, and this served not only to confirm much that the artists had learned through observation but also to enable them to systematically reconstruct equivalent experiences. Early in the 1880s, Georges Seurat began to employ just such a procedure, relying on divided color and relative values in form. In 1884 his works and those of Paul Signac caught the attention of a sizable group of painters, and a new kind of painting, proclaimed "Neoimpressionism," was launched. Although the new style shared with earlier methods the intensive, dispassionate analysis of visual experience, the composition of these paintings was clearly a product of calculated construction, not a "discovered" organization inseparable from the observation. Neoimpressionist paintings

were thus proofs of an artist's domination of the principles of vision; the artist was in no sense pleasurably lost in the complexities of sense.

The painters who believed in an art of pure vision might be divided, then, into two groups: those who steadfastly avoided rules and systems in order that each approach to nature would be a fresh revelation and a complete experience in itself, and those who wished to organize their observations in accordance with scientific laws and test their knowledge continuously in pictorial proofs. Both looked upon painting as a kind of experiment, an investigation, supported by a discipline that admitted of no emotional effusion or excessively personal manner. In their different ways, both groups painted pictures that called attention to the process of seeing instead of simply the thing seen, recreating a procedure in which the spectator joins to such a degree that the work of art itself seems the source of the experience and the bond between artist and viewer.

Édouard Manet (1867)
Art at the Moment (1866)

Émile Zola (1840–1902) came to the support of Édouard Manet when his own career had hardly begun. His novel *La Confession de Claude* had caused a minor scandal in 1865, but only with the publication of *Thérèse Raquin* (1867) was the direction of his career as a writer clearly evident. Throughout the 1870s and 1880s he became one of the best known of French writers, and as an active journalist he often defended unpopular causes. His Salon reviews of 1866, including a piece on Manet, were considered so controversial by the editor of *L'Événement* that three articles expressing an opposite viewpoint were thought necessary. As a result of the disagreement the young Zola resigned.

Zola was a schoolmate of Paul Cézanne and remained in touch with the painter, often defending his works, through the early part of his career. But Zola lost sympathy with the later trends in painting, and many artists, Cézanne in particular, were offended by his novel about the professional art world, *L'Oeuvre* (1886). His most controversial affair was his defense of Alfred Dreyfus in 1898, in which he accused the French General Staff of injustice and raised the issue of anti-Semitism, which was hotly discussed.

Zola was very conscious of the tendency called "Naturalism," and in his critical writing applied his theories to the theater and the visual arts as well as to literature. His "Le Naturalisme au Salon" appeared in *Le Voltaire,* June 18–22, 1880. The so-called *Groupe de Mélan* formed an influential salon about Zola at his summer home near Paris. Cézanne was a frequent guest until his breaking-off with Zola in 1886.

Zola's three-part essay on Manet ("The Man and the Artist," "The Works," "The Public") was published in the *Revue du XXe siècle* in January 1867; only the first portion of this essay is reproduced here. "Le Moment artistique" was first published in *L'Évènement* on May 4, 1866, as one in a series of Salon reviews, and republished in 1866 in a volume entitled *Mon Salon.* Both translations were made from Zola's *Oeuvres complètes* (Paris: Cercle du Bibliophile, 1969), 31:279–85 and 325–40.

Édouard Manet, *Émile Zola*, 1867–68, oil on canvas.

ÉDOUARD MANET

[Zola's essay is preceded by a brief description of the difficulty involved in writing the biography of so complex an artist as Manet.]

PART I: THE MAN AND THE ARTIST

Édouard Manet was born in Paris in 1832. I have only a few biographical details about him. The life of an artist, in our correct and disciplined time, is that of a peaceful bourgeois who paints pictures in his studio as others sell pepper behind their counters. The long-haired race of 1830, thank the Lord, has completely disappeared, and our painters have become what they ought to be, people who live like everyone else.

After having passed some years with the Abbé Poiloup at Vaugirard, Édouard Manet completed his studies at the Collège Rollin. At the age of seventeen, when he left college, he was seized by a love for painting. And what a terrible love that is! Parents tolerate a mistress, even two; they close their eyes, if necessary, to the dissipation of the heart and the senses. But the arts, painting, is for them the great Impure, the Courtesan who is always famished for young flesh, who must drink the blood of their children and strangle them panting on her insatiable breast. It is the orgy, the debauch without pardon, the bloody specter that from time to time raises itself within families and troubles the peace of domestic homes.

Quite naturally at the age of seventeen, Édouard Manet embarked as an ordinary seaman on a vessel that took him to Rio de Janeiro. Without doubt the great Impure, the Courtesan always famished for young flesh, embarked with him and succeeded in seducing him amid the luminous solitudes of the ocean and the sky; she appealed to his flesh, she played amorously before his eyes the sparkling lines of the horizon, she spoke to him of passion with the sweet and vigorous language of colors. On his return, Édouard Manet belonged entirely to Infamy.

He left the sea and went to visit Italy and Holland. However, he was still ignorant; he promenaded ingenuously; he wasted his time. And this is proven by the fact that on returning to Paris he entered as a student the studio of Thomas Couture,[1] and he remained there for six years, his arms tied by precepts and counsels, faltering in full mediocrity, not knowing how to find his

1. Thomas Couture (1815–1879), a popular teacher at the time, who emphasized a broad painting technique.—Ed.

way. He harbored a particular temperament that could not be bent to these first
lessons, and the influence of this artistic education that was contrary to his na-
ture acted upon his works even after he had left the studio of the master. For
three years he fought under this shadow, working without knowing too well
what he saw or what he wanted. It was not until 1860 that he painted the *Ab-
sinthe Drinkers,* a canvas that, although one can still find in it a vague impres-
sion of the works of Thomas Couture, already contains a germ of the artist's
personal manner.

Since 1860 the public has been aware of his artistic life. Memorable is the
strange sensation that some of his canvases produced at the Martinet exhibition
and at the Salon des Refusés in 1863; equally memorable is the tumult that the
paintings of *Christ and the Angels* and *Olympia* caused at the Salons of 1864 and
1865. In studying his works, I shall return to this period of his life.

Édouard Manet is of medium height, rather shorter than tall. His hair and
his beard are of a light chestnut; his eyes, narrow and deep, have a vivacity, a
youthful flame; his mouth is distinctive, narrow, mobile, a little mocking at the
corners. His entire face, of a fine and intelligent irregularity, announces ease
and audacity, scorn of foolishness and banality. And if from his face we would
pass to the person himself, we should find in Édouard Manet a man of ex-
quisite friendliness and politeness, of distinguished manner and sympathetic
appearance.

I am forced to insist upon these infinitely small details. The contemporary
farceurs, who earn their money by making the public laugh, have changed
Édouard Manet into a kind of bohemian, a braggart, a ridiculous bogeyman.
And the public has accepted these jests and caricatures as if they were true. The
truth does not at all match these puppets of fantasy created by professional
laughers, and it is well to show the real man.

The artist has declared to me that he adores the world and that he finds secret
delight in the perfumed and luminous delicacies of evening. Without doubt he
is enchanted by his love of broad and vivid colors; but there is also in the depths
of the man an innate need for distinction and elegance, of which I am also aware
in his works.

Such is his life. He works with vigor, and the number of his canvases is al-
ready considerable. He paints without discouragement, without lassitude,
walking straight ahead, obedient to his nature. Then he returns to his home and
there tastes the calm joys of the modern bourgeoisie; he frequents society assid-
uously; he leads the same existence as everyone else, with this difference: he is
possibly more peaceful and better mannered than others.

I have really had to write these lines before I could speak of Édouard Manet
as artist. Now I feel much more at my ease, having forewarned people about
what I believe to be the truth. I hope that people will stop treating as a dishev-
eled dauber the man whose physiognomy I have just sketched in a few strokes,

Henri Fantin-Latour, *Édouard Manet*, 1867, oil on canvas.

and that they will pay polite attention to the very disinterested judgments I am going to make about a convinced and sincere artist. I am persuaded that the exact profile of the real Édouard Manet will surprise a great many people. He will be studied, henceforth, with less indecent laughter and more suitable attention. The question becomes this: this painter assuredly paints in a completely naive and concentrated fashion, and it remains to be determined only whether he creates works of talent or is but grossly fooling himself.

I should not want to propose as a principle that a student's lack of success in obeying a master's direction is a mark of original talent, and to draw from that an argument in favor of Édouard Manet's wasting his time with Thomas Couture. Every artist necessarily goes through a period of groping and hesitation that lasts for a longer or a shorter time. It is agreed that each must pass this period in the studio of a professor, and I see nothing wrong with this. Advice, even if it retards somewhat the hatching of original talents, does not stop them from one day manifesting themselves, and sooner or later the advice is completely forgotten insofar as the artist has an individuality of some power.

Yet, in the present case, I prefer to consider the long and painful apprenticeship of Édouard Manet as a symptom of originality. If I were to name here all those students who were discouraged by their masters and who have eventually become men of first rank, the list would be long. "You will never do anything," says the schoolmaster. And this without doubt signifies: "Beyond me there is nothing good, and you are not I." Happy are those whom the masters fail to recognize as their children! They are of a race apart. Each of them brings his word to the great phrase that humanity is writing and will never complete; they have the destiny of becoming in their turn masters, egoists, complete and individual personalities.

It was, then, on escaping the precepts of a nature different from his own, that Édouard Manet tried to search out and to see for himself. I repeat, for three years he ached from the chastising raps he had received. He had on the tip of his tongue, you might say, the new word he was to contribute, but he was unable to utter it. Then his eyes cleared, he saw things distinctly, his tongue was no longer confused, and he spoke.

He spoke a language full of rudeness and grace, which infuriated the public. I do not maintain that it was an entirely new language or that it did not contain some Spanish terms, on which I shall have something to say elsewhere; but from the vigor and truth of certain images, it was easily understood that an artist was born to us. He spoke a language that he had made his own and that henceforth would be indeed his.

This is the way I comprehend the birth of every true artist, as, for example, Édouard Manet. Realizing that he was getting nowhere copying masters, painting nature as seen by personalities different from his own, it occurred to him quite naively one fine morning that it was up to him to try to see nature as it is

without considering it through the works and opinions of others. Once he had grasped this idea, he took any kind of object, whether a being or a thing, placed it at the end of his studio, and began to reproduce it on a canvas in accord with his faculties of vision and understanding. He tried to forget everything that he had studied in the museums. He strove not to remember the counsels he had been given, the paintings he had looked at. He retained nothing more than an individual intelligence, served by organs gifted in a certain way, confronting nature and translating it in his own manner.

The artist thus achieved a work that was his own flesh and blood. Certainly this work belonged to the great family of human works; it had sisters among the thousands of works already created; certain of these it more or less resembled. But it was beautiful with a beauty of its own; it lived, I mean, with a personal life. The different elements that composed it, possibly drawn from here and there, were fused into a whole with a new flavor and an individual aspect; and this whole, created for the first time, was a yet unknown facet of human genius. Henceforth Édouard Manet found his way, or, more correctly, he found himself; he saw with his own eyes; he had to give us in each of his paintings a translation of nature in the original language he had just discovered in the depths of himself.

And now I beg of the reader who has been good enough to read up to this point and has been willing to understand me, to place himself in the only logical position from which a work of art can be sensibly judged. Without this, we shall never understand each other: the reader will keep his accepted beliefs, I shall take off on quite different axioms, and we shall go on thus, moving farther and farther apart. Ultimately, he will consider me a fool, and I shall consider him a man of little intelligence. He must proceed as the artist himself proceeded: forget the riches of museums and the necessity of would-be rules; cast out recollection of the heap of paintings by dead painters; see nothing but nature, face to face, such as it is; finally, seek in the works of Édouard Manet only a translation of reality, peculiar to a temperament, beautiful in its human interest.

To my regret I must set forth here some general ideas. My aesthetic, or rather the science that I call modern aesthetics, differs too greatly from the dogmas taught until now that I run a risk in speaking before having been perfectly understood.

This is the crowd's opinion on art: there is an absolute beauty, located outside the artist, or, better, an ideal perfection toward which each artist strives and which each more or less attains. Thus, there is a common measure, this beauty itself, which is applied to each work, and depending on the degree to which the work approaches or misses the common measure, it is declared to have greater or lesser merit. Circumstances decreed that Greek beauty be chosen as the standard, with the result that judgments on all works of art cre-

ated by humanity depend on the greater or lesser resemblance the works bear to Greek works.

Thus, we have the varied progeny of human genius, which is always in labor, reduced to the simple hatching of Greek genius. Artists of that country discovered absolute beauty, and from then on all had been said. The common measure having been fixed, nothing was left but to imitate and to reproduce the models as exactly as possible. There are even people who would prove to you that the artists of the Renaissance were great because they were imitators. During more than two thousand years the world transforms itself, civilizations rise and crumble, societies develop or languish amid constantly changing customs; on the other hand, artists are born here and there, in the pale, cold mornings of Holland, in the warm, voluptuous evenings of Italy and Spain. But to what use! Absolute beauty is there, immutable, dominating the ages; against it are wretchedly broken all this life, all these passions, and all those imaginations that have found joy and suffering through more than two thousand years.

Here are my beliefs on artistic affairs. I take into consideration all humanity that has lived and that, before nature, at all hours, in all climates, in all circumstances, has sensed the imperious need to create humanely, to reproduce objects and beings by means of the arts. I thus take in a vast spectacle of which each part interests me and moves me profoundly. Each great artist has come to give us a new and personal translation of nature. Reality is the fixed element in this, and varied temperaments are the creative elements that have given works their different characters. It is in these different characters, in these always new aspects, that for me the powerfully humane interest of works of art consists. I should like to see the canvases of all the painters of the world brought together in an immense hall where we could go to read page by page the epic of human creation. And the theme would always be the same nature, the same reality; the variations would be the individual and original ways by which the artists had rendered God's great creation. It is within this immense hall that the crowd should place itself in order to judge works of art soundly. Here beauty is no longer an absolute thing, a ridiculous common measure. Beauty becomes life itself, the human element combining with the fixed element of reality, producing a creation that belongs to humanity. Beauty lives within us, not outside ourselves. What does a philosophical abstraction mean to me! Of what importance to me is a perfection dreamed up by a small group of men! That which interests me, a man, is humanity, my great mother, that which touches me, that which delights me. In human creations, in works of art, I seek to find behind each an artist, a brother, who presents nature to me under a new face, with all the power or all the sweetness of his personality. The work, thus seen, tells me the story of a heart and of a body, speaks to me of a civilization and of a locality. And when, in the center of the immense room where are hung the paintings of all the world's painters, I cast an eye on the vast assembly and find

there the same poem in a thousand different languages, I do not tire of re-reading it in each painting, charmed by the delicacies and the vigor of each dialect.

I cannot present here in its entirety the book I propose to write on my artistic beliefs, but will content myself with indicating the broader lines of it and what I believe. I do not topple any idol or deny any artist. I accept all works of art on the same basis, as manifestations of the human spirit. And all interest me almost equally; all possess true beauty: life, life in its thousand expressions, always changing, always new. The ridiculous common measure no longer exists. The critic studies a work in itself and declares it to be great insofar as he finds in it a strong and original translation of reality. He thus declares that the genesis of human creation has one more page, that an artist is born who gives nature a new soul and new horizons. And our creation extends from the past to the infinite reaches of the future. Each society will bring forth its artists who will manifest their personalities. No system, no theory can encompass life in its incessant productions. Our role as judges of works of art, then, is limited to setting forth the languages of temperaments, studying these languages, and saying what is supple and energetically new in them. If necessary, the philosophers can take care of drafting formulas. I wish to analyze only facts, and works of art are simple facts.

Thus I put aside the past; I have in hand neither rule nor measure; I stand before the works of Édouard Manet as before new facts that I want to explain and comment on.

What strikes me first in his paintings is a very delicate justness in the relationship of tones among themselves. Let me explain. Some pieces of fruit placed on a table stand out against a gray background. Among fruit, the color values form a complete range of tints, depending on whether they are more or less close together. If you take off from a note lighter than that in nature, the entire range must be consistently lighter; and the contrary effect must follow if you start from a darker tone. This is what is called, I believe, the law of values. I know of hardly anyone in the modern school besides Corot, Courbet, and Édouard Manet who has constantly obeyed this law in painting figures. The works gain from it a singular clarity, great truth, and charm of aspect.

Édouard Manet usually takes off from a lighter note than that of nature. His paintings are blond and luminous, of a solid paleness. Light falls white and broadly, softly illuminating the objects. The effect seems in no way forced; the characters and the landscapes bathe in a joyful brightness that fills the whole canvas.

What strikes me next is the necessary consequence of an exact adherence to the law of values. The artist, confronting any subject whatever, allows himself to be guided by his eyes, which perceive the subject in terms of broad tints that tend to control each other. A head placed against a wall is but a more or less

white spot against a more or less gray background, and the clothing next to the face becomes, for example, a more or less blue spot next to the more or less white spot. From this comes a great simplicity almost completely without details, an assembly of exact and delicate spots that at a short distance produce a painting of striking relief. I emphasize this characteristic of Édouard Manet's works because it is predominant in them and makes them what they are. The entire personality of an artist consists in the way his eye is organized: he sees blond and sees in masses.

The third thing to strike me is a grace that, although a bit dry, is charming. Let us be clear, however: I am not talking about the pink-and-white grace of porcelain doll heads. I refer to a penetrating and truly human grace. Édouard Manet is a man of the world, and in his paintings there are certain exquisite lines, certain delicate and charming attitudes that indicate his fondness for the elegances of the Salon. This is the unconscious element, the very nature of the painter. I want to take this occasion to protest against the relationship that some would like to establish between Édouard Manet's paintings and Charles Baudelaire's verse. I know that the poet and painter are linked by a lively sympathy, but I believe that I can affirm that the painter has never committed the foolishness, practiced by so many others, of wanting to put ideas into his paintings. The short analysis of his talent that I have just given proves with what naïveté he confronts nature. Whether he assembles several objects or several people, he is guided in his choice only by a desire to achieve beautiful spots, beautiful oppositions. It is ridiculous to want to make a mystic dreamer of an artist who obeys such a temperament.

After analysis comes synthesis. Let us take any painting by the artist and look for nothing more than what it contains: lighted objects, real creatures. The general aspect, I have said, is a luminous blondness. In the diffuse light, faces are cut into large flesh-colored planes, the lips become simple strokes, all is simplified and rises from the background in powerful masses. The justness of tones establishes the planes, fills the canvas with air, gives force to each thing. It has been said mockingly that Édouard Manet's paintings recall Épinal prints,[2] but there is much in this mockery that is actually praise. In both, the procedures are the same—colors applied in flat planes—but with the significant difference that the Épinal workmen used pure color without caring about values, while Édouard Manet multiplies the tones and establishes a just relationship among them. It would be much more interesting to compare this simplified

2. The town of Épinal in northeastern France is renowned for its manufacture of colored images or prints, a tradition dating back to the seventeenth century and made famous by the Pellerin family in the eighteenth century. The industry began with the depiction of religious subjects, particularly colored prints of saints, and during the early nineteenth century historic and patriotic subjects were also popular.—Ed.

painting with Japanese woodcuts, which resemble it in their strange elegance and magnificent splashes of color.

The first impression produced by one of Édouard Manet's paintings is a bit harsh. One is not used to such simple and sincere translations of reality. Then, as I have said, there are certain elegant severities that are surprising. At first the eye sees only some broadly applied colors. Soon objects take shape and assume their places. After some seconds the ensemble appears vigorous, and one feels a genuine pleasure in looking at this light and serious painting that renders nature with a gentle brutality, if I may express it thus. On coming close to the painting, one sees that the technique is more delicate than harsh. The artist uses only the brush and uses it quite prudently; there is no piling up of colors, but a unified layer. This daring man, who has been so mocked, follows very wise procedures. If his works have an individual aspect, they owe it only to the very personal way that he perceives and translates objects.

In sum, if I were questioned on the matter, if someone asked me what new language Édouard Manet speaks, I should reply: he speaks a language compounded of simplicity and justness. The note he provides is that blond note filling the canvas with light. The translation he gives us is a just and simplified translation built upon large groupings with only the masses indicated.

I cannot repeat too often that we must forget a thousand things in order to understand and enjoy this talent. It is not a matter of a search for an absolute beauty. The artist paints neither history nor the soul. What is called composition does not exist for him, and the task he undertakes is not that of representing a particular thought or historical act. For this reason he must not be judged either as a moralist or as a literary man: he must be judged as a painter. He treats figure painting the same way that still-life painting is treated in the schools. I mean, he groups figures in front of him a bit casually and then takes pains only to fix them on his canvas as he sees them, with the lively oppositions they create as some stand out from the others. Do not ask of him anything but a justly literal translation. He does not know how to sing or philosophize. He knows how to paint, and that is all. He has talent—and this constitutes his particular temperament—for grasping the dominant tones in all their nicety and for modeling things and beings in large planes.

He is a child of our time. I see him as an analytical painter. All the problems have been put into question; science has wanted solid foundations and has returned to the exact observation of facts. And this change has taken place not only in the scientific field; all understanding, all human works tend to search for firm and definite principles in reality. Our modern landscape painters have surpassed our history and genre painters because they have studied our countryside, content to translate the first bit of woods they come to. Édouard Manet applies this same method in each of his works. While others rack their brains to

invent a new *Death of Caesar* or *Socrates Drinking the Hemlock,* he quietly ar-
ranges a few objects and a few people in the corner of his studio and begins to
paint, analyzing the whole with care. I repeat, he is a simple analyst. His task
holds far more interest than the plagiaries of his colleagues. Thus art itself
tends toward a certitude; the artist is an interpreter of that which is, and his
works have for me the great merit of a precise description made in an original
and human language.

He has been reproached for imitating the Spanish masters. I agree that there
is some similarity between his first works and those of these masters: everyone
is somebody's son. But from his *Déjeuner sur l'herbe* on, he seems to me to
affirm clearly the personal identity I have tried to explain and briefly comment
on. The truth is, perhaps, that the public, seeing him paint Spanish scenes and
costumes, will have decided that he takes his models from beyond the Pyrenees.
From that it is not far to the accusation of plagiarism. So it is worth making
known that if Édouard Manet has painted *espadas* and *majos* [matadors and
young gallants], it is because he has some Spanish costumes in his studio and
finds their colors beautiful. He went to Spain only in 1865, and his paintings
have too individual an accent for him to be looked upon as only the bastard son
of Velázquez and Goya.

ART AT THE MOMENT

Perhaps, before making the slightest judgment, I should explain categori-
cally my way of looking at art, my aesthetic. I know that the fragments of opin-
ions I have been forced to assert quite incidentally have offended accepted ideas,
and that these seemingly unsupported blunt affirmations are held against me.

Like everyone else I have my little theory, and like everyone else I think mine
is the only one that is true. At the risk of not being amusing, I am going to set
down my theory. My likes and dislikes follow from it quite naturally.

For the public—and here I am not using the word in a bad sense—for the
public, a work of art, a painting, is an agreeable object that moves the emotions
in a way that is pleasant and frightful. It is a massacre in which panting victims
tremble and crawl beneath menacing guns; or it is a delectable young girl, pure
as snow, dreaming in the moonlight as she leans on the shaft of a column. What
I mean is that the crowd sees on the canvas a subject that seizes them either by
the throat or by the heart, and they ask no more from an artist than a tear or a
smile.

For me—for many people, I hope—a work of art is, on the contrary, a per-
sonal mark, an individuality.

I do not ask an artist to provide pleasant visions for me, or terrifying night-

Édouard Manet, *Déjeuner sur l'herbe,* 1863, oil on canvas.

mares. I ask him to free himself, body and soul, to proclaim loudly a powerful and individual spirit, a firm and strong character that can seize nature boldly in its hand and plant it erect before us, just as the artist sees it. In a word, I have the most profound disdain for little talents, for calculated flatteries, for that which study has been able to teach and relentless work has rendered familiar, for this one's historical sensationalism and that one's perfumed reveries. But I have the deepest admiration for individualistic works, for those that spring from a unique and vigorous hand.

This is not a matter of pleasing or not pleasing; it is a matter of being one-self, of baring one's heart, of energetically expressing one's individuality.

I am not for any school, because I am for human truth, which excludes all coteries and systems. The word *art* I dislike; it implies all kinds of ideas about necessary arrangements, an absolute ideal. To create art—is that not to make something apart from man and nature? I prefer that one creates from life; I want

everyone to be alive, to create freshly, apart from everything, according to one's own eyes and temperament. In a painting I look above all for a man, not a picture.

There are, according to me, two elements in a work: the real element, which is nature, and the personal element, which is man.

The real element, nature, is fixed and always the same; it exists the same for everyone. I would say that it might serve as a common measure in all created works, if I were to admit that there could be a common measure.

The personal element, man, on the contrary, is infinitely variable. There are as many works as there are different spirits. If temperament did not exist, all paintings would simply be photographs.

Thus, a work of art is always but the combination of a man, the variable element, and nature, the fixed element. The word *realist* means nothing to me, since I insist on subordinating reality to temperament. Create something true and I applaud; but create something personal and alive and I applaud more strongly. If you go outside this reasoning, you will be forced to deny the past and to create definitions that you will have to expand every year.

For it is another bit of foolishness to believe that, as regards artistic beauty, there exists an absolute and eternal truth. Single and complete truth is not for us, who fabricate every morning a truth that we sweat out each evening. Like everything, art is a human product, a human secretion. It is our bodies that exude the beauty of our works. Our bodies change according to climates and customs, and the secretion changes in the same way.

That is to say that tomorrow's work could not be today's. You cannot formulate any rule or set forth any precept: you must abandon yourself bravely to your nature and try not to lie to yourself. You are afraid to speak your own language, you who painfully try to spell out dead languages!

My urgent desire is this: I want no student works made after the masters' models; they remind me of the pages of writing I traced as a child from lithographed pages put up in front of me. I want no returning to the past, pretended revivals, pictures painted after an ideal put together from ideal bits collected from all times. I do not at all want anything that has no life, temperament, reality!

And now, I beg you, take pity on me. Imagine what a temperament formed like mine had to suffer yesterday, lost in the vast and cheerless nullity of the Salon. Frankly, for a moment I thought simply of giving up the job, foreseeing too much severity.

But then I am not going to offend the artists' tastes; rather, the artists have just offended my sympathies much more severely. Do my readers understand my predicament and say, "There is a poor devil who is really completely nauseated but who controls his sickness to preserve the decency he owes the public?"

I have never seen such a welter of mediocrities. There are two thousand

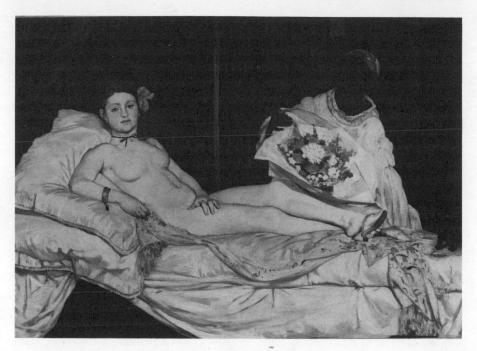

Édouard Manet, *Olympia,* 1863, oil on canvas.

paintings there, but not ten men. Of these two thousand canvases, twelve or fifteen speak to you in a human language; the rest content you with silly beauty-shop tricks. Am I too severe? I am only saying aloud what others are thinking to themselves.

At least I do not deny our own time. I have faith in it; I know that it is searching and working hard. We are in a period of struggles and fevers; we have our talents and our geniuses. But I do not want the mediocre and the powerful to be confused. I believe it is proper not to conceive an indifferent indulgence that bestows a word of praise on everyone and really praises nobody.

This is our epoch. We are civilized, we have boudoirs and salons. Whitewash is sufficient for the little people, but the rich must have paintings on their walls. So a whole corporation of workers has been created to finish the work begun by the masons. As you might imagine, many painters are needed, and they have to be turned out en masse. They are given, moreover, the best advice on pleasing and not offending the taste of the time.

Add to this the spirit of modern art. Confronted with the invasion of science and industry, artists, in reaction, throw themselves into a dream, into a shoddy

heaven of tinsel and tissue paper. Go see if the Renaissance masters dreamed of the adorable little nothings before which we swoon. They were men of strong character who painted wholeheartedly. We, we are nervous and apprehensive; there is a good deal of the feminine in us, and we feel so weak and so worn out that we resent robust health. Give us sentimentalities and affectations!

Our artists are poets. That is a grave insult to men who are not even asked to think, but I maintain it. Look at the Salon: there are nothing but strophes and madrigals. This one composes an ode to Poland, this other an ode to Cleopatra; there is one who sings in the manner of Tibullus, and another who tries to sound the great trumpet of Lucretius. I am not mentioning the battle hymns, elegies, spicy ballads, or fables.

What a farce!

For mercy's sake, paint, since you are painters, don't sing! Here is flesh, here is light! Make of it an Adam who will be your creation. You must be makers of men, not fabricators of shadows. But, of course, I know that a nude man is not quite proper in a boudoir. That is why you paint your great grotesque puppets that are no more indecent—or more alive—than the pink-skinned dolls of little girls.

Talent works differently, please note. Look at the few remarkable canvases in the Salon. They make a hole in the wall. They are almost offensive. They shout among the dulcet murmurs of their neighbors. The painters who create such works are outside the corporation of elegant house painters of whom I spoke. They are few in number; they keep to themselves, outside any school.

I have already said that the jury cannot be blamed for the mediocrity of our painters. But, since the jury believes itself obligated to be severe, why did it not spare us the sight of all this foolishness? If only the talented were admitted, a room three meters square would be big enough.

Have I been so revolutionary in regretting that some temperaments do not appear at the Salon? We are not so rich in distinct personalities to refuse what they produce. Of course, I know that temperaments do not die from a refusal. I defend their cause because it seems just to me. But at heart I am at ease about the health of talent. Our fathers laughed at Courbet, and now we go into ecstasies over him. We laugh at Manet, and our children will go into ecstasies over his canvases.

ADRIANO CECIONI

Telemaco Signorini (1884)
Vincenzo Cabianca (ca. 1884)

Adriano Cecioni (1836–1886) was a painter, sculptor, and critic who at a young age was part of the group of venturesome artists who gathered regularly at the Caffè Michelangelo in Florence during the 1850s. All were actively involved in the cause of a united Italy, and all were equally adamant about modern directions in painting. Their small pictures, composed of simple blocks of color that forcefully recorded impressions from the environs of Florence, were responsible for their identification as the *Macchiaiuoli* (spot-makers). Although they insisted on working directly from nature in the simplest manner possible, many members of the group—Giuseppe Abbati (1836–1868), Silvestro Lega (1826–1895), and Raffaello Sernesi (1838–1866), for example—composed their pictures with a structural quality strangely reminiscent of Tuscan painting of the fourteenth and fifteenth centuries. This aspect of their work was noted by various critics, including Telemaco Signorini (1835–1901).

The first public showing by the *Macchiaiuoli* painters was in the Pan-Italian Exhibition at Florence in 1861, where they received caustic criticism for seeking to debase art and to subvert society. As a result of the exhibition, however, the group drew more tightly together, using the term of opprobrium *Macchiaiuoli* as a defiant badge. Telemaco Signorini was one of the key members of the Caffè Michelangelo group, and his well-articulated ideas and experiments in painting, shared with Vito D'Ancona (1825–1884) and Vincenzo Cabianca (1837–1902), had considerable impact on the formation of the new group. With his literary background, he became one of the most persuasive critics and apologists for the new artistic tendencies in Italy.

Vincenzo Cabianca was one of the boldest of the *Macchiaiuoli* painters. Having studied in Milan and Venice, he came to Florence in 1853 and associated with the artists of the Caffè Michelangelo. Like most of the others in the group, he was a fervent patriot active in the cause of a free and united Italy. In 1862, and frequently thereafter, he exhibited his works in London. In 1868 he moved to Rome, where he spent the remainder of his life.

431

Cecioni's article on Signorini appeared originally in *La Domenica letteraria,* published in Rome on August 3, 1884. The critique on Cabianca, composed at about the same time, was first published much later, in Cecioni's collected writings, *Scritti e ricordi,* ed. Gustavo Uzielli (Florence: Tipografia Domenicana, 1905). Most copies of this edition were destroyed by fire prior to their distribution. The present translations were made from Uzielli's edition of *Scritti e ricordi,* pp. 302–4 and 333–34. In 1932 Enrico Somere republished Cecioni's writings under the title *Opere e scritti* (Milan: "L'Esame," Edizione d'Arte Moderna). 🌿

TELEMACO SIGNORINI

Signorini is a personality in the art world, and his personality consists in his having been one of the first to rise up against the older art, and one of the most open and efficient adversaries of religious respect for masterpieces representing aesthetic conventionalism, or the cult of form for the sake of form. All of the *Macchiaiuoli,* or Impressionists if you want to call them that, were in accord with this, their art consisting not in studying form but in studying how to render the impressions they received from nature by means of spots of color, of lights and darks. For example, a single spot of color for the face, another for the hair, another, let us say, for the handkerchief, another for the jacket or suit, another for the coat, another for the hands and feet, and likewise for the earth and sky.

The figures were hardly ever more than fifteen centimeters high, the dimensions of nature seen from a certain distance; that is, the distance at which the parts of the scene that have made the impression are perceived in terms of masses, not detail. Thus, a figure seen against a white wall or against the sky at sunset or against an area illuminated by the sun, was considered as a dark spot against a light spot, and in the dark spot account was taken only of the principal parts that formed it, that is, those that could be seen: for example, the head, but without the details of eyes, nose, and mouth; the hands without fingers; clothing without folds. This was done first of all because detail disappears at this scale; then because it was not in the nature of the *macchia* to include detailed study but rather to establish the principles that could serve as a solid base for the development of an entirely new art. These principles are *color, value,* and *relationship.*

Even the small painting was called a *macchia.* Although it might represent a scene of eight or ten figures, one called it a good or bad *macchia* in color or in light and dark, depending on how it came out. From this it is evident that the whole importance was given to *color* and *light and dark,* which produce *value* and *relationships* in a work of art.

Telamaco Signorini, *Leith,* 1881, oil on canvas.

It would be impossible to give an idea of the attempts made, especially for the effects of the sun. Color was painted over color, but it did not produce the value of light; then it was said not to depend on quantity but on quality, and the canvas was scraped to begin again with a new set of colors—the result was a failure. All of the powers of the palette were exhausted, but the effect of the sun was not obtained. Even artifices were brought into play, but to no avail. It was a

433

continuous making and undoing, testing, trying, retrying, and all to determine the just relationship of one value to another, whether through color or light and dark. One can understand why in this kind of research the study of form and contour would be left out or would hold a very secondary place. Contour, as such, played no part, nor could it play a part, because if the artists had had to study even one single part of their paintings through drawing, as, for example, the trunk of a tree, by that time the effect would have changed and the purpose of their studies would have been forfeited.

This much admitted, it would be foolish to insist that drawing existed where it could not be. Nonetheless, ignorant sorts who protest against badly drawn figures were not lacking. But Signorini knew how to defend himself in the face of any attack, direct or indirect, making fools of the students and professors of the Academy, to whom he directed at times such remarks of endearment that he made those present explode with laughter—with the exception, of course, of the friends and students of the person in question. The compassionate and sardonic way in which he treated those who did not enjoy his esteem was worse than injury. Enthusiasm, antipathy, and discouragement he normally expressed in a few exclamatory words, which were more effective than any lecture by virtue of the cavernous tone of voice in which he uttered them and by certain movements of the face, especially of the mouth, which his friends called "boccacce" [grimaces], with which he accompanied them. When he said to someone, for example, "How *pipi* you are!" the sneer consisted, more than in the phrase itself, in the movement of his lips and in his way of looking at the person over his glasses. He had a peculiar way of saying, "Are you good in composition?" or "Did Professor Paganucci teach you the name of this muscle?" Most often, when things went well, he got the reply, "You have broken my . . . ," and he would say, "Don't swear! If the Inspector knew about it he would throw you out of the Academy." To escape the embarrassment the other would say: "Goodbye." And he: "Goodbye, *pipi*." . . .

VINCENZO CABIANCA

. . . The word *macchia* has at times been misunderstood among the *Macchiaiuoli* themselves. Many of them believe that *macchia* means sketch, and that the study of gradations and of parts within the part, serving to finish the sketch, eliminates the *macchia* from the picture. This is the misconception. The *macchia* is the base and as such remains in the painting. Studies of form and detail have the function of determining the parts within it, without destroying it or rendering it insignificant. The true effect results from the *macchia* of *color* and of *light and dark,* each of which has its own value, determined by means of *relationship.*

In every *macchia* this relationship has a double value: as color and as light and dark. When one says, "The tone is right in color but not in value," one means that it is too light or too dark in relationship to the other tones. . . .

It remains a fact that the *macchia* is not a sketch but science and as such sparked a revolution against all systems for painting used before or after its appearance. First of all, it taught us that nature must be surprised. In fact, all of the realists' works represent, for better or worse, nature surprised by the artist in one of its infinite moments. But to capture this surprise, it is necessary to elaborate the method of reproducing the effect in the shortest possible time, that is, in the space of time that the effect itself lasts.

Not all the things that the *macchia* has taught us have been put to use, because of the ignorance and fickleness of the times. One of these things, scarcely begun, which brought greater light into art, was to have taught us that the pencil should have no part in creating the painting, which must be made wholly with the brush. Pencil and charcoal must not be used even to make the embryo of the parts that form the painting, because if they are used, the brush begins to work with those lines in a manner different from what it would if the lines were not there. The brush becomes slave to such preparation, whereas it should attack the virgin canvas and do everything, if possible, from the beginning or at a single time. Imposing this system as a means has resulted in the elaboration of the method. Moreover, one has to be convinced. It is truly absurd to believe that the pencil or charcoal lines help save time or give greater security in painting on the canvas. Instead the work increases and becomes more complicated for a variety of reasons, principally because when the painter has observed and studied a point from nature he must be able to put down his impression on the canvas immediately, without encountering anything that would break up or disturb the impression.

The discussion of this point could go on forever, but we shall come back to it later. For now I shall limit myself to repeating that the *macchia* is science, that its practitioners cannot esteem even the most prized works, ancient or modern, if these do not show evidence, at the least, that the principles regarding value and relationship are understood, much less taking into account all the other elements that make up the wisdom of modern art.

ÉMILE BLÉMONT

The Impressionists (1876)

GEORGES RIVIÈRE

The Exhibition of the Impressionists (1877)

Early in 1874 a group of painters, most of whom had been rejected frequently from the annual Salon, organized the "Société Anonyme des artistes peintres, sculpteurs et graveurs" in order to sponsor their own exhibitions. Their first showing, with thirty artists represented, was held from April 15 to May 15, 1874, in space made available by the photographer Nadar. For the most part, critical reception of the works was unfavorable, with much ridicule being leveled against pictures by Cézanne, Monet, and others who employed bright, freely applied colors. Louis Leroy of the *Charivari* (April 25, 1874) poked fun at this mode of painting by placing the tag *Impressionniste* on the central group of painters. The label, a play on the title of one of Monet's pictures, *Impression, Sunrise*, was by no means a new term. But it caught on with critics, and the painters themselves soon adopted it as a banner of combat.

Criticism of the group's second exhibition, held in April 1876 at the galleries of Durand-Ruel, was less frivolous but no less harsh. Albert Wolff, writing in *Le Figaro* (April 2, 1876), chose the occasion to attack the independent movement that threatened established modes and values. Only nineteen painters exhibited on this second occasion, with works by Monet, Degas, Sisley, Renoir, Pissarro, Morisot, and Caillebotte clearly dominating the exhibition. (Cézanne did not participate.) Armand Silvestre, writing in *L'Opinion* (April 2, 1876), attempted to explain to the public something of the painters' goals in using bright colors that had been applied quickly and out-of-doors: "For a vision of things refined to the point of obliteration and jaded by the abuse of conventions, they have substituted a kind of very summary and very clear analytical impression." Émile Blémont also, in the article translated here from *Le Rappel*

(April 9, 1876), tried to make it clear that the painters had good reason for their manner of painting.

In all, there were eight exhibitions by the Impressionists, the last in 1886. On the occasion of the third exhibition, in 1877, the young journalist Georges Rivière brought out a weekly review entitled *L'Impressionniste*. Only four issues of the journal were published, and much of the writing was contributed by Rivière himself. Translated here are an open letter to the editor of *Le Figaro*, which Rivière wrote in response to a damning review signed by a certain "Baron Grimme," and a longer enthusiastic critique by Rivière that appeared in the first issue of *L'Impressionniste* (April 6, 1876).

The principal painters of the group wrote little on the theories behind their art, but elaborate explanations, often quite technical, of the Impressionists' use of color came from outside critics. Such explanations, of course, are more useful in revealing the nature of the critical problem than in explaining the actual views of the painters. When the Impressionists did write about their works in correspondence, they merely emphasized the importance of seizing the motif and of concentrating totally on the act of seeing. Some members of the group later rebelled against this militant discouragement of structural principles, either in order to embrace the systematic form and color of Seurat or to return to more traditional compositional structures. At the start of the Impressionist movement, however, a concept of the artist's independence in candidly viewing nature seems to have been theory enough, at least for the principal artists involved.

The source for these translations is from Lionello Venturi, *Les Archives de l'impressionnisme* (New York: Burt Franklin, 1968), pp. 298 and 306–14.

ÉMILE BLÉMONT: THE IMPRESSIONISTS

What is an Impressionist painter? We have hardly been given a satisfactory definition, but it seems to us that the artists who group themselves—or are grouped—under this term pursue a similar end, though employing different manners of execution: to render with absolute sincerity, without arranging or attenuating, in a simple and broad technique, the impression awakened in them by aspects of reality.

For them art is not a minute and finicky imitation of what once was called *la belle nature*. They are not concerned with more or less slavishly reproducing beings and things or with laboriously reconstructing a view of the whole, petty detail by petty detail. They do not imitate; they translate, they interpret. They set out to extract the result of the multiple lines and colors that the eye perceives at a glance before an aspect of nature.

They are synthesizers, not analysts, and in this they are right, we believe. For if analysis is the method *par excellence* for science, synthesis is the true procedure of art. There are no other laws than the necessary relationships between things. They think, as did Diderot, that the idea of the beautiful is the perception of these relationships. And since there are perhaps no two men on earth who see exactly the same relationships in the same object, they see no need to modify their personal and direct sensation in accordance with this or that convention.

In principle, in theory, we believe then that we can fully approve of them.

In practice it is quite another thing. One does not always do what one intends to do, as it should be done. One does not always achieve the goal that one clearly envisages.

GEORGES RIVIÈRE: TO THE EDITOR OF
LE FIGARO (APRIL 6, 1877)

One remembers well when a few years ago a group of artists, united by the same tendencies, had the idea of holding an exhibition outside the official Salon, the insults that were hurled by the newspapers at these revolutionaries who were trying for something no one had yet thought of in art. At that time the newspapers had the mockers on their side; such painting was entirely different from that seen every day, and the public allowed itself to be carried away by any unhappy witticism directed against the young people who were doing such foolish things, they said.

The second exhibition was greeted with the same exclamations on the part of the press. Wolff, who has some pretensions as a connoisseur, could not find terms crude enough in his fertile brain to crush the artists who were struggling courageously against misfortune. The public, however, in view of the insistence with which the painters applied themselves to their continuing study, examined the works a bit more closely; the Impressionists emerged stronger from this second trial, sustained by a good number of remarkable men.

In 1877 the exhibition has had a huge success. On Wednesday everyone replied with alacrity to the exhibitors' invitation. The expressions of congenial feelings were many. It was with profound sadness, then, that Thursday morning I read the ridiculous and odious criticisms of the Impressionists. Aside from *Le Rappel, L'Homme libre,* and a few others, the papers were unanimous in their recriminations.

That in *Le Figaro,* among others, is unworthy of the talented man who signed it.

I do not indict these men for not understanding painting, but I do reproach

them for not discussing the matter with some competent and impartial people before writing articles that everyone reads with attention. I say this in their own interest, for the honor of the French press. It is really deplorable to present to the world this unprecedented spectacle of the press hurling idiotic, stupid, and hateful things at talented men, just at the moment in which their efforts are crowned with success.

It is a remarkable fact that the press is always behind. Instead of guiding the public, it follows it. A newspaper has never discovered that an artist has talent; the press has always repeated after the public, like a boring echo: Mr. X has a great deal of talent.

At the exhibition in the Rue Le Peletier, the critics saw nothing, neither the astonishing drawing nor charming young color of Renoir, neither the power of Monet nor the science and grandeur of Cézanne and Degas, of Pissarro, Sisley, and Caillebotte, not the unexpected and feminine charm of Mlle. Morisot— nothing. They laughed like pretentious ignoramuses.

I saw critics laughing in front of Monet's *Turkeys* and Renoir's *The Ball*. Had I asked them the cause of their hilarity, they would have been at a complete loss. There were others who laughed in front of Cézanne's *Bathers* and *Portrait of a Man*. Let them consult a few painters and they will regret their laughter.

The press has acted badly. We cannot repeat this too often. It has even acted clumsily, because the public was not with it. But then it has always acted this way. After having insulted Delacroix, it insulted Manet. Now that his talent has raised him above its attacks, it has gone after the Impressionists. But it has begun too late; the public makes a mockery of its comments by crowding in to admire the works that talented men submit for their judgment, a judgment which is sounder because it is more impartial than that of some vain creatures who always laugh at what they fail to understand.

The directors of newspapers should choose more carefully the men they assign as critics. This is a very important role, which they sacrifice, it would seem, without minding the ridicule that rebounds against themselves. To criticize a painting, it is not enough to have written four lines on a reception or a report on the Legislative Assembly. One needs an artistic education, which, alas, very few have taken the pains to acquire, as well as a respect for creative work that only a creator can have, that a critic, in consequence, will never have.

But this is preaching in the wilderness. The less one has produced, the less modest one is. I am sure that I shall convert no one among the editors of *Le Figaro*.

GEORGES RIVIÈRE: THE EXHIBITION OF THE IMPRESSIONISTS (APRIL 6, 1877)

What enchantment, what remarkable works, even masterpieces, are gathered together in the galleries in Rue Le Peletier! Nowhere at any time has such an exhibition been offered to the public. From the first moment, one is dazzled and charmed, and the further one goes the more the charm increases. In the first room are some very beautiful canvases of Renoir and paintings by Monet and Caillebotte. In the second gallery, Monet's large painting of turkeys, some paintings by Renoir, landscapes by Monet, Pissarro, Sisley, Guillaumin, Cordey, and Lamy give the room an inexpressible and quasi-musical gaiety.

On entering the second gallery, our attention is first drawn to Renoir's *The Ball* and a large landscape by Pissarro. Then you turn to admire the masterly canvases of Cézanne and the charming paintings, so fine and above all so feminine, of Mlle. Berthe Morisot.

In the large gallery adjoining, Monet, Pissarro, Sisley, and Caillebotte are brought together.

And at the back, in a little gallery, are Degas's astonishing paintings and some ravishing watercolors by Mlle. Berthe Morisot.

That is more or less the whole of the exhibition. The paintings have been hung with exquisite taste; each panel presents an agreeable effect with never a discordant note in the ensemble of works, which are, however, so different from one another.

The exhibition in the Rue Le Peletier shows us only living scenes that sadden neither the eye nor the mind: luminous, joyful, or grandiose landscapes; never those lugubrious notes that make a black spot on the eye.

Let us begin with the works of Renoir and with the most important of his paintings, *The Ball*. In a garden drenched in sun, scarcely shaded by a few thin acacias whose delicate foliage trembles in the slightest breath of air, some charming young girls in the full freshness of their fifteen years, proud of their light dresses that cost them little for material and nothing to make, and a group of gay young men make up the happy crowd that drowns out the orchestra with its hubbub. The lost notes of a quadrille can scarcely be heard from time to time, just enough to keep the dancers in step. Noise, laughter, movement, sun, in an atmosphere of youth: that is *The Ball* by Renoir. It is an essentially Parisian work. These are the same young girls who jostle us every day and whose babbling fills Paris at certain hours. A smile and ruffles are all they need to be pretty. Renoir has proved it. Look at the grace of the pretty girl resting on a bench! She chats, underlining her words with a delicate smile, and her eyes seek curiously to read the face of her companion. And that young philosopher astride his chair, smoking a good pipe! What profound scorn he must have for the frolicking dancers who seem to defy the sun in the order of the polka!

Edgar Degas, *Ballet Dancer Resting*, c. 1900–1905, charcoal drawing.

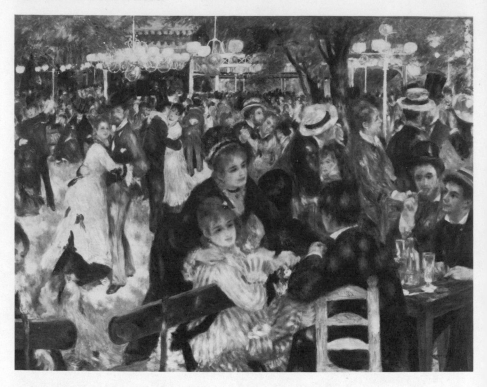

Auguste Renoir, *Bal au Moulin de la Galette,* 1876, oil on canvas.

Renoir surely has the right to be proud of *The Ball;* he has never been more inspired. It is a page of history, a precious monument of Parisian life rendered with rigorous fidelity. No one before him had dreamed of recording a simple fact of daily life on so large a canvas; it is an audacity that will be crowned by success, as it should be. This painting has a very important contribution to make to the future, which we must call attention to. It is a historical painting. Renoir and his friends have realized that historical painting is not the more or less laughable illustration of stories about the past. They have cleared a way that others will certainly follow. Let those who want to paint historical pictures paint the history of their own period, instead of disturbing the dust of past centuries. Of what importance to us are musical-comedy kings dressed up in blue or yellow robes, with scepters in their hands and crowns on their heads! When for the hundredth time you are shown St. Louis meting out justice under an oak tree, will we be much advanced by it? What documents do artists who devote themselves to such lucubrations leave for future centuries as the history of our time?

442

Every conscientious artist strives to immortalize his work; by what right do paintings that provide nothing new in the way of color or in choice of subject expect to achieve immortality?

To treat a subject for the tones and not for the subject itself, that is what distinguishes the Impressionists from other painters. There are, after all, some Italians, Belgians, and others who color little effigies dressed like us and who thus contribute, we might say, to the history of our period. We will not deny it; we will even add that photographers and tailors who publish fashion plates contribute no less than they. Are they for this reason artists? It is above all the study, the new way of showing a subject, that characterizes Renoir's very personal style. Instead of searching out the secrets of the old masters, Velázquez or Franz Hals, like the willing youngsters at the Quai Malaquais, Renoir has sought and found a contemporary note. *The Ball,* whose color has such charm and novelty, will certainly be the great success of this year's exhibitions of painting.

If, according to Boileau, "a faultless sonnet is worth more than a lengthy poem," I think that a perfect painting like *The Swing* is worth as much as *The Ball.*

What calm, what serenity the painting has! These certainly are people who have nothing to do; this is no longer the ball with its action, its consuming gaiety, the ball where dancers amuse themselves for a few hours that must serve for the rest of the week. No, here it peacefully slips by without incident in the middle of a great park where the luxurious foliage sparkles like a bouquet of emeralds. One feels that all passion is absent; these young people rejoice in life, in the superb weather, in the morning sun filtering through the foliage. What does the rest of humanity matter to them! They are happy. These are the final words that come to the mind of those who see this charming painting. None has given me more pleasure than this.

Renoir is exhibiting several portraits, among which a portrait of a child is very remarkable. What a charming little girl, with long blond hair falling around her shoulders and her large eyes wide open with curiosity. It is more than a portrait, it is a real painting. The portraits of Madame C. and Madame D. are very beautiful, both of them. They exhibit the same careful study of the tones that produce the effect of life by relating the figure to its surroundings. Madame S.'s portrait is very pretty. As pretty, I would say, as the original, and everyone will agree that one could hardly ask more of the painter. The political world is represented by a very good likeness of Mr. Sp., member of parliament for the Seine. The series of portraits is brought to a close by that of one of his associates, Sisley, an extraordinary likeness and of great value as a work of art.

Three studies—a woman in a bodice and two little canvases, the head of a woman and the head of a man—are charming and very Parisian. *The View of*

the Seine at Champrosay is a superb landscape, one of the most beautiful that has been made up to the present time. Never before has anyone produced such a striking sensation of a windy autumn day. *La Place Saint-Georges* is very beautiful. It is a morning effect with a May sun enflaming the flowering almond trees. One inhales the refreshing fragance of the great green trees bordering the gardens. *Sunset at Montmartre,* with its atmosphere of gold and diamonds, dazzles the eye. While the sun is still shining in the valley, the foreground, enclosed by a hedge, is already passing into the evening shadow. At the point of disappearing, the sun seems to double its intensity, the tile roofs sparkle, the leaves sing on the rippling branches, the white walls are caressed with metallic glints, and the horizon is lost in the dazzling light. Here and there, patches of shade made by hills whose summits are lost in gold stand out feebly like dying dreams. In this landscape is a power of color never before achieved.

Let us bring this enumeration to a close by citing a large panel depicting some magnificent red dahlias in a tangle of grass and liana. This great painting makes a splendid decoration.

Renoir's exhibition is, as you see, very important for the number as well as the quality of the works shown; it is much more complete even than those of past years.

We shall say no more; it is for members of the public themselves to appreciate these works exhibited for them; it is to their hearts that these paintings are addressed. If they are moved, the end is fulfilled. Nothing more could be asked of the artist, and the painter, we are sure, will be sufficiently repaid for his labors.

Monet, whose works we are going to try to describe, seems to be the exact opposite of Renoir. The power, the animation, in a word, the life with which the painter of *The Ball* infuses his people, Monet infuses into objects. He has discovered the soul in things. In his paintings, water splashes, locomotives run, the sails of boats billow before the wind, countryside, houses, everything in this great artist's works has an intense and personal life that no one before had discovered or even suspected.

Monet is not satisfied with rendering the impressive and grandiose aspect of nature. He has shown it as friendly and charming, the way the eye of a happy man would see it. An unhappy thought never arises to trouble the viewer before this powerful artist's canvases. After the pleasure of admiring them, one feels only the regret of not being able to live eternally in the midst of the luxuriant nature that blossoms in his paintings.

This year Monet gives us several canvases representing locomotives, by themselves or attached to a band of cars in the station of Saint-Lazare. These paintings have astonishing variety, despite the monotony and aridity of the subject. Here, more than anywhere else, is demonstrated the science of compositional arrangement, which is one of Monet's masterly qualities.

Claude Monet, *La Gare St.-Lazare,* 1877, oil on canvas.

In one of the largest paintings, the train has just arrived and the locomotive is about to leave again. Like an impatient and impetuous beast, animated rather than weary after the long journey it has just completed, it puffs out its plumes of smoke that stride against the glass roof of the great concourse. Around the monster, men swarm about the tracks like pygmies at the feet of a giant. On the other side, locomotives not in use sleep while waiting. You hear the shouts of employees, the shrill whistles of machines broadcasting their cries of alarm, the incessant noise of iron, and the formidable, panting breath of the steam.

You see the grandiose and mad activity of a railroad station: the ground trembles at each turn of the wheels, the walks are damp with sweat, and the air is filled with the acrid odor that emanates from burning coal.

In looking at this magnificent painting, you are seized by the same emotion as before the natural scene itself, and this emotion is perhaps even stronger because within the painting is the emotion of the artist as well.

Near this painting another of the same size represents the arrival of a train in bright sunlight. It is a joyous, lively painting. People hurry to leave the cars,

smoke retreats to the rear to rise higher in the air, and the sun, penetrating the glass roof, gilds the black rails and machines. In some paintings, the rapid and irresistible trains, enveloped in the light folds of smoke, are engulfed by the station. In others, the great immobile, scattered locomotives await their departure. The same power animates the objects in all of them, as only Monet knows how to do. Alongside the engines, running along endless rails, alongside the smoke and black dust, are smiling, calm, and joyous landscapes, such as the corner of a pond with dahlias, the garden of a country house, or the bank of a pond with deep, dark-blue water in which the tall trees are reflected. The garden of the Tuileries, with Paris drowned in the golden dust of the setting sun, is a remarkable work. The sketch for the same painting has a very special charm in its humility.

We deliberately chose to discuss first in the exhibition two artists of equal talent whose names have been associated in praise or criticism, but whose work, although departing from the same point, is so different.

We have shown the same fertility in each and a similar range; anything we could add would be superfluous.

Degas.

How to discuss this essentially Parisian artist whose every work shows as much literary and philosophical ability as linear art and the science of coloring?

With one stroke he tells better and faster everything that can be said about himself, because his works are always intellectual, fine, and sincere. He does not try to give the impression of a naïveté he cannot possess. Quite the contrary, his prodigious science is evident everywhere. His ingenuity, so attractive and individual, arranges his figures in the most unexpected and amusing way, at the same time that everything seems always true and normal. Moreover, Degas hates excess, which he considers Romantic confusion, the substitution of dream for life, in a word, panache. He is an observer. He never looks for exaggeration. The effect is always derived from nature itself, unforced. This is what makes him the most exacting historian of the scenes he shows us.

You no longer need go to the Opéra after having seen his pastels of "the ladies of the corps de ballet." His studies of these "café-concerts" have a greater effect on you than the place itself, because the artist has a science and an art that you do not. There is one of these "café-concerts" with a woman in a red gown that is truly marvelous. What art is shown in the women in the background in their muslin dresses, hiding behind their fans, and in the attentive spectators in the foreground, their heads raised, necks craning forward to listen with glee to a coarse song accompanied by vulgar gestures! The woman there! Isn't she, you guess, a somewhat soused contralto? The ideal of the public! How that gesture and that voice must be carefully studied in the silence of the boudoir by a pretty marchioness who will coax bravos from her friends when she sings: "Am I a cardboard woman?"

The gesture of this chanteuse as she leans toward the audience is extraordinary; it has to be the result of a success. This woman does not have what actors call "trac" [stage fright]. No, she challenges the audience, she questions it, knowing that it will respond as she wishes—she, the mistress of the despot whose vices she humors.

Then here are some women at the door of a café in the evening. One of them clacks her fingernails against her teeth as says, "not only that," which is a poem in itself. Another displays her large gloved hand on the table. In the background the rumbling of the boulevard fades into the distance. It is another extraordinary page of history. The little dancer holding her bouquet, the corps de ballet, the dancers in blue ballet dresses are such masterpieces that you will never be able to admire them enough.

Degas has put in the exhibition the portrait of a woman painted several years ago. The portrait is a marvel of design; it is as beautiful as the most beautiful Clouet, the greatest of the primitives.

Although Degas's exhibition may be relatively restrained, it is enough to show that the artist does not rest on his past and that he is still as much in the great artistic movement as his friends. His constant research, which is evident in all his works, establishes him in so secure a position that we have no need to defend him.

The Principles of Harmony and Contrast of Colours, and Their Applications to the Arts (1839)

Michel-Eugène Chevreul (1786–1889) was professor of organic chemistry at the Museum of Natural History in Paris. From his interest in the problems of color faced by the dyers at the Gobelin tapestry factories, he began his research into the perception of color as a practical, not simply a theoretical, pursuit. He first presented his ideas in 1828, and in 1839 published *The Principles of Harmony and Contrast of Colours*. The book went through many editions but only gradually had an effect on the practice of painting.

The basic principles upon which Chevreul's observations are based were not new. It had long been accepted that color was a perceptual phenomenon and not the property of objects, and many—including Goethe—had pointed out the relative nature of color. But Chevreul, working empirically with materials, was able to present a wide range of practical observations on just how complex the relative nature of color is. More important than his system, from the standpoint of the artist, was his acute awareness of the changing nature of colors, an awareness that eventually allied itself with that of the painter in his growing concern for the direct study of nature.

Two aspects of Chevreul's writings apply directly to painting: his theory of harmony and his analytical study of perception. His theories of harmony follow in the tradition of Runge and Goethe and served such later theorists as Charles Henry, although Henry found fault with some of Chevreul's conclusions. There was a persistent belief during the second quarter of the nineteenth century that, like music or formal proportion, color followed a harmonious scheme that could be understood mathematically. Of interest in this respect are the writings of David Ramsey Hay (1798–1866) and George Field (1777?–1854), whose theories had an impact on the decorative arts in England. (Field's writings influenced the interior structure of the 1851 Crystal Palace in London.) As painters became more concerned with observation, however, it was the analytical part of Chevreul's theory that interested them. The term *simultaneous contrast* was used to refer to several phenomena: that no color existed in

isolation; that no object could be isolated from its environment; and, by implication, that vision was characterized by an experience of interaction rather than by the identification or definition of things. Many of Chevreul's principles had been applied by artists for centuries as the result of either traditional practice or observation: the coloration of shadows, the neutrality of highlights, and so on. But the articulated principles underlying such effects had not been of concern, nor were they understood to be in any sense as complex as Chevreul realized they were. By the 1860s it was common for academies of art to have lectures on the physics of color, and artists regarded the works of Ogden Nicholas Rood (1831–1902) and others as meaningful for their efforts to capture the verity of their observations of nature.

When artists became interested in the nature of color as an aspect of perception, they were helped by the new range of colors available to them. The introduction of synthetic pigments, notably the coal-tar colors, made it easier to set a palette in accordance with the theoretical color circle, and little by little the traditional earth colors, so long the mainstays of the artistic procedure, lost their preeminent place in studio practice. Furthermore, the commercial availability of standardized paints, sold in convenient metal tubes, encouraged even those artists who wished to paint outside the studio to employ a wider selection of hues.

The source for the text is the first English edition of Chevreul's book, translated by Charles Martel (London: Longman, Brown, Green, and Longmans, 1854). ☙

PART I.

INTRODUCTION

(1.) It is necessary, in the first place, to explain some of the optical principles which relate,

Firstly, to the law of Simultaneous Contrast of Colours; and

Secondly, to the applications of this law in the various arts which make use of coloured materials to attract the eye.

(2.) A ray of solar light is composed of an indeterminate number of differently-coloured rays; and since, on the one hand, it is impossible to distinguish each in particular, and as, on the other, they do not all differ equally from one another, they have been divided into groups, to which are applied the terms *red rays, orange rays, yellow rays, green rays, blue rays, indigo rays,* and *violet rays;* but it must not be supposed that all the rays comprised in the same group, *red* for instance, are identical in colour; on the contrary, they are generally con-

sidered as differing, more or less, among themselves, although we recognise the impression they separately produce as comprised in that which we ascribe to *red*.

(3.) When light is reflected by an opaque white body, it is not modified in proportion to the differently-coloured rays which constitute white light; only,

A. *If this body is not polished,* each point of its surface must be considered as dispersing, in every direction through the surrounding space, the white light which falls upon it; so that the point becomes visible to an eye placed in the direction of one of these rays. We may easily conceive that the image of a body in a given position is composed of the sum of the physical points which reflect to the eye so placed a portion of the light that each point radiates.

B. *When the body is polished,* like the surface of a mirror for instance, one portion of the light is reflected irregularly, as in the preceding case; at the same time another portion is regularly or specularly reflected, giving to the mirror the property of presenting to the eye, properly situated, the image of the body which sends its light to the reflector;—one consequence of this distinction is, that if we observe two plane surfaces reflecting white light differing from each other only in polish, it results that in those positions where the *non*-polished surface is visible, all its parts will be equally, or nearly equally, illuminated; while the eye, when it is in a position to receive only that which is reflected irregularly, will receive but little light from the polished surface: on the contrary, it will receive much more when it is in a position to receive light regularly reflected.

(4.) If the light which falls upon a body is completely absorbed by it, as it would be in falling into a perfectly obscure cavity, then the body appears to us *black,* and it becomes visible only because it is contiguous to surfaces which transmit or reflect light. Among black substances, we know of none that are perfectly so, and it is because they reflect a small quantity of white light, that we conclude that they have relief, like other material objects. Moreover, what proves this reflection of white light is, that the blackest bodies, when polished, reflect the images of illuminated objects placed before them.

(5.) When light is reflected by an opaque coloured body, there is always

A reflection of white light,—and
A reflection of coloured light;

the latter is due to the fact that the body *absorbs* or extinguishes within its substance a certain number of coloured rays, and *reflects* others. It is evident that the coloured rays reflected are of a different colour from those absorbed; and also that, if they were combined with those absorbed, they would reproduce white light. We shall return to this subject in (6.).

Further, it is evident that opaque coloured bodies, when unpolished, reflect

irregularly both white and coloured light, by which we are enabled to see their colours; and that those which are polished reflect only one portion of these two lights irregularly, while they reflect another portion in a regular manner.

(6.) Let us now return to the relation which exists between the coloured light *absorbed,* and the coloured light *reflected,* by an opaque body, which makes it appear to us of the colour peculiar to this light.

It is evident, from the manner in which we have considered the physical composition of solar light (2.), that if we reunited the total quantity of the coloured light *absorbed* by a coloured body, to the total quantity of coloured light *reflected* by it, we should reproduce white light: for it is this relation that two differently coloured lights, taken in given proportions, have of reproducing white light, that we express by the terms

Coloured lights complementary to each other, or
Complementary colours.

It is in this sense that we say,

That Red is complementary to Green, and *vice versâ;*
That Orange is complementary to Blue, and *vice versâ;*
That Greenish Yellow is complementary to Violet, and *vice versâ;*
That Indigo is complementary to Orange Yellow, and *vice versâ.*

(7.) It must not be supposed that a red or yellow body reflects only *red* and *yellow* rays besides white light; they each (6.) reflect *all kinds* of coloured rays: only those rays which lead us to judge the bodies to be *red* or *yellow,* being more numerous than the other rays reflected, produce a greater effect. Nevertheless, those other rays have a certain influence in modifying the action of the red and yellow rays upon the organ of sight; and this will explain the innumerable varieties of *hue* which may be remarked among different red and yellow substances. It is also difficult not to admit that, among the differently coloured rays reflected by bodies, there is a certain number of them which, being complementary to each other, go to re-form white light upon reaching the eye.

SECTION I. ON THE LAW OF SIMULTANEOUS CONTRAST OF COLOURS, AND ITS DEMONSTRATION BY EXPERIMENT

Chapter I. Method of Observing the Phenomena of Simultaneous Contrast of Colours

Definition of Simultaneous Contrast

(8.) If we look simultaneously upon two stripes of different tones of the same colour, or upon two stripes of the same tone of different colours, placed

side by side, if the stripes are not too wide, the eye perceives certain modifications which in the first place influence the intensity of colour, and in the second, the optical composition of the two juxtaposed colours respectively.

Now as these modifications make the stripes appear different from what they really are, I give to them the name of *simultaneous contrast of colours;* and I call *contrast of tone* the modification in intensity of colour, and *contrast of colour* that which affects the optical composition of each juxtaposed colour.

Chapter II. The Law of Simultaneous Contrast of Colours, and the Formula Which Represents It

(16.) After having satisfied myself that the preceding phenomena constantly recurred when my sight was not fatigued, and that many persons accustomed to judge of colours saw them as I did, I endeavoured to reduce them to some general expression that would suffice to enable us to predict the effect that would be produced upon the organ of sight by the juxtaposition of two given colours. All the phenomena I have observed seem to me to depend upon a very simple law, which, taken in its most general signification, may be expressed in these terms:—

In the case where the eye sees at the same time two contiguous colours, they will appear as dissimilar as possible, both in their optical composition and in the height of their tone.

We have then, *at the same time,* simultaneous contrast of colour properly so called, and contrast of tone.

Chapter IV. On the Juxtaposition of Coloured Substances with White

(44.) White substances contiguous to those which are coloured, appear sensibly modified when viewed simultaneously with the latter. I admit that the modification is too feeble to be determined with entire certainty, when we are ignorant of the law of contrast; but knowing that, and seeing the modification effected by the white upon certain coloured substances, it is impossible to avoid recognising this modification in its *speciality* if at the same time the colours opposed to the white are not too deep.

Red and White

(45.) Green, the complementary of Red, is added to the White. The Red appears more brilliant and deeper. [Chevreul then examines orange, greenish-yellow, green, blue, indigo, violet, and black following this procedure.]

Chapter V. On the Juxtaposition of Coloured Substances with Black

(53.) Before stating the observations to which the juxtaposition of coloured and black substances has given rise, we must analyse the part the two contrasts—those of Tone and of Colour—perform in the phenomenon considered in its general bearing.

The black surface being deeper than the colour with which it is in juxtaposition, the Contrast of Tone must tend to deepen it still more, while it must tend to lower the tone of the contiguous colour, for the same reason, exactly, that White, on the other hand, if juxtaposed with it would heighten it. Thus much for Contrast of Tone.

(54.) Black substances reflect a small quantity of white light (4), and this light arriving at the eye at the same time with the coloured light of the contiguous body, it is evident that the black substances must appear tinted with the complementary of the coloured light: but the tint must be very faint, because it is manifested upon a ground having but a feeble power for reflecting light. Thus much for Contrast of Colour.

(55.) The lowering of the tone of a colour in contact with black is always perceptible; but a very remarkable fact is, the weakening of the black itself when the contiguous colour is deep and of a nature that yields a luminous complementary, such as Orange, Orange-Yellow, Greenish-Yellow, &c.

Red and Black

(56.) Green, the complementary of Red, uniting with the Black, causes it to appear less reddish.

The Red appears lighter or less brown, less oranged. [Chevreul then examines orange, greenish-yellow, green, blue, indigo, and violet following this procedure.]

Chapter VI. On the Juxtaposition of Coloured and Grey Substances

(63.) If one of the principal causes that prevent our seeing the modifications which coloured bodies tend to impart to white bodies juxtaposed with them is, the brightness of the light reflected by the latter, on the other hand, if the feeble light reflected by black bodies, is on the contrary, less favourable to our perception of the kind of modification they experience from the proximity of coloured bodies, particularly in the case where the complementary of the body is itself not very luminous, we may imagine that Grey bodies, properly selected with respect to height of tone, will, when they are contiguous to coloured substances, exhibit the phenomena of contrast of colour in a more striking manner than black or white substances do.

Red and Grey

(64.) The Grey appears greener by receiving the influence of the complementary of Red.

The Red appears purer,—less orange perhaps. [Chevreul applies the same analysis to orange, yellow, green, blue, indigo, and violet.]

.

SECTION II. ON THE DISTINCTION BETWEEN
SIMULTANEOUS, SUCCESSIVE, AND MIXED CONTRAST
OF COLOURS; AND ON THE CONNECTION BETWEEN THE
EXPERIMENTS OF THE AUTHOR AND THOSE MADE
PREVIOUSLY BY OTHER OBSERVERS

Chapter I. Distinction Between Simultaneous, Successive, and Mixed Contrast of Colours

(77.) Before speaking of the connection between my own observations and those of others, upon the contrast of colours, it is absolutely necessary to distinguish three kinds of contrast.

The first includes the phenomena which relate to the contrast *I name simultaneous;*

The second, those which concern the contrast I call *successive;*

The third, those which relate to the contrast I name *mixed.*

(78.) In the *simultaneous contrast of colours* is included all the phenomena of modification which differently coloured objects appear to undergo in their physical composition and in the height of tone of their respective colours, when seen simultaneously.

(79.) The *successive contrast of colours* includes all the phenomena which are observed when the eyes, having looked at one or more coloured objects for a certain length of time, perceive, upon turning them away, images of these objects, having the colour complementary to that which belongs to each of them.

.

(81.) The distinction of *simultaneous* and *successive* contrast renders it easy to comprehend a phenomenon which we may call the *mixed* contrast; because it results from the fact of the eye, having seen for a time a certain colour, acquiring an aptitude to see for another period the complementary of that colour, and also a new colour, presented to it by an exterior object; the sensation then perceived is that which results from this new colour and the complementary of the first.

.

Case

View of various Colours, more or less well assorted, seen
through the Medium of a feebly coloured Glass

(179.) Different colours, more or less well assorted according to the law of
contrast, being seen through a coloured glass which is not sufficiently deep as
to make us see all the colours of the tint peculiar to the glass, afford a spectacle
which is not without its charm, and which evidently stands between that
produced by tones of the same scale, and that by colours more or less well as-
sorted; for it is evident that if the glass was deeper in colour, it would cause
every object to appear entirely of its own peculiar colour.

(180.) We conclude from this that there are six distinct harmonies of col-
ours, comprised in two kinds.

Kind

Harmonies of Analogous Colours

1. The *harmony of scale,* produced by the simultaneous view of different
tones of a single scale, more or less approximating.

2. The *harmony of hues,* produced by the simultaneous view of tones of the
same height, or nearly so, belonging to scales more or less approximating.

3. The *harmony of a dominant coloured light,* produced by the simultaneous
view of different colours assorted conformably to the laws of contrast, but one
of them predominating, as would result from seeing these colours through a
slightly stained glass.

Kind

Harmonies of Contrasts

1. The *harmony of contrast of scale,* produced by the simultaneous view of
two tones of the same scale, very distant from each other.

2. The *harmony of contrast of hues,* produced by the simultaneous view of
tones of different height, each belonging to contiguous scales.

3. The *harmony of contrast of colours,* produced by the simultaneous view of
colours belonging to scales very far asunder, assorted according to the law
of contrast: the difference in height of juxtaposed tones may also augment
the contrast of colours.

.

Recapitulation of the Preceding Observations

(236). I will now give a *resumé* of the observations which appear the most
striking on reading the foregoing paragraphs, premising, however, that I do

not pretend to establish laws fixed upon scientific principles, but to enounce general propositions, which express my own peculiar ideas.

1st Proposition

(237). *In the Harmony of Contrast the complementary assortment is superior to every other.*

The tones must be, as nearly as possible, of the same height, in order to produce the finest effect.

The complementary assortment in which White associates most advantageously is that of Blue and Orange, and the reverse is that of Yellow and Violet.

2nd Proposition

(238). *The primaries Red, Yellow, and Blue, associated in pairs, will assort better together as a harmony of contrast than an arrangement formed of one of these primaries and of a binary colour, of which the primary may be regarded as one of the elements of the binary colour in juxtaposition with it.*

Examples

Red and Yellow accord better than Red and Orange.

Red and Blue accord better than Red and Violet.

Yellow and Red accord better than Yellow and Orange.

Yellow and Blue accord better than Yellow and Green.

Blue and Red accord better than Blue and Violet.

Blue and Yellow accord better than Blue and Green.

3rd Proposition

(239). *The assortment of Red, Yellow, or Blue with a binary colour which we may regard as containing the former, contrast the better, as the simple colour is essentially more luminous than the binary.*

Whence it follows that in this arrangement it is an advantage for the Red, Yellow, or Blue, to be of lower tone than the binary colour.

Examples

Red and Violet accord better than Blue and Violet.

Yellow and Orange accord better than Red and Orange.

Yellow and Green accord better than Blue and Green.

4th Proposition

(240.) *When two colours are bad together, it is always advantageous to separate them by White.*

In this case, we know that it is more advantageous to place each colour between White than in an assortment where the two colours are together between White.

5th Proposition

(241.) *Black never produces a bad effect when it is associated with two luminous colours. It is therefore often preferable to White, especially in an assortment where it separates the colours from each other.*

Examples

1. *Red* and *Orange.*

Black is preferable to White in the arrangements 2 and 3 of these two colours.

2. *Red* and *Yellow.*
3. *Orange* and *Yellow.*
4. *Orange* and *Green.*
5. *Yellow* and *Green.*

Black with all these binary assortments produces harmony of contrast.

6th Proposition

(242.) *Black, in association with sombre colours, such as Blue and Violet, and with broken tones of luminous colours, produces harmony of analogy, which in many instances may have a good effect.*

The harmony of analogy of Black, associated with Blue and Violet, is preferable to the harmony of contrast of the assortment White, Blue, Violet, White, &c., the latter being too crude.

7th Proposition

(243.) *Black does not associate so well with two colours, one of which is luminous, the other sombre, as when it is associated with two luminous colours.*

In the first instance the association is much less agreeable in proportion as the luminous colour is more brilliant.

Examples

With all the following assortments Black is inferior to White.

1. *Red* and *Blue.*
2. *Red* and *Violet.*
3. *Orange* and *Blue.*
4. *Orange* and *Violet.*
5. *Yellow* and *Blue.*

6. *Green* and *Blue*.
7. *Green* and *Violet*.

With the assortment *Yellow* and *Violet*, if it is not inferior to White, it never produces anything but a mediocre effect in its associations.

8th Proposition

(244.) *If Grey never produces exactly a bad effect in its association with two luminous colours, in most cases its assortments are nevertheless dull, and it is inferior to Black and White.*

Among the assortments of two luminous colours there are scarcely any besides those of Red and Orange with which Grey associates more happily than White.

But it is inferior to it, and also to Black, in the arrangements *Red and Green, Red and Yellow, Orange and Yellow, Orange and Green, Yellow and Green*.

It is also inferior to White with *Yellow and Blue*.

9th Proposition

(245.) *Grey, in association with sombre colours, such as Blue and Violet, and with broken tones of luminous colours, produces harmonies of analogy which have not the vigour of those with Black; if the colours do not combine well together, it has the advantage of separating them from each other.*

10th Proposition

(246.) *When Grey is associated with two colours, one of which is luminous, the other sombre, it will perhaps be more advantageous than White, if this produces too strong a contrast of tone; on the other hand, it will be more advantageous than Black if that has the inconvenience of increasing too much the proportion of sombre colours.*

Examples

Grey associates more happily than Black with—

1. *Orange* and *Violet*.
2. *Green* and *Blue*.
3. *Green* and *Violet*.

11th Proposition

(247.) *If, when two Colours combine together badly, there is in principle an advantage in separating them by White, Black, or Grey, it is important to the effect to take into consideration—*

1. *The height of tone of the Colours, and*
2. *The proportion of sombre to luminous colours, including in the first the broken*

brown tones of the brilliant scales, and in the luminous colours, the light tones of the
Blue and Violet scales.

Examples

(a.) *Take into consideration the height of tone of the colours.*

(248.) The effect of White with Red and Orange is inferior as their tone becomes higher, especially in the assortment *White, Red, Orange, White,* &c., the effects of the White being too crude.

On the contrary, Black unites very well with the normal tones of the same colours, that is to say, the highest tones, without any mixture of Black.

If Grey does not associate so well as Black with Red and Orange, it has the advantage of producing a less crude effect than White.

(b.) *Take into consideration the proportion of sombre to luminous colours.*

(249.) Whenever colours differ very much, either in tone or in brilliancy from the Black or White with which we wish to associate them, that arrangement where each of the two colours is separated from the other by Black or White, is preferable to that in which the Black or the White separate each pair of colours.

Thus the assortment White, Blue, White, Violet, White, &c. is preferable to the assortment White, Blue, Violet, White, &c., because the separation of the brilliant from the sombre is more equal in the first than in the second. I should add, that this has something more symmetrical relatively to the position of the two colours, and I must remark that the principle of symmetry influences our judgment of things more than is generally recognised.

It is also in conformity with the above, that the assortment Black, Red, Black, Orange, Black, &c. is preferable to the assortment Black, Red, Orange, Black, &c.

.

First Division

Imitation of Coloured Objects, with Coloured Materials in a State of Infinite Division

.

SECTION I. PAINTING ON THE SYSTEM OF CHIARO 'SCURO

Chapter I. On the Colours of the Model

(259.) The modifications which we perceive in a single coloured object—for example, in a blue or red stuff, &c. are they indeterminable, when these

stuffs are seen as the drapery of a vestment or as furniture, presenting folds more or less prominent, where, under given circumstances, are they determinable? This is a question which I shall undertake to resolve. First let us distinguish three cases where these modifications of colours may be observed.

1st Case. *Modifications produced by coloured lights falling upon the model.*

2nd Case. *Modifications produced by two different lights—as, for example, the light of the sun, and diffused daylight—each lighting distinct parts of the same object.*

3rd Case. *Modifications produced by diffused daylight.*

(260.) To render these matters easier of comprehension, we will suppose that in the two first cases the lighted surfaces are plane, and that all their superficial parts are homogenous, and in the same conditions, except that of lighting in the second case. In the third case we shall consider the position of the spectator viewing an object lighted by diffused daylight, the surface of which is not so disposed as to act equally in all its parts upon the light which it reflects to the eye of the spectator.

Article 1

Modifications Produced by Coloured Lights

(261.) These modifications result from coloured rays emanating from any source whatever, falling upon a coloured surface, which is at the same time lighted by diffused daylight.

(262.) The following observations have been made by partially exposing coloured stuffs to the sun's rays transmitted through coloured glass. The portion of stuff protected from these rays was lighted by the direct light of the sun. It is important to remark, that the portion of stuff which received the action of the coloured rays being exposed to diffused daylight, reflected also rays of that light which it would have reflected in case it had been protected from the influence of the rays transmitted to it through coloured glasses.

(263.) 1. *Modifications produced by Red light.*

When Red rays fall upon a Black stuff, it appears of a Purple-Black, deeper than the rest, which is lighted directly by the sun.

Red rays falling upon a White stuff, make it appear Red.

Red rays falling upon a Red stuff, make it appear redder than upon that part lighted at the same time by the sun.

Red rays falling upon an Orange-coloured stuff, make it appear redder than the part lighted at the same time by the sun.

Red rays falling upon a Yellow stuff, make it appear Orange.

Red rays falling upon a Green stuff, produce different effects, according to

the tone of the Green: if it is deep, it produces a Red–Black; if it is light, there is a little Red reflected, which gives a reddish grey.

Red rays falling upon a light Blue stuff, make it appear Violet.

Red rays falling upon a Violet stuff, make it appear purple.

[Chevreul next analyzes modifications produced by orange, yellow, and green lights in a similar fashion.]

Chapter II. Utility of the Law of Simultaneous Contrast of Colours in the Science of Colouring

Article 1

Utility of this Law in enabling us to perceive promptly and surely the Modifications of Light on the Model

(324.) The painter must know, and especially *see,* the modifications of white light, shade, and colours which the model presents to him in the circumstances under which he would reproduce it.

(325.) Now what do we learn by the law of *simultaneous contrast of colours?* It is, that when we regard attentively two coloured objects at the same time, neither of them appears of the colour peculiar to it, that is to say, such as it would appear if viewed separately, but of a tint resulting from the peculiar colour and the complementary of the colour of the other object. On the other hand, if the colours are not of the same tone, the lightest tone will be lowered, and the darkest tone will be heightened; in fact, they will appear by the juxtaposition different from what they really are.

(326.) The first conclusion to be deduced from this is, that the painter will rapidly appreciate in his model the colour peculiar to each part, and the modifications of tone and of colour which they may receive from contiguous colours. He will then be much better prepared to imitate what he sees, than if he was ignorant of this law. He will also perceive modifications which, if they had not always escaped him because of their feeble intensity, might have been disregarded because the eye is susceptible of fatigue, especially when it seeks to disentangle the modifications whose cause is unknown, and which are not very prominent.

(327.) This is the place to return to *mixed contrast* (81. and following) in order to make evident how the painter is exposed to seeing the colours of his model inaccurately. In fact, since the eye, after having observed one colour for a certain time, has acquired a tendency to see its complementary, and as this tendency is of some duration, it follows, not only that the eyes of the painter, thus modified, cannot see correctly the colour which he had for some time looked

at, but also another which might strike them while this modification lasts. So that, conformably to what we know of mixed contrasts (81. &c.), they will see—not the colour which strikes him in the second place,—but the result of this colour and of the complementary of that first seen. It must be remarked, that besides the defect of clearness of view which will arise in most cases from the want of exact coincidence of the second image with the first,—for example, the eye has seen a sheet of green paper A in the first place, and in the second place regards a sheet of blue paper B of the same dimensions, but which is placed differently—it will happen that this second image, not coincident in all its surface with the first A' as represented in the figure, the eye will see the sheet B violet only in the part where the two images coincide. Consequently this defect of perfect coincidence of images will be an obstacle to the distinct definition of the second image and of the colour which it really possesses.

(328.) We can establish three conditions in the appearance of the same object relative to the state of the eye; in the first, the organ simply perceives the image of the object without taking into account the distribution of colours, light, and shade; in the second, the spectator, seeking to properly understand this distribution, observes it attentively, and it is then that the object presents to him all the phenomena of simultaneous contrast of tone and colour which it is capable of exciting in us. In the third circumstance, the organ, from the prolonged impression of the colours, possesses in the highest degree a tendency to see the complementary of these colours; it being understood that these different states of the organ are not discontinued, but continuous, and that, if we examined them separately, it was with the intention of explaining the diversity of the impression of the same object upon the sight, and to make evident to painters all the inconveniences attendant upon a too prolonged view of the model.

I have no doubt that the dull colouring with which many artists of merit have been reproached, is partly due to this cause, as I shall show more minutely hereafter (366.).

Article 2

Utility of this Law in order to imitate promptly and surely the Modification of Light on the Model

(329.) The painter, knowing that the impression of one colour beside another is the result of the mixture of the first with the complementary of the second, has only to mentally estimate the intensity of the influence of this complementary, to reproduce faithfully in his imitation the complex effect which he has under his eyes. After having placed upon his canvas the two colours he requires, as they appear to him in the isolated state, he will see if the imitation agrees with his model; and, if he is not satisfied, he must then recognise the correction which has to be made. Take the following examples:—

1st Example

(330.) A painter imitates a white stuff, with two contiguous borders, one of which is red, the other blue; he perceives each of them changed by virtue of their reciprocal contrast; thus the red becomes more and more orange, in proportion as it approaches the blue, as this latter takes more and more green as it approaches the red. The painter, knowing by the law of contrast the effect of blue upon red, and reciprocally, will always reflect that the green hues of the blue and the orange hues of the red result from contrast, consequently in making the borders of a single red and a single blue, reduced in some parts by white or by shade, the effect he wishes to imitate will be reproduced. In the instance where it is found that the painting is not sufficiently marked, he is sure of what he must add without departing from the truth, otherwise he must exaggerate a little (311.). [Chevreul next presents similar examples for grey upon yellow and flat tints of the same color juxtaposed.]

Part III. Experimental Aesthetics of Coloured Objects

Section II. Interference of the Law of Simultaneous Contrast of Colours with Our Judgment on the Production of Different Arts Which Address the Eyes by Coloured Materials

1. Of the Arts of Painting with Coloured Materials in a State of So Called Infinite Division, Considered Relatively to the Physical State of These Materials, and the Speciality of the Art Employing Them

(861.) In the first place, I must explain the meaning of the expression *in a state of infinite division,* applied to coloured materials employed by painters: in reality, the division of these materials is not infinite, it is not even carried to the point attainable by mechanical means. If it were possible to perceive them in a painting by means of magnifying glasses, we should then see that a coloured surface, which appears of a uniform colour to the naked eye, is composed of distinct coloured particles, disposed in parallel or concentric lines, or in spots, according to the handling of the pencil. By these means we could distinguish in oil-paintings some parts which would resemble an enamel, because they would contain so many opaque particles which the drying oil does not make transparent, while the other parts would resemble a coloured glass, because the oily

vehicle does not contain sufficient opaque particles to be entirely deprived of its transparency.

I shall now consider, successively, painting in chiaro 'scuro and in flat tints.

Article 1

Painting in Chiaro 'scuro

(862.) In commencing with the fact that the pigments of the painter appear to be in a state of infinite division, we come to see clearly the possibility of tracing lines as fine as it is possible to make them, by means of a pencil filled with a fluid charged more or less with colouring materials, of intimately mixing these pigments together, so as to blend them with each other. From this state of things we deduce the possibility of making *a perfect delineation of the different parts of objects of which the painter wishes to reproduce the image, and represent exactly all the modifications of light which exist in the model.*

(864.) From the perfection of the drawing, and the gradation of white and coloured light, result the perfection of the imitation of all coloured objects, by means of which their image appears upon a plane surface, as if they were seen with the relief peculiar to them. From this possibility of imitating clearly the minutest details in a model, results the possibility of expressing upon plane figures all the emotions of the heart of man which are manifested by the expression of his countenance. From thence is derived the noblest, the loftiest part of the art which places the painter near the poet, the historian, and the moralist; a part upon which the critic pours his admiration to excite it in others, but which has no rules a master can impart to his pupils. I make this declaration in order that my intention may not be misunderstood, which has dictated to me the developments promised above (859.), relative to the correspondence of the harmonies of colour with the subject where they are employed—developments upon which I now enter.

(865.) If harmony of contrast is the most favourable to cause two colours to impart value to each other (845.), on the other hand, when we desire to derive the best possible advantage from a union of numerous brilliant colours in any work—a picture for instance—this diversity presents some difficulties for the harmony of the whole, which a smaller number of colours would not present, and particularly of colours less brilliant (859.). Accordingly, it is evident, that if we compare together two effective pictures, well adapted to be judged under the relation of colour, other things being the same, the one which presents the most harmony of contrast of colour will have the greater merit under the relation of the difficulty overcome in the employment of the colours; but we must not conclude that the painter of the other picture is not a colourist; because the

art of colouring is composed of different elements, and the talent of opposing pure colours with each other, is only one of these elements.

(866.) Let us now consider the relations existing between the subjects of painting and the harmonies they admit. We know that the more pictures address the eye by numerous contrasts, the more difficulty the spectator experiences in fixing his attention, especially if the colours are pure, varied, and skilfully distributed upon the canvas. A result of this state of things then is that, these colours being much more viv[i]d than the flesh-tints, the painter who wishes that his idea should be found in the expression of his figures, and who, putting this part of his art above the others, is convinced otherwise that the eyes of most people, ignorant of the art of seeing, being carried away by what they see at first, are incapable of returning from this impression to receive another; the painter, I repeat, who knows all these things, and is conscious of his power, will be restrained in the use of harmonies of contrast, and prodigal of the harmonies of analogy. But he will not derive advantage from these harmonies, especially if he selects a scene occupying a vast space filled with human figures, as in the "Last Judgment" of Michael Angelo, unless he avoids confusion by means of correct drawing, by a distribution of the figures in groups skilfully distributed over the canvas, so that they cover it almost equally, yet without presenting a cold symmetry. The eye of the spectator must embrace all these groups easily, and seize the respective positions; lastly, in penetrating one of them, he must find a diversity which will entice him to extend this examination to other groups.

(869). To conclude, in all I have said on the subject of the immediate applications of the law of contrast to painting, I have given precepts adapted to enlighten the artist as well as the critic, since he cannot avoid them without evidently being unfaithful in the imitation of his model. I have stated numerous considerations, in order that clearly separating by analysis the elements of the art which concur with those of which I have given the rules, they will not attribute to me ideas which I do not entertain, but, on the contrary, they will see plainly that I have never mistaken the qualities which neither instruct nor make the great artist. It is in this spirit that I have spoken of the harmonies of colours; and in distinguishing them into harmonies of analogy and harmonies of contrast, I have been led to observe that we cannot mistake with respect to the pleasure produced in us by the sight of various colours suitably assorted. When indicating the subjects in which it appeared to me the harmonies of one kind should dominate over the others, I spoke in a general, but not in an absolute manner. I remarked that if the painter, with the intention of attaining the highest rank in his art, would fix the attention by the expression of his figures rather

465

than by colour, and if, in consequence, he makes the harmonies of analogy pre-
dominate over the others, it will happen that if he misses his aim—he will have
a marked disadvantage in respect to the case where he would have employed
vivid and contrasting colours, the expression of his figures remaining the same.
On the other hand, I have remarked that the painter who would treat a subject
to which the harmonies of contrast belong, will place himself in an unfavour-
able position, other things remaining the same, if he has recourse to the harmo-
nies of analogy.

A result of this view is, that the critic must never compare two large com-
positions under the relation of colouring, without taking into account the dif-
ference which may exist in the accordance of each subject with one kind of har-
mony more than with the other.

CHARLES BLANC

The Grammar of Painting and Engraving (1869)

Auguste-Alexandre-Philippe-Charles Blanc (1813–1882) was a French writer and art critic of considerable renown. While a student of engraving and etching, he soon found that his talents lay more in the study than the production of art. He became an influential critic of the Salon exhibitions and in 1845 published the first volume of a planned series, *Histoire des peintres français au XIXe siècle*. In 1848 he was appointed as the nation's administrator of fine arts and actively sustained government support for the arts; with the *coup d'état* in 1851, he lost his official position. Again in 1870 he was named administrator and served until 1873. His monumental illustrated work *Histoire des peintres de toutes les écoles* was produced between 1849 and 1876 and, with the help of various authors, ran to fourteen volumes. Although not a particularly scholarly compendium, it found a wide audience.

In 1859 Blanc founded the *Gazette des beaux-arts*, a magazine devoted wholly to the fine arts both past and contemporary. Many chapters of his *Grammaire des arts du dessin*, published in 1867, first appeared in that widely read periodical. His biographical articles were brought together in *Les Artistes de mon temps* (1876). Concerned with broad matters of taste as well as with research in the fine arts, Blanc published *L'Art dans la parure et dans le vêtement* (1875) and *Décoration intérieure de la maison* (1882). A third volume was to have been concerned with the decoration of cities.

The *Grammaire des arts du dessin* was written to introduce the nonspecialist to the visual language of art. There are two aspects to the work: the defense of transcendent values in art, its mission and its multiple forms, and the explanation of technical matters necessary to appreciate more fully individual works of art. From the latter part the following chapter on color is taken. Despite Blanc's devotion to the ideal in art (he published a defensive biography of Ingres in 1870), he was quite aware of modern studies on color perception and its application to painting. Blanc's lucid explanation of the optical mixture of colors appeared well before such theories were used to explain the work of the "Impressionists." Yet for all his concern with the intricacy of color perception, for him simple apprehension of color took second place to expressiveness. The art-

ist, said Blanc, must choose the harmonies that most "conform to his thought." The new knowledge of color simply gave him a broader range of means for his task.

The following excerpt is reproduced from *The Grammar of Painting and Engraving,* translated by Kate Newell Dogget (New York: Hurd and Houghton, 1874), pp. 145–69. 🐟

XIII

. . . If there is affinity between chiaro 'scuro and sentiment, much more is there between sentiment and color, since color is only the different shades of chiaro'scuro.

Supposing the painter had only ideas to express, he would perhaps need only drawing and the monochrome of chiaro 'scuro, for with them he can represent the only figure that thinks,—the human figure, which is the *chef d'oeuvre* of a designer rather than the work of a colorist. With drawing and chiaro 'scuro he can also put in relief all that depends upon intelligent life, that is life in its relation to other lives, but there are features of organic, of interior and individual life that could not be manifested without color. How for instance without color give, in the expression of a young girl, that shade of trouble or sadness so well expressed by the pallor of the brow, or the emotion of modesty that makes her blush? Here we recognize the power of color, and that its rôle is to tell us what agitates the heart, while drawing shows us what passes in the mind, a new proof of what we affirmed at the beginning of this work, that drawing is the masculine side of art, color the feminine.

As sentiment is multiple, while reason is one, so color is a mobile, vague, intangible element, while form, on the contrary, is precise, limited, palpable and constant. But in the material creation there are substances of which drawing can give no idea; there are bodies whose distinctive characteristic is in color, like precious stones. If the pencil can put a rose under the eye, it is powerless to make us recognize a turquoise or a ruby, the color of the sky or the tint of a cloud. Color is *par excellence,* the means of expression, when we would paint the sensations given us by inorganic matter and the sentiments awakened in the mind thereby. We must, then, add to chiaro 'scuro, which is only the external effect of white light, the effect of color, which is, as it were, the interior of this light.

We hear it repeated every day, and we read in books that color is a gift of heaven; that it is an impenetrable arcanum to him who has not received its *secret influence;* that one learns to be a draughtsman but one is born a colorist,— nothing is falser than these adages; for not only can color, which is under fixed laws, be taught like music, but it is easier to learn than drawing, whose abso-

lute principles cannot be taught. Thus we see that great designers are as rare, even rarer than great colorists. From time immemorial the Chinese have known and fixed the laws of color, and the tradition of those laws, transmitted from generation to generation down to our own days, spread throughout Asia, and perpetuated itself so well that all oriental artists are infallible colorists, since we never find a false note in the web of their colors. But would this infallibility be possible if it were not engendered by certain and invariable principles?

What, then, is color?

Before replying, let us take a look at creation. Beholding the infinite variety of human and animal forms, man conceives an ideal perfection of each form; he seeks to seize the primitive exemplar, or at least, to approach it nearer and nearer, but this conception is a sublime effort of his intelligence, and if, at times, the soul believes it has an obscure souvenir of original beauty, this fugitive memory passes like a dream, and the perfect form that issued from the hand of God is unknown to us; remains always veiled from our eyes. It is not so with color, and it would seem as if the eternal colorist had been less jealous of his secret than the eternal designer, for he has shown us the ideal of color in the rainbow, in which we see, in sympathetic gradation, but also in mysterious promiscuity, the mother-tints that engender the universal harmony of colors.

Whether we observe the iris, or look at the soap-bubbles with which children amuse themselves, or, renewing the experiment of Newton, use a triangular prism of crystal to analyze a ray of light, we see a luminous spectrum composed of six rays differently colored, violet, blue, green, yellow, orange, red. How do these colors strike the eye? As sounds do the ear. As each sound echoes in modulating itself upon itself and passes, by vibrations of equal length, from fullness to a murmur, and from a murmur to silence, so each color seen in the solar spectrum has its maximum and minimum of intensity; it begins with its lightest shades and ends with its darkest.

Newton saw seven colors in the prism, doubtless to find a poetical analogy with the seven notes of music; he has arbitrarily introduced, under the name of *indigo*, a seventh color which is only a shade of *blue*. It is a license that even the greatness of his genius cannot excuse. These seven colors he called *primitive*; but in reality there are only three primitive colors. We cannot put in the same rank *yellow, red*, and *blue*, which are simple colors, and *violet, green*, and *orange*, which are composite colors, because we can produce them by combining two by two of the first three, the *orange*, by mixing yellow and red, the *green*, from yellow and blue, the *violet*, from blue and red.

Antiquity, which did not wait till Newton's day, to observe the colored light of the iris, admitted only three as truly mother-colors, and the evidence of truth forces us to-day to return to the principle of the ancients, and to say, there are three primary colors, yellow, red, blue, and three composite or binary colors,—orange, green, violet. In the intervals that separate them, are placed the

intermediate shades whose variety is infinite, and which are like the sharps of color which precede, and the flats of color which follow them.

Separated, these colors and these shades enable us to distinguish and recognize all the objects of creation. Reunited they give us the idea of white. White light is the union of all colors, all are contained and latent in it.

The composition of white light once known, we can define color. It is the property all bodies have of reflecting certain rays of light, and absorbing all others. The jonquil is yellow, because it reflects the yellow rays and absorbs the red and blue. The oriental poppy is scarlet, because it reflects only the red rays and absorbs the blue and yellow. If the lily is white, it is because, absorbing no ray, it reflects all, and a body is black because absorbing all rays, it reflects none. White and black, properly speaking, are not colors, but may be considered as the extreme terms of the chromatic scale.

White light containing the three elementary and generative colors, yellow, red, and blue, each of these colors serves as a *complement* to the other two to form the equivalent of white light. We call *complementary* each of the three primitive colors, with reference to the binary color that corresponds to it. Thus blue is the complement of orange, because orange being composed of yellow and red, contains the necessary elements to constitute white light. For the same reason, yellow is the complement of violet, and red of green. Reciprocally each of the mixed colors, produced by the union of two primitive colors, is the complement of the primitive color not employed in the mixture; thus orange is the complement of blue, because blue does not enter into the mixture that produces it.

Law of complementary colors. If we combine two of the primary colors, yellow and blue, for instance, to compose a binary color, *green,* this binary color will reach its maximum of intensity if we place it near its complement—*red.* So, if we combine yellow and red to form *orange,* this binary color will be heightened by the neighborhood of *blue.* Finally, if we combine red and blue to form *violet,* this color will be heightened by the immediate neighborhood of *yellow.* Reciprocally, the red placed beside the green will seem redder; the orange will heighten the blue, and the violet the yellow. It is the reciprocal heightening of complementary colors in juxtaposition that M. Chevreul called *"The law of simultaneous contrast of colors."*

But these same colors that heighten each other by juxtaposition, destroy each other by mixture. If you place red and green in equal quantities and of equal intensity upon each other, there will remain only a colorless grey. The same effect will be produced if you mingle, in a state of equilibrium, blue and orange, or violet and yellow. The annihilation of colors is called *achromatism.*

Achromatism is also produced if we mingle in equal quantities, the three primitive colors, yellow, red, blue. If we pass a ray of light across three cells of

glass filled with three liquids, yellow, red, blue, the ray that has traversed them will pass out perfectly achromatic, that is colorless. This second phenomenon does not differ from the first, for if the blue destroys the orange, it is because the orange contains the two other primary colors, yellow and red; and if the yellow annihilates the violet, it is because the violet contains the two other primary colors, red and blue. Thus we see how just is the expression, friendly and hostile colors, since the complementaries triumphantly sustain or utterly destroy each other.

To enable one to recall this phenomenon it is indispensable to the reader to form a chromatic rose or to have present to the mind that of which we give a drawing accompanied by a color engraving.[1]

At the angles of the upright triangle are the three primary colors, yellow, red, blue; at the angles of the reversed triangle, the binary colors, orange, green, and violet; between these six colors combined two by two are placed the intermediate shades; sulphur, turquoise, campanula, garnet, nasturtium, saffron.

Observe; if we choose in this rose three colored points, that form an equilateral triangle, the colors situated at these three points will have all the properties of the complementaries. Let us take, for instance, the sulphur, nasturtium, and campanula; these three tints, being placed at the angles of an equilateral triangle, will be perfectly achromatic, that is, united in equilibrium, they will absolutely destroy each other, while if we place together the sulphur and the garnet which is exactly opposite it, they will reciprocally heighten each other, because they are complements each of the other.

But the complementary colors have other virtues not less marvellous than those of mutually heightening and destroying each other. "To put a color upon canvas," says Chevreul, "is not merely to tint with this color all that the pencil has touched, it is also to color with its complement the surrounding space; thus a red circle is surrounded by a light green aureole, less and less strongly marked according to its distance from the red; an orange circle is surrounded by a blue aureole, a yellow circle by a violet, and reciprocally."

This had already been noticed by Goethe and by Eugène Delacroix. Eckermann relates ("Conversations de Goethe"),[2] "that walking in a garden with the philosopher, upon an April day, as they were looking at the yellow crocuses which were in full flower, they noticed that turning their eyes to the ground,

1. This rose of colors is a mnemonic image. It in some sort renders visible the law of complementaries, and expresses its truths. If we divide the circumference into 360° we see clearly that each of the perfect binary colors is equally distant from the two primaries that compose it. Thus orange is 60° from the yellow and 60° from the red. We see also where the domain of the six colors begins and ends.

2. Johann Peter Eckermann (1792–1854) published his *Gespräche mit Goethe* in 1839. Goethe's *Zur Farbenlehre* was published in 1810.—Ed.

they saw violet spots." At the same epoch, Eugène Delacroix occupied one day in painting yellow drapery, tried in vain to give it the desired brilliancy and said to himself: "How did Rubens and Veronese find such brilliant and beautiful yellows?" He resolved to go to the Louvre and ordered a carriage. It was in 1830, when there were in Paris many cabs painted canary color; one of these was brought to him. About to step into it, Delacroix stopped short, observing to his great surprise that the yellow of the carriage produced violet in the shadows. He dismissed the coachman, entered his studio full of emotion, and applied at once the law he had just discovered, that is, that the shadow is always slightly tinged with the complement of the color, a phenomenon that becomes apparent when the light of the sun is not too strong, and "our eyes," as Goethe says "rest upon a fitting background to bring out the complementary color."

Is this color produced by the eye? It is not for us to decide; but it is certain that in going out of a chamber hung with blue, for instance, for some moments we see objects tinted with orange. "Let us suppose," says Monge ("Géométrie Descriptive"),[3] "that we are in an apartment exposed to the sun, whose windows are covered with red curtains; if in the curtain there is a hole three or four lines in diameter, and a white paper be held at a little distance to receive the rays of light that pass through this hole, these rays will make a *green* spot upon the paper; if the curtains were green the spot would be red."

Monge does not give the reason of the phenomenon. I believe it is, that our eye being made for white light, needs to complete it when it receives only a part. To a man who perceives only *red* rays, what is necessary to complete the white light? Yellow and blue; but these are both contained in *green*. It is green then that will reëstablish the equilibrium of the light in an eye wearied by red rays.

From having known these laws, studied them profoundly, after having intuitively divined them, Eugène Delacroix became one of the greatest colorists of modern times, one might even say the greatest, for he surpassed all others, not only in the aesthetic language of his coloring, but in the prodigious variety of his motives and the orchestration of his colors. Like a singer endowed with the whole register of the human voice, he has widened the limits of painting by adding new expressions to the language of art.

Again, if we mix two complementary colors in unequal proportions, they will partially destroy each other, and we shall have a broken tone that will be a shade of grey. Make, for instance, a mixture in which there shall be ten parts yellow and eight violet; there will be destruction of color or achromatism for eight tenths, but the other two tenths will form a grey shaded with yellow, be-

3. Gaspar Monge (1746–1818) was one of the founders of the École Polytechnique in Paris. He published his *Géométrie descriptive* in 1798.—Ed.

cause there was excess of yellow in the mixture. Thus are formed all the innumerable varieties of color that we call lowered tones, as if nature employed for her ternary colorations the destruction of color, as she uses death to maintain life.

The law of complementary colors once known, with what certainty the painter will proceed whether he wishes to attain brilliancy of color, to temper his harmony or to make it striking by abruptly bringing together tints that suit the expression of a warlike or tragic scene. Suppose it is necessary to lower a vivid vermilion, the artist learned in the laws of color, instead of softening by soiling it at hazard, will lower it by the addition of blue, and thus will follow the path of nature.

But without even touching a color, one can strengthen, sustain, lower, almost neutralize it, by working upon its neighbor. If we place in juxtaposition two similars in a pure state, but of different degrees of energy, as dark red and light red, we shall obtain a contrast by the difference of intensity and a harmony by the similitude of tints. If we bring together two similars, one pure, the other broken, for instance, pure blue and grey blue, there will result another kind of contrast that will be moderated by resemblance. The moment colors are not to be employed in equal quantities, nor of equal intensity, the artist is free, but within the limits of infallible laws. He must try his *doses,* must distribute to his tints their places and rôles, calculate the extent he will give them, and make, as it were, a secret rehearsal of the drama his coloring will form. He must employ the resources of white and black, foresee the optical mixture, know the vibration of the colors, and finally take care of the effect the diversely colored light is to produce, according as it is of the morning or the evening, from the North or the South.

WHITE AND BLACK

Two centuries before Newton, Leonardo da Vinci wrote, "White is not a color by itself, it contains all colors." White, in truth, is never whiter, that is more perfect, than when it reflects the most light and is absolutely colorless. Of black there are several kinds: negative black, that produced by the thickest shades of night; black by intensity, that produced by a primary color at its highest degree of concentration. Suppose three cylinders of glass filled with the most concentrated yellow, the darkest blue, the most intense red; each of these three primary colors will give the notion of black. But if you mix white with this black, the quality yellow, red, or blue of the color in the cylinder will reappear, and the coloration will become more brilliant in proportion as you increase the quantity of white, in other terms, the quantity of light,—normal black is formed by the mingling of the three primary colors, in a state of equilibrium, and at their maximum of intensity, a mixture that produces, as we have seen, achromatism. "The richer the colors are in coloring principles," says

Charles Bourgeois ("Manuel d'Optique expérimentale"), "the more obscure is the achromatism."[4] As the least excess of yellow, red, or blue suffices to shade the achromatism, the painter in composing his black may leave in it an imperceptible coloration, in view of the effect he wishes to obtain. But freed from all shade, in a pure state, black is no more a color than white.

What, then, will be the effect of black and white in painting?

If the coloring of the picture is of extreme magnificence and of great variety, the white and black—whether in pure state or as grey—acting as non colors will serve to rest the eye, to refresh it, by moderating the dazzling brilliancy of the whole representation. But applied against a particular color the white heightens, the black lowers it. Why? Because a red, for instance, is less luminous the redder it is, if we place white near it becomes comparatively less light, consequently redder. On the contrary, if you place black beside the red, the latter will seem less red; for all that a color gains in light it loses in energy. The proof is that by force of light it would vanish in white, as by force of vigor and concentration it would resolve itself into black. One more example. Let us take *cinnabar*, a substance composed of sulphur and mercury, from which we obtain the brilliant red used in glass painting. The ore is a dull red, but as it is broken it acquires more surface, and penetrated by the white of the light loses the dull, dark color, and when reduced to an impalpable powder, becomes of a brilliant scarlet—*vermilion*.

Independent of these actions and reactions,—I say reaction because every color put beside white or black tints them slightly with its complement,—black and white have an aesthetic value, a value of sentiment. Thus the spot of white upon the mantle of Virgil in Delacroix' "Barque du Dante," is a terrible lighting up in the midst of the darkness; it shines like the lightning that furrows the tempest. At other times this powerful colorist uses white to correct the contiguity of two colors like red and blue. In one of the pendentives that so magnificently decorate the Library of the Corps Legislatif, the executioner who has cut off the head of John the Baptist is dressed in red and blue, two colors whose juxtaposition is softened by a little white which unites them without sacrificing the energy suitable to the figure of an executioner. Thus we realize a rare harmony, that of the tricolor-flag. Ziegler has observed that this flag spread out horizontally presents a discordant whole, but through the effects of the folds, the quantities become unequal and one color dominating another harmony is produced.[5] "The wind that agitates the stuff in varied undulations makes the three colors pass through all the attempts at proportion that an intelligent artist can do; sometimes the effect is admirable."

4. Charles Bourgeois (1759–1832), *Manuel d'optique expérimentale, à l'usage des artistes et des physiciens* (Paris: L'Auteur, 1821).—Ed.
5. Jules Ziegler (1804–1856), history and portrait painter, pupil of Ingres.—Ed.

White and black should appear in the picture only in small doses, black especially, which, instead of being extended over a great space, should be divided and repeated upon narrow spaces as a sordine to the color in a lugubrious picture. Black and white thus dispersed produce a tragic effect in the "Shipwreck of Don Juan," in which, upon a dark emerald sea, they detach themselves like funeral notes that express to the eye the anguish of these shipwrecked ones whom hunger has maddened and who are tossed between the hope of life and the grasp of death.

THE OPTICAL MIXTURE

One day in the library of the Luxembourg we were struck with the marvellously rich effect produced by Delacroix, the painter of the central cupola, where the artist had to combat the obscurity of the concave surface he had to paint, and to create an artificial light by the play of his colors. Among the mythological and heroic figures that made up the decoration, and which were walking in a sort of enchanted garden, we distinguished a half-nude woman, seated in the shadows of this Elysium, whose flesh preserved the most delicate, the most transparent tints. As we were admiring the admirable freshness of this rose-tone, an artist friend of Delacroix, who had seen him at work, said smiling, "You would be surprised if you knew what colors had produced the rosy flesh that charms you. They are tones that seen separately would seem as dull as the mud of the street." How was this miracle wrought? By the boldness with which Delacroix had slashed the naked back of this figure with a decided green, which partly neutralized by its complement rose, forms with the rose in which it is absorbed a mixed and fresh tone apparent only at a distance, in a word a *resultant* color which is what is called the optical mixture.

If at a distance of some steps, we look at a cashmere shawl, we generally perceive tones that are not in the fabric, but which compose themselves at the back of our eye by the effect of reciprocal reactions of one tone upon another. Two colors in juxtaposition or superposed in such or such proportions, that is to say according to the extent each shall occupy, will form a third color that our eye will perceive at a distance, without having been written by weaver or painter. This third color is a resultant that the artist foresaw and which is born of optical mixture.

But how to obtain these mixtures without making the form bend to the intentions of the colorist? That is the feeble side of all painting in which color dominates. When our eye perceives simultaneously several colors, the resultant effect depends upon the form of the objects colored, their proportions, their manner of being, their dependence, their grouping. To understand this let us suppose two complementary colors, red and green, placed in juxtaposition upon a rectangular panel divided into two bands R. G. the two colors will recip-

rocally heighten each other, especially along the frontier that separates them.

If now we cut another panel in very narrow parallel bands, and paint these bands alternately red and green, the eye no longer perceiving distinctly the red and green bands, the *individuality* of the color will disappear with the individuality of the form, and it will happen that the red and the green mingling with and destroying each other by this apparent mixture, optical mixture, the second panel will appear grey and colorless.

If the line of junction be broken so as to permit the mutual penetration of the contraries, it will produce upon the lines A B a perfectly colorless tint, upon condition that the indentations shall be small enough to be confounded to the eye. But if the proportion changes and the indentations are unequal there will appear a reddish grey or a greenish grey of charming delicacy.

A similar phenomenon will be produced upon a yellow stuff starred with violet and upon a blue stuff sown with orange spots.

THE VIBRATION OF COLORS

"The parallel between sound and light is so perfect it is sustained even in the least particulars." Thus said a savant of genius, Euler ("Lettres à une princesse d'Allemagne").[6] As the grave or sharp sounds depend upon the number of vibrations of the stretched cord in a given time; so we may say that each color is restricted to a certain number of vibrations which act upon the organ of sight as sounds do upon the organ of hearing. Not only is vibration a quality inherent in colors, but it is extremely probable that colors themselves are nothing but the different vibrations of light. Why does the flower, so fresh and brilliant, lose its color if we detach it from the stem? Because for want of the nourishing juice it will lose all vigor, all spring, and the tissue, like a relaxed cord, will not render the same number of vibrations.

The Orientals, who are excellent colorists, when they have to tint a surface smooth in appearance, make the color vibrate by putting tone upon tone in a pure state, blue upon blue, yellow upon yellow, red upon red; thus they obtain harmony in their stuffs, carpets, or vases, even when they have employed but a single tint, because they have varied its values from light to dark. A man who possessed marvellous knowledge of the laws of color and of decoration from having studied them in the Orient, Adalbert de Beaumont,[7] was the first among us to react against that equality of color we sought in our fabrics as a perfection, and which the Chinese properly regard as a fault. "The more intense the color, whether red, lapis-lazuli, or turquoise," says de Beaumont,

6. Leonhard Euler (1707–1783), *Briefe an eine deutsche Prinzessinn über verschiedene Gegenstünd aus der Physik und Philosophie* (Leipzig: J. F. Junius, 1773–1774).—Ed.
7. Adalbert de Beaumont (active 1880), author of works on Oriental ornamentation and of travel sketches.—Ed.

"the more the Orientals make it *miroiter,* shade it upon itself, to render it more intense and lessen its dryness and monotony, to produce, in a word, that vibration without which a color is as insupportable to our eyes as under the same conditions a sound would be to our ears."

COLOR OF THE LIGHT

In nature the light comes to us variously colored, according to climate, the medium, the hour of the day. If the painter have chosen an effect of colorless light, of diffused and grey light, the laws of the heightening and enfeebling of the colors will not be contrary to those of chiaro 'scuro, that is to say it will suffice to render vigorously the colors in the light and to soften them in the shadow (except for shining stuffs and polished bodies like satin, coats of mail, etc). But if the painter chooses a cold and blue light, or warm and orange, he cannot represent the phenomena produced if he has not the notions of color.

Blue drapery, for example, under the cold light of the north will have its blue heightened in the light, attenuated in the shade. On the contrary if the light is orange like that of the sun, this same drapery will seem much bluer in the shade and less so in the light. Why? Because the mixture of the complementary colors will have substituted a tinted grey for the pure blue of the stuff in the lightest portions. Now replace the blue by orange drapery, pour upon it the light from the north, the blue of this light will partly neutralize the orange, but that will happen only in the light, for in the shadow the orange, finding itself sheltered from the rays that would have taken its color, will preserve all the value the shadow can give it. Whence it results that the effect of colored light upon colors can be obtained only by the absolute knowledge of the phenomena we have described.

Such are the laws that must guide the painter in the play of colors; such are the riches at his disposal. Happy if he adds to optical beauty the expression of the wished-for sentiment, if tuning his palette to the diapason of the fable or history, he knows how to draw from it the accents of poetry. In truth it is only in our days that the eloquence, the aesthetic value of color has been discovered. Veronese and Rubens are always intent upon presenting a fête, playing a serenade, even when the drama represented demands sombre, austere, or cold harmonies. Whether Jesus Christ is seated at the marriage at Cana, or marches to Calvary, or appears to the disciples at Emmaus, Veronese scarcely changes the moral character of his colors. He does not renounce the enchantment of the eye, with naïve serenity he contradicts at need the severity of the theme by external magnificence. In his turn Rubens scarcely makes a difference in the coloring he uses to paint those superb women in the "Garden of Love," and that which will show us in a "Last Judgment," these same women, like a stream of fresh and rosy bodies, precipitated into hell. Even when he wishes to frighten he is determined to seduce.

More poetical, more penetrated by his subject, more moved by his emotions, Eugène Delacroix never fails to tune his lyre to the tone of his thought, so that the first aspect of his picture shall be the prelude to his melody, grave or gay, melancholy or triumphant, sweet or tragic. Afar off, before discerning anything, the spectator forebodes the shows that will strike his soul. What desolation in the crepuscular sky of the "Christ at the Tomb." What bitter sadness in the picture of "Hamlet and the Grave-diggers." What a sensation of physical well-being in the "Jewish Wedding in Morocco," whose harmony, composed of two dominant and complementary colors, red and green, gives the idea of coolness while allowing us to divine without an incandescent sun. What a flourish of trumpets in the coloring of the "Justice of Trajan," in which we see the Roman Emperor in his pomp and his purple issuing from a triumphal arch, accompanied by his generals, his trumpeters, and his eagles, while a woman bathed in tears, throws at his feet a dead child. Below, livid tones; above, the splendid, radiant gamut, an arch filled with azure, a sky that becomes dazzling by the contrast formed by the tones of an orange-colored trophy.

Thus colorists can charm us by means that science has discovered. But the taste for color, when it predominates absolutely, costs many sacrifices; often it turns the mind from its course, changes the sentiment, swallows up the thought. The impassioned colorist invents his form for his color, everything is subordinated to the brilliancy of his tints. Not only the drawing bends to it, but the composition is dominated, restrained, forced by the color. To introduce a tint that shall heighten another, a perhaps useless accessory is introduced. In the "Massacre of Scio," a sabre-tache has been put in the corner solely because in that place the painter needed a mass of orange. To reconcile contraries after having heightened them, to bring together similars after having lowered or broken them, he indulges in all sorts of license, seeks pretexts for color, introduces brilliant objects; furniture, bits of stuff, fragments of mosaic, arms, carpets, vases, flights of steps, walls, animals with rich furs, birds of gaudy plumage; thus, little by little, the lower strata of nature take the first place instead of human beings which alone ought to occupy the pinnacle of art, because they alone represent the loftiest expression of life, which is thought.

In passionately pursuing the triumph of color, the painter runs the risk of sacrificing the action to the spectacle. Our colorists go to the Orient, to Egypt, Morocco, Spain, to bring back a whole arsenal of brilliant objects; cushions, slippers, narghilehs, turbans, burnous, caftans, mats, parasols. They make heros of lions and tigers, exaggerate the importance of the landscape, double the interest of the costume, and of inert substances, and thus painting becomes descriptive; high art sensibly declines and threatens to disappear.

Let color play its true rôle, which is to bring to us the côrtege of external

nature, and to associate the splendors of the material creation with the action or the presence of man. Above all let the colorist choose in the harmonies of color those that seem to *conform to his thought.* The predominance of color at the expense of drawing is a usurpation of the relative over the absolute, of fleeting appearance over permanent form, of physical impression over the empire of the soul. As literature tends to its decadence, when images are elevated above ideas, so art grows material and inevitably declines when the mind that draws is conquered by the sensation that colors, when, in a word, the orchestra, instead of accompanying the song, becomes the whole poem.

FÉLIX FÉNÉON

The Impressionists in 1886
Neoimpressionism (1887)

Félix Fénéon (1861–1944) was one of the first French critics to pro-
mote Impressionist and Symbolist art. As editor of *La Revue indépendante*,
Fénéon regularly contributed reviews on controversial Parisian exhibitions; he
also occasionally wrote for the daily newspaper *Le Matin*.

The following passages were translated from Fénéon's *Oeuvres plus que com-
plètes*, 2 vols., edited by Joan U. Halperin (Geneva: Librairie Droz, 1970),
1 : 35–37, 71–72, and 74.—J.L.Y.

THE IMPRESSIONISTS IN 1886

From the beginning, the Impressionist painters, from a concern for truth
that made them limit themselves to the interpretation of directly observed
modern life and to landscape painted directly from nature, had seen objects as
interdependent, without chromatic autonomy, sharing luminous characteris-
tics with their neighbors. Traditional painting had considered objects as ideally
isolated and illuminated them with an artificial, weak light.

These reactions of colors, these sudden perceptions of complementaries,
this Japanese vision could not be expressed by tenebrous sauces concocted on
the palette. The painters therefore made separate notations, allowing colors to
affect each other, vibrate from abrupt contact, and recombine at a distance.
They enveloped their subjects with light and air, shading them in luminous
tones, even daring at times to sacrifice the modeling. Sun was at last captured
in their canvases.[1]

Their method, then, was to break up the colors. But this breaking up was
carried out in an arbitrary way: a particular stroke of paint might cast an effect

1. It is useful to read in *L'Art moderne* by J.-K. Huysmans (Paris, 1883, G. Charpentier), the
section "the Impressionist Salons of 1880, 1881, and 1882." One can also consult Théodore Duret's
monograph *Critique d'avant-garde* (Paris, 1885, G. Charpentier), and also, for information on the
technique of Neoimpressionism, my article in *L'Art moderne de Bruxelles*, September 19, 1886.

of red across a landscape, and this glowing note would be hatched with green. Georges Seurat, Camille and Lucien Pissarro, Dubois-Pillet, and Paul Signac divide their colors consciously and scientifically. This evolution is dated 1884, 1885, 1886.

In Seurat's *La Grande Jatte,* for example, if one examines a square decimeter covered with a uniform tone, he will find within each centimeter of the surface, in a swirling mass of tiny spots, all the single elements that make up the color. That lawn in the shade: some strokes, the majority, give the local color of the grass; others, of orange, sparsely scattered, express the only slightly perceptible action of the sun; others, of purple, cause the complementary green to intervene; a cyanic blue, induced by the proximity of a plot of grass in the sun, is built up toward the line of demarcation and diminishes progressively away from it. The plot of grass itself is made up of only two elements: green and solar orange, all interactions being destroyed under so furious an impact of light. Black being non-light, the black dog will take on color from the reactions to the grass, its predominant tone will thus be a deep purple; but it will also be attacked by a dark blue, induced by the neighboring luminous areas. The monkey on a leash will be spotted with yellow, its own quality, and speckled with purple and ultramarine. And there you have it—all too simple in writing, just crude indications; but in the painting itself the application is complex and delicate.

These colors, in isolation from each other on the canvas, recombine on the retina. One has, therefore, not a mixture of colored matter (pigments) but a mixture of colored light. Need one be reminded that for the same colors, the mixture of pigments and the mixture of light do not necessarily produce the same results? One knows as well that the luminosity of an optical mixture[2] is always much greater than that of a pigmentary mixture, as shown by the numerous equations for luminosity established by Rood.[3] For a mixture of carmine violet and Prussian blue that produces a gray-blue:

50 Carmine + 50 Blue = 47 Carmine + 49 Blue + 4 Black;

| mixture | mixture |
| of pigments | of light |

for Carmine and Green:
50 Carmine + 50 Green = 50 Carmine + 24 Green + 26 Black.

2. These two propositions are easily demonstrated with Maxwell disks. For information on these theoretical questions, see N. O. Rood, *Théorie scientifique des colours, ses applications à l'art et à l'industrie* (New York, 1881).

3. Ogden Nicholas Rood (1831–1902), American physicist and author, wrote several treatises on color theory, including that cited by Fénéon in note 2.—Ed.

It can be understood why the Impressionists, striving for the expression of extreme luminosity, want to substitute optical mixture for mixture on the palette—as Delacroix had already occasionally done.

Georges Seurat, the first to do so, has presented a complete, systematic paradigm of this technique of painting. His immense canvas *La Grande Jatte* is, at whatever part one looks, a patiently and monotonously spotted surface, a tapestry. Here, indeed, suavities are useless, faking impossible; there is no room for bravura performance; let the hand be numb, but the eye be agile, shrewd, and knowing; to paint an ostrich, a bundle of hay, a wave, or a rock, the manipulation of the brush remains the same. If one can maintain the virtues of ineffective "belle facture" [smooth handling] for the rendering, I imagine, of coarse grass, moving branches, or rough fur, "peinture au point" [pointillism] must be considered, at the very least, for the execution of smooth surfaces, especially the nude, to which it has not yet been applied.[4] The subject: under a sultry sky, at four o'clock, the island, boats slipping past, alive with a fortuitous Sunday, crowd enjoying the open air among the trees. These forty-odd characters are invested with a concise and hieratic design, rigorously drawn from the back, from the front, or from the side, seated at right angles, stretched out horizontally, rigidly standing, like a Puvis in modern dress.[5]

The atmosphere is transparent and singularly vibrant; the surface seems to oscillate. Perhaps this sensation, which one experiences also before certain other pictures in the same room, may be explained by Dove's theory:[6] the retina, prepared for the distinct ray of light to act upon it, perceives in very rapid alternation both the separate elements of color and their resultant mixture.

Paul Signac is fascinated by suburban landscapes. Those of his canvases that date from this year are painted in divided color. They attain a frenetic intensity of light as in *Les Gazomètres à Clichy* (March–April 1886) and *Le Passage du Puits-Bertin à Clichy* (March–April 1886), with its fences on which workpants and shirts are hung out to dry, the desolation of its scarred walls, its reddened grass and incandescent roofs, in a striking atmosphere that deepens as it rises to lose itself in an abyss of dazzling blue. In *L'Embranchement de Bois-Colombes* (April–May 1886), trees are scorched and shriveled, and seas boil under blazing skies. Signac also knows how to express the melancholy of gray weather, to imprison waters in quays; and we have his *Boulevard de Clichy par la neige* and his *Berge à Asnières* (November 1885).

In the preceding exhibitions, Camille Pissarro triumphed with his vegetable gardens, his *Plaine du chou,* his *Sente du chou,* and his *Clos du chou,* superb land-

4. Seurat, who then was studying the nude, was about to begin *Les Poseurs* in the autumn of 1886.
5. Pierre Puvis de Chavannes (1824–1878), whose decorative murals were admired by Symbolist artists.—Ed.
6. Heinrich Wilhelm Dove (1803–1879), German physicist.—Ed.

FÉLIX FÉNÉON

scapes roughly and confidently brushed. Transforming his style, he brings to Neoimpressionism his mathematical rigor of analysis and the authority of his name. From this point, he systematically divides his tones: sunny landscapes, white houses in flowering orchards, retreating plains, tilled fields crisscrossed with slender trees, space unlimited and very high, fleecy clouds dappling the blue. Also his are some very beautiful pastels, principally linear, in which peasants stretch, dress, lie, eat, and toil. There are gouaches. There are etchings reproducing the streets and the port of Rouen.

Alongside Camille Pissarro, his son Lucien is exhibiting. His watercolors are tasteful and fresh, and he has executed a series of woodcuts of rural types, both animals and people, with the exemplary simplicity of the primitive wood engravers.

NEOIMPRESSIONISM (1887)

It is that tendency toward darkness, ultimately a depressing effect, which is the weakness of all earlier painting.

(Gustave Kahn)

One room of the third exhibition of the *Société des Artistes Indépendants* (Pavilion of the City of Paris) is assigned to some fifty Impressionist paintings. The participants are Georges Seurat, Paul Signac, Dubois-Pillet, Lucien Pissarro, and Charles Angrand. We will try to formulate here, more completely than in 1886,[7] the importance of the reform undertaken by them and by their elder associate, Camille Pissarro. The Brussels reader may well recall the canvases of Camille Pissarro and Georges Seurat that he saw at the last Salon of the *Vingtistes*.[8]

I

Latent in Turner and Delacroix (the Chapelle des Saints-Anges, Saint-Sulpice, etc.), Impressionism attempted to formulate itself into a system with Edouard Manet, Camille Pissarro, Renoir, Claude Monet, Sisley, Cézanne, and Ludovic Piette. These painters were distinguished by an excessive sensitivity to the reactions of colors, by a tendency to break up tones, and by an effort to invest their canvases with an intense light. In the choice of subjects,

7. See *L'art moderne,* September 19, 1886: *L'impressionisme aux Tuileries.*
8. Les Vingt, a group of avant-garde Belgian painters, published *L'art moderne* and organized annual exhibitions to which the original twenty members invited an equal number of outside artists, including at times foreigners. Camille Pissarro and Georges Seurat participated in February 1887.

they banished history, anecdote, and dreams; and as discipline for their work, they advocated painting rapidly and directly from nature.

If the word *impressionism* is to retain a somewhat precise meaning, it must apply only to the work of the "luminists." This consequently eliminates Mary Cassatt, Degas, Forain, and Raffaelli, whom a puzzled public has lumped under the same rubric as Camille Pissarro and Claude Monet. It is true, of course, that all of them sought a sincere expression of modern life, scorned academic methods, and exhibited together.

One remembers the first Impressionist exhibitions. Between the definitive canvases and the ferocious splashes of color, the constitutional stupidity of the public was dumbfounded. That a color might wake its complement—ultramarine, yellow; red, blue-green—seemed mad to them. Although the most solemn physicists might have declared, in a pompous tone, that the definitive effect of darkening in all colors of the spectrum is virtually the adding of larger and larger amounts of violet light, yet the public always rebelled when confronted with violet shadows in a painted landscape. Accustomed to the bituminous sauces that the head cooks of the schools and academies concoct, they were staggered by "peinture claire" [painting of light]. Let's admit it, a revolutionary itch did occasionally torment the public; so they paid court to some respectable types: de Nittis, Rolle, Carrier-Belleuse, Dagnan-Bouveret, Goeneutte, Gilbert, Béraud, Duez, Gervex, Bastien-Lepage—and these then characterized their great orgies of modernity.

As for technique, still nothing was precise: the Impressionist works had a look of improvisation, harsh and approximative, summary.

.

III

. . . In their scenes with human figures they show the same aversion to the accidental and the transitory. The critics who are fond of anecdotes complain: they show us mannequins, not human beings. These critics are not weary of the Bulgarian's portraits, which seem to ask: "Guess what I am thinking!" They are not at all distressed to see on their walls a man whose slightly obscene expression is immortalized in a knowing wink, or some flash of an idea that has been on its way for years.

The same critics, ever perspicacious, compare the Neoimpressionist paintings to tapestries, to mosaics, and condemn them. Even if it were exact, this argument would be of paltry value; but it is illusory: take a few steps back, and all the multicolored specks melt into undulant, luminous masses. The technique, one might say, vanishes; the eye is no longer attracted by anything but that which is essentially painting.

This uniform and rather abstract execution leaves the originality of the artist intact, even serves it—need one bother to note that? Indeed, to confuse Camille Pissarro, Dubois-Pillet, Signac, and Seurat would be idiotic. Each of them imperiously professes his difference—if only by his own interpretation of the emotional sense of color, by the degree of sensitivity of his optic nerves to this or that stimulation—but never by any monopoly on easy tricks.

Surrounded by a swarm of mechanical copyists of externalities, these four or five artists impose the sensation of life itself; for them, objective reality is simply a theme for the creation of a superior and purified reality in which their personalities are transfused.

Carpentry. A start toward the abandonment of the strictly white and flat frame is evident. Neoimpressionism this summer will show large oak frames with white liners several centimeters wide. Those of Albert Dubois-Pillet are gallantly adorned with beading. Charles Angrand's are of matte gold. All remain rectangular, although it seems more reasonable to surround a landscape with an oval or round frame.

VI

ART AS CREATION

"Art for art's sake" was used as a scornful epithet by artists who wished to feel closely allied with the dynamic flow of society, yet for others it was a defiant credo. Beginning during the 1860s, an increasing number of European artists insisted that the greatest contribution that art, like music, could make to society was to remain art. As Baudelaire said of poetry, "A poem has no other end than to be itself." In other words, the artist's creative faculty should avoid social, political, or philosophical entanglements, which would constrain its freedom to produce those pleasures peculiar to art itself. Art provides a quality of life enhancement, Bernard Berenson would write near the end of the century, and Benedetto Croce, who much admired the essays of Vittorio Imbriani, concluded that there was an aesthetic emotion, separate from others, that could be satisfied only by the aesthetic experience, free from moral or ethical associations. Art, then, was not the imitation of either an ideal or a visual world but the product of an artist who was moved to create.

In 1846 Edgar Allen Poe wrote a brief essay, "The Philosophy of Composition," that purported to describe how he had composed "The Raven." Whether the description was accurate or not, the clarity with which he set forth the procedure of an artist building up his work with a kind of expressive logic much impressed Baudelaire, who translated the essay. In the early 1860s the poet Stéphane Mallarmé also translated Poe and later wrote, following Poe's idea, "Given an impression, a dream, a thought, [the artist] *must* express it in such a way that it produces the maximum effect in the soul of the audience—an effect entirely calculated by the artist." That a work of art is a carefully calculated construction responding to the inner dictates of the artist was a view shared by many of the poets who published in *Le Parnasse contemporain,* beginning in 1866. Théophile Gautier in particular, himself a painter of sorts, held that a poem was an object built from sounds and images that were suggestive and agreeable in themselves. He wrote a sonnet to Ingres's *La Source,* extolling its qualities as a sensuous, evocative object.

To be sure, these forms, whose poetic logic was conferred by the inner workings of a poet's mind, were not going to be accessible to all. Indeed, it

was clear to these poets, as it was to a later group in England, that art was not necessarily for everybody. The sensibility required to enjoy a work of art was the product of a refinement quite foreign to the middle class, with its concern for mercantile values and social formalities. Art was there for those capable of appreciating it: art was, in a sense, sacred and not to be violated by mundane considerations. To vulgarize the artistic sensibility would be to lose a vital element of human awareness. The poet was not obligated to make himself understood by society; rather, it was society's responsibility to strive to understand the poet if it wished to retain its soul.

In 1863 Whistler exhibited his *White Girl* at the Salon des Refusés and puzzled many by his seeming caprice of painting a girl in a white dress against a white wall, standing on a white bearskin. In terms of subject matter, critics pointed out, the canvas made little sense. The challenge to the perception of white on white was to recur, however. Giovanni Fattori, for example, painted a white horse standing on white sand in front of a white wall. By calling attention to a very subtle interplay of color and form, the artist demanded a concentration on the pictorial means themselves. Seen as a harmony in near whites, Whistler's painting is quite understandable and remains a pleasure. This extreme refinement of taste, which found satisfaction in Chinese and especially Japanese art and blue-and-white porcelain, was looked upon as decadent in both England and France, partly because it was in direct contrast to accepted social values, and partly because it fostered elitism. But although the efforts of Whistler, Gustave Moreau, Wilde, and Huysmans may have been effete, their assumptions were to be echoed in the twentieth century.

In contrast, there was nothing effete about Imbriani, and the artists he knew spent their time in the countryside and avoided literary salons. Imbriani put his blunt finger on an essential point: regardless of the style of a painting, its content lay in its form, not its subject matter. Most particularly, the *macchia* (literally, "spot," but inferring compositional effect) stimulates the imagination to the point of productivity. That is, the work of art is the beginning of a creative experience for the spectator, not a recollection or a confrontation. To be sure, although this experience demands the same attention to formal matters that would make Whistler's *White Girl* intelligible, it need not be considered a rarefied skill. Imbriani in his robust way sees the creative experience simply as a basic fact of art. The language is accessible to all who are willing to put themselves in the hands of the artist.

Possibly this last was the hardest thing to do. Whether one stood for one or another system of social reform or for a vigorous maintenance of the status quo, the active social man had no doubts about his own integrity, and he certainly knew a thing when he saw it. In the 1870s, authoritarian standards were being tightened, not loosened. Consequently, Conrad Fiedler's essay on judging a work of art was rather bolder than it might seem today. He maintained

that the serious artist was always right; a lack of comprehension was the fault of the viewer. Each work challenged the viewer to readjust his values in the light of the new experience, to try to sense within himself something of the artistic necessity that prompted the work in the first place. Viewing art was an active engagement with the artist.

But why should form, quite out of natural context, have the power to provoke the mind and engage the viewer in a gratifying creative experience? This question had interested psychologists as well as critics of art for some years. The coincidence between bodily change and mental states had been much discussed late in the eighteenth century in an especially interesting way by the scientist-mystic Emanuel Swedenborg, whose writings were seen in a new light in the later nineteenth century. The promoters of classical style, of the picturesque and the beautiful, of formal expression such as was described by Miel, all recognized to some degree the sympathy between organized action and feeling. But their artistic language was circumscribed by a limited expressive goal. Gustav Fechner's *Elements of Psychophysics* (1860) launched anew the study of the relationship between body and soul, now to be investigated in terms of modern experimental science. The end was not to discover the language of a limited number of emotional states, but to understand how deeply this emotional activity is rooted in the life of man. The "subject matter" was creative aliveness, as opposed to a total passivity, not one or another namcable emotion.

Although they approached the study very differently, the physicists Theodor Lipps and Edmond Fischer were also concerned with perception, studying what they called *Einfühlung* (empathy), the capacity to identify oneself totally with an action or a thing seen. Such investigations provided the basis for much later art and criticism.

VITTORIO IMBRIANI

The Fifth Promotrice Exhibition, Letters IV and V (1868)

Toward the middle of the nineteenth century, many critics of art, conscious of the responsibility attached to their relatively new profession, began to concern themselves increasingly with the question of reality as expressed in the plastic arts. They began by trying to apply the terminology of literary criticism simply, but quite rigorously, to painting and even sculpture. For narrative works, the system of criticism was simple: first a description of the subject, with as many learned excursions as possible; then the examination of the characters and incidents illustrated; and finally a comment on the execution. In discussing the matter of a work's reality or truth, the critic referred to two criteria: the aptness of the characters and their historic suggestiveness, and the completeness with which all the details of the scene—for each detail presumably assisted the narrative—were rendered. While the more perceptive critics made value judgments on different, quite personal, bases, even so fine a critic as Baudelaire was unable to define clearly the relationship between form and subject matter that made some works visually alive, others only literal illustrations. The nature of the problem, both in painting and in criticism, was realized only slowly.

One of the liveliest movements toward a greater reality in painting itself— that is, toward painting that carried the full impact of immediate sensory experience—was developing in Italy. Many schools, each working in its own fashion, had a single goal: painting that would merit the badge of truth. Landscape schools in Piedmont, Florence, and Naples were devoted to capturing the full impression of nature, and the international group of *campagna* painters in Rome had long depicted the brilliance of Italian sunlight for the world to see. From these groups of painters arose a few critics of remarkable quality; regrettably, they have been neglected outside of Italy, as has the painting itself. To the modern reader, certainly the most impressive of these critics is Vittorio Imbriani (1840–1886) of Naples.

Imbriani was a critic, poet, and storyteller; his comments on art form a very minor part of his lifework. But a few pages from his review of the Fifth Pro-

motrice exhibition in Naples of 1867 are so startlingly acute that Benedetto Croce held them to embody the kernel of Imbriani's entire aesthetic. Another point of interest in these few pages is that they begin with an apology and a refutation. Imbriani did not evolve as a critic, but reached his mature critical understanding, so he suggests, through sudden enlightenment. This new vision forced him to declare false and misleading his earlier judgments, although his goal, sincerity and truth in art, remained the same. Imbriani's spectacular conversion dramatically illustrates the shift from classical criteria for aesthetic judgment to a basis for judgment that was to characterize much later criticism.

The critic devoted to "realism" had first of all to divorce himself from the preconceptions of classical criticism, which were based on notions of ideal form and elevated subject matter. Nor could he be content to accept any theatrical vestiges of the school he had come to define loosely as "romantic." By 1863 Pietro Selvatico could write, "the century sings with Giusti:

> In corpo e in anima
> Servi il reale,
> E non ti perderà
> Nell'ideale.
>
> [In body and soul
> serve the real,
> and lose yourself not
> in the ideal.]

But the definition of "real," as opposed to the "classic" and "romantic," and its use in making judgments became a problem. For Selvatico, the followers of nature were divided into two groups: those who imitated nature minutely, but only those things that were pertinent to the idea to be expressed by the painting; and those who represented everything before them without making any selection. Selvatico, like most, preferred the first because he did not wish to relinquish the element of "thought" in painting, and such a painter could combine the weight of traditional subject matter with the new language of truth. The perfect example of such a painter was Bernardo Celentano (1835–1863), and it was in praise of Celentano that Imbriani wrote his first art criticism.

Bernardo Celentano, born in Naples, went to Rome in 1854 to form himself as a painter. He was devoted to the high ideals of the older historical painters but spurned both their generalized style and the more recent painterly methods inspired by Delacroix—the former he decried as inaccurate, the latter as slovenly. Instead he tried to develop a manner of painting that in its accuracy of imitation would deny itself as a manner. He wrote in satisfaction with regard to his painting of *The Ten:* "No one, however, has praised the color, the grace or the partial execution of detail: an evident indication that the truth of the scene and of the intonation absorbs all other praise, and this I like."

His method of working gave to artistic vision a new scientific authenticity. For each historical painting he posed his artist friends in costume in the sunlight and had them photographed as a group and singly, "to get the effect of the whole and the accidental effects of light." The photograph was the check on his own vision, arresting transient effects that might escape him in direct observation. It served, moreover, as an inspiration. "Seeing all those people dressed in character and expressing all those sentiments and passions of my thoughts, and all illuminated by a flood of sunlight, I received a strong impression of the *true* picture as I before had imagined it, and was seized with an indescribable ardor to begin work."

It was this ardor of truth expressed in the meticulous study, in the denial of "style," that impressed Imbriani when, shortly after the painter's untimely death, a retrospective exhibition of his work was shown in Naples. In *La libertà italiana* of March and April 1864, Imbriani used the work of Celentano to castigate the proponents of the Academy, to illustrate the new order of art that found beauty only in truth, and truth only in that which was observable in nature. He agreed that the greatness of Celentano, or his potential greatness, for he had died so young, was his degree of success in combining an unrelenting observation of nature with the highest literary taste. The understatement of *The Ten,* in which no dramatic action is portrayed yet whose subject makes the static composition seem tense and fraught with terror, was a remarkable example. Furthermore, the subject was Italian, from local history, and Imbriani agreed with many theorists of his time that the moving truth they were seeking could be realized only by penetrating the mass soul of the people; this truth transcended the personal. In spirit he agreed with Celentano's plaint, "Oh, when will that treasure of Filippo Palizzi be thrown full force into inventive painting!"

Yet by the time Imbriani published his praise of Celentano, the Neapolitan landscape painter Palizzi had become just as devoted to a study of nature in his work and ideas as Celentano. The freshness of Palizzi's color and the brilliance of his sunlight were matched by few others before the French Impressionists. But, as Celentano suggested, Palizzi was not concerned with the "quadro di invenzione." In fact, he often chose notably humble subjects—a clump of weeds, a shaggy burro—that defied literary association; such subjects, according to the theory of Selvatico and Imbriani's commentary on Celentano, were rendered with truth but lacked *idea*.

In the next blast Imbriani leveled at the Neapolitan Academy, the importance of the literary idea was beginning to weaken and the seeds of a theory were discernible. In June and July 1865 Imbriani and his friend Saro Cucinotta put out the only two numbers of what was projected as a weekly review to publish the papers of the Institute of Fine Arts of Naples: *L'arte moderna*. In his discussion of a landscape painting competition, the winner of which would go to

Florence for study, Imbriani took the first steps in the direction of a theory of art that would give value, even in terms of idea, to such simple studies as those of a haystack by Palizzi.

Such attempted rationalizations of the value of pure landscape are clear indications of the gap that separates the bases of nineteenth-century artistic judgments from those of the present. Justifications were based on a concept of natural philosophy as explained by Constable, on a kind of Ruskinian pantheism, and only finally on a new acceptance of mood or emotional evocation in nature, as recognized by the Barbizon painters. Imbriani's theory, however, was based neither on a philosophic or literary comprehension of nature nor on an unexamined emotional response to the natural scene. It was set forth as the re-examination of the term *macchia* (literally, "spot"; plural, *macchie*), which had long been used in relation not to nature but to painting. *Macchia,* used generally to refer to the total compositional effect, had recently been used more by artists than by critics; in traditional criticism it had been relegated to a secondary post. Through a re-examination of *macchia*, Imbriani intended to effect a revision of the relationship between subject matter and form.

Not until December 1867 was Imbriani able to employ the term to clarify fully in his own mind the problem of values that had puzzled him and to expound in remarkably lucid fashion a theory of far-reaching implications. Imbriani's review of the "Fifth Promotrice" was published between December 25, 1867, and February 10, 1868, in the appendix of the Florentine political and literary journal *La patria* as a series of thirteen letters to his friend Saro Cucinotta (whom he addresses as Ciarusarvangadarsana). Later in 1868 the letters were published without amplification as a separate pamphlet. The style is characteristically extravagant, with a rich vocabulary spiced with colloquialisms and ingenious neologisms. Irony serves him as a sure weapon, and the very absurdity of some of his examples acts not only to illustrate vividly his point, but also to render foolish the pompous language of the proponents of academic idealism. In the fourth and fifth letters, published on January 9 and 12, 1868, he states his theory. The remainder of the letters are devoted to discussion of the individual works in the exhibition.

Imbriani's position is, simply stated, that "the *macchia* is the sine qua non of the painting, the indispensable essential which can sometimes make one forget any other quality that may be absent, and which can never be supplied by any other." The *macchia* is "an accord of tones, that is, of dark and light, capable of evoking in the soul a sentiment of any sort, exalting the fantasy to the point of productivity. . . . The *macchia* is the pictorial idea. . . ."

An awareness of expressive and symbolic form, as separate from form seeking to approximate a predetermined perfection demanding a high degree of finish, has been evident at various times throughout the history of criticism. It lay behind De Piles's evaluation of the striking, immediate effect of a painting,

his acceptance of Rembrandt and Rubens. It recurs in eighteenth-century characterizations of the picturesque, and the inexplicable quality of hasty sketches—so often lost in completed works—puzzled many nineteenth-century artists. The practical observations of Leonardo da Vinci, which included finding suggestions for compositions in the drying plaster of a wall, caught the imaginations of many and were sometimes used to bolster bold but guarded statements on the nature of painting. More and more in the nineteenth century, music, considered the most evocative and least imitative of the arts, was used by analogy to explain pictorial qualities, and many critics by mid-century had accepted as fact that there might be not one but various equally acceptable modes of painting. Oddly enough, modes of painting classified as "schools" sometimes were listed as categories along with types of subject matter. But Imbriani's statement, which overlooks categories of style or execution, yet gives new meaning to both, goes far in its explicitness to clarify reasonably qualities that had been apparent to many but inexplicable.

It is tempting to link Imbriani's theory with the work of a group of his Florentine contemporaries, contemptuously referred to as *Macchiaiuoli* ("little spot-lovers"), who later used *macchia* as a key word in explaining their work. But it is doubtful if Imbriani would have responded favorably to their very logical projection of his stated beliefs. In the eight final letters he gives decided evidence of artists' lack of success in applying his teachings. Much of this criticism is devoted completely to subject matter; he falls occasionally into arbitrary consideration of relief and "finish," and sometimes his evaluations seem to be based wholly on personal fondness or dislike of the artists themselves or their political alignment. Yet amid such wittily stated but not very perceptive criticism, his humor betrays a happy insight. In discussing a carefully finished painting by Giuseppe de Negris, he remarked: "But perfection in Art is like some women who want to be carried off forcibly; but who, by profound, sensitive, conscientious affections—by all care and attentiveness—can rarely be seduced."

The source for this translation is Vittorio Imbriani, *Critica d'arte e prose narrative,* edited by Gino Doria (Bari: Giuseppe Laterza, 1937), pp. 40–51.

THE FIFTH PROMOTRICE: FOURTH LETTER

NAPLES, JANUARY 9, 1868

. . . When the philosophers admitted Art into the circle of their disquisitions, they said in their agreeable language that in every work of Art, a poem, score, statue, building, painting, there had to be an Idea. They spoke well indeed, but they did not speak clearly, and unfortunately they themselves were

deceived by their polysensical vocabulary and were misunderstood by the public and by artists. I too erred; I confess it and repent. Padre Ciarusarvangadarsana, prostrate at your holy knees, and full of contrition for my *Letter on Bernardo Celentano*,[1] I retract all, from the first syllable to the last: absolve me for not having had even sufficient judgment to suspect, at least, that the pictorial idea could and must differ substantially from the poetic; pardon me for having presumed to reduce paintings to learned pages of books. Pardon this unpardonable foolishness only out of regard for the repentance I feel and because of the virtue I demonstrate in shaming myself so publicly for the greater edification of the few who take art seriously.

Yes, gentlemen, every painting must contain an idea; but a pictorial idea, not just a poetical idea; just so, every poem must contain an idea, but a poetical idea, not a philosophical one. And all the doctrine that might be transfused into it does not make a poem of Giambattista Vico readable, just as all the poetry with which they are crammed is not enough to satisfy the eye in the frescoes of Kaulbach there in the stairway of the New Museum in Berlin.[2] Even every plant, every animal contains an idea; although in these it is no longer syllogism and ratiocination: it is vegetation, it is life. When the idea of beauty is given definition in the artistic idea, it is modified by every Art in such a way as to change nature and appearance completely. But don't think that it is like the same water transformed into drops of various forms and colors. Not at all! It is like carbon, which becomes both coal and diamonds. I might call this phenomenon ideal isomorphism. That which is thought in poetry is motive in music, and type in sculpture.

But in what does the pictorial idea consist? What is the thing that constitutes the painting and that it cannot be without, at least if it is to be called a painting? The soul, in brief, of the painting? Well, I believe it to be the *macchia,* a word whose meaning I am going to take the liberty of defining at length in order to avoid equivocations like those provoked by *idea.*

I remember that one time in your studio you showed me the album printed for the Florence Exhibition of 1861. Seeing I was not content with the engravings and photographs, you took the volume from me, saying you wanted to show me something better in it. The better thing was a fly flattened between two pages, just as nicely as could be. And you exclaimed, "Look, what a beau-

1. Imbriani's "Bernardo Celentano" was originally published in installments in *La libertà napolitana,* March–April 1864, nos. 83, 89, and 96. It was reprinted as *Bernardo Celentano* (Naples: Pomigliano d'Arco, 1864).—Ed.

2. Giambattista Vico (1688–1744), a Neapolitan philosopher and jurist; Wilhelm von Kaulbach (1805–1874), influenced by the work of the Nazarenes, designed frescoes for the Neues Museum at Berlin in 1845.—Ed.

tiful *macchia* [spot]! There, really, is a picture!" These words made me thought-
ful, and I remembered how as a boy I used to sprinkle ink on a piece of paper,
then fold it, to be delighted by the capricious designs, by the *macchia* that
resulted.

If in an inkspot, if in a squashed fly, there can be a picture—in a rudimentary
state, to be sure—it is evident that the essential element, the constituent, of this
picture is not in the expression of the faces, not in the perspective or in the
disposition of the groups, not in as many other accidentals to which excessive
value is attributed by this one or that.

Another time I was in the studio of Filippo Palizzi which you know well.[3]
With the simple addition of a couple of houris and a cupboard well stocked
with food and drink, I should picture it paradise, if I had the weakness to be-
lieve in it. Why? Because I can't conceive of greater enjoyment and delight than
that which I find in contemplating the *studies* that line its walls. But let's return
to the theme. Among the many paintings, on one wall hung a tiny sketch a few
centimeters across, splendidly framed, in which there were only four or five
brushstrokes. Well, in all conscience, Ciarusarvangadarsana, I tell you—you
doubtless remember the *macchietta*—those five brushstrokes, which repre-
sented nothing at all definable, were so happily composed that no other paint-
ing in the two rooms, no matter how perfect plastically or interesting in sub-
ject, seemed to me to equal them. That formless harmony of colors moved me
to spirited gaiety. I could not take my eyes from it, and the more I looked at it,
the more my imagination swarmed with harmonious visions. In a word, it had
stimulated the productivity of my mind, which is exactly the end that art pur-
poses, since the modification to which art subjects material is but the means
adopted to move my imagination.

Forgive me a third example. I fell in love for a while with the fragment of a
column of wonderful African marble displayed for sale at a marble dealer's shop
in Constantinople Street. No one knows all the loveliness of marble who has
not seen my fragment of column. A beauty, I swear! An incomparable *macchia,*
which pulled the cords and set in motion the bells of fantasy. Like the burning
glass that ignites in objects flames it does not have in itself, it awakened in my
mind a thousand charming fantasies, not expressed and defined in the form of
the veinings, but responding to the sentiment explicit in them. And to demon-
strate how precise this sentiment was, I shall tell you that all the images sug-
gested to me by those *macchie,* throughout the infinite number of times I saw
them, were of beautiful feminine nudes, modest and shy, who tried to hide
themselves from the greedy eye of the rapt gazer, as those in the fairy tales who
come out of an opened orange or from a split rock or from a chopped-down

3. Filippo Palizzi (1818–1899), one of the founders of nineteenth-century naturalism in
Italy.—Ed.

tree, as those in chivalric poems trembling on some rock, exposed to the voracity of sea monsters. Never a clothed image, never a masculine image, never an image of lascivious nudity came to me from the *macchie* of that African marble, not even when I tried to evoke it through thought: proof that the *macchia* had its own character, which it imposed upon me.

Every evening Filippo Palizzi, before closing up shop, washes his brushes, cleans his palette, and spreads the colors that remain on his palette knife over the white canvases destined to receive his future thoughts. Thus he not only prepares the canvases with a layer of paint to which successive colors will better adhere, but often obtains some strange and singular stains that arouse in him the idea for a painting that he later executes. And this last example serves to demonstrate how a simple indeterminate *macchia* may find definition not only in the mind of the spectator but also under the hand of the brushholder, who knows how to develop effectively from it that picture which our imagination constructed ideally. Michelangelo saw his statue in the rough form of the mass and did nothing more with the chisel than remove a few importune scales that partially hid it from him; and in the same way, Palizzi, on some happy occasions, only adds to the casual *macchia* a somewhat greater precision of form.

And how many beautiful *macchie* are often made on the tablecloth from drops of wine, tomato sauce, and coffee that fall upon it. And speaking of that . . . what time is it? Five. Goodbye now; you are fine and good, these discourses are fine and good, but dinner is even finer and better. *Amicus* Ciarusarvangadarsana, *magis amica coquina.* Remember your hungry

<div style="text-align: right">Quattr'Asterischi****</div>

THE FIFTH PROMOTRICE: FIFTH LETTER

NAPLES, JANUARY 12, 1868

What, then, is the *macchia* reduced to its final definition? An accord of tones, that is, of dark and light, capable of evoking in the soul a sentiment of any kind exalting the fantasy to the point of productivity. And the *macchia* is the sine qua non of the painting, the indispensable essential, which can sometimes make one forget any other quality that might be absent, and which can never be supplied by any other. This *macchia* is the pictorial idea, just as the musical idea is a given accord of sounds that the maestro calls a *motif.* And in the same way that there must be at the basis of the longest and most varied score a fundamental motif from which all organically unfolds and derives, so at the basis of the most enormous painting, even if it is as large as Michelangelo's *Last Judgment,* there must be a particular organization of light and dark from which the work takes its character. And this organization of light and dark, this *macchia,* is what really moves the spectator. It is not at all, as the vulgar delude themselves, the

expression of the faces or the sterile materiality of the bare subject. Equally in music it is not the attached words, the libretto, but the character of the melody that produces emotion in the listener, and wrings tears, and quickens the pace, and fills with fury, and leads to dancing, and quiets the disturbed.

And here, my fine Ciarusarvangadarsana, I am pushed by the demon against my will to consider a philosophical question, the position of which seems totally changed by the above ideas on the essence of painting and on the nature of the pictorial idea. You know that in aesthetics there are disputes on the system of the arts; every philosopher pretends to classify them in his own way, deducing criteria from the materials, from the states of the imagination, from the degrees of independence of the work. Saint Hegel classified the arts into symbolic, classical, and romantic; Vischer, more Hegelian than Hegel, reduced them to fundamentals that he and many others consider undeniable: *objectivity* (plastic arts), *subjectivity* (music), *conciliation of objectivity with subjectivity* (poetry).[4]

Our Antonio Tari opposes this classification and wants to dethrone poetry and make painting declare *"Esci di là, ci vo' star io"* ["Get away from there, that's where I want to be"].[5] You know Tari; he is a great philosopher, like Giambattista Vico, who, largely for the same reasons as Vico (it is not necessary to specify them here) is little appreciated by his contemporaries. These blessed Italians when they stumble over a great genius act like greedy children who, if the dessert is brought to the table, want to save it. But "he who saves, saves for the cat"; it happens, then, that a foreigner finds out and dresses himself up with our peacock plumes and—goodnight!—someone is cheated out of an honest and merited glory. So Tari classifies the arts otherwise than all the preceding classifiers, concentrating attention only on the link between form and content. Thus he obtains three cycles: *semi-arts* (landscape gardening, music, dance, pantomime, ornament); *whole arts* (architecture, sculpture, painting, poetry, music); *evanescent arts* (declamation, oratory, dialectic). Leaving aside the semi-arts and the evanescent arts, which would give much discussion, let us note only how painting is placed by Tari actually at the vertex of the artistic pyramid, and, according to him, bests even poetry, if not for comprehension and nobility of intention, then for the normality of the organism consistent in the achieved equilibrium postulated in art between form and content. "Equilibrium, which only painting, as its special aim, grasps. Art of sentiment and not of intellectuality; art of color and not of materiality. Nature and Spirit, the world of things and that of ideas, meet in vision, an immaterially material point, in which just (as Byron said) a look can contain an entire soul. So the

4. "Saint Hegel" is, of course, a reference to the philosopher Georg Wilhelm Friedrich Hegel (1770–1831); Friedrich Theodore Vischer (1807–1887), a German philosopher, aesthetician, and poet.—Ed.
5. Antonio Tari (1809–1884), author of several works on aesthetics.—Ed.

rainbow of peace between *Form* and *Ideal content* does not show itself in the heavens of the arts except in the art of the brush."

However, it may seem mad impudence to rise against an opinion of Tari's; the confutation of very great men must not be risked by one *"Che star non posse con Orlando a prova"* [who cannot be tested like Orlando Furioso], yet I allow myself to oppose this classification and take sides with poetry expelled from its legitimate throne by Tari. Painting seems to me to remain, unfortunately, a step lower, almost opposite music, and to be but the music of colors, as music is but the painting of sounds. These two arts are directed equally at the *sentiment* and move it, one with the harmonies of light, the other with harmonies of sound. Both have, then, an equivalent material element that limits them in narrow confines: narrow, that is, in comparison with the infinite field poetry occupies.

And now let us scrutinize the entire content of that *macchia* which we define by the harmony of light and shadow. Effects of light and dark are not presented without an effect of color; rather, color is the effect itself, rather, it is light itself rendered visible by its relationship with dark. Light and dark, speaking absolutely, equally deny the activity of the eye, which can see nothing defined in either; it is from their varied mixture that color results. This is the second element we find in the *macchia,* immediately after the tone. But under color there is yet something else; color does not exist for itself alone, lodged in the air; just as the grapevine and the ivy do not mount to the sky on their own power, but require some sort of support to maintain them upright, so color needs to rest on forms and incorporate itself in objects. Not otherwise than through the will of the philosopher or critic can it detach itself from these, in which alone it exists, without which it is not imaginable, and it pleases us in the degree to which it characterizes well the object. The squashed fly between the pages of your album, the little sketch with the four brushstrokes in Palizzi's studio, the rosy veining in my column of African marble, the canvases smeared with colors left on the palette after a day's labor—all contain the harmony of colors necessary for a painting, impel my fancy to imagine this painting possible, but are not yet the painting itself. The first beat of the motif is certainly not the whole score, even though the entire score is only the explanation of that first beat. Color becomes a full element of art only when it serves to determine the form that only it can characterize to the sense of sight.

We are now, then, in a position to explain more practically what the *macchia* is. It is the portrayal of the first faraway impression of an object, or rather, of a scene, the first and characteristic effect that is impressed on the artist's eye whether he sees the object or scene materially or perceives them with his imagination or memory. It is the salient, the characteristic feature in the effect of light, produced by the special grouping of variously colored people or things. And when I say "far away," I do not refer to the fact of material distance, but rather to that of moral distance, which consists in not yet having taken in

the full perception of all its particulars, an assimilation that can take place only through prolonged understanding, through loving attention.

To this first indeterminate, distant impression that the painter affirms in the *macchia,* there succeeds another, distinct, minute, particularized. The execution, the finishing of a painting is simply a continuous coming closer to the object, which extricates and fixes that which has passed under the eyes in a dazzling procession. But I repeat, if it lacks that first fundamental harmonious accord, the execution, the finish, no matter how great, will never succeed in moving, in evoking in the spectator any sentiment, while on the other hand the solitary, bare *macchia,* without any determination of objects, is most capable of arousing such sentiment.

Do not imagine that I think I am telling you anything very new: this theory can be recognized *in nuce* in the words Vincenzo Cuoco put in the mouth of the crotoniate Nicomaco:

> Do you see that woman walking along the beach? The west wind now blowing in her face fills out her dress a bit and blows her hair about. The first image that comes to me is of an almost cylindrical mass of dark to which are attached two other masses that might be called conical, one at the head, the other larger, at the feet, both having their vertices opposite the side from which the wind is blowing. This is the first image, confused, obscure; and if either I or the woman should pass in a hurry, this will be the only image that I shall have. But if I continue to observe her, this first image will be little by little rendered more clear and more distinct. I shall observe all the parts. The dark that the hair creates will appear to me less dense than that of the dress, and even this will be a bit shaded in comparison with that of the body. Neither the one nor the other will seem to me any longer two cones, but the dress will evidence groups of different darks that fold gracefully one over the other.[6]

Now note a phenomenon. In the painter's coming closer in his attention and execution to that which formed the *macchia,* it too often happens that part of the vigor is lost; in fact it is sometimes lost entirely. How frequently are not the sketches for a painting, artistically speaking, a great deal superior to the executed painting itself, all polished and perfect? But it is always the case that the first cast of any work of art reveals more powerfully the artist and his thought than the work when polished and complete. The very incorrectness that causes the character to be overstressed exaggeratedly in the first manifestation of a powerful impression adds efficacy to the manifestation. Execution weakens the first robust perception; close attention often generates confusion. The *macchia* is entirely the artist's; it is his own way of fixing the proposed theme, it is his idea, it is the subjective part of the painting; on the other hand, the execution is the objective part, it is the subject that takes on value and imposes itself. He is in truth a consummate artist, and can boast of having produced a masterpiece

6. Vincenzo Cuoco (1770–1823), a writer with strong nationalist tendencies. Nicomaco's speech is contained in his *Platone in Italia* (Turin: Unione Tipografico-editrice, n.d.), p. 236.—Ed.

by *antonomasia,* who succeeds in reproducing details with such exactness as to create illusion, without in the least way attenuating or losing the expressive *macchia.* It sometimes happens; it is not impossible.

So the *macchia* from pure accord of tones is established in the harmony of colors, and the color is determined in the forms. It is well; the painting is finished. Let us consider a bit the impression it produces on one who lingers to look at it. I believe that in the effect of the pictorial work we shall find a new reason for assigning it its place on the same step as music. And it is resigned to remain without murmur, except in the crazy lucubrations of the not illustrious but famous *music of the future,* which pretends to obtain from that art that which it cannot give, just as it is impossible to squeeze blood out of a turnip; that is to say, the determinacy of the passion, the full and absolute individuality. But of this, my boy, the day after tomorrow; that is, if the day after tomorrow is still host to your

<div align="center">

*Quattr'Asterischi*****

</div>

JAMES MCNEILL WHISTLER

Mr. Whistler's "Ten O'Clock" (1885)

Like Courbet, whose work Whistler admired early in his career, James McNeill Whistler (1834–1903) flaunted his unconventional views on art before critics and the public. But, in contrast to Courbet, for Whistler art existed outside any social context and was created primarily as an expression of the artist's vision of the beautiful—"art for art's sake." His "Ten O'Clock" lecture, delivered at London, Cambridge, and Oxford in 1885, asserted this independence of the artist from all social issues. The art object should be regarded as beautiful in and of itself, not in connection with extraneous moral values. In his "nocturnes," "symphonies," and "arrangements," Whistler sought to embody this aspect of his aesthetic stance, creating works of art that had for their singular goal the exploration of the harmonious in tone, line, and color.

While in Paris working under Marc-Gabriel Charles Gleyre (1808–1874), Whistler became an early admirer of Japanese prints and was befriended by Degas and Fantin-Latour. After settling in London in 1859, he returned frequently to Paris and was eventually named a Chevalier of the Legion of Honor. The symbolist poet Stéphane Mallarmé greatly admired Whistler's work and translated "Ten O'Clock" into French in 1888.

The lecture is reproduced in its entirety from the original 1885 edition (London: Chatto and Windus). —J.L.Y.

Ladies and Gentlemen,

It is with great hesitation and much misgiving that I appear before you, in the character of The Preacher.

If timidity be at all allied to the virtue modesty, and can find favour in your eyes, I pray you, for the sake of that virtue, accord me your utmost indulgence.

I would plead for my want of habit, did it not seem preposterous, judging from precedent, that aught save the most efficient effrontery could be ever expected in connection with my subject—for I will not conceal from you that I mean to talk about Art. Yes, Art—that has of late become, as far as much discussion and writing can make it, a sort of common topic for the tea-table.

Art is upon the Town!—to be chucked under the chin by the passing gallant—to be enticed within the gates of the householder—to be coaxed into company, as a proof of culture and refinement.

If familiarity can breed contempt, certainly Art—or what is currently taken for it—has been brought to its lowest stage of intimacy.

The people have been harassed with Art in every guise, and vexed with many methods as to its endurance. They have been told how they shall love Art, and live with it. Their homes have been invaded, their walls covered with paper, their very dress taken to task—until, roused at last, bewildered and filled with the doubts and discomforts of senseless suggestion, they resent such intrusion, and cast forth the false prophets, who have brought the very name of the beautiful into disrepute, and derision upon themselves.

Alas! ladies and gentlemen, Art has been maligned. She has naught in common with such practices. She is a goddess of dainty thought—reticent of habit, abjuring all obtrusiveness, purposing in no way to better others.

She is, withal, selfishly occupied with her own perfection only—having no desire to teach—seeking and finding the beautiful in all conditions and in all times, as did her high priest Rembrandt, when he saw picturesque grandeur and noble dignity in the Jews' quarter of Amsterdam, and lamented not that its inhabitants were not Greeks.

As did Tintoret and Paul Veronese, among the Venetians, while not halting to change the brocaded silks for the classic draperies of Athens.

As did, at the Court of Philip, Velasquez, whose Infantas, clad in inaesthetic hoops, are, as works of Art, of the same quality as the Elgin marbles.

No reformers were these great men—no improvers of the ways of others! Their productions alone were their occupation, and, filled with the poetry of their science, they required not to alter their surroundings—for, as the laws of their Art were revealed to them, they saw, in the development of their work, that real beauty which, to them, was as much a matter of certainty and triumph as is to the astronomer the verification of the result, foreseen with the light given to him alone. In all this, their world was completely severed from that of their fellow-creatures with whom sentiment is mistaken for poetry; and for whom there is no perfect work that shall not be explained by the benefit conferred upon themselves.

Humanity takes the place of Art, and God's creations are excused by their usefulness. Beauty is confounded with virtue, and, before a work of Art, it is asked: "What good shall it do?"

Hence it is that nobility of action, in this life, is hopelessly linked with the merit of the work that portrays it, and thus the people have acquired the habit of looking, as who should say, not *at* a picture, but *through* it, at some human fact, that shall, or shall not, from a social point of view, better their mental or moral state. So we have come to hear of the painting that elevates, and of the

duty of the painter—of the picture that is full of thought, and of the panel that merely decorates.

A favourite faith, dear to those who teach, is that certain periods were especially artistic, and that nations, readily named, were notably lovers of Art.

So we are told that the Greeks were, as a people, worshippers of the beautiful, and that in the fifteenth century Art was engrained in the multitude.

That the great masters lived in common understanding with their patrons—that the early Italians were artists—all—and that the demand for the lovely thing produced it.

That we, of to-day, in gross contrast to this Arcadian purity, call for the ungainly, and obtain the ugly.

That, could we but change our habits and climate—were we willing to wander in groves—could we be roasted out of broadcloth—were we to do without haste, and journey without speed, we should again *require* the spoon of Queen Anne, and pick at our peas with the fork of two prongs.

And so, for the flock, little hamlets grow near Hammersmith, and the steam horse is scorned.

Useless! quite hopeless and false is the effort!—built upon fable, and all because "a wise man has uttered a vain thing and filled his belly with the East wind."

Listen! There never was an artistic period.

There never was an Art-loving nation.

In the beginning, man went forth each day—some to do battle, some to the chase; others, again, to dig and to delve in the field—all that they might gain and live, or lose and die. Until there was found among them one, differing from the rest, whose pursuits attracted him not, and so he stayed by the tents with the women, and traced strange devices with a burnt stick upon a gourd.

This man, who took no joy in the ways of his brethren—who cared not for conquest, and fretted in the field—this designer of quaint patterns—this deviser of the beautiful—who perceived in Nature about him curious curvings, as faces are seen in the fire—this dreamer apart, was the first artist.

And when, from the field and from afar, there came back the people, they took the gourd—and drank from out of it.

And presently there came to this man another—and, in time, others—of like nature, chosen by the Gods—and so they worked together; and soon they fashioned, from the moistened earth, forms resembling the gourd. And with the power of creation, the heirloom of the artist, presently they went beyond the slovenly suggestion of Nature, and the first vase was born, in beautiful proportion.

And the toilers tilled, and were athirst; and the heroes returned from fresh

victories, to rejoice and to feast; and all drank alike from the artists' goblets, fashioned cunningly, taking no note the while of the craftsman's pride, and understanding not his glory in his work; drinking at the cup, not from choice, not from a consciousness that it was beautiful, but because, forsooth, there was none other!

And time, with more state, brought more capacity for luxury, and it became well that men should dwell in large houses, and rest upon couches, and eat at tables; whereupon the artist, with his artificers, built palaces, and filled them with furniture, beautiful in proportion and lovely to look upon.

And the people lived in marvels of art—and ate and drank out of master-pieces—for there was nothing else to eat and to drink out of, and no bad build-ing to live in; no article of daily life, of luxury, or of necessity, that had not been handed down from the design of the master, and made by his workmen.

And the people questioned not, *and had nothing to say in the matter.*

So Greece was in its splendour, and Art reigned supreme—by force of fact, not by election—and there was no meddling from the outsider. The mighty warrior would no more have ventured to offer a design for the temple of Pallas Athene than would the sacred poet have proffered a plan for constructing the catapult.

And the Amateur was unknown—and the Dilettante undreamed of!

And history wrote on, and conquest accompanied civilisation, and Art spread, or rather its products were carried by the victors among the vanquished from one country to another. And the customs of cultivation covered the face of the earth, so that all peoples continued to use what *the artist alone produced.*

And centuries passed in this using, and the world was flooded with all that was beautiful, until there arose a new class, who discovered the cheap, and foresaw fortune in the facture of the sham.

Then sprang into existence the tawdry, the common, the gew-gaw.

The taste of the tradesman supplanted the science of the artist, and what was born of the million went back to them, and charmed them, for it was after their own heart; and the great and the small, the statesman and the slave, took to themselves the abomination that was tendered, and preferred it—and have lived with it ever since!

And the artist's occupation was gone, and the manufacturer and the huckster took his place.

And now the heroes filled from the jugs and drank from the bowls—with understanding—noting the glare of their new bravery, and taking pride in its worth.

And the people—this time—had much to say in the matter—and all were satisfied. And Birmingham and Manchester arose in their might—and Art was relegated to the curiosity shop.

Nature contains the elements, in colour and form, of all pictures, as the keyboard contains the notes of all music.

But the artist is born to pick, and choose, and group with science, these elements, that the result may be beautiful—as the musician gathers his notes, and forms his chords, until he bring forth from chaos glorious harmony.

To say to the painter, that Nature is to be taken as she is, is to say to the player, that he may sit on the piano.

That Nature is always right, is an assertion, artistically, as untrue, as it is one whose truth is universally taken for granted. Nature is very rarely right, to such an extent even, that it might almost be said that Nature is usually wrong; that is to say, the condition of things that shall bring about the perfection of harmony worthy a picture is rare, and not common at all.

This would seem, to even the most intelligent, a doctrine almost blasphemous. So incorporated with our education has the supposed aphorism become, that its belief is held to be part of our moral being, and the words themselves have, in our ear, the ring of religion. Still, seldom does Nature succeed in producing a picture.

The sun blares, the wind blows from the east, the sky is bereft of cloud, and without, all is of iron. The windows of the Crystal Palace are seen from all points of London. The holiday-maker rejoices in the glorious day, and the painter turns aside to shut his eyes.

How little this is understood, and how dutifully the casual in Nature is accepted as sublime, may be gathered from the unlimited admiration daily produced by a very foolish sunset.

The dignity of the snow-capped mountain is lost in distinctness, but the joy of the tourist is to recognise the traveller on the top. The desire to see, for the sake of seeing, is, with the mass, alone the one to be gratified, hence the delight in detail.

And when the evening mist clothes the riverside with poetry, as with a veil, and the poor buildings lose themselves in the dim sky, and the tall chimneys become campanili, and the warehouses are palaces in the night, and the whole city hangs in the heavens, and fairy-land is before us—then the wayfarer hastens home; the working man and the cultured one, the wise man and the one of pleasure, cease to understand, as they have ceased to see, and Nature, who, for once, has sung in tune, sings her exquisite song to the artist alone, her son and her master—her son in that he loves her, her master in that he knows her.

To him her secrets are unfolded, to him her lessons have become gradually clear. He looks at her flower, not with the enlarging lens, that he may gather facts for the botanist, but with the light of the one who sees in her choice selection of brilliant tones and delicate tints, suggestions of future harmonies.

He does not confine himself to purposeless copying, without thought, each blade of grass, as commended by the inconsequent, but, in the long curve

of the narrow leaf, corrected by the straight tall stem, he learns how grace is wedded to dignity, how strength enhances sweetness, that elegance shall be the result.

In the citron wing of the pale butterfly, with its dainty spots of orange, he sees before him the stately halls of fair gold, with their slender saffron pillars, and is taught how the delicate drawing high upon the walls shall be traced in tender tones of orpiment, and repeated by the base in notes of graver hue.

In all that is dainty and lovable he finds hints for his own combinations, and *thus* is Nature ever his resource and always at his service, and to him is naught refused.

Through his brain, as through the last alembic, is distilled the refined essence of that thought which began with the Gods, and which they left him to carry out.

Set apart by them to complete their works, he produces that wondrous thing called the masterpiece, which surpasses in perfection all that they have contrived in what is called Nature; and the Gods stand by and marvel, and perceive how far away more beautiful is the Venus of Melos than was their own Eve.

For some time past, the unattached writer has become the middleman in this matter of Art, and his influence, while it has widened the gulf between the people and the painter, has brought about the most complete misunderstanding as to the aim of the picture.

For him a picture is more or less a hieroglyph or symbol of story. Apart from a few technical terms, for the display of which he finds an occasion, the work is considered absolutely from a literary point of view; indeed, from what other can he consider it? And in his essays he deals with it as with a novel—a history—or an anecdote. He fails entirely and most naturally to see its excellencies, or demerits—artistic—and so degrades Art, by supposing it a method of bringing about a literary climax.

It thus, in his hands, becomes merely a means of perpetrating something further, and its mission is made a secondary one, even as a means is second to an end.

The thoughts emphasised, noble or other, are inevitably attached to the incident, and become more or less noble, according to the eloquence or mental quality of the writer, who looks, the while, with disdain, upon what he holds as "mere execution," a matter belonging, he believes, to the training of the schools, and the reward of assiduity. So that, as he goes on with his translation from canvas to paper, the work becomes his own. He finds poetry where he would feel it were he himself transcribing the event, invention in the intricacy of the *mise en scene,* and noble philosophy in some detail of philanthropy, courage, modesty, or virtue, suggested to him by the occurrence.

All this might be brought before him, and his imagination be appealed to, by a very poor picture—indeed, I might safely say that it generally is.

Meanwhile, the *painter's* poetry is quite lost to him—the amazing invention, that shall have put form and colour into such perfect harmony, that exquisiteness is the result, he is without understanding—the nobility of thought, that shall have given the artist's dignity to the whole, says to him absolutely nothing.

So that his praises are published, for virtues we would blush to possess—while the great qualities, that distinguish the one work from the thousand, that make of the masterpiece the thing of beauty that it is—have never been seen at all.

That this is so, we can make sure of, by looking back at old reviews upon past exhibitions, and reading the flatteries lavished upon men who have since been forgotten altogether—but, upon whose works, the language has been exhausted, in rhapsodies, that left nothing for the National Gallery.

A curious matter, in its effect upon the judgment of these gentlemen, is the accepted vocabulary, of poetic symbolism, that helps them, by habit, in dealing with Nature: a mountain, to them, is synonymous with height—a lake, with depth—the ocean, with vastness—the sun, with glory.

So that a picture with a mountain, a lake, and an ocean—however poor in paint—is inevitably "lofty," "vast," "infinite," and "glorious"—on paper.

There are those also, sombre of mien, and wise with the wisdom of books, who frequent museums and burrow in crypts; collecting—comparing—compiling—classifying—contradicting.

Experts these—for whom a date is an accomplishment—a hall mark, success!

Careful in scrutiny are they, and conscientious of judgment—establishing, with due weight, unimportant reputations—discovering the picture, by the stain on the back—testing the torso, by the leg that is missing, filling folios with doubts on the way of that limb—disputations and dictatorial, concerning the birthplace of inferior persons—speculating, in much writing, upon the great worth of bad work.

True clerks of the collection, they mix memoranda with ambition, and, reducing Art to statistics, they "file" the fifteenth century, and "pigeon-hole" the antique!

Then the Preacher—"appointed"!

He stands in high places—harangues and holds forth.

Sage of the Universities—learned in many matters, and of much experience in all, save his subject.

Exhorting—denouncing—directing.

Filled with wrath and earnestness.

Bringing powers of persuasion, and polish of language, to prove—nothing.

Torn with much teaching—having naught to impart.

Impressive—important—shallow.

Defiant—distressed—desperate.

Crying out, and cutting himself—while the Gods hear not.

Gentle priest of the Philistine withal, again he ambles pleasantly from all point, and through many volumes, escaping scientific assertion, "babbles of green fields."

So Art has become foolishly confounded with education—that all should be equally qualified.

Whereas, while polish, refinement, culture, and breeding, are in no way arguments for artistic result, it is also no reproach to the most finished scholar or greatest gentleman in the land that he be absolutely without eye for painting or ear for music—that in his heart he prefer the popular print to the scratch of Rembrandt's needle, or the songs of the hall to Beethoven's "C minor Symphony."

Let him have but the wit to say so, and not feel the admission a proof of inferiority.

Art happens—no hovel is safe from it, no Prince may depend upon it, the vastest intelligence cannot bring it about, and puny efforts to make it universal end in quaint comedy, and coarse farce.

This is as it should be, and all attempts to make it otherwise, are due to the eloquence of the ignorant, the zeal of the conceited.

The boundary line is clear. Far from me to propose to bridge it over—that the pestered people be pushed across. No! I would save them from further fatigue. I would come to their relief, and would lift from their shoulders this incubus of Art.

Why, after centuries of freedom from it, and indifference to it, should it now be thrust upon them by the blind—until, wearied and puzzled, they know no longer how they shall eat or drink—how they shall sit or stand—or wherewithal they shall clothe themselves—without afflicting Art?

But, lo! there is much talk without!

Triumphantly they cry, "Beware! This matter does indeed concern us. We also have our part in all true Art!—for, remember the 'one touch of Nature' that 'makes the whole world kin.'"

True, indeed. But let not the unwary jauntily suppose that Shakespeare herewith hands him his passport to Paradise, and thus permits him speech among the chosen. Rather, learn that, in this very sentence, he is condemned to remain without—to continue with the common.

This one chord that vibrates with all—this "one touch of Nature" that calls aloud to the response of each—that explains the popularity of the "Bull" of Paul Potter—that excuses the price of Murillo's "Conception"—this one un-spoken sympathy that pervades humanity, is—Vulgarity!

Vulgarity—under whose fascinating influence "the many" have elbowed "the few," and the gentle circle of Art swarms with the intoxicated mob of mediocrity, whose leaders prate and counsel, and call aloud, where the Gods once spoke in whisper!

And now from their midst the Dilettante stalks abroad. The amateur is loosed. The voice of the aesthete is heard in the land, and catastrophe is upon us.

The meddler beckons the vengeance of the Gods, and ridicule threatens the fair daughters of the land.

And there are curious converts to a weird *culte,* in which all instinct for at-tractiveness—all freshness and sparkle—all woman's winsomeness—is to give way to a strange vocation for the unlovely—and this desecration in the name of the Graces!

Shall this gaunt, ill-at-ease, distressed, abashed mixture of *mauvaise honte* and desperate assertion, call itself artistic, and claim cousinship with the art-ist—who delights in the dainty—the sharp, bright gaiety of beauty?

No!—a thousand times no! Here are no connections of ours.

We will have nothing to do with them.

Forced to seriousness, that emptiness may be hidden, they dare not smile—

While the artist, in fulness of heart and head, is glad, and laughs aloud, and is happy in his strength, and is merry at the pompous pretension—the solemn silliness that surrounds him.

For Art and Joy go together, with bold openness, and high head, and ready hand—fearing naught, and dreading no exposure.

Know, then, all beautiful women, that we are with you. Pay no heed, we pray you, to this outcry of the unbecoming—this last plea for the plain.

It concerns you not.

Your own instinct is near the truth—your own wit far surer guide than the untaught ventures of thick-heeled Apollos.

What! will you up and follow the first piper that leads you down Petticoat Lane, there, on a Sabbath, to gather, for the week, from the dull rags of ages, wherewith to bedeck yourselves? that, beneath your travestied awkwardness, we have trouble to find your own dainty selves? Oh, fie! Is the world, then, exhausted? and must we go back because the thumb of the mountebank jerks the other way?

Costume is not dress.

And the wearers of wardrobes may not be doctors of taste!

For by what authority shall these be pretty masters? Look well, and nothing have they invented—nothing put together for comliness' sake.

Haphazard from their shoulders hang the garments of the hawker—combining in their person the motley of many manners with the medley of the mummers' closet.

Set up as a warning, and a finger-post of danger, they point to the disastrous effect of Art upon the middle classes.

Why this lifting of the brow in deprecation of the present—this pathos in reference to the past?

If Art be rare to-day, it was seldom heretofore.

It is false, this teaching of decay.

The master stands in no relation to the moment at which he occurs—a monument of isolation—hinting at sadness—having no part in the progress of his fellow men.

He is also no more the product of civilisation than is the scientific truth asserted, dependent upon the wisdom of a period. The assertion itself requires the *man* to make it. The truth was from the beginning.

So Art is limited to the infinite, and beginning there cannot progress.

A silent indication of its wayward independence from all extraneous advance, is in the absolutely unchanged condition and form of implement since the beginning of things.

The painter has but the same pencil—the sculptor the chisel of centuries.

Colours are not more since the heavy hangings of night were first drawn aside, and the loveliness of light revealed.

Neither chemist nor engineer can offer new elements of the masterpiece.

False again, the fabled link between the grandeur of Art and the glories and virtues of the State, for Art feeds not upon nations, and peoples may be wiped from the face of the earth, but Art *is*.

It is indeed high time that we cast aside the weary weight of responsibility and co-partnership, and know that, in no way, do our virtues minister to its worth, in no way do our vices impede its triumph!

How irksome! how hopeless! how superhuman the self-imposed task of the nation! How sublimely vain the belief that it shall live nobly or art perish!

Let us reassure ourselves, at our own option is our virtue. Art we in no way affect.

A whimsical goddess, and a capricious, her strong sense of joy tolerates no dulness, and, live we never so spotlessly, still may she turn her back upon us.

As, from time immemorial, has she done upon the Swiss in their mountains.

What more worthy people! Whose every Alpine gap yawns with tradition,

and is stocked with noble story; yet, the perverse and scornful one will none of it, and the sons of patriots are left with the clock that turns the mill, and the sudden cuckoo, with difficulty restrained in its box!

For this was Tell a hero! For this did Gessler die!

Art, the cruel jade, cares not, and hardens her heart, and hies her off to the East, to find, among the opium-eaters of Nankin, a favourite with whom she lingers fondly—caressing his blue porcelain, and painting his coy maidens, and marking his plates with her six marks of choice—indifferent, in her companionship with him, to all save the virtue of his refinement!

He it is who calls her—he who holds her!

And again to the West, that her next lover may bring together the Gallery at Madrid, and show to the world how the Master towers above all; and in their intimacy they revel, he and she, in this knowledge; and he knows the happiness untasted by other mortal.

She is proud of her comrade, and promises that, in after years, others shall pass that way, and understand.

So in all time does this superb one cast about for the man worthy her love—and Art seeks the Artist alone.

Where he is, there she appears, and remains with him—loving and fruitful—turning never aside in moments of hope deferred—of insult—and of ribald misunderstanding; and when he dies she sadly takes her flight, though loitering yet in the land, from fond association, but refusing to be consoled.

With the man, then, and not with the multitude, are her intimacies; and in the book of her life the names inscribed are few—scant, indeed, the list of those who have helped to write her story of love and beauty.

From the sunny morning, when, with her glorious Greek relenting, she yielded up the secret of repeated line, as, with his hand in hers, together they marked, in marble, the measured rhyme of lovely limb and draperies flowing in unison, to the day when she dipped the Spaniard's brush in light and air, and made his people live within their frames, and *stand upon their legs,* that all nobility and sweetness, and tenderness, and magnificence should be theirs by right, ages had gone by, and few had been her choice.

Countless, indeed, the horde of pretenders! But she knew them not.

A teeming, seething, busy mass, whose virtue was industry, and whose industry was vice!

Their names go to fill the catalogue of the collection at home, of the gallery abroad, for the delectation of the bagman and the critic.

Therefore have we cause to be merry!—and to cast away all care—resolved that all is well—as it ever was—and that it is not meet that we should be cried at, and urged to take measures!

Enough have we endured of dulness! Surely are we weary of weeping, and our tears have been cozened from us falsely for they have called out woe! when there was no grief—and, alas! where all is fair!

We have then but to wait—until, with the mark of the gods upon him—there come among us again the chosen—who shall continue what has gone before. Satisfied that, even were he never to appear, the story of the beautiful is already complete—hewn in the marbles of the Parthenon—and broidered, with the birds, upon the fan of Hokusai—at the foot of Fusi-Yama.

CONRAD FIEDLER

On Judging Works of Visual Art (1876)

Conrad Fiedler (1841–1895) pursued a law career until age twenty-five, when a meeting with Hans von Marées (1837–1887) stimulated his interest in art and led him to investigate theoretical aspects of the process of artistic creation. Through Marées, Fiedler also met the sculptor Adolph von Hildebrand (1844–1918). Beginning in 1874 the three resided together during the spring months in a monastery outside of Florence. In 1876, drawing upon these experiences, Fiedler wrote *On Judging Works of Visual Art,* a treatise in which he sought to evaluate art from the perspective of the creative artist.

Fiedler's other works include a biography of Marées, published in 1889, the essay *Modern Naturalism and Artistic Truth* (1881), and *On the Origin of Artistic Activity* (1887). Among the theorists and art historians influenced by Fiedler's writings were Benedetto Croce (1866–1952) and Heinrich Wölfflin (1864–1945). The translation reproduced here is by Henry Schaefer-Simmern and Fulmer Mood, from Conrad Fiedler, *On Judging Works of Visual Art* (Berkeley and Los Angeles: University of California Press, 1957), pp. 27–58.—J.L.Y. ✍

CHAPTER THREE

I. The understanding of art can be grasped in no other way than in terms of art. Only if we see the world before us in terms of the particular interest of the artist can we succeed in reaching an understanding of works of art that is founded solely on the innermost essence of artistic activity. In order to be able to grasp the artist's concern with the visible world it is well to remember that man's interest in appearances is divided into two principal types. They start from perceptual experience but soon come into opposition to each other. It is to the independent and free development of perceptual experience that we must look for the peculiar power of artistic talent.

Man's way of relating himself to the world by means of his sensibilities can be different in kind and degree. There are infinite gradations between dullness and indifference and the highest sensitivity. Many persons face objects with a

Hans von Marées, *Portrait of Conrad Fiedler*, 1869–71, oil on canvas.

sense of strangeness and are unable to establish any relationship with them; in their dependence upon their own inadequate sensibilities they are inaccessible to the power of visual phenomena, and rightly one regards this unresponsiveness as a deficiency in the individual organization. Others, because their nature is richer and more highly refined, are more receptive to the visual world. And while the former, as it were, lack the organs by which they can grasp the qualities of things, the latter, at least now and then, are aware that they are being exposed to the influences of these qualities; they do not sink to the completely indifferent state, but neither do they rise above an occasional partial and limited sensitivity to things. Thus, one may feel beauty vividly, yet will always be touched by a single quality, whereas the complete object, whether beautiful or not, remains alien to him. It is the rare privilege of highly organized, sensitive persons that they can achieve immediate contact with nature. Their relation to an object does not arise from single effects; on the contrary, they grasp its very existence, and they feel the object as a whole even before they break up this general feeling into many separate sensations. For such persons as these there is a pleasure and a delight in the vital existence of things far above such differences as the beautiful and the ugly: it is a grasping not of single qualities but of all nature itself, which later on turns out to be the carrier of those many separate qualities. Such feelings for the single qualities of things, as well as that feeling for nature as a whole above and beyond the sensitive apprehension of its single qualities, can attain high degrees of intensity within persons at given moments. It rises to fervor and to ecstasy and forms the basis of passionate personal enthusiasms.

Sensation cannot be conceived apart from perception [i.e., the experience of the senses]. Yet it is questionable whether an increase in sensation also means an increase in perceptual comprehension. Sensation already occurs with perception that is little developed. The strength of sensation depends on the susceptibility of our feelings and not on the amount of our perceptual experiences. Indeed, if we watch ourselves closely we shall find that our sensation does not stimulate and further, but rather hinders, the growth of our visual conceptions. Our feeling is something else than our visual conceiving, and if the former dominates then the latter must step back. For example, in sensing the beauty of a particular object we may occupy ourselves with this sensation entirely, without proceeding a single step toward the perceptual mastering of the object. However, at that moment when interest based on visual conception takes hold of us again, we must be able to forget every sensation in order to further our perceptual grasp of the object for its own sake. Because many persons are all too quick to transform perceptual experience into feeling, their perceptual abilities consequently remain on a low level of development.

It is a chief requirement of artistic talent that it shall possess an especially refined and sensitive susceptibility to certain qualities of things. In preëminent

artists we may, indeed, occasionally meet with that profound relationship, mentioned earlier, of sensation and of a feeling for the totality of natural objects. But the presence of such refined feelings is not yet an indication of artistic talent. To possess such feelings is the main prerequisite for artistic as well as for every other mental productiveness; for he who does not seek to grasp nature with the power of his intuition will never succeed in subjugating her to his higher mental consciousness. But the artist becomes an artist by virtue of his ability to rise above his sensations. It is true that sensation accompanies him in all the phases of his artistic activity and keeps him continuously in a close relation to all things, that it nourishes in him the warmth of life by which he himself is connected with the world. Sensation continuously provides him with the material the transformation of which is the fulfillment of his mental existence. Yet, however heightened his sensations may be, he must always be able to master them with the clarity of his mind. And although the artist's creation is possible only on the basis of an extraordinarily intense feeling, nevertheless this artistic creation has been made possible by his still more extraordinary power of mind, which even in moments of the most intense sensory experience preserves unimpaired the calmness of objective interest and the energy of formative creation.

2. In abstract cognition we possess the means of submitting appearances to certain demands of our thinking faculties, and thus of appropriating them for ourselves by transforming them into conceptual Gestalt-formations. We exercise these faculties thousands of times without being aware of it. We consciously increase this ability when we are driven by our higher intellectual needs to comprehend the world. This is the process which leads us to mental mastery of the world by means of conceptual thinking. It is a specific mental process that leads to the conceptual Gestalt-formation of the world. Although the process is familiar to us, it is nevertheless a mysterious one, for by means of it a sudden inexplicable transition takes place from sensuous to nonsensuous, from visible to invisible, from perception to abstraction [—from that which is seen to that which is a concept of the seen. *Translators*].

In times when science offers explanations of the world, and interest in those explanations not only possesses the most gifted minds but also penetrates all educated circles, we meet with the general opinion, first, that outward appearances of objects are unessential in comparison with the inner meanings which science tries to draw from them; second, that science has already arrived at complete understanding of the external appearance of objects and looks upon perceptual cognition as no more than a preliminary to its own higher, scientific, cognition.

But how can we differentiate between essential and unessential when speaking of objects of nature? Such judgments are relative, changing with one's standpoint. And if only that seems essential upon which for the time being one

is concentrating his contemplative gaze, one has no more than a subjective right to declare other aspects of objects of nature unessential.

Furthermore, it must be noted that scientific observation is by no means based upon complete perception. In scientific observation, perception can be of interest and value only so far as it makes possible the transition to abstract concepts, and this transition occurs on a comparatively low level. Already, in everyday life, man clings to perception only until the transition to abstract thinking becomes possible for him. He repeats this process innumerable times, and every perceptual experience vanishes as soon as, by means of his conceptual thinking, he draws out of perception that which all too often he believes to be its one and only essential content. Scientific observation would completely lose its way if outward appearances in themselves had value for it and if it stopped with them and did not advance to the creation of concepts. In remaining at the stage of perception one would soon face a rich profusion of experience which no concept could ever denote and encompass. Of all sciences, natural science is the most dependent upon the exact observation of the shapes and mutations of objects as well as the relationships between the parts and the whole. He who must with exactness observe objects with respect to their outward appearance, memorize them and make them his own in order to draw conclusions from his mental picture of them, would not admit that knowledge attained solely from perceptual experience could extend far beyond his own special purpose. But those persons who require for scientific purposes a rich perception of nature know that a tendency for abstract thinking makes the understanding of perception difficult. The more they advance in transforming perception into abstract concepts, the more incapable they become of remaining, even for a short while, at the stage of perception. And if they judge a work of art by the yardstick of their knowledge of nature and consider it to be a copy of nature, the meagerness of their perception of nature reveals itself at once in the insufficiency of their demands upon works of art. They believe that they are able to check upon the artist's knowledge of nature, transfer their way of looking at nature to the artistic imitation of nature, and see in it essentially nothing but a scientific illustration of conceptual abstraction. In effect, since a work of art would thereby be reduced to a mere instrument of evoking perceptions and of dissecting nature as a whole into isolated fragments and features in order to make more readily recognizable that which in the world of complicated appearances is difficult to grasp, they would thus ignore perception entirely in order to find the meaning of art.

Finally, even if one must admit that perceptual experience cannot be entirely transformed into abstract concepts, and that concepts derive from perception and therefore cannot be wholly given up, the scientific investigator will, nevertheless, always consider a perceptual activity inferior if it does not lead to clear concepts dominating perception. Although he may have grasped the world in

his own way and thereby fulfilled the needs of his mind, he nevertheless errs if he believes that through abstract thinking alone all human intellectual capacities have been recognized and fulfilled. To remain at the stage of perception rather than to pass onward to the stage of abstraction does not mean remaining on a level which does not lead to the realm of cognition; rather, it means keeping open other roads that also arrive at cognition. But if cognition attained by perceptual experience is different from cognition reached by abstract thinking, it can nevertheless be a true and final cognition.

Among different persons, we can notice even in their early youth different mental attitudes: some endeavor to draw concepts from their sensory experience and direct their attention to the inner causal connections between appearances, while others, less concerned with these hidden connections, exercise their mental powers in contemplation of the outward conditions of the visible world. Either kind of observation reveals itself early in gifted men. But these different kinds of observation manifest different relations to the world. And as some persons, if really gifted, do not stop short with a desire for dry and barren knowledge, so others will be led beyond the desire to know the things transmitted to them by perception into an activity by which they begin to approach and to grasp the entire world of appearances.

However, the fallacy is widely diffused that by means of science man may be able to subjugate the world in accordance with the demands and faculties of abstract cognition so that he may hope to become capable of possessing the world mentally as it actually is. And although man admits that the solutions of the tasks assigned to science are infinitely remote, he still knows, even if these solutions can never be reached, that they lie at the end of the road on which he travels. But there is one thing that man is not always clear about: even should science reach its most distant aims and realize its boldest dreams, even should science grasp the entire essence of the world scientifically, we would still have to face riddles the very existence of which would be hidden from all science. The struggle for the conquest of nature, led by the scientist, results in his becoming the scientific conquerer of the world. This may entitle him to the highest pride; yet he cannot prevent other persons from thinking that for themselves little has been accomplished by the achievements of science, and they on their part may feel a peremptory desire to submit the world to an absolutely different process of mental appropriation.

As a rule, everyone will think that his way of making the world intelligible to himself is the most important way. Nature is very stingy in the procreation of individuals who, being endowed abundantly with all mental faculties, are able to express the multifarious content of the world. There are many who seek versatility by submitting many objects to one mode of contemplation; but there are few who can be versatile in submitting one object to many modes of contemplation.

3. Each time that sensation is awakened and abstract concepts appear, perception [i.e., pure sensory experience] vanishes. The quanta of perceptual experience that lead both to sensations and to concepts differ greatly, but even the largest quantum is small in contrast to the infinitude of perceptual experiences available to man. Only he who is able to hold onto his perceptual experiences in spite of both sensation and abstraction proves his artistic calling. It is rare, however, that perceptual experience attains independent development and impartial existence.

Man's sensitivity varies enormously with sex, natural gifts, age, and time; also, the quanta of concepts and abstract knowledge that he possesses vary widely. It is enough to remind oneself of simple, well-known facts in order to certify that in single individuals there is likewise a great variation in types and quanta of visual conceptions. And usually there is a low degree of development of the faculty of visual conceiving. Even if we were misled by assuming that persons equally gifted with the same keen senses and using them in identical surroundings would arrive at visual conceptions of the same quality, we should soon learn that the visual conception of each would be entirely different. The truth of this statement would be apparent the moment an argument should begin about the outward appearance of even a very simple object of daily use—an argument in which everyone would be forced to give an account of his memory image of that object. Rarely do visual conceptions mature to a stage of independent clarity. Knowledge of even a simple object is generally limited to the aspects common to the type, and rarely does such knowledge extend to the special peculiarities pertaining to that individualized object. Whenever we are long surrounded by particular objects, these become so impressed upon our memories that we notice immediately any slight change in their shapes, or their replacement by other objects, however small the differences in these may be. Yet we have only to change the conditions under which these objects were familiar to us in order to prove that the knowledge of which we seemed so certain is not certain, that that knowledge suffices only as long as the original conditions remain. Is it not sometimes difficult to recognize the identity of persons, even though one has always been intimate with them?

Of objects offered to his perceptions, man mostly acquires images that are composed of but a few of all the possible elements which objects actually present to his faculties of perception. This is not merely the fault of the reproductive memory, which is unable to keep a clear, complete image for a long time after the object is no longer present; rather it is the fault of the original act of perception itself, which was incomplete. Thus man carries on his visual perceptive experience in a very neglectful way. Generally he shows himself more inclined to extend his abstract knowing than his visual knowledge. Also, everyday life puts to the test much more frequently the extent and precision of a person's conceptual knowledge than the completeness of his visual conceptions.

The total evaluation achieved by any one person is much more often founded upon his capacity for abstract knowing than upon his ability for concrete conceiving.

Education has the task of fitting the intellectual powers of man to the needs of life. Education almost exclusively furthers the capacity for forming concepts. If in education more attention than usual is at times given to perceptual experience, this additional attention is likely to be superfluous and may even be harmful if perception is given more room in the curriculum only as a means of attaining concepts. There is no need of special devices that will bring perception near to man. However strong and well trained man's thinking faculty may be, he will always find himself confronted with an infinite task if he has to master all the perceptual experiences which life inescapably presents to him. The more independent and self-reliant man's abstract thinking faculties are trained to become, the more powerful tools they will be in contrast to perceptual experience. The demand that more attention be paid to perception in man's education would only be justified if it were understood that, for man, perception is something of independent importance apart from all abstraction and that the capacity for concrete perceiving has as strong a claim to be developed by regular and conscious use as the capacity for abstract thinking has. It should be understood that man can attain the mental mastery of the world not only by the creation of concepts but also by the creation of visual conceptions.

Almost everywhere, however, the capacity of perceiving decays, becoming restricted to an almost unintentional casual use. Even persons who have but a very limited knowledge of the world, because their mental capacities are limited or because they must maintain themselves by manual occupations, nevertheless understand the meaning of the necessity that the human mind must grasp the world conceptually. They at least know the necessity that lies behind the questions which scientific research seeks to answer. Thus the infinite, before which man with his longing and striving for knowledge stands, will occasionally become clear to them. In contrast, those who restlessly enlarge their funds of abstract knowledge will only with difficulty grasp the fact that man with his mental capacities also stands face to face with an infinity in his perceptual experience and that the realm of the visible world can also be a field of investigation. For these it will be difficult to understand that even to the most eminent minds it is granted to take only some few steps toward the understanding of the visible world, and such efforts must appear immeasurable to those who endeavor to penetrate more and more into the comprehension of the visible.

4. Only he will be able to convince himself of the infinite possibilities for the visual comprehension of the world who has advanced to the free and independent use of his perceptive faculties.

As long as perception serves some explicit purpose, it is limited, it is unfree.

Whatever this purpose may be, perception remains a tool, and it becomes superfluous once the purpose is attained. If other mental activities should be recognized as justified only when employed for some definite explicit purpose, we would regard such an evaluation as a narrow-minded restriction. Man has ever felt an irresistible drive to make a free use of his powers, after once having found out that they are serviceable to the needs of life. Indeed, the products of the free use of mental capacities are honored as the highest of human achievements. That activity, however, which we should think the most natural one that man can engage in, namely, the grasping of the visible world, is a most complicated process. It is certain that man understands the necessity of educating himself to greater care in the observing of things and the memorizing of the acquired images. It is also certain that those purposes for which perception is a tool attain increased importance. Out of the drudgery of the daily needs of life, perception rises to the service of the noblest pleasures and becomes the tool of the highest endeavors. But always, nevertheless, the aims of perception are predetermined and it terminates once the set goal is attained.

It is the essential characteristic of the artist's nature to be born with an ability in perceptual comprehension and to free use of that ability. To the artist perceptual experience is from the beginning an impartial, free activity, which serves no purpose beyond itself and which ends in that purpose. Perceptual experiences alone can lead him to artistic Gestalt-formations. To him the world is but a thing of appearances. He approaches it as a whole and tries to re-create it as a visual whole. The essence of the world which he tries to appropriate mentally and to subjugate to himself consists in the visible and tangible Gestalt-formation of its objects. Thus we understand that to the artist perceptual experience can be endless, can have no aim or end fixed beyond itself. At the same time, also, we understand that to the artist perceptual experience must have immediate meaning, independent of any other purpose that can be produced by it.

The artist's relationship to the world, which to us remains incomprehensible as long as we as nonartists stand in our own relationship to the world, becomes intelligible to us once we consider the artist's relationship as a primary and peculiar connection between his powers of visual comprehension and the objects visually comprehended. And this relationship is based on a need which in turn is an attribute of man's spiritual nature. The origin and existence of art is based upon an immediate mastering of the visible world by a peculiar power of the human mind. Its significance consists solely in a particular form of activity by which man not only tries to bring the visible world into his consciousness, but even is forced to the attempt by his very nature. Thus the position in which the artist finds himself while confronting the world has not been chosen arbitrarily, but is determined by his own nature. The relation between himself and the objects is not a derived but an immediate one. The mental activity with which he opposes the world is not fortuitous, but necessary, and the product of his men-

tal activity will not be a subordinate and superfluous result, but a very high achievement, quite indispensable to the human mind if that mind does not want to cripple itself.

5. The artist's activity is often said to be a process of imitation. At the basis of this notion lie errors which beget new errors.

First, one can imitate an object only by making another which resembles it. But what agreement could exist between the copy and the object itself? The artist can take but very little from the quality of a model which makes it an object of nature. If he tries to imitate nature he will soon be compelled to combine in his copy some very different aspects of the natural object. He is on the way to encroaching upon nature's creative work—a childish, senseless enterprise, which often takes on the appearance of a certain ingenious boldness, usually based on absence of thought. Where efforts of this kind are concerned, the trivial objection is justified that art, so far as it is imitating nature, must remain far behind nature, and that imperfect imitation must appear as both useless and worthless since already we are amply supplied with originals.

Imitation which aims merely at copying outward appearances implies that one starts from the premise that there is in nature a substantial capital of minted and fixed forms at the disposal of the artist and that the copying of these forms is a purely mechanical activity. Hence arises the demand, on the one hand, that artistic imitation should serve higher purposes, that is, that it should be a means of expressing something independently existent, not in the realm of the visible but in the realm of the invisible; and on the other, that the artist in his imitations should represent nature purified, ennobled, perfected. Out of his own mastery he should make demands on the natural model; what nature offers should serve him as a basis for that which nature might be if he had been its creator. Arrogance justifies itself and capriciousness becomes intellectual power. Man's unfettered imagination, inflated to vainglory, is taken to be artistic creative power. The artist is called upon to create another world beside and above the real one, a world freed from earthly conditions, a world in keeping with his own discretion. This realm of art opposes the realm of nature. It arrogates to itself a higher authority because it owes its existence to the human mind.

6. Artistic activity is neither slavish imitation nor arbitrary feeling; rather, it is free Gestalt-formation. Anything that is copied must first of all have existed. But how should that nature which comes into being only through artistic representation have an existence outside of this production and prior to it? Even at the simplest, man must create his world in its visual forms; for we can say that nothing exists until it has entered into our discerning consciousness.

Who would dare to call science an imitation of nature? Yet one could do so with as much right as to call art an imitation. In science, however, one sees much more easily that it is simultaneously an investigation and a formulation, that it has no other meaning than to bring the world into a comprehensible and

comprehended existence by means of man's mental nature. Scientific thinking is the natural, the necessary activity of man, as soon as he wakes up from a dull, animal-like state to a higher, clearer consciousness. Art as well as science is a kind of investigation, and science as well as art is a kind of Gestalt-formation. Art as well as science necessarily appears at the moment when man is forced to create the world for his discerning consciousness.

The need of creating a scientifically comprehended world, and with it the possibility of producing such a world, arises only at a certain level of mental development. Likewise, art too becomes possible only at that moment when the perceived world appears before man as something which can and should be lifted up to a rich and formed existence. It is the power of artistic phantasy that brings about this transformation. The phantasy of the artist is at bottom nothing else than the imaginative power which to a certain degree all of us need in order to get any grasp at all upon the world as a world of visible appearances.

But this power of ours is weak, and this world of ours remains poor and imperfect. Only where a powerful imagination with its indefatigable and sharp activity calls forth from the inexhaustible soil of the world elements after elements does man find himself suddenly confronted with a task immensely complicated, where before he has found his way without difficulty. It is phantasy that, looking far out round itself, summons together and conjures up on the narrowest ground the abundance of life which from dull minds is withheld. Through intuition one enters into a higher sphere of mental existence, thus perceiving the visible existence of things which in their endless profusion and their vacillating confusion man had taken for granted as simple and clear. Artistic activity begins when man finds himself face to face with the visible world as with something immensely enigmatical; when, driven by an inner necessity and applying the powers of his mind, he grapples with the twisted mass of the visible which presses in upon him and gives it creative form. In the creation of a work of art, man engages in a struggle with nature not for his physical but for his mental existence, because the gratification of his mental necessities also will fall to him solely as a reward for his strivings and his toil.

Thus it is that art has nothing to do with forms that are found ready-made prior to its activity and independent of it. Rather, the beginning and the end of artistic activity reside in the creation of forms which only thereby attain existence. What art creates is no second world alongside the other world which has an existence without art; what art creates is the world, made by and for the artistic consciousness. And so it is that art does not deal with some materials which somehow have already become the mental possession of man; that which has already undergone some mental process is lost to art, because art itself is a process by which the mental possessions of man are immediately enriched. What excites artistic activity is that which is as yet untouched by the human mind. Art creates the form for that which does not yet in any way exist for the

human mind and for which it contrives to create forms on behalf of the human mind. Art does not start from abstract thought in order to arrive at forms; rather, it climbs up from the formless to the formed, and in this process is found its entire mental meaning.

7. In the artist's mind a peculiar consciousness of the world is in process of development.

To some degree, everyone acquires that consciousness which, when developed to a higher level, becomes the artistic consciousness of the world. Every man harbors in his mind a world of forms and figures. His early consciousness is filled with the perceiving of visible objects. Before the capacities of forming concepts and of submitting the consequences of natural processes to the law of cause and effect have been developed in him, he stores his mind with the multifarious images of existing objects. He acquires and creates for himself the many-sided world, and the early substance of his mind is the consciousness of a visible, tangible world. Every child finds himself thus situated. To him the world is that which is visually apparent, so far as the world attains an existence through his mind. The child acquires a consciousness of the world and, even before he knows anything about it, before he can denote what it is by the expression "world," possesses the world. When other mental forces have grown in man and become active, and provide him with another consciousness he very easily fails to appreciate that earlier consciousness by which he had been first awakened on entering life. He now believes that his early stage of existence was an unconscious one, like that of animals, when compared to the new consciousness of the world which he has attained. In mastering the world as a concept he believes that only thus does he possess it and that his early consciousness is doomed to decay. While he struggles to bring the world of concepts within himself to richer and clearer consciousness, the world of appearances remains for him scanty and obscure. He does not pass from a lower, unconscious stage to a higher, conscious one, but rather sacrifices the one for the sake of building up the other. He loses his world by acquiring it.

Had man's nature not been endowed with the artistic gift, an immense, an unending aspect of the world would have been lost to him, and would have remained lost. In the artist, a powerful impulse makes itself felt to increase, enlarge, display, and to develop toward a constantly growing clarity, that narrow, obscure consciousness with which he grasped the world at the first awakening of his mind. It is not the artist who has need of nature; nature much more has need of the artist. It is not that nature offers him something—which it does not offer to anyone else; it is only that the artist knows how to use it differently. Moreover, through the activity of the artist, nature rather gains a richer and higher existence for him and for any other person who is able to follow him on his way. By comprehending and manifesting nature in a certain sense, the artist does not comprehend and manifest anything which could exist apart from his

activity. His activity is much more an entirely creative one, and artistic production cannot in general be understood except as the creation of the world which takes place in the human consciousness and exclusively with respect to its visible appearance. An artistic consciousness comes into being in which solely the experience with appearances becomes important and leads to visual conception and in which everything steps back that is of other importance to man than the visual experience.

The mental life of the artist consists in constantly producing this artistic consciousness. This it is which is essentially artistic activity, the true artistic creation, of which the production of works of art is only an external result. Wherever men live, this activity appears. It is a necessary activity, not because men are in need of the effects produced as a consequence of it, but much more because man has been endowed with its power. Already, at a very low level of development, this faculty becomes active in very primitive individuals, be it ever so simple a manifestation. We can trace its existence back to where it does not yet manifest itself in a work of art. But it is not necessary for this activity to exist in a very high degree in order to outweigh the other sides of the mental nature and to imprint upon the individual the stamp of the predominantly artistic talent. From this point forward we discover an immense variety and gradation until we arrive at those rare appearances in which that power, risen to its highest degree, seems to be superhuman because it surpasses the common measure of human power.

The mental artistic activity of the artist has no result: the activity itself is the result. It expends itself every single moment in order to start afresh every following one. Only while his mind is active does man possess that to which he aspires. The clarity of consciousness toward which the individual advances at any given moment does not secure to him a lasting possession which he can enjoy at leisure. No; for each flash of consciousness vanishes at the moment at which it arises and so makes room for a new one. Furthermore, the artist's mental activity is by no means constantly progressive and incessantly increasing. It reaches its culmination in a particular person at a single moment. His checkered consciousness of the world which is the substance of his mental existence yields, at happy moments, clear inner visions. But this momentary activity of the mind is the clear light that illuminates the world for him in a flash. In vain will he try to fix this flash. If he shall behold it again, he must re-create it himself. And just as this occurs in one person's life, so it occurs also in the life of mankind. Vainly do we flatter ourselves with the thought that the cognitive truth to which a single highly gifted person has penetrated is never lost to the world. With the individual, the individual's private cognition also passes away. No one possesses it who does not know how to re-create it anew. And often it happens that long years pass before nature produces individuals who can only just guess at the magnitude and the clarity of consciousness of their distant

predecessors. Since Leonardo's time, who can boast of having seen, even from far away, the summits of this man's artistic cognition of the world?

Artistic activity is infinite. It is a continuous, incessant working of the mind to bring one's consciousness of the visible world to an ever richer development, to a Gestalt-formation ever more nearly complete. All emotional forces serve this purpose: all drives, passion, all enthusiasms, are of no avail to the artist if they are not harnessed in the service of this specific mental activity. Man allows form after form to emerge from the shapeless mass into his consciousness; yet, for all that, the mass still remains inexhaustible. It is not presumptuousness but shortsightedness to think that man's artistic activity could ever reach its ultimate, its highest aim. Only through artistic activity does man comprehend the visible world, and for as long as artistic activity has not disclosed them to his consciousness he does not know which regions are for him obscure and hidden. Whatever vantage points he has reached afford him views upon regions as yet unattained. And the more the artist extends his sway over the world, the more the limits of the visible world itself retreat before his eyes. The realm of appearance develops infinitely before him because it grows out of his ceaseless activity.

8. Artistic consciousness in its totality does not go beyond the limits of the individual; and it never finds a complete outward expression. A work of art is not the sum of the creative activity of the individual, but a fragmentary expression of something that cannot be totally expressed. The inner activity which the artist generates from the driving forces of his nature only now and then rises to expression as an artistic feat, and this feat does not represent the creative process in its entire course, but only a certain state. It affords views into the world of artistic consciousness by bringing from out of that world one formed work in a visible, communicable expression. This accomplishment does not exhaust, does not conclude this world, for just as infinite artistic activity precedes this feat, so can an infinite activity follow. "A good painter," says Dürer, "is inwardly full of figures, and if it were possible that he could live forever, he would have always something new from his inner stock of ideas, of which Plato writes, to pour forth through his works."

Although the mental activity of the artist can never fully express itself in the form of a work of art, it continuously strives toward expression and in a work of art it reaches for the moment its highest pitch. A work of art is the expression of artistic consciousness raised to a relative height. Artistic form is the immediate and sole expression of this consciousness. Not by roundabout ways does the artist arrive at the employment of the artistic form; he need not search for it in order to represent herein a content which, born formless, is looking for a body in which it may find shelter. The artistic expression is much more immediate and necessary, and at the same time exclusive. A work of art is not an expression of something which can exist just as well without this expression. It

is not an imitation of that figure as it lives within the artistic consciousness, since then the creation of a work of art would not be necessary for the artist; it is much more the artistic consciousness itself as it reaches its highest possible development in the single instance of one individual. The technical manipulation by which a work of art is contrived is a necessity for the artistic mind as soon as that mind feels the need of developing to the highest pitch that which dwells within it. Technical skill as such has no independent rights in the artistic process; it serves solely the mental process. Only when the mind is not able to govern the creative process does skill attain independent significance, importance, cultivation, and so becomes worthless artistically. From the very outset the mental processes of the artist must deal with nothing but that same substance which comes forth into visible appearance in the work of art itself. In a work of art the Gestalt-forming activity finds its way to externalized completion. The substance of such a work is nothing else than the Gestalt-formation itself.

9. If we ask ourselves at what final, culminating point a single artistic endeavor should be fulfilled, we find that, as the human mind in general in its search of cognition cannot rest until convinced of the need of reaching such a culminating point, so the artist too is forced to cultivate his visual conception to the degree that visual conception itself is absolutely necessary to him. Through the power of artistic imagination visual conception of the world grows ever richer in configurative forms. However, although we are compelled to admire this creative power that leads to breadth and variety, we must nevertheless acknowledge, if we are at all able to follow it so far, that the ability to bring each configuration to a complete artistic existence is the noblest artistic endeavor. Following along this path, the artist leaves behind him that which appearances had meant to him in various earlier stages of development. The more appearances are subjected to the powers of his artistic cognition, the more their qualities lose their power over him.

When the artist develops his visual conception to the point where "this way and no other" becomes a necessity for him, this process differs from that of the scientific investigator who regards a process of nature as a necessity. He who does not contemplate the world with the interest of the artist, if he at all feels the desire to take notice of the appearances of objects, attempts but to investigate the conditions of their origins. Only with difficulty, however, will he come to understand that there is a need of visually comprehending appearances as such, independently of a knowledge of their origins. To quote Goethe: "Thus a man, born and trained to the so-called exact sciences, will not easily conceive, at the height of his intelligence, that there could likewise exist a phantasy that is exact, without which art is essentially inconceivable." Very few persons feel any need of developing their visual conceptions to such a degree that

these take on the character of necessity. However averse they may be to any unclearness and arbitrariness in their understanding of the internal relationships of the visible world, however strenuously they may strive to order this chaos of phenomena into a necessary whole, and however far they may have advanced in their endeavors, for them the visible world nevertheless remains a chaos in which the arbitrary rules. The artist, however, cannot acquiesce in such a state of affairs. Unconcerned with other things, he does not release his perceptual experiences until they are developed into a visual conception, clear in all its parts, something that has attained a complete, necessary existence. This is the highest stage to which his productive cognition can attain. Complete clearness and necessity have become one.

CHARLES HENRY

The Chromatic Circle (1888)

GEORGES SEURAT

Letter to Maurice Beaubourg (1890)

GUSTAVE KAHN

Seurat (1891)

A central idea underlying the manner of painting known as Neo-impressionism is the concept of the union of opposites. The principal proponent of the style, Georges Seurat (1859–1891), wrote in 1890, "Art is Harmony. Harmony is the analogy of contrary and similar elements of *tone,* of *color,* and of *line.*" Earlier, in *Cercle chromatique* (1888), Charles Henry (1859–1926) had traced the idea that harmony is the union of opposites, of *complementaries,* to a pre-Socratic thinker, Pythagoras. The critic Alphonse Germain (1861–?), in an article on the history of color theory, wrote that Seurat had derived his theory of harmony from the aphorism of another Greek writer, Heraclitus: "The conciliation of opposites is harmony." (Germain's article appeared in *La Plume,* September 1, 1891, pp. 1–20.) The origin of the idea, however, is less important than its recognition by critics as an underlying tenet of Seurat's work. In an article written on Seurat's death, for example, Gustave Kahn (1859–1939) applies the concept of the union of opposites to the painting *Le Chahut.*

From these various writings, there emerges the Symbolist side of Neo-impressionism or, more precisely, the relationship of Neoimpressionism to

late-nineteenth-century scientific transcendentalism. The immediate source of this transcendentalism is the science of psychophysics, the study and measurement of nature, as conceived by Gustav Fechner in *Elements of Psychophysics* (1860). Psychophysics assumes the union of Cartesian opposites, mind and matter, body and soul, and concerns itself not with the study of matter—outer nature—but with the determination of the sense-impressions that create in us the representation of the idea of matter. The pervasiveness of this idea and attitude can be seen in a letter addressed to Henry in 1882 by the Symbolist poet and mystic writer Jules Laforgue (1860–1887), whom Kahn describes as an "adept of modern Buddhism." Laforgue declares that in Germany Impressionism is thought to be an offshoot of Fechner's law, which posits that the magnitude of sensation is proportional to the magnitude of the stimulus. Indeed, in its basic assumption, psychophysics can be taken as the scientific formulation of Blake's "contraries," Baudelaire's "correspondences," and Chevreul's or Henry's "complementaries."

In his "Réponse des symbolistes" (1886), Kahn asserts that Henry's work verifies the essential transcendentalism of the Symbolist idea, because both Henry's science and Symbolist art are "founded on the purely idealist philosophical principle that causes us to reject completely the reality of matter and admit the existence of the world only as representation." In a fundamental way, Henry is Schopenhauer reborn as a scientist, and in Henry's thought we have the psychophysical formulation of the world as representation. From the harmony and contrast of colors comprising the Chromatic Circle proper, Henry deduces a universal system of harmonies or energies whose dynamism is to be found in the perpetually self-transforming interplay of *directions,* the whole of which is summed up in the Chromatic Circle as Universal Symbol, the container of *all* directions. With this in mind, one can begin to glimpse some of the reasons that Henry's erudite and often abstruse work was so highly regarded by the Symbolist generation.

The unique aspect of Henry's thought is revealed in his interpretation of the various experiments in the *Cercle chromatique.* The experiments themselves can be described as classic psychophysical investigations into autokinesis, the nature of sensory illusions, and alternate perceptual states. Thus, Henry considers light, color, form, and sound—the basic outer components of expression that constitute "art"—both as physical properties, whose nature is vibratory energy, and as psychic functions that can be calculated according to the nature and intensity of the vibratory stimulus. Given a general knowledge of the nature and form of the psychophysical sense elements, the artist can use these elements to create correspondingly dynamogenous [dynamically expansive] states of consciousness. Henry's idealism is manifested in the notion that art can serve as an instrument in leading the mind to higher and more expanded states of

awareness through a proper application of psychophysical knowledge: in this lies the true marriage of science and art, the dream of Leonardo and the dream of Seurat.

Kahn, the "originator" of free verse, Seurat, the painter of the modern Pan-Athenaic procession, and Henry, the creator of a mathematical and experimental aesthetic—all were close to one another, all born in 1859, the year Darwin published *The Origin of Species*. In their respective interests and personalities one can see a triad of energies, not unlike the triad of complementary colors or Seurat's triad of color, tone, and line. Thus, in Kahn's description and analysis of Seurat and his work, in Seurat's own terse, aphoristic statements on harmony (so reminiscent of those ancient fragments of pre-Socratic or Taoist thought), and in Henry's philosophical summation, the *Cercle chromatique*, we have a composite view of late-nineteenth-century scientific transcendentalism. If Charles Henry is the movement's leading French spokesman, surely Georges Seurat is its artist.

The excerpts by Henry were translated by José A. Argüelles from the 1888 edition of *Le Cercle chromatique*, and are similar to translations by the same author in *Charles Henry and the Formation of a Psychophysical Aesthetic* (Chicago: The University of Chicago Press, 1972), pp. 162–74. Seurat's letter is reproduced from Walter Pach, *Georges Seurat* (New York: Duffield and Company, The Arts, 1923), pp. 24–25. Gustave Kahn's "Seurat," which first appeared in *L'Art moderne*, vol. 11, no. 14 (April 5, 1891), pp. 107–10, is reproduced from Norma Broude, ed., *Seurat in Perspective* (Englewood Cliffs, N.J.: Prentice-Hall, 1978), pp. 20–25. ✄

CHARLES HENRY: THE CHROMATIC CIRCLE

PRELIMINARY IDEAS

The observational and experimental method that, aided by calculus, has succeeded in astronomy and physics with brilliant and well-known results, is incapable of helping us know the molecular world, for the delicacy of these phenomena render experiments uncertain wherever they are possible. Informant of facts, this method is a fortiori incapable of determining *that which ought to be*, that is to say, the normal character of living reactions.[1]

1. In speaking of the "molecular world," Henry makes no distinction between matter and mental phenomena (psychic experience). Henry's contention has been borne out by leading experimenters in quantum mechanics and nuclear physics, particularly in the theories of indeterminacy, complementarity, and the dual nature of quanta as wave and particle. See Werner Heisenberg, *Physics and Philosophy: The Revolution in Modern Science* (New York: Harper, 1958), and Niels Bohr,

I have succeeded in making precise that which can be understood as the *normal* and have founded on the necessary laws of our representations[2] a method that offers to the fundamental hypotheses of the sciences all the certitude of which they are susceptible and will permit us, without a doubt, to penetrate by these deductive processes into the infinitely minute molecular world. I have chosen the best-studied excitations: lights, colors, forms, sounds. I have shown that the phenomena known under the names of *optical illusions, consonance, dissonance, modes,* and *harmony* are particular cases of subjective functions, possessing in common with all nervous reactions *contrast, rhythm,* and *measure;*[3] and I have seen that these functions permit the formulation of a law of organization, an ideal norm for living reactions. I have had manufactured instruments like the *Aesthetic Protractor,* and the *Chromatic Circle,* which make possible the amelioration of forms and the harmonies of colors.[4] Moreover, the theory is general. Dynamogenous dumbbells, thermometers, and aesthetic pressure gauges will soon, I hope, be applied in conjuring up the imminent dangers by which the abuse of destructive excitants and the ignorance of our true needs menace us. My method is essentially schematic, that is to say, adapted to the abstract and simplifying character of our representations.

Essays, 1958–1962, on Atomic Physics and Human Knowledge (New York: Interscience Publishers, 1963). For advice on the descriptions that Henry gives of the various experiments in *Cercle chromatique,* I am indebted to Dr. Charles T. Tart, editor of *Altered States of Consciousness* (New York: Wiley, 1969).

From this idea of the essentially subjective uncertainty in dealing with submicroscopic phenomena, Henry as well as the chief theorists of nuclear physics came to realize the limits of traditional science. At this level of research the physical shades into the psychic and vice versa, and thus the "objectivity" of Cartesian science is transcended and a new structural basis of knowledge is postulated. Herein lies the significance of the psychophysics developed by Henry.—J.A.A.

2. *Representation* is a key term with Henry and puts him very much in the tradition of Schopenhauer. Thus, for Henry, the world and its laws are basically constructs derived from the "representations" we have within us and which can be expressed as *art* or, more precisely, as *symbols.* This fundamental assumption of the psychophysical attitude is summed up by Lama Govinda Anagarika: "The Buddhist does not enquire into the essence of matter, but only into the essence of sense-perceptions which create in us the representation of the idea of matter" (*Psychological Attitude of Early Buddhist Philosophy* [London: Rider, 1961], p. 133).—J.A.A.

3. Contrast, rhythm, and measure are the ways in which consciousness *differentiates* and *expands* itself; they are also chief aesthetic principles. Henry develops this general idea not only in *Cercle chromatique,* pp. 24–52, but also in "Le Contraste, rythme et la mesure," *Revue philosophique* 28 (October 1889): 356–81. See also J. Hericourt, "Une Théorie mathématique de l'expression: Le Contraste, le rythme et la mesure d'après les travaux de M. Charles Henry," *Revue scientifique* 44 (November 1889), pp. 586–93.—J.A.A.

4. Henry discusses the aesthetic protractor in *Rapporteur esthétique, permettant l'étude et la rectification de toutes formes avec une introduction sur les applications et l'art industriel, à l'histoire de l'art, à l'interprétation de la méthode graphique* (Paris, 1888). The *Cercle chromatique* was published in two editions: a theoretical one, from which this text was translated, and a practical one, which contains the actual chromatic circle. This circle is essentially like Chevreul's, but mathematically "corrected" and constructed so that the angles and directions corresponding to the rhythmic numbers can be determined with their appropriate colors.—J.A.A.

That which is most important to psychic functions is *continuity*. When the thought flow ceases, there is fatigue; when the cessation is violent, there is suffering. We can define pleasure: the continuity of psychic functions; pain: the discontinuity of these functions. But we can only represent—and thus, study scientifically—ourselves as movements: we must make precise what relation exists between psychic functions and movements.

Observation and reason show that the psychic functions can be considered as movements which have been or will be like virtual movements.

There is no sensation without an arrest of movement and, consequently, without a virtual movement in an inverse direction. If one fixes an object without displacing the visual axis and without closing the lids, the vision becomes indistinct. Reciprocally, a moderated movement of the luminous object makes vision much easier. If one touches an object without moving the finger, all notion of contact disappears after a few seconds. Vierordt has demonstrated that tactile sensitivity grows from the rest of the member to its periphery,[5] that it depends on the size of the movements, and that it is, for each segment of the member, proportional from the distance of the points of contact on the skin to the member's axis of rotation. There is no auditory sensation without a variation of the muscular tension of the tympanic membrane. If one sets in motion the tone la_3 to the extremity of a rubber tube hermetically fixed at the other end to the right ear, and if one attaches hermetically to the left ear a rubber tube transmitting the pressures of a Politzer insufflation bag, each light pressure effected on the bag to the left ear produces a light attenuation of the sound in the right ear; thus there is at the same time as the passive displacements, the production of active movements, a synergetic action of accommodation in both ears. Thus, odor can be exercised only with the respiratory movements; taste, with the movements of the tongue.

Likewise, we can say that there is no idea without virtual movements becoming real movements. This is confirmed daily by the facts produced by instruments such as the plethismograph or Mosse's scales, which measure the modifications in the vascular phenomena in correlation with the slightest emotion. Thirty-four years ago Chevreul rendered justice to the so-called exploratory pendules and divinatory rods in proving that observed movements—given the experiment of a ring suspended by a thread—are the products of unconscious muscular movements, the direction of which movements is determined by the corresponding idea.[6] The exactitude of these observations has been con-

5. Hermann Vierordt (1853–1902), medical doctor and professor of physiology at Tübingen, wrote *Das Sehen des Menschen* (1881) and *Kürzer Abriss der Perkussion und Auskultation* (1884), long considered one of the standard texts on the subject.—J.A.A.

6. The reference here is to the study of Michel-Eugène Chevreul, *De la baguette divinatoire, du pendule dit explorateur et des tables tournantes* (1854). In addition to *De la loi du contraste simultané des*

firmed. Recently Charpentier drew attention to an optical illusion no less instructive.[7] When one looks for a period of time and in complete darkness at an immobile object of small diameter that is dimly lighted, this object appears to move by itself. The angular speed of the apparent displacement is an average of 2° to 3° per second; the direction of the displacement is variable. Most often for the subject, the object appears to proceed along a curved line moving upward, and from within to without; these are normal directions.[8] The total extension of displacement can attain and surpass 30°, that is, a twelfth of the circumference; these points should be well noted.[9]

It suffices to imagine seeing another object or to execute an act in another direction in order to provoke the apparent displacement of the object in this direction. The observer can voluntarily make his attention undergo small displacements in various directions around the object considered without ceasing to perceive the continuous movement of the latter in the original direction, and

couleurs et de l'assortiment d'objets colorés (1839), from which an excerpt appears in Part V, Chevreul wrote *Des couleurs et de leurs applications aux arts industriels à l'aide des cercles chromatiques* (1864). In many ways, Henry's work is an expanded realization of Chevreul's idea. See also Faber Birren's re-edition of the English version of Chevreul's work, *Principles of the Harmony and Contrast of Colors* (New York: Reinhold, 1967).—J.A.A.

7. Pierre-Marie-Augustin Charpentier (1852–1816), physician and neurophysiologist, published a variety of psychophysiological research studies, beginning in 1877 with a study of the emotional-sensorial excitations of the heart. His later work included a number of retinal-optical studies relating to light-sensitivity, photometry, the persistence of impressions, the speed of nervous reactions, and the like. Charpentier's research, typical of psychophysiology for the period, is very closely related to Henry's work in this regard. As is evident from the experiments discussed by Henry, these researchers placed great emphasis on the idea of the psychic nature of experience, and their experiments are presented as "evidence" supporting the law of psychomotor reactions: "Every variation of a physiological work is represented by real or virtual changes of direction of energy" (*Cercle chromatique*, p. 14).—J.A.A.

8. The idea of directions is crucial to an understanding of Henry's aesthetic. Direction, movement, change—psychophysically manifest as the modulations of light, color, form, or sound—is the basic reality. Thus, in the *Cercle chromatique* the first section following the introduction deals with "Interior Work and Directions" (pp. 11–24). The basic model of Henry's universe can be viewed as a continually self-transforming cycle, or *spiral,* whose motivating mechanism is the ongoing exchange and transformation of energy from one state to another, all states being complementary. Artistically applied, the theory of directions is the aesthetic-mathematical expression of the Symbolist idea, for psychically, the directions are transformed into symbols, or, conversely, we know directions only *symbolically.* In this sense, the directions are symbols, as it were, of sensory experience; and since for Henry, the world *is* representation, it is primarily a *symbol*—or Baudelaire's "forest of symbols"—whose actual content is profoundly psychic in nature. Thus, the artist is one who realizes and actualizes the various symbols contained in the psyche.—J.A.A.

9. For Henry, a Neopythagorean mystic, the number 12 is most important. It is "rhythmic" according to Henry's formula (any of the numbers 2, 2^n, or any primary number of the form $2^n + 1$, or the product of the power of 2 multiplied by any of the primary numbers of this form), and he notes that according to the research of Wilhelm Wundt, the famed German psychologist, twelve representations are the maximum extent of consciousness for relatively simple and successive representations, and thus define the "normal" limits of memory (*Cercle chromatique*, pp. 32–33).—J.A.A.

the illusion persists even in the indirect vision for all the points of fixation of attention. One can provoke the illusion of a determined direction while rubbing on the closed eye, which does not partake of the experience. It is not the eye that accomplishes by itself the movement, but rather, the eye fixing its attention upwardly, the object would seem to proceed reciprocally downward. Let us suppose, on the contrary, simultaneous to the idea of a second object, for example, a closed door, the virtual taking into possession of this object by our organs of perception; then, the idea of the object changing, the organs will change place and the first object will be displaced in this direction.[10]

I could cite a great number of facts that denote, simultaneous to perception, the virtual realization of the object by our natural mechanics; but I believe it useless to insist on this point of view so familiar to contemporary psychology, as evident by itself and without which it would be impossible, moreover, to understand anything of the suggestions of the idea brought about by the attitude and of the attitude by the idea.

In summing up, one can consider the sensation and the idea as virtual exercises of our natural mechanics: the sensation corresponds to a real movement that terminates in a virtual movement; the idea, to a virtual movement that is concluded in a real movement, but more or less quickly and under a different form according to the nature of the subject.

The aesthetic problem is posed under a new form and, this time, scientifically: "Which are the movements that the living being can describe continuously? Which are the movements that it can describe only discontinuously?" One sees that this problem does not depend on general mechanics but on another mechanics, which one could designate under the name *situational mechanics,* and the object of which has been made precise in this passage from a celebrated text by Poinset: "Mechanics itself would present us with two kinds of mechanics; first, that which calculates the quantities of movements, the forces and speeds; then there is that which is seen only in the disposition of the bodies—their reciprocal play, the manner in which they develop their ways—and this without having avoided either the direction of these lines, or the time that the bodies take to describe them, or the forces that are necessary in order to move them."[11]

On the other hand, this problem of the continuity and discontinuity of physiological movements is no different from the problem of dynamogeny and inhibition, which has been posed in modern works, above all in the fine re-

10. This entire idea is reminiscent of William Blake's concept in "Jerusalem": "If Perceptive Organs vary, Objects of Perception seem to vary: If the Perceptive Organs close, their Objects seem to close also."—J.A.A.

11. Louis Poinsot (1777–1859), geometrician and member of the French Academy of Sciences, is considered one of the creators of static mechanics. Here Henry quotes from Poinsot's *Éléments de statique.*—J.A.A.

search of Brown-Sequard.[12] According to the definition of this eminent physiologist, *dynamogenous* are those nervous irritations that, more or less instantaneously, for a duration more or less long, in those nervous or contractile parts more or less distant from the place of irritation, will more or less exaggerate a function; *inhibitory* are those irritations that under the same conditions will more or less make a function disappear. The effects of inhibition are still known under the name *phenomena of arrest*. The notion of discontinuity and the notion of arrest are identical: the notion of continuity is related to the idea of the acceleration of functions, an accelerated movement being able to be considered as a movement whose continuity is augmented each instant.

Everyone knows that to each agreeable sensation corresponds a growth in the available force, to each disagreeable sensation, a diminution. These facts Feré has made precise by measuring in hysterical patients as well as normal subjects the variations of the force according to the nature of the sensation on a dynamometer.[13] Thus, with a certain Dr. G., the force of whose right hand varies from 50 to 55 kilograms, as soon as his nostrils are quickly approached by a flask of pure musk he declares it disagreeable and sees his force lowered to 45 kilograms. If one places the flask at a certain distance, he declares the odor very agreeable, and the dynamometer registers 65. With a hysteric, the approach of the flask of musk determines a very agreeable sensation that translates into a rise from 23 to 48 on the dynamometer.

One can thus consider as an absolute general range, as aesthetic as it is physiological, the following problems: "Which are the movements the living being can describe continuously? Which are the forms that these conditions impose upon perception?"

12. Charles-Édouard Brown-Sequard (1817–1894), eminent doctor and neurophysiologist, taught at Paris and Harvard. In 1878 he succeeded Claude Bernard (under whom Henry studied during the mid-1870s) to the chair of Experimental Psychology at the Collège de France. In 1886 he was made president of the Biology Society of the Academy of Sciences. Brown-Sequard performed a great deal of research on nervous and muscular systems and on the therapeutic methods pertaining to them—one of which therapies, opotherapy, is a pioneer form of organ transplant. In its application, Henry's aesthetic had a broadly therapeutic function: that of clearing up the sundry illusions to which the various sense organs are subject and which collectively create individual and social malaise.—J.A.A.

13. Charles Feré (1852–1907), contemporary psychophysiologist whose research Henry draws upon in the *Cercle chromatique*. In 1887 Feré published *Sensation et mouvement*. Related to Henry's and Feré's studies of kinesthetics is the work of Étienne Jules Marey (1830–1904), the developer of chronophotography (a predecessor of cinema), a friend of Henry's and author of *Étude de la locomotion animale par la chronophotographie* (Paris, 1887). The psychophysiological study of motion executed an incalculable influence in altering the perception of nature from static to fluid and dynamic. This change is particularly crucial for understanding the art of the 1890s—"Art Nouveau"—as well as the art of the first decades of the twentieth century. Thus, from Impressionism to Cubism, one witnesses a gradual disintegration of the classic one-point perspective system developed during the Renaissance.—J.A.A.

CONCLUSION AND VOCABULARY

I have given all the developments necessary to a theory of visual sensation and to the illustration of a chromatic circle; as these particular problems could not be resolved without the general problem, I have been obliged to take up the aesthetic problem so that I could return to the scientific problem by this consideration, already evident to me under diverse forms, for the psychic functions are virtual movements, either continuous or discontinuous. I have studied the conditions of continuity and discontinuity, which are nothing other than the conditions of dynamogeny and inhibition of physiological functions, and I have mathematically made precise the forms of perception imposed by these conditions.

The essential result is that our representations are necessarily cyclical in form, either continuous or discontinuous. As dynamogeny is only an emission of electricity, and inhibition an emission of heat or a raising of temperature, I have been able to make precise the intimate and evident liaisons within the living being: in psychic phenomena, as pleasure and pain; in mechanical phenomena, as continuity and arrest; and in physical phenomena, as electricity and heat.

Furthermore, these modes of action are veritably irreducible since they correspond to modes of irreducible and elementary representation.[14] The study of the mechanism of potentials is thus an illusory problem. Accordingly, in the future there will be a greater precision to the point at which cosmogonies and in general the so-called problems of origin will be something other than speculations as illegitimate as they are unjustifiable.

The last two chapters are examples of this method of necessary representations,[15] which, it seems to me, ought to be substituted for the speculations on energy and matter, for those inextricable hypotheses on ether and other subtle media, and for the intuitions more or less falsified by the individual sickness and social milieux that constitute philosophy and the sciences. It is to these double reactions—continuity and discontinuity—that all scientific facts must finally be related, be they the subjective determinations that constitute mathematics or the objective determinations that are the aim of the natural sciences.

14. For Henry, unlike the physiologist Hermann von Helmholtz, the ultimate element of perception, be it for the organ of sight or of sound, is irreducible and cannot be "explained." See Henry's "L'Oeuvre opthamologique de Thomas Young," *La Revue blanche* 8 (1895): 473–77.—J.A.A.

15. The two chapters to which Henry refers deal with the nature of absolute thermal and electrical measurements deduced from subjective functions, and the general equation of mechanics, which reads: "It is necessary and sufficient for the equilibrium and for all the possible systems of virtual moments, that the sum of reversible virtual moments be zero, and the sum of nonreversible virtual moments be zero and negative" (*Cercle chromatique,* p. 161).—J.A.A.

The first point of view has been presented by Wronski and demands important developments in the general theory of functions;[16] the second is presented in the works of Maxwell, Lorentz, Wilhelm Weber, and Kohlrausch, who, by absolutely different ways, are agreed in demonstrating the presence of electric currents in luminous undulations and in reducing all physical forces to electricity, to heat, and to universal gravitation.[17] As the representations of the living being are now related to these mathematical operations, it is possible to found on this subjective point of view a method of direct transformation of the expression of the facts into quantitative formulas.

It is evident for all scholars worthy of the name that certitude in the sciences can be obtained only by a principle superior to the experiment: the inductive method, precious instrument of research in the extreme specialities, is only an instrument of truth on the condition of yielding finally to the deductive method. When Wronski thought of deducing from the absolute all human knowledge, past and to come, he was deceived, for the idea of the absolute is only a phenomenon whose affirmation and negation are subject to the laws of

16. Joseph-Marie Hoene-Wronski (1778–1853), Polish mathematician and philosopher, with whom Henry felt a great affinity (see Gustave Kahn, "Charles Henry: Quelques souvenirs de jeunesse," *Cahiers de l'étoile*, no. 13 [January–February 1930]: 58). Having served with Kosciuszko and Dumbrowski in the Napoleonic wars, Wronski had a revelation of the "higher truth" in 1803 and resolved to dedicate the rest of his life to its dissemination. His publications include *Philosophie critique découvert par Kant* (1803), *Introduction à la philosophie mathématique* (1811), *Philosophie de l'infini* (1814), *Union finale de la philosophie et de la réligion, constituant la philosophie absolue* (1831- 39). Having emigrated to France, Wronski became a colorful character in his own right, appearing in Balzac's *Recherche de l'absolu* ("Martyrs ignorés"), as Grodninski, the philosopher who sells the absolute to a Parisian banker. Henry's synthesizing cosmic outlook must be attributed to Wronski. Though Wronski's mathematical ideas appear in Henry's work, Henry's only specific writing on the Polish mathematician is *Wronski et l'esthétique musicale* (Paris, 1887).—J.A.A.

17. Here lies the seed of Henry's later lifework, which culminated in the publication *Essai de généralisation de la théorie de rayonnement: Résonateurs gravitiques, résonateurs biologiques . . .* (1924), in which Henry puts forth his universal field theory of the ultimate interchangeability of the phenomena of nature, be they biopsychic, gravitational, or electromagnetic: All phenomena are variables of a universal quantum wave.

James Clerk Maxwell (1831–1879), Scottish physicist, was the first to develop the idea of the electromagnetic nature of light and heat, confirmed by the experiments of Hertz. Henry was in the vanguard of thinkers in realizing the applications and implications of the then-budding theories of radiation and quantum mechanics.

Hendrik Antoon Lorentz (1853–1928), Dutch physicist, developed during the 1890s the electronic theory of matter and received the Nobel prize for physics in 1902.

Wilhelm Weber (1804–1891), professor of physics at Halle, Göttingen, and Leipzig, worked with the mathematical physicist C. F. Gauss (1777–1855) on the concept of terrestrial magnetism and invented a scientific system of magnetic and electrical units based on the fundamental units of length, mass, and time.

"Kolrausch" is Rudolf Kohlrausch (1809–1858), German physicist at Göttingen, who published with Weber in 1857 *Electrodynamischen Massbestimmungen* and who is the inventor of an early electrometer; Kohlrausch's son Frederick (1840–1910) also engaged in electrical research and wrote *Über den absoluten elektrischen Leitungwiderstand des Quicksilbers* (1888).—J.A.A.

our organization.[18] His attempt could rest only on an intuition more or less complete of the law of our organization, and it would be within *this* law that the absolute would have to be sought, if an indefinitely evolutive law could be said to be absolute. Pythagoras felt it to be so: but his great intuition degenerated rapidly in speculations without issue. When Descartes founded on thought the principle of all certitude and related the form to number, when Leibnitz completed the mathematical work of Descartes by a practical conception of infinity and strove to found a living and ordered dynamism, when Kant demonstrated space and time to be forms of perception—these great thinkers were obedient to that point of view which promises to the principles of science all the certitude of which they are susceptible and to the practice of notable simplifications.

VOCABULARY

Continuity, discontinuity. Property of an ideal movement of power, or lack of it, to be described without interruption in time and space: a cycle whose ideal radius symbolizes the radius of the circle—unity normally realized by the upper-right or -left appendages and is continuous; it is relatively discontinuous when its ideal radius symbolizes the radius of a maximum pseudo-cycle realized by the coordination of the upper and lower, right and left appendages; it is absolutely discontinuous when it is larger or smaller than any defined cycle and can be realized only by points or by instants in an ideal translation, more or less complete, of the center.

Contrast. Subjective function that reduces the representations to certain types, such as the complementary, and the relations to natural units, the groups of certain aggregates.

Evolution (law of). Law after which the successive representations tend to become simultaneous and reciprocal—a law that must not be forgotten at any point in this text. One can construct the curve of evolution in the direction of time if one notes after my fundamental theorem that the purely successive groups that can be represented by primary numbers, the successive groups becoming more and more complex, will be symbolized by the sums of successive primary numbers. According to this law, each time that one of the sums can be placed under the form of a product, it will tend to be realized under that form. Let us take on the x- and y-axes in equal lengths the series of numbers; let us make on the x-axis the sums of the primary numbers: $1+2=3$; $3+3=6$;

18. Here Henry is probably referring to his general law of psychomotor reactions: the reduction of phenomena to that of psychophysical energy exchanges; see his *Sur une loi générale des réactions psychometrices* (Paris, 1890).—J.A.A.

$6+5=11$; $11+7=18$. . . . One sees that for the second and fourth successions [6 and 18] the sums are composite numbers: let us raise the perpendiculars in each to the points that correspond to the sum-products and to the product-sums, and let us join the different points of intersection; one then has the curve of probable distribution of errors according to their order of size.[19]

Functions of one side; two-sided functions. Representations that are marked to the left *or* the right, to the right *and* to the left, according to their degree of continuity or discontinuity, and that consequently participate in the more or less precise laws to which analogous representations are subject.

Matter. After the principles already admitted, it is *that which is directed* in our representations, that is to say, the radii of an ideal cycle, that can always be assimilated at some point of arrest, given that the cycle is only an ideal. The representation of inorganic matter is thus equivalent to a circular group of points of arrest or to a great cycle that is absolutely discontinuous.

Representation. All expression, more or less motor, conscious or not, of a concrete or abstract idea.

Reversible, irreversible. A reversible change is that which can be indifferently produced in one direction or another by an infinitely minute modification of the state of the body. A nonreversible change is that which under the action of the same force cannot be produced indifferently in one direction or another. This distinction corresponds to that of simultaneous or continuous representations and to successive or discontinuous representations.

Rhythm, measure. Character or representations that, by their relation to others, are the occasion of virtual movements, continuous or *dynamogenous.*

GEORGES SEURAT: LETTER TO MAURICE BEAUBOURG, AUGUST 28, 1890

ESTHETIC

Art is harmony. Harmony is the analogy of contrary elements and the analogy of similar elements of *tone, color and line,* considered according to their dominants and under the influence of light, in gay, calm, or sad combinations.

The contraries are:

For tone, one more clear (luminous) for one more dark:

19. Henry's law of evolution is most singular and can be taken as a metaphorical exercise in Neopythagorean number mysticism. Later in his life, Henry is reported to have said, "One cannot make mathematics if one is not a poet." Indeed, it was the poet Jalaludin Rumi (1205–1273) who had expressed poetically Henry's mathematical law: "Man is the product of evolution. He continues

For color, the complementaries, that is to say a certain red opposed to its complementary, etc. (red-green, orange-blue, yellow-violet);

For line, those forming a right angle.

Gaiety of *tone* is given by the luminous dominant; of *color,* by the warm dominant; of *line,* by lines above the horizontal.

Calm of tone is equality between dark and light; of color, equality between warm and cold; in line, it is given by the horizontal.

Sad tone is given by the dark tone dominant; in color by the cold dominant; in line by descending directions.

Technique:

Taking for granted the phenomena of the duration of the impression of light on the retina—

Synthesis necessarily follows as a result. The means of expression is the optical mingling of the tones and of the tints (local color and that resulting from illumination by the sun, an oil-lamp, gas, etc.), that is to say, of the lights and their reactions (the shadows), following the laws of *contrast,* of gradation and of irradiation.

The frame is in the harmony opposed to that of the tones, the colors and the lines of the picture.

GUSTAVE KAHN: SEURAT (1891)

Death, cruel to arts and letters even when it strikes an artist already laden with years and accomplishments, is more bitter still, more bewildering, when it chooses a man still young, in his thirties, an apostle of a new truth, the axioms and applications of which he had only just barely the time to work out.

Seurat is dead at the age of thirty-one.

Physically, he was tall and well-proportioned. Thanks to his abundant black beard and his thick, slightly curly hair, his face, apart from its flaring nostrils, resembled those of the mitered Assyrians on the bas-reliefs. His very large eyes,

this process. But the 'new' faculties, for which he yearns (generally unknowingly) come into being only as a result of necessity. In other words, he now has to take a part in his own evolution. 'Organs come into being as a result of necessity. Therefore increase your necessity'" (see Idries Shah, *Special Problems in the Study of Sufi Ideas* [London, 1966]). "New organs" can be taken as the new "sum products" of which Henry speaks. In terms of the history of mathematics, Georges Bohn (*Cahiers de l'étoile,* no. 13 [1930]: 73–74) points out that Henry's mathematical system and concept are, with their emphasis on simple numbers in increasing succession, as in the law of evolution, most closely related to Planck's quantum theory in which states of energy transformations are also represented by successions of simple primary numbers.—J.A.A.

extremely calm at ordinary moments, narrowed when he was observing or painting, leaving visible only the luminous points of the pupils beneath the lowered lashes. An accurate but very badly printed profile drawing by Maximilien Luce shows him at the easel (in *Les Hommes d'aujourd'hui*).

Beneath a somewhat cold exterior appearance, dressed always in dark blues and blacks—a neat and correct appearance that prompted Degas in a moment of humor to nickname him "the notary"—he guarded within himself a nature full of kindness and enthusiasm. Silent in large groups, among a few proven friends he would speak animatedly about his art and its aims. The emotion that filled him at these moments made itself visible in a slight reddening of his cheeks. He spoke in a literary manner and at considerable length, seeking to compare the progress of his own art with that of the auditory arts, intent upon finding a basic unity between his own efforts and those of the poets or musicians.

The biography of Georges Seurat is uneventful and lacking in picturesque details. While still young, he entered the studio of Lehmann at the École des Beaux-Arts. He remained there for four years, and as a souvenir of this, he kept hanging upon his wall an academy (a painted study of a male nude) and a conservative landscape. Discouraged by his attempts at painting, not yet having found his path, but gifted enough to perceive that conventional daubing was not to be his destiny, he took refuge in pure drawing. For several years he used nothing but black and white, amassing in this way an impressive collection of notes; he discovered, moreover, at least embryonically, the process he would later apply to painting.

His research consisted of rigorously transposing into *values* the gradations of shadow, the contrasts of white and black, of working the drawing as though he were in fact painting with a restricted palette. Instead of enclosing his figures with wirelike lines, he worked with masses of black and white, thus achieving vigorous modeling. Four portfolios are filled with these experimental works. They include the figures for his first large painting, the *Baignade,* studied, restudied, diversely modeled, until he had attained the simple, full, and flowing line that constituted for him the major interest of drawing. They include, too, studies of nocturnal shadows on lighted windowpanes, curious masks chosen for the intensity and simplicity of their expression.

We next encounter the first large painted canvas, the *Baignade,* which marks Seurat's passage through Impressionism and is his single most important effort in this style. In 1886 he exhibited totally new works, and with Camille Pissarro, Paul Signac, and others, he founded Neo-Impressionism, a school based on a new technique that he had invented.

I do not wish to review here the theory of Neo-Impressionism in 1886, the theory of a school that vulgar criticism has labeled Pointillist. The reader will find it very well described in a work by Félix Fénéon, *The Impressionists in 1886*.

What may be said here to characterize this stage in the artist's thought is that this technique had been indicated to him by two sources, the writings of Chevreul and Rood, and by presentiments of this technique in the work of older painters; he himself cited Delacroix's murals in Saint Sulpice, and he also claimed to have discovered divided color in works by Veronese and Murillo.

He had been attracted, moreover, by the early technique of Renoir and also that of Camille Pissarro, two painters who had tried, in essence, to achieve modeling in painting by means of the interlacing of small, colored lines. The question of the frame of the painting, very important to Seurat, was resolved by the white frame, which acted upon the canvas as an isolating agent. The usual gilt frame was rejected because it had too darkening an effect. The white frame, in its function, reflected the technique of these colorists, who, in order better to judge a color or tone, were in the habit of lowering their eyes for a moment to a neutral white surface like a piece of paper or a newspaper.

His achievement was the construction, from these diverse principles, of a rigorous and new esthetic.

The success of the Neo-Impressionists was so great at this point, especially among their literary colleagues, that they became the object of jealousy, and hostilities developed between them and members of the old Impressionist group.

Seurat was still not completely satisfied. He was living in a studio on the seventh floor of a house on the Boulevard Clichy. A small, monastic room, it contained a low, narrow bed, facing some of the older canvases, the *Baignade,* and some seascapes. In this white-walled studio hung his souvenirs of the École des Beaux-Arts, a small painting by Guillaumin, a Constantin Guys, some works by Forain—paintings and drawings that had become habitual for him and, in their coloration, a familiar part of his wall—a red divan, a few chairs, a small table on which sat side by side some friendly reviews, books by young writers, brushes and pigments, and his horn of tobacco. Standing against a panel, covering it completely, the *Grande Jatte,* which he studied again and again with a restlessness ever renewed, searching out all of its tiniest defects, seeking perpetually to satisfy his conscience.

In this small, narrow, and uncomfortable studio, cold in winter and torrid in summer, Seurat lived before his canvas daily for three months. Grown thinner, he left it to rest himself by painting seascapes, and he returned with six canvases, all different in motif and intent.

Seurat's restlessness grew out of the following reflections: "If, scientifically, with the experience of art, I have been able to find the law of pictorial color, can I not discover a system equally logical, scientific, and pictorial that will permit me to harmonize the lines of my painting as well as the colors?"

Seurat's dream was to discover this logically. For even though he believed that a scientific esthetic could not impose itself entirely upon a painter, because

there are intimate questions of art and even of technique that only a painter can raise and resolve, he nevertheless felt an absolute need to base his theories on scientific verities. His mind was not entirely that of a born painter, a painter like Corot, content to place pleasing tonalities on a canvas. He had a mathematical and philosophical mind, fit to conceive art in some form other than painting. I can explain more readily by saying that if some painters—and good painters at that—give the impression that they could have been nothing but painters, Seurat was one of those who give the impression that they have been induced to devote themselves to the plastic arts because of one aptitude that they possess among many, an aptitude that happens to be more highly developed in them than any of the others.

It was during this period of searching that he became acquainted with the work of Charles Henry on a scientific esthetic, in particular, the *Chromatic Circle,* the preface to which goes well beyond the single question of color to fathom the phenomena associated with line. This provided Seurat with only the basis, the precise and demonstrable basis that he had needed, and it enabled him to arrive at his final synthesis, noticeable ever since his seascapes at Crotoy and fully affirmed by his canvases *Le Chahut* and *Le Cirque.*

This latest step in his evolution was clearly described in a biography by Jules Christophe, and certainly this exposition of the principles involved had been approved by the painter. We reproduce it in its entirety in order to leave unaltered its conciseness and its clarity.

"Art is Harmony, Harmony is the analogy between Opposites and the analogy between Elements Similar in tonal value, color and line; tonal value, that is, light and shadow; color, that is, red and its complement green, orange and its complement blue, yellow and its complement violet; line, that is, directions from the Horizontal. These diverse harmonies are combined into calm, gay and sad ones; gaiety in terms of tonal value is a luminous dominant tonality; in terms of color, a warm dominant color; in terms of line, lines ascending (above the Horizontal); calmness in terms of tonal value is an equal amount of dark and light, of warm and cool in terms of color, and the Horizontal in terms of line. Sadness in terms of tonal value is a dominant dark tonality; in terms of color, a cold dominant color; and in terms of line, downward directions. Now, the means of expression of this technique is the optical mixture of tonal values, colors and their reactions (shadows), in accordance with very fixed laws, and the frame is no longer, as at first, simply white, but contrasts with the tonal values, colors and lines of the motif."

Let us add that, in conversation, Seurat defined painting for me as "the art of hollowing out a surface."

His taste in older art leaned in the direction of the hieratic, as in the Egyptians and the primitives. He was particularly attracted by the most flexible works, like Greek friezes and the works of Phidias; his choices among the ro-

mantic masters and the landscapists were broad, but, save for Delacroix, without enthusiasm.

Among the old style Impressionists, he stated freely that the three most important leaders, by virtue of their work and the influence they exerted upon other painters, were Degas, Renoir, and Pissarro.

Like almost all of the Impressionists, he was indebted to the Naturalist movement. And why not? For in their preoccupation with modern Paris and the modern street, in their evocation of the contemporary scene, the writers aligned themselves with the painters, at least in principle.

He declared himself able to paint only what he could see. The frescoes of ideological painting seemed to him lacking in essential qualities of luminosity. He did not feel, moreover, that in order to be intellectual a painting had to convey an allegory or a dramatic scene. For him, the dream was contained by the canvas itself, evoked by the canvas, by the idealization of the models or the motif.

That is why, in his ideal of harmony, in placing around his figures those accessories relevant to them, he wanted to give them a value by means of the direction of their lines and their arbitrary coloration. And, certainly, the modest accessories that surround his *Poseuses,* female bodies transfigured by light and by the elegance of line, are they not, by virtue of their essentially pictorial qualities, as beautiful and as decorative as the background décor of any imaginary fresco? And if one were to look really carefully at *Le Chahut,* one would see it, not as a painted image, but as a diagram of ideas, and one might read it thusly:

Dancers in a single rhythm, animated by the direction of the movement, congealed because it is the dominant movement, the leitmotif of the only action that interests us in these dancers, their dance. The female dancer's head, made admirably beautiful by the contrast of its official smile, almost priestly, with the tired delicacy of its small, fine features, marked by desire, conveys to us that this beauty has its complete meaning only in this principal activity of this feminine mind, thus to dance: this act becomes for the dancer something solemn because it is habitual. The male dancer is ugly, ordinary, a banal coarsening of the feminine physiognomy next to him. The smiling light of the female figure diminishes him, for he is not exercising an aptitude peculiar to his sex; he is merely plying an ignoble trade. His coat tails are forked, like the devil's tail in pictures by the old visionaries. The orchestra leader, chance director of this solemnity, closely resembles the male dancer; they are stamped out of the same mold and are both there by trade. As a synthetic image of the public, observe the pig's snout of the spectator, archetype of the fat reveler, placed up close to and below the female dancer, vulgarly enjoying the moment of pleasure that has been prepared for him, with no thought for anything but a

laugh and a lewd desire. If you are looking at all costs for a "symbol," you will find it in the contrast between the beauty of the dancer, an elegant and modest sprite, and the ugliness of her admirer; between the hieratic structure of the canvas and its subject, a contemporary ignominy.

This truly pictorial and artistic manner of seeking the symbolic (without troubling too much over the word) in the interpretation of a subject was, in his opinion, the most truly suggestive, and he was not alone in this opinion.

This demonstration of the subject, as it exists in *Le Chahut,* can be found in other canvases as well, particularly in *La Parade,* his first night effect in the cities, so willfully pallid and sad. But all of this is pointless. I had simply wanted to show that, for Seurat, the cerebral element, the value of thought, was equal to the value of all else, solely preoccupied as he was with painting as an ideological system.

List of Illustrations and Credits

Unless otherwise noted, the photographs of oil paintings, drawings, and prints were obtained from the owners; the prints of photographs from the photographers.

BEAUTY AND THE LANGUAGE OF FORM

James Stuart and Nicholas Revett, "Temple of Jupiter Olympius," 1794, engraving. From *The Antiquities of Athens*, vol. 3 (London: John Nichols, 1894), plate 2.

Sir Joshua Reynolds, *Self-Portrait*, 1775, oil on canvas. Uffizi Gallery, Florence, Italy.

Johan Zoffany, *The Academicians of the Royal Academy*, 1771–72, oil on canvas. National Portrait Gallery, Her Majesty the Queen's Collection, London, England.

Paolo Veronese, *Perseus and Andromeda*, 1803, engraving. From *Annales du Musée et de L'Ecole Moderne des Beaux-Arts*, vol. 4 (Paris: Chez C. P. Landon, 1803), plate 49.

A. R. Mengs, *Parnassus*, pen and ink drawing. Graphische Sammlung Albertina, Vienna, Austria.

Jacques-Louis David, *Self-Portrait*, 1791, oil on canvas. Uffizi Gallery, Florence, Italy.

William Gilpin, *Lake Scene with Cattle*, watercolor. Private collection. Photograph courtesy of the Courtauld Institute of Art, London, England.

Alexander Cozens, (a) *Ink Blot 14* and (b) *Ink Blot 40*. From *A New Method of Assisting the Invention of Drawing Original Compositions and Landscape*. Photographs courtesy of the British Museum, London, England.

René-Théodore Berthon, *The Dream of Orestes*, 1817, oil on canvas. Musée des Beaux-Arts, Dijon, France.

Gluck, Musical score. From Edmé-François Miel, *Essai sur les beaux-arts, et particulièrement sur le Salon de 1817; ou Examen critique des principaux ouvrages d'art exposés dans le cours de cette année* (Paris: Didot le Jeune, 1817–1818).

Abraham Teniers, *Village Fete* (after David Teniers), c. 1650s, engraving. From Jane Davidson, *David Teniers the Younger* (Boulder, Colo.: Westview Press, 1979), plate 3. Photograph courtesy of the British Library, London, England.

Marcantonio Raimondi, *Massacre of the Innocents* (after Raphael), c. 1513–15, engraving. Museum of Fine Arts, Boston, Massachusetts, Harvey D. Parker Collection.

Jean-Auguste-Dominique Ingres, *Portrait de l'Artiste*, c. 1864, oil on canvas. Koninklijk Museum voor Schone Kunsten, Antwerp, Belgium.

Jean-Auguste-Dominique Ingres, *The Vow of Louis XIII* (engraving after Luigi Cala-matta, with annotations by Ingres), Bibliothèque Nationale, Paris, France.

ART AND THE COMMUNITY OF SOULS

Johann Heinrich Füssli, *The Artist Moved by the Grandeur of Antique Fragments*, 1778–80, red chalk and sepia wash. Kunsthaus Zurich, Zurich, Switzerland.

Friedrich Overbeck, *Italia und Germania*, 1811–28, oil on canvas. Kunstdias Blauel, Gauting, West Germany.

William Blake, *The Laocoön*, c. 1822, line engraving. Fitzwilliam Museum, Cambridge, England.

Friedrich Overbeck, *Self-Portrait with Bible*, 1809, oil on canvas. Museum für Kunst und Kulturgeschichte der Hansestadt Lübeck, Lübeck, West Germany.

Friedrich Overbeck, *Device of the Lukasbund*, 1809, drawing. From Keith Andrews, *The Nazarenes: A Brotherhood of German Painters in Rome* (Oxford: Oxford University Press, 1964), p. 20.

Tommaso Minardi, *Self-Portrait*, 1806, oil on canvas. Uffizi Gallery, Florence, Italy.

Tommaso Minardi, *Madonna del Rosario* (copy after Raphael), 1841, watercolor. Uffizi Gallery, Florence, Italy.

Jean-Auguste Dominique Ingres, *Portrait of Étienne-Jean Delécluze*, 1856, graphite and white chalk on cream wove paper. Fogg Art Museum, Harvard University, Cambridge, Massachusetts, Grenville L. Winthrop Bequest.

Pierre-Nolasque Bergeret, *The Barbus in David's Studio*, c. 1805, lithograph. Museum Dahlem, Berlin, West Germany. Photograph courtesy of Photoatelier Jörg P. Anders.

Édouard Manet, *Profile Etching of Charles Baudelaire* (state 2), c. 1862. From Harris, *Édouard Manet: Graphic Works* (New York: 1970), Collector Editions, figure 123. Photo-graph courtesy of the New York Public Library; Astor, Lenox, and Tilden Foundations.

TRUTH TO NATURE AND THE NATURE OF TRUTH

Joseph Wright of Derby, *Sir Brooke Boothby*, 1780–81, oil on canvas. Tate Gallery, London, England.

Pierre-Henri de Valenciennes, *Biblis Changed into a Fountain*, Salon of 1793, oil on canvas. Réunion des musées nationaux, Paris, France.

Pierre-Henri de Valenciennes, *Rome, a Sky Filled with Clouds*, c. 1780–86. Réunion des musées nationaux, Paris, France.

Philipp Otto Runge, *We Three,* 1805, oil on canvas. Hamburger Kunsthalle e. V., Hamburg, West Germany.

Philipp Otto Runge, *Rest on the Flight into Egypt,* 1805–6, pen, pencil, and wash sketch. Hamburger Kunsthalle e. V., Hamburg, West Germany.

Philipp Otto Runge, *Rest on the Flight into Egypt,* 1805–6, oil on canvas. Hamburger Kunsthalle e. V., Hamburg, West Germany.

Asher B. Durand, *Kindred Spirits,* 1849, oil on canvas. New York Public Library; Astor, Lenox, and Tilden Foundations.

Sir J. E. Millais, *John Ruskin,* 1854, oil on canvas. Private collection. Photograph courtesy of Thames and Hudson, London, England.

John Constable, *Self-Portrait,* c. 1800, pencil drawing. National Portrait Gallery, London, England.

Camille Corot, *The Little Shepherd* (second version), c. 1856, glassplate print. Metropolitan Museum of Art, Jacob H. Schiff Fund, 1922, New York.

Benjamin Robert Haydon, *Torso of Dionysus Exhibited in the Park Lane Museum,* 1809, pencil drawing. Private collection. Photograph courtesy of Thames and Hudson, London, England.

Gustave Courbet, *Burial at Ornans,* 1849–50, oil on canvas. Musée du Louvre, Paris, France.

Nadar (Félix Tournachon), *Champfleury* (Jules Fleury), 1865, photograph. Caisse Nationale des Monuments Historiques et des Sites, Paris, France.

Bartholomeus van der Helst, *The Banquet of the Civic Guard, June 18, 1648, to Celebrate the Conclusion of the Peace of Münster,* 1648, oil on canvas. Rijksmuseum-Stichting, Amsterdam, Netherlands.

Nadar (Félix Tournachon), *Jean-François Millet,* c. 1855, photograph. Caisse Nationale des Monuments Historiques et des Sites, Paris, France.

Jean-François Millet, *The Gleaners,* drawing. Hugh Lane Municipal Gallery, Dublin, Ireland.

Jean-François Millet, *The Sower,* lithograph. New York Public Library; Astor, Lenox, and Tilden Foundations; Samuel P. Avery Collection.

Gustave Courbet, *"Bonjour M. Courbet," The Meeting,* 1854, oil on canvas. Musée Fabre, Montpellier, France. Photograph courtesy of Claude O'Sughrue.

ART AND SOCIETY

Nadar (Félix Tournachon), *Théophile Thoré,* c. 1865, photograph. Caisse Nationale des Monuments Historiques et des Sites, Paris, France.

Peter Paul Rubens, *Drunken Silenus Supported by Satyrs,* oil on canvas. National Gallery, London, England.

Gustave Courbet, *Les Paysans de Flagey, Revenant de la Faire,* 1850, oil on canvas. Musée des Beaux-Arts, Besançon, France. Photograph courtesy of J. E. Bulloz.

Gustave Courbet, *Proudhon and His Children in 1853,* 1865, oil on canvas. Musée du Petit Palais, Paris, France. Photograph courtesy of J. E. Bulloz.

Abel Lewis, *William Morris,* 1880, photograph. William Morris Gallery and Brangwyn Gift, London, England.

AN ART OF PURE VISION

Édouard Manet, *Émile Zola,* 1867–68, oil on canvas. Musée du Louvre, Paris, France. Photograph courtesy of Arts Graphiques de la Cité.

Henri Fantin-Latour, *Édouard Manet,* 1867, oil on canvas. Art Institute of Chicago, Stickney Fund.

Édouard Manet, *Déjeuner sur l'herbe,* 1863, oil on canvas. Musée du Louvre, Paris, France. Photograph courtesy of Arts Graphiques de la Cité.

Édouard Manet, *Olympia,* 1863, oil on canvas. Musée du Louvre, Paris, France. Photograph courtesy of Arts Graphiques de la Cité.

Telamaco Signorini, *Leith,* 1881, oil on canvas. Uffizi Gallery, Florence, Italy.

Edgar Degas, *Ballet Dancer Resting,* c. 1900–1905, charcoal drawing. The Santa Barbara Museum of Art, Santa Barbara, California, gift of Wright S. Ludington.

Auguste Renoir, *Bal au Moulin de la Galette,* 1876, oil on canvas. Réunion des musées nationaux, Paris, France.

Claude Monet, *La Gare St.-Lazare,* 1877, oil on canvas. Réunion des musées nationaux, Paris, France.

ART AS CREATION

Hans von Marées, *Portrait of Conrad Fiedler,* 1869–71, oil on canvas. Staatliche Kunst-sammlungen Dresden, Dresden, East Germany.

Index